BERNARD BERENSON

Formation and Heritage

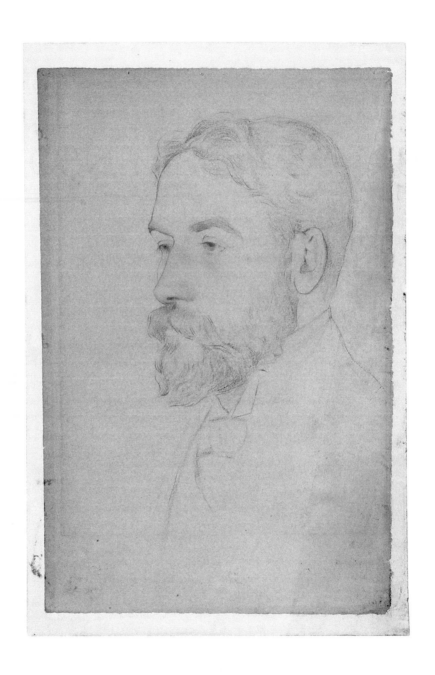

BERNARD BERENSON

Formation and Heritage

JOSEPH CONNORS *and*
LOUIS A. WALDMAN, *Editors*

VILLA I TATTI

THE HARVARD UNIVERSITY CENTER FOR ITALIAN RENAISSANCE STUDIES

© 2014 Villa I Tatti, The Harvard University Center
for Italian Renaissance Studies | itatti.harvard.edu

Printed in the United States of America by Sheridan Books, Inc.

LIBRARY OF CONGRESS CATALOGING-IN-PUBLICATION DATA

Bernard Berenson: formation and heritage.—First [edition].

pages cm.—(Villa I Tatti ; 31)

"The core of the present volume consists of the papers
presented at the conference 'Bernard Berenson at Fifty,'
held at I Tatti from 14 to 16 October 2009."

Includes bibliographical references and index.

ISBN 978-0-674-42785-3 (paper)

1. Berenson, Bernard, 1865–1959.
2. Art critics—United States.
I. Connors, Joseph.
II. Waldman, Louis A.

N7483.B47B47 2014

709.2—dc23

[B]

2013036803

Book and cover design: Melissa Tandysh
Book production: Dumbarton Oaks Publications

Cover illustration: William Rothenstein, *Bernard Berenson*, 1907.
Frontispiece: James Kerr-Lawson, *Bernard Berenson*, ca. 1898.
Both images are from the Berenson Collection, Villa I Tatti—
The Harvard University Center for Italian Renaissance Studies.
(Photo: Paolo De Rocco, Centrica srl, Firenze,
© President and Fellows of Harvard College.)

Contents

ONE

Introduction

JOSEPH CONNORS

Bernard Berenson: Critical Reception, 1959–2009

THE CORE OF THE PRESENT volume consists of the papers presented at the conference "Bernard Berenson at Fifty," held at I Tatti from 14 to 16 October 2009, on the fiftieth anniversary of Mr. Berenson's death on 4 October 1959. Somewhat to our surprise, we found that there was a passionately engaged public and enough fresh research to fuel a much longer conference. Indeed, several papers have been added post-conference that represent interesting new research. The cult of personality that surrounded Berenson as he aged had dissipated for the most part in the decades following his death, and his ideals as an art historian can no longer be said to be at the center of the field. But there is a new generation deeply concerned with the historiography of art history and the intellectual roots of connoisseurship. It was this interest that we principally wanted to address.

In the years immediately following Berenson's death, aside from numerous obituaries in the Italian and international press, one might single out three more thoughtful evaluations of his life and work: two glowingly positive and one distinctly negative. In her warm memoir of 1960, Iris Origo avoided any evaluation of Berenson's literary production and left aside the commercial side of a life built on connoisseurship in order to dwell on the man she knew as a reader of catholic tastes and an insatiable traveler. Even in old age, she reminds us, he traveled to distant and uncomfortable lands, never without the famous lists or the projected book on the decline of classical form on his mind, but driven as well by an unquenchable thirst for knowledge through sight. Zest for life came with intense

looking, whether in the distant Balkans, or in Libya, or in the hills above Vincigliata and the garden at I Tatti: "Each day, as I look, I wonder where my eyes were yesterday."[1]

Meyer Schapiro visited I Tatti on 21 May 1927, after a year of travel in Europe and the Middle East. Then twenty-three and a graduate student at Columbia University, Schapiro had been born, like Berenson, in Lithuania, although his family emigrated soon afterward to America. Schapiro recorded his impressions in a letter later that day: Berenson was at first crusty and created a bad impression by ranting against Schapiro's teacher at Columbia. But he soon changed his tone and eventually gave this unknown student many hours of his time, walking through the collection and inviting his views. Berenson also wrote of the visit shortly afterward, not without admiration for the intellectual acumen of his young countryman: "I put him to the task, I showed him my jade libation cup and my little bronze candlestick and he praised them and discoursed about them as smartly as Solomon did about the hyssop that grows on the wall."[2] The admiration was not reciprocated, however. The mature Schapiro, socialist in politics, brilliant interpreter of modern art, and theoretician of art history, felt a mounting disdain over the years for the "Sage of Settignano." He revisited I Tatti in 1931, but it did not heal the rift, and by the 1940s we find him drawing a satirical cartoon featuring "Mr. Berenson and the Collector."[3] Berenson's death in 1959 seemed to call for comment, and the appearance of Sylvia Sprigge's journalistic biography in 1960 provided enough information on the commercial side of Berenson's career to arouse his indignation. Schapiro articulated his distaste for everything that the older man stood for in an article published in *Encounter* in January 1961.

"Mr. Berenson's Values" is a thoroughly negative obituary. Schapiro criticized Berenson for rejecting his Jewish identity, but thought it showed through in character traits such as his "Talmudic" fondness for working over the fine points of attribution. He belittled claims that Berenson discovered Paul Cézanne and established the reputation of Henri Matisse, focusing instead on the rejection of modern art in the latter half of Berenson's career. Schapiro grudgingly found value in the abstract concepts of his early writings—ideated sensations, tactile values, life-enhancement—but lamented that Berenson failed to summon up the intellectual energy to revise and synthesize the "Four Gospels." Instead, Schapiro complained, he concentrated on the refinement of the lists under the influence of his clients and retainers: "His sensibility became the instrument of

☞ I would like to express my thanks to all the staff of Villa I Tatti for their help in organizing the symposium of 2009, in particular to Louis Waldman for his enthusiastic collaboration, and to Susan Bates, Angela Lees, and Françoise Connors for the smooth running of the event. Thanks for their suggestions during planning also go to Jaynie Anderson, Jane Martineau, Patricia Rubin, and Patrizia Zambrano. Over my term as director of Villa I Tatti, access to the photographic and documentary archives at Villa I Tatti was graciously facilitated by Fiorella Superbi, and in the year preceding the conference by Ilaria Della Monica, Giovanni Pagliarulo, and Sanne Wellen. Publication of this volume is indebted to Lino Pertile, the current director of Villa I Tatti, and to Jonathan Nelson, who expertly took over production. To them and to all who assisted with this book, I express my warmest thanks.

1 Origo 1960, 153.
2 Damisch 2007, 15f., n. 2.
3 Schapiro and Esterman 2000, 172.

a profession."[4] Rubbing in Berenson's own misgivings late in life about the path his career had taken, Schapiro treated him as a miraculously surviving symbol of the sweetness of life before 1914, with its untaxed income and opportunities for an aesthetic style of life.

Kenneth Clark, who had lived at I Tatti in 1925 and, in spite of personal differences and the diverging direction of his scholarship, remained a brilliant disciple of Berenson. He delivered a magisterial eulogy in Florence, in Palazzo Vecchio, which was published in *The Burlington Magazine* in September 1960. In it, Clark elaborates some of the points already made in an obituary he wrote for the London *Times* the previous year. Although Clark's *Burlington* article came out four months before Schapiro's, it reads uncannily like a point-by-point response to the American scholar's attack. There are naturally some concessions to the genre of eulogy, such as the lines on Berenson's love for the Italian landscape and his lifelong bond, in war and peace, with the Italian people. The main thrust of the piece, however, is a critical examination of Berenson's intellectual achievements, exactly the domain disparaged by Schapiro. Clark perceptively sees the origin of his aesthetic concepts in Johann Wolfgang von Goethe and, closer to home, in the writings of the Florentine-based sculptor Adolf von Hildebrand. He captures their impact on a world dominated by Ruskinian appreciation of art as illustration, and he finds Berenson's most original idea, ideated sensations, to be a valid basis for criticism. On the other hand, Clark explores Berenson's initiation into Morellian connoisseurship, the skill that would eventually derail his career as a writer and aesthetician. He notes the swelling of Berenson's reputation after his reviews of the New Gallery Exhibition of 1894, when, as Clark memorably puts it, "his attacks so alarmed collectors and dealers that there was nothing for it but to persuade this terrible poacher to turn game-keeper."[5] Clark re-poses the question Berenson often asked himself late in life—that is, whether, in pursuing connoisseurship, he had taken the wrong path. Clark reminds us that Berenson says, in his *Sketch for a Self-Portrait,*

> I cannot rid myself of the insistent inner voice that keeps whispering and at times hissing "you should not have competed with the learned nor let yourself become that equivocal thing, an 'expert.' You should have developed and clarified your notions about the enjoyment of the work of art. These notions were your own. They were exhalations of your vital experience."[6]

In a thought experiment, Clark puts himself inside the head of Berenson and tries to see why, at the crossroads of his early maturity, he chose connoisseurship over criticism, the lists over the essays. Though the lists were originally, according to Clark, "a sharp weapon used to assault an inert mass of tradition, they themselves became the mass, the canon, the object of assault."[7] They could not be left forever as they stood in the 1890s. The

4 Schapiro 1961, 64.
5 Clark 1960, 382.
6 Ibid., 384.
7 Ibid., 383.

demand for names was relentless; the lists were constantly being updated in his head, and it was infuriating for him to be sent corrections that he had already made, but not published, years before. On the other side of the balance, Clark observes that the aesthetic concepts were already embodied in such rich, dense texts that Berenson feared he would only be repeating himself if he went back to them. In any case, he felt that his real achievement was conversation, not the written word. Clark gives Berenson's melancholic self-evaluation Homeric resonance by saying that Berenson treated ideas and knowledge in the way the ancient bards treated legend and poetic imagery: as an inexhaustible reservoir to be drawn on for the delight of his audience, without wanting to deprive them of life by fixing facts and ideas on a printed page.

Correspondence is by its nature reciprocal, and in Berenson's case it was conversation meditated in the slow pace of letters that were eagerly opened and, "except for *billets-doux*,"[8] read aloud before Mary Berenson and Nicky Mariano. Berenson consecrated hours each day to his correspondence. Although Joseph Duveen gave Mary a typewriter in 1922, she though it impolite to use the device for personal correspondence. Berenson's hand became crabbed with age and it takes great patience to read the late letters, though sometimes Mariano would type them up, not to send but as records. The archives at I Tatti contain thousands of letters from hundreds of correspondents. Mariano managed to put them in order when cleaning out the house after Berenson's death; she felt that even the unimportant letters might help to create an image of his "spiderweb," with its threads spun out in every direction. She relied on them to supplement her reminiscences in the charming memoir that she published in 1966, *Forty Years with Berenson*. Her inventory of the correspondence was published in 1965; a continually updated copy is kept in the archives of Villa I Tatti and is now available on their website.

The letters sent out from I Tatti by the thousand are findable to some extent in the archives of the Berensons' correspondents, and several of the articles in this volume are based on discoveries in far-flung repositories. Some, like Belle da Costa Greene, destroyed Berenson's letters, which, in Samuels's apt phrase, seemed to him a kind of homicide.[9] Many more kept them, however, and they are waiting to be brought to light.

The known correspondence and diaries, not available to the first biographer, Sylvia Sprigge, were the basis for the major event in the study of Bernard Berenson since his death, the publication of Ernest Samuels's two-volume biography, *Bernard Berenson: The Making of a Connoisseur*, in 1979, and *Bernard Berenson: The Making of a Legend*, in 1987. Samuels had consulted the Berenson Archive while doing research for his biography of Henry Adams, and he realized that the master of I Tatti could himself be the subject of a fascinating study. Between Berenson's death in 1959 and Mariano's in 1968, the archives were the property of Berenson's companion, Elisabetta "Nicky" Mariano, and not initially part of the bequest to Harvard University. After her death in 1968, the archive passed to Mariano's heirs, the family of her sister, the Baronessa Anrep, only coming into the possession of the Harvard Center in 1984. Samuels had unlimited access to

8 Trevor-Roper 2006, 157.
9 Samuels 1987, 541.

the archives during this time of transition and used them to produce a scrupulous, even-handed biography, "official" only in its unfettered access to the sources, but in fact anything but hagiographic. Among its other qualities, it is beautifully written—anyone who reads the first chapter on Berenson's Lithuanian childhood, for example, will want to read further. Samuels's work will long be the basis of scholarship about Berenson and his world, and every article in the present collection is indebted to it.

Two recent books explore individual correspondents who are represented in the archive by extensive *fondi* of colorful and zesty letters. Heidi Ardizzone's *An Illuminated Life* relies in the earlier chapters on Belle da Costa Greene's 615 letters to Berenson, many of which are passionate love letters. As noted in the essay on Katherine Dunham in this volume, Ardizzone's fine book sheds light on the boundaries imposed by race in the society in which Berenson moved, and the strategies by which these boundaries might be transgressed. Hugh Trevor-Roper, historian of early modern England and later Regius Professor of Modern History at Oxford University, Master of Peterhouse in Cambridge University, and Lord Dacre of Glanton, visited I Tatti in the summer of 1947 on the recommendation of Mary's brother, Logan Pearsall Smith. Berenson enjoyed the meeting enormously and invited Trevor-Roper to return whenever he was in Italy and to write from Oxford. This he did, with gusto—the historian and the connoisseur maintained an avid correspondence for the dozen years prior to Berenson's death. Trevor-Roper's half of the exchange was published in exemplary form by Richard Davenport-Hines in 2006; Berenson's half, now kept with the Dacre papers in the Bodleian Library, was judged to be less interesting and only occasionally appears in Davenport-Hines's notes. Essentially, Berenson offered Trevor-Roper an ear that delighted as much as his own in the wicked and the cutting, and his rehearsals of academic battles at Oxford were preparation for the grand narratives of English history that he planned and researched, but in the end failed to write.

The business of connoisseurship, dismissed with contempt by Schapiro and explained away with regret by Clark, has attracted wave after wave of interest, especially in publications of the past decade. Berenson's participation in the art market, first as agent for Isabella Stewart Gardner, then in collaboration with Otto Gutekunst of Colnaghi, and finally on retainer from Joseph Duveen, has been studied in Cynthia Saltzman's 2008 book on American collectors of the belle époque and in Meryle Secrest's detailed biography of Joseph Duveen, published in 2004. A play by Simon Gray, *The Old Masters*, which opened in London in 2004 and moved to New York in 2010 (and was even performed at I Tatti in 2009), draws attention to the drama of Berenson's final encounter with Duveen, when Berenson refused to attribute the Allendale *Nativity* to Giorgione, as advantageous as that would have been for both parties. Ironically, most scholars now believe, contra Berenson, that the painting is indeed by Giorgione. Recently there has been work on some of the other relationships that allowed Berenson to maintain his high style of life. In his book on Henry Walters and Berenson, published in 2010, Stanley Mazaroff documents in fine-grained detail the formation of the Walters collection from the point of view of the collector, delineating a relationship in which Berenson appears more of a dealer than he does with Gardner.

Berenson's changing attitudes to the art of his own day, from his early championing of Matisse and Cézanne to his later rejection of modern art, have already been the subject of a probing book of 1994 by Mary Ann Calo. A light has been turned more recently on the appreciation of Matisse by Gardner and her friends, in Anne McCauley's essay of 2003 in the Isabella Stewart Gardner Museum catalog, *Eye of the Beholder*. McCauley explores the appreciation of this revolutionary artist in generally conservative circles that overlapped so much with Berenson's. A paper presented at the I Tatti conference by Alan Chong, which is not included in the present collection, also addressed the nexus between Gardner and the fauvist painter. Berenson acquired a small painting by Matisse, *Purple Beeches*, in Paris in 1910. Eventually he gave it to his friend Prince Paul Karageorgevic of Yugoslavia, and he presented paintings by Camille Pissarro (*Rural Scene*) and Charles Conder (*At the Seashore*) to the future Museum of Contemporary Art in Belgrade that was being built up with Prince Paul's encouragement. The Serbian connection has now been illuminated thanks to the efforts of his daughter, Princess Elizabeth Karageorgevic, to bring her father's vision as a collector to light, principally via the catalog of the Prince Paul Museum in Belgrade, published by Tatjana Cvjetćanin in Serbian in 2009 and in English in 2011.[10] Berenson's Matisse returned to Florence in 2007, one is tempted to say in triumph, for the exhibition *Cézanne a Firenze*, held in Palazzo Strozzi. The accompanying catalog is a pioneering study of the reception of Cézanne in Florence through the collecting activities of two American expatriates, Berenson's friend Egisto Fabbri and his rival Charles Loeser—fascinating figures who were explored further in the exhibition of 2012, *Americans in Florence*.

The evolution of the collection over time and its placement in the villa have been the subject of several recent studies. In 1997, Patricia Rubin, at that time acting director of the Harvard Center, delivered a paper on this topic at a conference in the Georgetown villa in Fiesole, Le Balze, which was then published in 2000 in the acts of the conference, *Gli Anglo-Americani a Firenze*. The formation of the entire collection will be the subject of a detailed chapter in a forthcoming catalog being prepared under the direction of Carl Brandon Strehlke and Machtelt Israëls.

To return to a point raised by Schapiro, there will be a sensitive treatment of Berenson's ambiguous relationship to his Jewish roots in a forthcoming biography by Rachel Cohen in the series *Jewish Lives*. A prelude to her findings can now be read on the internet, in a virtual exhibition curated by Jonathan K. Nelson in 2012 on the Villa I Tatti website, entitled "Berenson at Harvard: Bernard and Mary as Students." The online catalog presents helpful, short biographies of the personalities who taught Berenson at Harvard, including his instructors in Hebrew and Oriental languages. It also collects his writings in Harvard literary publications as an undergraduate.

Finally, some mention should be made of recent studies of Berenson's scholarship. In a monograph of 2006, Antonella Trotta has returned to Berenson's first work of art history, *Lorenzo Lotto*, which originally came out in 1895 and has been republished

10 Cvjetćanin 2011.

several times, most recently by Luisa Vertova in 2008.[11] In 2009, Carmen Bambach contributed an exemplary study of Berenson's 1903 *Drawings of the Florentine Painters*, published for a series of critical articles on the founding books of art history in *The Burlington Magazine*. She offers a remarkable analysis of Berenson's method as a pioneer in a new field, underlining in his monumental achievement while not glossing over its shortcomings.

Paradoxically, the essay by Berenson that was most quickly doubted and eventually rejected by the connoisseurship community is the one that has recently received the most attention. It is the famous article "Amico di Sandro," first published in the *Gazette des Beaux-Arts* in 1899 and republished in *The Study and Criticism of Italian Art* in 1901. In it, Berenson isolates the oeuvre of a painter close to Sandro Botticelli and deeply influenced by him, but distinct from his best-known disciple, Filippino Lippi. Patrizia Zambrano published the first Italian translation of the article in 2006, with an in-depth introduction. Hard on the heels of her monograph on Filippino, which was coauthored with Jonathan Nelson in 2004,[12] her introduction charts the influence of Walter Pater's image of Botticelli on Berenson, as well as the idea, expressed by Gustavo Frizzoni as early as 1891, that there had to be an intermediate personality. She notes the earliest skepticism of the new and as yet unnamed artist on the part of Herbert Horne, who eventually won over the initially credulous Roger Fry. Fond of his own creation, Berenson would keep Amico di Sandro in his lists until 1932. Zambrano also traces the great schism between Berenson and Roberto Longhi, finding the ultimate refutation of Berenson's Florentine-centric Renaissance in Longhi's 1927 monograph on Piero della Francesca. Her introduction is closely argued and her wide reading in the history of connoisseurship is demonstrated in cornucopian notes. "Amico di Sandro" is also the subject of a close reading in 2011 by Jeremy Melius, who emphasizes, in postmodern critical prose, the concept of personhood in relation to the psychology of William James and the aesthetics of Vernon Lee.[13] All such studies refer to the founding of scientific connoisseurship by Giovanni Morelli. The burgeoning field of Morelli studies was opened up by a conference in Bergamo in 1987 and by Jaynie Anderson's ongoing publication of Morellian sources as well as interpretations of his personality and work.[14] These publications seldom explore the Berensonian world, which is a generation later, but they lay the foundation for the study of the origins of scientific connoisseurship.

The Essays in the Present Volume

Connoisseurship in Theory and Practice:
Isabella Stewart Gardner, Jean Paul Richter, Otto Gutekunst, Umberto Morra

Isabella Stewart Gardner helped to finance Berenson's travels in Europe after Harvard, when he was a promising literary figure with the ambition of becoming a new Goethe. After months of seemingly directionless letters from Europe from the young Harvard graduate,

11 Trotta 2006.
12 Zambrano and Nelson 2004.
13 Melius 2011.
14 Anderson 1999 and 2000; and Morelli 1991.

she grew disillusioned and broke off their correspondence. A chance meeting in London in 1893, however, rekindled the friendship at just the right time. Gardner had come into her full estate of $2 million with the death of her father in 1891, and Berenson had refashioned himself into the leading connoisseur of early Italian art, with many contacts among dealers and noble families in need of money. It was a match made in heaven. The letters between Berenson and his first important patron were published in full by Rollin Van N. Hadley in 1987. They form the foundation of a perceptive article by Patricia Rubin in a 2000 issue of *Apollo*, and are also the basis of Antonella Trotta's Italian monograph of 2003, *Rinascimento Americano*. Gardner exerts a perennial fascination. The world of personalities and objects that she built around herself, first in Back Bay and later in Fenway Court, has been studied in two recent exhibitions at the Gardner Museum: *The Eye of the Beholder*, held in 2003; and *Gondola Days*, held in 2004. Her interest in the Orient and voyage to the Far East, a trip Berenson never managed to make, were the subjects of another innovative exhibition, *Journeys East: Isabella Stewart Gardner and Asia*, held at Fenway Court in 2009.

Several essays in this volume return to Gardner and the formation of her collection, exploring the origins of Berenson's eventual vocation as a paid expert. Dietrich Seybold examines the role that Jean Paul Richter (1847–1937), art historian and connoisseur-dealer, had in the development of Berenson's self-conception. At first, the connection might seem purely commercial. The Giambono *St. Michael Enthroned* that presides over the I Tatti dining room today came onto the London market in 1893 as "German school." Berenson immediately saw the correct attribution and acquired a partial interest in the painting along with Richter. The Giambono continued to hang in Richter's London house until Berenson bought out Richter's interest. It entered I Tatti in 1900, the year of the Berensons' marriage.

Seybold shows, however, that the connection ran deeper than commerce. When the twenty-four-year-old Berenson first met Richter in 1889, he was, of course, the well-known author of the great two-volume collection of Leonardo da Vinci's notes and manuscripts, first published in 1883. He was also the rising star in scientific connoisseurship, achieving the height of fame in this field after the death of his master, Giovanni Morelli, in 1892. Berenson's youthful appraisal of the older figure showed his own ambition: "This is a very famous critic—but I did not feel so very little beside him."[15] Richter made his fortune with the export from Italy of two major works by Andrea Mantegna and Giorgione. His lesson for the young American was that one could live by connoisseurship. Although it would take a dozen years, Berenson eventually came to outshine his early role model as the foremost connoisseur of his day, and he engaged in the trade more than Richter ever had. Richter opened up possibilities for the young Berenson, but he also foreshadowed the ambiguities that Berenson never shed about his own career.

15 See Berenson to Senda Abbott (Berenson), Easter Sunday (21 April) 1889, Bernard and Mary Berenson Papers, Biblioteca Berenson, Villa I Tatti—The Harvard University Center for Italian Renaissance Studies (hereafter BMBP).

Otto Gutekunst, director of Colnaghi's gallery in London from 1894 to his retirement in 1939, has now emerged as a key figure in most of the Gardner acquisitions that used to be credited to Berenson alone. Jeremy Howard, head of research at Colnaghi's in London, draws in his article on the archives of the firm as well as on the Berenson Archive to illuminate the relationship between Berenson and this dealer of high aesthetic sense. Howard's essay complements both Cynthia Saltzman's book of 2008 on the formation of Old Master collections in America and his own history of the Colnaghi firm, published in 2010. Gutekunst had started as a print dealer but then entered the field of Old Master paintings just at the time when the British aristocracy was looking for ways to cope with debilitating death duties. He was the essential middleman in Gardner's acquisition of the thirty or so Old Master paintings that form the core of her collection, in particular Botticelli's *Tragedy of Lucretia* and Titian's *Europa*. Berenson and Gutekunst encouraged Gardner to think of herself as an Isabella d'Este. They did not just sell her paintings, but transformed them into objects of sublimated desire. Beginning in about 1904, Berenson began to drift away from Colnaghi as he came into the powerful gravitational field of Joseph Duveen. Howard closes with one of the most touching of the many letters quoted in this book, in which Gutekunst, indignant for a moment at his friend's excessive high-mindedness, questions the arrogance of an elite inner circle whose hands are always clean and who think they make no mistakes. The friendship nevertheless endured until Gutekunst's death in Geneva in 1947.

The mixture of flattery, idealism, and banter that characterizes Berenson's letters to Gardner came to shape a little-known appendage to Fenway Court. Robert Colby's essay on the Altamura garden pavilion that stood at the rear of the Gardner Museum from 1907 to 2009 shows how architecture, even *architettura minore*, can be a bearer of symbolic meaning. When Fenway Court was finished in 1903, Gardner turned to the rear garden, which was supposed to be surrounded by walls and a high, ivy-covered trellis to keep out the prying eyes of a fast-developing quarter. It became possible to build the garden wall and its attached gatehouse once the final vacant lots were acquired in 1907. Gardner's architect, Willard T. Sears, submitted a design for a handsome Venetian-style garden pavilion, four stories high with a clock and open loggia, to serve as rear entrance and centerpiece of the garden-encompassing wall. But when Gardner received a postcard from the Berensons, dated 4 May 1907, showing the Bari Gate of Altamura, a picturesque fortified town in the instep of the boot of Italy, she immediately adopted this baroque design, with its violin-curve volutes, instead of the Venetian-style loggia that was, in effect, more consonant with the character of her museum.

Altamura had a meaning for the Berenson circle that went deeper than a modest city gate. It was the title of an essay published in the third and last number of a short-lived periodical, *The Golden Urn*, in 1898. Logan Pearsall Smith, Mary's brother, later claimed authorship, probably rightly, but there was considerable input, partly playful and partly serious, from Bernard and especially Mary as well. The essay described a fictional monastic community, Altamura, which sheltered the worshippers of St. Dion, who went through a ritual year dedicated to the cultivation of beauty and the rejection of everything that smacked of capitalism, modernity, and the values of the middle class. Only true aesthetes

could be Dionites, but occasionally grandes dames could visit, a hardly veiled allusion to Isabella Stewart Gardner. The rest of this number of *The Golden Urn* was devoted to an extensive list, organized by city and museum, of the Renaissance paintings that Dionites would cherish as icons of the religion of beauty. This was certainly the contribution of the Berensons, in the format that would eventually grow into their famous lists.

Colby's research, conceived while he was a curatorial fellow at Fenway Court, and later continued as a fellow at I Tatti, might have deepened the debate surrounding the enlargement of the Gardner Museum, had it been taken into account. But the preservationist community was not, in the end, successful in preventing the demolition of the Altamura gatehouse, which occupied the site that Renzo Piano intended for the new entrance to the museum. It succumbed to the wrecker in 2009. The ideal expressed in 1898 in the "Altamura essay," as important as it was in the self-conception of the Berenson circle, succumbed soon enough to Berenson's dealings in the art market and to the realities of connoisseurship as a profession, with all the tedious labor involved in revising the *Drawings of the Florentine Painters* and the ever-changing lists. Much of Berenson's writing in old age shows his regret at his turn away from the more purely aesthetic and literary ideals of his youth. But the ideal of a "lay monastery" devoted to conversation and the contemplation of beauty, to enhancement of the whole personality, and to "life-enhancing" scholarship survived in the foundation document for the Harvard University Center for Italian Renaissance Studies that I Tatti was to become after Berenson's death.

Count Umberto Morra di Lavriano (1897–1981) was a close friend of Berenson from his first introduction to I Tatti in 1925 to Berenson's death in 1959. Both felt an elective affinity across an age gap of thirty years. Both were passionate about English literature and both were deeply interested in contemporary political events. Morra, the aristocrat with a royalist background, was intensely antifascist, especially after his friend Piero Gobetti was attacked by fascist thugs, dying soon afterwards as the result of his beating. After that point in 1926, Morra went underground, operating clandestinely from his villa near Cortona, though making frequent visits to I Tatti until the time Berenson himself was forced into hiding in 1943. One of the qualities that endeared Berenson to Morra was his skill as a listener, one who abetted conversation by his ability to hold up the less vocal end of a dialogue without flattery but with deep sympathy and understanding. It is said that Morra's *Conversations with Berenson* comes closer than any other source to capturing the evanescence of Berenson's conversational flow. Robert and Carolyn Cumming knew Morra well in their student days in Italy in the 1970s. In their essay, they recount their experience of the man and describe the deep personal qualities that drew both them and Berenson to him.

Berenson and the Germans: Adolf von Hildebrand, Aby Warburg
The most widely recognized phrase in all of Berenson's aesthetic writing is "tactile values." Alison Brown is a distinguished intellectual historian and student of Renaissance politics, an author of books on Bartolomeo Scala and on the fortune of Lucretius in the Renaissance as well as on works on the circle of Anglo-Saxon expatriates around the Berensons. She was a student of Ernst Gombrich at the Warburg Institute and first came

across tactile values in his lectures. Her essay looks at this concept in the writings of the sculptor and theorist Adolf von Hildebrand and in the philosophy of William James.

In Hildebrand's *Das Problem der Form in der Bildenden Kunst*, which Berenson read and annotated, the sculptor says that, for the visual artist, the central problem is to endow a flat surface with three-dimensionality. The artist rouses the tactile sense and creates ideated sensations that communicate vitality and life-enhancement. Reading Hildebrand helped break Berenson's writer's block when starting on *Florentine Painters of the Renaissance* and eventually allowed him to see the affinity between Masaccio and modern artists, such as Edgar Degas. On the other hand, William James, Berenson's teacher at Harvard and a visitor to Florence in 1892–93, helped shape his conceptions of will, energy, and life-enhancement. Although there was mutual suspicion between the professor and the future connoisseur, somehow they felt, in common, that when we look at a work like Antonio Pollaiuolo's *Hercules*, a fountain of energy springs up under our feet and works its way into our veins. The psychologist-cum-philosopher and the aesthete-cum-connoisseur helped each other to see Renaissance art in new ways.

Florence was important in the shaping of the other great protagonist of early twentieth-century art history, Aby Warburg. Bernd Roeck, who holds the chair of general modern history and Swiss history at the Universität Zürich, published a book on the young Warburg in 1997, then turned to a study of Warburg in the Florentine context in the largest sense—*Florenz 1900: Die Suche nach Arkadien*, published in German in 2001 and in English translation in 2009. He explores the multifaceted society in which Warburg moved, beginning with his first visit as a student in 1888 and continuing though his famous lecture at the International Conference of 1911 in Florence. Roeck explores Warburg's Botticelli in terms of the late nineteenth-century cult of the artist, but also studies the larger German expatriate community, the antiquarians and dealers, the litterateurs, and the aesthetes of all stripes, including a perceptive chapter on Berenson and Anglo-Saxon villa culture. All of this is put into the context of the other Florence—the "real" world of violent labor unrest, lopsided economic development, and conflict between the demolishers of the historic center and the international outcry in the name of preservation.

In his paper, Roeck begins by returning to the fundamental theme of his book, "the people who come to terms with the present by attempting to flee from it." He seeks to understand the paradoxical roots of modernity and the space opening up for an avant-garde in the midst of world-renowned collections of Renaissance masterpieces. The essay is focused not so much on Berenson as on the stage on which Berenson acted out his performance. Hildebrand and Berenson's rival in collecting and connoisseurship, Charles Loeser, makes an appearance. We are reminded that the first mention of Cézanne in the literature of art history occurs in Berenson's *Central Italian Painters of the Renaissance* of 1897, evoking a theme that was explored in the groundbreaking exhibition, *Cézanne a Firenze: Due collezionisti e la mostra dell'Impressionismo del 1910*, organized in Palazzo Strozzi in 2007. Roeck intersperses, in pointillistic detail, evocations of the sounds and scents of the city on the Arno as noted by perceptive visitors. The second half of the essay deals with the Parisian art dealer, Wilhelm Uhde, now little known but in his day a pivotal figure of the avant-garde, who formed a collection of works by Pablo Picasso, Georges

Braque, Henri Rousseau, Jean Dufy, André Derain, and Maurice de Vlaminck, thus combining a love of the Florentine Quattrocento and the Florence of Jacob Burckhardt with a veneration for Edouard Manet's *Olympia*.

Claudia Wedepohl, an art historian and archivist at the Warburg Institute in London, highlights a key meeting in Hamburg in 1927, when Berenson first visited Warburg's library. The two scholars had not met since 1898 and each held the other in relatively low esteem: Berenson disdained iconography, while Warburg belittled mere connoisseurship and disliked Berenson's arrogant personality. The surprise was mutual when the meeting went rather well. Warburg dwelt on a *cassone* panel from the Jarves collection at Yale University, which he had discovered in a visit to Berenson's photographic archive at I Tatti in 1898. Mary had attributed the panel to the "Master of Virgil's *Aeneid*," a constructed personality of the sort that delighted early twentieth-century connoisseurs. Warburg, on the other hand, wanted to fit the panel into his analysis of festivals and jousts in Florentine society, an example of "cultural-historical iconography." The two schools of thought could, in this fruitful moment of truce, focus on the same work of art. Warburg went further and tried to show Berenson that his method could complement that of the connoisseur. Both felt the appeal of Hildebrand's theory of forms, which stood at the heart of Berenson's tactile values. Wedepohl shows how Warburg's psychology ultimately derives from Robert Vischer's 1873 doctoral dissertation, which introduced *Einfühling*, a term later translated by Vernon Lee as "empathy," into art history. Warburg warns the viewer not to succumb to empathy but to keep a distance from the work, quite the opposite of Berenson's approach. Wedepohl also shows how, as early as 1900–1, Warburg began to distance himself from the aestheticizing approach and from the Morellian method to which Berenson was to remain faithful all his life. Thus, the meeting of 1927 was a moment of cordiality masking an ever-widening intellectual divide.

Islamic and Oriental Art

On a tour of I Tatti, the perceptive visitor will be struck by a small number of Islamic works discreetly interspersed with the Renaissance paintings that dominate the collection. In the Berenson Reading Room (known in the Berensons' time as the "Big Library"), visitors may note a pair of colorful miniatures from a treatise on automata, *Kitāb fī ma'rifat al ḥiyāl al-handasiyya* (*Book of Knowledge of Ingenious Mechanical Devices*) by al-Jazari, illustrated in Mamluk Egypt in 1354. Near the Signorelli corridor hangs a leaf from the Great Mongul (formerly Demotte) *Shahnama*. There are several illuminated manuscripts kept under lock and key, and one of the great privileges of I Tatti is to be shown the illustrated *Anthology* of Baysunghur, the princely hero of the book but also the incarnation of the Orientalist-Renaissance ideal that guided collectors and scholars at the opening of the twentieth century, a phenomenon studied by Priscilla Soucek in a perceptive article of 2001.

These works have justly attracted attention. The great scholar of Islamic art, Richard Ettinghausen, studied them closely for his catalog of the Berenson Islamic collection, published in 1961. The Great Mongol *Shahnama* from which Berenson's leaf derives is treated in depth in a number of publications from the 1979 thesis of Mariana Shreve

Simpson, through the 1980 monograph by Oleg Grabar and Sheila Blair, to the 2004 book by Robert Hillenbrand. Angelo Piemontesi treated the Persian manuscripts in an article of 1984, while Gauvin Bailey wrote on the Islamic manuscripts in a pair of useful articles in *Oriental Art* in 2001 and 2002. All these scholars concern themselves with the dating and attribution of the objects, but what remains to be studied is the place of Oriental art, and of a larger image of Islam and the Orient, in Berenson's imagination, a task begun by Michael Rocke in an article of 2001.

Mario Casari, who teaches classical Persian literature at the University of Rome "La Sapienza," explores Berenson's interest in Islamic art. Berenson conceived of himself in this early period partly as a literary figure and partly as a philologist in the late nineteenth-century sense of the term, when language was seen as the key to culture. From his upbringing in the Jewish world of Lithuania, Berenson of course knew some Hebrew, but at Harvard he added courses in Sanskrit and Arabic. Had he been granted the Harvard traveling fellowship for which he applied in 1885, to study Arabic in Berlin, he might have had a serious career in Oriental research, but instead he followed his literary bent and let the difficult languages lapse. His remained a romantic Orientalism. Casari illuminates the roots of this mentality in unpublished juvenilia from the Harvard period. Berenson's openness to Islamic art (and Mary's as well) came from a visit to the great Munich exhibition of 1910. The enthusiasm for Islamic and especially Persian art, seen as an Oriental parallel to the patronage of the Medici, set off a phase of collecting lasting only a short time, from 1910 to 1913. There was much selling as well as buying, but I Tatti retains a small but refined collection, with three illuminated Persian manuscripts and six detached miniatures (four Persian and two Arabic) at its core.

By 1917, Berenson's resources had become strained and he had ceased collecting Islamic and Oriental art. In any case, by that time the collection was largely closed, and only a handful of Western paintings entered I Tatti in the 1920s or later. His archaic and amateur Orientalism was beginning to become apparent to colleagues and specialists. As time passed, his attitudes hardened and skepticism of emerging postcolonial countries in the Middle East set in, accompanied by an anti-Arab attitude over the founding of the state of Israel. Still, he continued collecting books on Islamic art. Newcomers to the Biblioteca Berenson often note with surprise the existence of the Asian and Islamic Collection, now housed in two rooms in the Geier Library, containing a thousand exhibition and sales catalogues, 1,200 periodical volumes, and 3,500 books, many unique in Italy, as well as a set of the photographs of early Islamic architecture taken by K. A. C. Creswell, a project partially subsidized by Berenson.

In the publication of the Sassetta altarpiece carried out under the editorship of Machtelt Israëls in 2010, Carl Brandon Strehlke, adjunct curator at the Philadelphia Museum of Art, contributed a penetrating essay on Berenson's interest in the art of Asia, showing how Berenson absorbed the culture of Oriental art fostered in the Boston of his youth. Against this backdrop, it becomes easier to understand the rapturous parallel Berenson drew in 1903 between Buddhist and Franciscan spirituality. Perceptive visitors note that the three Sassetta panels at I Tatti stand amid a small collection of East Asian bronzes, reinforcing the point made in Berenson's writings. One of the treasures of the

Berenson collection is the sixth-century Buddhist altar kept in the Signorelli Corridor amid Renaissance paintings and other Chinese objects dating from the third millennium to the nineteenth century.

Strehlke continues and deepens this research in his essay for this volume. Berenson's early Japonisme (as a Harvard student he had pronounced Hiroshige "better than Whistler") matured during his 1894 visit to the Museum of Fine Arts in Boston with Denman Ross to meet Ernest Fenollosa. At that visit, Chinese paintings of the twelfth century sent all of them into rapture. On a visit to the Freer Gallery in Washington in 1914, Berenson said that if he were starting out he would devote himself to the arts of China. In that year, he acquired the precious early scroll painting now exhibited in the Signorelli Corridor, *Dancing Girls of Kutcha*, then thought to date from the Tang dynasty. Mary at first refused to share his enthusiasm for Asian art, and mocked the Javanese Buddha head from Borobodur and the Chinese saint which came from a Paris dealer in 1909. But she converted to Oriental art in general after the couple's visit to the Islamic exhibition in Munich in 1910. Berenson's juxtaposition of Asian and Renaissance art was without parallel in the late Victorian world.

Strehlke also traces Berenson's long friendship with Yashiro Yukio. Berenson was introduced to this young art historian from Japan by Laurence Binyon in 1921. Yashiro aspired to absorb the master's critical methods and introduce them to Japan. Berensonian ideals and connoisseurship pervade Yashiro's monograph of 1925 on Botticelli. Although contact was cut off during the war years, Yashiro's loyalty remained firm. He dedicated his book, *2000 Years of Japanese Art*, to Berenson in 1958. He shepherded the Japanese translation of *Italian Painters of the Renaissance* through the press in 1961. It bore a dedication to Yashiro that Berenson composed before his death in 1959. Stressing the analogy between Botticelli's swift, flame-like modeling and Japanese line drawings, Berenson praised his one Asian disciple: "Thanks to you, my dear Yashiro, we Europeans have come to have subtler and more penetrating appreciation of the achievement of your countrymen and they of ours."

The Protégés:
Kenneth Clark, Arthur Kingsley Porter, Paul Sachs, Daniel Varney Thompson Jr.

William Mostyn-Owen, one of the most authoritative and eloquent voices at the conference, fortunately managed to submit his essay before his death in 2011. He came to know Berenson well as his amanuensis and confidant for six years in the late 1950s, and he published the complete bibliography of Berenson's writings on the occasion of Berenson's ninetieth birthday in 1955. He writes with wit and subtlety on the relationship between Berenson and Kenneth Clark, lasting three decades, during which the devoted but sometimes reluctant disciple became, through his public role in Britain and through television, known to a far wider public than the scholar he acknowledged as his master.

Clark came to I Tatti in 1925. Berenson took him on as assistant, not full collaborator, in the preparation of the second edition of the *Drawings of the Florentine Painters*. It was not the right role for Clark, and although the residence was long and the returns

frequent, he felt the need to strike out on his own and make a career in the museum world in Britain. Still, Clark absorbed a great deal from Berenson, even while remaining open to other currents of thought, including those of Alois Riegl and Aby Warburg. Their letters show Berenson's longing for a figure who might fill the role of spiritual son, while Clark, for all this admiration, maintained the distance of the disciple. Mostyn-Owen paints a deft portrait of the two personalities, highlighting the differences between Berenson, who, if he needed listeners, shunned publicity, and Clark, who needed the adulation of a large audience. Opening with the long obituary that Clark wrote of Berenson in the London *Times* in 1959, he closes with Clark's address at I Tatti in 1980. Clark told the assembled fellows that Berenson's value as a critic was as high as John Ruskin's, and that at the heart of his old books and dry lists there was learning, intelligence, sensibility, and faith in man, even if imperfectly expressed.

Kathryn Brush is a medievalist who also writes on the origins and historiography of the field in America and Germany. She is the author of a 2003 book on the Fogg Museum at Harvard University, the repository of the papers of one of its early professors of medieval art, Arthur Kingsley Porter. The Porter Archives are rich and vast, forming the basis of her forthcoming intellectual biography of this seminal figure in the historiography of medieval art in America. In the present volume, she studies the deeply imbricated friendship between Berenson and Porter, which spanned a gulf of wealth and class and traversed barriers now tacitly accepted between specialists of the Middle Ages and the Renaissance. Porter was an internationalist who disregarded modern frontiers as he charted the spread of medieval sculpture along the pilgrimage roads. Berenson's early mission was to show his generation that one could live with the primitives, and Porter absorbed this lesson as a student at Yale, studying the famous Jarves collection of Italian painting while reading Berenson's "Four Gospels." Porter was wealthy, and his collecting followed Berenson's lead, with Niccolò di Pietro Gerini and the early Sienese masters as his first acquisitions. Porter modeled his corpus of Lombard churches on Berenson's 1903 corpus of Florentine drawings. It was daring to take a format conceived for painting and rework it for architecture, but it worked well, and was later followed by Richard Krautheimer in his corpus of early Christian basilicas in Rome.[16]

Porter and Berenson explored Burgundy together after the First World War, but it was Berenson's influence that nudged Porter away from the devastated regions of France to the pilgrimage roads, which Berenson explored for three months in 1919 before Porter had seen them in person. Porter, in turn, whetted Berenson's appetite for the twelfth century and provided him with material and ideas for his overarching study, never completed, of the decline and resurrection of form between Constantine and Giotto. Much later, Berenson's short book on the Arch of Constantine, a fragment of the larger project published in 1954, was dedicated to the memory of Porter and to that of Denman Ross, his mentor in Chinese art. Berenson was so fond of Porter that he invited him and his wife to live at San Martino a Mensola in 1919 and then loaned them the main villa at I Tatti in the winter of 1920–21. Porter's most famous book, *Romanesque Sculpture of the Pilgrimage*

16 Krautheimer et al. 1937–77.

Roads, was penned, in part, at Berenson's desk. Porter the medievalist was, in Berenson's eye, the ur-I Tatti fellow, and as the concept of a center for Mediterranean art after his demise took shape, Berenson thought of Porter as his successor. All this was cut short by the tragedy of Porter's death, probably by suicide, in 1933.

David Alan Brown, curator of Italian painting at the National Gallery of Art in Washington, is himself a veteran of the famous Museum Course given over four decades at the Fogg Museum. He examines the figure who did most to shape that course between 1921 and 1948, Paul Sachs. Both Sachs and Berenson were short, dapper men with a cosmopolitan outlook, Jews whose exceptional abilities won them high positions in the art world and in society. Neither had studied art history in a university setting, though both affected the teaching of it profoundly. Sachs was more the popularizer, while Berenson was one of the most intellectually ambitious scholars of his time, but a bond of trust formed between them. Sachs was the first person at Harvard to whom Berenson revealed his intention of bequeathing I Tatti to his alma mater. Berenson lectured in Sachs's course in 1921, and his *Rudiments of Connoisseurship* and *Three Essays in Method* were required reading in addition to his lists. David Alan Brown also gives a profile portrait of a protégé whom Sachs sent to Berenson, John Walker, who stayed at I Tatti for three years, from 1930 to 1933. Like Clark, Walker went on to become head of a national gallery, and his influence was important in insuring that the reluctant Harvard Corporation ultimately accepted Berenson's bequest. Walker eventually left a lively picture of daily life at I Tatti in his autobiography of 1969, *Self-Portrait with Donors*. His successor at the National Gallery of Art, J. Carter Brown, left his own touching reminiscence of Berenson in the last years of his life in a preface to Hanna Kiel's collection, *Looking at Pictures with Bernard Berenson*, in 1974.

Walker and Clark were gilded youths, but Berenson also maintained a warm friendship with an engineer and scientist from much further down on the social and academic scale, Daniel Varney Thompson Jr. (1902–1980). Every Anglo-Saxon student of medieval painting will know something of pigments and techniques through the English translation of Cennino Cennini's *Il libro dell'arte*, published by Thompson in 1933 and thereafter kept constantly in print. Thea Burns, an I Tatti fellow and, at the time of the conference, a paper conservator at the Weissman Preservation Center of Harvard University, resurrected this forgotten and improbable friendship, which was maintained through letters up to the time of Berenson's death. Berenson never affected an interest in the techniques of tempera and oil painting, which he dismissed along with his other bugbears, Germanic philology and American art appreciation. None added to the deeper aesthetic appreciation that was his life's goal. To some extent, theirs is a dialogue of the deaf, with Thompson constantly stressing that art cannot exist without craftsmanship, and Berenson retorting that technical data was like prenatal information, irrelevant to a person's biography. Nonetheless, the friendship somehow endured. Thompson emerged as a key figure in establishing the laboratory approach to painting in England and America. He also wrote on colors and on the making of parchment, and helped to establish the text of several important medieval treatises on the arts in Latin and German. Burns contrasts Thompson's purely philological approach with more modern methods that might

question the literary genre of a text or the historical milieu in which it was written. This Thompson did not attempt. He remained, however, the master of the medieval recipe, giving painstakingly exact translations of technical terms and experimenting with the processes described to see how they actually worked. What Berenson rebuffed, Harvard embraced. The Museum Course of Edward Forbes was an inspiration to Thompson, and he, in turn, furthered the scientific analysis which eventually became a distinguishing mark of the culture of art history at the Fogg Museum.

Pietro and Carlo Alberto Foresti, Archer Huntington, Katherine Dunham

Elisabetta Landi uses the archives of the Landi-Foresti family to reconstruct a friendship and to sketch profiles of a father and son who were major figures in the intellectual life of their native town, Carpi, during Berenson's youth and maturity. Pietro Foresti was a protagonist of the "imagined, rediscovered Renaissance" of the later nineteenth century. His ambition as a collector is apparent in the rooms of Palazzo Foresti in Carpi, a worthy sibling of the more famous house museums of the time, such as the Bardini and Sacrati Strozzi in Florence and the Poldi Pezzoli and Bagatti Valsecchi in Milan. Pietro Foresti was also involved in the founding of the Museo Civico of Carpi and subsidized the restoration of the vast Palazzo Pio di Carpi. His son, Carlo Alberto Foresti (1878–1944), moved to Milan and formed his own art collection and dealership. The paintings that passed through his gallery are studied here in the light of a correspondence with Berenson that lasted from 1926 to 1935. Several are identified with the help of the "homeless" paintings section in the Berenson photographic archive. In the essay, local patriotism and civic pride intertwine with the world of collecting, dealing, and international trade in Old Masters.

Mary Berenson's charm and love of literature captured the attention of the man the Berensons most wanted to meet during their visit to the United States in 1908–9. Archer Huntington was one of the richest men in the country as well as a scholar of note, translator of El Cid, and founder of the Hispanic Society of America. Isabelle Hyman, professor of Renaissance art and architecture at New York University, discovered the correspondence between Berenson and Huntington in the library of Syracuse University, which is the repository of the Huntington family papers. Their epistolary friendship lasted from 1908 until Archer's death in 1955. Their correspondence, unlike that which Berenson carried out with Isabella Stewart Gardner or Henry Walters, was not generally about the acquisition of works of art, but simply testimony to an enduring friendship. Huntington nominated Berenson for membership in the American Academy of Arts and Letters, and in his letter of thanks, Berenson reveals how important this American honor was for him as an expatriate. The Huntington archives also contain the journal of A. Hyatt Mayor, eventually the distinguished curator of prints at the Metropolitan Museum of Art in New York, during his visit as a young Oxford student to I Tatti in 1925–26. It provides a rare glimpse into life at I Tatti at the time of Berenson's rapprochement with the exhaustingly talkative Vernon Lee and the arrival of Kenneth Clark.

The editors of this volume, although immersed in Berensoniana as director and assistant director for programs at I Tatti, chose to look not at Berenson as an art historian but

rather at his relationships with figures of contemporary culture in mid-twentieth-century America, personalities famous in their own right but seldom linked in the popular mind with I Tatti. Ernest Samuels had already consecrated a few pages to the epistolary relationship between Berenson and Ernest Hemingway. The two men never met, but they remained in touch by letter over the years 1949 to 1957. Berenson was already in contact with Hemingway's third wife, Martha Gellhorn, and greeted his fourth wife, Mary Hemingway, with "What number are you?" when she visited in 1948. At Hemingway's request, Berenson wrote a tribute for the dust jacket of *The Old Man and the Sea*, "this short but not small masterpiece." The Hemingway letters are at I Tatti. Louis Waldman discovered the Berenson half of the correspondence, and so was able to reconstruct one of the liveliest, and certainly the most profane, of the literary exchanges of Berenson's later years; it is hoped that his findings will soon be published in another format.

As Samuels observed, Berenson took a good deal of pride in the variety of his notable guests. Once, however, the parade of celebrities included someone who touched his heart. Katherine Dunham was an Afro-American social scientist trained in anthropology at the University of Chicago, but also a professional dancer and choreographer. Following field research in Jamaica and Haiti in 1935, she founded the first black dance troupe in the United States and toured regularly on five continents until 1955. She was also the founder of dance anthropology as a field. She sought out Berenson during a visit to Florence in 1948 or 1949 and maintained a correspondence with him until his death a decade letter. About 130 letters testify to a loving friendship that ignored barriers of race and age and anchored Dunham's career during a period of personal turmoil and global travel. When she revealed her plan to perform *Southland*, a ballet about lynching in America, in Paris in 1953, Berenson advised against it. Their friendship briefly cooled, but soon returned to a greater degree of intimacy than ever. Berenson's relationship with Belle da Costa Greene a generation earlier had rapidly turned into a passionate affair with a woman who had, in effect, "passed" from her father's world of black activism to white society. In contrast, Katherine Dunham fully identified with her black heritage and campaigned vocally against discrimination. A world traveler with her dance troupe, in her long and beautifully crafted letters she lent the aging Berenson an anthropologist's eye though which to view the rapidly changing societies of Asia, Latin America, and even the United States. When an honorary doctorate was conferred on her by Harvard University in 2002, at the age of 92, she cited Berenson as one of the major influences on her life. The letters she and Berenson wrote to each other testify to the depth of a most unusual friendship.

TWO

Bernard Berenson and Jean Paul Richter

The Giambono's Provenance

DIETRICH SEYBOLD

FOR ABOUT SEVEN YEARS, and before moving into I Tatti, Michele Giambono's *St. Michael Archangel Enthroned* (Fig. 1) had a London address: 14 Hall Road, London, N.W.; and an exact position: "on the staircase."[1] In the 1890s, 14 Hall Road was the address of a once famous connoisseur named Jean Paul Richter (Fig. 2), and the story of the relationship between him and Bernard Berenson is the story behind that particular painting, now in I Tatti's dining room. This story is less about provenance in a conventional sense than about the archaeology of a deeply ambivalent human relationship, which will lead us through the first fifteen years of Berenson's career.[2] Berenson remained completely silent on his relationship with Richter,[3] which was, to a large extent, one of mutual observing. Although this is not actually a story about ghosts, I am going to speak about memories, and I have to speak about unwanted memories as well. But first, I should like to reintroduce the once famous connoisseur.

1 For "on the staircase," see Richter to Berenson, 4 September 1894, Bernard and Mary Berenson Papers, Biblioteca Berenson, Villa I Tatti—The Harvard University Center for Italian Renaissance Studies (hereafter BMBP).

2 This paper is based on archival research in the United States and in Italy, within the framework of a biographical inquiry into Richter, made possible by the Schweizerischer Nationalfonds, Bern.

3 This is not to say that Berenson did not acknowledge Richter's advice or writings in his own scholarly works. By "silence," I refer to Berenson's never mentioning Richter in his recollections—i.e., in his scattered attempts to approach autobiography—and, as such, not mentioning Richter as a biographical influence.

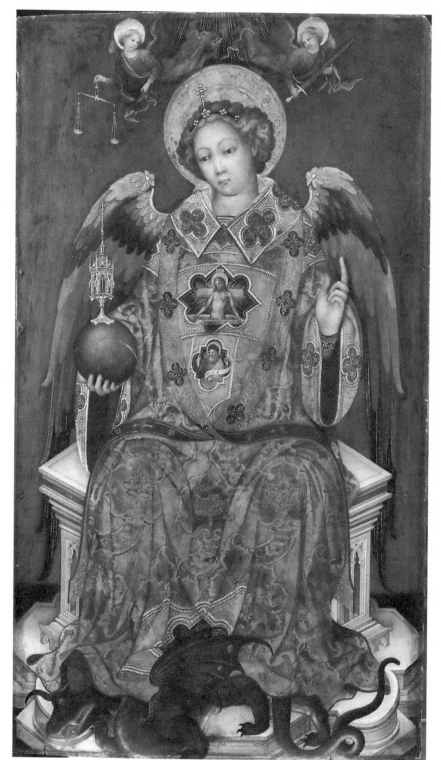

1

Michele Giambono,
*St. Michael Archangel
Enthroned*, 1440–45,
tempera on panel.
Villa I Tatti, Florence.

Reintroducing Jean Paul Richter

In the summer of 1889, we find Jean Paul Richter correcting the proof sheets of Giovanni Morelli's Roman "gallery book," not in his study but outside in Piazza Massimo d'Azeglio, in front of his apartment at number 28.[4] Berenson was allowed to read the proofs in advance.[5] Generally speaking, Richter represented a link between the world of Morelli and the world of Berenson. After fifteen years of collaboration with Morelli, Richter was in contact with Berenson for, again, about fifteen years. Thus, while certainly not being a figure of the same status in connoisseurship as Berenson, he is a key witness to connoisseurship's history. The greater part of Richter's professional life can be documented on the basis of his diaries not because he intended the diaries to speak to posterity, but because he wanted to review his multifaceted activities day by day.[6]

Richter was eighteen years older than Berenson. Coming from a socially modest East German Protestant background, he had become, after many shifts in career, the most ambitious, diligent, and energetic student of Morelli prior to Berenson.[7] Although Richter sometimes sounded dogmatic in his identification with Morelli, his approach to connoisseurship was pragmatic and eclectic,[8] and he was occasionally capable of surprising moves. He is best known as the editor of a heavyweight anthology of Leonardo da Vinci's writings,[9] and he remains a pioneering navigator of the *mare magnum* of Leonardo's notes. It is worth mentioning here that Richter showed himself as somewhat tone-deaf when it

4 Jean Paul Richter, diary, 18 July 1889, Jean Paul Richter Diaries, Rare Book, Manuscript, and Special Collections Library, Duke University, Durham NC [now the Richter Archives, Onassis Library for Hellenic and Roman Art, The Metropolitan Museum of Art, New York] (hereafter JPRD).

5 Berenson to Maxime Bôcher, 3 December 1889, BMBP (partially quoted in Samuels 1979, 99–100).

6 See the Jean Paul Richter Diaries (which consist of the bulk of the extant diaries of Jean Paul Richter and his wife, Louise M. Richter) as well as the Gisela M. A. Richter Archives, Onassis Library, The Metropolitan Museum of Art, New York (several of Richter's diaries have recently been discovered among these materials related to his one daughter, but, insofar as these cover other time periods, they are not relevant within our context).

7 For very basic biographical information, see "Necrology," *American Journal of Archaeology* 41 (1937): 607–608.

8 Richter's development as a writer on connoisseurship can be highlighted by a comparison of his early "programmatic" and more dogmatic article on Morellian connoisseurship (Richter 1888) with the preface and especially the long and no less programmatic introduction to his catalog of the Mond collection (Richter 1910, v–vii, 1–50). In this latter text, Richter is apparently influenced by Berenson's notion of supplementing Morellian method with a "sense of quality" and aspiring to an "art of connoisseurship." Nonetheless, maybe apart from the subtitle of the catalog, Richter is avoiding a typically "Berensonian" vocabulary, while at the same time he is foreshadowing a more "humanistic" (i.e., "later") Berenson by stressing formal qualities as well as subject matter, content, and—although Richter avoided the notion—a "life-enhancing" function of great art. Richter, however, did not aspire to be a theorist of the enjoyment of art or of scientific connoisseurship; his more "programmatic" statements should always be seen together with what he actually did: how he approached the individual problem of attribution and how he, in a more general sense, approached art as an individual person.

9 Richter 1970 (in its essence, apart from the reproductions, a reprint of the second edition of 1939). The first edition was published in London in 1883.

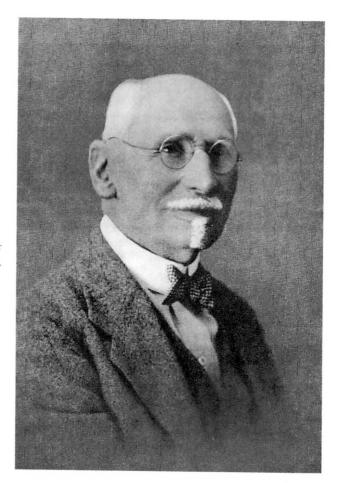

2
Jean Paul Richter
(1847–1937).

came to the dominant melodies of aestheticism. For example, as a Leonardo philologist he never quoted or even mentioned Walter Pater.[10]

What is important to note is that among the Morellians, Richter represented an aggressive will for social ascent by connoisseurship, and that the last phase of this ascent to fame and fortune took place before Berenson's eyes. While the less ambitious Gustavo Frizzoni lived on his inheritance and dealt only occasionally,[11] Richter represented in the fullest degree the archetype of dealer-connoisseur. He worked in partnership over twenty-five years largely with a single collector, the German-born industrialist Ludwig Mond, who was a pioneer of the British chemical industry and whose collection Richter regarded as one of his lifetime achievements.[12] If he was not the first dealer-connoisseur,

10 Richter's "not-quoting Walter Pater" was notified in an anonymous review (*The Academy* 435 [4 September 1880]: 178) of Richter's early short biography of Leonardo da Vinci (Richter 1880).

11 See Kannes 1998, 581–583.

12 The best account of Ludwig Mond and his family is a thesis on Henriette Hertz, who lived with the Monds and later became the benefactress of the Bibliotheca Hertziana: see Rischbieter 2004. For the Mond collection, see Richter 1910 and Saumarez Smith 2006.

Richter was nevertheless one of the first to establish his social position on the basis of a connoisseurship that aspired to objectivity (whether justified or not), while, based on that status, living off expertise and trade. Dealing was for him less a deliberate choice than an outcome of circumstance. Despite considering it several times, Richter avoided an academic career,[13] even though he had to overcome a certain personal resentment of the trade to pursue a career as a dealer.[14]

By 1892, after Morelli's death, Richter stood at the pinnacle of his career. Socially established, he had an audience with the Queen of Italy. He organized picture cleanings for Count Doria and also revised the sections on Roman galleries for Baedeker's guides.[15] It was rumored that he might disturb the transfer of the Borghese Collection to the Italian state by buying parts or the whole for foreign clients.[16] In short, during a brief interregnum, Richter stood out in the public eye for scientific connoisseurship, and for people who knew him well he represented economic success derived from expertise on paintings and from trade. One detail worth mentioning here to complete the sketch of Jean Paul Richter is that King Ludwig II of Bavaria (Luchino Visconti's Ludwig) grew so enthusiastic over some catalogs that Richter had provided that he knighted the connoisseur, elevating him into the Bavarian Order of St. Michael, first class.[17]

Richter and Berenson met in April 1889 in Florence.[18] From that moment, it would take Berenson about twelve years, partly spent in association with Richter, to outshine the latter as a connoisseur. This happened with Richter knowing it, accepting it, and stepping aside without resentment.[19] Berenson's first feeling, after meeting Richter, can be summed up in a single paraphrase: "This is a very famous critic—but I did not feel so

13 Richter's vacillating stance regarding the possibility of an academic career shows in his letters to Giovanni Morelli as well as in (sometimes abbreviated) copies of his letters and postcards to Carl Justi: Nachlass Jean Paul Richter, Allgemeines Archiv der Bibliotheca Hertziana, Rome (hereafter Bibliotheca Hertziana). The letters that Richter actually sent to Carl Justi are kept by the Universitäts- und Landesbibliothek Bonn (I only have consulted the copies which Richter provided for himself).

14 When Richter, in a letter to Morelli, pointed—despisingly—to the "Händlerinteresse" of Wilhelm Bode, he was about to embark on his own career in applied connoisseurship (see Richter to Morelli, 2 July 1884, Bibliotheca Hertziana); the comment thus displays a state of passage, probably associated with uneasiness and shame (which appear to be the driving forces behind such "finger-pointing"). For a comment made by the young Bernard Berenson upon Richter's "interest as a merchant," see below.

15 Jean Paul Richter, diary, 1892, JPRD, passim. Richter provided sections (or revisions of sections) to many volumes of the Baedeker guidebooks throughout his life.

16 See Barberini 1984, esp. 43 n. 22, in which Richter is mentioned.

17 Cf. the title page of the first edition of Richter's Leonardo anthology. Richter had provided catalogs of the Wallace Collection for the king.

18 Jean Paul Richter, diary, 15 April 1889, JPRD. If there had been contact before, as has been suggested in Simpson 1987, 54, it is not apparent to me from the available sources. In Richter's view, Berenson had come to his flat at Piazza Massimo d'Azeglio 28 to see an *Annunciation* by Fra Filippo Lippi, which later became part of the collection of Henriette Hertz and was eventually bequeathed by her to the Italian state (today: Galleria Nazionale di Arte Antica, Palazzo Barberini, Rome).

19 There is no indication that Richter ever saw this relation in terms of rivalry, although in later years he occasionally seemed inclined to make efforts to show Berenson that he was still to be taken seriously as a connoisseur (see, for example, Richter to Berenson, 26 November 1900, BMBP). During this period, Richter increasingly turned back to his earlier interest in Early Christian art. His letters

very little beside him."[20] By the turn of the century, Berenson had come to be seen as the standard-bearer of Morellian connoisseurship, enriched with elements of aestheticism and aesthetical thinking; and simultaneously, like Richter before him, he represented economic success based on expertise and trade.

While Richter's relationship with Morelli had basically been a warm friendship,[21] his relationship with Berenson was, on a human level, rather superficial. Beyond mutual observing, the relationship was stabilized by common interest, mutual loyalty, and trust, though not without latent tensions and, from Berenson's side, not without rivalry.[22] There was, at best, room for elements of friendship, or, at least, for a shared joy in the intellectual adventure of connoisseurship as well as for a common passion for the lesser-known painters of Verona.[23] Their careers were closely intertwined for about fifteen years. Reviewing this relationship, I will focus on a few connections, starting with the early years.

The Early Years

In 1889, Richter had actually met two young men whom he introduced into Morellian connoisseurship, but he only became a mentor to one of them: Enrico Costa (who, in contrast to Berenson, had met Morelli before).[24] Costa is remembered as a traveling companion of Berenson, and especially, in a famous incident, as sitting with him one morning at a "rickety table outside a café" in the lower town of Bergamo while they vowed

to Berenson dating from the late 1890s and the early years of the twentieth century are extant (and kept at the Biblioteca Berenson).

20 Berenson to Senda Abbott (Berenson), Easter Sunday (21 April) 1889, BMBP. The passage refers to Berenson visiting the Uffizi Gallery together with Richter, probably on 15 April, the day they apparently first met.

21 This is not to say that it was not on some levels a complicated friendship, too. See the full Morelli–Richter correspondence at the Bibliotheca Hertziana (for the problematic nature of the partial edition of this correspondence, which nonetheless gives a good impression of the pair's common passion, enthusiasm, and joy in connoisseurship, see note 22).

22 The full Morelli–Richter correspondence occasionally reveals anti-Jewish resentment on both sides of the friendship. Along with many other issues of a more problematic nature, all of this has been left out of the partial edition of this correspondence (Richter and Richter 1960), which has made available only about two-fifths of the material. In Richter's case, these prejudices would disappear over the years, at least on the surface, but it is still possible that Berenson came to hear anti-Jewish innuendos (not necessarily pointed at him). Richter's more general prejudices form a harsh contrast to his individual friendships with the Monds and Henriette Hertz, who all represent a secular Jewish milieu.

23 Verona is one of the symbolical links between the world of Morelli (being born in Verona in 1816) and the world of Berenson. Richter was known to have worked on a comprehensive study on the Verona school of painting, and it would be worthwhile to follow Berenson's intellectual development that led to the *North Italian Painters of the Renaissance*, and especially to his *Three Essays in Method*, from this early point of departure and on this single path (a draft of Richter's long-awaited but never published book is kept at the Marquand Library, Princeton University). A more detailed account of this "Verona bond" will be given in my biography of Richter.

24 The point of departure for discussing Costa's biography might currently be Gamba 1912. According to this source, Costa had already visited Morelli in June 1889 (while Berenson's first visit dates from January 1890).

to pursue lives of connoisseurship.[25] But he had also become Richter's protégé, assistant, friend, informant—and client. Coming from a noble family, Costa lived on 600 F a month. He could afford to buy paintings and drawings. He possessed a huge collection of photographs, and he and Richter would often explore the latest photographic equipment.[26] While Costa was emphatically taken under the wing of Richter, we cannot say the same for Berenson.[27] Richter would later refer to Costa as "my Costa," but he would never consider the more reluctant and independent Berenson as "his," although he would refer to the two of them as "we," meaning "fellow Morellians."[28]

Berenson appeared from time to time in Richter's sights as more of an enigmatic satellite. We know of at least twenty-one contacts between them in the crucial year of 1890, in Florence, Rome, and London.[29] This included common visits to galleries and dealers, attending auctions at Christie's, and, last but not least, lunch at the house of Ludwig Mond.[30] For both Berenson and Costa, Richter represented the opportunity to be socialized into rational and scientific connoisseurship as well as into the utilitarianism of trade, and the two men responded to that opportunity in quite individual ways.[31]

Although it has been suggested that Berenson took the opportunity to enter into commercial activities with Richter from the beginning,[32] the chronology is somewhat different, with a crucial nuance. In contrast to Costa, Berenson showed reluctance to enter into dealing at first, judging Richter as *trop marchand*," only to return to this opportunity nolens volens a few years later, when he overcame, as Richter had years before, his

25 Berenson 1949, 60. Berenson recalled how, sitting at that table, he had displayed to Enrico Costa the possibility of rigid, selfless devotion to scientific connoisseurship. Yet it should be noted that Berenson, acting as an informal agent for his friend Ned Warren, had purchased his very first painting, a Bronzino, in that very spring and rather before "Bergamo" (see Berenson to Mary Costelloe, 19 October 1890, BMBP; I have used the transcript of this letter, kept among the materials related to Mary Berenson's unpublished "Life of BB"). Hence, the "Bergamo monologue" should be read as an evocation of a moment of selfless idealism rather than as a full account of what Berenson, from that moment on, would do in his life (although, without a doubt, the passage had this suggestive quality, replacing a more ambivalent reality, upon which Berenson kept silent, with an evocation of a purely idealistic vision). A more detailed chronology of "Berenson in 1890" should be attempted, possibly in the form of a (commented and illustrated) chronicle that would put Berenson's recollections into biographical and historical context.

26 Jean Paul Richter, diaries, 4 November 1889 ("600 francs"), and 1889 and 1890, passim (acquisitions, photography), JPRD.

27 The metaphor "taken under his wing" is used in Samuels 1979, 90, referring to Berenson and Richter.

28 Richter to Hertz, 25 August 1892, Bibliotheca Hertziana ("my Costa"), and Richter to Berenson, 22 January 1901, BMBP (for Richter stressing a common identity as members of one and the same "school").

29 Jean Paul Richter, diary, 1890, JPRD, passim.

30 Jean Paul Richter, diary, 24 July 1890, JPRD (lunch at the Monds' house). It is possible, however, that they met by chance, or at least without any intention to actually meet each other, at auctions (as, for example, on 28 June at Christie's; see Jean Paul Richter, diary, 1890, JPRD).

31 At this point, and on a level of biographical writing, one is forced to decide how to deal with the conflicting traditions of biographical writing on Berenson. Hence, this point can be regarded as being the entrance into a highly contended territory.

32 Simpson 1987, 58–64, esp. 61.

resentment of the trade.[33] Berenson embarked on a similar career as Richter,[34] but came to explore connoisseurship in a more extreme way than Richter had ever done. In Berenson's biography, every facet was to become proportionally larger than in Richter's, but concomitantly Berenson's inner conflict and self-laceration were to grow more dramatic.

The year 1890, which witnessed many scenes of symbolic importance, brings us a mystical, ecstatic Berenson who responds emotionally to art but is also the rationalizer of that mystical experience and—next to a scientific, positivistic Berenson in the vanguard of art criticism—a Berenson who is confronted with the trade for the first time and who starts, in small steps, to engage in it.[35] One symbolic scene takes place in the Borghese Gallery in Rome. Berenson, as he later recalled, fell into rapture before a certain painting but was cut short by a severe Morellian who pointed to the little pebbles in the foreground of the painting as characteristic for that painter.[36] Umberto Morra recalled that this mentor was Gustavo Frizzoni. Be that as it may, we know from Richter's diaries that it was he who guided Costa and Berenson through the Borghese Gallery on 25 February.[37] I would like to focus on this latter scene, because I want to illustrate what it meant to be guided by Jean Paul Richter.

Why had Richter actually come to Rome at all? In brief, he came because he was being sued by the Italian government in a matter of art export, and he wanted to avoid having to go to court. He approached Prime Minister Francesco Crispi and blamed his legal troubles, probably rightly, on the young Adolfo Venturi, who he thought was the driving force behind an exemplary lawsuit and trial, which took place in Venice shortly afterward.[38]

33 Although Richter's diaries from that period provide a full and very detailed chronicle of all his commercial activities—for example, regarding all of his transactions with Enrico Costa—I have found no evidence to support Colin Simpson's claims that Berenson actually "scouted" for Richter; that Richter, under his name, sold Berenson's finds at Christie's; or that Berenson was at all involved in Richter's commercial activities. Unfortunately, a "Richter–Berenson correspondence" that the author seems to have seen (in original or in "mimeographed form"; cf. ibid., 289) has apparently vanished (or is identical with the extant letters by Richter kept at the Biblioteca Berenson, all of which, however, date from later years). I was not able, on the basis of the references given by Simpson, to track down such a correspondence, which would include a "Berenson side." For "*trop marchand*," see McComb 1964, 4 (Berenson to Mary Costelloe, 13 February 1891; the idiom is italicized here). It is as one-sided to perceive Richter merely as a (Leonardo) scholar as it is to perceive him mainly as a dealer. A more detailed discussion of his ambivalent identity will be part of my Richter biography.
34 Mary Berenson, in her unpublished "Life of BB" (Part II, 2, BMBP), declared that she had been the influence that led Berenson to see his studies "in the light of a professional career," which, she adds, he did "rather unwillingly."
35 See the references concerning the "Bergamo monologue" above.
36 For a first version of that symbolical scene, given by Berenson himself, see the preface of Berenson 1918, vii. For a later version, given by Umberto Morra after what he had heard from Berenson, see Morra 1965, 223 (referring to the date of 11 December 1936).
37 Jean Paul Richter, diary, 25 February 1890, JPRD.
38 See Jean Paul Richter, diaries, 1887–1891, JPRD, passim. A more extensive account of the "Malaspina monument affair" will be part of my biography of Richter (the object in question is the *Monument of Marchese Spinetta Malaspina*, a cenotaph purchased by Richter for the South Kensington Museum [now the Victoria and Albert Museum], London, where it is still kept, and, after a recent restoration, newly presented). For Richter's view of Venturi's role within the affair, see Jean Paul Richter, diary, 5 February 1890, JPRD. The trial took place on 27 March.

I am not sure if Berenson was ever aware of all this. In any case, the Berenson who emerges is hardly Mephistophelian; what we see is rather a mystical Berenson in the Mephistophelian setting of Palazzo Borghese.[39] Berenson would later inherit some of Richter's animosity toward Venturi, just as Richter had inherited Morelli's animosity toward Wilhelm von Bode a decade earlier.[40]

Despite his legal troubles, however, Richter managed to make a considerable fortune with just two transactions in these very years, involving the export of major works by Andrea Mantegna and Giorgione.[41] By doing so, Richter crossed a thin, almost invisible line in the Morellian world view: the principle that major works by major artists were to be considered part of the national heritage, not objects of the export trade.[42] The financial outcome nevertheless allowed Richter to buy a house in London that was built, we might say, on applied connoisseurship—namely 14 Hall Road, where we first encountered the Giambono. The story of how he exported a Giorgione and made a fortune appears in Richter's diaries, and it would later appear, in instructive detail, in the diaries of Mary Berenson.[43]

The *St. Michael Archangel Enthroned* and the Story of Berenson's Ascent

The *St. Michael Archangel Enthroned* by Giambono was apparently purchased by Jean Paul Richter on a Saturday morning in July 1893 at Christie's, probably spontaneously, for less than £20, after Richter had purchased shoes and a suit for his son. The attribution in the auction room had been "German school."[44] In this very year, Richter had noticed Berenson's "sharpened" judgment on paintings.[45] The story of the *St. Michael Archangel*

39 For Berenson's own use of "Mephistophelian," see Berenson 1962, 35 (Berenson to Mary Costelloe, 29 September 1890).

40 For a recent discussion of the Berenson–Venturi relationship, see Iamurri 2008 (the "Malaspina monument affair," however, is not discussed, nor is Richter's probable impact on the relationship). Richter's relation to Wilhelm von Bode, again, can best be described as very ambivalent (a more detailed account will be provided in my biography of Richter), but it is important to note that, despite the bad feeling between Morelli and Bode, the Richter–Bode relationship was not purely antagonistic or hostile.

41 See Jean Paul Richter, diary, 1891, JPRD, passim (with detailed information concerning all commercial activities and with "cash accounts"). The two paintings are the *Portrait of a Young Man* (*Giustiniani Portrait*) by Giorgione (Gemäldegalerie, Berlin; it was sold by Richter to "Berlin") and Mantegna's *Holy Family with St. John* (now at the National Gallery, London; it was part of the Mond Bequest and was then sold by Richter to Ludwig Mond).

42 It appears that Gustavo Frizzoni tried to "rescue" the Giorgione for the Brera Gallery, Milan, and that the export caused some estrangement between Richter and Frizzoni (see Jean Paul Richter, diary, 1891, JPRD, passim). At any rate, it is striking that Richter sold the painting only after Morelli's death, and, as far as to "Berlin," just to Morelli's antagonist Wilhelm von Bode.

43 Jean Paul Richter, diary, 25 April 1891, JPRD; Mary Berenson, diary, 27 September 1896, BMBP (quoted in Samuels 1979, 251–252).

44 See Jean Paul Richter, diary, 22 July 1893, JPRD (and appendix with corresponding "cash accounts"), as well as Richter 1910, 53–62, esp. 62. Richter had bought more than one painting at Christie's in July 1893, for a total of £22.12, and the price for each painting cannot be determined on the basis of this total. Given the sum, however, it is highly likely that the price for the *St. Michael Archangel Enthroned* had been "less than 20 pounds."

45 Jean Paul Richter, diary, 8 July 1893, JPRD.

Enthroned is the story of Berenson's ascent told from a different point of view, and it illuminates the psychology of the Richter–Berenson relationship.

The act of attribution, at least the public act, was Berenson's, in his subversive pamphlet of 1895 on Venetian painting in the New Gallery.[46] This leap into the limelight caused animosity that probably ricocheted onto Richter, too.[47] The attribution itself was a bold one, given the fragmentary artistic personality of Giambono, though here Berenson was standing on the shoulders of Giovanni Battista Cavalcaselle and Morelli.[48] The former protégé, who had questioned Richter's attributions from the beginning,[49] was now indeed challenging his mentor, not only on Richter's territory but on a painting hanging in the staircase of the mentor's own house. Richter, for his part, showed no inclination to wrangle for long over the labels "German school," Stefano da Verona, and Giambono.[50]

46 See Berenson 1895, reprinted in Berenson 1901, 93. Berenson, in discussing Giambono, is mentioning a panel "by the same artist," owned by Richter—a panel which, to Berenson's regret, had not been shown at the exhibition in the New Gallery (cf. note 50 below). The attribution thus is given only in passing, and neither Berenson nor Richter ever discussed it more in depth, at least not in their writings. Richter had sent Berenson's pamphlet to Carl Justi, saying in a corresponding letter (or postcard) that it contained "despite some exaggerations much truth" and that it—unsurprisingly—raised "much bad blood" (see Richter to Justi, 12 March 1895, Bibliotheca Hertziana).

47 It is my conjecture that the animosity initiated by Berenson was transferred to some degree to Richter on the occasion of the Doetsch sale in the summer of that very same year. Being a devastating experience for Richter, this episode can be interpreted as a decisive moment or even the turning point in Berenson outshining Richter as a connoisseur. With a catalog provided for Christie's, Richter had publicly associated the "scientific objectivity" of Morellian connoisseurship with the interest of a seller. The public, confronted with another "arrogance" of the Morellian "school," reacted with hostility, and the sale ended in disaster (see Jean Paul Richter, diary, 24 June 1895, JPRD; and cf. Secrest 1980, 137–138). The event certainly had an effect on the self-imagining and self-representation of Morellian connoisseurship, whose self-confidence had been at its pinnacle in the early 1890s; and it certainly served as a warning for Berenson, who would never publicly display the "business of attribution and authentification"—i.e., the association of science and commerce—in providing an auction catalog (though he would choose to work for the selling side before and during his partnership with the house of Duveen, and would profit directly from the sale of works of art that he had authenticated).

48 The act of attribution is not completely untransparent here, but it is transparent only to a very limited degree. Berenson, in his pamphlet, referred to a number of works by Giambono, insofar as we assume that he applied "Morellian tests" (one reference being the Giambono from the Mond Collection). On the other hand, Giovanni Battista Cavalcaselle had already given a proto-Morellian description of a painting he had seen in a Paduan collection, and Cavalcaselle had thought about an attribution to Giambono, without actually giving the painting—thought to be "too good" for Giambono—to that particular artist (for references, see Russoli 1962, no. 27). Thus, it might be that Berenson, knowing Cavalcaselle's description, was led to recognize, in Richter's acquisition, the described painting, and that he decided that Cavalcaselle's first but rejected idea had been right (while his actual attribution and his doubt had been all wrong).

49 Cf. Berenson to Bôcher, 3 December 1889, BMBP; and Jean Paul Richter, diary, 25 February 1890, JPRD, passim (Richter had to "admit" an attribution, given by Costa or Berenson).

50 Richter would recall the discussions that took place on the occasion of the exhibition in the New Gallery even decades later (see Richter 1935, 72 n. 51, regarding a work by Stefano da Verona). Richter's apparently vacillating stance on the attribution of his *St. Michael Archangel Enthroned* is perhaps revealed by a diary entry saying that he had given a "German school" to the Royal Academy Winter Exhibition (see Jean Paul Richter, diary, 4 January 1895, JPRD). If this work is identical with the work that Berenson referred to in his pamphlet, Berenson corrected his "mentor" while the panel was on display under another label, unchallenged by the "mentor"—whose name, however, "stood" for the label.

By the time of this challenge on the scholarly field, Richter and Berenson had become allies in trade. Ludwig Mond, Richter's main patron, had by now an established collection and did not contemplate further acquisitions.[51] Berenson, for his part, was interested in drawing on Richter's collection for his first two major clients, Theodore M. Davis and Isabella Stewart Gardner. Here, I must skip the intertwining of the history of collections, and I must also pass over the intertwining of two careers in the still mysterious affair of the so-called Donna Laura Minghetti-Leonardo,[52] which would only turn the whole account into something of a ghost story. We should keep in mind, however, that it had been Jean Paul Richter who had arranged this ominous "Leonardo" sale in 1898;[53] this sale had unpleasant repercussions for Berenson, who was becoming the more famous of the two and a target of attacks and gossip.[54] The affair, with its nightmarish overtones, endangered Berenson's ascent.[55] Berenson's silence about his relationship with Richter might have been based on a noble motive, namely protecting a Leonardo scholar's reputation, as well as the less noble desire to gloss over their inexplicable error in the field of Leonardo attribution.

In the same year, 1898, Berenson signed his interest in the Giambono over to Richter and negotiations over the painting began.[56] A significant detail is that Richter intended to include a gift to his loyal partner in this transaction, but Berenson, probably sensing the obligation that such a gift would put him under, refused Richter's suggestion.[57] The Giambono would pass to Berenson for its "normal" price—that is, £250.

Richter probably expected Berenson to sell this painting to a client, because the first version of that gift included a substantial commission for Berenson in the price, which Richter apparently regarded as "to be meant for the actual customer."[58] What follows is significant. Berenson did not sell the "glowing panel" (one notes the Paterian language),[59] suggesting that he was now well enough established financially to keep items he enjoyed.[60] This came at the time when the Berensons were installing themselves at I Tatti, with the

51 A short history of the Mond Collection will be part of my biography of Richter.

52 New evidence in the case will be presented in another article.

53 Richter to Berenson, 27 May 1898, BMBP.

54 See Pantazzi 1965, as well as De Marchi 2001, 165–168 and 189–190 (with corresponding notes).

55 Berenson had to explain to Isabella Stewart Gardner why Theodore M. Davis got the painting (and not her), and how he got it: see Hadley 1987, 135–136, 137, 139, etc. For undertones of jealousy and rivalry, see ibid., esp. 137, 143.

56 It was offered to Berenson in the aforementioned letter from Richter to Berenson, 4 September 1898, BMBP.

57 See especially Jean Paul Richter, diary, 28 February 1900, JPRD.

58 The diary entry of 28 February 1900 shows that Berenson first explicitly refused the inclusion of a commission, and when Richter offered him a small Bonifazio de'Pitati as a gift instead, Berenson appeared to refuse this too, saying "it is very sweet of you."

59 Berenson 1901, 93. As to the language used, cf. the essays on Johann Joachim Winckelmann and especially on the "School of Giorgione" in Pater 1980.

60 A recollection by Luisa Vertova reveals Berenson's later attitude toward the painting and at the same time sheds light on Berenson's attitude as a collector and an owner: "One day I praised to Berenson the subdued richness of its [the Giambono's] colours: the reds merging into the brown and gold, the yellowish green of the angels' robes brought into relief by the bottle-green ground. Unlike the average collector, Berenson was critical of his possessions and praise elicited his severity. 'The colour, yes, is good. But don't you see how hopeless the drawing is? It looks like a paper doll with a paper

first payment on the Giambono made before and the second after their moving in.[61] The Berensons were married at the close of 1900, and Richter made them a present that is still in the villa, the little Bonifazio de' Pitati.[62]

I will conclude at this point, although the relationship continued with further intertwinings or, one might say, contrapuntal developments in the two men's careers.[63] In historiographical terms, one might ask what actual impact Richter may have had on Berenson, if any, recalling Berenson's silence. Richter's role is surely undervalued in all the Berenson biographies; my own estimate is not a low level of influence but rather a direct influence,[64] as well as a strong indirect one, in the early years. Richter was a social catalyst, mentor, and

dress on that is too big for it. All the same', he added, 'those arabesques on the dress, and the dragon's tail, are gorgeous'" (Vertova 1963, 65).

61 Jean Paul Richter, diary, 26 April 1900 and 31 January 1901, JPRD.

62 See Jean Paul Richter, diary, 22 January 1901 and 26 April 1900, JPRD (for Richter promising a small Bonifazio—one of two that he owned—as a gift). Probably this wedding gift was identical to the Bonifazio of the Berenson Collection (see Russoli 1962, no. 89).

63 While the Berensons moved into Villa I Tatti, Richter set off to create his own "villa existence." The place he chose was at San Felice Circeo—the "cyclopean walls" on Monte Circeo literally being his "high walls"—but this utopia was ended by the First World War. Nonetheless, his time at San Felice Circeo saw him establishing a counterpoint within his life to the business of connoisseurship, and turning back to his earlier interest in Early Christian art, preparing, in collaboration with his assistant Alicia Cameron Taylor, a book on the mosaics of Santa Maria Maggiore in Rome. He also turned, in his general eclecticism, to new fields of knowledge such as iconography and iconology, and in 1906 sold thirty-four paintings, the bulk of his collection, to a "neighbor" of the Berensons: Henry W. Cannon, a banker from New York residing in Villa Doccia, whose collection was eventually given, by Henry W. Cannon Jr., to Princeton University. And he played a more informal but nonetheless important role in the creation of the Bibliotheca Hertziana, where, at least for a short moment and before the actual establishment of the institution, he had the opportunity to meet Enrico Costa again.

64 This is not to say that Richter was not a very cultured man, as he was—as was Berenson—well-read in many languages. Still, one is inclined to ask what intellectual influence might not have existed if Berenson had never met Richter, who—on an intellectual level—represented only one voice of Morellian connoisseurship. Berenson, in the winter of 1890, had written to Mary Costelloe that he was always interested "in what Richter had to say," but that he "would never expect him to say it well" (Bernard Berenson to Mary Berenson, 22 November 1890, BMBP; I have consulted the transcript within the materials related to Mary Berenson's unpublished "Life of BB"), the negative prejudice concerning Richter's literary taste being due only to Richter's admiration for Carl Justi). Still, I would interpret Berenson's attitude toward Richter, and especially the attitude expressed in this letter, as seeing Richter more as a general point of reference than as an original thinker who actually influenced him with original thoughts. In 1890, Richter offered Berenson and Costa the opportunity to study his collection of drawings with him (see Jean Paul Richter, diary, 16 March 1890, JPRD), and Carmen C. Bambach is right in assuming that Richter could have had promoted Berenson's general study of drawings (see Bambach 2009, 693). Berenson would not acknowledge Richter as an influence who had first pointed him to the importance of a corresponding nuanced "philology of the eye," however, and neither, it appears, did Richter expect him to do so. The latter's reaction to Berenson's magnum opus was ambivalent (see Richter to Berenson, 24 August 1903, BMBP) because, on the one hand, Berenson had acknowledged the impeccable choice of Leonardo drawings that Richter (actually helped by Morelli) had presented in his Leonardo anthology, while, on the other, he had expressed his neutrality regarding the question of whether Richter—as a philologist—had delivered as impeccable a work (during the 1880s his anthology had been the target of severe attacks). The Richter–Berenson relationship, it appears, did languish after 1900, because neither side, in the long run, passed the "test of loyalty"; and, within a long series of such "tests," the issue discussed here represents only one example.

critic, but also a lodestar on how to live on the proceeds of connoisseurship while managing to rise in society. He was an ally in trade, and last but not least a witness of the "making of another connoisseur." We recall the young Berenson's sentiment: "This is a very famous critic—but I did not feel so very little beside him." On the level of memory and its politics, Richter represented much of what Berenson had wanted to do, and much of what Berenson had resented, and kept on resenting, while he was doing it. The archaeology of this human relationship thus not only leads us through Berenson's early career but also exposes his inner conflicts, which may illustrate the deeper meaning of his silence about Jean Paul Richter. It is not a silence that expresses a lack of import, but rather one filled with ambiguity.

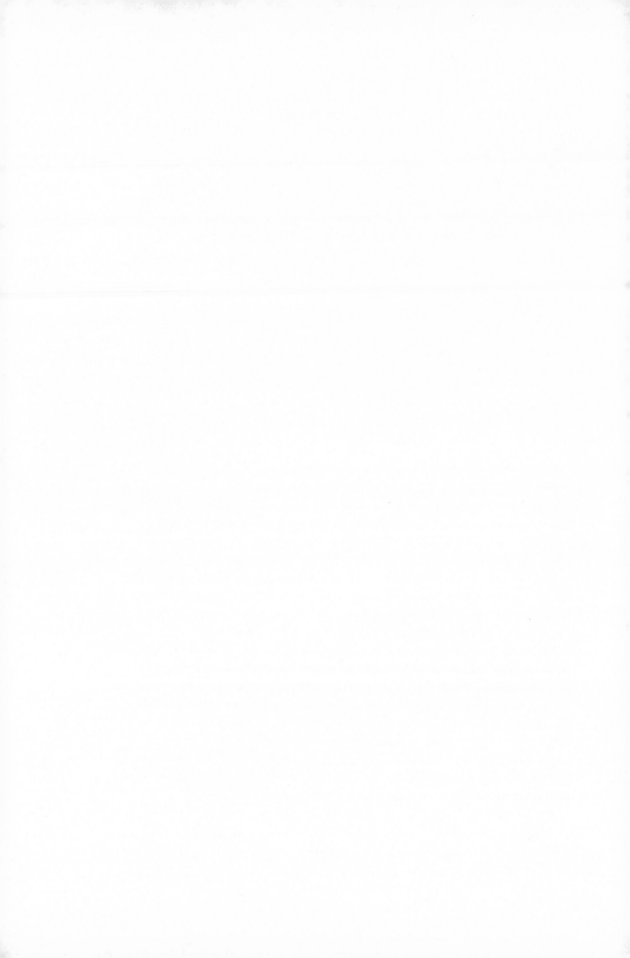

THREE

Art, Commerce, and Scholarship

The Friendship between Otto Gutekunst of Colnaghi
and Bernard Berenson

JEREMY HOWARD

THROUGHOUT HIS LONG LIFE, Bernard Berenson had a very equivocal relationship with the art trade. In 1909, as he was in the initial stages of his long secret business relationship with Joseph Duveen, he wrote to the collector Robert Altman: "I am very little a business man and my tastes and habits are for the quiet life of a scholar...I am not well fitted to cope with all the unpleasant details attending important transactions in works of art."[1] This was undoubtedly how Berenson liked to see himself, and how he would have preferred to be viewed by posterity. Constitutionally nervous, he found the business of art dealing stressful and constantly felt that his relationship with the trade threatened to compromise his independence and integrity as an art historian.

But there were two sides to this relationship. For all his distaste for the art trade, Berenson could, when occasion demanded, be as commercial as his dealer colleagues—Benjamin Altman said he had "the makings of one of the best merchants I ever saw"[2]—and his links with the trade brought him the wealth that enabled him to establish himself as an independent scholar. It was thanks to his commercial activities that he was able to buy and develop Villa I Tatti, with its great library and art collection, and to build up the astonishing photographic collection which underpinned his connoisseurship; the relationships that he forged with collectors, dealers, and museum curators undoubtedly helped to establish his international reputation as the preeminent authority on Italian Renaissance art.

1 Samuels 1987, 87.
2 Ibid., 77.

Both Ernest Samuels[3] and later Joseph Simpson[4] have drawn attention to the important role played by Duveen in providing the financial support that underpinned Berenson's career from 1912 until the Second World War—a role which was taken on after the war by Georges Wildenstein. But the key player in laying the foundations for Berenson's later success was undoubtedly a much less well-known figure: Otto Gutekunst, the brilliant director of Colnaghi who supplied the majority of the great pictures that Berenson sold to Isabella Stewart Gardner between 1894 and 1902 and who served as an important mentor to Berenson as he cut his teeth in the world of the international art market (Fig. 1). Their friendship, which lasted for over fifty years, is charted in a remarkable series of letters in the archives of I Tatti and Colnaghi, which provide fascinating insights into the workings of the international art market between the 1890s and the Second World War. Although business relations between the two men effectively came to an end in the early 1900s, the friendship endured until Gutekunst's death in 1947. Gutekunst's letters provide some poignant glimpses into the nature of this friendship as well as throw light on the career of an art dealer who played a key role in the Old Master paintings market of the Gilded Age.

During most of the nineteenth century, Colnaghi was known primarily as a print publisher and dealer—a "capital print shop," in the words of William Hazlitt. But between the mid-1890s and the 1930s, the firm assumed a dominant position in the Old Master paintings field, selling some of the greatest masterpieces to come onto the market to the Gemäldegalerie, European collectors, and above all the American millionaires whose private collections laid the foundations for the great American museums. The credit for this migration of art treasures has often been given to the charismatic Joseph Duveen,[5] but in fact, by the time Duveen entered the paintings market in around 1907, Colnaghi was already long established in this field, having sold a string of masterpieces to Mrs. Gardner and major pictures to the Gemäldegalerie in Berlin, as well as supplying some great masterpieces to Henry Clay Frick. The man who played a key role in this transformation of Colnaghi's business was the aptly named Otto Gutekunst (Otto "good art"), a brilliant connoisseur and masterly salesman who was a director from 1894 until his retirement in 1939. Eclipsed in later years by Duveen, marginalized by Berenson (who ensured that he himself, rather than Gutekunst, took credit for the pictures that Gutekunst discovered and sold to Mrs. Gardner), and to an extent also overshadowed by Colnaghi's American associate Knoedler & Co., Gutekunst has never really been given the credit that is his due.[6] And yet he is one of the unsung heroes of Colnaghi's history, playing a vitally impor-

3 Ibid.
4 Simpson 1987.
5 See, for example, Behrman 1958.
6 At least, not until comparatively recently. The first writers to draw attention to his significance were my former colleagues at Colnaghi, Nicholas Hall (see Hall 1992, esp. 11–15 and 22–25) and the late Donald Garstang (see Garstang 1984, 21–23). More recently, Gutekunst's significance has been re-evaluated in Saltzman 2008, esp. 67–71 and chapters on Frick and Duveen; Saltzman 2010; Chong 2010; and Howard 2010. The present article is an expanded version of the latter essay. I am greatly indebted to the above authors for their illuminating insights.

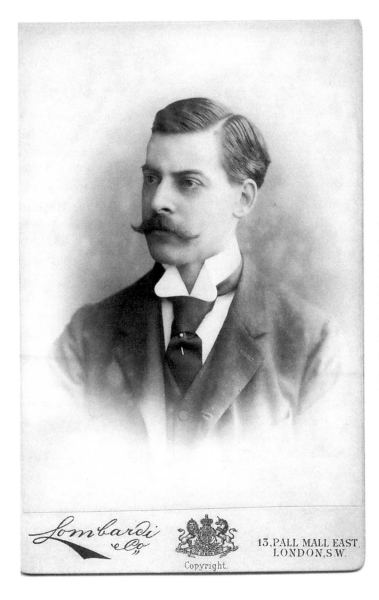

1

Otto Gutekunst in
ca. 1900, photograph by
Lombardi. Bernard and
Mary Berenson Papers,
Biblioteca Berenson,
Villa I Tatti—The Harvard
University Center for
Italian Renaissance Studies.
(Photo: © President
and Fellows of
Harvard College.)

tant role in the art market of the Gilded Age, establishing Colnaghi's pivotal position in the Old Master field, and doing much to establish the fame and fortune of the young Berenson in the 1890s.

The son of a famous print dealer and auctioneer from Stuttgart, Gutekunst was born on 9 September 1865.[7] He settled in London in 1885 after completing his military service in Germany, and in June 1899 he opened a print gallery with Edmond Deprez at 18 Green Street, St. Martin's Place. His father, Heinrich G. Gutekunst, had established in 1856 the London branch of Goupil et Cie, the Paris-based firm of print sellers who later employed

7 Birth certificate, Colnaghi Archives (hereafter CA).

Theo van Gogh; Heinrich returned to Stuttgart in 1864, being "succeeded by Mr Obach (the founder of the firm of that name now amalgamated with that of Colnaghi)," according to the *Times* obituary of 1914.[8] There, the elder Gutekunst established an auction house specializing in prints and drawings whose catalogues, according to the *Times*, were "regarded as the most scholarly productions of their kind in Germany."[9] Meanwhile, Otto's brother, Richard Gutekunst, established himself as a well-known print dealer in Grafton Street. In 1882, Otto married Obach's daughter Lena, and the manager of Obach's business, Gustavus (Gus) Mayer, was to become Otto Gutekunst's junior partner and co-director of Colnaghi when the two firms merged in 1911.

Otto inherited his father's connoisseurship in prints and drawings, while being linked by marriage with one of the leading Anglo-German print-dealing dynasties. During the late 1880s, Gutekunst and his partner Deprez sold some notable prints to George Salting,[10] and a major group of François Clouet drawings, now at Chantilly, from the collection of the Earl of Carlisle to the Duc d'Aumale, for £8,000 (Deprez dealing with the duke and Gutekunst sharing the negotiations with the earl).[11] The Earl of Carlisle later sold Gutekunst the first picture to be bought, albeit indirectly from the firm, by Henry Clay Frick,[12] and some of the relationships forged with the aristocracy through his dealing in prints and drawings were eventually to bear fruit in Gutekunst's later career as an Old Master picture dealer.

In 1894, Deprez and Gutekunst formed a partnership with William McKay—who had inherited the old Colnaghi business, via his father, from Dominic Colnaghi—and the three moved to a gallery at 13/14 Pall Mall East, near the National Gallery. For the next thirteen years, until Deprez retired, they were to form a formidable triumvirate, and although Gutekunst was the junior partner, he was to take on an increasingly important role, particularly in developing sales to Germany and America and winkling out paintings from private collections.

The year 1894 was an excellent time to be launching into Old Master dealing in London. Since the 1870s, the British aristocracy had been suffering the effects of an

8 Obituary, *Times*, 8 January 1914.

9 Ibid.

10 See Coppel 1996, 194, 197–198. Coppel notes that Gutekunst and Deprez habitually used a special mount-maker, Robert Guéraut (Lugt 2210), who specialized in mounts for print connoisseurs, all of which were stamped "mounted by R. Guéraut" on the verso.

11 Negotiations took place between July and December 1889, with the deal finally concluded on 30 December. The Colnaghi letter books suggest that both partners were involved with dealings with the earl, although the majority of the letters are in Deprez's hand.

12 The so-called *Portrait of a Young Artist*, then attributed to Rembrandt van Rijn, which Berenson offered to Gardner in June 1896. "I have never seen a Rembrandt which I have personally liked so well. From any view, it represents the master at his happiest moment, when he had surmounted all his difficulties and had not yet become careless": Berenson to Gardner, 2 August 1896; see Hadley 1987, 61. Gardner did not take the bait, however; the picture was subsequently bought by Henry Clay Frick in 1899 through Tooth, and is now in the Frick Collection, New York. Unfortunately, despite Berenson and Gutekunst's high opinion of it, this painting, like so many Rembrandts sold during this period, has not withstood the rigors of modern scholarship and is now considered to be by a follower of the artist.

agricultural depression. The passing of the Settled Land Act of 1882, which allowed the entails on family trusts to be broken, gave rise to an immediate spate of aristocratic sales—these included, in 1886, the great collection of pictures from Blenheim Palace, from which a Raphael altarpiece was sold to the National Gallery for £75,000, then a world-record price. The year 1894, in which Gutekunst joined Colnaghi, brought the introduction of death duties, regarded by many as the final nail in the coffin of the landed classes; that same year, *Punch* ran a cartoon entitled "Depressed Dukes" in which the Duke of Devonshire complains to the Duke of Westminster that "if matters continue the way they are going, I shall not be able to keep a tomb over my head, let alone a roof."[13] It was a bad time to be a British duke, but a good time to be a banker, a diamond merchant, or an art dealer. By 1914, roughly half the art treasures from British private collections reproduced by Colnaghi and Agnew's in their magisterial *Gems of the Manchester Art Treasures Exhibition* (1858) had been dispersed. The beneficiaries were a handful of museums, a large number of European and American collectors, and the auctioneers and dealers who acted as their intermediaries. For Otto Gutekunst, who irreverently referred to such art treasures as "big, big game,"[14] the breakup of the British aristocratic collections provided unrivaled opportunities for big game hunting.

Until the late 1890s, when the export laws were tightened up,[15] Italy was also a fertile hunting ground for pictures, and during that decade Gutekunst paid frequent visits there, developing links particularly with the Florentine trade. These included dealers such as Stefano Bardini and Elia Volpi as well as scholarly expatriate *marchands-amateurs* such as Jean Paul Richter,[16] Herbert Horne, and (though he hated to consider himself in that light) the young Berenson. Gutekunst regarded Volpi "as a beast and a liar"[17] and

13 *Punch*, 30 June 1894, reproduced in Cannadine 1990, 97, pl. 14.

14 Gutekunst to Berenson, 20 May 1897, Colnaghi letter books (hereafter CLB).

15 Up until 1903, any chattels which were not subject to a permanent trust (*fidecommesso*) were deemed "free" and could be sold or exported from Italy with the permission of the government and on the payment of export duty. A new law was passed in June 1902, which took effect in June 1903, controlling the export of works of art which were deemed of national importance (*Times*, 17 June 1903). Moreover, even before 1903, during the late 1890s, the Italian government was beginning to display an increasing determination to prosecute those who flouted the law. These included Prince Chigi, whose Sandro Botticelli, bought by Colnaghi, was spirited out of Italy in 1899. According to Augustus Hare, "Prince Chigi recently sold to the firm of Colnaghi for 315,000 lire the famous Botticelli *la Virgine col bambino benedicente l'offerta d'un angelo* and was condemned by an iniquitous count to pay the whole sum to the Treasury as a fine": Hare 1903, 50. In point of fact, according to the *Times* (17 June 1903), the government lost its case against Prince Chigi, who was let off with a nominal fine; nonetheless, the hardening export position made Italy an increasingly difficult place to buy art.

16 According to Saltzman 2008, 68, Berenson met Gutekunst through Richter. This is quite possible, though there is no evidence of it. What is certain is that Richter had dealings with Gutekunst from 1891 onward, and that Richter offered a Paris Bordone to Gardner in that same year. Richter and Berenson shared a client in Theodore M. Davis in 1894 and Gutekunst certainly knew Charles Loeser, so there were evidently links between the three men and between Richter and Gardner, although, since they were moving in the same circles, it is hard to be categorical about who introduced Berenson to Gutekunst. I am grateful to Dietrich Seybold for valuable information on this point.

17 Saltzman 2008, 70.

Bardini, with whom Gutekunst negotiated over the purchase of two Raphael portraits, as wildly overpriced ("how can one buy from Bardini?" Gutekunst wrote to Berenson),[18] but until the turn of the century the noble Italian families were still a source of "big, big game." From the collection of Prince Chigi, for example, came two of the greatest Italian pictures that Colnaghi was to sell to America: Botticelli's *The Madonna of the Eucharist* (Fig. 2) now in the Isabella Stewart Gardner Museum, and Titian's *Portrait of Aretino*. The Aretino portrait was sold to Henry Clay Frick having been exhibited triumphantly at Colnaghi in 1905, where the *Times* compared it very favorably with the "so-called Ariosto" (now known as the *Man with a Quilted Sleeve* or *Portrait of Girolamo (?) Barbarigo*) recently bought by the National Gallery, then just across the road from Colnaghi's old gallery.[19] Things were changing, however. When the Chigi Botticelli was spirited out of Italy in 1897, it provoked a storm in the press, and the prince faced a severe fine. By 1903, Charles Holmes had written that Italy was "practically closed to picture buyers."[20] There were some intrepid individuals who were prepared to flout the regulations—such as Colnaghi's Parisian associate, the dealer Trotti, who drove the Cattaneo van Dycks out of Italy rolled up in tubes strapped to the underneath of his sports car[21]—but generally speaking Italy had become a much more complicated and expensive place in which to buy art.

Increasingly, therefore, Britain, whose private collections had been so enormously enriched as a result of the French Revolution and Napoleonic Wars, was perceived as the most fruitful hunting ground for masterpieces. Here, Colnaghi's long-standing relationships with the artistocracy were a great advantage, and the young Gutekunst must have learned a lot from his senior partner, the much older William McKay. The well-connected "noble Scot," as Gutekunst nicknamed McKay in one of his letters to Berenson, provided an entrée into many of the great private collections. Doubtless, he also gave Gutekunst some fatherly advice, and the two men formed a very effective double act. In 1894, for example, they managed to extract two highly important pictures from Lord Ashburnham: a Botticelli of the

18 Gutekunst to Berenson, 1 November 1900, CLB.
19 *Times*, 27 July 1905: "when the Darnley Titian, miscalled 'Ariosto' was bought last year for an enormous and excessive price for the National Gallery, the world was reminded how rare these authenticated works by the greatest men have now become . . . It is pleasant, therefore, to record that a first-rate Titian of undoubted genuineness has just found its way to Britain. Today, at Messrs P and D Colnaghi's gallery in Pall Mall East, those who are interested in art may see the superb *Portrait of Pietro Aretino* from the Palace of Prince Chigi in Rome, where it till lately had remained unknown except to a few students."
20 Holmes 1903, 15.
21 See Saltzman 2008, 205. The purchase of the Cattaneo van Dycks (now at the National Gallery of Art, Washington) was negotiated by Gutekunst's partner, Edmond Deprez, and the paintings were bought by Colnaghi in partnership with Knoedler and Trotti. Trotti delivered the canvases to Le Havre, where Charles Carstairs took delivery of them and arranged for their cleaning and restoration. Gutekunst's stance on the breach of export laws (and indeed US import controls) was relatively principled by the standards of the time—he refused to smuggle paintings on behalf of Gardner, for example—but, while he generally avoided direct involvement, he certainly knew of these activities and was involved indirectly. In 1899, for example, Colnaghi took delivery of a painting then attributed to Fiorenzo di Lorenzo, which had been smuggled out of Italy by the Berensons in a cargo of dolls; see Hall 1992, 11.

2

Sandro Botticelli, *The Madonna of the Eucharist*, early 1470s, tempera and oil on wood. Isabella Stewart Gardner Museum, Boston.

Tragedy of Lucretia, which Gutekunst sold through Berenson to Isabella Stewart Gardner (the first Botticelli to be sold to America), and a magnificent Rembrandt of *Preacher Anslo and His Wife*, which McKay sold to the Gemäldegalerie, organizing its shipment to Germany in conditions of the utmost secrecy because neither Wilhelm von Bode nor the earl wanted it to be known publicly that the picture had been sold.[22]

Gutekunst's deftness in dealing with the British aristocracy comes through in his carefully crafted "cold call" letter of 2 May 1895, to Lord Pelham-Clinton-Hope. It reads: "We venture with reluctance to approach your lordship on a somewhat delicate matter, having

22 McKay to Bode, 3 August 1894, CLB: "We shall send off the Rembrandt to you direct next August via Hamburg. I have taken the greatest precaution on your account, as well as my own, that it is not known where the picture goes."

been urged repeatedly to do so by one of our best and richest clients," before going on to ask whether there might be "any chance of your lordship's collection of pictures being sold privately" (there was, although it took another three years of negotiation).[23] Another aristocrat who was persuaded to yield up his treasures was Lord Darnley, from whom in 1896 Gutekunst acquired, in perhaps the greatest coup of his career, the Titian *Europa*, sold to Isabella Stewart Gardner. Many of these impoverished aristocrats required extremely careful handling because they were proud as well as poor. Lord Darnley, Gutekunst confided to Berenson, was "a most touchy and peculiar man."[24] Officially the *Europa* was "'not for sale' in the owner's words. At the same time 'it <u>can</u> be bought for £18,000.'"[25] Gutekunst's combination of shrewd understanding of the market and diplomacy generally ensured that the paintings were acquired, though one major picture that got away was Thomas Gainsborough's *The Blue Boy*, later bought by Gutekunst's great rival Duveen.

Until about 1895, American collectors played almost no part in this burgeoning Old Master market. It was dominated largely by European collectors and above all by the Gemäldegalerie in Berlin, regarded with awe and suspicion by the guardians of British heritage and headed by the brilliant and predatory Wilhelm von Bode (Fig. 3), a man, according to Max Friedländer, with "an ambition almost amounting to genius."[26] By 1894, McKay had already established an important business relationship with Bode, and it was McKay rather than Gutekunst who was responsible for most of the early Colnaghi dealings with Berlin. But the young Gutekunst, who had the obvious advantage of being German, started to play an increasingly important role in dealings with Berlin in the later 1890s, writing letters in German to Bode which were signed by McKay[27] and negotiating the purchase of the magnificent Hope Collection of Dutch and Flemish pictures. This highly important en bloc purchase involved three years of negotiation and a suit in Chancery; to raise the money, Gutekunst had to put together a complicated syndicate involving the dealer Asher Wertheimer, Colnaghi, and the Gemäldegalerie. Through this one deal, however, the Gemäldegalerie acquired a string of masterpieces—Mrs. Gardner gained two Rembrandts and a painting then attributed to Gerard ter Borch for £30,000, roughly 25 percent of what the whole collection had cost. Bode, who acted as art adviser to Sir Alfred Beit, ensured that Beit took the wonderful pair of Gabriel Metsus (now in the National Gallery of Ireland) that Mrs. Gardner had failed to buy and which were beyond the budget of the Gemäldegalerie, and that Berlin received a small painting by Albrecht Dürer as a thank-you present.

Until the early 1900s, Berlin played a very important role in the international art market. Wilhelm von Bode, whom Morelli nicknamed the *Kunstkaporal* (corporal of art), was an extremely powerful ally whom Gutekunst carefully cultivated, feeding him

23 Gutekunst to Lord Pelham-Clinton-Hope, 2 May 1895, CLB.
24 Gutekunst to Berenson, 19 February 1896, CLB.
25 Ibid.
26 Friedländer 1969, 20. For more on Bode and the British, see Dieckvoss 1995; Warren 1996, 101–106; and Bode 1997.
27 In August 1897, McKay apologized in a letter to Bode that "my partner Mr. Gutekunst being away, I am obliged to write in English": McKay to Bode, 18 August 1897, CLB.

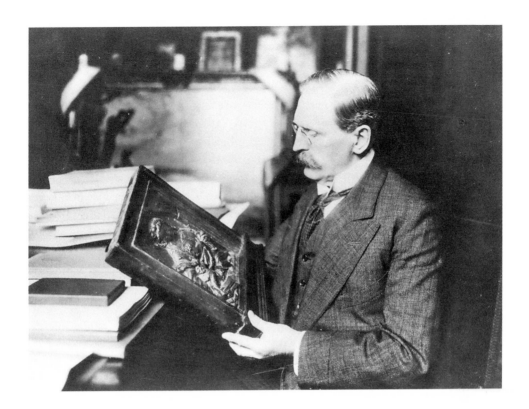

3

Dr. Wilhelm von
Bode, ca. 1900.
(Photo: b p k
Bildagentur für
Kunst, Kultur und
Geschichte, Berlin.)

snippets of gossip, information on pictures coming onto the market, and occasional presents in kind, which were donated to the museum, in return for introductions to clients such as the Beits and the Prince of Liechtenstein. In an age when the worlds of academe, museums, and the trade were far more deeply enmeshed than they are today, Bode's opinion was sought not just on attributions, but also on prices. Gutekunst was frequently in Berlin cultivating the patrons of the Gemäldegalerie, a job which he evidently regarded as more profitable than pleasurable ("Lord save us from art lovers," he confided in one letter to Berenson),[28] and he was also offered paintings by Bode in a private upstairs room of the museum. These included a putative Bellini from the Kahn Collection, which Gutekunst turned down on Berenson's advice, writing to thank "BB" ominously for "the peep behind Dr Bode's curtain" and adding that he would be careful "to be even more guarded with [Bode] in future."[29] The relationship between Bode and Berenson was characterized by a mutual dislike bordering on loathing, and Berenson's

28 "Carissimo amico. We—the Countess and humble self have been here a fortnight and glad to go back tomorrow. Berlin collectors and art lovers!! Heaven protect one! However, I managed to get a few sheckels out of them!": Gutekunst to Berenson, Hotel Kaiserhof, Berlin, 31 October 1910, Bernard and Mary Berenson Papers, Biblioteca Berenson, Villa I Tatti—The Harvard University Center for Italian Renaissance Studies (hereafter BMBP).

29 Gutekunst to Berenson, Hotel Kaiserhof, Berlin, 16 October 1909, BMBP.

jealousy of Gutekunst's close relationship with Berlin comes through in some of the letters in the Colnaghi Archives. [30]

The links with Berlin remained important to Colnaghi throughout the early 1900s, and even when the rise in art prices meant that Bode was no longer able to compete with the Americans, he fulfilled an important role for Gutekunst as an "underbidder." In 1906, for example, Gutekunst told Henry Clay Frick via Knoedler that he was not prepared to budge on the price of a Rembrandt *Self-Portrait* because Berlin was interested, and that same year Gutekunst sold his first painting to the Metropolitan Museum of Art, a "beautiful early Holbein Portrait," when Bode was not prepared to pay the full asking price. "You shall have first refusal of this if I can keep it away from Bode," Gutekunst wrote to Roger Fry[31]—the painting ended up in New York rather than Berlin.

In 1902, McKay wrote to Bode, "I fear that the Americans are upsetting our old ideas of prices,"[32] and from then onward the market started to shift decisively toward America. Already during the 1890s, Gutekunst had pulled off some spectacular sales to the United States, and a key factor in his success was his relationship with the young Bernard Berenson. Precisely when and how the two men met is not certain. One suggestion[33] is that they may have been introduced by Jean Paul Richter, the German expatriate scholar-dealer resident in Florence whom Berenson had met in 1889 and with whom Gutekunst had had business dealings since 1891; another is that they might have been introduced by Charles Loeser. What is certain is that by 1894, the year that Gutekunst joined Colnaghi, their friendship was blossoming, and their partnership in business was to lead to some of the most spectacular sales of the late nineteenth century. Initially Berenson seems to have been very reluctant to become involved with the art trade,[34] but, egged on partly by his future wife Mary Costelloe[35] and partly by his new friend Gutekunst,[36] Berenson found that his scholarly activities were increasingly underpinned by art dealing as he acted as an adviser to Colnaghi's first great American client, Isabella Stewart Gardner (Fig. 4).

30 "Our Berlin friends, of whom you seem jealous without sound reason—in fact you yourself carry on a considerable correspondence with my friend Friedländer on anything German or Flemish, will be very angry with us. But we owe them nothing now and I cannot help it. They are most anxious to have the Bristol Velaszquez only they dare not move without von Bode and he has not seen the picture himself": Gutekunst to Berenson, 20 February 1901, CLB. On the antipathy between Berenson and Bode, see Brown 1996, 101–106.

31 Gutekunst to Fry, 21 February 1906, CLB.

32 McKay to Bode, 31 January 1902, CLB.

33 See note 16, above.

34 Berenson criticized Richter for being "*trop marchand*," according to Seybold, this volume. According to Ernest Samuels, Bernard and Mary Berenson used to refer to the art trade as the "pig trade": see Samuels 1987, 4.

35 See Strachey and Samuels 1983, 82: "When it came to buying and selling on their account, Mary took to it all with considerably more zest—and less conscience—than he, delighting in the perils as well as the rewards."

36 See Samuels 1979, 308–309, for an account of Berenson's ambivalence toward dealing and Gutekunst's encouragement.

4

John Singer Sargent,
*Portrait of Isabella
Stewart Gardner*, 1888,
oil on canvas. Isabella
Stewart Gardner
Museum, Boston.

In March 1894, Berenson had asked his publisher to send a copy of *The Venetian Painters of the Renaissance* to the great Boston art collector who had helped sponsor his travels in Europe but from whom he had become estranged five years earlier. The book, and Berenson's accompanying letter, brought about an immediate rapprochement. Mrs. Gardner, who had begun under the tutelage of Charles Eliot Norton to collect books and rare manuscripts, was entering a new phase as a collector of Old Master paintings and "had urgent need for guidance in the raging competition for the art treasures of the Old World."[37] This Berenson was very happy to supply, with the discreet help of Gutekunst.

On 1 August 1894, Berenson wrote to Mrs. Gardner with a spectacular proposal: "How much do you want a Botticelli? Lord Ashburnham has a great one—one of the greatest—a death of Lucretia to rival the 'Calumny' of the Uffizi." What Berenson did not reveal is that the painting (Fig. 5) was already being handled by Colnaghi, and that it was in fact Gutekunst, rather than Berenson, who, together with McKay, conducted all the negotiations with the earl.[38] The following December, when Berenson met Mrs. Gardner in Paris, she agreed to buy the picture for £3,200, around two and a half times what she had spent two years earlier on Johannes Vermeer's *The Concert*. It marked the beginning of her career as a serious collector of Renaissance art and was also the start of a triangular relationship between Gutekunst, Berenson, and Mrs. Gardner lasting until 1902, in which Mrs. Gardner acquired some two dozen masterpieces that laid the foundations for the future Isabella Stewart Gardner Museum. It was also, as Alan Chong has noted, "the beginning of Berenson's career as a salesman for Colnaghi," though it was a career in which he scrupulously avoided, whenever possible, mentioning the name of the firm, presenting Colnaghi to Mrs. Gardner as shippers, middlemen, or occasionally "his agents."[39] Another fact concealed from Mrs. Gardner was that Berenson, while working as her agent on a 5 percent commission basis, was also splitting the profits equally on works of art handled by Colnaghi and often recommended to her pictures which he owned in shares with the firm. Although Gutekunst was happy to play along with this initially, Berenson's subterfuge was to become an increasing source of anxiety, leading to a major crisis of confidence in which the gallery was ultimately the loser.

For the time being, though, business was booming and the triangular relationship was proving advantageous to all three parties. Two years after the sale of *The Tragedy of Lucretia*, Gutekunst and Berenson pulled off their biggest coup: the sale to Mrs. Gardner of Titian's *Europa* (Fig. 6), one of the greatest Italian Renaissance paintings in America and the pearl of the Gardner collection. The story of its acquisition is one of the most sensational chapters in Gutekunst's high-octane career and was certainly a defining moment in the relationship between him, Berenson, and Mrs. Gardner. Originally painted in the 1560s for Philip II of Spain, the picture had been held in high regard by Titian himself, who wrote to the Spanish king in 1562 that "she [*Europa*] may be the

37 Ibid., 188.
38 A payment of £2,500 was made to Lord Ashburnham on 20 December 1894 (journal accounts, CA).
39 See Chong 2010, 27.

5

Sandro Botticelli,
The Tragedy of Lucretia,
ca. 1500–1, oil on
wood. Isabella
Stewart Gardner
Museum, Boston.

seal of the many other works that were ordered and furnished to you by me." In 1623, the picture was offered to Charles I of England (a fact later highlighted by Berenson to Mrs. Gardner), but it remained in Spain following the breakdown of his negotiations for the hand of the infanta before passing, in the eighteenth century, into the Orléans Collection. Brought to London in the late eighteenth century along with that astonishing galaxy of Italian and northern pictures, it was acquired in 1824 by the fifth Earl of Darnley and, until 1896, hung at the Darnleys' countryseat, Cobham Hall, where it had been seen and admired in the 1840s by Dr. Gustav Friedrich Waagen and Sir Charles Eastlake. Like so many British aristocrats, the Earls of Darnley were short of money in the 1890s, and in June 1895 McKay contacted Bode to say that Lord Darnley had approached him "through a relation with a view to sell the famous picture of Europa by Titian." McKay added that he knew Bode had "had the picture under consideration for some time," but offered to act as an intermediary, adding: "I have no doubt that I could buy it much cheaper than you."[40] Later that month, it seems that Bode visited Cobham Hall with Gutekunst, who, as the German-speaking partner, was playing an increasingly important part in the firm's dealings with Berlin. Although Bode was (for reasons of discretion) not mentioned by name to the Earl of Darnley, he is almost certainly the "gentleman in question" who "only came to England for one day" referred to in Gutekunst's letter to the earl of 25 June.[41] At the end of the letter, Gutekunst requested an interview with the earl as soon as possible. Not one to waste any time, he then followed up his

40 McKay to Bode, 1 June 1895, CLB. For more detail on the earlier history of the *Europa*, its reception in Britain in the nineteenth century, and the circumstances leading to its sale to Mrs. Gardner, see Howard 2013.

41 "I am much obliged for your Lordship's favour received yesterday morning, and immediately took the gentleman in question, who had arrived the evening before, to Cobham Hall, as he only came to England for one day": Gutekunst to Lord Darnley, 25 June 1895, CLB.

6

Titian, *Europa*, ca. 1560–62, oil on canvas. Isabella Stewart Gardner Museum, Boston.

thank-you letter to the earl with another letter (signed "Colnaghi," but in Gutekunst's handwriting) which was designed to open the way for negotiations over price.[42]

At that point, negotiations seemed to founder, possibly over the question of the price, because Bode was a mean buyer. But the following year (1896), the sixth earl died and on 19 February Gutekunst wrote excitedly to Berenson to say that he had been offered "one of the finest Titians in existence":

> My dear Boy,
> Thanks for your cheque which has come today. So far so good.
> The pictures (Rembrandt and Tintoretto) will leave tomorrow and are packed as well as anything <u>can</u> be packed. If anything should happen to them it will not be <u>our</u> fault. The funds cannot be there by the time you receive this letter. I trust Mrs J [Mrs. Jack Gardner] will be very pleased with these 3 pictures. . . .
> The 'Velázquez' still has all my attention. Also a Titian.

42 "One object in asking for an interview was to avoid delay, by ascertaining what price you might be prepared to accept for the picture of 'Europa' by Titian as we are now seriously entertaining its purchase and have as yet no authoritative statement from your Lordship on that point": Gutekunst to Lord Darnley, 26 June 1895, CLB.

Jeremy Howard

Lord Darnley's (whose name, by the way must not be mentioned, as he is a very touchy and peculiar man) "Ariosto" is not to be believed. Out of the question! But the Europa is a picture for a great coup. There is <u>absolutely nothing</u> against it, except, perhaps, for some scrupulous fool, the subject, which is very discreetly and quietly treated. You will find all about this in Crowe and Cavacescelle page 317 etc and chiefly 322 and 323. "Tis one of the finest and most important Titians in existence. Condition is <u>perfect,</u> not considering the dark varnish, and the landscape alone is a masterpiece of the 1st water. The price is £18,000 but we ought to get 20,000, if anything at all, and will divide whatever he might in the end be willing to take for cash. It would be jolly if Europa came to America? Eh? Now as to the photo. I cannot approach Lord Darnley in any way again except with a firm offer. But I had a lengthy interview with his nephew whom I know very well. He told me that he had himself vainly applied for a photo for <u>himself</u> some time ago but he promised to lend me if he should get one. He says that someone is now after the picture so that I cannot of course guarantee anything. The picture is in nobody's hand and "not for sale" in the owner's words. At the same time "it <u>can</u> be bought for £18,000." This is the man's position. Now tell me what you think. [43]

At this point, Berenson, who was later to describe the beauties of the Titian so eloquently to Mrs. Gardner, had almost certainly not seen the picture in the flesh and may not even have known of its existence, which accounts for the care with which Gutekunst described its quality and condition, even giving the page reference in Crowe and Cavacescelle. Not for the only time in their relationship, Berenson seems to have been content to rely upon Gutekunst's connoisseurship as well as his negotiating skills. Why Gutekunst was so damning about Lord Darnley's "other" Titian, the "so-called Ariosto" (*Man with a Quilted Sleeve* or *Portrait of Girolamo (?) Barbarigo*), is hard to fathom given that this picture, one of Titian's greatest early portraits, was a painting that Colnaghi had tried to buy from Lord Darnley a year earlier.[44] Gutekunst probably had commercial reasons for wanting to focus Berenson's attention on the "picture for a great coup" and not to muddy the waters with Mrs. Gardner or with the "touchy and peculiar" Lord Darnley by attempting to negotiate on both pictures simultaneously, although we know from his correspondence with Berenson that he was hoping to get "other things" out of the earl in due course.[45]

Berenson did not immediately offer the painting to Mrs. Gardner because he had already approached her about an even more expensive picture: Gainsborough's *The Blue Boy* (Fig. 7), then belonging to the Duke of Westminster, for which he had been advised by Gutekunst that Mrs. Gardner would have to offer at least £35,000 ($150,000), almost twice the price of the *Europa*. Calculating that Mrs. Gardner would not be able to raise

43 Gutekunst to Berenson, 19 February 1896, CLB.

44 There is a letter signed "P & D Colnaghi" written by McKay to Lord Darnley on 5 January 1895 (CLB) asking "whether you would be disposed to part with your picture by Titian of Ariosto now in the exhibition of Old Masters."

45 Gutekunst to Berenson, 28 April 1896, CLB.

7

Thomas Gainsborough,
The Blue Boy, ca. 1770,
oil on canvas.
Huntington Library,
Art Collections, and
Botanical Gardens,
San Marino.

the money to buy both pictures, Berenson offered the *Europa* instead to Susan Cornelia Warren, wife of Samuel Warren, president of the Museum of Fine Arts in Boston. It was perhaps fortunate for Berenson, as things turned out, that he had been unable to send Mrs. Warren a photograph because Gutekunst had experienced major problems obtaining one, so Warren had not yet responded.

Then, in May 1895, Gutekunst finally received a reply from the Duke of Westminster about the Gainsborough. As he had feared, the duke's reaction was decidedly lukewarm: "he only smiled coldly...at the same time he was interested to hear of the offer, etc.," Gutekunst wrote to Berenson.[46] The duke had obviously just been testing the market,

46 Saltzman 2008, 76.

and the deal was off. In the meantime, Mrs. Gardner had responded enthusiastically to Berenson by telegram saying that she would buy the Gainsborough, using a prearranged code: "YEBB" ("Yes, Blue Boy"). This presented Berenson with a very awkward dilemma. He was most anxious to compensate Mrs. Gardner for her disappointment by offering her the Titian, in his view "a far greater picture" than the Gainsborough, but he had committed a grave sin, as her agent, in offering the picture first to another Boston collector, when he was supposed to give her first pick of any paintings coming onto the market. To rectify the situation required the most careful diplomacy, and the letter written by Berenson to Mrs. Gardner on 10 May 1896 was a masterpiece of salesmanship, in which Berenson, beginning on a note of contrition, called upon all his resources of flattery and Pateresque word-painting:

> Now on bended knee I must make a frightful confession. Just a week ago I thought The Blue Boy so certainly yours that I did something stupid in consequence. 'Tis a tale with a preface, and this you must briefly hear. One of the few great Titians in the world is the Europa—which was painted for Philip II of Spain, and, as we know from Titian's own letter to the King, despatched to Madrid in April 1562. Being in every way of the most poetical feeling and of the most gorgeous colouring, that the greatest of all the amateurs, the unfortunate Charles I of England had it given to him when he was in Madrid negotiating for the hand of Philip the Fourth's sister. It was then packed up to await his departure. But the negotiations came to nothing, and Charles left Madrid precipitately. The picture remained carefully packed—this partly accounts for its marvellous preservation—and finally came in the last century into the Orleans Collection. When that was sold some hundred years ago, the Europa fell into the hands of a lord whose name I forget and then Lord Darnley's, and is now probably to be bought for the not extraordinary price of £20,000 (twenty thousand pounds). This is my preface. Now list to my doleful tale. Of all this I became aware just a week ago when I had no doubt I could get you The Blue Boy. I reasoned that you would not be likely to want to spend £20,000 on top of the £38,000. But the Titian Europa is the finest Italian picture ever again to be sold—I hated its going anywhere than to America, and if possible to Boston. So in my despair I immediately wrote to Mrs. S. D. Warren urging her to buy it.
>
> Now as you cannot have The Blue Boy I am dying to have you get The Europa, which in all sincerity, personally I infinitely prefer. It is a far greater picture, great and great tho' The Blue Boy is. No picture in the world has a more resplendent history, and it would be poetic justice that a picture once intended for a Stewart should rest at last in the hands of a Stewart.
>
> But you have forbidden me to bring you into rivalry with any one else. Yet I have given you my reasons and I trust you will sufficiently consider the exceptional circumstances. I am under no obligation to Mrs Warren. If you cable as soon as possibly you can make up your mind after receiving this, your decision will in a perfectly bona fide way come before Mrs. Warren's and then the Europa

shall be yours. Cable, please the one word YEUP = yes Europa or NEUP = no Europa to Fiesole as usual. I am sending a poor photograph which will suffice if you look patiently to give you an idea.

And now, dear Mrs. Gardner, I have told you my doleful tale. Forgive me. Get the Europa, and if you decide to get her … please do not speak of her to any one until she reaches you, so as to spare me with Mrs Warren. Please address Fiesole until June 3.

Very sincerely yours, Bernhard Berenson.[47]

Mrs. Gardner responded instantly, agreeing to purchase the picture for £20,000, and on 15 June 1896 a payment of £14,000 to Lord Darnley was recorded in the Colnaghi account book.[48] Three days later, Berenson wrote to Mrs. Gardner to say that "at last, after the suspense that to me has been harrowing the *Europa* is yours. All sorts of hitches, and rival offers came up which threatened to shipwreck things but now we are safe in port, and to-day I cabled to send the cheque at once, as the sooner it is paid for and is absolutely ours the better."[49] Once she had paid, the profit was split evenly between Berenson and the gallery, with Berenson receiving £4,000 (£3,000 plus his £1,000 commission from Mrs. Gardner) and Colnaghi earning £3,000 on the deal.[50]

Because of delays over shipping the picture, the Titian did not arrive in Boston until the end of August, prompting a torrent of telegrams and letters of increasing urgency and anxiety from Mrs. Gardner. "Up to this moment Europa has not appeared and I am gnawingly impatient," she wrote to Berenson on 18 August.[51] Whereas Berenson, who was constitutionally nervous, tended to fall ill under the strain of these interchanges, Gutekunst's response to her insistent demands was on the whole cheerful and positive—but occasionally even he was provoked to good-humored wrath, and in one letter to Berenson he enquired: "Has the cloud burst yet & have you heard from our lady across the seas? Or have you, better still, taken the initiative and blown her up?"[52] Fortunately, on 25 August the Titian arrived in Boston just as Mrs. Gardner had reached the point of cabling Berenson "to ask what could be the matter," and on 19 September she wrote to Berenson to say that she had just concluded a two-day "orgy": "the orgy was drinking myself drunk

47 Berenson to Gardner, 10 May 1896; see Hadley 1987, 55–56.

48 Journal accounts, CA. That same day £16,000 was credited by Berenson to the Colnaghi trade account for Titian's *Europa*. A further payment of £1,000 (presumably commission owing) was paid by Berenson to Colnaghi on 11 July 1896.

49 Berenson to Gardner, 18 June 1896; see Hadley 1987, 57.

50 It is not the case, as suggested in Saltzman 2008, 77, that Berenson "deceived both his client and his partner" by secretly keeping £2,000, giving his partners a mere £2,000 profit and himself £5,000 (including his £1,000 commission) on the deal. I am grateful to Alan Chong (see Chong 2010, 28) for pointing this out. Nevertheless, Berenson did deceive Gardner by his failure to disclose that he was sharing profits with Colnaghi and he also ended up with a larger share of revenue on the whole deal than Colnaghi did.

51 Hadley 1987, 63.

52 Gutekunst to Berenson, 30 January 1897, CLB.

with Europa and then sitting for hours in my Italian garden at Brookline, thinking and dreaming about her."[53]

Gutekunst's fears that the subject of *Europa*—"although very discreetly and quietly treated"[54]—might be too erotic for Bostonian tastes proved entirely unfounded when it came to this particular Bostonian collector. In fact, it was the very sensuality of the subject matter that clearly constituted a large part of its appeal to Mrs. Gardner, as is evident from the highly charged nature of her letters to Berenson. As so often in their relationship, works of art became objects of sublimated desire. They also allowed her to play the role of the Renaissance patron and collector, identifying herself with Isabella d'Este as well as with other great collectors of the past, such as her "Stewart" predecessor Charles I. In this relationship, art dealing became a form of seduction, in which Berenson was cast by her in the role of the "serpent" while she was the "too willing Eve."[55]

The *Europa* fulfilled another important requirement in establishing Mrs. Gardner's preeminence over other Bostonian collectors as well as impressing the artistic community: "Mr Shaw, Mr Hooper, Dr Bigelow, and many painters have dropped before her. Many came with 'grave doubts'; many came to scoff; but all wallowed at her feet," she wrote to Berenson with huge relish,[56] enjoying vicariously the subjugation of her male visitors by female beauty. The installation of the *Europa* was an aesthetic and social triumph, and in her New Year letter of 1 January 1897 Mrs. Gardner described to Berenson how she was waiting in the drawing room of her house in Beacon Street for the electrician to arrive "to arrange for Europa's adorers when the sun doesn't shine."[57]

The *Europa* deal was a prelude to other important sales to Mrs. Gardner, the pace of which escalated during the later 1890s. These included Botticelli's *Madonna of the Eucharist*, Fra Angelico's *Dormition and Assumption of the Virgin*, two Rembrandts (one now considered workshop), Peter Paul Rubens's *Portrait of the Earl of Arundel*, two portraits by Hans Holbein, a small Raphael *Pietà*, and a bust by Benvenuto Cellini of *Bindo Altoviti*—in toto almost thirty works of art, which provided the core Old Master collection of the Gardner Museum. Although not all the attributions have stood the test of time, it was a remarkable achievement and a tribute to Gutekunst's pertinacity and connoisseurship, Berenson's discrimination and powers of persuasion, and, because she was a lady who certainly knew her own mind, Mrs. Gardner's own taste and personality. Given how great a contribution Colnaghi made to the formation of the Gardner collection, it is perhaps surprising, as Alan Chong has observed,[58] that the firm remained consistently unpopular with Mrs. Gardner—when, that is, she deigned to acknowledge their

53 Gardner to Berenson, 19 September 1896; see Hadley 1987, 65–66.
54 Gutekunst to Berenson, 1 November 1900, CLB.
55 Gardner to Berenson, 12 January 1898: "He [Mr. Gardner] thinks every bad thing of you, and I too am beginning to look upon you as the serpent; I myself being the too willing Eve." See Hadley 1987, 116.
56 Gardner to Berenson, 19 September 1896; see Hadley 1987, 66.
57 Gardner to Berenson, 1 January 1897; see Hadley 1987, 72.
58 Chong 2010, 26.

contribution at all. This did not make for an easy relationship, and matters were made worse when Jack Gardner began to suspect Berenson of profiteering. As mentioned, at that period the lines between academe, the museum world, and the trade were not nearly as clearly drawn as they are today; many scholars, such as Herbert Horne, J. P. Richter, and R. Langton Douglas straddled both worlds, while museum directors like Bode were also deeply involved in the trade. But a certain amount of discretion was required, and as early as May 1896 Gutekunst wrote to Berenson to warn him that tongues were beginning to wag:

> By the by I must give you a warning—as a friend. When I saw Dr Gronau some weeks ago, in talking of things generally, we fell to talking of you and your latest books, etc. And he said he was going to see you in Florence. He seemed to think he had heard you had been selling pictures, that is not only advising people or friends to buy certain ones, but making money this way . . . so be careful![59]

Two years later, these rumors, combined with those put about by jealous rival dealers concerning the allegedly large profits made by Colnaghi, had obviously come to the ears of Jack Gardner, who exploded in anger at Berenson. Isabella Stewart Gardner wrote to warn him that "*They* say (there seem to have been many) that you have been dishonest in your money arrangements with people who have bought pictures."[60] The ensuing crisis threw Berenson into paroxysms of despair—"at times," Mary Berenson confided to her diary, he was "almost suicidal." As so often in their relationship, it was Gutekunst who stood firm and did his best to calm and reassure the anxious Berenson: "You must not worry and fret like a nervous young woman. Surely the money you and we made all along was easily made. Neither you nor I have ever had such a windfall as Mrs. G before, nor shall we ever in our lives have another . . . it will stop of its own account soon enough."[61]

Things came to a head soon after Jack Gardner's death, when Isabella Stewart Gardner found out from the former owners, the Pole-Carew family, that there was a substantial discrepancy between the £16,000 that had been paid by Colnaghi for a pair of portraits by Holbein and the £20,000 that she had been charged. While Colnaghi's share of the profit was not, in fact, that unreasonable, the price had been bumped up by Berenson's secret front-end commission. Gutekunst did his best to patch things up, promising to shield Berenson, but advised that honesty was the best policy: "The question is, might it not be safer and better to do business for her openly, for 10% or 15% rather than run such risks + worries which are very trying?"[62]

Mary Berenson, realizing how important Colnaghi was to her and Bernard's financial future, urged Berenson to "argue and argue with her that Colnaghi's are invaluable for her gallery. Take her to Agnew's miserable show which is the best he could have done

59 Gutekunst to Berenson, 2 May 1896, CLB.
60 Gardner to Berenson, 25 September 1898; see Hadley 1987, 154.
61 Gutekunst to Berenson, 1 November 1898, CLB.
62 Gutekunst to Berenson, 16 June 1899, CLB.

for her all these years and compare that with the Titians, the Crivelli, the Botticelli, the Pesellinos and all the other things they have got for her!"[63] But the damage was done, and, preferring to blame Colnaghi than admit that her brilliant protégé had been guilty of duplicity, Mrs. Gardner vented her spleen on the gallery: "I never liked the Colnaghis," she wrote to Berenson in 1899, "and do you remember I said, at the time of their delay in sending the Crivelli to Paris, that I absolutely did not want to have anything more to do with them again. I have been very sorry to see that you have still employed them, but now I am sure the end has come."[64]

As it turned out, the end had not quite come, and Mrs. Gardner continued to buy through Berenson from Colnaghi until 1902, though the pace of her acquisitions had slowed. In 1899, the date of the Pole-Carew Holbein scandal, Colnaghi almost pulled off a coup to rival the sale of the *Europa*. They had agreed to buy Titian's great masterpiece, *Sacred and Profane Love*, from the Villa Borghese for the record price of £150,000. Berenson had been carefully priming Mrs. Gardner to buy the picture, which he said would hang perfectly in her collection along with the *Europa*.[65] The negotiations broke down, however, partly for legal reasons, when the Italian government intervened and bought the villa and its collection for the nation, and partly because the colossal price seems to have been a stumbling block with Mrs. Gardner's trustees.

The formation of Mrs. Gardner's collection was the defining but by no means only aspect of the relationship between Berenson and Gutekunst in the years around the turn of the century. Increasingly, as his fame grew, Berenson was developing relationships with other American collectors and being encouraged by Gutekunst to buy shares in paintings with Colnaghi on very favorable terms. Despite the fact that they were almost exact contemporaries, Gutekunst, during the 1890s, seems to have played an almost fatherly role in their relationship, and his letters are full of enquiries about Berenson's health, advice on the art market and how to deal with collectors, and exhortations to Berenson to take more exercise (Gutekunst suggested he should take up fencing): "it will do you, not only the world of good, but is absolutely imperative for one like you, delicate, and much given to indoor life and work for the head."[66] Although Gutekunst frequently consulted Berenson on the attributions of Italian paintings, Berenson tended to defer to Gutekunst's superior knowledge of northern paintings ("the children of my fancy and longing," in Gutekunst's words)[67] and sometimes suggested pictures in his own field of expertise that he hadn't actually seen, such as the Raphael *Pietà* bought by Mrs. Gardner, on the basis of Gutekunst's recommendation.[68] Berenson also relied

63 Mary Berenson to Bernard Berenson, 9 June 1899; see Strachey and Samuels 1983, 76.

64 Gardner to Berenson, 31 May 1899; see Hadley 1987, 177.

65 Berenson stated that *Sacred and Profane Love* represented "the keystone to an arch of the building to which all along I have devoted my best energies": Berenson to Gardner, 13 July 1899; see Hadley 1987, 182.

66 Hall 1992, 14.

67 Gutekunst to Berenson, 15 December 1897, CLB.

68 Saltzman 2008, 68, quotes a letter written by Berenson to Gardner describing the Raphael in terms that suggested firsthand acquaintance with the picture ("so golden clear the colour, so dainty the

heavily on Mary Costelloe, soon to become his wife, whom he would sometimes send to Colnaghi to look at paintings when he was unable to be in London. In the summer of 1896, for example, he asked her to make an appointment with Gutekunst to view an important Diego Velázquez which he was thinking of offering to Mrs. Gardner, and report back to him: "as I do not like to deal in big game without an autopsy . . . I should not ask you to do this if I did not believe you as competent as any living person to have an opinion."[69]

During the second half of the 1890s, Mary, who was often in England visiting her family, played an increasingly important role as an intermediary in the business relations between Colnaghi and Berenson, and she is mentioned warmly in Gutekunst's letters. Following the Berensons' marriage in 1900, Gutekunst made a point of ending many of his letters with an uxorious message from him and his "Countess" to "you and your Duchess" and painting a picture of connubial bliss startlingly at variance with the reality of the Berensons' much more open relationship and Bernard's view of marriage as "a sacrament tempered by adultery."[70] This was perhaps just one reflection of Gutekunst's idealism. For all his astuteness as a dealer, his relationship with Berenson was characterized by a high degree of honesty and trust, bordering at times on naïveté, and an exalted view of loyalty and friendship. His tendency to overlook Berenson's subterfuges over Mrs. Gardner and associations with other dealers went beyond sheer pragmatism, invaluable though Berenson was to Colnaghi. From the time that Berenson took the lease on the villa, I Tatti and the scholarly life that Berenson led there became for Gutekunst a paradigm opposed to the hurly-burly of the London art market to which he returned frequently in the letters.[71] The durability of their friendship, which lasted way beyond the time when they had ceased to have any business dealings with one another, proves that it was not just founded on commercial considerations.

The tension between the worlds of scholarship and commercial art was one that was to color much of Berenson's career, and was a conundrum with which Gutekunst

trees"). This was clearly not the case, however, because in November 1900 Gutekunst wrote to Berenson saying that he was glad he had offered Gardner the picture, and adding: "the only pity is that you never saw it, for it is such a gem": Gutekunst to Berenson, 1 November 1900, CLB.

69 Quoted in Samuels 1979, 248.

70 Although Berenson's early views on marriage were rather Victorian (see Samuels 1979, chap. 26, "A Victorian Husband"), the Berensons enjoyed a tempestuous married relationship which was far from monogamous and anything but serene. Gutekunst's chivalrous compliments in his letters—for example, "How is Queen Mary the Stately? My cloak at her feet, myself to my knees before her" (Gutekunst to Berenson, 19 October 1905, CLB)—and his unremitting uxoriousness must have seemed to Berenson quaintly old-fashioned and idealistic, if not also faintly tongue-in-cheek. Some of Gutekunst's letters to Berenson are signed "Peter and Wendy," evoking J. M. Barrie's *Peter Pan*. This contrasts with Berenson, who, even in his eighties, wrote that he "dreamed of Fair Women as the wolf dreams of the lamb": see Samuels 1987, 533.

71 One early example is a letter written to Berenson on 7 March 1901 (CLB): "Spring must by this time be making its glorious entry into Toscana. I wish I were with you if only Saturdays to Mondays. I am driven mad with work and worry and am very tired." On 7 January 1936, Gutekunst wrote, in a rather similar vein: "You are so lucky to be able to enjoy such a calm secluded life in your lovely surroundings and country, while we are thinking of buying a second-hand Noah's Ark to escape the floods all around."

sympathized. While offering Berenson every encouragement to partner Colnaghi in various transactions, he also realized that "business is not always nice and I am the last to blame you, a literary man, for disliking it." On the other hand, if Berenson wanted "to make money likewise as we do," he needed to do "likewise as we do and keep a watchful eye on all good pictures and collections you know of or hear of in good time and let me know."[72] In effect, Berenson was being offered a partnership, but in return he had to become a scout for Colnaghi and be much more vigilant; in return Gutekunst held out the promise of future partnership deals and the possibility of taking a greater slice of the business. The proposal was put rather bashfully in a private letter now at I Tatti, written in March 1901 from Gutekunst's home in Streatham Hill, in order to avoid the prying eyes of other members of the firm. Gutekunst explained that he had been put up to it by Deprez and McKay, and had concocted a sort of

> family letter, or episcopal admonition . . . a school-masterly production—a menu made up by McKay, Deprez and P and D Colnaghi, a real hash of what I should say and did not want to say. You will get it in another form, but the usual style anyhow, for it is to be committed to the dull private letterbook of the firm.[73]

The gist of the proposal, Gutekunst wrote, was that "we want to train you to keep a keener look out on things in general and to be as mobile as possible in business matters." The proposal, however clumsily worded, can hardly have come as a surprise to Berenson, because he and Mary had already been thinking on similar lines and, in fact, the initial approach seems to have come from the Berensons. Shortly beforehand, Bernard had asked Mary to sound out Gutekunst as to whether it might be possible for him to join the firm, because he was worried that Mrs. Gardner was "buying less and less" and anxious to "be connected with someone who has a market."[74] In the event, however, nothing came of the proposal. Possibly the cause lay in the slump which hit the art market in the early 1900s, but possibly Berenson had decided, after the very successful trip that he had taken on Gutekunst's advice to the United States in 1903, when he was lionized by a number of American collectors, that he could afford to plow his own furrow independently of Colnaghi. Whatever the reason, from about 1904 he began to drift away from Gutekunst, who was rather hurt by his friend's coldness: "I thought, like a neglected mistress, a slight lack of interest, and I will not say friendship in my old friend."[75] Meanwhile Berenson had obviously realized that if he was to secure his financial future, he needed to build relationships in America, which he did first with the New York dealer Eugene Glaenzer and then eventually, in 1912, by signing a secret partnership agreement with Duveen.

72 Gutekunst to Berenson, Sunnyside, 17 Telford Avenue, Streatham, London, 14 March 1901, BMBP. In the event, seemingly, the proposal was not "committed to the dull private letterbook of the firm."
73 Ibid.
74 Samuels 1979, 357.
75 Gutekunst to Berenson, 9 November 1902, BMBP.

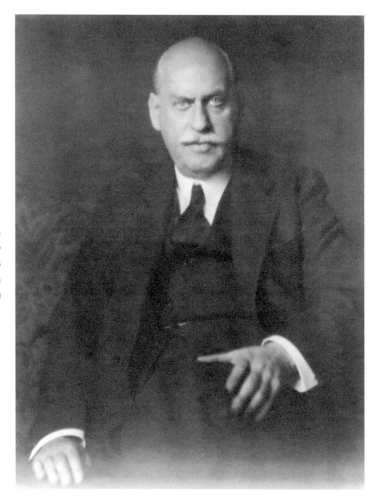

8

Charles Carstairs,
ca. 1928. (Photo
courtesy of Charles
Towers and Diana
Towers McNamara.)

Berenson's place as Colnaghi's linkman with American collectors was taken by the ebullient "Charlie" Carstairs of Knoedler (Fig. 8), a man more at home on the golf course than in a library or concert hall who was as open as Berenson was opaque. Gutekunst and he enjoyed a delightfully humorous and trusting relationship and a correspondence which was so voluminous that in one letter Gutekunst warned Carstairs: "My dear Charlie, be careful you don't get writer's cramp. It is a horrid disease, though one doesn't die of it."[76] This relationship led to some of the great Colnaghi deals of the next decade.

In 1900, Deprez made a trip to America to try to sell a Rembrandt to Frick and cultivate some American clients, but he was unsuccessful in establishing a direct line to the industrialist; from about 1905, Knoedler became the main conduit for American sales. Carstairs seems to have had an implicit faith in Gutekunst's connoisseurship, so much so that Robert Sterling Clark recorded in his diary that "the talk around London is that Knoedler's will buy nothing unless it is approved by Colnaghi's. Otto Gutekunst is a

76 Gutekunst to Carstairs, 1 February 1910, CLB.

'don' for telling drawings and pictures and Mayer [Gustav Mayer, who joined the firm in 1911] is excellent."[77]

Despite the extraordinary number of great pictures sold to America during this period, Gutekunst seems to have done all his business there at arm's length and curiously there seem to be no records of his visiting—although he did plan trips there in the autumn of 1909 and again in the following year that had to be canceled.[78] Instead, he relied upon intermediaries, or on Colnaghi's traveling salesman "Mr Bromhead." On 22 September 1909, Gutekunst wrote to J. P. Morgan to excuse himself for not coming to New York in person to show Morgan a Schongauer: "I greatly regret being unable to show it to you myself and explain the greatness of it."[79] The trusty Bromhead was dispatched instead, with instructions on exactly what he should say about the picture to Morgan and orders not to say anything to Knoedler about what he was up to. Clearly, Gutekunst was trying to establish an independent line to the great American collectors, but in this he was largely unsuccessful: "If you remember," he wrote to Morgan, who was complaining that Gutekunst had offered all the best things to Frick, "you had the offer before him, of such pictures as Titian's Aretino, the Ilchster Rembrandt, Mr Widener's Marchese Cattaneo full lengths of van Dyck, before you bought two of them through Seligmann."[80] He was equally unsuccessful in trying to sell directly to Robert Altman and Rodolphe Kahn. Instead, the great sales of the period leading up to the Great War, which included the masterpieces sold to Frick but also the Van Dyck Cattaneo portraits[81] and the wonderful Vermeer of the *Woman Weighing Gold*, were all sourced by Colnaghi in Europe (often by Gutekunst) and sold in America through Knoedler. So successful was this relationship that there was talk of a formal partnership between the two galleries in 1911.[82]

One of the masterpieces bought as a result of this collaboration was a painting which never went to America: Holbein's *Christina of Denmark, Duchess of Milan* (Fig. 9), the greatest picture ever sold by Colnaghi to the National Gallery in London. Gutekunst knew that in order to tempt the Duke of Norfolk to sell to Colnaghi, he would need to come up with an offer that was substantially more than the £40,000 which the National Gallery thought it was worth based on what had been paid for Velázquez's *Rokeby Venus*. He also knew that his great rival Duveen, who had already offered £35,000, was after the picture. The purchase of the picture required great audacity, and here Gutekunst showed all his skill in negotiation, reassuring his partners that their gamble would pay off and playing a cool hand of poker with Duveen:

77 Robert Sterling Clark Diaries (Diaries Series, Sterling and Francine Clark Papers, Sterling and Francine Clark Institute, Williamstown, Massachusetts; hereafter Clark Diaries), 19 December 1923, 2–3.

78 "Our trip across the Atlantic has become problematical. For business reasons we may not go at all": Gutekunst to Berenson, 24 October 1910, CLB. The previous year he also had to cancel a meeting with J. P. Morgan in New York; see below.

79 Gutekunst to Morgan, 2 September 1909, CLB.

80 Ibid.

81 These were sourced by Edmond Deprez, Gutekunst's partner, who handled all the initial negotiations with the Cattaneo family.

82 Hall 1992, 18.

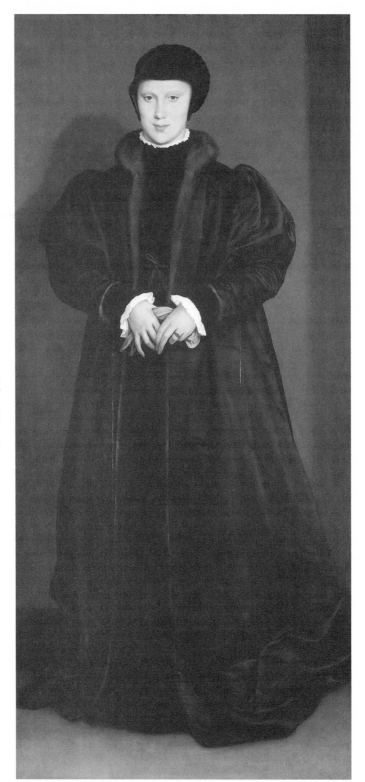

9

Hans Holbein the
Younger, *Christina of
Denmark, Duchess of Milan,*
1538, oil on panel. National
Gallery, London.

Duveen has again brought up the Norfolk H in a long conversation with me yesterday. He said amongst other things £39,000 had been offered by somebody—he thought by us—that he had now offered £50,000 and failed! I pretended to be astounded and to think that the Duke did not really have any idea of selling the picture. I know the Duke is still away and nobody can reach him by letter or otherwise, but the moment he does return, our man, who is a relation of his, will move in and keep us carefully au fait ... The N picture is H's masterpiece, in a sense, and worth £100,000![83]

Colnaghi and Knoedler secured the picture for £61,000, at that time a world-record price for a Holbein, and the National Gallery was given nine days to come up with a matching bid. It was a bitter blow to Duveen, and by a curious irony, Berenson, who had actually been the one (unknown to Gutekunst) on whose advice Duveen had upped his bid from £40,000 to £50,000,[84] witnessed the moment when Duveen heard the devastating news that his bid had been trumped by Knoedler in partnership with Berenson's old friend from Colnaghi: "When the message came through that it had been sold to Knoedler's ... Joe nearly went off his head. It was a terrible blow."[85] Meanwhile, Carstairs had offered the picture to Frick, who agreed to buy it for £72,000. When the news of this leaked out it provoked an immediate public outcry, the strength of which was well captured by a *Punch* cartoon entitled "Hans across the Sea" (Fig. 10), showing a wicked Uncle Sam with a bag of dollars trying to drag Christina out of her frame and onto a waiting steamer. Thanks to a valiant campaign by the National Art Collections Fund (NACF) and a last-minute anonymous donation, Christina was rescued, her virtue intact, and restored to the comfortable embrace of John Bull (Fig. 11). Despite all the opprobrium the duke and the dealers received in the gutter press, it was clear to more thoughtful commentators such as Sir Robert Witt that the real culprits were the niggardly treasury and the gallery's pusillanimous trustees. As Witt wrote, "the reluctance of certain persons to assist in our enterprise may have been based on an unwillingness to pay dealers' profits, but in point of fact it would have paid Messrs P and D Colnaghi better to have transferred the picture immediately to the purchaser without giving any option to the nation."[86] This was certainly true, because by the time Colnaghi had paid a donation of £2,000 to the NACF campaign, the firm had made only around 15 percent profit on an insecure outlay and, by doing the patriotic thing, had risked jeopardizing its relations

83 Gutekunst to Carstairs, 18 April 1909, CLB.
84 Samuels 1987, 77. According to Samuels, Joseph Duveen's uncle Henry Duveen sought Berenson's "judgement of the market even outside the Italian field. For example, when Joe Duveen offered £35,000 for one of the greatest Holbein masterpieces, *The Duchess of Milan*, for which the Duke of Norfolk was said to be asking £50,000, Henry thought they ought to go up to £40,000 if necessary. 'Before doing so', he wrote to Berenson, 'I should like your views on the subject ...' Encouraged by Berenson's reply, the firm finally raised their offer to £50,000."
85 Samuels 1987, 83.
86 Sir Robert Witt, letter to the *Morning Post*, 4 June 1909.

10

Bernard Patridge,
"Hans across the Sea,"
cartoon published by
Punch, 12 May 1909.
Colnaghi Archives.

HANS ACROSS THE SEA?

Stranger (U.S.A.) "ONCE ABOARD THE LINER, AND THE GYURL IS MINE!"

[The Duke of Norfolk has sold Hans Holbein's masterpiece, "Christina, Duchess of Milan," and there is a danger of its leaving the country.]

with Knoedler and Frick.[87] The Holbein affair had the positive effect, as far as the NACF was concerned, of drawing public attention to the chronic lack of funding for Britain's national museums and the fact that, as Charles Holroyd observed, "if the Nation wanted to hold on to its treasures it would have to learn to pay for them."[88] It also confirmed that Uncle Sam had become the biggest buyer on the London art market, a tendency increased by the abolition of the 20 percent US import tax in 1912. Lastly, it established that Colnaghi and Knoedler, who could take on the mighty Duveen and win, were among the most important art dealers of the Gilded Age.

During the boom years up to the First World War, Colnaghi made not only some spectacular sales but also some spectacular purchases. In one year (1911), for example,

87 Frick's response was to send an irate telegram to Knoedler, which read "REGRET FAILURE. THOUGHT YOUR PARTNERS MIGHT HAVE TAKEN LIBERTIES. HAVE WRITTEN": quoted in Saltzman 2010, 35.

88 Holroyd 1909, 137.

SOMETHING HAS TURNED UP.

THE HOLBEIN DUCHESS: *I ne-ver—will—desert—Mr. Bull!*
MR. MICAWBER BULL: *Something* HAS *turned up!*
[The anonymous gift of £40,000 at the last moment has saved the Holbein Duchess for the National Gallery.]

11

"Something Has
Turned Up,"
cartoon published
by *Westminster
Gazette,* 7 June 1909.
Colnaghi Archives.

they bought three Vermeers, the most spectacular of which, *Woman Weighing Gold* (later sold to Widener), was shown in a carefully orchestrated exhibition at Colnaghi attended by over a hundred visitors a day, including the Queen and Prince of Wales.[89] This not only advertised what Colnaghi had to prospective buyers, but also sent a clear message to prospective sellers.

That year, McKay retired and Gustavus Mayer, manager of Obach and a great expert on prints, replaced him as Gutekunst's partner. Colnaghi and Obach, as they then became, moved into a sumptuous gallery designed by H. V. Lanchester and E. A. Rickards (Fig. 12), until recently occupied by Partridge; this was thought to be more appropriate for the new company's millionaire clientele,[90] though Robert Sterling Clark described it as "very

89 See *Observer,* 11 December 1910; *Times,* 2 December 1910; and *Times,* 17 December 1910, where it was reported in the Court Circular that the Queen, the Prince of Wales, and Lady Bertha Dawkins "honoured Messrs P & D Colnaghi yesterday afternoon to inspect the newly-discovered painting by Johannes Vermeer of Delft, *A Lady Weighting Pearls* [*sic*]." According to Saltzman 2008, 223–224, "Gutekunst had the firm of White Allom design a setting for the picture, which he hung at Colnaghi's for two weeks. He also lined up photographs of Vermeer's thirty-four other pictures—'the whole of the known work of Vermeer together.'"

90 According to James Byam Shaw, the move was a response to remarks such as that of Henry Clay Frick, who asked Gutekunst "why he dealt from a shabby little place like that," referring to the old gallery in Pall Mall East. See Shaw 1968, 138.

12

View of the
Colnaghi Gallery
on New Bond
Street, ca. 1912.
Colnaghi Archives.

luxurious, but dark and badly laid out,"[91] and the average visitor must have found it very
intimidating, as James Byam Shaw recalled, to enter "by way of a vast hall between two
great walnut desks to left and right, curved like the horns of the moon, under fire from
a battery of eyes which the salesman trained upon him."[92] There up until the war, they
traded as P & D Colnaghi and Obach, dropping the name Obach in 1914 in response to
anti-German prejudice. On the second floor, Gutekunst, who had a very fine singing
voice, had a music room, where one evening he entertained Nancy Cunard "and sang to
her and some of her Covent Garden friends."[93] He and "the Countess," as he affection-
ately called his wife Lena, moved into a large house in Hyde Park Gardens, where they
displayed the bronzes and paintings from his growing art collection. Despite the threat of
war, 1914 was an annus mirabilis when art prices reached an unprecedented high, and in

91 "The Colnaghi co. had a huge store on Bond Street, very luxurious but dark and badly laid out. The
 Govt have taken this over for offices": Clark Diaries, 26 August 1942, 3–5.
92 Shaw 1968, 138.
93 Gutekunst to Berenson, 20 December 1942, BMBP.

that year Gutekunst sold a magnificent Francesco Guardi interior to the Alte Pinakothek in Munich and no fewer than twelve pictures to Robert Sterling Clark, one of the few American collectors with whom Gutekunst had established a direct line of contact without involving Knoedler. Chief among these was an altarpiece by Piero della Francesca, now in the Sterling and Francine Clark Art Institute. "Dear Gus," Gutekunst wrote to Mayer:

> I had some considerable trouble in making Clark realise that there is no other hand admissable in the Piero. He thought of Melozzo and all kinds of things. And the photo I sent him gave him a poor idea of the condition as well, showing all the cracks etc. But before the picture, it all vanished again and the deal was definitely fixed and payments discussed etc. I was with him all day, also at the Nat Gal and the Wallace Collection.[94]

The outbreak of war caused a great slowdown in business and strong anti-German prejudice which affected both partners, but particularly Gutekunst, who received abusive letters from his old friend Robert Langton Douglas[95] and was later interned.[96] There were some continuing sales to America, and during the 1920s two important new billionaire clients: Calouste Gulbenkian and Andrew Mellon. Like Frick, Mellon was primarily a client of Knoedler, and it was through Knoedler that Colnaghi sold a great Rembrandt *Self-Portrait*, which Gutekunst had acquired from the Duke of Buccleuch, and arguably the greatest Holbein now in America, the *Portrait of Edward VI* bought by Colnaghi in 1924 in competition with Duveen. Cheated of his prize, "the octopus and wrecker"[97] Duveen did his best to spoil relationships with Mellon by bad-mouthing the picture, and in 1927 a frantic telegram was sent from Colnaghi to the Holbein expert Dr. Paul Ganz: "DUVEEN HAS TOLD COLLECTOR WHO BOUGHT LITTLE HOLBEIN PORTRAIT THAT EVERYTHING EXCEPT THE FACE IS COMPLETELY REPAINTED MOST IMPORTANT THAT THIS SHOULD BE DISPROVED IN LETTER FROM YOU. GUTEKUNST WILL BE IN PARIS. . . . PLEASE SEE HIM FOR FURTHER DETAILS."[98] Fortunately, Ganz must have done what was required to reassure Mellon, and the little Holbein is now one of the most admired northern Renaissance paintings in the National Gallery of Art in Washington.

These two sales were a prelude to the greatest single deal in the firm's history: the sale of the Hermitage pictures to Andrew Mellon in 1930–31, in which it was Gus Mayer

94 Gutekunst to Mayer, 29 October 1913, CLB.
95 Gutekunst to Douglas, 3 and 8 December 1914, CLB; see also Hall 1992, 23.
96 See Saltzman 2008, 242. This was also confirmed orally by Gus Mayer's daughter Katharina Mayer-Haunton, although the present author has been unable to find any reference to Gutekunst's internment in the Colnaghi Archives.
97 Gutekunst first coined this epithet in a letter to Berenson of 20 March 1909 (CLB), not suspecting how deeply enmeshed Berenson already was in Duveen's tentacles by this stage, although it was not until 1912 that Berenson signed an official partnership agreement. See Simpson 1987, 137.
98 Colnaghi to Ganz, telegram, 1 April 1927, CLB; Gutekunst to Ganz, 20 June 1927, CLB.

rather than Gutekunst who played the major role.[99] The sale, one year after the Wall Street crash, appeared to deny the economic laws of gravity, but it proved to be a swan song. During the 1930s, the effects of the Great Depression caused a slump in the art market from which even the grandest dealers, like Duveen, were not immune. Although the market briefly rallied in the late 1930s, the closing years of the decade were clouded with the threat of impending war and Gustav Mayer's bankruptcy. The letters written to Berenson by Gutekunst, then in his late sixties, reflect both the slump in the art market and the depression of a dealer who had lost his appetite for the business and was longing to retire. "I am making a desperate effort to retire," he confided to Berenson in 1936, "but fear I may find no basis."[100] "Business every once in a while seems to pick up," he wrote in 1939, "until a fresh break in Wall Street, or the events in the Far East, or some speech by Mussolini and Hitler, knocks it on the head."[101] Increasingly, he found himself looking back nostalgically to the beginning of his Colnaghi career "at Pall Mall East where I was happy," or asking Berenson's advice on a picture he had seen half a century ago such as an *Annunciation* attributed to Filippino Lippi at Corsham Court: "I think it is definitely by the master, but perhaps not in quite perfect condition."[102]

Later that year, Gutekunst and "the Countess" shut up their house in England, put their books and paintings into store, and moved to a small hotel in Lausanne. Resigning as a director of Colnaghi, Gutekunst gave over half his shares to Mayer and the other directors. The following year (1940), as an economy measure, Colnaghi moved to 15 Old Bond Street and shared space with Knoedler. Unable to realize much for his private collection, and with major problems getting money out of England, Gutekunst and his wife (Fig. 13) spent the years of the Second World War in considerable deprivation. "As to Gutekunst," Robert Sterling Clark confided to his diary in 1942, "all he had left was his collection of pictures and drawings. He and his wife, (nee Obach), 'The Duchess' [*sic*] as she was nicknamed, they were living in a pension in Lucerne [*sic*]!!! Extraordinary as Mrs G was supposed to have a good fortune inherited from her father Obach!! But they spent money hard and fast."[103] They could not afford to buy books, and Gutekunst, who had spent his career surrounded by beautiful paintings, found that there was little to feed his appetite in wartime Switzerland. He still played golf, but his principal consolations were nature and music. "I can still sing quite well," he wrote to Berenson, "and, when the spirit moveth me, paint and sketch . . . in fact with my eyes and mind I am always painting, but so beautifully that I dare not and cannot put it to canvas . . . so I have nothing to show for it."[104]

Apart from with "the Countess" ("my great treasure and one of God's masterpieces"),[105] one of Gutekunst's most enduring relationships was with Bernard Berenson, to whom he continued to write letters for over half a century. Despite Berenson's earlier

99 Ekserdjian 2000.
100 Gutekunst to Berenson, 3 July 1936, CLB.
101 Gutekunst to Berenson 17 December 1939, BMBP.
102 Gutekunst to Berenson, 5 May 1943, BMBP.
103 Clark Diaries, 26 August 1942, 3–5.
104 Gutekunst to Berenson, Hotel Montana, Lausanne, 24 September 1945, BMBP.
105 Gutekunst to Berenson, 1 February 1931, BMBP.

13
Lena Gutekunst in
Lausanne, ca. 1945.
Bernard and Mary
Berenson Papers,
Biblioteca Berenson,
Villa I Tatti—The
Harvard University
Center for Italian
Renaissance Studies.

disloyalty and disingenuousness with regard to their business relations, Gutekunst
was remarkably forgiving. But in 1937, Berenson obviously touched a raw nerve when
he failed to include two of Gutekunst's paintings then attributed to Titian in his lists,
and then offered what Gutekunst saw as the backhanded compliment of saying that if
Gutekunst had devoted his life to learning, he would be the equal of many others who
had done so. "Down from your pedestal," replied Gutekunst:

> to what else have I devoted my life? Who, after all, are this holy circle "the best
> of you"? Do they not all make mistakes? . . . Have they all not from time to time
> accepted things they rejected afterward and rejected some they accepted later?
> Are not you all like me, just after money—we openly you quietly, less can-
> didly? . . . so let us drop this humbug . . . I do so mightily resent this high-brow
> superior attitude . . . I will not take place to a living soul regarding eye & experi-
> ence or honesty of endeavour & dealing & sincerity, nor in balanced knowledge
> and understanding of pictures, drawings, prints of all schools. I am no specialist,

not an art historian, critic or writer. I am an expert who has to stand by his guns and I have always paid for my mistakes myself.[106]

This moving and eloquent rebuke provides Gutekunst's finest epitaph—but in a way Berenson was right, because as with so many art dealers who left no publications, Gutekunst's enormously important contribution to the formation of so many great collections was soon to be forgotten. It must have been galling for Gutekunst, who had done so much to promote Berenson's early career and give him the financial security that underpinned his scholarship, to see Berenson's star in the ascendant, his villa, library, and collections intact, while Gutekunst was living in relative poverty and obscurity, starved of pictures, his shoes worn through, and without enough money to buy books.[107] Yet, if there was any bitterness, Gutekunst did not let it show in his letters to Berenson, which in his closing years were full of tender reminiscences and the hope, never to be fulfilled, that one day he might have the opportunity to revisit I Tatti, which he hadn't seen since 1914.[108]

Gutekunst died in February 1947 in the hotel where he and Lena had taken refuge upon the outbreak of the Second World War. They had no children—Otto's legacy is to be found both in the great collections he helped to form and in the tradition of connoisseurship at Colnaghi, which was inherited soon after his retirement by a young captain in the Scots Guards, whom Berenson had asked about in one of his letters.[109] His name was James Byam Shaw, the great postwar director of Colnaghi. Fortunately the pessimism about Colnaghi, which runs through Gutekunst's last letters, was not to be justified. The year he retired, in an effort to avoid insolvency, the firm moved out of its enormously expensive premises in the old Partridge building to share space with Knoedler at 15 Old Bond Street. Toward the end of December, Gutekunst wrote to Berenson to say that he was resigning:

I have tendered my resignation to the old firm, who seem to be able to carry on in some mysterious way. They succeeded in surrendering the strangling lease of '145 and are moving into Knoedler's old place in Old Bond Street at the end of this week. I am glad to be out of all that . . . maybe the firm, who are now saving some £15000 a year will make profits again when this war is over.[110]

106 Gutekunst to Berenson, 30 December 1934, CLB.
107 "My clothes are becoming shabby, I am getting very thin and skinny . . . one's boots and shoes get very worn here as the whole town is a long and steep slope . . . originally I only came out with enough clothes for a summer holiday": Gutekunst to Berenson, Hotel Montana, Lausanne, 6 May 1942, BMBP.
108 "How is your garden and your lovely view? . . . we should so much like to go to Italy for a few weeks, but unless I can sell something of ours in America or here, I cannot get the money to do so": Gutekunst to Berenson, Hotel Montana, Lausanne, 19 April 1940, BMBP. "[W]e often think of you two in your lovely garden with the beautiful view and wish we had gone to Italy more often": Gutekunst to Berenson, Hotel Montana, Lausanne, 6 May 1942, BMBP.
109 "The young gentleman you refer to—Byam Shaw—is a captain now in the Scots Guards and abroad, if still alive": Gutekunst to Berenson, Hotel Montana, Lausanne, 20 December 1942, BMBP.
110 Gutekunst to Berenson, 26 December 1939, BMBP.

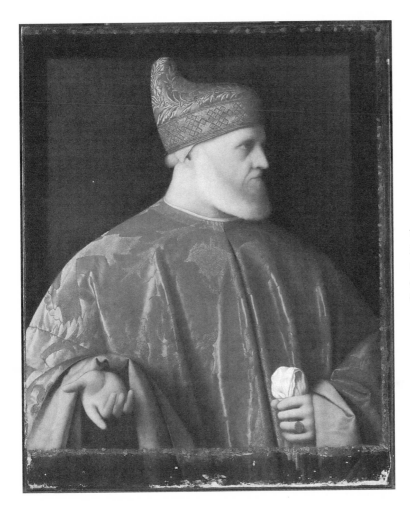

14

Vincenzo Catena,
*Portrait of the Doge, Andrea
Gritti*, late 1520s, oil
on canvas. National
Gallery, London.

In the event, despite the firm's parlous finances and Mayer's bankruptcy,[111] Colnaghi survived, though by the skin of its teeth.

The "Titian" *Portrait of the Doge, Andrea Gritti* (Fig.14), however, which had provoked Gutekunst's angry letter to Berenson in 1935, remained a bone of contention even after Gutekunst's death, fully justifying the reservations that Berenson had obviously had, but found difficult to express directly to Gutekunst, about its traditional attribution. This picture, which was very famous in the nineteenth century when it belonged to John Ruskin (who cited it in the James McNeill Whistler libel action as proof of the care with which Titian finished his pictures), started to receive critical scrutiny in the

111 "Gus Mayer is, or was, bankrupt, and is no longer a director, of course, but only a clerk under his former employees and a new director put in by the bank": Gutekunst to Berenson, 20 December 1942, BMBP. According to Mayer's daughter, her father's bankruptcy was precipitated not by the slump in the art market but by his ill-advised farming ventures.

1930s, partly because of those rather hard-edged qualities which Ruskin had admired. Already, in 1931, Johannes Wilde had rejected the ascription to Titian and proposed an alternative attribution to Vincenzo Catena, and two other German art historians in the 1930s—Hans Tietze and Luitpold Dussler—also rejected the traditional attribution to Titian.[112] Berenson, who was normally very robust over questions of attribution, obviously felt torn between loyalty to his old friend and his instincts as a connoisseur. On Gutekunst's letter to Berenson of 15 December 1935, in which Gutekunst wrote to ask why Berenson had not included the Gritti portrait in the lists in his *Venetian Painters of the Renaissance*, there is an annotation by Berenson which reads: "Insert in my lists only pictures of whose attribution I feel confident. In yr case I remember only one picture attr. by you to Titian. It is the profile of Doge Gritti. I never told you that in my opinion it was a Titian and I never thought so."[113]

On a more emollient note, however, Berenson then added: "send me a photo without much delay and, if it seems to me like a real Titian, I shall be able to squeeze it in to the Italian translation of which I am now correcting the proofs."[114] In 1947, the year of Gutekunst's death, the picture was proudly presented by Lena Gutekunst to the National Gallery, London, as a Titian, despite growing doubts over the attribution, and six years later it appeared in the first English monograph on Catena as fully attributed to Catena. Sir Philip Hendy, the director of the National Gallery, then had the unenviable task of trying to explain tactfully to Lena that her husband's prized Titian was by a more minor—though, he argued diplomatically, in some ways no less interesting—master.[115] Berenson's stance on this remained somewhat equivocal, as was arguably the case throughout his life on the relationship between art history and the trade. Whether out of loyalty to his old friend, or fear of offending Lena, or because he really had come to believe that the painting was by Titian, he stuck by the traditional Titian attribution. But in the 1957 English edition of the *Venetian Painters* lists, published two years before Berenson's death, Gutekunst's Gritti portrait was listed as by Titian "after Catena."[116] Was this scholarly equivocation or a final act of personal loyalty? One cannot be sure, but it was a rather singular and touching epilogue to a lifelong friendship between a masterly dealer and a great connoisseur.

112 See the discussion in Robertson 1954, 69.

113 BMBP.

114 Annotation, 19 December 1935, to Gutekunst to Berenson, 15 December 1935, BMBP.

115 This whole sad story was first drawn to my attention by Dr. Nicholas Penny, director of the National Gallery, in a brilliant lecture at the "Colnaghi 250" symposium, July 2010. The correspondence relating the story is in the National Gallery Archives.

116 Berenson 1957, 1:187, no. 5751.

FOUR

Palaces Eternal and Serene

The Vision of Altamura and Isabella Stewart Gardner's Fenway Court

ROBERT COLBY

THE 8 DECEMBER 1907 edition of the *Boston Herald* claimed to have solved the mystery of a new building at Isabella Stewart Gardner's Fenway Court: "STOREHOUSE BUILT COSTLY AS PALACE" (Fig. 1). It went on to explain how the building was erected to house works of art for which there was no room in the museum, which had been completed only four years before. Its curious and monumental design (Figs. 2 and 3), the newspaper noted, was based on that of a monastery. Like most everything at Fenway Court, the whimsical structure with its baroque detail, austere walls, and oversize trellises was the subject of intense speculation, although its chief practical function was to house carriages and motorcars.

Gardner died in 1924, and over the course of the twentieth century the building fell into disrepair. The once-high walls were incrementally lowered and the trellises dismantled, leaving the impression of a stand-alone outbuilding: "the carriage house" (Fig. 4). In July of 2009, the Isabella Stewart Gardner Museum demolished what remained of the structure in order to build a new addition.

In its original design, the building referred to Altamura, an aesthetic utopia that was the subject of an essay conceived of by Bernard Berenson, Mary Smith Costelloe, and her brother Logan Pearsall Smith.[1] "Altamura" appeared in 1898 in the trio's self-published

∞ I would like to thank Gardner Museum archivist Kristen Parker for extensive assistance in identifying important archival material for this article. Thanks are due to Louis Waldman and Jonathan Nelson of Villa I Tatti, and to I Tatti archivist Ilaria Della Monica, who kindly sent copies of archival

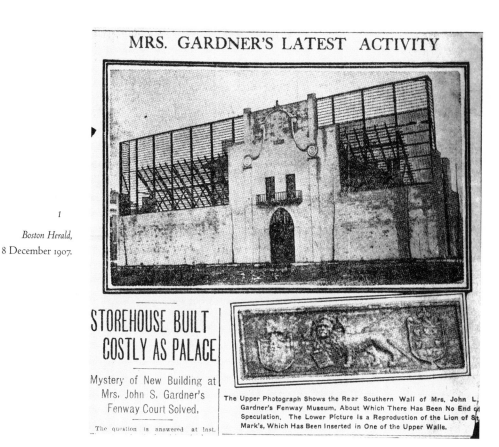

1

Boston Herald,
8 December 1907.

MRS. GARDNER'S LATEST ACTIVITY

STOREHOUSE BUILT COSTLY AS PALACE

Mystery of New Building at Mrs. John S. Gardner's Fenway Court Solved.

The question is answered at last.

The Upper Photograph Shows the Rear Southern Wall of Mrs. John L. Gardner's Fenway Museum, About Which There Has Been No End of Speculation. The Lower Picture Is a Reproduction of the Lion of St. Mark's, Which Has Been Inserted in One of the Upper Walls.

"little periodical," *The Golden Urn*, and described the yearlong liturgy of a fictive English monastery dedicated to "St. Dion" in an indeterminate Italian locale. The essay outlines a new religion, expressing the full measure of aestheticism's philosophical potential as Epicurean materialism that was yet possessed of a transcendent dimension.

There was, in fact, a real Altamura in southern Italy, and in 1978 Rollin Hadley discovered in the Gardner Museum Archives a postcard Berenson sent to Gardner of an

material related to Altamura from the Bernard and Mary Berenson Papers. Mary Clare Altenhofen of the Fine Arts Library at Harvard University first alerted me to the existence of the unprocessed Logan Pearsall Smith Papers at Houghton Library, Harvard University; I would like to thank the staff of Houghton Library for making the archives available on numerous occasions. Anthony Majahnlati and Trevor Fairbrother offered important suggestions at an early stage. I would like to thank my colleagues Sarah Parker, Timothy Riggs, and Annah Lee at the University of North Carolina, who kindly read drafts of the article and offered valuable suggestions. I am indebted to Janice Hewlett Koelb for her insights and thought-provoking suggestions, to Rachel Oberter for important methodological questions, to Patricia Vidgerman for her insights and editorial corrections, and to Linda Docherty, who kindly offered extensive comments and corrections that helped immeasurably to refine my argument. Research for this article was supported by an Everett Helm Visiting Fellowship from Lilly Library, Indiana University, Bloomington.

1 Smith, with Berenson and Smith Costelloe 1898.

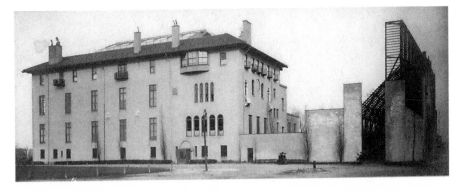

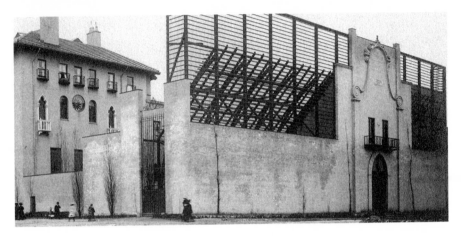

imposing ceremonial archway there (Fig. 5). This was the source of and catalyst for the new structure, which was to be the final stage of Fenway Court's exterior.[2] In this way, the real Altamura (which Gardner had never visited) came to stand in for the fictive Altamura. As an example of the transformation of an idea into form, the creation of the new building is a compelling demonstration of the means by which Isabella Stewart Gardner gave shape to her particular vision.

The purpose of this article is to provide documentation on the building, its origins, and its construction, and to examine the culture in which the ideas it represented took shape—and how these may inform our understanding of Gardner's project to build her unusual museum. In so doing, the article also amends the scant attention in the scholarly literature on Bernard Berenson and Altamura.[3] Archival material presented here for the first time suggests that "Altamura" was a manifesto for a philosophical religion embody-

2 Hadley 1978.
3 While there has been no examination of Altamura among Berenson scholars, it was fundamental to Meryle Secrest's understanding of Berenson's career and professional life in *Being Bernard Berenson* (Secrest 1979). In his biography on Berenson, Ernest Samuels describes Altamura as "an elegant and mellifluously phrased fantasy which burlesqued the life of exquisite sensation and lofty thinking of Bernard and Mary's Fiesole circle": Samuels 1979, 273.

4
Carriage House,
Isabella Stewart Gardner
Museum, Boston. (Photo:
Kevin J. Mowatt, 2007.)

ing Mary, Bernard, and Logan's aesthetic ideals at a key moment in their overlapping intellectual lives.

No surviving documents detail the meaning Gardner attributed to the "carriage house" complex (or the main palace building, for that matter). Aside from the building itself, the only pieces of evidence to be found are mentions of its construction in the Fenway Court payment ledgers, and in Gardner's correspondence with Berenson and

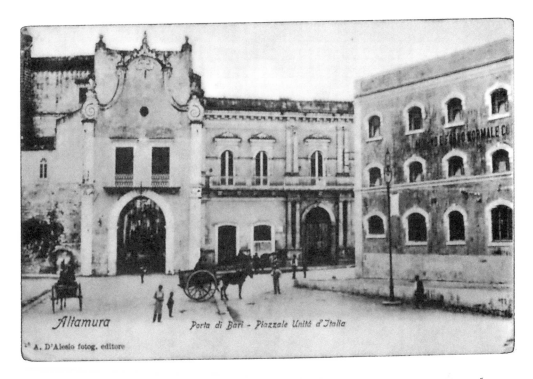

Altamura *Porta di Bari - Piazzale Unità d'Italia*

A. D'Alesio fotog. editore

Porta di Bari,
Piazzale Unitá
d' Italia, postcard,
4 May 1907. Isabella
Stewart Gardner
Museum, Boston.

with her architect, Willard T. Sears. In the payment ledgers, the structure is referred to as the "garden house," which may have reflected its function as part of the walled garden; its elaborate trellises gave continuity between garden and building and blocked the view of the encroaching urban fabric, as new buildings went up in the surrounding area.[4] But the most compelling feature was the exterior, the large portal with its dramatic elevation, whimsical baroque detail, and an anthropomorphic quality that softened its bold monumentality. Gardner also situated the portal off-center such that it was closer to, and more visible from, the Tremont Entrance of the Frederick Law Olmsted–designed Back Bay Fens (Fig. 6). This is the view recorded in a 1922 photograph (Fig. 7), where columnar maples and ivy soften its austere aspect and give the portal the appearance of great age. Though it was referred to in one letter as "the carriage house," the portal itself was never used for carriage access to the building (carriages housed within entered and exited from either side). Nor was it intended as a storehouse as the *Herald* article had claimed.[5] Given

4 For the building's original payment documents, see note 5.
5 The street upon which it was laid out was never completed by the Fenway developers, and Gardner bought the land in 1913 to connect the main lot with five smaller lots she had bought in 1911 (Fig. 10; lot numbers 6, 7, 12, 13, and 14). For the purchase of the five lots and the street, see Will and Codicil of Isabella Stewart Gardner, probated 23 July 1924 in the Probate Court of Suffolk County, Commonwealth of Massachusetts, Boston, 1924 (hereafter Will and Codicil), 6. For Gardner's purchase of the land marked out for the street in 1913, see Suffolk County, Massachusetts, Grantors Ledger, 1911–20, 163–164, citing plan 2781.541. As for the question of the original use of the building and the possibility of storage, a letter in the Gardner Museum Archives shows that as a condition of permitting approval, the Boston City building department

6

Olmsted, Olmsted,
and Eliot, detail
of *Plan of Portion
of Park System from
Common to Franklin
Park: Including Charles
River Basin, Charlesbank,
Commonwealth Avenue,
Back Bay Fens, etc.,* 1894.
Harvard University
Map Collection,
Cambridge.

the elaboration of detail on the exterior, the structure can be considered as a facade to the entire complex when seen from the Tremont Entrance.[6]

Given the rear facade's size and potential importance to the Fenway Court design, why did Gardner not include it in her original design for the building when she first had plans drawn up in 1899? When she began building the museum, she did not yet own the lots at the end of the block. These two small lots (Fig. 8), laid out according to the Fenway area's original development plan for Back Bay–style townhouses, were owned by Paul and

stipulated: "The interior of the building is not to be partitioned off, or finished; to have stairs and floors for storage." Sears to Gardner, 26 June 1907, Isabella Stewart Gardner Museum Archives (hereafter ISGMA), Boston.

6 As part of his Boston Parks System project, Olmsted designed the Tremont Entrance (now truncated and known as Evans Park) as one of several access points to the Fens, the reclaimed land dramatically reconfigured between 1878 and 1895. For the history of the Fenway's construction, see Zaitzevsky 1982, 54–57. The entrances acted as a transition from the urban environment into the more natural, meandering parkland. As seen on the original Olmsted design, the Tremont Entrance connected Huntington Avenue (then called Tremont Street from the entrance to the Brookline border) with the Fens. It was later closed off by a lot where the Massachusetts College of Art building now stands. In its original design, passersby would have been afforded a good view of the large museum facade and, in certain respects, it may have appeared as a kind of monumental portal; it surely masked the rear of the palace building, the elevation of which was composed with none of the formality of the main facade.

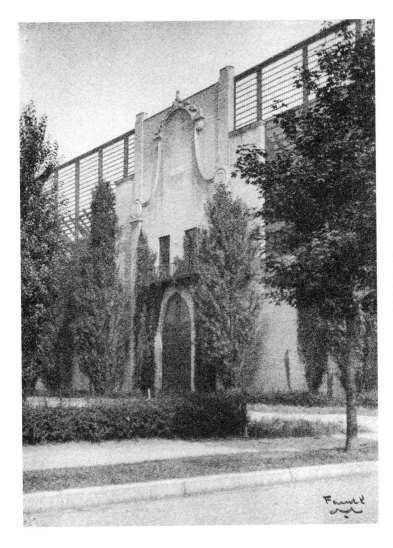

7

Maynard workshop,
Carriage House, 1922.
Isabella Stewart Gardner
Museum, Boston.

Rachel Thorndike until Gardner purchased them on 22 March 1907.[7] Gardner made at least one attempt within this restricted lot plan to create a building that would serve as a garden pavilion and carriage house. In March of 1903, less than three months after the museum's gala opening on 1 January, she commissioned her architect to "build the clock tower on the carriage house."[8] A surviving drawing (Fig. 9) shows a four-story edifice flanked by forms evocative of ancient Roman aqueducts (though with pointed arches) and topped by a trellis that serves to shield the interior profile of the building from the outside and to allow light to pass through. The elevation is adorned with an arcade, a clock, and a pediment. Given that the exterior wall was to abut the two lots zoned for townhouses in the rear, the articulated facade is inward-facing. In addition to providing lateral access to

7 The date of the purchase of the two lots is recorded in Will and Codicil, 2.
8 Transcript, Willard T. Sears, diary, 7 May 1903, ISGMA.

8

Detail of *Atlas of the
City of Boston, G. W.
Bromley & Co.,* 1902.
Harvard University Map
Collection, Cambridge.
(Photo courtesy of Mary
Kocol.) The designated
area is Fenway Court,
showing Isabella S.
Gardner as owner. Lot
Sec. 9E[1] was owned by
Rachel S. Thorndike until
22 March 1907.

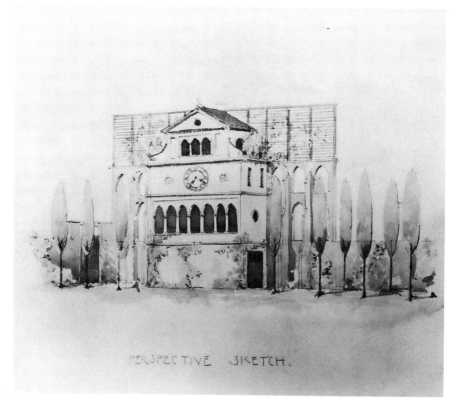

9

Willard T. Sears,
*Design for
Carriage House,*
ca. 1903. Isabella
Stewart Gardner
Museum, Boston.

10

Detail of *Atlas of the City of Boston,
G. W. Bromley & Co.*, 1912. Harvard
University Map Collection,
Cambridge. (Photo courtesy of
Mary Kocol.) The palace building is
labeled Fenway Court. The carriage
house at the end of the lot is
shaded, the designation
of a masonry building. In 1911,
Gardner bought five lots across
the street: 6, 7, 12, 13, and 14. In 1913,
she bought the lot of land on which
the street was laid out.

a carriage, its chief function would appear to be that of a garden pavilion and to screen the view. This version was not executed, however. Only in 1907 did Gardner acquire the two additional lots (Fig. 10), and three months later, building for the rear facade began.

The Career of Isabella Stewart Gardner, Fenway Court, and the Re-enchantment of the World

The compound of Fenway Court as Isabella Stewart Gardner imagined it can best be seen in a 1925 aerial photograph (Fig. 11), taken a year after Gardner died. It shows the massing of the main building and, in the rear, the top of the floating facade attached on both sides to high walls that surrounded the garden, creating a kind of enclosed, noble precinct. Cypress-like maples growing up around the buildings further create the effect of a world apart.[9]

9 The species has been identified as either a fastigiate Norway maple or Freeman maple. I would like to thank Corbin Harwood and Kyle P. Wallick for this information.

As a total work of art, the building can be understood as an expression of cultural "re-enchantment." Re-enchantment as cultural production has been defined as the transposition of transcendent meaning onto repurposed forms in the face of the loss of transcendent meaning elsewhere.[10] The entire Fenway Court project, its architectural forms and collections, can be seen as cultural re-enchantment in the form of romanticism, which, as Edward Tiryakian has suggested, was the chief mode of re-enchantment in the nineteenth century.[11] Romanticism-as-worldview (as distinct from, but growing out of, the romantic literary and artistic movements of the late eighteenth and early nineteenth centuries) shows a multivalent critique of modernity: of capitalism, industrialization and the destruction of the natural world, the new consumer culture, a conformist middle-class ideal, positivism, and the expansion of science into daily life. Michael Löwy and Robert Sayre have explored how romanticism functioned as an imaginative alternative to modern life.[12] A devotion to the past (such as the Gothic Revival), bohemianism and later dandyism, travel to and study of preindustrial and exotic cultures, aestheticism's "religion of art," revived archaic religious practices, and aristocratic self-fashioning all became strategies of response or subversion to the ideals of modern, middle-class society. Romanticism-as-worldview represents one-half of the dialectical nature of modernity, a process of disenchantment and re-enchantment, where cultural forms were reinvented and reinfused with displaced spiritual values.[13] Ironically, the upper middle class who benefited most from the new capitalist structure could be those most susceptible to the charms of its alternatives. Isabella Stewart Gardner exemplifies this well: as the wife of John Lowell Gardner, wealthy financier and member of one of Boston's most prominent families, "Mrs. Jack" was yet *bohémienne*, exemplifying the late nineteenth-century tendency of upper-middle-class women to adopt bohemian fashion and sensibility as a way of elevating themselves above the pragmatic, mercantile classes from which they had sprung.[14]

Collectively, post-Calvinist, bourgeois Boston manifested many strains of romantic culture that distinguished it from the ambient of other East Coast urban centers. Though a New Yorker by birth, and socially conventional in the years following her 1860 marriage, Gardner's transformation from eccentric lady of fashion in the 1870s to bibliophile, art collector, museum builder, and cultural arbiter in the 1890s was shaped by Boston's particular cultural offerings. These were informed by the extension of British romanticism in its three major phases: the romantic Christianity of the Anglo-Catholic movement, the Gothic Revival associated with John Ruskin, and the aestheticism of Walter Pater.[15] Gardner was Anglo-Catholic, a member since 1870 of the Boston Church of the Advent, an outgrowth of the Oxford Movement.[16] When the church relocated to its new

10 Schneider 1993; see also Elkins and Morgan 2009.
11 Tiryakian 1992.
12 Löwy and Sayre 2001.
13 Tiryakian 1992.
14 For the bohemian style as an expression of middle-class self-critique, see Graña 1964.
15 For the relationship between these forms of British post-romanticism, see Fraser 1986.
16 For Gardner's religious life, see Lingner 2001. For a general discussion of Gardner's religious activity, see Shand-Tucci 1997, 129–145.

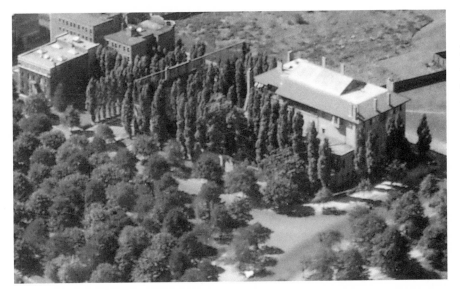

Detail of *Fairchild Aerial Survey Inc., Aerial View, Boston, Mass., Longwood-Fenway*, 1925, photograph. Boston Public Library, Boston. The detail shows Fenway Court, the top of the rear facade, and the columnar maples that surrounded the property.

neo-Gothic building on Brimmer Street in 1883, she and her husband donated an elaborately carved altarpiece, adding to it in 1890–91 with sculptural elements that featured St. Isabella and St. Elizabeth flanking the Crucifix.[17] Gardner's allegiance to Anglo-Catholicism spilled over into an appreciation of Catholic ritual and church history. She claimed descent from the Catholic Stuart dynasty and since the 1880s was a member of the Order of the White Rose, an organization dedicated to the dynasty's celebration.[18] She possessed memorabilia associated with Mary Stuart, Queen of Scots, including a prayer book inscribed with the martyred sovereign's name. It was even reported that she dressed as the tragic figure for Christmas Eve Mass in her private chapel.[19] Fenway Court's two chapels are expressions of Gardner's religious devotion and its artistic and performative dimensions.[20] These expressions of romantic Christianity fused seamlessly with Ruskin's medieval revivalism, which was promoted in Boston by Gardner's mentor, Charles Eliot Norton (1827–1908), who guided Gardner's initial intellectual formation and book-collecting.[21] Norton believed that neo-Gothic architecture, particularly Venetian Gothic, was particularly well suited to be the outward form of the new moral commonwealth to which Boston society should aspire.[22] Fenway Court can be understood as Gothic Revival in a truer sense than the Ruskinian train depots that were cropping up throughout the Anglo-American world: it included the actual "stones of Venice"

17 Both "Isabella" and "Elizabeth" are derived from the same name, Jezebel. Gardner's patronage of the Church of the Advent was discussed in Docherty 2000; I am grateful to Linda Docherty for providing me with a copy of her lecture.

18 See Shand-Tucci 1997, 129–132; and Lingner 2001, 34.

19 See Shand-Tucci 1997, 129–132; and Lingner 2001, 34.

20 Docherty 2000.

21 For Gardner's relationship with Norton, see Carter 1925, 93ff.

22 Dowling 2007, 57–67.

as architectural spolia. In addition, the public mandate of the Isabella Stewart Gardner Museum, established "for the education and enjoyment of the people forever," may be understood as a Nortonian legacy, perhaps the best example of the patrician-sponsored civic education for which Norton fervently advocated.[23] Yet, this public-minded gesture of Bostonian institution-founding can be read simultaneously as a capital-liquefying exercise in aristocratic self-fashioning, creating a lasting monument to Gardner's self-styled regal persona, "Isabella of Fenway Court."

The architectural forms of Gardner's new museum, the palace building and rear facade, reflected the significance of Italy in her cultural imagination. As is well known, the main palace—built and installed between 1899 and 1902—was modeled on a Venetian palace, though with the facades on the inside to form the ingenious court-yard (Figs. 12 and 13). For British and American travelers, preindustrial Italy (or rather, its preindustrialized regions, such as Venice) was a place of picturesque, imaginative retreat. In the 1880s, the Gardners traveled frequently to Venice and gravitated to the circle of Anglo-American expatriates (which included Henry James) that frequented Palazzo Barbaro, recently purchased by the Curtis family of Boston.[24] Seen through the lens of romantic imagination, the Barbaro represented the miraculous survival of an otherwise lost Venetian past, borne like an ark into the modern era. The strength of the Barbaro's evocative power, and the means of its preserved cultural memory, lay in its largely intact interiors that distinguished it from its despoiled neighbors. Rosella Zorzi has explored how this vision was given epistolary and literary shape by Henry James and the means by which it was later given physical form in Fenway Court itself.[25]

In *The American Scene* (1907), Henry James concluded the Boston chapter with an allusion to Fenway Court, which he had visited in 1904, just a year after its completion. In contrast to the "new" Boston, with its Chicago-style high-rises—"the horrific glazed perpendiculars of the future"—it was at Gardner's museum "that one feels the fine old disinterested tradition of Boston least broken."[26] In its accumulative aesthetic and richly historicist architecture, Fenway Court was a counterpoint to the new, modern Boston. Like Palazzo Barbaro, Fenway Court was to be an abode and repository of history, its interior fixed by Gardner's will and never to be altered or amended.[27]

The final stage of Gardner's cultural evolution was aestheticism, which showed itself in her eclectic interior installations. In this, Gardner was one among several Gilded Age female patrons, such as Catharine Lorillard Wolfe, who favored the "artistic," aesthetic style of interior decoration.[28] Adherents of decorative aestheticism, such as Wolfe, prized domestic objects of diverse cultures and periods for their visual qualities and delighted in compelling juxtapositions to create interiors of widely eclectic style. While aestheti-

23 Will and Codicil, 3.
24 See the essays in Chong 2004.
25 Zorzi 2004.
26 James 1907, 245–246.
27 Will and Codicil.
28 Macleod 2008, 87–91.

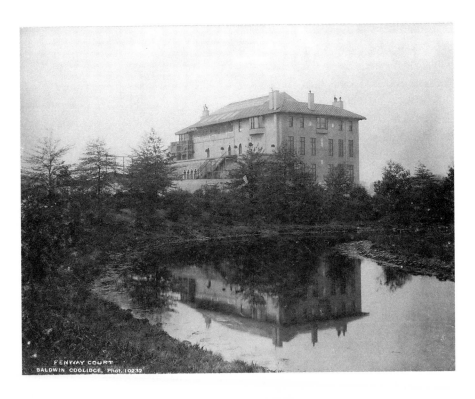

cism in Britain offered middle-class consumers an expression of taste that could elevate their social standing, in America it was the style favored by members of the Gilded Age elite.[29] By the early 1880s, the "artistic style" was firmly established in the fashionable Back Bay circles of which the Gardners were a part.[30] While domestic decoration as cultural production was aestheticism's high-end consumerist manifestation, Gardner was surely aware of the origins of the movement as the heightened response to art as sensation, famously exemplified by Walter Pater's 1873 *The Renaissance: Studies in Art and Poetry*. Aestheticism located art's significance out of time, in the immediate present, as the inspiration for quasi-mystical experience. Gardner's experience of aestheticism as a "religion of art" eventually took the form of a devotion to Asian art in the early years of the twentieth century, accelerated by her close association with Okakura Kakuzo (Okakura's famous *Book of Tea* was keyed to a Western aesthetic sensibility).[31]

Jonathan Freedman has defined a more philosophically informed version of aestheticism that I believe Gardner aspired to: "a more highly valued mode of esthesis . . . a life [lived] in the spirit of art, as a generous, ennobling, and tragic spectacle . . . an aestheticism of imaginative freedom."[32] Gardner's understanding of this version of aestheticism would have been shaped not only by Walter Pater's *Renaissance* and the culture of aestheticism that grew up in Boston in the 1880s, but also by Pater's later novel, *Marius the Epicurean: His Sensations and Ideas* (1885). *Marius* exemplified philosophical aestheticism and included an alluring historicist dimension. Reading *Marius* in 1886, Gardner wrote an appreciative (now lost) letter to Pater, whom she had met socially in London earlier that year.[33] He replied with a cordial note to insert into her copy of the book. Tellingly, she included *Marius* in her self-compiled 1906 *Choice of Books from the Library of Isabella Stewart Gardner, Fenway Court*; it was the only work by Pater so included.[34]

Marius offered a historical vision of the past that was the ideal setting for the pursuit of sensation raised to philosophical significance. The novel tells the story of a young Roman patrician who considers a series of philosophical stances—Stoic, Christian, Epicurean—in what may be considered Pater's intellectual and psychological autobiography.[35] Marius appreciates and supports members of the early Christian community in Rome—to the extent of dying in place of one of the Christians as a pseudo-martyr—all the while remaining an Epicurean. The Epicureanism offered in the novel is a philosophical defense of the pursuit of sensation that resembles ancient Epicureanism in its cultivation of the human senses and existential experience, and yet is deeply moralistic. The

29 For aestheticism in America, see Stein 1986.
30 For the aesthetic interior ca. 1880, see King 1883–84.
31 For Gardner's Asian travel and Asian art collecting, see Chong and Murai 2009.
32 Freedman 1986, 398.
33 Pater to Gardner, 1 October 1885, ISGMA. In his reply, Pater acknowledges her initial letter, which no longer survives, and thanks her for her praise of his work. He had learned "from our charming host of two months ago" that she desired a piece of his writing to "put into Marius," suggesting that they had met earlier in a social setting.
34 Gardner 1906, 53.
35 Hughes 1975.

Epicureanism Marius adopts—a "noble" version of Cyrenaicism, where the pursuit of sensation and experience leads to aesthetic perfection—is claimed not to oppose the old morality, but is defined as "an exaggeration of one special part of the whole."[36] (The novel has been fruitfully described as a response to the criticism of Pater's amoral "Conclusion" to *The Renaissance*.)[37] *Marius* affirms the value of Christian virtue while proclaiming the ultimate good of sense experience.

In what reads like a statement of core aesthetic doctrine—echoing the famous life analogy of the "hard, gem-like flame" from *The Renaissance*—Marius's religion of experience is described as "the pleasure of the ideal *now*... certain moments and spaces of [the Cyrenaic's] lives were high-pitched, passionately coloured, intent with sensation, and a kind of knowledge which, in its vivid clearness, was like sensation... they apprehended the world in its fulness, and had a vision, almost 'beatific,' of ideal personalities in life and art."[38] But here, the pursuit of sensation in the "ideal *now*" was balanced with the cultivation of memory to remedy "the sinking of things into the past."[39]

> Could [Marius] but arrest for others also, certain clauses of experience, as that imaginative memory presented them to himself! In the grand, hot summers, he would have imprisoned the very perfume of the flowers. To create—to live, perhaps, a little beyond the allotted span, in some fragment even, of perfect expression—was the form his longing took, for something to hold by and rest on, amid the "perpetual flux."[40]

To aestheticism's search for sensation is here added the desire for permanence in the face of change. In *Marius*, permanence is found in the "religion of the villa" that begins the novel and foreshadows its conclusion. Marius's philosophical progress begins with a description of this religion of the hearth and its site in the family villa, White Nights: a "religion of usages and sentiments rather than of facts and beliefs, and attached to very definite things and places.... Deity is in this Place!"[41] As Pater describes in the early chapter about the villa, this "severe and archaic religion" was to be the protagonist's ultimate belief system, guiding him through his philosophical peregrinations and in the end providing him with the strength to endure martyrdom.[42]

Marius offered attentive readers like Gardner a "religion of sensation" that was also a religion of place and history. White Nights was a domicile that embodied its own philosophy and religion—the domestic sphere as sacred space. Gardner may have had cause to ponder many of these themes as she considered plans for her unusual museum.

36 Pater 2008, 172.
37 Vogeler 1964.
38 Pater 2008, 172–173.
39 Ibid., 103.
40 Ibid.
41 Ibid., 7–8.
42 Ibid., 16.

Gardner's intellectual formation was shaped by the overlapping expressions of British romanticism as they were present and culturally relevant in Boston during the period between 1870 and 1900: Anglo-Catholicism, the Gothic Revival, and Pater's aestheticism (as informed by *Marius*). Gardner, of course, was not alone in this path of cultural evolution: Bernard Berenson and Logan Pearsall Smith were also protégés of Charles Eliot Norton as students at Harvard and discovered Pater in the 1880s, making aestheticism into a vocation and new religion.[43] Berenson set off to Europe in 1888 with a copy of *Marius* among his belongings.[44] Mary could recite lengthy passages by heart and considered it "the instrument of her conversion."[45] The trio of expatriates would use the Epicurean philosophy of Pater's novel as the touchstone of their own aesthetic religion when they came to write "Altamura," as discussed in more detail below.

Gardner began seriously purchasing art in the early 1890s with the proceeds of an inheritance left by her father.[46] As a collector, her activities are generally described as those of an advanced Gilded Age patron of the arts in the company of her much richer New York counterparts: America's first real collector of Old Master painting, to be followed by the likes of J. P. Morgan and Henry Clay Frick.[47] Though supported and encouraged by her husband Jack, Berenson was Isabella's chief collaborator when she began to collect in earnest. Gardner had known the young man of promise when he was a student at Harvard in the 1880s; he was a frequent visitor to her Beacon Street townhouse salons. Gardner's Boston was the world of learning and cultural achievement that was to be Berenson's antidote to his impoverished upbringing in the immigrant quarter. No doubt the vision of a living culture witnessed in her drawing room had presented the possibility of cultural distinction as vocation. Gardner and other members of her circle supported Berenson in a postgraduate study year in Europe after he failed to receive one of Harvard's prestigious travel fellowships. Berenson wrote Gardner frequently in those first years abroad, letters filled with surprisingly introspective revelations and self-analysis as he attempted to articulate his aspirations for a literary career. The letters suggest a keen sympathy and close confidence between the two, despite their age difference, with Gardner acting as a mentor and mirror reflecting Berenson's hopes for distinction. After a hiatus of several years, Gardner and Berenson reestablished their friendship in the mid-1890s. With the publication of *Venetian Painters of the Renaissance* in 1895, Berenson had emerged as a professional connoisseur in the new scientific manner of aesthetic criticism and, at the same time, had begun advising Americans buying art in Europe. Gardner was by then collecting art but was aware of her need for assistance in navigating the world of the Old Master trade. Gardner was to be Berenson's first major client. In their lengthy correspondence, he was frank (if not always honest) about the schemes he was concocting for new

43 Berenson describes Pater's influence on his intellectual formation in many later writings. See, for example, the diary entry dated 2 October 1956, published in Berenson 1963c, 452. For Pater's influence on Logan Pearsall Smith, see Smith 1938, 206–208.

44 Simpson 1986, 51.

45 Parker 1959, 103.

46 For an outline of Gardner's career as a collector, see Chong 2003, ix–xviii.

47 Saltzman 2008.

acquisitions, but he combined business with an exalted form of flattery, addressing her not infrequently as "Lady Isabella."[48] Such rhetoric reveals the delightful fiction that lay at the heart of the pursuit of art. Berenson's job was not only to identify works of art suitable to his clients, but to cast over them a kind of magic spell: their purchase was to have a transformative and elevating effect. Berenson's perpetual stream of banter, gossip, and business details maintained a generally intimate tone, but one that he would drop with a flourish to strike the pose of the courtier and engage with Isabella's regal persona. As preceptor and mirror of Gardner's princely self, Berenson was a sounding board for his client's ideas about a private museum.

In 1896, Isabella and Jack initiated plans to tear down the Beacon Street townhouse where they had lived since 1861 and to rebuild it as a museum, with living quarters on the top floor; to this end, they engaged the architect Willard T. Sears.[49] In a letter to Berenson dated 19 September 1896, Gardner describes her hopes for the new enterprise: "I think I shall call my Museum the Borgo Allegro. The very thought of it is such a joy.... But don't you agree with me that my Museum ought to have only a few [works of art], and all of them, A. No. 1.s. Or do you think otherwise?"[50] This is one of the few, but among the most explicit, surviving comments Gardner made about the museum, and it shows how she was trying out different ideas leading up to the final concept and inviting feedback from Berenson. Following the death of her husband in December 1898, Gardner asked Sears to design a building for a new location.[51] Land was purchased in the newly reclaimed "Back Bay Park" (the Fenway).[52] For her new project, Gardner chose a different guiding spirit from that which she had invoked in relation to the "Borgo Allegro." Instead of a museum of masterpieces alone, her palace building was to be a marvelous fusion of art, architecture, and romantic, cloistered atmosphere. Altamura should be included among the many strands that, woven together, may be said to form the inspiration for Fenway Court.

On 31 July 1898, five months before she would begin plans for her new museum, Berenson wrote to Gardner from the Northumberland home of Sir George Trevelyan; the letter was infused with the ethos of worldview romanticism as re-enchantment.[53] Berenson had just journeyed from the "magic cloister and enchanted gardens" of Cambridge. There he had talked "deeply of metaphysics and poetry and frivolously of politics," thus proclaiming dandy ideology in the elevation of the nonutilitarian over the pragmatic. The letter begins with Berenson asking if Gardner had received the latest installment of *The Golden Urn*. "Read the account of *Altamura*. You are the only person in the world who could really live it—indeed you do already. Should anything like it be ever realized upon earth you must be our first visiting monarch." Berenson's effu-

48 For the multidimensional nature of Berenson's relationship with Gardner, see Chong 2003, xi–x.
49 Transcript, Willard T. Sears, diary, 1 September 1896, ISGMA. I am grateful to Kristen Parker for providing me with this reference.
50 Hadley 1987, 66.
51 Carter 1925, 171–172; transcript, Willard T. Sears, diary, 30 December 1898, ISGMA.
52 Carter 1925, 174.
53 Hadley 1987, 146–147.

sive imperatives show the slippage in agency that was suggestive of his and Gardner's mutually enhancing enterprises in these years. Gardner's reply to Berenson's letter has not survived, but in his next, dated 13 August, Berenson begins by thanking her for the "charming acknowledgment of *The Golden Urn*. I was sure you at all events would appreciate it, and of course you have."[54]

Given Gardner's evident enthusiasm, Berenson's response leaves open the tantalizing question of what share Altamura had in Gardner's thinking about her museum project when she began it several months later. Certainly the question of Altamura problematizes Berenson's role in his chief patron's enterprise to build a personal museum. While the history of their relationship has traditionally focused on Berenson's capacity as art buyer and pseudo-courtier, he may have had a more significant role in giving philosophical shape to Gardner's museum. (In the mid-1890s, Berenson had not fully committed to the path of professional connoisseur and was still pursuing aesthetic philosophy as intellectual vocation. Altamura, as I will discuss below, may have served as the repository of these interests.) To what extent, then, was Fenway Court a manifestation of Altamura: "high walls" to enclose a realm of the eternal present, where history and art could be experienced as religion?

Palaces against the Skies:
The Vision of Altamura and the Berenson Circle

"Altamura" was published in 1898 in the third and final number of *The Golden Urn*, the periodical Logan Pearsall Smith, Mary Smith Costelloe, and Bernard Berenson had created in 1896 to publish essays, lists of "sacred pictures," and a treasury of evocative literary excerpts.

By the time they wrote "Altamura," Bernard and Mary had successfully established themselves as leading critics of Italian Renaissance painting, with countless articles and reviews as well as Berenson's monograph on Lorenzo Lotto and three volumes on Venetian, Florentine, and Central Italian Renaissance artists. Berenson had begun to earn considerable sums assisting Americans hunting for Old Master paintings, chief among them Gardner herself. Widely published and widely known, Bernard and Mary had carved out an imposing position in the Anglo-American circle in Florence, in the literary marketplace, and in the Old Master trade. While the couple would not marry until 1900, following the death of Mary's first husband, Frank Costelloe, they lived in adjacent villas and pursued their mutually enhancing enterprises together.

In the mid-1890s, Berenson was deeply engaged with philosophical and metaphysical speculations.[55] Around 1895, he was moving in the direction of aesthetic philosophy, and yet chose the path of the professional connoisseur and further engagement with the marketplace.[56] He looked back on these years with heightened nostalgia when he came to write his *Sketch for a Self-Portrait* in 1948:

54 Ibid., 148.
55 Samuels 1979, 236.
56 See Alison Brown's contribution to this volume.

Recall the summer of 1895 . . . Your mind worked as never before and, shame, never since. You had visions, clear, detailed visions of what you should do for years and years to come—a lifetime, in fact. Remember, you mapped out one book on ideated sensations, and another of life-enhancement, and a third on the portrait. Instead of accepting this revelation as the light to guide you for the rest of your days, as the Pisgah sight of your promise, you let yourself be seduced into undertaking a work of the Drawings of the Florentine Painters. How could you be so easily lured away from the path that divine guidance had opened and lit up for you?[57]

In *Sketch for a Self-Portrait*, the decision to abandon philosophical inquiry and become an expert connoisseur is dramatized as a fall from grace:

The magical world—Spengler's happiest phrase—is a fairy world. I dwelt there for my first thirty years. It was hard to abandon it, to be driven out of Paradise even as our first parents were. Like them, as described by our sublimest poet, heir of all that is most noble and majestic in Israel, in Greece and in Rome, I looked back often and with what homesickness and heartsickness! But there is no return.[58]

Written in 1897 and published in 1898, "Altamura" may have functioned for Berenson as a place to imagine pure aesthetic and philosophical pursuits at the moment when he was beginning to be drawn away from them, though it emerged out of a close collaboration between himself, Mary, and Logan.

After Mary's marriage to the Irish barrister Frank Costelloe, the Smith family moved with the newlyweds to London, arriving in 1888. Logan went up to Oxford, enrolling at Balliol College and graduating in 1891. After a sojourn in Paris, where he wrote his first published work, *The Youth of Parnassus and Other Stories of Oxford Life* (1895), Logan moved to Venice in 1896; there, he took one of the two apartments behind the unfinished facade of Palazzo Venier on the Grand Canal. He would soon begin making frequent trips to Florence to stay with Mary, and from there he would join Bernard and Mary in their travels. Following in the footsteps of his friend and literary role model Henry James, Logan cultivated the leisurely life of a man of letters, supported by an annuity and generous remittances from his parents. Though he would eventually become a fixture in London literary circles as a superior stylist and discerning critic, in the 1890s he was still seeking to make his mark. His tastes were much shaped by aestheticism, as he had drunk deeply from the Paterian well while at Oxford. "Altamura" has traditionally been ascribed to Logan with Berenson's collaboration, but as we shall see, Mary too may have played a significant role in its inception.[59]

57 Berenson 1949, 39.
58 Ibid., 134.
59 The essay appeared in the third volume of *The Golden Urn* without authorship, but it appears to have been originated by Logan Pearsall Smith. In the Bernard and Mary Berenson Papers, Biblioteca Berenson, Villa I Tatti—The Harvard University Center for Italian Renaissance Studies, a typed manuscript of the article is ascribed to Smith in Mary's handwriting. Berenson wrote in a later

"Altamura" describes an imagined English monastery in the remote mountains of Italy dedicated to "St. Dion."[60] Most of the essay is given over to a description of the sect's elaborate liturgy. The purpose of Altamura's religion is revealed in the first page of the essay: to "render holy all human experience," a sentiment reflecting a core tenet of aesthetic doctrine.[61] Its elaborate yearlong ritual was a hymn to life's consecration, filled with pagan rites, pious disillusions, and hopes for redemption. Altamura's calendar begins in March, celebrating moral sentiment and the "God of the Deists . . . 'l'éternel Géomètre', the Benevolent Creator of Broad Church Theology."[62] The following months chart an archetypal life cycle: youth and dawn (April); young love and innocent passions (May); action and power (June); their rewards in rank, pomp, and beautiful ladies (July); pastoral retreat (August); elegy (September); pagan pleasure (October); and death (November). The final three months (December, January, and February) are given to contemplations of the soul and the search for salvation, and are dedicated to pity, art, and religion and metaphysics. "Altamura" described a comprehensive philosophy that affirmed life in both its materialist and cosmic dimensions.

The name "Altamura" itself conjures a fortresslike association of "high walls," a world of cloistered refuge from profane reality. The inhabitants of Altamura did venture forth on "pilgrimages" to visit "sacred pictures," just as Berenson and Mary ventured forth on their perpetual journeys around Italy looking for Renaissance paintings; a list of "Sacred Pictures" composed the balance of the volume of *The Golden Urn* in which "Altamura" appeared.[63] The books the Altamurans read are the books that Bernard, Mary, and Logan read and frequently included in their digests of "sacred texts" that otherwise made up the contents of *The Golden Urn*: William Wordsworth, Theocritus, Virgil, William Blake, Robert Herrick, John Keats, Christopher Marlowe, John Milton, Matthew Arnold, and Walter Pater. In addition to the romantic authors, others reflect the values of worldview romanticism in the nineteenth century. The inclusion of Arnold and Pater is the only indication that Altamura was conceived as a present reality. The concluding paragraph of the essay reveals Altamura to be a place of imaginary retreat from modernity and the flight from utilitarian pursuits:

> Freed from that narrow, feverish grind of passions and activities which is called "Life," the Dionites derive a richer and more wonderful sense of self-conscious existence from the contemplation of Nature, the mountains, the stars, the changing moons and seasons; from the study of their sacred books, and the devout

diary entry that the original idea had come from him and the two had written it together. Smith later reedited it and included it in his collection of essays, *Reperusals and Re-Collections* (Smith 1936, 78–84), without acknowledgment of Berenson's contribution.

60 Smith, with Berenson and Smith Costelloe 1898, 99–107.

61 Ibid., 99.

62 Ibid.

63 Ibid., 107.

worship of those great forces and persons and works of art in which the spirit of Being has been most splendidly manifested.[64]

Experience of nature and time guided by the rhythm of the seasons offers the basis for a more self-aware experience of life, contrasting the "feverish grind" of modernity, a kind of somnambulist, unconscious state of unregulated urges and passions. For the Dionites, "sacred" books and art are among those matters infused with the "spirit of Being," an expression of aestheticism as the religion of re-enchanted art. In keeping with worldview romanticism, Altamura offers a vista into the past through historicist imagination: "From their mountain thrones they see spread before them all ages and epochs, and the echo of contemporary disturbances comes but faintly to their ears. Ancient Greece and Rome are indeed as near to them in spirit as modern cities."[65]

Seen from the lofty heights of Altamura, the view of the world is a kind of phantasmagoria of past cultures, a vision that rivals the din of modern life. This may have performed a therapeutic function for the authors. The sect's doctrine is the famous dictum from Book II of Lucretius's *De rerum natura*: "Nil dulcius est, bene quam munita tenere edita doctrina sapientum templa serena."[66] *Otium*, the life of detached and leisured contemplation, is the basis of the sect's philosophy. The concluding line of "Altamura" reveals the purpose of philosophical pleasure: "by real and devout enjoyment, the burden of the world's joylessness can be, in some mystic way, abated."[67] In keeping with Berenson's philosophical pursuits in the mid-1890s, the Dionites' chief longing closely echoes Arthur Schopenhauer's belief in the power of art and nature to relieve anxiety and mental pain. In the final volume of his monumental work, *The World as Will and Representation*, Schopenhauer invoked Epicureanism to explain the value of pleasure as escape: "the peace always sought but always escaping us on the ... path of willing ... the painless state, prized by Epicurus as the highest good and as the state of the gods; for that moment we are delivered from the miserable pressure of the will."[68] For Berenson, who had long sought out a path in life that would elevate him above the sordidness of daily existence, pleasure in art and nature could be a path to psychological emancipation as well as distinction.

In the late nineteenth century, "Epicureanism" was a byword for aestheticism generally, but the trio's aesthetic philosophy seems especially inspired specifically by Pater's *Marius the Epicurean*. In an 1897 letter defending his aesthetic pursuits to a friend, Berenson called himself not only an "Epicurean" but a "new Cyrenaic," a reference to the precise sect of Epicureanism that Marius adopted.[69]

Altamura's St. Dion, a sanctified incarnation of the pagan god Dionysus, echoes the seemingly paradoxical identity of Marius, the Epicurean as presumed martyr-saint. In

64 Ibid.

65 Ibid.

66 Ibid., 99. "Nothing is more welcome than to hold the lofty and serene positions well fortified by the learning of the wise." Translated in Carus 1908, 41.

67 Smith, with Berenson and Smith Costelloe 1898, 107.

68 Schopenhauer 1969, 196.

69 Samuels 1979, 278.

Marius, Pater describes how the Cyrenaic and Christian saint are nearly indistinguishable: "it may be thought that the saint, and the Cyrenaic lover of beauty, would at least understand each other better than either would understand the mere man of the world. Stretch them one point further, shift the terms a little, and they might actually touch."[70]

What for Pater was a carefully defended philosophy was for Berenson and his circle the makings of a program of life. They had transferred a visionary ideal to the blueprint for an experiential reality. Newly arrived in Italy in 1896, Logan seems to have acted as a catalyst for the vision of Altamura and the literary journal in which the essay would appear. While living in Venice, Logan appears to have originated the title and most likely the concept of *The Golden Urn*. In October of 1896, Logan wrote his sister a letter that captures the picturesque tone in which the periodical was conceived:

> With a wood fire and an easy chair and Pater's beautiful "Gaston de Latour" to read, I have rather enjoyed these autumn rains. You can be really melancholy in Venice in the autumn, and real rich melancholy is a much harder thing to find than Happiness, which can be won any day by a well-digested dinner and a game of whist. I mean to write some autumnal prose to be published in the "Golden Urn"—doesn't thee think that a good name for our paper? "In Golden Urns draw light" (Milton) could be the motto.[71]

"Altamura" originated the following year, in the summer of 1897. In a letter dated 4 June, Logan, who again appears to have initiated the idea, wrote to Mary:

> I want to write for the next Golden Urn an account of our religion as if it already existed "among the remote romantic Italian mountains," and I want a name to call it by. I thought the name of some place "The Purple Order of _ _" what would be a good name? Was there any saint Pagan and Catholic enough—in the true sense of Catholic? Here is a motto for us from Flaubert[:] "Inclinons-nous devant tous les autels."[72]

Logan's intriguing reference to "our religion" suggests that "Altamura" was an earnest attempt to describe a new gospel. The letter shows that Logan conceived of the pagan-Catholic saint soon to be called "St. Dion." The quotation appears in Gustave Flaubert's correspondence with Madame Roger des Genettes, in which the novelist exhorts her to cast off the memory of the Catholic orthodoxies of the ancien régime and to join him

70 Pater 2008, 171.

71 Smith to Smith Costelloe, Venice, 10 October 1896, Houghton Library Manuscripts Department, 2005 M-4, Logan Pearsall Smith Papers (hereafter LPSP) (Unprocessed), Box 1, Folder: "Typed Copies of Letters to Various." The Milton quotation comes from book 7 of *Paradise Lost*, in the section describing the creation of celestial bodies.

72 The letter is inscribed "High Buildings," dated 4 June, and can be dated to 1897 as Logan describes the completion and decoration of his new home which had just been readied for his return from Italy in that year. LPSP, Box 4: "LPS Letters 1897–99."

Monte Oliveto
Maggiore, near
Siena. (Photo:
Palma Bernardi.)

in bowing "before all the altars."[73] As a principle of aesthetic doctrine of the worship of all life experience, Flaubert's sentiment finds expression in the opening paragraph of "Altamura": "a Religion interpreting and rendering holy all human experience."[74]

As Berenson would later explain, the idea for "Altamura" came from a visit that Logan and Berenson made to "il Monistero," the eighth-century Abbey of Sant' Eugenio outside Siena that had been converted into a villa by the Griccioli family, who purchased it in 1812:

> I used to go there often and at one time toyed with the idea of buying it and of living there with a few choice spirits in a sort of Thélème. I went there at least once with my brother-in-law Logan Pearsall Smith, and out of this came the sketch concocted by us together about Altamura, printed in the first number of the *Golden Urn*.[75]

Altamura was also inspired by visits to Monte Oliveto Maggiore in the Crete Senese. Berenson brought Smith to Monte Oliveto in February 1897 during one of his frequent picture-hunting tours. Monte Oliveto Maggiore (Fig. 14) was a Benedictine monastery that Berenson had frequented in the early 1890s, and was a catalyst for his Catholic conversion in 1891. He first went there to study the frescoes of Sodoma and became enchanted

73 Flaubert 1991, 72.
74 Smith, with Berenson and Smith Costelloe 1898, 99.
75 Berenson 1963c, 74. Thélème was François Rabelais' Epicurean revision of monastic community in *Gargantua and Pantagruel*.

with the life of the monastery, the kindly abbot who would eventually receive him into the Church, and the well-stocked library. His loss of faith in the following years did not keep him from returning often throughout the decade. The monastery's associations for Berenson seem to have transferred readily to his traveling companion. In a letter to his mother, Logan described the experience:

> Little walled towns on the tops of mountains, with great palaces built there in their native hamlets by Popes and Princes, monasteries in almost inaccessible places, with great halls and cloisters, and white robed monks who entertained us delightfully and gave us cells to sleep in—it was all wonderful, and the harnessing up of the old ram-shackle wagon in the frosty morning light, and the driving on through the [illegible] sleepy dusty morning hours, reminded me very much of camping out. Only instead of game and waterfalls we were hunting for old pictures. The excitement is just the same and our hearts beat when we stopped our carriage and went into some little unknown church which might (and often did) contain some splendid picture.[76]

The countryside Logan describes is the countryside of the traveler whose eye has been trained to see the world through an aesthetic lens. Churches, palaces, and especially pictures are the new sources of delight instead of waterfalls, the erstwhile goal of the traveler in search of the picturesque. The hunt for pictures was part of Berenson's regular itinerary for seeking out any and all paintings during his frequent travels throughout Italy. For Logan, however, it was one among several picturesque elements—art, landscape, and architecture all flowed together in a general romantic vision of Italy. In a similar letter to his father, Logan writes:

> [We] climbed up into some of those mountain towns that one sees in Italy from the railway, and found beautiful churches and palaces and pictures. One night we passed in a great old monastery, way up in an almost inaccessible place among the mountains—an enormous, almost deserted monastery with only three monks left, who entertained us in a most friendly way. The next morning we started out at sunrise, and drove through a most beautiful remote romantic country hunting into all sorts of country churches for pictures that had never been known before.[77]

Monte Oliveto and the "remote romantic" countryside seem to have worked a kind of spell on Logan. A sense of discovery attends these immediate reflections, a discovery of a new geographic landscape and a newfound spiritual landscape within: "our religion . . . among the remote romantic Italian mountains."

76 Logan Pearsall Smith to Hannah Whitall Smith, 27 February 1897, Villa Rosa, LPSP (Unprocessed), Box 4: envelope inscribed "Feb 27, 1897 Mother."

77 Logan Pearsall Smith to Robert Pearsall Smith, 1897 ("Friday"), Villa Rosa, LPSP, Box 4: "LPS Letters 1897–99."

The architecture of Altamura, described as a "monastic palace," may have been inspired in part by Monte Oliveto itself, with its multiple courtyards (Figs. 15 and 16) and Renaissance frescoes.[78] The imaginary Altamura was said to have comprised "great halls, colonnades, and terraces, once the mountain court of the princes of Orsara."[79] The Altamurans came to possess the court and made it their convent, but preserved many of its original appointments. The notion of a "cloistered court" was a fitting visual form to express the pietistic, aristocratic vision of Altamuran sanctuary.

Altamura also provided the model for an ideal social type. In a passage in her 1898 diary, Mary describes a luncheon visit by Arthur Galton: "the nearest to an 'Altamuran' we have ever come across."[80] Galton, whom Berenson had met in 1887, was a fixture of aesthetic Oxford when he returned to study classics after abandoning his vocation as a Catholic priest.[81] Walter Pater had praised him in print as "a lover of our [that is, English] literature at once enthusiastic and discreet."[82] Galton was apparently disenchanted with modern society, and preferred life in the country with his dachshund and his Tacitus. As a historian, moralist, and critic, Galton's literary taste and prolific if disinterested studies recommended him as an ideal embodiment of Altamuran ideals. As represented by Galton, aesthetic Oxford (and the Cambridge of the "magic cloister and enchanted gardens"), which had so enthralled Berenson, may have provided the living model for Altamura's atmosphere.

As a place of imaginative retreat, Altamura offered Bernard and Mary an antidote to the poison of personal attacks, in particular an 1898 novel by Berenson's fellow Harvard graduate, Robert Herrick, called *The Gospel of Freedom* and based on their controversial relationship and aesthetic vocation.[83] Herrick had met up with Berenson in Paris (where the novel begins) in 1892, and later in Florence in 1895 (where it ends). To Berenson's alarm, the author plowed much of their actual conversion into the novel in order to create the character of "Simeon Erard," a clever son of immigrant Jewish parents from New Jersey who, with the help of wealthy benefactors, abandons his impoverished family to study in Europe. In the novel, the Smith clan (called the "Anthons of St. Louis") also featured heavily; the pretext of its underlying moral about the possibilities and perils of the emancipated modern woman was Adela Anthon Wilbur's flight from her first husband, a sympathetic Chicago tycoon. Logan appears in a particularly withering portrait as a self-effacing, literary hanger-on. Herrick's real target, in fact, was aestheticism itself, and the novel aims at an acute critique of the "aesthetic type" figured as the unappetizing foil for the ideal of vigorous, pragmatic American manhood.

78 Smith, with Berenson and Smith Costelloe 1898, 102.

79 Ibid.

80 Mary Berenson, diary, 6 June 1898. I am grateful to Jeremy Boudreau for alerting me to this reference and to Ilaria Della Monica for sending me the full citation.

81 For a sketch of Galton, see Marwill 1988, 28–29.

82 Pater 1889, 8.

83 The episode is discussed in Samuels 1979, 267–269. Herrick had succeeded early in his career as a novelist in a firmly moralistic mold and took up a position in the English department at the University of Chicago.

15

Interior courtyard
of Monte Oliveto
Maggiore, near
Siena. (Photo:
Thomas Pollin.)

In a diary entry dated May 1898, Mary writes: "I read a book by Mr. Herrick of the Chicago University of which Bernard is the hero and I the heroine—a book in which we are both represented as loathsome reptiles. I was angry about it at first and then laughed— but in rather a sad way."[84] The next entry continues the same thread: "Berenson laughed at it too, but the American point of view does make us sick. We consoled ourselves reading the third number of the Golden Urn." Retreating behind "high walls," Altamura was a refuge from the "American point of view," modernity in its middle-class utilitarianism, rationalism, and moralism.

84 Mary Berenson, diary, 29 May 1898. I am grateful to Ilaria Della Monica for alerting me to this reference.

16

Interior courtyard
of Monte Oliveto
Maggiore, near
Siena. (Photo:
Filippo Prezioso.)

Altamura's visionary quality was the subject of an anecdote Logan recounted in an
1899 letter to his sister Alys about a precocious young cousin of Berenson's then studying
at Harvard who had come to Florence to visit his uncle. Smith made sport at the young
man's expense when he discovered him looking at a map of Italy for Altamura. "He thinks
it would be pleasant for a while there, and says he would like to visit it, though he could
not stay long, as it is not <u>real life</u>."[85] The young man mistakenly believed Altamura to be an
actual place, but also stood in judgment over its aesthetic philosophy, offering, to Logan's
dismay, an echo of "the American point of view." Logan's response registers the private
world Altamura represented. It was only for the initiated.

High Walls:
Altamura and Fenway Court

As the letters Berenson sent to Gardner in 1898 suggest, the vision of Altamura resounded
with Gardner at a key moment in her thinking about a new museum. The celebration of
art in the essay's final section might have been particularly alluring. Found in the liturgi-
cal months that pertain to the soul's search for redemption, the realm of art is a visionary
world, a lofty retreat from the profanity of modern, daily existence:

> January is given to art; and in the dark days of winter, when this world is black-
> ened with frost or dimmed with fog, the Altamurans conjure up that other world,

85 Logan Pearsall Smith to Alys Smith, 18 March 1899, Il Frullino, via Camerata, Florence, LPSP
(Unprocessed), Box 4: envelope inscribed "March 18, 1899, Alys."

sun-gilt, eternal and serene, which, little by little, man has constructed out of, and above, the infamy and chaos of his existence; that world of temples and palaces against still skies, of landscapes and splendid cities, where magnificent human persons sit clothed in splendour, listening to music, or to noble verse discoursing tales of antique destiny.[86]

"Altamura" contains an earlier passage that might have been even more alluring to Gardner. It comes in July, "the month of Rank, Pomp and Riches," halfway through the Altamuran calendar:

July too is the month of Beautiful Ladies—not the flower-like maidens young men adore, but the queens of arts and years, who dwelt in palaces, and wearily listened to the half-sincere adulations of kings and princes. Helen, Thais, Phryne, Lesbia, the Queen of Egypt, Mary Queen of Scots, Mary Magdalen, Lucretia Borgia, Caterina Sforza, Isabella d'Este, all are now remembered; their altars and statues are heaped and crowned with flowers; and songs, once pedantically penned by princes and Court poets, are sung in their honour.[87]

While Altamura was open only to the initiated, in July great ladies and monarchs were permitted entrance to the outer courts:

And only in this month is the law relaxed which so rigidly excludes the outside world from Altamura: profane feet are, of course, never allowed in the inner cloisters, but in the lodges certain great ladies of the world are allowed to sojourn, and entertainment is made for visiting monarchs.[88]

When Berenson wrote to Gardner in 1898 with the promise that she would be "our first visiting monarch," he was surely echoing this section, establishing himself as the gatekeeper to Altamuran paradise and courtier to Isabella, a latter-day "queen of arts and years." Gardner is well known for her own identification with the illustrious women of history, among them Isabella d'Este and Mary Queen of Scots. It is hard not to see the kind of exemplary persona Gardner cultivated reflected in this passage: Isabella of Fenway Court.

Since at least 1903, the year Fenway Court opened, Gardner had been intent on constructing a garden pavilion/carriage house in the rear of the complex, but had not settled on a design that would fit well with the lot as it then existed. In 1906, she visited Berenson in Florence for the long-anticipated visit to his villa, I Tatti. Immediately after returning to Boston, Gardner began plans for the rear facade. That Berenson and Gardner had been corresponding about the project is clear in Berenson's letter dated 5 January 1907, about

86 Smith, with Berenson and Smith Costelloe 1898, 106–107.
87 Ibid., 102.
88 Ibid., 103.

the laying of the first stone for the "new building."[89] On 22 March, Gardner was able to purchase the two remaining lots at the end of the block (compare Figs. 8 and 10), which allowed her to reimagine the project with an exterior-facing facade.[90]

On 4 May 1907, Berenson sent Gardner a postcard showing the Porta di Bari (Fig. 5) and the Piazzale Unitá d'Italia in the Apulian town of Altamura where the Berensons were touring. He jotted on the back: "This is the real Altamura—delightful—all the same."[91] The casual tone suggests that Altamura had remained a topic of conversation since 1898—they would surely have had occasion to speak about it when Gardner visited Berenson in Florence the year before. (Berenson had also taken Gardner to Monte Oliveto Maggiore in 1899, only a year after "Altamura" was published.)[92] Though it does not appear that Berenson intended to suggest by his postcard that Gardner use this as a model for the new building about which they had already been corresponding, she clearly saw how it could serve this purpose and wasted no time in having the image of the Porta di Bari turned into a design for the new building. By 26 June, within a mere eight weeks of the date of Berenson's postcard sent from Italy, Gardner commissioned and signed off on blueprints and, through the offices of her architect, submitted them to the permitting board, secured the necessary permits, and hired a contractor.[93]

Early photographs of the complex show a design of enormous physical presence (Figs. 2 and 3). The massive structure invokes Altamura in its literal meaning as "high walls" and is imposing in a way that the front of the palace is not. It is possible that Gardner was advised against building a wall up to the full height without the structural support provided by the shed roof of the central facade; instead, the rest of the elevation was completed with a trellis flush with the top of the building and angled to match the shed roof. Ivy was used to achieve the look of a contiguous wall as seen in a photo taken in 1922 (Fig. 7). A nearly identical drawing (Fig. 17) to the one cited above (Fig. 9) shows the same elevation of arcade, clock, and pediment, but its structural form is close to the version as finally built with its shed roof and distinctive capped piers. The stepped buttresses (a different solution to the structural problem of the high walls) are of course different from the trellises of the final design, but the drawing may represent an attempt to include the evocative interior from the earlier 1903 version. Financial or permitting considerations may have prevented Gardner from realizing the project as here proposed, but the drawing shows how the carriage house may still have been imagined as a garden pavilion, which may offer another explanation as to why it was called the "garden house."[94]

89 Hadley 1987, 392.
90 The date of the purchase of the two lots is recorded in Will and Codicil, 2.
91 ISGMA. See Hadley 1978.
92 For Berenson and Gardner's trip to Monte Oliveto, see Samuels 1979, 335.
93 Sears to Gardner, 26 June 1907, ISGMA.
94 The first payment, probably referring to the large trellises: "15 Nov. 1907 C. F. Letteney for carpenters work done upon garden house and wall at F[enway] C[ourt] $4,000." The second, the payment to the architect, 16 December: "Willard T. Sears for professional services rendered in the construction of a garden house and wall upon a new lot of land added to Fenway [Court], $2690." (The new lot was purchased 22 March 1907, and extended Gardner's holdings to the entire block.) Ledgers 1900–7, Ledger 2, 24, ISGMA.

In addition to providing architectural resolution to the building complex, I suggest that the structure memorialized the vision of Altamura. The large and impractical nature of the building (the trellises alone cost $4,000) and the speed with which Gardner set about implementing its design signal its meaning beyond practical function.[95] It would be one among several commemorative gestures at Fenway Court—the Yellow Room as an ode to James McNeill Whistler; the installation of the Buddha Room to include remembrances of Okakura Kakuzo[96]—but the size and visibility of the rear facade may further suggest the predominant significance of the ideals Altamura represented in the entire Fenway Court project. Berenson's influence on Gardner, however, is complicated by Gardner's early influence on Berenson at a key moment in his education. Their relationship can best be understood as one of mutual reflection, a kind of double mirroring of aspiration through cultural endeavor. Each sought in the other a realization of a dream that required the other to achieve. Given the scale of the building as a commemorative gesture, Altamura may indeed have reflected shared ideals that took shape in the entire project for Fenway Court, introduced as they were in the very months before Gardner began her museum project. Not only did she delay construction until after she had purchased all the parcels of the large lot, but it would appear that she held back until she found a form that would suitably embody Altamura.

If Palazzo Barbaro, the model of Fenway Court's palace architecture, can be seen as the preservation of an idealized past, the vision of Altamura offered a sympathetic

95 For the cost of the building, see note 94 above.
96 For the commemorative nature of the Yellow Room and Gardner's relationship with Whistler, see Docherty 2008. For the Buddha Room and Okakura, see Chong and Murai 2009, 40–41.

image of cloistered retreat. Like the Venetian palace seen through the romantic lens of American expatriates that sojourned there, the walls of Altamura formed the boundaries of a world outside of contingency and set above the sordid reality of modern existence. But Altamura also suggested a program of life where all experience was celebrated and art and nature were infused with transcendent meaning. While the exact purpose of the structure—more floating facade than actual building—may yet be fruitfully debated, I believe it is useful to consider it a representation, the outward form of an inward reality, revealing to the initiated and concealing from the uninitiated the enchanted world behind its walls.

~~~~~

## Appendix

After the current article was completed, I discovered a letter from Isabella Stewart Gardner to Bernard Berenson in the Hannah Whitall Smith Papers at the Lilly Library, Indiana University, Bloomington. It is the only letter from Gardner in the collected papers of Mary Berenson's mother and has never been published. The letter, signed "Isabella" and dated 1 August 1898, reveals Altamura's importance to Gardner. She wrote the letter before she received Berenson's letter dated 31 July 1898 that is referenced above, in which he inquires if she had received *The Golden Urn* and exhorts her to live out its doctrine.

> August 1st
> P.O. Pride's Xing
> [Beach Hill, Beverly]

> The Precious Urn came yesterday. I am gladder and gladder to get it each minute for I know you were thinking of me when you ordered it to be sent; and for the pleasure I have had this morning in reading it; and because I feel sure that *some day*, you *will* find your way to these shores and do for us here what your imagination does there. Fancy a real Altamura here, at Brookline for instance—Yes? You will do it? I feel, a little, as if it were Amalfi here. I look *down* from my high window straight into the curling sea. The sight and the sounds, and the thought of you make me long for an Altamura—Please.
> > Yours
> > Isabella

> Did you get my letter pleading for the Cellini at the *very low* price?

This letter suggests that Altamura may have served as an important inspiration for Fenway Court itself, which Gardner began in 1899.

*Robert Colby*

FIVE

# Bernard Berenson and "Tactile Values" in Florence

ALISON BROWN

$F$OR ME, THE MOST vivid impression of reading *The Italian Painters of the Renaissance* in the 1950s was Berenson's use of the words "tactile values" to describe the life-enhancing achievement of Florentine painters. I soon understood that "tactile" did not mean what I initially thought it did, when adjured by Berenson to look at Sandro Botticelli's *Venus Rising from the Sea* in order to have my "tactile imagination . . . roused to a keen activity." It was not Botticelli's nude *Venus*, I learned, but Giotto's sober *Madonna*, "satisfactorily seated" upon a "throne occupying a real space," that best represented these values.[1] So, as my contribution to Berenson's fiftieth anniversary celebrations, I decided

∞ I have many debts to acknowledge in writing this paper. First of all, to the former director of I Tatti, Joseph Connors, for generously inviting me to contribute to the conference. I am also indebted to its librarian, Michael Rocke, for providing me with all the relevant books I needed to read—at a time of great personal inconvenience to him, when the library was being reorganized—which enriched my argument in various ways. Similarly, I thank Ilaria Della Monica and Elisabetta Cunsolo for enabling me to read letters and especially Mary's journals in the Berenson Archive, and to Louis Waldman for editorial help and guidance on *Valori plastici*. For help with illustrations, I am indebted to Giovanni Trambusti and Giovanni Pagliarulo in the Fototeca at I Tatti, and to Paul Taylor at the Warburg Institute in London. Patricia Burdick and Erin Rhodes have given me generous help in finding and providing me with photographs of Vernon Lee from the Collection of Vernon Lee Materials at Colby College. Among friends who have contributed valuable references to Berenson and tactility, I would particularly like to thank Andrew D. Roberts (to whom I owe my quotations from R. G. Collingwood, Roger Hinks's *Gymnasium of the Mind*, and Dugall S. McColl), as well as Mario Casari and Robert Cumming, whose contributions came during the conference itself (and later). To Starr Brewster, I owe especial thanks for his help and

to return to his evocative concept of tactile values to understand better what it meant and how it originated within Berenson's circle in Florence—"the polemically inclined expatriates populating Florence's hillsides in the 1890s," as Joseph Connors nicely called them when asking me if I had any more to say about them on this anniversary occasion. What follows is my attempt to describe how the concept was born and how quickly it was adopted by these expatriates and their children, as it was by me many years later, as an emblem of Berenson's achievement among a wide lay public.

The change that came over painting at the end of the nineteenth century has been described as "nothing short of revolutionary," for whereas everyone "had supposed that painting was a 'visual art'"—the painter being "a person who used his eyes, and used his hands only to record what the use of his eyes had revealed to him"—along came someone who "began to paint like a blind man," his still lifes being like things that have been "groped over with the hands," and his interiors needing to be circumnavigated with caution as the spectator finds himself "bumping about those rooms." This painter was not a Renaissance artist, and the writer was not Berenson: the artist was Paul Cézanne and the writer R. G. Collingwood, writing about Cézanne in *The Principles of Art* in 1938. But Berenson then enters Collingwood's narrative as the person who discovered that, when we approach the Italian painters looking for "tactile values," we see that they yielded the same revolutionary results. "When Mr Berenson speaks of tactile values," Collingwood wrote, "he is not thinking of things like the texture of fur and cloth....he is thinking...not of touch sensations, but of motor sensations, such as we experience by using our muscles and moving our limbs."[2]

Movement is closely related to tactile values, as we shall see. According to Berenson's own late recollections (in his *Aesthetics and History*, written during the Second World War and published in 1950), his ideas about movement came to him when "one morning, as I was gazing at the leafy scrolls carved on the door jambs of S. Pietro outside Spoleto, suddenly stem, tendril and foliage became alive and, in becoming alive, made me feel as if I had emerged into the light after long groping in the darkness of an initiation. I felt as one illumined." And since then, he went on, "everywhere I feel the ideated pulsation of vitality, I mean energy and radiance" (Fig. 1).[3] Recalling this incident in his diary in 1949, he said that this "almost dramatic revelation" was essentially what he had called "movement" in his *Italian Painters*. It was similar to the more gradual "eye-opening" that happened to him in the Brancacci Chapel, where one day, having for some time regarded frescoes as narrative, he became consciously aware of "tactile values, of bulk, of the third dimension." Contrasting the gaiety of the Masolinos and "substantiality" of the Masaccios with the "flimsy, tissue-papery Filippino Lippis," he exclaimed: "Surely I might have been directed

---

generosity in providing me with images and material from his family archives and for allowing me reproduce them here.

1    Berenson 1952a, 44, 67, pls. 107, 204; earlier editions are referred to below in note 6.

2    Collingwood 1938, 144, 146–147.

3    Berenson 1950a, 68–69.

to look for tactile values and movement instead of having to stumble on them, although that perhaps was great fun."[4]

This is somewhat disingenuous, to say the least, since the tactile revolution was under way some years earlier, as the response not only to impressionism and the discovery of photography but also to new intellectual stimuli: the evolutionary psychology of thinkers like William James (after Charles Darwin and Sigmund Freud) and the German philosophers Georg Wilhelm Friedrich Hegel and Friedrich Nietzsche, whose book *The Birth of Tragedy* was very fashionable at the time. We know, as well, that Mary and Bernard were reading and copying extracts about "muscular and tactual sensations" from books like Edmund Gurney's *Power of Sound* in 1892, around the time when Mary recorded an enthusiastic encounter with sculpture on their visit to Spoleto: "Quarrelled—or rather, were cross. The door of San Pietro is <u>splendid</u>."[5]

4   Bernard Berenson, diary, 28 February 1949, in Berenson 1962, 279; cf. Berenson 1949, 127–128, where Berenson calls his experience of color in Assisi "a revelation almost as rejuvenating as the one I had years before with regard to form and movement while facing the facade of San Pietro at Spoleto."

5   Bernard and Mary Berenson, journal, 14 November 1892, Bernard and Mary Berenson Papers, Biblioteca Berenson, Villa I Tatti—The Harvard University Center for Italian Renaissance Studies (hereafter BMBP); Mary and Bernard also visited Spoleto on 3 May 1893—"4 hours of Rapturous enjoyment" (ibid.). On Gurney, see Samuels 1979, 152–153. On the theory's earlier roots in English empiricism, see Gombrich 1960, 15 (quoting George Berkeley's *New Theory of Vision* [1709], that all our knowledge of space and solidity must be acquired through the sense of touch and movement).

But although Berenson may have had his illuminating experience of movement in 1892 or 1893, tactile values were certainly not part of his vocabulary when he was writing *The Venetian Painters of the Renaissance*, which was published by Putnam's in 1894 as the first of his four volumes on Italian painting.[6] (They were all published together in 1930 by the Oxford University Press as *The Italian Painters of the Renaissance*, and then republished in 1952 by Phaidon in the edition in which I first read them.) In the 1894 volume on Venice, Berenson contrasted the Venetians' popular and colorful paintings and their "delight in life" with the Florentines' inability to distinguish painting from sculpture and architecture, being "already too much attached to classical ideals of form and composition, in other words, too academic, to give embodiment to the throbbing feeling for life and pleasure."[7] By the time he was discussing the Florentines in his second volume, *The Florentine Painters of the Renaissance*, published by Putnam's in 1896, he had found new terms in which to describe their achievement, "tactile values" now replacing form to describe "the more static sources of life-enhancement," as he later put it, whereas "movement" referred to "the various communications of energy."[8]

So, we have a period of two years from 1894 to 1896 in which to trace the birth of these three interrelated concepts: tactile values, movement, and life-enhancement. Using both Bernard's library and Mary's journal, we can reconstruct quite accurately the books and the people who influenced Bernard's thinking in this period—especially the German sculptor Adolf von Hildebrand, the German philosopher Nietzsche, and the American psychologist William James—with a small input from a clever, critical Englishwoman, Violet Paget, better known as Vernon Lee, to whom I shall return in my conclusion for a final assessment of "tactile values" within Berenson's circle of expatriates and their children.

First of these influences was Adolf von Hildebrand (Fig. 2). With his friends, the painter Hans von Marées and the art critic and collector Konrad Fiedler, Hildebrand wanted to return to a theory of form that was neither a priori nor purely impressionistic.[9] When Bernard and Mary met him in the 1890s, he was living in the former convent or friary of San Francesco di Paola in Florence, below Bellosguardo (in which he had initially lived with von Marées and Fiedler), "a beautiful villa on the other side of Florence," as Mary described it in 1897, "with his lovely, lovely wife and a huge family of daughters and one little son"; he was, she thought, "the greatest living sculptor."[10] Bernard had met Hildebrand three or four years earlier, possibly in 1893, certainly in April 1894, when he

6   *The Florentine Painters of the Renaissance* was published by Putnam's in New York in 1896, followed by *The Central Italian Painters* in 1897, and *The North Italian Painters* in 1907, each with a valuable "Index" of places and painters that Berenson later published separately, together with many illustrations, as *The Italian Pictures of the Renaissance* (the two volumes on Florence were published in 1963). On Berenson's disinterest in aesthetics at this time, see note 56 below.

7   Berenson 1952a, 7–8.

8   See "The Decline of Art" (the final section of *The North Italian Painters*), Berenson 1952a, 199–200.

9   See Venturi 1948, 420, 424–430; Lodovici 1949, 3–32; and Brewster 1994, 14–25. Von Marées died in 1887 and Fiedler in 1895.

10  Mary Berenson to her children, 24 March 1897, in Strachey and Samuels 1983, 69. On Hildebrand's wife Irene and their six children, see Brewster 1994, 86–100; and Mary Berenson, journal, 4 April 1894, BMBP, 32.

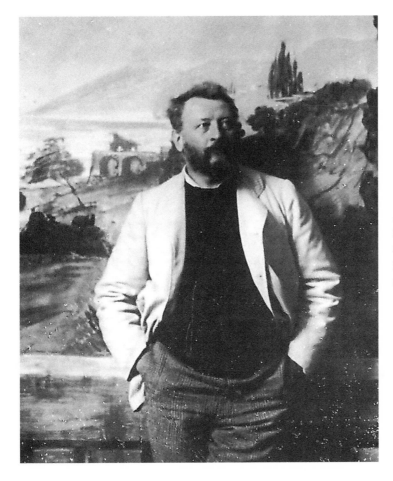

2

Adolf von Hildebrand
in middle age, 1903. Villa
San Francesco di Paola,
Florence. (Photo courtesy
of Starr Brewster.)

visited Hildebrand with Carlo Placci a year after the publication of Hildebrand's small
but influential book on art theory.[11]

In this book, *Das Problem der Form in der bildenden Kunst* (translated as *The Problem of
Form in Painting and Sculpture*), Hildebrand as a sculptor reacted against impressionism
and the "so-called positivistic conception of Art" that found truth "in a casual appearance
or form of an object," as though we saw things two-dimensionally as a newborn child sees
"in the first few hours of life when ideas are first beginning to develop." This, he wrote,
was a tendency that had been "fostered through the discovery of photography." But as "we
cannot strip off our ideas at will [since] it is just by the aid of these ideas that we see," he
reestablished their importance not by returning to Hegelian or Platonic idealism but by
appealing to our memory of touch and movement.[12] These memories, or mental images,

11   Ernest Samuels refers to a 1893 meeting (unreferenced) in Samuels 1979, 230. Mary Berenson,
      journal, 4 April 1894, BMBP, 32: "Carlo Placci took Bernhard to call upon the sculptor Hildebrand.
      Miss Paget told me their story . . ."
12   Hildebrand 1893, 29–30, and 1907, 43–44.

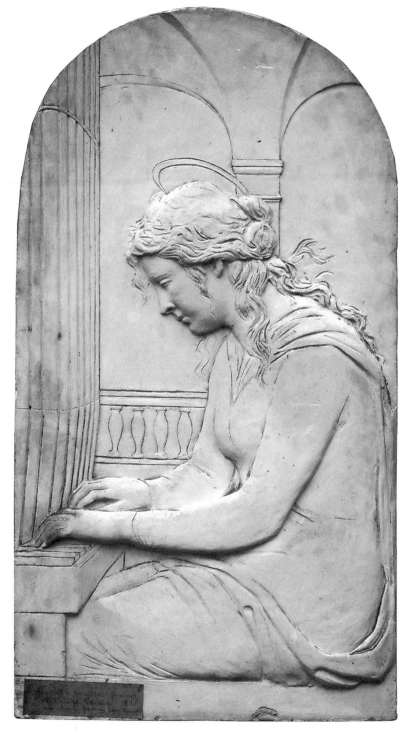

*3*
Adolf von
Hildebrand, plaster
cast relief of *Lisl von
Herzogenberg Playing the
Organ*, 1893. Villa San
Francesco di Paola,
Florence. (Photo
courtesy of Villa I
Tatti—The Harvard
University Center for
Italian Renaissance
Studies.)

were essential in solving what he defined as "the problem the artist has to solve," or "THE REAL PROBLEM IN ART," as Berenson wrote in capitals in the margins of his copy of the first 1893 edition of *Das Problem der Form*: that is, the problem of how to create a sense of space or three-dimensionality on a flat surface.[13] The artist, Hildebrand said, does it by using form and movement to create space and depth, improving on nature by unifying it and animating it, which not only vitalizes us but provides us with the source of our aesthetic enjoyment of a work of art. His relief of *Lisl von Herzogenberg Playing the Organ* (Fig. 3) well illustrates how he used solid form and movement, as well as architecture, to create space and three-dimensionality on a flat frieze surface.

Form (or tactile values) and movement—as well as vitality—are key concepts in Berenson's *Florentine Painters* and in his later *Aesthetics and History*, in which he attempted to sum up his aesthetic theory in a sort of glossary that includes these three terms.[14] His debt to Hildebrand has already been recognized by Ernst Gombrich in a couple of deft pages in his *Art and Illusion* (repeated by Samuels in his biography of Berenson). In them, Gombrich describes how, when Berenson wrote "his brilliant essay on the Florentine painters," he "formulated his aesthetic creed in terms of Hildebrand's analysis," with his "gift for the pregnant phrase" summing up the whole of Hildebrand's argument in the sentence, "the painter can accomplish his task only by giving tactile values to retinal impressions."[15] Berenson's quite heavily annotated copy of Hildebrand's *Das Problem der Form* in the I Tatti Library bears Gombrich out in showing how carefully Berenson summarized relevant parts of its argument in the margins in English, noting especially (as we have seen) what "das Problem" was and the topics described above. His comments show that he approved of Hildebrand's attempt to better nature by unifying forms within a relief, writing in the margin: "that is the real reason why Gothic is so disturbing to the eye & fine antique or Romanesque or Renaissance so soothing. In Gothic little or nothing is done for the <u>peace</u> of the eye, which is left to wander about like a bird lost in a church." And he enthusiastically wrote "BRAVO" in capitals in the margin where Hildebrand refers to the superstitious regard of the uncultured mind for placing statues in the dead centre of squares instead of setting them against flattened landscapes to suggest their form—an opinion that was a matter of contention with Vernon Lee, as we shall see.[16]

Hildebrand's ideas must also have been in Berenson's mind when he wrote to Mary from Berlin in July 1895, just after his main writing burst on *The Florentine Painters*: "Even if our primary sensations of space be three-dimensional (which I would not deny), the third dimension in precise form must largely be the result of tactile and locomotor sensations."[17] And I like to think that there is also an allusion to what Hildebrand wrote about children's art and primitivism in a letter Mary wrote the previous year to

13  Hildebrand 1893 (I Tatti copy), 43–44.
14  Berenson 1950a, 60–63 ("Tactile Values"), 63–67 ("Ideated Sensations," referring to life-enhancement and the communication of energy, vitality, and excitement), 67–72 ("Movement"), and 74 ("Tactile Values and Movement in Sculpture"); cf. pages 115–116 below.
15  See Gombrich 1960, 16; and Samuels 1979, 230.
16  Hildebrand 1893 (I Tatti copy), 82 and 101.
17  Bernard Berenson to Mary Berenson, Berlin, 31 July 1895, in Berenson 1962, 83–84.

her children in England—then nearly seven and five years old—thanking them for their drawings and telling them, perhaps a little dauntingly, that "there is this very funny thing, that *all* little children, no matter what race they belong to or where they live . . . all draw almost exactly alike. Funnier still, even grown-up people . . . used to draw just like this, and indeed you still find peasants and savages drawing in the same way."[18]

What we know with certainty is that Hildebrand's book was the subject of heated debate in November 1895, when Mary and Bernard "dined at Miss Paget's and discussed sculpture, apropos of Hildebrandt's '<u>Problem der Form</u>'" (Fig. 4). According to Mary's journal, Vernon Lee went on to protest "violently . . . that a statue should be not composed like a bas-relief, or a series of bas-reliefs, & said that to her the great artistic quality of a statue was that it <u>compelled you to walk around it</u>"—an opinion from which Mary and Bernard dissented, as Bernard's comments in *Das Problem der Form* suggest he would have done.[19] The following April, when *The Florentine Painters* was in proof but not yet out, Bernard "dined with the Hildebrandts & greatly enjoyed them," Mary reported, and since "he and Herr Hildebrandt not only seemed to think alike on all subjects but had actually struck out [i.e., produced] the same phrases . . . it was," Bernard had said, "almost embarassing [*sic*]."[20] Perhaps it was a little embarrassing. The key ideas Berenson was reflecting on in the summer of 1895, "tactile and locomotive sensations," clearly owed much to Hildebrand. Mary, in fact, admitted this in the course of her correspondence with Vernon Lee over the plagiarism charge in 1897; and some time later, in 1913, when Roberto Longhi asked Berenson what he owed to Hildebrand and his close friends Fiedler and von Marées, Berenson merely replied—"with a half-truth"—that Fiedler was only a name to him, without ever mentioning Hildebrand.[21]

Nevertheless, it was—as Gombrich says—Berenson who vivified these ideas in *The Florentine Painters of the Renaissance* in 1896, in his clear summing up of how as children we unconsciously learn about depth from touching and grasping things and moving our muscles: "Psychology has ascertained that sight alone gives us no accurate sense of the third dimension. In our infancy, long before we are conscious of the process, the sense of touch, helped on by muscular sensations of movement, teaches us to appreciate depth, the third dimension, both in objects and in space." The function of the artist is to "rouse the tactile

18  Mary Berenson to her children, 7 April 1894, in Strachey and Samuels 1983, 55.

19  Mary Berenson, journal, 29 November 1895, BMBP, 36 (a passage titled "<u>Vernon on Aesthetics</u>"). Vernon Lee's views were repeated in the article "Beauty and Ugliness," first published in *The Contemporary Review* (Lee and Anstruther-Thomson 1897, 35 and 38 [note]), which was the cause of their quarrel (see note 59, below), but were revised when it was republished in *Beauty & Ugliness and Other Studies in Psychological Aesthetics* (Lee and Anstruther-Thomson 1912, 219 and note)—she now walked around statues of the "pre-Lysippian (Hildebrand) type . . . to find the points of view; but once . . . found, I stop."

20  Mary Berenson, journal, 17 February 1896, BMBP, 96.

21  See Brown 2005, 199, discussed more fully below. See also Iamurri 1997, 77 and n. 69: "I got a book of his [Fiedler's] name some twenty years ago, but I am sure I never got ahead the first page." Longhi was referring to Benedetto Croce's article, "La teoria dell'arte come pura visibilità (Von Marées, Fiedler, Hildebrand)."

4
Vernon Lee,
January 1914.
Colby College
Special Collections,
Waterville.

sense" in order to create what Berenson later called the "ideated sensations" that communicate vitality and life-enhancement to a work of art.[22]

Although Hildebrand had talked about "vitality," the concept of life-enhancement probably came from another source: Friedrich Wilhelm Nietzsche. As we know from Mary, Bernard was reading Nietzsche in 1895, after "enjoying" Hegel's *Aesthetics* and what she calls William James's "Philosophy of Art" the previous year.[23] In March, they were both reading Nietzsche. Having finished *The Death of the Gods*, Bernard had embarked on *Thus Spoke Zarathustra*, while Mary was "still plodding along in" *Beyond Good and Evil*. By May, they had reached *The Birth of Tragedy*, which Mary reported "is the best thinking on aesthetics from our point of view—the really psychological—that Bernhard knows."

22  See Berenson 1952a, 40, and 1950a, 63–67.

23  Mary Berenson, journal, 5 March 1894 and 19–24 March 1894, BMBP, 13 and 19–24 ("Bernhard began Hegel's Aesthetics"); journal, 7 March 1894, BMBP, 14 ("Bernhard read James' 'Philosophy of Art'"); and journal, 8 March 1894, BMBP, 15 ("I read James' 'Philosophie de l'art'); see note 37, below.

What he valued in Nietzsche, she wrote on 17 May, was that Nietzsche "consistently hates all that makes against life & loves all that makes for it." Since this was only two days after "Bernhard began his Florentines" (before admitting a day later that he despaired of writing about them, "because he no longer enjoyed them as a school"), it may well have been Nietzsche who helped to break his writer's block.[24] For only nine days later, Mary wrote that Bernard had "deserted the theory" that art's purpose is to "Uplift!" or "broaden" life. Instead, he "suddenly broke out in praise of the Degas on the mantelpiece as 'the greatest of all works of art'. 'Why ?' . . . A good deal of hesitation & feeling round, and at last the right reason hit on the head, because it conveys life directly." "Effects of space & composition belong to architecture & are rightly called 'architectonic.'"—she continued—"But painting can communicate life—livingness—itself. This is the purely aesthetic artistic standard of art." "Neither Maud [Cruttwell] nor I looked half so much alive as Degas' ballet girl bending down to tie her slipper," she reflected poignantly, before returning to Nietzsche with the comment that his "'Wertschätzungen' ['criteria of excellence'], which are all reducible to the criterion whether it makes for or against life, have helped forward Bernhard's ideas."[25] Berenson then incorporated Edgar Degas into *The Florentine Painters* by comparing his achievement with Leonardo da Vinci's mastery over the art of movement in the unfinished "Epiphany" and with his stimulating and convincing tactile values in the "Monna Lisa."[26]

During June 1895, Berenson wrote the chapter on Masaccio that was crucial to his concept of tactile values. As he explained in *The Florentine Painters*, he never saw Masaccio's Brancacci Chapel frescoes "without the strongest stimulation of my tactile consciousness. I feel that I could touch every figure, that it would yield a definite resistance to my touch."[27] That month, he told his sister Senda that he was "nominally . . . writing on the Florentine painters, but really my absorbing interest is to know why, to find out the secret of our enjoyment of art." "Some day," he went on, "I hope to get there. In my heart of hearts I think I am already farther on the way than any one has ever been before."[28] Two weeks later he told Senda that he had never felt so busy, thinking of nothing but his book: "never have I enjoyed myself more"; Mary agreed that Bernard's period "of grappling with

24  Mary Berenson, journal, 12 March 1895, 15 May 1895, and 16 May 1895, BMBP, 103, 124, and 125: "after tea a little talk about aesthetic emotion. It began with Bernhard's wail that he could not write about the Florentines"; and journal, 17 May 1895, BMBP, 128 on "Nietzsche's "Wertschätzungen," cf. 132 (26 May 1895). The titles of Nietzsche's books are cited in German; cf. Samuels 1979, 209. See also Berenson to Senda, 8 March 1895, BMBP (248), describing Nietzsche as "a singularly paradoxical, conceited, involved German" whose real merit was to shake all new orthodoxies and in doing so to sweep out "many a corner untouched by a broom for many & many a year."

25  Mary Berenson, journal, 26 May 1895, BMBP, 130–132 ("the essence of essences is to be a sheath, an envelope of just 'plain life' . . . [Maud and I] were not sheaths of aliveness as the painter made that figure") and 132–133 (continuing, "although Nietzsche, while railing against any such intention, is in fact very hygienic, while Bernhard's beating his brains to find the kernel of the artistic element in the work of art").

26  Berenson 1952a, 65, pls. 192, 193. On Degas's "life-enhancing qualities," see also Berenson 1950a, 102.

27  Berenson 1952a, 50, pl. 139.

28  Berenson to Senda, 2 June 1895, BMBP, 253, partly in Samuels 1979, 229.

the Book" was "one of the happiest and most <u>growing</u> months of our lives," as the two understood more and more about "the 'why' of real art enjoyment."[29] Later that summer, Berenson experienced another revelatory moment after Mary left him in Germany on her way to England. "Recall the summer of 1895," he wrote in his *Sketch for a Self-Portrait.* "You had the *Florentine Painters* behind you. You were a wanderer in Germany. You were alone, you had no company but your thoughts." And what he thought about was his vision for a lifetime's work, three books on "ideated sensations," "life-enhancement," and "portraits." This vision indicates the importance of the new direction his work had taken after this summer completing *The Florentine Painters of the Renaissance*—even though he then allowed himself to be "seduced" (as he put it) into writing about Florentine drawings instead, which led him down the path of connoisseurship rather than art criticism.[30]

Berenson had told his sister in June that psychology, not philosophy, would provide the answer to why we enjoy art. Later that year, in a discussion over lunch "about Aesthetics" (starting from Vernon Lee's "remark that <u>her</u> remarkable system was 'pure Metaphysics—and Psychology,' evidently confusing, as most people do, the two points of view"), Bernard carefully explained why "most people hop from the Metaphysical into the Psychological without realizing the difference," he himself being "the first person"—according to Mary—"to be fully aware of the difference and to determine to keep unwaveringly to the psychological."[31] Although, as we have seen, both Hildebrand and Nietzsche contributed to Bernard's psychological approach to aesthetics, it was a third person whose influence was perhaps more pervasive. This was Berenson's old teacher of psychology at Harvard University, William James, brother of Henry, the novelist (Fig. 5). To James, Berenson later said, he owed "eternal gratitude," since before he had reached his twenties, James had made him understand through his writings that "in order to liberate oneself from metaphysic one had to be immersed in it and study it thoroughly."[32] By his own admission, Berenson got only "mediocre" marks in psychology at Harvard, and his future brother-in-law, the philosopher Bertrand Russell, was very critical when hearing about his ideas from Mary during her summer visit to England in 1895.[33] But Berenson's heavily annotated copy of the second (1893) edition of James's dense two-volume *Principles of Psychology* shows that he had read it carefully, perhaps in response to Russell's criticism and suggestion that he reread it in July, even though it still left his ideas "in a muddle."[34] In October, he wrote that psychology was "more and more absorbing" him, and he urged one

---

29  Berenson to Senda, 19 June 1895, BMBP, 252; Mary Berenson, journal, 17 June 1895, BMBP, 140.

30  Berenson 1949, 36; cf. Berenson 1962, 84 (commenting to Mary from Berlin on 3 and 5 August on aesthetic pleasure and "that almost unconscious element ... at the bottom of real pleasure in art"). Samuels apparently fails to mention this moment of insight when in Germany (Samuels 1979, 229, 231–233).

31  Mary Berenson, journal, 29 November 1895, BMBP, 34–35.

32  Morra 1965, 227. I am indebted to Mario Casari for introducing me to this book for its interesting reference to Berenson and Vernon Lee.

33  Berenson 1949, 81; and Samuels 1979, 231–232.

34  James 1893 (I subsequently quote from the 1893 edition annotated by Berenson in the I Tatti Library); and Samuels 1979, 233.

5

William James,
ca. 1894–95,
photograph by
Sarah Sears.
MS Am 1092,
Houghton Library,
Harvard University,
Cambridge.

correspondent, the pseudonymous "Michael Field," "as she loves me & herself . . . to get the large edition of James's *Psychology* & to read it diligently. Great shall be the fruit thereof." [35]

For Berenson, *The Principles of Psychology* was fruitful in providing a theoretical basis for many of his already formulated ideas, as we can see from his marked passages on tactile perception, motor types, sensation, the mind and the will—as well as the importance of habit, which Patricia Rubin has suggested may well have influenced Berenson's own lifestyle. [36] The will was especially important, not only for Berenson's personal philosophy—as we shall see—but also for its role in his and James's aesthetic theory. For among the emotions that are released by ideas grasped and stored up in the mind, James included aesthetic emotion *"pure and simple"*—that is, "the pleasure given us by certain lines and masses, and combinations of colors and sounds," which is entirely sense-based ("an

35 Mary Berenson, journal, 24 October 1895, BMBP, 195, quoting Bernard Berenson to "Michael." "Michael Field" was the pseudonym of Katherine Bradley and her niece Edith Cooper.

36 Rubin 2000a, 208.

*Alison Brown*

absolutely sensational experience"). This emotion caused what Edmund Gurney called "the stirring of the hair—the tingling and the shiver" when listening to music (quoted by James in a note that Berenson marked with an asterisk), which is then transformed by the will into energy and action.[37] According to this theory of emotion, the mind acts simply as a selective agency, or "a theatre of simultaneous possibilities," from which it chooses ideas like flowers gathered from our experience to help us "towards a better route for survival"—just as an artist "selects his items" to create the unity and harmony that makes work of art superior to works of nature.[38] The markings in Berenson's copy of *The Principles of Psychology* show how well James's theory of art tied in with Hildebrand's to provide an underpinning for the theory of tactile values.

Yet the influence of William James on Berenson was not limited to this one difficult book alone, as we can see from Berenson's references to James's other writings—especially *The Will to Believe* and *The Energies of Men*—and from his many fond reminiscences of his teacher throughout his later life. In January 1941, for instance, he recalled that, "at Harvard I preferred the conversation of James, of Toy, of Climer, of Wendell, to that of fellow-students," these men being also the professors whose writings, he later recalled, influenced him "while at college."[39] (Mary, too, knew James at college, during the time she was at "The Annex" [later Radcliffe], and it is interesting to note that when she was lecturing on art at the Colony Club in New York in 1909, she listed him, not Berenson, as one of the four influences who started "The New Art Criticism.")[40] Berenson's own affectionate memories of James include his manner of teaching, how he was "sitting lightly, almost swinging on the corner of his desk, holding forth in his zestful, engaging, amusing way" when "suddenly a sarcastic Puritan popped up from his bench and cried out: 'Mr James, to be serious for a moment'... Roars of laughter in which the Professor joined greeted the impertinence."[41] "William James used to say," he recalled on another occasion, "'Come, let us gossip about the universe!'"; "William James used to say that every gush of feeling should be followed by adequate action, or (he implied) the feeling turned to poison"; "William James used to say to us as youngsters that we did not know whether we were worth ten dollars only or ten thousand. I feel today as uncertain," Berenson wrote in 1951.[42] And so on. Still other reminiscences came from walks together in Rome and

---

37  James 1893, 2:468–469. This suggests that Mary is referring to *The Principles of Psychology* when she talks of Bernard and herself reading James's "Philosophy of Art," or "Philosophie de l'art," in March 1894.

38  Ibid., 1:287–288, in passages marked by Berenson; cf. James 1909, 105. James refers to "the Lange-James theory" in James 1901, 117–118. On his philosophy, see Perry 1912, 349–378, "Appendix: The Philosophy of William James"; and Bordogna 2008, esp. 145–151.

39  Berenson 1952b, 41–42 (25 January 1941); cf. Berenson 1962, 209. See also Berenson 1964, 451–452 (2 October 1956).

40  Mary Berenson to Gardner, 31 January 1909; see Strachey and Samuels 1983, 149: "Morelli for Connoisseurship, Milanesi for History, William James for Psychology and Pater for Aesthetics."

41  Berenson 1949, 50.

42  Berenson 1952b, preface (February 1947), 10; Berenson 1964, 67 (16 March 1948); ibid., 234 (27 October 1951); cf. Berenson 1949, 46. Other reminiscences recall James saying "I run after interruptions," James on Georges Santayana and James on "the business of philosophy": Berenson 1964, 27 (27 July 1947), 276 (28 September 1952), and 321 (14 October 1953).

Florence, where James hated being hemmed in by Florentine walls: "It was churlish to deprive one of the view. It made him mad."[43]

James, one has to admit, was also maddened, waspishly, on this visit to Florence in 1892–93 by "these people" who were "all eaten up with contempt for each other's blunders, blindnesses, perversities and ignorances." And although he found Berenson "very interesting," even "a genius" (as he wrote on the same day to another friend), he described Berenson to a Harvard colleague as having "a noble gift of the gab, perceptions, *dazu* and learning, and good visual images" but also "terrible moral defects, I imagine—keeps me off by his constant habit of denunciation of the folly of everyone else and the pretension to the only right and objective knowledge."[44] Mary, too, had her defects. For "that rare and radiant daughter of Pearsall Smith of Philadelphia," now "older, more political and harder . . . but still very handsome," was "quite infernal when she gets on the subject of art history, which is now the serious occupation of her life"; this was a feeling that Mary reciprocated, by finding her heart "filled all day long with hatred & bitterness on account of James and his twaddle about Art."[45]

Despite all this, James had a pervasive influence on Berenson's personal philosophy, or what Berenson called his "house of life." Proposing this "house of life" in 1946 as an alternative to the extremes of nihilism and Catholic or communist dogmatism, Berenson wrote in his diary: "Why not rather admit that there is a formative energy in our make-up that drives us to the formation of a society, with its hierarchies, its morals . . . its arts, its sciences, its religions, all tending to make a House of Life in which we each of us can find a home? It is essentially William James's 'Will to believe.'"[46] Some years earlier, Berenson had already marked with five crosses a passage in James's *Principles of Psychology* (which later recurs in his *Will to Believe*), describing how the will, by acting as if something were real, makes it real.[47] The crosses suggest the importance that the idea had for him, as an aspect of his belief in the ability of the will to create reality and value by its strength and persistence. He returned to what he meant by "will" in his *Sketch for a Self-Portrait*: "It is not *libido* but what Nietzsche meant by *der Wille zur Macht*, what William James meant

43  Berenson 1952b, 129–130 (23 October 1943); cf. Berenson 1964, 90–91 (28 July 1948). On W. L. Myers's death in Rome, see Berenson 1949, 125; on Papini, see Morra 1965, 165–166 (21 October 1933).

44  James to Elizabeth Ellery Sedgwick Child, Florence, 5 January 1893, in James 1992–2004, 7:366; cf. James to Grace Ashburner, 5 January 1893, in ibid., 364; James to Josiah Royce, 18 March 1893, in ibid., 402.

45  James to Child, in ibid., 366; James to Royce, in ibid., 401–402, to whom James describes Mary, "erst Mary Smith of the Annex," as collaborating "platonically" with Berenson on a catalog of Lotto. See also Bernard and Mary Berenson, diary, 6 January 1893, BMBP; cf. Mary Berenson to Pearsall Smith, 14 January 1893, in Strachey and Samuels 1983, 51: James "*will not* look at anything except as an illustration of his a priori theories about art . . . What can you think of a man's intellectual method when he applies it only in spots?"

46  Bernard Berenson, diary, 10 December 1946, in Berenson 1962, 261.

47  James 1893, 2:321; see also James 1896, 29: "there are cases . . . where faith in a fact can help create the fact." On Carlo Placci's death in 1941, Berenson described in his diary how he had "in all innocence" lent Placci *The Will to Believe* shortly after it was published (with unfortunate results); see Berenson 1952b, 32–33 (14–24 January 1941).

when he invented the phrase 'the will to believe.' Alois Riegl with his *Kunstwollen*—the will to art, the imperative in taste, the style which imposes itself on society at a given moment, and from which nobody ventures or even wishes to depart."[48] And two years before he died, in 1957, he reverted to the same definition in order to explain his aesthetic theory to Prentice Towsley: "History tells me that Value in every field is a matter of 'Will To,' as Schopenhauer perhaps first used it, as Nietzsche used it in the Will to Power, as William James used it in the Will to Believe, as Riegl used it in the Will of Art. It is a matter of urges which takes hold of people in a given moment. If it lasts long enough it is called Ethics in the field of ordinary life, Aesthetics in the various realms of art."[49]

Closely associated with this "urge" is the "formative energy" required to raise our level of energy beyond what we think possible, which is achieved through "excitements, ideas and efforts," but especially through the will. This was the theme of James's "spectacular and controversial speech" to the American Philosophical Association in 1906 on "The Energies of Men," one of several speeches by James that Mary, Bernard, and Nicky Mariano read together in the dark days of the Second World War, a faint pencil note in the copy of it in Berenson's library recording that "M.B. read to Nicky and B.B. Nov. 8 1942, Settignano."[50] A month later, Berenson listed the speech in his book *One Year's Reading for Fun (1942)*, where he agreed "entirely" with James urging people to go on beyond what they thought was possible, though confessing that after doing this himself when he was forty, he had a nervous breakdown and now had to stop in time when he felt fatigue approaching.[51]

As a philosophy for life, James's emphasis on the will was foreshadowed by what he wrote to a friend as a young man, that "we can, by our will, make the enjoyment of our brothers stand us in the stead of a final cause" and, knowing that "enjoyment on the whole depends on what individuals accomplish," be able to lead an active and happy life, adding to "the welfare of the race in a variety of ways."[52] It is also close to the ideas that Berenson expressed in his *Diaries* for two decades, from 1941 until 1958, the year before he died: his "house of life," his "faith" (not in the Church but "in the certainty that life is worth living . . . confidence in life as worth while, confidence in humanity . . . zest . . . enjoyment of the individual human being as a work of art"), his pleasure in viewing works of art as a religious experience, even after nearly seventy years, as he says, of growing familiarity with them.[53] In the present context, it also reflects the ideas that Berenson wrote about in *Aesthetics and History*: tactile values, now defined as "representations of solid objects when communicated . . . in a way that stirs the imagination to feel their bulk, heft their

---

48  Berenson 1949, 50.

49  Berenson to Towsley, 12 July 1957, in Berenson 1962, 377.

50  James 1911, 229.

51  Berenson 1960a, 158 (9 December; between 14–20 December, he read James's *Pluralistic Universe*, which he said he did not recall reading before; ibid., 160 and 162). On the speech, see Bordogna 2008, 265.

52  James (aged twenty-six) to Thomas Ward, Berlin, January 1868, in James 1992–2004, 4:248–249, cited in Brown 2005, 196.

53  Berenson 1952b, 322 (21 July 1944), cf. Berenson 1962, 238; see Berenson 1964, 336 (24 February 1954), on going in his youth to see "an art museum, a building, a famous landscape, with reverence . . . it was more like a religious experience."

weight ... to grasp, to embrace, or to walk around them"; movement, called "the manifest indwelling energy that vitalizes the delimiting outlines of an artefact," a "vital energy," accompanied by "an ideated tingling on and in my own skin"; and life-enhancement, "the ideated plunging into a state of being, or state of mind, that makes one feel more hopefully, most zestfully alive; living more intense, more radiant a life ... reaching out to the topmost peak of our capacities." And here we should remember how he described Antonio Pollaiuolo's *Hercules Strangling Antaeus* in *The Florentine Painters* in 1896: "As you realize the suction of Hercules' grip on the earth, the swelling of his calves with the pressure that falls on them, the violent throwing back of his chest, the stifling force of his embrace ... you feel as if a fountain of energy had sprung up under your feet and were playing through your veins."[54]

Such a subjective response to art does not, perhaps, constitute an aesthetic theory. Expressing the hope that Mary would provide, as a sequel, "an *aperçu* of what Mr Berenson's system exactly is," Vernon Lee admitted to Mary in 1932 that she herself had failed to discover it; she wrote that despite having read "I think all his books, I have not succeeded in piecing it together & have been too shy to ask *a voce*."[55] Among the "most poignant of my regrets" that run through Berenson's diaries is his failure to write the book on "Aesthetics ... Style ... Value" that Towsley asked him about in 1957: "You ask if I have ever written on these matters. No, but I have touched tangentially on them in the second part of my little book on *Aesthetics and History*. I fear all this will be very disappointing."[56] A decade earlier, when the English scholar and diarist Roger Hinks discussed *The Italian Painters* with Berenson on a visit to I Tatti, Berenson admitted that his sensibility (unlike Hinks's) had not changed at all over the last forty to fifty years, and that the book he was writing as his "last word on the subject," *Aesthetics and History*, "differs hardly at all from my first words on the subject."[57] Vernon Lee herself has been partly blamed for Berenson's failure to produce the book he was planning on the "Science of Art Criticism" due to the fallout from their quarrel over plagiarism, to which it is unnecessary to return here.[58] Their disagreements were not about tactile values, which she always accepted and acknowledged as Berenson's own original idea. In the article "Beauty and Ugliness" that was the source of the plagiarism charge, she acknowledged in a note that "in his remarkable volume on Tuscan painters (1896), Mr. B. Berenson has had the very great merit, not only of drawing attention to muscular sensations (according to him in the limbs) accompanying the sight of works of art, but also of claiming for art the power

54  See Berenson 1950a, 60, 67–68, 129, and 1952a, 61, pl. 166.

55  Lee to Mary Berenson, 9 April 1932, cited in Brown 2005, 202.

56  Berenson to Towsley, in Berenson 1962, 377, cf. 201, 265, 292, 296; Berenson 1964, 229–230. In *One Year's Reading for Fun* (1942) (Berenson 1960a, 37), Berenson says he tried to read Bernard Bosanquet's *History of Aesthetic* in 1892 but it bored him because it was "so remote from and so irrelevant to my curiosities of that time," and similarly that he had failed to read Johannes Volkelt's *Äesthetik des Tragischen* until 1942; Berenson 1952b, 85–86, cf. Berenson 1964, 22–23 (on Heinrich Wölfflin).

57  Hinks 1984, 133. See also page 120 below.

58  See Wellek 1966, 249. On Lee's early friendship with Berenson, including encouragement of his proposed book "On Scientific Art Criticism" and later quarrel with him, see Brown 2005, 197–203, 207 n. 55; Gunn 1964, 147–160; and Samuels 1979, 174–175, 283–290.

of *vitalising*, or, as he calls it, *enhancing life*"—although, she went on, this was for "a different and more intellectual reason" than her own.[59] This must refer to their differences over movement and empathy, for whereas Bernard—according to Mary—attributed life-enhancement to the perception of "tactile values" and "movement," Vernon Lee and her friend Kit Anstruther-Thomson suggested that it was "all due to breathing"—or, as Henry Brewster more irreverently put it, that "the sense of form proceeds from the lungs and not as Mrs Costello maintains, from the knee pan."[60]

Brewster leads me back to my circle of polemical expatriates and the longer-term influence of "tactile values" on them. Although "H. B." no longer lived in Florence, he was intimate with them all: with the Berensons, to whom he was introduced by Vernon Lee. He was a friend, too, of Henry James; and, of course, a close friend of the Hildebrands, to whom he became related through the marriage of his son Christopher to Lisl von Hildebrand (Fig. 6). As an essayist and an acute observer of the social scene in Florence, Brewster provides us with an interesting reflection of the art debate raging among his friends in the 1890s in his book *The Statuette and the Background*, written between 1892 and 1896 (the latter being the same year in which *The Florentine Painters* was published). In it, one of the characters, challenging the idea that art has a moral purpose, says that eyes have nothing to do with art, which is to do with "forms and colours": "We may talk for hours, or write volumes, about the reason for the beauty of this statue and that picture—it is all by the side of the mark," because "only those who have in some degree the power of abstraction in their eye, recognize the artistic effort when they see it."[61] This is a statement with which, I think, Brewster's future relative Adolf von Hildebrand would have agreed and whose ideas it surely reflected.

Although Brewster was a friend of Henry James rather than his brother William, we know that in 1890 he had sent William—through Henry—an earlier book of his on *The Theories of Anarchy and of Law*, which raises in dialogue form the wider issues of belief, skepticism, and Nietzschean egotism underlying the aesthetic debate. William's interest in Brewster's book is revealed by the many underlinings and comments in the margins of his copy (now in the Houghton Library at Harvard) which anticipate his own interest in anarchy and pragmatism.[62] Vernon Lee, too, admired this "subtle and ... cosmopolitan"

59  Lee and Anstruther-Thomson 1897, 225; see also Lee 1896, in which she approves of "tactile values" but not of "notions of self-conscious 'Wille zur Macht,'" the Nietzschean concept that she vigorously attacked in "Nietzsche and the 'Will to Power'" (Lee 1904, reprinted together with her article "Professor James and the 'Will to Believe'" in Lee 1908, 161–231).

60  Mary Berenson, draft letter to Lee, September–October 1897, BMBP; Brewster to Ethel Smyth, 4 November 1897, in Brewster 1994, 301; both cited in Brown 2005, 199. In his review of "Beauty and Ugliness," Dugall S. McColl writes that "their object is to prove ... that the apprehension of Form depends on various organic changes in the body ... the chief of them being respiration and the muscular tensions that go to make up the sense of balance ... this [William James's well-known theory of emotion] the ladies are assuming": McColl 1931, 304–305.

61  Brewster 1896, 31–33. "The Statuette" was lengthened with a second essay at the suggestion of Henry James: see Brewster 1994, 242–245; and James 1957, 187–190. Henry James's "misconstruction" of its argument is noted in Halpern 1959, 227–228, 236–237.

62  See Henry James to William James, 9 March 1890, in James 1992–2004, 2:132, referring to *The Theories of Anarchy and of Law: A Midnight Debate* (Brewster 1887), which struck Henry as "rather exquisite

6

Lisl von
Hildebrand,
*Henry B. Brewster*,
ca. 1904, drawing.
Villa San
Francesco di
Paola, Florence.
(Photo courtesy
of Villa I Tatti—
The Harvard
University
Center for Italian
Renaissance
Studies.)

book and wrote a critical appreciation of it that was republished in her *Gospels of Anarchy*, a volume of collected essays that was in turn admired by William James—despite his earlier hostility toward Lee—as "both a masterly and a good minded production."[63] So, although he was not a member of this Florentine circle, William was closely connected with it and with its polemics, especially after his 1892–93 visit to Florence.

---

& remarkable." For the book's influence on William, see Halpern 1964, 474–475 (cf. Halpern 1959, 192–193); and Coon 1996, 84; for its argument, see Brewster 1994, 176–177; and Brown 2006, 128–129.

63   Lee 1908, 14–40; James to Charles Strong, 28 July 1908 (strongly recommending "all but the chapter on myself"); James to Reginald Robbins, 3 August 1908; cf. Vernon Lee's later response, 29 April 1909 ("for has not your *Psychology*, read, re-read till it is almost falling to pieces, made an epoch in whatever philosophical thought I am capable of?") in James 1992–2004, 10:63, 72, 204–205. On Lee and James's earlier relationship, see Gunn 1964, 138–139; and James 1992–2004, 2:249–250, 253, 255, 264.

As we have seen, William James was not an ardent admirer of Berenson at that time, nor of "the sort of historic philosophy of painting" that Berenson was planning, which James said he lived "in hopes of growing into."[64] Yet by 1898, when he received his copy of *The Central Painters of the Renaissance*, he was "*entusiasmé* [*sic*]": "You've done the job this time, and no mistake . . . so true psychologically," he wrote to Berenson. "Of course, I like particularly what you say of habits of visualizing etc. in their connexion with taste. I think your 'life-enhancement' and your 'tactile values' are ultimate analyses of the effects you have in mind . . . I am sure that you are on sound lines."[65] And only two months later, when describing to his wife the pines and cedars in California, he wrote "they are beauties . . . and the tactile values (as Berenson would say) suggested by their true rotondity, make them beautiful in the extreme." Less beautiful but equally tactile were Rome's "inconceivably corrupted, besmeared & ulcerated surfaces"; well disproving "that beauty is all made up of suggestion," he wrote to a friend in 1900, "their 'tactile values,' as Berenson would say, are pure gooseflesh" (a pleasing variant on "tingling," if not quite what Bernard had in mind).[66] A generation later, in 1954, it was William James's son, another William, an artist, who wrote admiringly to Berenson: "Dear BB. You have to let me address you thus because that is how I am accustomed to refer to you!" He wished he might discuss drawing with Berenson, because, he wrote, "it is the basis of everything when it includes the <u>depth</u> as well as the other two dimensions. I think that is what you referred to by 'tactile values'."[67]

The next generation of Hildebrands also wrote admiringly to Berenson. It was in the middle of the Second World War, in 1943, that Lisl, herself an artist like the young William James, wrote to Berenson after discovering "with immense delight your little book on Italian Renaissance." Saying how much she had missed by not knowing it existed, she went on to refer to the great discussions and disagreements they had had when BB visited them. "What delighted me particularly," she wrote, "was to see that you are not or were not then, at all a relativist as you pretended to be in our conversations. You do believe in an unchangeble [*sic*] truth in art in this book . . . The book is itself life-enhancing."[68] Lisl may have been wrong in thinking Berenson was not a relativist, but her letter is valuable for reminding us of "the conversations" that these polemical expatriates enjoyed with each other. It also reminds us of the value of Berenson's *Italian Painters* as a guide for English-speaking tourists such as Edith Wharton, who recalled in 1934 how she began to feel "almost guilty for having read Pater and even Symonds with such zest" before Berenson's

---

64  James to Grace Ashburner, 5 January 1893, in James 1992–2004, 7:365.

65  James to Berenson, 15 June 1898, BMBP; see also Mary Berenson, journal, 1898, BMBP, 53–54.

66  William James to his wife Alice, Wawona, Calif., 15 August 1898, in James 1992–2004, 8:410; James to Frances Rollins Morse, Rome, 25 December 1900, in James 1992–2004, 9:392.

67  William James Jr. to Berenson, Tipperary, 27 May 1954, BMBP. James adds that he is staying with the daughter of Violet Ormond, John Sargent's youngest sister: "The house is full of interesting painting."

68  Brewster Hildebrand to Berenson, 16 November 1943, BMBP; she must be referring to the first (1930) edition of *The Italian Paintings*. On Lisl, see Starr Brewster's introduction to the catalog *Natura e bellezza* (Brewster Hildebrand 2007, 5–7), which has an uncorrected version of this letter on pp. 82–83.

"first volumes on Italian Painting" were published, through which "lovers of Italy learned that aesthetic sensibility may be combined with the sternest scientific accuracy."[69]

By then, the vogue for Berenson's "tactile values" had spread outside these Florentine circles. The initial reception was not entirely favorable. E. M. Forster had a dig at "the tactile values of Giotto" in *A Room with a View*, published in 1908, where Lucy's enthusiasm for them is portrayed as symptomatic of the English "Baedeker-bestarred" approach to Italy; and in 1930 Roger Hinks had another dig at both Berenson and Forster in a letter to a friend, in which he expressed his surprise and delight at finding *The Italian Painters of the Renaissance* lasting so well, despite initially seeing in it nothing but "'tactile values,' 'life-enhancing' and all those other bits of B.B. talk" that, he said, immediately brought *A Room with a View* to mind.[70] In Italy itself, older art historians like Pietro Toesca and Adolfo Venturi responded guardedly to the publication of the last of the four volumes of *Italian Painters* in 1907. It was the young Roberto Longhi and Lionello Venturi who first appreciated Berenson's "valori tattili," and they were followed, after the first impressionist exhibition in Florence in 1910, by avant-garde critics who adopted his structural comparisons between Degas, Cézanne, and Italian Renaissance artists as a useful model for interpreting French postimpressionism.[71] The English neo-Hegelian philosopher R. G. Collingwood praised Berenson for the same reasons, as we have seen. Referring to what he called "the Cézanne–Berenson" approach to painting as a tactile experience, Collingwood stated in 1938 that "every one who takes any interest in Renaissance painting nowadays is Mr. Berenson's pupil."[72] This was only intermittently true after the war. As well as regretting his failure to write his anticipated book on aesthetics, Berenson also felt a "pang" in 1946 that his name appeared in footnotes but not in bibliographies, and the following year, after hearing from his publishers that there was no sale for *The Italian Painters*, he commented that "in America as well as in England nobody wants to read me." Yet far from being "all but forgotten," both his name and his sales were revived after the new Phaidon edition came out in 1952, when I first read him.[73]

So, despite these fluctuations, Berenson's concept of tactile values lives on, not as part of a scientific or idealistic theory of art, perhaps, but as a vindication of the value of art within the new sense-based, pluralistic universe that William James and nearly all my hillside expatriates inhabited—Vernon Lee, Brewster, and not least, the Berensons themselves.

69  Wharton 1934, 141.

70  Forster 1978, 9 (introduction), 35, 43, 46, cf. 144 on the Arthur Schopenhauer and Nietzsche in Mr. Emerson's library. According to Oliver Stallybrass, Forster read Berenson's *Florentine Painters* in 1907, commenting: "Oh so badly written" (ibid., 237). I am indebted to Robert Cumming for alerting me to Forster's "tactile values of Giotto," and subsequently for sending me an extract from *Pictures and People* (Hinks and Royde-Smith 1930, 112–113).

71  See Iamurri 1997, 69–90, referring especially to Ardengo Soffici, Emilio Cecchi, and Berenson's friend Carlo Placci; I am indebted to Louis Waldman for extending my interest into this period through Iamurri's article. Berenson refers to Cézanne in "Central Painters," which came out in 1897 (Berenson 1952a, 122), reverting to him in 1938 (and in the previous year to "tactile values [the sense of form]"); see Morra 1965, 246 (December 1937), 268–269 (November 1938).

72  Collingwood 1938, 146.

73  Bernard Berenson, diary, April 1946, in Berenson 1962, 265; Berenson 1964, 10–11 (24 March 1947), cf. note 56 above; and Samuels 1987, 544.

SIX

# Bernard Berenson's Florence,
## 1900

BERND ROECK

ERNARD BERENSON'S FLORENCE: that is a long story. It is important to remember that it begins in the twilight of Old Europe and ends on the threshold of our own times, after the Second World War. In this article, I present what might be called the phantasm of Florence around 1900. Berenson himself will recede into the background while I illuminate the stage on which he performed his Florentine life—one built of words, images, and airy associations. I would like to relate how the "myth of Florence" emerged as a discourse, one that lives on. I will try to explain why travelers from the north around 1900 focused their desires, their *Sehnsucht*, upon Florence instead of Rome or Venice, while the latter became the magical city of desire in the twentieth century. Furthermore, I will place Florence and its myth in a wider context of discourse about the Renaissance—indeed, I will see it as producing that very discourse. Florence and the idea of the Renaissance are intimately entwined.

My second topic will be the birth of the avant-garde from the spirit of the art of the past, especially Renaissance art. I invite you to make the acquaintance of an art dealer and writer who is much less well known than Berenson, though they were contemporaries. Wilhelm Uhde spent time in Florence around the turn of the century, and provides an example of what made the Florentine fin de siècle so special: the encounter of the Old European tradition of art with the struggle to create the distinctive artistic language of modernism.

## Florence, London, Boston

The image of Florence changed several times in the course of the nineteenth century. Most importantly, a city of advanced modernism was transformed into the archetypal retreat of Old Europe, sought out by the modern tourist as the fabled Land of the Renaissance. From the historian's vantage point, I will try to say a few words about the "real" Florence in Berenson's day. It was a time of delayed modernization, accompanied by a rash of strikes and suicides. But I am not proposing that there is such a thing as a "real" Florence, standing massive and firm behind the images and texts, although something that looks like that is presented in the images and texts. Instead, I would like to argue that around 1900 there were *multiple* Florences, some of which can be at least partially reconstructed. All we have are fragments, and we assemble these to create a Florence that somehow seems always new. Berenson's I Tatti forms a part of that picture, a small Old World inside the mythic Old World—like one Russian doll inside another—that is Florence.

This is the story of a myth constructed from images, poems, novels, and nebulous emotions. It is a phantasm that never actually existed, or rather, only existed in part. Still, we are bound to give credence to fragments of something that might have existed, and transpose what allegedly survives in memory into our times. When we do this, a new Florence emerges: our Florence, seen in historical distance. Our imagination glimpses it as something gone and lost forever. Its "otherness" is produced by the very act of imagination, but it could never be grasped in its "entire reality" by contemporaries, not even by Berenson. His essentially aesthetic mode of perception was exceptional, though to judge from his writing about the experience of the contemplation of beauty, at times his perspective was distorted by his role as a merchant of beauty.

Like all history, our account of Berenson's Florence is a project in constant change, selected from tradition and from our own reflections and emotions. Among these range the usual sinister companions of all historical work. If the historian is not cold as ice or ultracalculating like a computer, he or she will experience some element of grief and longing for what has been lost and for what is not easily grasped, and also some fascination, even romantic enthusiasm, for Old Florence. These preoccupations shape the historian's experience of Florence, arising from memories and experiences and molding the imagination. One thinks of the sounds of the city and even of its smell: the chimney fires in autumn, the fumes of traffic, the pungency of archives—dust, paper, detergent—even the incomparable whiff of Florentine churches. Nineteenth-century writers from Anatole France to Hermann Hesse and Thomas Mann consciously played the olfactory card in their evocative images of Florence. Their books and letters are full of roses and blossoming jasmine, of peach trees and flourishing oranges. Thomas Mann remembers the flower maidens of the via Tornabuoni filling the air with the scent of daffodils and jonquils, and with apple and almond blossoms.[1] Rainer Maria Rilke enumerates fragrant yellow roses, small yellow flowers like roses from a wild heath, as well as violets and cypresses.[2] Paul Klee writes

---

1   Roeck 2009, 87.
2   Rilke 1994, 12.

in his diary: "heavy smell of wisteria and lilac here to be found in large amounts."[3] And one of the first accounts we have of an evening with Berenson at I Tatti includes a remark by Mary Costelloe about flowers in the dining room.[4]

The ideal images in our mind become symbols of a wider context. Take, for example, the moment in which Berenson kneels down in front of Sandro Botticelli's *Pallas and the Centaur*,[5] a scene probably set in the Palazzo Pitti. Few images provide clearer insights into the meaning of *Kunstreligion*. Berenson seems to suggest that Italian art is a vessel for the highest values, and that its innermost mysteries are explicated in his writings. Art, whether by Botticelli or Edgar Degas, might not simply "uplift or broaden life but instead communicate life, livingness itself."[6] This idea has its origins in traditional mimesis theory: "Painting can convey life more forcibly, more essentially, than the living thing itself." The "aesthetic moment" was essentially religious in character.

What we have here is a complex play of approaching, internalizing, and distancing of emotions, imaginations, and reflections. It is a fluctuating and unfinished discourse, open to additions, extensions, and revisions, even to neglect. Naturally, Florence as an object of historical investigation remains an emotionally charged place—this is what makes it difficult as a subject. It is not a city to submit easily to the cool razor of academic hermeneutics. The historian himself admits being taken by the city; indeed, he has to be, since otherwise he would not be the right person to speak of it. In our profession, we are all Florentines, and when we speak of Florence, we are speaking about ourselves. "Ogni pittore dipinge sé," says the Tuscan proverb, and "Ance io soi florentan" says the Friulan.

Already the city's name and coat of arms with the lily suggests verdant pastures: "Florence," "Firenze bella," "A Firenze il fiore, a Prato l'amore." The very name casts a spell and arouses myriad iridescent, shifting images. In Jacob Burckhardt's eyes, Florence became the city at the dawn of modernity, although this reading began to be disputed with the "revolution of the medievalists"[7] unleashed by Wallace Ferguson in 1948. More precisely, it is the center of humanism and Renaissance culture, the birthplace of the monumental tradition of Renaissance painting with central perspective and of architecture *all'antica*, the center of modern political theory and of the "Machiavellian moment." In Johan Huizinga's words, it is the city of "gold and purple."[8]

The myth of Florence as the birthplace of a blooming modernity is a nineteenth-century construction. Johann Wolfgang von Goethe, the most famous visitor to Italy in the eighteenth century, paid scant attention to the Athens on the Arno. There are only a few lines on it in his *Italian Journey*: "At ten o'clock our time, on the twenty-third, we emerged from the Apennines and saw Florence lying in a broad valley which was amazingly densely cultivated and scattered with villas and houses as far as the eye could see."

---

3   Klee 1968, 110.
4   Weaver 1997, 45.
5   Roeck 2009, 181.
6   Calo 1994, 63.
7   See Ferguson 1963, 11, and 1948.
8   Huizinga 1930, 89.

He passes the "pleasure garden of Bovoli [*sic*]," catches a glimpse of the duomo and the baptistery, which appeared to him "not as the apotheosis of human wit." That is all on Florence. He notices the fine condition of Tuscan roads and bridges as well as their beautiful and grand appearance: "Everything looks like a doll-house." The Italy he is seeking lies farther south. Florence appears to him mainly as a wealthy town, a symbol of the enlightened government of Archduke Pietro Leopoldo: "The city displays the wealth upon which it was built as well as a series of fortunate governments."[9] Goethe had already discovered Palladio in the Veneto, but strangely he takes no note of the great architecture of the Renaissance in Florence.

Goethe's view, in other words, was that of the public minister of Saxe-Weimar, the kind of man who felt obliged to praise the practice, used in the Romagna, of repairing streets with crushed bricks. Rome, by way of contrast, appears to him as a monumental historical myth, the "*Weltknoten*," or World Knot, as Ferdinand Gregorovius termed it.[10] To late eighteenth-century eyes, Florence, which was destined to become one of the last holdouts of Old European culture a century later, has a distinctly modern appeal. The travelers of Goethe's time find it a place of rationality and civility, rather like an Italian Leipzig or Berlin. This comparison would have fitted Turin much better, but Florence was far from the main touristic route between Venice and Rome and remained beneath the horizon of travelers.

## Florence: The First Essentially Modern Place

In a sense, Burckhardt's famous idea of Florence as the first essentially modern place and of the Florentines as protagonists of modern subjectivism finds its origin already in Goethe's *Italian Journey*. Hans Baron's concept of civic humanism may be regarded as its most distinguished successor.[11] Still, another four or five writers were of crucial importance in the genesis of this idea: William Roscoe, who championed Lorenzo the Magnificent; Simonde de Sismondi of Geneva; Jacob Burckhardt of Basel; John Ruskin; and finally Walter Pater, whose aestheticism proved so influential for Bernard Berenson. Sismondi praised the late medieval republican commune. The modern individual, who could thrive in the fertile atmosphere of political freedom and culture, "grew on this compost heap of human imperfection."[12] Roscoe and Sismondi provided the basis of Burckhardt's picture. They rendered Florence politically correct, so to speak, and placed it in the tradition of nineteenth-century liberalism that dominated England and Berenson's East Coast America. There, the wealthy elites imitated Lorenzo the Magnificent and Pope Leo X, collected works of art, and built palaces in the Florentine style. Furnishing this lifestyle with appropriate accessories earned Berenson and his colleagues a fortune. Berenson himself provides an excellent example of this attitude—in his eyes, his own age resembled the

---

9    Goethe 1970, 116–117.
10   Gregorovius 1991, 203.
11   Baron 1955.
12   White 1973, 247.

Renaissance. His contemporaries considered him "a curious remnant from a forgotten age."[13] Berenson himself declared that he belonged to an age that ended with the First World War: "My century, my own, is the nineteenth. I am and remain a mid- or at best a late Victorian—not Edwardian, let alone Georgian."[14] This view may help explain the relative—not absolute—distance at which he held modern art.

## Burckhardt: Metahistory

It was another "Alteuropäer" who spread this view of modern Florence as an ideology. Jacob Burckhardt invented the conception of the Renaissance Italian as the first modern man, "the firstborn among the sons of modern Europe."[15] What is not well known, however, is that his construction of the Renaissance and of Florence was designed in opposition to the Hegelian philosophy of history. Georg Wilhelm Friedrich Hegel exercised an influence on the whole of nineteenth-century historiography, especially its ideas of periodization, which can hardly be overestimated. As a kind of collective unconscious, it still has an impact on contemporary historiography, especially in the German-speaking world.

Toward the end of the fourth section of *The History of Philosophy*, Hegel equates the "restoration of sciences," the "flourishing of the fine arts" (note the floral metaphor once again), and the "discovery of America and the passage to India by the Cape" as the "blush of dawn."[16] The term "Renaissance" was still unknown to Hegel, but the concept was already there in embryo. For the first time, after much storm and thunder and the "long, eventful, and terrible night of the Middle Ages," a bright day was announced, "a day which is distinguished by science, art, and inventive impulse, that is, by the noblest and highest [elements], which humanity, rendered free by Christianity and emancipated through the instrumentality of the Church, exhibits as the eternal and veritable substance of its being."

This passage comes quite near to Burckhardt's account. Hegel already summarizes what will be the core of the Swiss historian's idea of "Renaissance": the discovery of the world and of man, the high standard of the arts, and the "emancipation" of the human spirit. Here we already have the keywords of Burckhardt's *Civilization of the Renaissance in Italy*. But in Hegel's argument the "dawn" is followed by the "day," marking a fundamental break. In Hegel's view, with the "day" the Reformation began a "third period of the German world, a period of Spirit conscious that it is free, and inasmuch that it wills the True, the Eternal—that which is in and for itself Universal."[17] This period signified the onset of the modern age. Most contemporary accounts still follow this pattern; "Renaissance and Reformation," or even simply the comprehensive category "Renaissance," remain a rare metanarrative, at least in German-speaking historiography.

---

13    Calo 1994, 6.
14    Ibid., citing Berenson 1963c, 102.
15    Burckhardt 1930, 95.
16    Hegel 2007.
17    Ibid., 412.

In his *Civilization of the Renaissance*, Burckhardt slightly changed the perspective by turning Hegel's dawn into the bright day. Burckhardt's modernity finds its origins neither in Wittenberg nor on board Christopher Columbus's *Santa Maria*. Instead, the discovery of the world and the triumph of subjectivism find their roots in Italy, especially in Florence. Burckhardt places the city at the center of a process of seminal historical importance:

> The most elevated political thought and the most varied forms of human development are found united in the history of Florence, which in this sense deserves the name of the first modern State in the world. . . . That wondrous Florentine spirit, at once keenly critical and artistically creative, was incessantly transforming the social and political condition of the State, and as incessantly describing and judging the change.[18]

It is here, and not in Martin Luther's Germany, that the modern world begins.

Burckhardt rejected Hegel's philosophy of history as the "bold assumption of a world-plan."[19] His own concept of history was nonteleological, refusing to accept any preconditional, dialectic relationship between the Middle Ages and modernity. His was, instead, an essentially if unconsciously aesthetic view of history. It was Florence's outer appearance, its surface in a very literal sense, that brought Burckhardt to a change of perspective. Moreover, his concept of Renaissance came under the influence of the seventh volume of Jules Michelet's 1855 *Histoire de France*.[20] Michelet coined the term in his 1840 lectures at the Collège de France and then popularized it as the signature of the period in his monumental work. Like Burckhardt, he applied the concept to all aspects of human existence (as pointed out by Francis Haskell).[21] Even Burckhardt's famous chapter title, "The Discovery of the World and of Man," is literally borrowed from Michelet. Like Burckhardt several years later, Michelet emphasized the arts as the crucial element of the concept of Renaissance. What characterized his Renaissance as a distinctive period were the arts that let man conquer the detested Middle Ages and its despised Gothic culture. Far from just copying Michelet, Burckhardt modified Michelet's concept of Renaissance in certain crucial aspects. Michelet's Renaissance is largely a sixteenth-century affair, while Burckhardt focused on the Quattrocento and placed Italy at the center of his reflections.

Finally, Burckhardt not only excelled as an innovative historian and art historian but also proved an extraordinarily gifted writer who knew the value of metaphor. Indeed,

---

18  Burckhardt 1930, 53.

19  "This bold assumption of a world plan leads to fallacies because it starts out from false premises": Burckhardt 1943, 81. And see ibid., 80: "The philosophy of history is a centaur, a contradiction in terms." Original German version in Burckhardt 2000, 355: "Dieses kecke Antizipieren eines Weltplanes führt zu Irrtümern, weil es von irrigen Prämissen ausgeht"; nota bene that the English translation is not literally correct. Cf. White 1973, 236–237.

20  Cf. Buck 1990; see also Rehm 1929, reprinted in Rehm and Habel 1969, 34–77.

21  Haskell 1993, 273–277.

it was to Burckhardt that Hayden White turned for a suitable subject for his project of metahistory.[22] In White's idiosyncratic system, Michelet appears as a writer of comedy in a romantic mode, whereas Burckhardt is seen as a satirist. In Burckhardt's words, the "common veil" made of "faith, illusion and childish prepossession" that enwrapped the "dreaming or half-awake" medieval man was first lifted in Italy, especially in Florence.[23] His essay, as he calls it, took him out into the "wide sea."[24] His metaphors and allegories were accompanied by lively depictions that no reader will forget; as White argues, in *Civilization of the Renaissance*'s narrative, as generally in historiography, the boundaries between reconstruction and fictional construction are systematically blurred.

Strangely enough, the arts as such are not accorded a place in Burckhardt's seminal work. Therefore, the historical concept underlying his *Civilization of the Renaissance* can be understood in its entirety only when read together with his *Architecture of the Renaissance in Italy* and his *Cicerone*. The reason for this omission might be Burckhardt's conviction that art does not just refer to the divine but is itself the object of religious devotion. In his view, as in Arthur Schopenhauer's, the holy and "gifts of heaven" elude reason, and so does art. Speaking of great works of art, the agnostic Burckhardt can adopt a solemn, almost religious style, as when he affirms that such works resemble the "divine" and the "eternal."[25]

The historiographical model that Burckhardt applied to his narrative had much in common with Giorgio Vasari, in particular with the Aretine writer's notion of a continuous evolution of the arts culminating in Michelangelo.[26] For both, this evolution took place in Rome and Florence. Burckhardt praised the Florentine school for being "the birthplace of a liberating genius."[27] The city on the Arno thus became for him a "sanctuary of art," and its works became evidence for the universal change he located in the Renaissance.

## Florence as Counterimage: Aspects of an Allegory

To his German-speaking readers, Burckhardt's *Civilization of the Renaissance* and his *Cic* (as he called *Cicerone*) were the workshop in which he constructed both an imaginary Florence and a Florence-centric "Renaissance-ism." Both works were reprinted again and again up to 1900.[28] Burckhardt reached such a degree of fame that the Florentine city council approached him for advice on the competition for a new facade for the duomo, which he politely declined to offer.[29] The immense influence of his works reveals itself

---

22  Cf. White 1973.
23  Burckhardt 1930, 95.
24  Ibid., 1.
25  Cf. Burckhardt 1978, 812.
26  Cf. Belting 1978.
27  Burckhardt 1978, 812.
28  Cf. Buck 1990, 5.
29  Burckhardt 1961, 237.

in the user directories of the Gabinetto Vieusseux, which offer documentation (unfortunately underused) on what was read in nineteenth-century Florence.

Thus, the Old Florence that Burckhardt celebrated so eloquently was transformed into a metaphor not for the dawn of modernity, but for a past shimmering in crystalline forms and shining colors. Its beauty offered an escape from the constantly shifting present. John Ruskin evoked a similar Florentine utopia, only with a slightly different accent.

Florence became a refuge to the European and North American educated middle classes, a place of dreams of perfection in this lifetime. Evidence can be found in abundance in the letters, diaries, travelogues, novels, and stories by Isolde Kurz, Thomas and Heinrich Mann, Hermann Hesse, Henry James, E. M. Forster, and many more. For example, listen to Isolde Kurz: "Those who freshly arrive in Florence from the outside and still feel modern life in their bones, feel like a ball being thrown into a woollen sack."[30]

## Florence as the European Other

More bizarre figures, like Charles Godfrey Leland, who smelled the odor of witches in Florence, may hint at Florence as a metaphor of the European collective unconscious of the late nineteenth century. Although visitors in a romantic or esoteric mood would seem to confirm this line of approach, Sigmund Freud himself was not one of them. When he came to Florence in September 1896, he stayed in a rather glamorous place, the villa "il Gioello" that had once been the residence of Galileo Galilei.[31] An avid tourist, Freud nonetheless resisted the city's metaphorical allure. He refers to the "illusion of southern beauty,"[32] or was it just the heavy scent of flowers that made him dizzy? The city on the Arno is put into a familiar perspective: "While I write this, the view upon Florence reveals a sea of gleaming lights, just like those one sees from the Belvedere. Only it's Florence and not Vienna."[33] It was during this visit that Freud's notorious and somewhat odd engagement with the work and personality of Leonardo da Vinci began.[34]

And then there are the lights. Imbricated with every image of Florence, they have their own history, just like the heavy, romantic, even decadent Florentine scent. Listen to Isolde Kurz's glorification of a Florentine sunset: "The sun set over the Arno, the sky was open with flaming glory. Towers, domes and palaces, all in a glowing forge.... We settled in the hall with a garden view."[35] Or take Henry James: "The domes and towers were washed over with a faint blue mist. The scattered columns of smoke, interfused with sinking sunlight, hung over them like streamers and pennons of silver gauze; and the Arno, twisting and curling and glittering here and there, was a serpent cross-striped with silver."[36] Moonlit nights, evenings in June under the brilliant stars, filled with the

30 Roeck 2009, 47.
31 Cf. Schlesier 2004.
32 Roeck 2009, 84.
33 Ibid.
34 Cf. Herding 1998.
35 Roeck 2009, 240.
36 James 1987, 395–396.

heavy scents of thousands of flowers, fireflies dancing through the night—this was a place in which to dream for Aby Warburg, Isolde Kurz, and many others.

What we have is not so much Florence as the fin de siècle image of Florence as the European Other, a city that categorically rejects the present. South, not north; sun and summer, not rain and snow; colors, not drab gray; always spring, never winter. Rilke writes in his Florentine diary: "From our winter-shaped terrain / I've been cast far out, into spring."[37] Silence reigns, a hush so different from the noise of modern capitals, and there is purity and clarity of outline, not the muddle and mix-up of the industrial age. Rilke again: "Here's life's quiet place of sacrifice / Here day is still deep."[38]

The literary salons and artistic circles deserve attention, although in 1900 they were already in decline. The sculptor Adolf von Hildebrand held court in San Francesco; Isolde Kurz and Aby Warburg give accounts of his glamorous receptions, where young ladies floated through the gardens like fairies, attended by dignified servants in uniforms. The place can still be visited, and the benches with their fabled views are still there. Hildebrand remained the central figure of the German circle that was in close contact with the Bostonian, Bernard Berenson. (Connections to others were brokered by the eternal "friend of friends," Carlo Placci.)[39] Hildebrand, moreover, exercised some influence on Berenson's development as a theorist of art with his essay of 1893, *Das problem der Form in der Bildenden Kunst.*

By 1900, the salon of Hildebrand and Ludmilla Assing had ceased to exist. At I Tatti, Berenson presided over his own circle of artists, collectors, and art historians. Aby Warburg disliked Berenson, whom he called a "nerd and a snob" with "cold blue eyes."[40] About the circle around Charles Loeser, a friend of Herbert Horne, very little is known, except that he hosted concerts in his villa and collected the works of Paul Cézanne. One wonders if Berenson encountered Cézanne's art in this context as well as in Paris; regardless, when he visited Ambroise Vollard, he did not seem too convinced of "Sezanne's" importance (as he spelled it in a letter to Mary Costelloe). Claude Monet he appreciated much more.[41] When Berenson elaborated his view in his 1897 *Central Italian Painters*, Cézanne's art was relatively well known among Renaissance enthusiasts:

> In spite of the exquisite modeling of Cézanne, who gives the sky its tactile values as perfectly as Michelangelo has given to the human figure, in spite of all Monet's communication of the very pulse beat of the sun's warmth over fields and trees, we are still waiting for a real landscape. And this will come only when some artist, modeling skies like Cézanne's, able to communicate light and heat as Monet does, will have a feeling for space rivaling Perugino's or even Raphael's.[42]

37  Rilke 1994, 9.
38  Ibid.
39  Calo 1994, 56; on Placci, see Cambieri Tosi 1984.
40  Roeck 2009, 160.
41  Calo 1994, 76–81.
42  Berenson 1897, 122; cf. Calo 1994, 76.

These thoughts have been widely disputed in recent research, but Berenson remains the first American to comment upon the great Cézanne in print. He might have even drawn attention to Cézanne on the part of Roger Fry, the discoverer of Piero della Francesca.

Literally and metaphorically, the view of the "other Florence" comes from a distance, even a social distance. The travelers' "alternate reality" was situated on islands within the more plebeian Florence, where Chianti was drunk and simple fare like pigs' ears eaten (to Warburg's disgust)—the Florence of bouillon and steaks and the Gran Caffè Doney. It was in cloistered enclaves like I Tatti on the hills of Fiesole, or in Piazzale Michelangelo overlooking the Arno, that romantic fantasies were nourished and Florence dreamed into a city of art.

It was Berenson's truculent neighbor, Violet Paget, who set out to investigate the emotions stimulated by an encounter with artistic beauty. Looking at the painted surface allowed a vision through it to imaginary worlds that were not necessarily germane to the reality of Florence or even of the Renaissance. The "philistinism of interpretation" that Susan Sontag engages so vehemently [43] (Berenson's friend Hermann Obrist can be regarded as an early ally) [44] in fact served as a kind of precondition for the Florentine myth, which grew out of the ideas of Burckhardt and Pater as well as out of the interpretations of Berenson. Visitors searched for relics of the medieval and Renaissance town, but what they found in the art and buildings was what these poetic interpreters read into them. In a sense, these works were the creations of the wordsmiths who wrote about them and the *ciceroni* who showed them around the museums, churches, and monuments. For example, can we think of Botticelli's works in the Uffizi in any way that was not put into words by these writers? What foreigners saw was not only the works of Botticelli but rather objects crafted in cooperation with Vasari, Pater, Horne, and possibly even Aby Warburg. This is still the case today.

Renaissance art necessarily remains a thing of the past to us. We cannot grasp its own pure aesthetics, even if we were to admit that something like this exists. We appreciate Botticelli's paintings and Filippo Brunelleschi's cupola as objects made five hundred years ago, but we do not actually admire their own aesthetic structure. It is the subtexts and contexts—what Jacques Derrida called "passepartouts" [45]—that turn objects into the art we admire and reflect upon. On the one hand, painting affirms the artist's absence, while on the other, it reveals its own absolute presence at the moment of viewing. Nevertheless, any written text, any sculpture or building of stone, reveals its historicity in its very materiality, where we see the traces of the artist's hand. Thus art historians, and sometimes even historians, become the artist's collaborators. They reunite the artists with their work and transform them into "Old Masters." Whether the museum label reads "Botticelli" or not is of crucial importance for the work's reception. There is no absolute aesthetic, only a relative one, grounded in history. Even the woodworm in the Leonardo panel—what an exquisite manner of dining!—serves as proof of age and authenticity. This is equally true

43  Sontag 1994, 1–14.
44  Calo 1994, 48–49.
45  Derrida 1987, 12–13.

for Renaissance buildings as for Florence as a whole, continuing up to the present. What we admire is the palimpsest of layers that makes up the city's history. Our modern astonishment remains founded upon a way of "reading" introduced by Burckhardt, Ruskin, and many others, all writers of verve and intellectual sophistication—and the Florence of Giovanni Villani, Francesco Guicciardini, and Niccolò Machiavelli, even the Florence remembered in the multitude of *ricordanze*, proved a perfect setting for this enterprise.

## The "Real" Florence

The letters, diaries, essays, novels, and poems of *forestieri* (foreigners) essentially shape our image of Florence, constructing the Florence that appears before our eyes when we pronounce the city's name. It is no surprise that a darker social reality disturbed the charming picture of an old and beautiful Florence. When Rilke witnessed the Florentine mob throwing stones at the Loggia dei Lanzi during the May Troubles in 1898, he was stunned into consternation.[46] Most diaries of the time simply ignored the event. In fact, all during this period Florence was undergoing a process of modernization and experienced its own version of Haussmannization, including rampant real estate speculation and widespread demolition of ancient buildings. That this process stopped short of the old center and the Oltrarno is due to the protest of the *forestieri* as well as the action of some natives, like Prince Orsini.[47]

Nevertheless, the sanitary conditions of the quarters that were being demolished to make way for the streets, squares, and neo-Renaissance *palazzi* were indeed poor. Florence could share with Paris the observation of Charles Baudelaire that its walls changed more quickly than the hearts of its people. Around 1900, the city slowly and hesitantly grew out of its ancient walls. Meanwhile, the municipal authorities were increasingly successful in cleaning up the urban space. The decline in the mortality rate, especially infant mortality, was a direct consequence of the newly installed sanitation.

Around 1900, the Florentine *comune* counted nearly 200,000 inhabitants (compared to 114,000 during its brief period as the national capital).[48] In spite of sustained population growth, it remained a city of small trades and light industry. Only a few enterprises attained national importance, such as the Richard Ginori bone china factory in Doccia, which employed 1,400 workers. The backwardness of the city's industrial base is revealed by the fact that a tobacco factory employing 2,000 workers stood next to the craft of braiding straw as Florence's joint most important employer. A small middle class, consisting of civil servants, university professors, teachers, lawyers, and some entrepreneurs, was confronted on the one hand by a wealthy landed aristocracy, and on the other by a mass of workers, petty tradesmen, servants, day laborers, and washerwomen. Finally, the clergy still occupied an important and visible position in the social fabric.

46  Rilke 1994, 39.
47  See Fei 1977; and Roeck 2009, 123–124.
48  Roeck 1999.

Modernity became noticeable on the margins. Village farmers still used mules to carry goods to the urban markets, while horses remained the preferred means of transport generally—horsepower drove the *tranvai* (streetcars) that passed the duomo and baptistery at an almost disrespectfully close distance. But Florentines had already discovered the bicycle as means of transport as well as a symbol of status, and even the mayor was proud to ride one. Likewise, Florentines attended the early cinema of the brothers Lumière and were astonished by it. The level of industrialization was not high, but the city was linked to national and international networks of communication. The introduction of gaslight allowed the conquest of the Florentine night. Lengthy debates in the city council argued the case for a reorganization of public transport as well as for the abolition of the *dazio*, the customs duty collected at the periphery. The Florentine family, however, did not begin to conform to the typical nuclear family of western Europe until the 1950s. [49]

Florence thus witnessed a delayed modernization, and that delay lent credibility to those who tried to find in Florence one of the last islands of Old Europe. Under the surface, however, change was rampant. Improved sanitary measures reduced the mortality rate, abetted population growth, and thus caused shortages in the food supply; all of this put pressure on the job market. Industries that could absorb the growing number of unemployed were still lacking. A city underpinned by traditional structures was particularly susceptible to crisis. This is the background to the May Troubles of 1898, which resembled more an old-style food riot than a modern revolutionary movement. [50] The rioters' objectives were limited; no one demanded a completely different society.

Here we have a structural reason for Florence's difference from the general pattern of Catholic cities. An extraordinarily high suicide rate can be established from the official statistics as well as from coverage in *La Nazione*. Émile Durkheim observed that the dramatic increase in suicide in western and northern Europe during the nineteenth century was a sinister side effect of the profound change in living conditions in the age of industrialization. Durkheim's figures (a 411 percent increase in Protestant Prussia from 1826 to 1890, a 318 percent increase in Catholic France in the same period) fit the diagnosis of a "secolo nervoso," an age of hysteria and neurasthenia. [51]

The contrast between the Florence of the *forestieri* and a harsher reality can be grasped in vignettes in *La Nazione*, in the *Fieramosca*, or in *Il Marzocco*, and they also appear in what might be called the urban soundscape. Daytime noise was caused by human activity, as the city council tried to keep noisy trades on the periphery. There were no machines to be heard in the city; automobiles were almost fantasy objects. But the Florentines seemed to like what Freud called "infernal noise, screaming, cracking their whips, playing the trombone in the street—you can't stand it!" [52] The thundering *tranvai* were the ancestors of today's omnipresent Vespas and motor scooters, and cannon shot fired from the

49  Roeck 2009, 48, 260 n. 11.
50  See Colajanni 1898 and Colapietra 1959.
51  See the main thesis of Radkau 1998.
52  Roeck 2009, 83.

Belvedere could be heard every noon. The transition to modernity from the bourgeois period, which began in some sense in the time of Dante, proceeded slowly.

On the other hand, the Florentine night was quiet for an early modern night. Paul Klee adored the nightingale's song under a pale April moon, and Lilian Whiting noticed the sound of invisible steps on the street pavement by night. In synesthetic mode, Rilke loved the starlit stillness and the mild light covering everything with "soft tenderness."[53]

## Florence and the Avant-Garde

The impact of Florentine art on the birth of the European avant-garde—inhibiting but at times also stimulating—remains an underresearched but instructive aspect of Florentine culture around 1900. Florence can be regarded as an ambivalent laboratory or studio of artistic modernity. First, the sheer mass of outstanding examples of older architecture, painting, and sculpture was simply overwhelming. Florence, of course, was and still is one of the few magical places of reference in world art. It inspired writers of all kinds to create historic novels, poems, stories, and even epics in verse. Rilke writes in his Florentine diary:

the new land lays itself lustrously
into my wavering hands.
And I take the beautiful gift,
Want to mold it quietly,
Unfold all its colors
And hold it, full of shyness
Up toward YOU.[54]

Rilke addresses Lou Andreas-Salomé, symbol of the eternal female as well as the young, diffident poet's arch-temptation.[55] His perspective is unconsciously deeply historical. He turns back to the giants of the past who represent the existence of the artist to which the twenty-three-year-old was still aspiring. He chooses art as his own path to eternity, accepting metaphysical homelessness and solitude. He explains to Andreas-Salomé, "This is how I feel!"[56]—like the heir of a deity reaching forward through millennia until the birth of God.

The historical model could prove challenging, not to say overpowering. Henry James, alluding in his story "The Madonna of the Future" to Balzac's *Chef d'oeuvre inconnu*, yielded to the double temptation to confront the giants of the Renaissance on equal terms and seek absolute beauty, like the aestheticists in *Il Marzocco*. James's story begins in the moonlit Loggia dei Lanzi, where the narrator meets the protagonist, a young painter.

53    Rilke 1994, 13.
54    Ibid., 9.
55    Ibid., 113.
56    Ibid., 113–114.

They become friends and praise the giants of the Renaissance while exploring the city's churches and museums. Both complain about the present, judging it to be busy, hectic, gray, and dire. The painter rhapsodizes about a painting of perfect, unseen beauty beyond all comprehension. Finally, in the artist's dingy studio the narrator sees a veiled easel, and unveils it. It holds an empty canvas.[57]

James's story appears to symbolize the vain quest for a Platonic ideal, a perfection that cannot even be imagined, let alone materialized. It is about *Sehnsucht* and hopelessness and the Rilkean idea of the "possibility of a new life." The debates in *Il Marzocco* focused on the same set of ideas. Already the Pre-Raphaelites and the arts and crafts movement had tried to stand on the shoulders of giants but still work toward new artistic forms. We appreciate their attempts today perhaps more than is their due. Herbert Horne,[58] next to Arnold Dolmetsch[59] one of the arts and crafts movement's most interesting practitioners, was deeply convinced of the absolute validity of Quattrocento aesthetics. The aesthetic forms they developed had roots in the Quattrocento but went beyond them in their untimeliness. Significantly enough, Horne was also an art historian.

Berenson, Horne, and others did not really want to escape from the shadows of the Renaissance. They lived in the past. Unlike Berenson, who presided over Florence like a prince, Horne approached ancestral spirits shyly. He never actually lived in the grand salone of Palazzo Horne, but rather ensconced himself in the attic. Both had read Ruskin, but both escaped romanticism through the scientific examination of Renaissance art, which they appropriated, literally. Horne's *Botticelli* was not only a product of the arts and crafts movement but a milestone in Botticelli research. Like Berenson, he was criticized for his "clinical" examination of Renaissance art by enthusiasts and adherents of naive perception such as Hermann Obrist. For them, he had objectionably objectified his feelings.

Many young artists confronted the past with self-confidence. Rilke can be taken as an example, but this was even more the case with the futurists—indeed, they went too far in some respects. Other artists encountered the past in Florence, but also set out from it on the path to modernity. The superabundance of art posed a problem, especially art born of the historicism of the nineteenth century, when every style was revived in experimental form. The century produced architecture in the Gothic, baroque, Romanesque, rococo, and Renaissance styles. Apartments were equipped with historicist furniture, meals were taken from historicist dishes, and walls were decorated with paintings which could reproduce any historical style. Japanese woodcuts were all the rage. Berenson bought a bronze Buddha of the Northern Wei dynasty as well as other objects of Asian art from Paris dealers, and he put Lorenzo Lotto's appreciation of interior decor on a level with that of the Japanese.

Artists like Karl Theodor von Piloty and Jean Louis Ernest Meissonier mastered to perfection the artistic techniques developed over centuries. One only has to examine the portraits of another adoptive Florentine, the American John Singer Sargent, whose work

---

57  James 1999.
58  See Fletcher 1990; Preyer 2000; and Roeck 2009, 128–130.
59  Campbell 1975.

used to be compared to Anthony van Dyck, to realize that some sort of culmination had been reached.[60] No wonder that a connoisseur like Berenson struggled to develop a theory to explain his astonishment at beauty, whatever that might be.

I believe that the examination of these conundrums, more than a study of economic and social change, reveals the reason for the advent of the avant-garde. Beyond the art of a Sargent, and certainly beyond that of a Burne-Jones, Millais, or Rossetti, the route to abstraction lay open. Paul Cézanne's *Bathing Woman*, Pablo Picasso's *Demoiselles d'Avignon*, Constantin Brancusi's *Egg*, and Kazimir Malevich's *Black Square* are more statements about the end of the art of Old Europe than they are reflections of a society racked by change. With recourse to classical form, considering that the square and the oval are deeply classical and not naive, a way out of the dilemma had been found. Not surprisingly, Berenson's interlocutor Hermann Obrist fulminated against all sophisticated interpretation while also counting himself among the protagonists of abstraction and the admirers of Vassily Kandinsky in Munich.[61] Berenson himself appreciated Botticelli for the same "self-sufficiency he had previously compared to that of Degas and the Japanese wood-carver Hokusai."[62] He did not, however, establish any relationship with Picasso or cubism—indeed, it has been said that he held cubism in contempt as an intellectual, logical art that left no room for the emotions.

The dialectic between old and new took place in an art world that prized the original and the modern. Berenson might have grasped this pattern and gained insight into the art of his own times when he tried to emphasize the element of the new and the singular in Lorenzo Lotto or Piero della Francesca.

## A Colleague: Wilhelm Uhde

As we have seen, the turn of the century brought with it a desperate quest for new paths in art. Artistic exploration led in many directions at once. In Florence, Hans von Marées, the most distinguished representative of modernity, shared a workshop with Adolf von Hildebrand for a time.[63] Auguste Rodin came to Florence in 1875, and later to Rome to study Michelangelo's *non finito*. Pierre Puvis de Chavannes and Maurice Denis spent time in Florence. And of course, Florentine art also influenced artists who did not have the opportunity to confront it *sur place*. In the last part of my paper, I would like to look in detail at the remarkable case of the art dealer and writer Wilhelm Uhde.[64] He and Berenson never met, but they make interesting parallels. Uhde was an enthusiastic panegyrist of "great" modernism and an important dealer. His case shows that Florence could open up fundamentally different worlds to different personalities. He was a pivotal figure

---

60  Kilmurray and Ormond 1998, 170, no. 67.
61  See Calo 1994, 49, 106.
62  Ibid., 64.
63  Cf. Sattler 1962.
64  Roeck 2007.

of the avant-garde, on a level with Daniel-Henry Kahnweiler in Paris and with Leo and Gertrude Stein.[65] A tastemaker of modern art, Uhde provides insights into the key issue of the period: the ascendancy of the new. He lets the historian palpably touch this fundamental problem.

Until the turn of the century, Uhde displayed conventional tastes. He admired the Florentine Trecento, idolized and wrote about Botticelli, and stood in amazement before the sculptures of Michelangelo. There was, at this point, no sign of his later admiration for avant-garde art, and his background offers no clue as to why he would become a major proponent of modernism.

Uhde was born on 28 October 1874 in Friedeberg in West Prussia. His was a family of jurists, and this docile son of a district attorney studied law in Berlin, returning to his province as an apprentice lawyer. Overcome by boredom and ennui, Uhde traveled to Florence in 1899–1900, where he was welcomed by the German colony around Richard Wagner's son-in-law, Henry Thode, and by Heinrich Brockhaus, the director of the Kunsthistorisches Institut. An encounter with Warburg had an unhappy outcome, however, as Warburg never forgave Uhde for ridiculing him as the minor *érudit* Wahrmund in his drama *Savonarola*.[66] This obscure little piece already shows a romantic dislike of the academic approach to art, an antipathy that grew more pronounced in Uhde's short essay on Botticelli, where he took issue with Warburg's iconological approach. As Uhde recalled later, he did not yet experience paintings sensually but rather studied them intellectually. Later he came to this conclusion: "You cannot capture the big game of great quality with the mousetraps of knowledge and reflection."[67] In a dark corner of the library of the Kunsthistorisches Institut, he discovered Burckhardt's *Civilization of the Renaissance* and *History of Greek Culture*, which made a profound impression on him in spite of the disapproval of it by the institute's professional art historians.

Uhde was numbered among the "supermen on Easter holiday" (*Übermenschen in den Osterferien*) whom Warburg scathingly mocked.[68] His Florence is drawn sometimes from Burckhardt, sometimes from Ruskin:

> When I stood in front of the serene facades of colorful marble of ancient churches and monasteries, and saw in cloisters angels and Madonnas that exuded the artists' vitality, I felt the fresh winds of an age when happiness was the main characteristic. . . . What I felt and saw elevated me above daily grief. I felt my powers rise, felt recovered and alive, eager for activity and expansion.[69]

In short, here we have the typical traveler from the north once again.

65  Cf. Fitzgerald 1995; and Gee 1981.
66  Roeck 2001.
67  Uhde 1938, 85.
68  Gombrich 1970, 98.
69  Uhde 1938, 77.

In the museums, Uhde echoed Burckhardt when he saw paintings "lit by the dawn of humanity that were, like the landscape, tender and solemn at the same time."[70] From his Florentine vantage point, he issued scathing criticisms of what he perceived as cultural decay in his native country.[71] Although he was never really attracted to academic art history, he decided to study it on his return to Germany. Munich was his first choice, then Rome, then Florence once again. Finally he wound up at the University of Breslau, studying with Richard Muther. This was no coincidence: Muther was a promoter of modernity, though his imprecise, essayistic style shows an emotional and sentimental approach toward the arts.[72]

By traveling to Florence, Uhde escaped what he called the "triviality of everyday life" as well as a profession he abhorred. He left a provincial town marked by "racial hatred, political suppression, noses kept to the grindstone, the arrogance of officials along with ignorance and contempt for everything intellectual." His homosexuality, as important as this was in the makeup of his personality, would remain concealed, as was the custom.

In 1904, Uhde was offered the opportunity to leave behind his small town in West Prussia and travel to Paris, supported in part by his father. In the words of his friend, Jean Cocteau, his Paris was "the heart of the wheel, the center of the center, a place where speed falls asleep on the spot."[73] Enthusiastically and poetically, he described what he saw in the museums: "Tintoretto's alert men," "Veronese's pompous people," and Rembrandt's late self-portrait. All this shows that he knew his Burckhardt well—but what impressed him most was Edouard Manet's *Olympia* in the Musée du Louvre.[74]

Uhde participated in the life of the Parisian *bohème*,[75] learned to know the dealers Durand-Ruel, Bernheim, and Vollard, and encountered the work of Cézanne for the first time. He met Käthe Kollwitz, who would later stay at the Florentine art colony, the Villa Romana in the via Senese, founded by Max Klinger.[76] He remained in close touch with Leo and Gertrude Stein. Kahnweiler, who opened his gallery in 1907, remained a lifelong friend. To comply with convention, Uhde married Sonja Terk, a young Russian, but they broke up after a year when she fell in love with the painter Robert Delaunay.

Through his acquaintance with Picasso and Henri Rousseau, Uhde became a "merchant of beauty."[77] By 1914, he was already one of the most successful art dealers in Paris. Uhde organized important exhibitions in Germany and Switzerland, showing Odilon Redon in Berlin, Picasso and Rousseau in Berlin and Cologne. Georges Braque was his next big discovery—Uhde was the first to buy and sell his works. Later, in a book about Picasso, Uhde gave a firsthand account of the emergence of cubism,[78] allowing

70  Ibid., 79.
71  Uhde 1899.
72  Cf. Kultermann 1981, 239.
73  Ibid., 115.
74  Uhde 1904.
75  Gautherie-Kampka 1995.
76  Windholz 2005, 33.
77  Gelhaar 1993, 37–45.
78  Cf. Rubin 1989, 45–46.

him to enter the annals of art history. The most important document of his friendship with Picasso was the portrait, now in St. Louis, which the cubist painter made of Uhde at the same time as Kahnweiler's portrait, allegedly in exchange for a small Barbizon school painting.

Uhde cultivated an enthusiastic, supportive, and occasionally critical relationship with artists like Picasso, Braque, and Rousseau. It is said that the Douanier, while working on his *Snake Charmer*, asked for Uhde's advice on composition and color, thus affording Uhde a cameo role in the genesis of the painting. Around 1910, Uhde personally owned a remarkable collection of works by Picasso, Braque, Rousseau, Raoul Dufy, André Derain, Maurice de Vlaminck, and—another discovery—Marie Laurencin. But as Kahnweiler commented: "Il a joué un rôle très important dans l'évolution de l'art modern. Or, il n'a pas la place qu'il mérite."[79]

Looking back over his career, Uhde remembered the difficulties of finding the key artists in the confusing art world:

On the open path of modern art, very carefully I approached those who were destined to form the style of a new age. There were no official guidelines; nothing was there to lead the way but one's own proper instinct. No wonder, that I got lost on side roads, went astray a time, or stopped at stations that were not worth the effort. However, there came the day when everything that did not live up to the highest standards and did not comply with the new ethos was outcast with an almost puritan rigor.[80]

To Uhde, the reasons for the "aesthetic confusion" of his times lay in a general social and intellectual crisis. His times lacked "idea" and direction. Life had become shallow and arbitrary, but "comfortable and more interesting in terms of tempo"[81] at the same time. With scathing sarcasm he declared: "Wireless telegraph and airship had been invented—everything was in perfect order."[82]

A *Kulturkritik* of this stamp was hardly unique, however. Aby Warburg, for example, held similar views. In his autobiography, Uhde presents himself as the archetypical Old European intellectual whose ideals have vanished and whose religion has evaporated. Even as a child he is said to have knelt before the domestic stove and exclaimed, to his mother's horror: "Idol, I worship thee!"[83] The Good God of old was gone and His place was taken by art. Uhde was convinced that man needed an object of worship: "As Ruskin says somewhere: No matter what you worship: Diana, fire or roots—you have to be human enough to know what it means to worship and to venerate."[84]

79  Brassaï 1964, 326.
80  Uhde 1938, 144.
81  Ibid., 69.
82  Ibid., 109.
83  Ibid., 18.
84  Ibid., 47.

The question of what to worship in art remained open around 1900. Uhde, like others, attributed the confusing range of choice to the chaotic social and political conditions of the "nervous age." Old Masters, historicist society painters, impressionists, symbolists, and the real pioneers of modernism, like Marées and Cézanne, were all on offer simultaneously. In the circle around Uhde, only Manet reigned undisputed. The impressionists had their day, while Cézanne, Gauguin, Picasso, and others championed by Uhde had yet to appear on the scene. To advocate the young required "the courage to stand up against a world of collectors, dealers, critics, and say aloud: This is great art! With older art, the labels are written, opinions are made, and almost everyone agrees with them." To trace the things that counted in this increasingly fissured and confusing art world was no small matter. Uhde would succeed in doing so more than many of his contemporaries.

## The Two Florences

The Uhde revealed in his autobiography had a penchant for the occult and was a hopeless romantic with a deeply emotional approach to art. He distinguished between the analytic "prattle of the exegetes," so upsetting to Susan Sontag, and an emotional-sensual approach to beauty that shirked rational reflection to arrive at mystic contemplation. At almost every meeting with Picasso, he stood with the artist in silence before paintings. Similarly, Berenson's friend Obrist wrote in a letter to Berenson's wife Mary: "We don't want critics so much to tell people what they are to like as to tell them little and to say out always simply what they feel really."[85] (In his text, "think" is crossed out and replaced by "feel.")

For all that, Uhde never despised "passatism," the nostalgic love of older art. He thought that the study of older paintings prepared one for newer art. He clearly admired the German romanticists, such as Philipp Otto Runge, Caspar David Friedrich, and Karl Blechen. The art he saw in Florence also made a profound impression on him; there, he became sensitive to "primitive and intimate painting," and a "great quality of feeling" dawned on him and prepared him "publicly to speak up for an art based on the same assumptions."[86]

Like Ruskin, Uhde assumed that the "primitive" painters of the fourteenth century were expressing pure, monastic emotions. To approach this art, the viewer had to overcome the scientific mentality and strive for an "innocence of the eye": "How much imagination needs to be killed before the human is coming to life."[87] History and reflection would have encumbered the experience. Medieval and Renaissance works somehow remained allegories for Uhde, accessible only indirectly and not fathomable by the senses:

What linked me to the great intensity of the works of Giotto and Cimabue was not yet the instinct which later on taught me to admire the higher reality of Picasso, and what led me to Fra Angelico was not yet the feeling of highest humanity which later made me turn to the paintings of Henri Rousseau. Every beggar in

85  Calo 1994, 48.
86  Uhde 1938, 92.
87  Ibid., 79.

Florence had a more innocuous and more natural approach to the works of art than me.[88]

Uhde's Florence was an imaginary construct, an ideal refuge. In a thousand ways, it was the counterimage of his native Poznan, and the brilliant lives led in it the glittering foil to the career of a Prussian clerk. For him, Florence was Burckhardt's Florence;[89] even more so, it was the Florence of Pater and Ruskin. His Florence was "twofold." In his inner eye, he saw the simple, naive Florence of the Middle Ages, with church bells ringing through sunny summer mornings, but at the same time he saw it as the emblematic place of modernity, a space of order and rationality. Like Burckhardt, Uhde compared this twofold Florence to Venice, favoring the Tuscan metropolis as a city of art on a level with Paris.[90] The capital on the Seine was the real comparison for Florence, but: "In Paris, beauty was present. Past and present, memory and life were jointly united."[91]

For Uhde, Manet's *Olympia* was the ideal expression of this complexity. He regarded the work as a peak of modernity, one that summed up a tradition beginning with Titian's *Venus of Urbino* and culminated in the onset of modernism. Both urban metaphors, Paris and Florence, meet in this painting: "Manet's *Olympia* was flesh of our flesh. To us, it served as a holy symbol of an artistic and pictorial tradition that seemed immortal to us and perhaps it is immortal."[92]

The art of the avant-garde that Uhde followed as dealer and writer shared, in his view, the authenticity of great Tuscan art. Fra Angelico and the Douanier Rousseau, Giotto and Picasso existed in parallel. One could trace Uhde's "theory of creative vision"—indeed, his entire aesthetics—back to fashions of the eighteenth and nineteenth centuries, where the artist was already seen as a somnambulant whose mission leads to the highest of ends. He is a divine creator whose work can claim absolute validity, and the beauty he produces is true not because it reproduces life but because it raises the terrestrial and the ephemeral to a higher plane, transcending time and history.[93]

The "legend of the artist" is familiar from the Renaissance. It formed, even in Uhde's day, part of the marketing strategy that artists used to affirm themselves in the confusing world of modernity. According to this idealized image of the artist, Picasso could never have created his revolutionary work by calculation and reason. Cubism, the artistic achievement of the century, could not be the result of mere patient dissection. Metaphorically speaking, for Uhde, modernity emerges when Florentine rationality is overcome.

A parallel might perhaps be drawn between the rational perspective or the harmonic of forms of the early Renaissance and the construction of cubistic pictorial space,

---

88 Ibid., 38.
89 Cf., for example, ibid., 79.
90 Burckhardt 1930, 44–45, 53–54.
91 Uhde 1938, 113.
92 Ibid., 115.
93 Cf., for example, Burckhardt 1978, 812.

although Uhde did not feel it was proper to address this issue. But there are artists of the nineteenth and early twentieth centuries whose work can be related to the painting and sculpture of the Quattrocento and Cinquecento: Marées, Denis, and Puvis de Chavannes learned lessons from Piero della Francesca; Hildebrand and Rodin from Michelangelo. Modern architecture reveals an impressive Florentine genealogy as well: Le Corbusier found the Uffizi interesting, and the Carthusian monastery of the Certosa di Galluzzo represented for him a kind of epiphany of crystalline form that had direct bearing on his early work in La Chaux-de-Fonds.[94]

In Uhde's thinking, the force behind cubism is Platonic Eros. We hear an echo of the Old European aesthetics familiar from Burckhardt's *Cicerone* in passages like these:

> Passing by the unsatisfying haphazard realisation of things in nature, he [Picasso] had advanced from the earth to a heaven in which he was inspired by archaic forms, the Platonic Ideas. His aim was to render the essence and the eternity of things, and to fill his paintings completely with this higher reality. It was *love* of pure and eternal things that drove his efforts. His means were plasticity and volume, the sense of cubism.[95]

The degree of immediacy between art and life remained decisive in the judgment of quality. Although he held Braque and Picasso in equally high esteem, Uhde identified minuscule differences between them according to this criterion. The logical consequence was the mystification of his own "art of the eye," in which both the creation of great art and its identification required the same "logic of the heart." It may be for this reason that the rational Florence of Le Corbusier (and Burckhardt) occupied a less important place in Uhde's thoughts than the innocent, naive Florence of Ruskin. Quiet, medieval Florence better suited Uhde's project of modernity. He sought an immediate, simple beauty requiring no explanation or interpretation. Paradoxically, Picasso's cubist work, as well as that of his avant-garde contemporaries, could be regarded as classical in a more general sense. For Uhde, avant-garde art meant not a break with tradition but a return to elementary forms. Classical modernity was classical while still modern. This insight proves Uhde's stature as a connoisseur.

Uhde praises Braque for the actual invention of cubism, which he characterizes as a style that fulfills something that began with Jean-Siméon Chardin and Jean-Baptiste-Camille Corot.[96] Like Picasso, Braque found a pure, essential form, a hypertruth, which captured the essential by solemnly exaggerating it. He placed other modernists in various other traditions. In Oskar Kokoschka, whom he met in the 1930s, he found the spirit of Gothic and baroque art. He applied the same explanatory pattern to Picasso. If the spirit of Gothic was revived in early cubism, a spirit like the baroque of Würzburg can be found in later works like *Guernica*. Here we see a glaring chasm opening up between Uhde's

94 Von Moos 2009, 140–141.
95 Cf. Uhde 1926; for Uhde's general view of Picasso and Braque, see Uhde 1938, 231.
96 Uhde 1938, 236.

world and that of Berenson when it came to the relationship between the Renaissance and the art of their time. Only regarding Salvador Dalí might they have agreed; poor Uhde, who died in 1947, was unfortunate enough to live next door to the surrealist painter in Paris during his final years.

We have come to the end of a long and complex journey. Berenson's Florence remained, it must be said, a minor spot on the map of modernity, and its protagonists spent little time there. Berenson himself had reservations regarding avant-garde painting and sculpture, although he appreciated Cézanne and purchased a Matisse. But Florentine art could and did serve as both a model and a foil for modernity. For a second time, the city on the Arno had a part to play in the formation of an avant-garde.

SEVEN

# Bernard Berenson and Aby Warburg
## *Absolute Opposites*

CLAUDIA WEDEPOHL

O N 23 AUGUST 1927, while on a trip through northern Europe, and after meeting
with one of Joseph Duveen's lawyers in Hamburg,[1] Bernard Berenson paid a visit
to a German colleague and acquaintance of long standing: the art and cultural histo-
rian Aby Warburg (Fig. 1). The meeting, which took place after an interval of more than
twenty years at Warburg's private library in Hamburg, the Kulturwissenschaftliche
Bibliothek Warburg (KBW), was a meeting of two scholars in their sixties who can rightly
be called the founding fathers of opposing, even antagonistic methods for the study of
Italian Renaissance art. Despite his aim to be acknowledged as a theorist, Berenson is
best known for his more practical skill in connoisseurship and for his persuasive critical
judgments about works of art. As a method devoted to establishing unambiguous attribu-
tions, connoisseurship was primarily if not exclusively based on the systematic study of
inconspicuous "morphological characteristics" in paintings—details in the literal sense.[2]
Warburg, coiner of the often-quoted phrase "God is in the detail," focused no less on tell-
ing details, but promoted a fundamentally different approach to works of art, a method he

---

∞ I am deeply indebted to Elizabeth Sears for her always intelligent and perceptive comments and
corrections.

1  Berenson had advised the British art dealer Joseph Duveen since 1906 and signed a first contract with
him in 1907. This gave Berenson a percentage of the price of a sale in exchange for his authentication.
Discussions in Hamburg with Duveen's lawyer, Lewis Levy, concerned the terms of a new contract.
See Samuels 1987, 350.

2  Berenson 1902, 116.

*1*
Aby Warburg, 1929.
Warburg Institute,
London.

initially called "philological" and later "cultural-scientific" (*kulturwissenschaftlich*). Not only did he draw upon cultural-historical details from archives to gain insight into period mentalities and to explain the formation of artistic styles, but he also drew attention to minutiae in works of art and showed the symbolic meaning of a specific subject matter in its contemporary context. His approach would revolutionize art history. It set the stage for the development of a hermeneutic method that would ultimately marginalize Berenson's approach and dominate art historical research in the immediately following generation—a method he began to call "Ikonologie."

*Claudia Wedepohl*

# Hamburg 1927

Whereas Berenson left no personal record of his introduction to the KBW, and his traveling companion Nicky Mariano only described it as "unforgettable, although not pathetic at all,"[3] Warburg left more than one account of the event. The most detailed is contained in the diary (*Tagebuch*) of the KBW, an institutional journal in which, from 1926 onward, Warburg and his closest collaborators, Fritz Saxl and Gertrud Bing, recorded activities and discussed tasks. We can begin with this account.[4]

> Yesterday a first-class critical day which went felicitously well: agreement with Berenson, recte: "reconciliation." We have stood from the outset in hostile opposition to one other, since 1898. I saw him as a style-sniffer [*Stilschnüffler*] and as a describer of the individual artwork [*Einzelkunstwerkbeschreiber*] and thought he was overvalued in the art trade, whereas he despised German erudition [*Gelehrsamkeit*] as well as inventiveness in the realm of psychology [*psychologische Fabulierkunst*] in a man like Schmarsow.[5] Besides, with respect to antiquity he was a recreation-seeker [*Rekreationssucher*]. "He didn't want to be digging around all day long."[6] Moreover, we were then at a disadvantage living in our bedsit [*chambre garni*],[7] and my still being dependent on the dull Brockhaus;[8] I simply avoided his snobbishness. One other time I visited him in Settignano and there I found the small photograph of the Giostra [i.e., a *cassone* panel] which Felix then had enlarged.[9] I had it available yesterday (and didn't even recall that I owed it to Berenson). The visit started with our customary fencing [*Scheingefecht*]: while still in the reception room Berenson made some pointed remarks about Carlyle

3  Mariano 1966, 153.

4  For the original German text, see the Appendix to this essay. Unless otherwise indicated, all translations are mine.

5  The German art historian August Schmarsow (1853–1936), a scholar of Renaissance and northern European art and architecture and an art-historical theorist, had invited a group of eight students from various German universities, among them Aby Warburg, to attend a privately taught semester in Florence (1888/89); it was during this semester that Warburg found the topic for his doctoral dissertation. Despite their private character, these seminars on Masaccio and Italian sculpture effectively marked the beginning of the Kunsthistorisches Institut in Florence. See Hubert 1997, 14–15, and 1999, 340–347. On Berenson's "distaste for the pedantries of German scholarship," see Samuels 1979, 315.

6  Warburg quotes Berenson's own wording from their very first meeting; see below.

7  The expression must be an ironical exaggeration: in October 1897, Aby Warburg moved with his new wife Mary into an apartment at 42 viale Principessa Margherita; in September 1898, they moved to 23 via Lungo il Mugnone; and later, in October 1900, to 1 via Paolo Toscanelli, where the family stayed until they left Florence in May 1904. During these years, the couple spent their summers in Hamburg.

8  The art historian Heinrich Brockhaus (1858–1941) became the first director of the Kunsthistorisches Institut in Florence in 1897, and held the post until 1917. See Hubert 1997, 19–28, and 1999, 351–357.

9  Warburg does not remember this correctly. It was his brother Paul Warburg who had ordered photographs of the *cassone*, kept in the Jarves collection at Yale University. See Paul Warburg to Aby Warburg, 8 February 1903, Warburg Institute Archive (hereafter WIA), Family Correspondence (hereafter FC); and Paul Warburg to Aby Warburg, 21 February 1905, FC.

and Norton which I calmly parried and corrected. I described my visit to Norton. The fact that everything progressed toward an almost enthusiastic mutual understanding was owed to the presence of Mr. and Mrs. Kingsley Porter (whom he had brought with him)[10] as well as the presence of his librarian, Miss Nicky Mariano, who is not only very knowledgeable: she seems to be an "angelo custode" to the delicate man. In the reading room the literature on stamps immediately attracted his attention; it amounted to: Barbados—Vergil—Neptune—Dürer, the *Pathos formula* (proved convincing even up to the Acropolis of Oraibi (a revelation for Americans).[11] Most impressive, however, was the enlarged photograph of the cassone and the possibility of dating the horses' reins—Guidagnolo—that delighted him since he is convinced that the painter is Domenico Veneziano and had only been waiting for the date.[12] I took the opportunity to tell Berenson that I am hoping to study the cassone myself at Yale, and that I wish to go to Cleveland as well, on account of the "Corso del Palio" (NB Kingsley Porter is well acquainted with Mr. Williken, the director of the museum; the idea that I would come over was later taken up with deep sympathy); at the end I explained that I was hoping to build bridges between German and American students, that there could be no better example than Mr. Kuhn. "Our student", Mrs. Kingsley Porter said, "and we will show you even better ones over there." "So there you have it." Happily Saxl had reason to join the group, because I had wanted the "fencing sheet" ["*Paukblatt*"] (NB: where is the photograph? Filed with images relating to festivals?).[13] This meant there was a valuable double-defense [*Zweistimmigkeit*] in the battle over Eissler's [sic] character which Berenson couldn't quite place.[14]—Miss Bing was unfortunately missing; I shouldn't have allowed her to stay away. At the end of the

10  Berenson had met the Kingsley Porters to begin a ten-day joint excursion. See Brush 2003, 223; and Samuels 1987, 350. Arthur Kingsley Porter (1883–1933) was a medievalist art historian who specialized in Romanesque sculpture and architecture. It was when he was traveling in France between 1918 and 1920 to lead efforts in architectural preservation that he had met Bernard Berenson; the two subsequently became friends and went on many trips together. Kingsley Porter joined Harvard University's fine arts department in 1920 and after some years of teaching in France returned to Harvard in 1925.

11  This passage refers to an exhibition of books and photographs relating to the symbolism of postage stamps, at the time still in place after the lecture Warburg had given ten days earlier. The occasion was a visit by Edwin Redslob, the Prussian *Reichskunstwart* (a high-ranking civil servant in the Weimar Republic who was responsible for art), on 13 August 1927; see below. For the summary of his theories repeated for his guests, Warburg uses the German term *abschnüren*, which refers metaphorically to an old-fashioned medical treatment.

12  For the already mentioned *cassone* panel depicting a tournament in Piazza Santa Croce, now attributed to Apollonio di Giovanni or his workshop and kept in the Jarves collection at Yale University, see below.

13  This is Warburg's nickname for a folio from a manuscript transcribed by Bartolomeo da Coiano, recording the names of contestants in a tournament (*Turnierprotokoll*) in 1429 (WIA, III.62.3.2); the page can be seen on plate 28/29 of the last version of the *Mnemosyne Atlas* series. In a scene in the background of the *cassone*, a man is seen actually preparing such a document. Warburg repeatedly displayed a copy of the Coiano folio alongside illustrations of tournaments. The name "Paukblatt" derives from "pauken," the usual term for "academic" fencing in students' fraternities. See Warburg 2000, 48–49, no. 3, there wrongly identified as a folio from the *bottega* book of Apollonio di Giovanni.

14  Warburg refers to the Austrian archaeologist and historian of religion Robert Eisler (1882–1949).

visit I wanted to present a "separatum" ["*Abteiler*"]. Instead of immediately going into action, Heydenreich,[15] whom I had instructed, proceeded through the hierarchy [*Instanzenzug*]: whenever—tired to death—4:15 to 7:45—I require some support, everybody (including myself) is nothing but an atom in our planetary system. I don't allow narcissistic stubbornness [*Holzbockigkeit*]. Otherwise I am very satisfied with the impression our library had on these visitors.

Warburg provided a second, much shorter account of Berenson's visit in his personal diary. There, he characterized his role in the small dispute with which the reunion began as an act of "taming the irony" of his counterpart, noting that thereafter his guest "functioned wonderfully."[16] The subject of the dispute was the character of two charismatic personalities: Charles Eliot Norton, who, as the first professor of art history to have been appointed in North America,[17] had a certain influence on Berenson's formation, and Norton's friend Thomas Carlyle, the eminent Victorian writer. Warburg is known to have had portraits of both men on display in his reception room: a photograph of Norton and, in all likelihood, a copy of James McNeill Whistler's famous portrait of Carlyle.[18] The presence of the portraits may have triggered the discussion.

James Loeb, Warburg's brother-in-law and Berenson's former classmate, an investment banker and classical scholar, had introduced Warburg to Norton during Warburg's visit to Boston and Cambridge in October 1895.[19] In a diary entry of that time, Warburg refers to their "[d]igression to Carlyle," and he notes that "Norton describes him in a wonderful manner."[20] Warburg seems to have been particularly interested in learning about

15 Ludwig Heinrich Heydenreich (1903–1978) was a historian of Renaissance architecture then preparing his dissertation under Erwin Panofsky. From 1927 to 1929, Warburg had employed him as assistant at the KBW. Shortly afterward, he took up a fellowship at the Kunsthistorisches Institut in Florence; in 1943, he would become its director. In a letter to Fritz Saxl and Gertrud Bing of 10 March 1946, Heydenreich informs his former colleagues that he prevented the confiscation of Villa I Tatti by the SS, and stresses that he would not forget that he had become acquainted with Berenson at the KBW and had met him for the first time in Florence together with Warburg and Bing (WIA, General Correspondence [hereafter GC], Heydenreich, 1946). After the war, Heydenreich became founding director of the Zentralinstitut für Kunstgeschichte in Munich. See Schäfer 2003, 249–255.

16 WIA, III.11.77, fol. 8545: "B[erenson] musste erst etwas entironisiert w[erden], dann aber funkte er wunderbar."

17 Erwin Panofsky quotes Norton's son, who described his father's teaching as "Lectures on modern morals illustrated by the arts of the ancients." See Panofsky 1955, 324.

18 This was probably a copy of the famous portrait in the Kelvingrove Art Gallery and Museum in Glasgow, bought in 1891. Warburg called his reception room the "Carlyle Room," and the sitter "the Scotsman who is England's and Germany's most valuable common property." See Aby Warburg to Paul and Felix Warburg, 11 May 1926, FC; Aby Warburg to James Loeb, 14 June 1928, GC; Aby Warburg to James Loeb, 23 June 1928, GC.

19 James Loeb later retired to become a philanthropist. For Mary and Bernard Berenson, he was a valuable link to wealthy Jewish circles in New York City. See Samuels 1979, 414.

20 WIA, III.10.1, fol. 15r: "N[ach]m[ittags] zu [Charles Eliot] Norton.... Schweifung auf [Thomas] Carlyle. Norton schildert mir ihn wundervoll.... Ist das ein treuer Idealist. Seit Hubert Janitschek tot ist, habe ich keinen so gern gehabt und so gern mit ihm gesprochen. Meine S[chrift] ihm geg[eben]." Warburg presented a copy of his doctoral dissertation (Warburg 1893), supervised by Hubert Janitschek, to Norton.

the Scotsman's personality, congenial to him, for in many ways Carlyle's philosophical novel *Sartor Resartus*, which assimilated many of the premises of German idealism, corresponded to Warburg's own cultural-philosophical ideas.[21] In Warburg's eyes, Norton, too, was a "faithful idealist." The memorably stimulating conversation they had that afternoon left Warburg with the feeling that the two had spoken not merely to be heard and understood, but rather to confirm to themselves that they shared the basic principles of the life of the mind.[22] Norton's interest in a historical approach to art encouraged Warburg to remain in contact with him and to send him copies of all his publications. Warburg received in return more than one grateful response, full of admiration.[23] Berenson, in contrast, had a very different impression of Norton, who did not share his admiration for a writer like Walter Pater. As a young man Berenson had taken very seriously Pater's invitation to his readers to become "aesthetic critics." He had accepted Pater's advice to learn "to distinguish, to analyze, and separate from its adjuncts, the virtue by which a picture, a landscape, a fair personality in life or in a book produces this special impression of beauty or pleasure, to indicate what the source of that impression is, and under which conditions it is experienced."[24] Norton was no friend to this way of thinking and, according to Berenson, said to Barrett Wendell, his fellow teacher at Harvard, that "Berenson has more ambition than ability." Berenson could neither forget nor forgive Norton's disapprobation. He wrote that he stopped sending Norton copies of his books once Norton had described his monograph on Lotto as "mistaken in method and mistaken in purpose."[25]

These episodes show that Berenson's initial tension with Warburg, the backdrop to the intense three-hour encounter, was rooted in the two men's methodological formation. It epitomized the rift between an ethical and an aesthetic appreciation of art. The encounter may serve as a point of departure for discussing the personal and professional relationship between two of the most influential art historians of the twentieth century, both of whom, despite a certain reluctance to get work into print, shaped their discipline as private scholars outside of university departments.[26] I shall highlight differences between them but

21  It has been observed that the parallels between Warburg and the main character, Dr. Teufelsdröckh (the author's alter ego, whose arguments are based on experience rather than theoretical conclusiveness), are particularly striking. See Villhauer 2002, 39–44; and Sprang 2009.

22  Aby Warburg to Charlotte and Moritz Warburg, 11 October 1895, FC: "Mit Norton selbst hatte ich einige der anregendsten Stunden meines Lebens, von jener Art Conversation, nach denen man fühlt, daß man gesprochen hat, nicht um gehört oder verstanden zu werden, sondern um sich der inneren Gemeinsamkeit der Grundprincipien im geistigen Leben zu versichern."

23  Warburg's sister-in-law, Nina, reported to Warburg on 1 June 1902 that Norton had made a flattering comment about his latest book [*The Art of Portraiture and the Florentine Bourgeoisie*] and had asked his daughter Lilly to translate it. See WIA, III.10.2, fol. 72r: "Nina erzählt mir, daß Ch[arles] Elliot [sic] Norton sich in der schmeichelhaftesten Weise über mein Buch [*Bildniskunst und florentinisches Bürgertum*] ausgesprochen und es s[einer] Tochter Lilly z[um] Uebersetzen gegeben habe."

24  Pater 1893, xi. Cf. Brown 1979, 38.

25  Norton must have made the remark to Wendell around 1885 when Berenson was still an undergraduate at Harvard. In 1894, he published an unsigned review of Berenson's "Lorenzo Lotto: An Essay in Constructive Art Criticism" in the *London Athenaeum*. See Berenson 1949, 44–45, 50; and Samuels 1979, 32, 37–38, 50, 202.

26  Warburg's so-called inhibition with respect to publishing has been much discussed among scholars, as well as his characteristic "eel-soup style" (as he called it). Rather than inhibition, however, this

also call attention to some easily overlooked similarities, which go beyond their common interest in fifteenth-century Italian art and the common experience of living and studying in Florence.[27] Both, only a year apart in age, left substantial specialist libraries of a distinctively different cast. Berenson's private arcadia, the Villa I Tatti in Settignano, was, it has been argued, intended to provide an antidote to academic classroom learning.[28] The four-floor, purpose-built library at Heilwigstrasse 116 in Hamburg, by contrast, was emphatically academic and embodied in its selection and its shelving system Warburg's way of thinking and educational mission. I shall argue that Warburg developed the method reflected in the structure of his library as, quoting Kenneth Clark, a "reaction against the formalist or stylistic approach," precisely the approach of Bernard Berenson.[29]

## A Case Study in Method

The centerpiece of the conversation between Warburg and Berenson on 23 August 1927, which, for Warburg, became the symbol of their "reconciliation," was the photograph of a *cassone* panel in the Jarves collection at Yale University. It shows a fragment of a wedding chest representing a "Tournament in Piazza Santa Croce," with more than a hundred animated figures distributed in the urban space watching the joust as it unfolds. Palaces are shown in the background and the church itself is seen on the left. The panel is today (after some controversy) attributed to Apollonio di Giovanni or the workshop that he led together with Marco del Buono Giamberti (Fig. 2).[30] Throughout his scholarly life—from around 1900 up to October 1929, when he incorporated a photo of the painting in the final series of plates for the *Mnemosyne Atlas*—Warburg used the *cassone* to demonstrate the application of his cultural-historical method.[31] He, like Berenson, was coming to rely on the comparative use of photographs, a relatively new method that enabled him to demonstrate formal continuities and revivals across cultures and time.[32]

---

trait should be seen as a struggle to discover the most precise form of expression to describe the complexity of the processes recognized. See Wedepohl 2009, 31–32, 44–46 (with references to the authors discussing this phenomenon). Berenson, on the other hand, admits to having been lazy when it came to writing for print: "strenuous days spent in galleries and churches, research, reading. No, that was not my work. . . . I seldom felt disposed [to writing for print] and have not yet overcome the reluctance." See Berenson 1949, 31–32.

27  Cf. Roeck 2009.

28  Rinehart 1993, 89.

29  Clark 1974, 189.

30  Callmann 1974, 62–63, and 1996. Callmann considers the piece an autograph, whereas Gombrich follows Wolfgang Stechow in assigning it to Apollonio's workshop. See Stechow 1944; and Gombrich 1955, 21.

31  Figure 2 shows the second panel from Warburg's so-called Hertziana lecture, delivered on 19 January 1929. For the story of the acquisition of the reproductions shown, see below. It is likely that the panel Berenson saw on 23 August 1927 contained a similar composition. See Warburg 2000, 48–49.

32  The invention of the halftone reproduction technique in the 1890s had given both scholars the opportunity to develop their methodological tools. Cf. Warburg's remark of 1901 that "[w]ith the aid of photography, the comparative study of painting can now be carried further," in Warburg 1999, 305. See also Berenson 1995; Romano 1995, 153–155; and Keller 2001.

36

37

2

Panel two of
Warburg's lecture held
at the Bibliotheca
Hertziana in January
1929, containing a
large photograph of
Apollonio di Giovanni
(and workshop),
*Tournament in Piazza
Santa Croce*, ca. 1460,
tempera on panel,
Yale University Art
Gallery, New Haven,
and a smaller color
scheme, Warburg
Institute, London.

One of these occasions was Warburg's presentation titled "The Function of the Postage Stamp in the International Traffic of Figurative Language" (*Die Funktion der Briefmarke im bildersprachlichen Weltverkehr*), held ten days before Berenson's visit.[33] The large pinboards (best described as movable partitions), on which Warburg had arranged the examples selected for the presentation, were still in place in the elliptical reading room of the KBW when the Americans arrived (Fig. 3). As his summary of Berenson's visit suggests, Warburg must have recapitulated his principal argument for his guests, expounding one of his key theories: that symbols originated in the formation of "archetypical" forms through a "battle between idealism and realism," in each instance making manifest the creator's aptitude for either abstract or naturalistic depiction. The examples he refers to in his *Tagebuch* imply that he demonstrated how typical seventeenth-century symbolism *all'antica* had been revived in contemporary stamps.[34] In this context, the *cassone* tournament scene is likely to have functioned as an example of the display of personal heraldry which, according to Warburg, was the precursor of the impersonal emblems of nations.

Warburg's interest in Quattrocento *cassoni* stemmed from research he had carried out around 1890 when writing his doctoral dissertation on Sandro Botticelli, defended in 1892. His fascination with the *cassone* genre grew when he embarked on a new project, devoted to the impact of antique prototypes on the choice of subjects and the formation of style in Italian secular painting.[35] The underlying idea was to explain the genesis of the idealizing style *all'antica* and its increasing dominance over typical realistic depictions of

---

33   WIA, III.99.1.2, fol. 65.

34   Two lectures were given, the first by *Reichskunstwart* Edwin Redslob, and the second by Warburg. See WIA, III.99.1.1, *Die Briefmarke als Kulturdokument* (*The Postage Stamp as a Document of Culture*); and WIA, III.99.9, *Hamburger Fremdenblatt*, 14 August 1927.

35   Gombrich 1955, 16.

3

Reading room of the
Kulturwissenschaftliche
Bibliothek Warburg
(KBW) in Hamburg,
with Warburg's
*Bilderreihe* relating to
the afterlife of Ovid,
1926. Warburg
Institute, London.

costumes *alla franzese* as reflecting the patron's state of mind under the impression of the immense transformations in fifteenth-century society. This study never materialized, but Warburg mentioned it frequently as a large book in preparation, and announced it in his article "Dürer and Italian Antiquity" of 1905 as "a forthcoming book on the beginnings of autonomous secular painting in the Quattrocento." The project was reborn in the late 1920s in the *Mnemosyne Atlas*, left incomplete at Warburg's death.[36]

In May 1899, Warburg's research took a decisive turn when his older colleague Heinrich Brockhaus, director of the Kunsthistorisches Institut in Florence, shared with him the discovery of a unique source: Carlo Strozzi's copy of the so-called order book of the principal workshop (*bottega*) producing *cassoni* in Quattrocento Florence.[37] In his diary entry for 27 May 1899, Warburg records that Brockhaus had also discovered the names of two painters who had executed the 150 *cassoni* listed in the order book: Marco del Buono and Apollonio di Giovanni. A week later, with the help of Alceste Giorgetti, Warburg found further proof in the Archivio Nazionale of the collaboration between these two artists, calling the *bottega* book "a discovery of immense value."[38] Shortly

36  Warburg 1999, 276, 558 n. 1. Drafts of the project with several working titles and notes on the topic, collected between 1898 and 1908, are extant.
37  Warburg 1999, 298 n. 8. The list of orders, covering the years 1443 to 1465, is preserved in fols. 107–113 in MS 37.305 (Strozziano) in the Florentine Biblioteca Nazionale.
38  WIA, III.10.2, fol. 22r.

afterward, he must have transcribed the document, and later in the same year he began a relentless search for surviving *cassoni* from this workshop, diligently noting and painstakingly identifying coats of arms on pieces housed in collections throughout Europe and North America.[39] Although this search, massive in scale and dependent on chance discoveries, could never have been concluded and was eventually abandoned, Warburg agreed many years later to allow Paul Schubring to publish his transcription and some of his comments on the *bottega* book in Schubring's seminal work on *cassoni*.[40] From the unpublished documents kept in the Warburg Institute Archive, however, it becomes clear that what was published by Schubring represents only a fraction of the research Warburg had conducted, and that Warburg's potential contribution to the study of *cassoni*—in particular, the identification of contemporary heraldry—was substantial. Although, as Ernst Gombrich rightly stressed in 1955, he did not succeed in assigning a single surviving object to Apollonio's and Marco del Buono's *bottega*, Warburg's notes preserve tentative attributions, many of which would be confirmed by the next generation. Gombrich himself was able to attribute the wedding chest depicting the *Tournament in Piazza Santa Croce* in the Jarves collection with certainty to Apollonio's shop. This was possible only after Wolfgang Stechow had identified the so-called Oberlin *cassone*, decorated with scenes from Greek history, as a work of Apollonio; the painter had previously been called the Virgil Master, the Dido Master, or the Master of the Jarves Cassoni.[41]

The discussion of the origin of this group of *cassoni* bearing images of similar themes, however, had begun much earlier. It was Mary Berenson who had first shed light on the master of these chests (who was later identified by Gombrich as Apollonio)[42] when she recognized him as the author of the miniatures in a Virgil manuscript, and went on to attribute the Jarves *cassone* with the joust to the same hand. As early as 1901, she called him the Virgil Master.[43] Even before the publication of this attribution, a shared interest in this group of *cassoni* seems to have led to a discussion with Warburg. Proof of this discussion lies in the very fact that Warburg's attention was first drawn to the *Tournament in Piazza Santa Croce* by the small photograph that the Berensons possessed,[44] and by the fact that Mary Berenson acknowledged Warburg as the source of information about two other

39    Oskar E. Warburg to Aby Warburg, 21 September 1899, FC; Charlotte Warburg to Aby Warburg, 9 October 1899, FC.

40    Schubring 1915, 88–89, Appendix II.

41    See Gombrich 1955, 17; and Stechow 1944, 17.

42    Cod. 492, Biblioteca Riccardiana, Florence.

43    Logan 1901, 335.

44    Warburg's two accounts contradict one another slightly; his memory seems to have faded after almost thirty years. In the *Tagebuch* of the KBW, he writes that he found the photograph during a visit to Berenson's house in Settignano, whereas he writes to Felix that he discovered the photo about 1898 (when the Berensons lived in via Camerata); it is therefore impossible to establish the precise date of his discovery. A conversation Warburg must have had with Berenson about the *cassone* painter Pier Francesco Fiorentino on 16 February 1899 is recorded in a note; see WIA, III.2.1, *Zettelkasten*, no. 29a, fol. 010/004817. For Berenson's moves and the lease of Villa I Tatti in 1900, see Samuels 1979, 323, 341, and 1987, 57.

*cassoni* she attributed to the "Virgil Master."[45] Faithful to their interest in attributions, the Berensons seized the opportunity to examine the same pieces in person and to confirm their assumptions a few years later, during their trip to the American East Coast and Midwest in 1903–4.[46] At the same time, Warburg had already gone one step further by suggesting that both of the Jarves *cassoni*, the one with scenes from the *Aeneid* and the one showing the tournament, had been produced in what was apparently the most prolific and fashionable workshop of its time, and that Marco del Buono was their maker.[47]

Warburg's growing interest in the tournament *cassone*, and more especially in the subject of the historical joust itself, is documented from February 1903 onward. In that year, he asked his brother Paul in New York City—a banker known for his part in the creation of the US Federal Reserve System—to order a photograph of the object. Paul Warburg commissioned the New York photographer Carl Glucksmann to go to New Haven to photograph the item, measure it, and produce a painted color scheme (Fig. 2). In addition, either Aby or Paul asked the historian and diplomat Lewis Einstein, when on one of his trips through American collections, to make a detailed transcription of all legible inscriptions.[48]

Although the *cassone* panel no longer carries the coat of arms of its patron, inscriptions on the reins of the contestants' horses document some of their names and various coats of arms decorate trumpets, shields, and caparisons. This evidence prompted Warburg to identify the precise historical moment in which the piece was created, and thus to date it. After receiving the photographs, he decided that he would like to submit an article on the *cassone* panel to the series *Italienische Forschungen*, coedited by Brockhaus for the Kunsthistorisches Institut in Florence.[49] He later postponed the submission and finally withdrew the essay, which he had begun to draft, in favor of a projected study of stylistic preferences in secular painting in the circle of Lorenzo de' Medici, with a focus on *cassoni*.[50] A last attempt to interpret the scene is documented in 1905, when Paul Warburg himself became involved. Paul's idea was to confirm his brother's hypothesis that an unidentified coat of arms was that of a condottiere who had presented himself in Piazza Santa Croce. He thought he could detect a particular dog on several costumes and caparisons, but it could apparently not be associated with any impresa that Warburg had studied.[51]

---

45  Logan 1901, 336. The piece, kept in the Museum August Kestner in Hannover, is treated in Warburg's dissertation; see Warburg 1893, 40, and 1999, 117–118. Warburg went to Hannover to examine this object in September 1900; see WIA, III.10.2, fol. 47r.

46  After the Berensons saw items in the Jarves collection, Mary noted in her diary that several of the attributions in its catalog "were authoritatively contradicted": see Brown 1979, 19.

47  WIA, III.2.1, *Zettelkasten*, no. 7, fol. 012/005923.

48  Carl Glucksmann to Aby Warburg, 8 March 1903, GC; Lewis Einstein to Aby Warburg, 9 March 1903, GC. The photographs—in the form of three enlargements of details, each measuring 43.4 × 60 cm—survive at the Warburg Institute along with the color scheme (Fig. 2).

49  Heinrich Brockhaus to Aby Warburg, 17 and 31 October 1903, GC; Aby Warburg to Heinrich Brockhaus, 22 October and 17 November 1903, GC; Aby Warburg to Wilhelm von Bode, 9 November 1903, GC.

50  WIA, III.62.3.3, draft containing the description of the *cassone* with a *Tournament in Piazza Santa Croce*, 7 fols.

51  Paul Warburg to Aby Warburg, 21 February 1905, FC.

In a paper given in 1902 at the International Art Historical Congress in Innsbruck, Warburg called the method he was using to analyze the wedding chest "cultural-historical iconography," meaning the confrontation of the artwork with contemporary documents, private and public, and even the reading of the object itself *as* a historical document.[52] Stating that he had developed this method as an autodidact, and naming genealogy and heraldry as auxiliary sciences (*Hilfswissenschaften*) that can help identify patrons, he explained how this method could contribute to an understanding of the genesis of styles through the taste of these same patrons. This is indeed one of the first methodological statements (if not the very first) made by Warburg among fellow art historians. Contrasting his method to aestheticism, he says: "Art history has to begin working with the artifact, and it has to work from higher to lower: that way [the discipline] will gain by means of general empathy the so-called aesthetic scale of value which, however, should only be a signal for penetrating the artifact deeper, but in reality often functions as a self-sufficient aim."[53]

Warburg made another important methodological statement in the very same year in a letter addressed to his colleague and friend Adolph Goldschmidt, which confirms his increased interest at the time in questions of methodology. Referring to an earlier conversation about "trends in modern art history" (*Richtungen der modernen Kunstwissenschaft*), Warburg classifies groups of scholars according to the tradition in which their approach to works of art stands. Berenson features in this list next to Morelli as connoisseur and "attributionist," and both are assigned to the group of "enthusiasts" (*enthusiastische Kunstgeschichtler*). According to Warburg, this form of enthusiasm is "proper to the propertied classes, the collector, and his like." The representatives of this group, "the clan of snoopers," are in his estimation professional admirers who seek to define, defend, or extol the qualities of the artist as hero. They are typically hero-worshipers possessing the temperament of the gourmand.[54]

Methodology remained Warburg's main concern when, in the winter semester of 1925/26, he prepared his first seminar as honorary professor at the recently founded University of Hamburg.[55] In this context, the depiction of the *giostra* in Piazza Santa

---

52  WIA, III.57.1.1, *Wappen, Stammbäume und Inventare als methodische Hilfsmittel der Kunstgeschichte (inbesondere der italienischen) im Dienste der kulturgeschichtlichen Iconographie* (*Coats of Arms, Genealogical Trees, and Inventories as Methodological Aides of Art History in the Service of a Cultural-Historical Iconography*).

53  WIA, III.57.1.1, fol. 17v: "Die Kunstgeschichte muß vom Kunstwerk und von oben nach unten arbeiten: so bekommt sie durch eine allgemeine Einfühlung, den s[o]g[enannten] aesthetischen Wertmesser, der nur ein Signal zum Weit[er]eindringen sein sollte, tatsächlich aber oft schon als selbstgefälliger Endzweck genügt."

54  WIA, III.57.2.2, fol. 3: "Zu dieser Gruppe der Enthusiasten gehören auch die Kenner und 'Attribuzler', denn sie bewundern ohne Adjektiv, indem sie die Eigenart ihres Helden abzugrenzen, zu schützen oder zu erweitern suchen, um ihn als einheitlich logischen Organismus zu begreifen—Bayersdorfer, Bode, Morelli (Venturi), Berenson sowie das schnuppernde Gelichter der Gronau, Mackowsky. Es sind Heroenverehrer, die eben in den letzten Ausläufern nur noch das Temperament eines Gourmands beseelt; die neutral abwägende Schätzung ist eben die urtümliche Enthusiasmusform der besitzenden Klasse: des Sammlers u. d[er] seinigen." Translation after Gombrich 1986, 142–143. Giovanni Morelli, as a trained physician, had introduced comparative anatomy to connoisseurship.

55  On 19 February 1912, the senate of Hamburg had granted Aby Warburg the title of professor. He was appointed honorary professor on 19 August 1921, after the foundation of the university in 1919.

Croce served once again as an example, enabling him to demonstrate an "art-historical exegesis on a cultural-historical basis." At the same time, it functioned as an exemplary case of the survival of chivalric themes in fifteenth-century Florence, represented in the narrative style (*Erzählstil*).[56] Warburg's notes, sketched out for the first session of this seminar on 25 November 1925, confirm his insistence on two general points: the necessity of taking into consideration the "spirit of the time" (*Geist der Zeit*), and of "respect of the detail" (*Respekt vor der Einzelheit*). This would lead to a full picture of the artifact in its historical context. As attention to detail he counted both deciphering iconographical clues on the *cassone* (coats of arms and *imprese*) and assessing the style of the painting. By consulting printed books (Schubring's volume) and analyzing contemporary documents (the *bottega* book in the Florentine archives), and even by seeking out modern parallels (the reenactment of a historic tournament Warburg had observed in Brussels in 1905), the art historian would get a feeling for the time of the artifact's production. The combination of all these aspects, the defining feature of his "iconological" method—a term he later would use almost exclusively, abandoning the term "iconography"—would explain the object. On the other hand, the phenomenon of an emergence of idealistic figures *all'antica* (i.e., the clearly visible representations of *Chronos* and *Fortuna* on the banners of the two fencing parties depicted on the *cassone*) in the depiction of fifteenth-century festival culture was taken to reflect the spirit of the time.[57]

During the 1927 encounter, the Jarves collection *cassone* evidently furnished a means to demonstrate to Berenson a fundamentally different approach to Quattrocento Florentine art. Warburg implies in the *Tagebuch* entry that he even succeeded in convincing his rival that his particular attention to details could provide clues for dating an artwork in a way that complemented Berenson's own approach. The notes in his card files remain as witness to his diligent research on every detail of the painting, and they foreshadow the questions that the very same object would provoke in the coming years.[58] Especially critical clues for the circumstances of the piece's production were, in addition to the coats of arms, two names inscribed on horses' reins, decipherable as "SER NOCE" and "GUIDAGNOLO." After a long and ultimately unsuccessful search for the former, Warburg had identified the latter as Guidagnolo di Ranieri: "un delecto homo d'arme" of the *famiglia* of Federico da Montefeltro, Count of Urbino, who in 1446 was sent to Florence to serve Piero de' Medici. This historical event was documented in a letter which

---

His seminar was dedicated to *The Visual Culture of the Early Florentine Renaissance (Die künstlerische Kultur der florentinischen Frührenaissance)*, and had two mottos: "We seek out our ignorance and fight it wherever we find it" ("Wir suchen unsere Ignoranz auf und schlagen sie, wo wir sie finden") and "God is in the detail" ("Der liebe Gott steckt im Detail"). See WIA III.113.9, fol. 2. Cf. Warburg 1992, 618; and Stimilli 2004, 102–103.

56  WIA, III.95.5, fols. 162–166.

57  With regard to the distinction between Warburg's use of the terms "iconographical" (*ikonographisch*) and "iconological" (*ikonologisch*), see Schmidt and Wuttke 1993, 24–34.

58  WIA, III.62.3.2, fol. 8 and III.63.3.3, fol. 2. Cf. *Handbook of the Collections: Yale University Art Gallery*, New Haven, 1992, 135.

Warburg found among the *Carte Strozziane*.[59] He became thus convinced that the wedding chest was commissioned in that very year, a date he proposed not only to Berenson but also to Richard Offner, as a letter from December 1927 reveals.[60] That Berenson ever thought Domenico Veneziano was the painter cannot be proved and is unlikely, as in his 1932 version of the *Italian Pictures of the Renaissance* he attributes the panel (as his wife had done over thirty years before) to the Virgil Master, or rather his shop.[61] In the posthumous 1967 version of the same work, the name is replaced with Apollonio di Giovanni.[62]

## Antagonisms

Warburg's opinion of Berenson's character evidently differed from his assessment of Berenson's approach to Renaissance art. The afternoon spent together in 1927 could reconcile him to the man, yet his judgment about what the art historian stood for remained negative, even beyond his unreserved rejection of any collusion between scholarship and the art trade.[63] It may even be that Berenson, who during their Florentine years was without doubt considered the greater authority on Italian art,[64] provoked Warburg's lifelong rejection of aestheticism as a stance. Famously in 1923 (although certainly with hindsight), Warburg went so far as to describe a developing "disgust of an aestheticizing art history" as a young scholar. He wanted to replace the purely formal examination of the artwork with the explanation of its origin as "a biologically necessary product situated between artistic expression and religious practice."[65] Yet his polemical position did not mean that he was insensitive to aesthetic forms of expression; on the contrary, understanding the physiology of the perception and the production of forms as a primordial act of civilization, and thus of culture as such, stood in the center of his ambitious redefinition of aesthetics on the basis of physics, biology, and psychology.

When the two scholars met for the first time, Berenson had already made public his personal conviction that the "highest aesthetic delight" was the prime goal of looking at

---

59  WIA, III.2.1, *Zettelkasten*, no. 7, fol. 012/005951. Warburg mentions that, according to Bernardino Baldi, the same Guidagnolo had injured Count Federico da Montefeltro in 1450, causing the loss of his right eye; this fact cannot be confirmed by the printed sources.

60  Warburg to Richard Offner, 12 December 1927, GC.

61  Berenson 1932, 347.

62  Berenson 1963a, 18.

63  In June 1929, after a visit with Warburg to I Tatti, Gertrud Bing called Berenson a "wholesale art merchant" (*Kunst-Großhändler*). In the same *Tagebuch* entry, she summarized Warburg's recommendations for improving the situation at the Kunsthistorisches Institut in Florence; among them, she lists "an energetic holding back against any connection with the art trade, however loose." See Warburg 2001, 465.

64  Samuels 1979, 316.

65  The passage is contained in the autobiographical notes preceding Warburg's 1923 lecture on the snake ritual. See WIA, III.93.4.1, fol. 8: "Ausserdem hatte ich vor der ästhetisierenden Kunstgeschichte einen aufrichtigen Ekel bekommen. Die formale Betrachtung des Bildes—unbegriffen als biologisch notwendiges Produkt zwischen Religion- und Kunstübung—(was ich freilich erst später einsah)—schien mir ein so steriles Wortgeschäft hervorzurufen, dass ich nach meiner Reise in Berlin im Sommer 1896 zur Medizin umzusatteln versuchte."

art, and that the artifact should evoke "a pleasurable state of emotion" in its beholders and "enhance their whole personality."[66] Arguably, he intended to explain this effect scientifically in his *Florentine Painters of the Renaissance* of 1896. He meant to define universally affective qualities that generate pleasure as an objective impression through the mechanism of perception that he called "tactile values." These tactile values were essentially features of the artist's representation of the third dimension transmitted to the observer's retina. They had the potential to "rouse the tactile sense" or to "stimulate the tactile imagination," and thus to activate a certain form of delight.[67] While the terminology Berenson introduced to the theory of appreciation stemmed, as scholars have stressed, from William James's *Principles of Psychology*, published in 1890, shortly before the author visited Florence and met with the expatriate community,[68] Berenson's prime source was, according to Ernst Gombrich, Adolf von Hildebrand's innovative treatise, *The Problem of Form in Painting and Sculpture* (*Das Problem der Form in der bildenden Kunst*) of 1893. This theoretical text was written from the point of view of the practitioner, a sculptor living in Florence whom Berenson met in 1894. Gombrich claims that Berenson "formulates his aesthetic creed—'the painter can accomplish his task only by giving tactile values to retinal impressions'—entirely in terms of Hildebrand's ideas," which likewise influenced Warburg's theoretical notions regarding the persistence of archetypal forms. It was precisely this persistence of basic forms of expression that Warburg tried to demonstrate before Berenson and his friends on 23 August 1927.[69]

Hildebrand's distinction between form as it exists (*Daseinsform*) and form as it appears (*Wirkungsform*)[70] had thus appealed to both scholars, although they applied the sculptor's explanations differently. While Berenson focused on the impression of the artifact on the beholder, Warburg turned his attention to the artist's perception of forms and the way the artifact became a repository of psychic energies.[71] Ultimately, however, Warburg's ideas were rooted in the theories that Robert Vischer put forward in his doctoral dissertation, *On the Optical Sense of Form* (*Über das optische Formgefühl*), of 1873. Vernon Lee had popularized this text among English expatriate circles in Florence and translated the new term *Einfühlung* as "empathy."[72]

According to Vischer, the desire to empathize with an object is triggered by the movement of the eyes—that is, in active perceiving (*Schauen*) rather than in passive looking (*Sehen*). The act of perceiving is described as aiming to gain an impression of all dimensions of an object through an upward and downward movement of the eyes, by "sensing"

---

66  Berenson 1896, 5, 8, 10. Berenson continues by stating: "Precisely this is what form does in painting: it lends a higher coefficient of reality to the object represented, with the consequent enjoyment of accelerated physical processes, and the exhilarating sense of increased capacity in the observer."

67  Berenson 1896, 4.

68  James 1907, 2:65–67, 109, 248.

69  Gombrich 1968, 14.

70  Hildebrand 1893, 63–82.

71  Cf. Boehm 1999.

72  Samuels 1979, 152.

it. The "sensation" evoked could either be pleasant or unpleasant.[73] The crucial point is that Vischer tries to explain how a physical movement, the vibration of the optic nerve, is transformed into an emotional reaction, a movement of the soul. He presumes that the similarity or dissimilarity between the two movements generates feelings either harmonious or disharmonious. Thus, for example, Berenson's preference for the unemotional ("non eloquente") yet explicitly three-dimensional, "tactile" art of Piero della Francesca—his appreciation of the painter's "sensibilità al volume"—could find a scientific explanation.[74] Warburg took Vischer's theory a step further, however. He assumed that any arousal of the human being's soul—the producer's and the recipient's alike—is based on an act of comparison (*Vergleichsact*). Projected onto the artifact, principally through the depicted figure's posture and gestures, movement could thus be transmitted to the beholder.[75] This theoretical notion helped him to explain stylistic choices so that, according to his own theory, the deliberate intensification of outward movement increased the empathetic potential of an image. In the "Prefatory Note" to his dissertation, Warburg declared that he had gathered "evidence" directly relevant to a "psychological aesthetics," and stated that he observed "within the milieu of the working artist an emerging sense of the aesthetic act of empathy as a determination of style."[76] Time and again, however, he warns the beholder (including the scholar) to avoid succumbing fully to the act of empathy, to "keep a distance" from the object—the opposite of Berenson's approach.

Proximity and distance, self-enhancing identification and scientific abstraction lie at the core of Warburg's theoretical notions, yet they also form the basis of the methodological credo that he defined and tested during his years in Florence. For the first time, he distanced himself from the ideal of an artwork that acted as stimulant, and contrasted his own method of "exact research" with a reliance on "subjective taste," which confines itself to passionate discussions about beauty in art.[77] His explanation of this phenomenon, however, is twofold. Not only does the beholder instinctively seek pleasure in art, but the artist also tries to accommodate this instinctive tendency. The ultimate result, he stated, was the development of mannerism, precursor of the highly moving baroque style.[78]

---

73  Vischer 1873, 2. Cf. Schindler 2000, 19–20.

74  Berenson 1950c, 14, 16, 21. Bernard Berenson never refers directly or indirectly to Vischer, and disapproved of theory as such; the consonance between Vischer's and his own ideas, however, is quite obvious.

75  Warburg calls this phenomenon "substitutionalism" (*Substitutionalismus*). See WIA, III.2.1, *Zettelkasten "Aesthetik,"* fol. 270.

76  Warburg 1999, 89.

77  An example is the introduction to a monographic lecture (one in a series of four) on Leonardo da Vinci and his art, delivered between 18 September and 1 October 1899 in the Hamburger Kunsthalle. See WIA, III.49.2, fol. B: "Die Anhänger der exakten Forschungen sehen nur spöttisch auf die Symptome dieser ersten Krisis des subjektiven Geschmacks, die sie für das Endziel des Kunstgenusses halten, während sie nur der Beginn des Kunstverständnisses ist. Für die 'exakten' ist die Kunstgeschichte eine Damenconditorei, in der mit überströmender Suade und überflüssiger Leidenschaftlichkeit erörtert wird, ob etwas schön gemacht oder 'tabu' ist."

78  WIA, III.49.3, fols. 43–44: "Dem Zuschauer wird die Einfühlung in das Bild erleichtert; diese Bequemlichkeit aber brachte die große Gefahr mit sich, dass die freundlichen Manieren im Bilde so beliebt wurden, daß sie, von Schülern mehrfach wiederholt, eben zu Manierismus führten."

The text in which Warburg most seriously began to distance himself from empathetic aestheticism is his so-called Fragment of the Nymph, which he himself called "Ninfa fiorentina," a fictional poetic dialogue with his friend, the literary critic and art historian André Jolles.[79] Two extant letters, composed around the end of 1900 and the beginning of 1901, as well as a number of earlier sketchy drafts, show the two friends pretending to discuss Domenico Ghirlandaio's invention of the fruit-bearing girl in his *Birth of St. John* in the Tornabuoni Chapel of Santa Maria Novella. These letters can rightly be called Warburg's manifesto in support of a "philological" analysis of artworks with attention to detail. The method owes much, ideologically and terminologically, to Hermann Usener, even if the known dictum "God is in the detail" cannot be traced earlier than Warburg's seminar of 1925, when he referred to it as the motto of his early days.[80]

How Warburg exploited the inconspicuous "detail" has already been seen in his work on *cassoni*. In "Fragment on the Nymph," he introduces the genealogy of the patrons who commissioned the paintings in the chancel of Santa Maria Novella, the Tornabuoni. After diligently reconstructing the historical context of the commission through documents, Warburg concludes that the pictorial program was a thanks offering for family prosperity and a petition for future good fortune:

> It is in fact a religious performance that the Tornabuoni family stages here in honor of the Virgin Mary and Saint John. Giovanni Tornabuoni has happily succeeded in securing the patronage of the choir and gaining the right to decorate it with frescos, and the new members of his own family can appear in person as characters in the holy legend.[81]

Warburg's interpretation of the fresco cycle bears a hitherto unnoticed resemblance to Berenson's characterization of these scenes as "*tableaux vivants* pushed into the wall."[82] This suggests that Warburg's analysis of the fresco, perhaps indirectly addressed to Berenson as a methodological statement, was based on a common reading of the scene.[83]

79  See Contarini and Ghelardi 2004; and Wedepohl 2009, 32–40, with bibliographical references relating to earlier publications.

80  Warburg to Johannes Geffcken, 16 January 1926, GC. Davide Stimilli has stressed the impact of the classical philologist and historian of religion who had been Warburg's most influential teacher at Bonn University, and in particular his work *Philologie und Geschichtswissenschaft*, from which Stimilli quotes: "The philological descent in the detail [*die philologische Vertiefung in das Detail*] leads to the vantage point from which new insights in the life and work of the nations can be gained" (translation by Stimilli). See Stimilli 2010, 158; see also Usener 1882, 27. Usener's essay as a possible source was first suggested in Wuttke 1978, 54–55.

81  WIA, III.55.2, fol. 1: "[D]ie Tornabuoni führen hier nämlich ein geistliches Schauspiel auf, zu Ehren der Jungfrau Maria und Johannes des Täufers. Giovanni Tornabuoni ist es glücklich gelungen, das Patronat des Chores und das Recht zur bildlichen Ausschmückung zu erwerben und nun dürfen seine Angehörigen als Figuren der heiligen Legende persönlich auftreten."

82  Berenson 1896, 64.

83  I disagree with Ernst Gombrich's interpretation of Warburg's analysis as being inspired by contemporary perception of the liberation and emancipation of the modern woman. See Gombrich 1986, 109.

Moreover, the motif that seems to have triggered Warburg's attack on aestheticism, the appearance of the fruit-bearing girl, had already raised the particular interest of one historian, namely Hippolyte Taine, who linked her to an ancient nymph.[84] Despite his statement in 1927 that it was the "too nervous mobility" of Filippino Lippi's female figures that had first struck him as transgressing the ideal of beauty,[85] Warburg in the "Fragment" evoked Ghirlandaio's maid as the prototypical example of the agitated *ninfa*, combining movement and femininity. She served him in the discussion of two aspects of aestheticism: the platonic ideal of beauty, either "charming" (*lieblich*) or "sublime" (*erhaben*), and primitivism. In addition, the motif allowed him to comment on myopias occasioned by Morellian connoisseurship. I will here address both aspects, drawing in particular on extant drafts and examining passages deleted from the polished final version of the letters.

The point of departure for the dialogue was Jolles's pretended infatuation with the vivid young maid who strides into the picture with a plate of fruit balanced on her head: she becomes a contemporary beauty with whom he has fallen in love. Warburg, in his response to Jolles's letter, elaborated in several drafts, opposes his friend's inclination to follow the maid "in a Platonic flush of desire through the spheres like a winged idea," and counters that she is forcing him to turn his "philological gaze downward to the earth from which she rose."[86] In draft after draft, he invents ever new metaphors to demonstrate that his "scholarly conscience does not recognize the expressions of rapture and enthusiasm as adequate instruments."[87] He invokes fantasy realms such as "the island of the blessed" (*Insel der Seeligen*) or "Cockaigne" (*Schlaraffenland*) to set against the "soil of bare facts," the former being associated with a "sensitive" (*empfindsam*) rather than a "critical" (*kritisch*) perception, or with an "erotic" rather than an "intellectual" approach,

84  Taine 1900, 149: "[D]ans la *Nativité de saint Jean* une autre debout est une duchesse du moyen âge; près d'elle, la servante qui apporte des fruits, en robe de statue, a l'élan, l'allégresse, la force d'une nymphe antique, en sorte que les deux âges et les deux beautés se rejoignent et s'unissent dans la naïveté du même sentiment vrai."

85  WIA, I.10.1, fols. 3–4: "Als ich zuerst 1888 nach Florenz kam, war mein und meiner jetzigen Frau höchstes Ideal Raffaels Madonna aus dem Hause Gran Duca. Das heisst, die in sich abgeschlossene weltentrückte Schönheit der italienischen Seele war das Symbol für das Neuland, das wir uns als Gegengewicht gegen den hastenden Tag zusammen eroberten. Deshalb erschien mir z.B. Filippinos übernervöse Beweglichkeit wie ein unbegreiflicher Verstoss und beinahe wie ein widerwärtiger Aufruhr gegen die Gesetze schönheitsvoller Zusammengefasstheit wie sie von den 'Primitiven' Italiens ausging, die eben in ihrer innerlichen 'Einfalt' das Ideal des Italienreisenden bildet."

86  WIA, III.55.2, fols. 1–2: "Es lockt Dich, ihr wie einer geflügelten Idea durch alle Sphären im platonischen Liebesrausche zu folgen, mich zwingt sie, den philologischen Blick auf den Boden zu richten, dem sie entstieg und staunend zu fragen: wurzelt denn dieses seltsam zierliche Gewächs wirklich in dem nüchternen florentinischen Erdboden." For a drafted variation, see WIA, III.55.3.5, fol. 7: "Auch ich bin in Platonien geboren und möchte mit Dir auf einer hohen Bergesspitze dastehend [den] Flug der Ideen schauen und wenn unsere laufende Frau kommt, freudig mit ihr wirbelnd fortschweben. Aber mir ist es nur gegeben nach rückwärts zu schauen und in den Raupen die Entwicklung des Schmetterlings zu genießen." Translation after Gombrich 1986, 110: "I, too, was born in Platonia and I should like, in your company, to watch the circling flight of ideas from a high mountain peak; I should like, at the approach of your lightfooted girl, joyfully to whirl away with her. But such soaring movements are not for me. It is given to me only to look backwards and to enjoy in the caterpillars the development of the butterfly."

87  Ibid.

expressed in "rapturous passion" (*stürmischer Leidenschaft*). Warburg, however, demands "art-historical rationality" (*kunsthistorische Besonnenheit*), and once again his aim is to present his conclusion that the incapacity to distance oneself from the object is the sign of an instinct-driven, "primitive" desire to grasp a thing physically rather than intellectually, to identify with and possess the artifact:

> The exhausted culture-lover of the present who goes to Italy to restore himself turns away from banal realism, expressing his feeling of superiority with a discreet smile: Ruskin's word of command sends him to the cloister, to a mediocre Giottesque fresco, where he is supposed to rediscover his own primitive sensibility in the touching, unspoiled and simple Trecento painters. Ghirlandaio, however, is no rural bubbling fountain of refreshment for Pre-Raphaelites, nor is he a romantic waterfall whose cascades inspire the other type of traveler, the superman on an Easter holiday with Zarathustra in the pocket of his loden coat, to gather new and vital courage in the struggle for survival, even against authority.[88]

Last but not least, the "Fragment on the Nymph" stands as an example of Warburg's own diligent documentary studies in the Florentine archives—according to Gombrich, inspired by Eugène Müntz's research on patronage[89]—and casts light on his opinion of the connoisseur's approach of Giovanni Morelli. While in his Leonardo lectures of 1899 Warburg had called the Morellian method a constructive contribution to the "solid criticism of style" (*solide Stilkritik*),[90] here he criticizes it as "too near-sighted" (*zu nahsichtig*) and calls its findings only valuable as for "the necessarily diligent separation of materials." As a self-sufficient method, Warburg considers it "grotesque." He could hardly have anyone other than Berenson in mind when he refers to those colleagues who "sniff their way through art history on hand and foot."[91] Although Berenson would publish his encomium on the method inspired by the writings of the autodidact Giovanni Morelli, *The Rudiments of Connoisseurship*, only in 1902, his life, he says, had changed one afternoon in 1888 when he came upon Morelli's writings. He decided thereafter to dedicate his "entire activity" to connoisseurship.[92] And he remained faithful ever after to the

88  WIA, III.55.2, fol. 12: "Mit dem diskreten Lächeln innerer Überlegenheit wendet sich der moderne müde Kulturmensch auf seiner italienischen Erholungsreise von so viel banalem Realismus ab: ihn zieht Ruskins Machtgebot hinaus auf den Klosterhof, zu dem mittelmäßigen Giottesken Fresko, wo er in dem lieben, unverdorbenen, einfachen Trecentisten sein eigenes primitives Gemüt wieder zu finden hat. Ghirlandajo ist eben keine ländlich murmelnde Erfrischungsquell[e] für Präraffaeliten, aber auch kein romantischer Wasserfall, dessen tolle Cascaden dem andern Reisetypus, dem Übermenschen in den Osterferien, mit Zarathustra in der Tasche seines Lodenmantels, neuen Lebensmut einrauscht zum Kampf ums Dasein, selbst gegen die Obrigkeit."

89  Gombrich 1986, 105.

90  WIA, III.49.2, fol. 3: "Anderseits sehen wir, dass wir heute eine solide Stilkritik besitzen, die mit dem ganzen Ernst naturwissenschaftlicher Detailbetrachtung arbeitet."

91  WIA, III.55.3.5, fol. 8: "[W]enigstens bin ich keiner von den Dir verhaßten Morellianern, die sich nach Deinem grotesken Ausdruck auf Händen und Füßen durch die Kunstgeschichte schnuppern."

92  Berenson 1949, 51.

method, unaffected by the developments around him, writing in 1949: "The endless footnotes flooding the few lines of text in archaeological and historical works, not to speak of such malodorous swamps as anthropology, sociology, politics and kindred writings, are, in themselves, so neutral that they serve equally to affirm what the last generation has denied and the next will affirm again."[93]

## Opponents

In 1927, as he looked forward to Berenson's visit, Warburg obviously expected scrutiny from his methodological rival, the undisputed and self-assured authority whose presence he seemed to have avoided thus far. Long before, after the very first meeting of the two on 5 May 1898, he recorded his opinion of his opponent's character, beginning, as was typical for him, with physiognomy: "Berenson: cold blue eyes, a striver and a snob, affected acuteness. No enthusiasm for publishing documents for him. 'I find pleasure in reading Greek, performing music; don't want to be digging around all day long.'"[94] Berenson was quite conscious of the impression he made on his colleagues, admitting later in his life that he gave offense by acting as if he did not think people were worth talking to, "whereas it was only that I wanted to change the subject, *umsteigen* in Mark Twain's phrase, to topics less controversial, more amiable, more amusing."[95] The young Warburg probably felt dismissed, and although he acknowledged without reservation Berenson's immense contribution, thanks to "the fabulous talent of his eyes," to bringing better order to the inventories (*Bestände*) of Italian art, he remained harsh in his general judgment, even twenty-seven years later. "As a type," he wrote to his younger brother Felix in 1925, Berenson was professionally "the absolute opposite of my own ideal" since he led his life as an "egocentric epicurean." Warburg continued:

> He is by no means a teacher. And when somebody sits comfortably in a niche with a nice view, this will in most cases serve as a narcotic so that [Berenson] can foist one of his many artworks upon him, with one wet and one dry eye, as a "selling friend" (the equivalent of a paying guest). This combination of art trade and art science has undermined him morally and cost him his good reputation, which he otherwise deserves as a scholar; I am thus—even if I am not too happy with myself in other respects right now—very satisfied about the pedagogical thrust of my library in comparison with such a type.[96]

93 Ibid., 63.

94 WIA, III.10.2, fols. 10–11: "Berenson kalte blaue Augen, Streber u. Snob, eine affectirte Schärfe (Dokumente für ihn publiziren) kein Enthusiasmus. Ich lese für mich griechisch, treibe Musik, mag nicht den ganzen Tag graben!" Berenson himself admitted that he attracted "culture-snobs," and refers to his pleasure in reading Greek: see Berenson 1949, 65, 83–85.

95 Berenson continues: "But no, some folk will insist on behaving like a monkey on a stick and never stop till they have exhibited to their abundant satisfaction those parts of themselves which others are perchance less eager to see." Berenson 1949, 63.

96 Aby Warburg to Felix Warburg, 16 April 1925, FC: "Er ist allerdings als Typus ein absoluter Gegensatz meines Ideals; denn wenn er auch durch seine fabelhafte Augenbegabung dazu beigetragen hat, die

This attitude helps to account for Warburg's surprised pleasure in the "reconciliation" that occurred during the visit, thanks to Berenson's unexpectedly sympathetic agreement with his ideas. A source of particular satisfaction for Warburg, however, was the prospect of a future connection with Harvard, Berenson's alma mater, as his subsequent report to Felix Warburg confirms. Felix had followed the lead of Jacob H. Schiff, his father-in-law, and become president, chairman, trustee, or board member of numerous charitable organizations. Among these was the visiting committee of the Fogg Museum of Harvard University, to which he had belonged since 1913.[97]

As a collector of prints and European paintings, Felix Warburg, a partner in the New York banking firm Kuhn, Loeb & Co., was certainly someone with whom the Berensons would have wished to become acquainted. Berenson himself, born into a relatively poor Lithuanian Jewish family, was attracted to members of the powerful and politically influential international circles to which Aby and Felix Warburg belonged. Writing to her mother in 1904, Mary Berenson admitted frankly that they wanted "to be in with all the rich Jews in New York," because Bernard and she had "an ideal of life that alas requires us to have enough money for ourselves and for the people we love, not to have to worry about it."[98] As is well known, they succeeded. Through the lucrative role of authority to wealthy collectors, Berenson was able to afford a lifestyle similar to that of his clients, the same wealthy class that generously funded Aby Warburg's enterprises. Years later, in a note dated 14 April 1947, Berenson denied that it was "mere snobbishness" that had brought him "to admire works of art among the upper classes," and explained: "Snobbishness is not admiration of people with a more attractive, more fascinating way of living than our own and the desire to frequent them and enjoy them as living works of art, but to adopt their standards at the expense of our own."[99]

Felix Warburg, on the other hand, who admitted that he shared Aby's views of Berenson and recognized his opportunism, also valued Berenson's professionalism, of which he had repeatedly made use.[100] Since Felix also valued his brother's opinion about his acquisitions, the correspondence between the two Warburg brothers is a rich source for any appraisal of the relationship between Aby and his American colleague.

---

Bestände der italienischen Kunstproduktion klarer zu ordnen, so ist das Ideal seiner Lebensführung an sich doch das eines egozentrischen Selbstgenießers. Ein Lehrer ist er gar nicht, und wenn jemand an seiner Nische mit der schönen Aussicht bequem sitzt, wird das in sehr vielen Fällen nur zur Narkose dienen, um ihm nachher eins von seinen vielen Kunstwerken mit einem nassen und einem trockenen Auge als 'selling friend' (Pendant zu paying guest) anzuhängen. Diese Mischung von Kunsthandel und Kunstwissenschaft hat ihn moralisch untergraben und ihn um das Ansehen gebracht, dass [sic] er sonst als wissenschaftliche Persönlichkeit verdient; daher bin ich mir doch, wenn ich mir sonst jetzt nicht gerade gefalle, mit der pädagogischen Ausbuchtung meiner Bibliothek gerade einem solchen Typus gegenüber sehr zufrieden.'

97  See Chernow 1993, 234–257; and Brush 2003, 27–29.
98  Samuels 1979, 413.
99  Berenson 1962, 264.
100 Felix Warburg to Aby Warburg, 20 April 1925, FC: "Deine Ansicht über Berenson teile ich gänzlich. Er hat sich seine Kenntnisse der Kunst erworben & nützt sie zu seiner & seiner kleinen Schar von Freunden & befreundeten Händlern aus.—Aber er kennt seinen Kram schon & sein Apparat ist sehr perfect." Felix Warburg received several opinions from Berenson. See Limouze 1995, 15.

While on a trip to Italy in April 1925, Felix Warburg and his wife Frieda were invited to I Tatti, which Felix described as "a splendid villa which [Berenson] has transformed completely for his own purposes…without a lecture room, but with vistas, artistically focused on sculptures or open views." He seemed prepared to admire the owner's leisurely approach to scholarship.[101] The purchase of a number of paintings must have been Felix's reason for being in contact with Berenson, who subsequently offered his somewhat tentative views about their attribution:

> I am delighted to receive the photos of your Italian pictures….I am very glad to discover that it is you who own the Predella of the Pesellinesque Polyphycle [*sic*], most of which is now in the National Gallery. I remember seeing them some 25 years ago at Cav. Ant. Gellis at Pistoja. The other photos interest me more than a little, but it is hazardous to dispute attributions of pictures when one has not seen the originals. Most of yours seem, however, obviously correctly described—the Cozzarelli for instance. The Lorenzo San Severino is startling. I have never before seen or heard of a Saint who takes a group of worshippers under his mantle.[102]

Felix sent his photographs, too, to his brother Aby, with the result that a rare example of Warburgian connoisseurship is preserved:

> Since gratitude for friendliness should not seduce me into a self-serving adulation [*streberhafte Schmeichelei*], I shall say straight away which paintings I don't like very much [*nicht schmecken*]. In fact there are only two which don't strike me as good. Firstly the Montana which I dislike as much as its frame; it has the feel of a replica. The Madonna's head is misdrawn and empty, and the hands are unspeakably bad, at least in the photograph. I should be glad if I were wrong. The same is true for the so-called Memling, which, if it is a genuine one, certainly cannot be earlier than 1510, but looks like a pasticcio. All other pictures are of good quality. Excellent are the 4 predella pieces by Pesellino which would make any gallery happy, even the largest one. I'd have to see the colors of the Bellini. They are probably its main value. The Raphael (which Swarzenski, by the way, calls undoubtedly genuine) is very attractive. I should like to see the original. As a cultural historian I am particularly interested in the so-called Filippo Lippi, because of the brilliant portrait of a bagpiper, as well as in the Defendente de' Ferrari owing to the unusual lighting problem."[103]

---

101 Felix Warburg to Aby Warburg, 4 April 1925, FC.

102 Felix Warburg to Aby Warburg, 30 July 1925, FC, with a copy of Berenson's original letter, dated 12 July 1925, enclosed.

103 Aby Warburg to Felix Warburg, 7 July 1925, FC: "Dankbarkeit gegen Freundlichkeit soll mich aber nicht zu einer streberhaften Schmeichelei verführen, darum sage ich gleich, welche Bilder mir nicht so gut gefallen. Es sind eigentlich nur zwei, die mir nicht schmecken. Erstens der Montana, der mir ebenso wenig wie sein Rahmen gefällt. Er schmeckt nach später Replik. Der Kopf der Madonna ist verzeichnet und leer und die Hände sind unglaublich schlecht, wenigstens auf der Photographie.

In the indirect competition between Bernard Berenson and Aby Warburg, the latter is more frank, hedges less, and articulates the interest of certain pictures for his own research. Unfortunately, we do not have Felix's response to Aby's assessment. It comes as no surprise, however, that two years later Aby would share with Felix his thoughts about Berenson's visit to his library. This becomes the third witness to the meeting. Aby first confirmed Felix's sense that the meeting would be amicable and went on to thank him explicitly for his role in making the visit successful.[104] The articulately emotional letter Aby wrote on 27 August 1927 is more explicit than the KBW diary entry and effectively sums up his appraisal of Berenson's character:

[The visit] went extremely well as your amicable brotherly nose—an excellent organ—had already sensed [gewittert]. Your share in this success is twofold: firstly I was able to see the inner, human side of the man Berenson, which he does not betray to everyone, because you had alluded to it (i.e., his testament); secondly we connected personally through the large photograph of the *cassone* front.... My attention had been drawn to this work of art by a small photograph I found during my only visit to Berenson's house (around 1898). Despite the inadequate size I could tell it was an important piece for the history of secular art.... Thus all inhibitions gave way to a mutual respect which I would not have been able to feel 20 years ago (apart from my objections to his commercial background) owing to his habit of giving himself airs by offering people acidic if often spot-on sarcasm. He made attempts of this kind at the outset of the visit; they disappeared, however, like butter in the sun when I parried patiently, and without acrimony. Most favorable was the fact that he brought with him Kingsley Porter, the well known, and here in Germany highly esteemed, art historian, and his charming wife. Both displayed such a beautiful and open enthusiasm, combined with such a devout expertise, that the company of all three, and of Miss Mariano—who seems to be a kind of guardian angel to the delicate Berenson—gave rise to an afternoon whose aura provoked a great yet totally unembarrassed enthusiastic mutual respect for which Mary and I will always be grateful. Mrs. Kingsley Porter wrote in a very friendly thank-you letter: "My husband says he envies our students who will have the privilege of working in your library." This remark relates to my telling them that I was planning to travel to America, perhaps in the coming spring, with the

Wenn ich mich irre sollte es mich freuen. Das gleiche gilt von dem sogen[annten] Memling, der, wenn er echt ist, sicher erst um 1510 herum anzusetzen ist, aber den Eindruck eines Pasticcio macht. Die anderen Bilder haben alle Qualität. Ausgezeichnet sind die 4 Predellen-Stücke von Pesellino, die jeder, selbst der größten Galerie Freude machen würden. Den Bellini müsste ich erst einmal in der Farbe sehen, das wird wohl seine Hauptqualität sein. Der Rafael, von dem übrigens Herr Schwarzenski [recte: Swarzenski] als einem unbedingt echten sprach, ist sehr anziehend. Ich möchte ihn wohl im Original sehen. Mich interessiert als Kulturhistoriker besonders der sogen[annte] Filippo Lippi wegen des glänzenden Porträts des Dudelsackpfeifers und der Defendente de Ferrari wegen des ungewöhnlichen Beleuchtungsproblems."
104 No document relating to this remark is extant.

goal of bringing Harvard and Hamburg into closer and more permanent connection as places for study.[105]

The rest of the letter makes even clearer Warburg's larger purpose in reporting to his brother. Warburg wanted to demonstrate his connection with respected American art historians who had strong links to Harvard. It was his plan to build a link between Hamburg and Harvard, an enterprise his four brothers were extremely reluctant to support. Travel to America would have been the starting point, but the visit and lecture tour was rendered impossible by the results of a medical examination in May 1928 showing that Warburg's heart was too weak for him to sustain such a strenuous trip. Although Warburg's plans never materialized, an exchange of letters with other American scholars, and in particular with Paul Sachs from the Fogg Art Museum,[106] confirms that Warburg's main purpose would have been creating the conditions for the education of the next generation:

> But if the quick [schnelle] connection between America and old Europe continues to progress so satisfactorily as it currently does, I can see the day coming when both our institutes will be able to complement each other in a most satisfying way. We will be glad if our German students over there with you could learn how insight into and experience of the artistic process might influence the training of an art historian in the most positive way, and the K.B.W. would consider it, in return, a most welcome duty to be allowed to show you how the pictorial element

105 Aby Warburg to Felix Warburg, 27 August 1927, FC: "Der Besuch [Berensons] verlief ganz ausgezeichnet, wie Deine brüderliche und freundschaftliche Nase—ein ganz ausgezeichnetes Organ—richtig gewittert hat. Nach zwei Richtungen hin hast Du an diesem Erfolge Anteil: erstens sah ich den Mann Berenson von seiner inneren, menschlichen Seite, die er nicht jedem verrät, weil Du (Testament) mir Andeutungen darüber gemacht hast; zweitens kamen wir in persönlichen Kontakt durch jene grosse Photographie von der Truhenvorderseite. . . . Auf dieses Kunstwerk war ich durch eine kleine Photographie gekommen, die ich bei meinem einmaligen Besuch bei Berenson (etwa 1898) fand, und die mir trotz des unzureichenden Formats verriet, dass hier ein ganz bedeutendes Monument zur Geschichte der weltlichen Kunst vorläge. . . . [S]o fielen nunmehr alle Hemmungen für eine gegenseitige Hochschätzung, die mich vor 20 Jahren (abgesehen von Einwänden gegen seinen weltwirtschaftlichen Hintergrund) nicht hätte erfüllen können, weil er die Gewohnheit hatte, sich durch einen ätzenden und meistens zutreffenden Sarkasmus vor den Leuten ein air zu geben. Erste Versuche der Art lagen bei unserem Zusammentreffen auch vor, verschwanden jedoch wie Butter an der Sonne, als ich sie in aller Ruhe und ohne Bitterkeit parierte. Sehr günstig wirkte, dass er Kingsley Porter, den bekannten, bei uns in Deutschland sehr hoch geschätzten Kunsthistoriker mit seiner reizenden Frau mitbrachte. Beide wurden von einem so schönen und offenen Enthusiasmus getragen, verbunden mit opferwilligstem Sachverstand, dass das Zusammensein mit den Dreien und mit Miss Mariano—die offenbar eine Art Schutzengel für den zarten Berenson ist—sich zu einem Nachmittag gestaltete, dessen Fluidum eine hohe und doch ungenierte enthusiastische Gegenseitigkeit hervorrief, für die Mary und ich stets dankbar sein werden. Frau Kingsley Porter meinte in einem sehr liebenswürdigen Dankesbrief: 'My husband says he envies our students who will have the privilege of working in your library'. Diese Bemerkung bezieht sich darauf, dass ich sagte, dass ich im nächsten Frühjahr vielleicht eine Reise nach Amerika machen wollte, zu dem Zweck Harvard und Hamburg als Studienplätze in gesteigerte und dauernde Verbindung zu bringen."

106 The former banker and associate director of the new Fogg Museum would later be instrumental in the transfer of Villa I Tatti by terms of Berenson's will to Harvard. See Samuels 1987, 325, 396, 498.

examined in connection with verbal documents— in poetry or prose—becomes a more palpable object of cultural scientific art history.[107]

With hindsight, Warburg's enthusiastically pursued but little-known attempt to export his cultural-historical method to the US in the 1920s seems indeed almost prophetic in view of the development forced by the emigrations of the 1930s.

Warburg also explained his plans to the sociologist Edwin R. Seligman, writing that it would be "useful for both sides to make the cultural historical method . . . known in America," while he expected "reciprocal advancement of [his] own ideas from American positivism."[108] In another letter to Seligman, he contrasted his method explicitly with any notion of life-enhancement and self-indulgence in relation to art:

> I can well imagine that for outsiders and for art historians in the usual style it is not easy to see that sociology and art history should live in closest contact. Especially in America precisely that trend in art history, which takes the description of the individual work of art as its self-sufficient goal and therefore implicitly grants the owner the right to the most personal artistic <u>enjoyment</u>, has now arrived. Please do not let yourself be shaken by any kind of *bonsens* from at least looking at the contact between sociology and art history as the object of an inevitable recognition. This is precisely what I hope to demonstrate in 1928, notwithstanding all the difficulties. . . . Word and image as a higher unity must be interrogated as spiritual documents in order to recover the essence of the European man (and of mankind in general).[109]

107 Warburg to Sachs, 7 June 1927, GC: "Wenn aber die schnelle Verbindung zwischen Amerika und dem alten Europa weiter so erfreulich fortschreitet, sehe ich den Tag nicht mehr in weiter Ferne, wo unsere beiden Institute sich aufs Erfreulichste ergänzen können. Wir werden froh sein, wenn unsere deutschen Studenten bei Ihnen drüben erleben dürfen, wie der Einblick und das Miterleben des künstlerischen Prozesses die Ausbildung des Kunsthistorikers glücklich beeinflussen, und die K.B.W. würde es andererseits als eine besonders willkommene Pflicht ansehen, wenn wir Ihnen zeigen, wie das bildhafte Element durch Zusammenschau mit den sprachlichen Urkunden— dichterischer und prosaischer Art—zum plastischeren Objekt einer kulturwissenschaftlichen Kunstgeschichte wird."

108 Warburg to Edwin R. Seligman, 17 August 1927, GC: "Ich glaube, dass seit den 32 Jahren, die seit meiner ersten Reise nach Amerika vergangen sind, die Kunstgeschichte sich soweit entwickelt hat, dass es für beide Teile lohnend ist, von ihrer durch mich gepflegten kulturwissenschaftlichen Tendenz in Amerika Kenntnis zu geben, weil ich von dem amerikanischen Positivismus eine wesentliche Förderung meiner Ideengänge erwarte."

109 Warburg to Edwin R. Seligman, 1 November 1927, GC: "Ich kann mir freilich denken, dass es für die Aussenstehenden u. für die Kunsthistoriker im üblichen Stil nicht ganz leicht ist, einzusehen, warum Gesellschaftswissenschaft und Kunstgeschichte miteinander in engster Fühlung leben sollten. Besonders in Amerika ist ja gerade die Richtung der Kunstgeschichte, die die Beschreibung des Einzelkunstwerks zum Selbstzweck macht, u. damit auch dem Besitzer das Recht auf persönlichsten Kunstgenuss implicite einräumt, eben erst angekommen. Lassen Sie sich bitte von keiner Sorte von Bonsens darin erschüttern, dass Sie den Kontakt zwischen Soziologie u. Kunstgeschichte wenigstens als Objekt für eine unerlässliche Rekognoszierung ansehen. Eben dieses hoffe ich trotz aller Schwierigkeiten, die ich zu überwinden habe, 1928 ausführen zu können. . . . Wort u. Bild als höhere

It is quite likely that Warburg's strong desire to "break through to America" played a role in the successful "reconciliation" with Berenson. Despite the evidently persistent differences between Warburg and the self-declared "humanist," who, in the footsteps of Walter Pater, condemned the inability to appreciate art,[110] Warburg felt convinced of his success in demonstrating to Berenson the relevance of details in paintings (details other than the notorious ears and fingernails on which Morelli focused) for answering questions of dating and attribution. Ultimately, one remains unconvinced that Berenson was indeed converted to Warburg's approach. Although he seems to have shown on this occasion an unexpected goodness of heart—an attitude which Gertrud Bing, after having spent an evening at I Tatti in 1929 together with Warburg, would characterize as the "'mature' human touch" (*"altersreife" Menschlichkeit*)—his wholesale rejection of Erwin Panofsky's all too technical method proves his commitment to his own position. Berenson's response to Paul Sachs's attempt to grant Panofsky a professorship at Harvard reveals personal and professional antipathy. Berenson called into question Panofsky's ability as a teacher of art history and even his decency as a colleague; in short, he saw Panofsky as the incarnation of his natural rival.[111] Panofsky's 1953 definition of "history of art" as standing in opposition to "aesthetics, criticism, connoisseurship and 'appreciation,'" and rather being "the historical analysis and interpretation of man-made objects to which we assign a more than utilitarian value,"[112] reminds us once again of the fundamental differences between Warburg's approach and that of Berenson.

Only two years after Berenson's trip to Hamburg, his young apprentice Kenneth Clark attended Warburg's methodologically fundamental lecture at the Bibliotheca Hertziana in Rome, delivered on 19 January 1929. "Thenceforward my interest in 'connoisseurship,'" Clark concluded in his description of the event, "became no more than a kind of habit and my mind was occupied in trying to answer the kind of questions that had occupied Warburg. The parts of my writing that have given me most satisfaction . . . are entirely Warburgian."[113] It was indeed effectively the following generation that profited most from the substantial support that the two private scholars, Warburg and Berenson, had received from private wealth. Berenson acknowledged this in his autobiographical *Sketch for a Self-Portrait*, expressing a strong belief in the continuity of his work:

> Not only did [the material advantage] enable me to pay for assistance in any work, for comfort at home and abroad, and for expensive journeys, but it gave me the means to acquire the books and photographs that my study and research

Einheit sollen als seelische Dokumente nach dem Wesen des europäischen Menschen (bzw. des Menschtums überhaupt) befragt werden." Translation (with small variations) after Stimilli 2005, 201.

110  Pater 1893, xvi; cf. Samuels 1987, 402.

111  Berenson's response was sent to Sachs as a cable. See Panofsky 2001, 722: "Learned industrious ambitious uses Talmudic dialectic to prove that in every field he alone is master. His work in my field deplorable in itself and deliberately unfriendly to me." Ernest Samuels refers to Berenson's characterization of Panofsky as the "Hitler of art study": see Samuels 1987, 402–404.

112  Panofsky 2001, 322.

113  Clark 1974, 190.

required. The only boast I feel like making is that the library I have accumulated item by item during the last fifty years will enable those that come after me to continue my kind of work for generations to come. It will require relatively little outlay to keep it up to date.[114]

Warburg, in contrast, chose to address his benefactors directly. Using his typical metaphor-laden language, he thanked his brothers more than once, stressing the "intellectual" interest of the family's generous investment in his institution and writing: "your help and sympathy for my enterprise has served a public purpose which only in later years, after we are gone, will prove its strength as an intellect-attracting force."[115]

114 Berenson 1949, 41–42.
115 Aby Warburg to Paul Warburg, 8 June 1926, FC: "dass Eure Hilfe und Anteilnahme an meinem Unternehmen einem überpersönlichen Zweck zu Gute gekommen ist, der sich erst in viel späteren Jahren über unsere Köpfe hinweg in einer geistversammlenden Kraft bewähren wird."

~~~~~

Appendix

Extract from the KBW *Tagebuch*

Warburg Institute Archive, III.15.1.3, fols. 65–67. The transcript is based on the original, with minor corrections to the published text; see Warburg 2001, 134–135.

Gestern ein sehr glücklich verlaufener kritischer Tag erster Ordnung: Verständigung mit Berenson, recte: 'Aussöhnung'. Seit 1898 standen wir zuerst uns durchaus feindselig gegenüber. Ich fand ihn als Stilschnüffler und Einzelkunstwerkbeschreiber und im Kunsthandel überschätzt, er verachtete die deutsche Gelehrsamkeit und psychologische Fabulierkunst in einem Typus wie Schmarsow. Außerdem war er dem Altertum gegenüber aesthetischer Rekreationssucher: 'er wolle nicht den ganzen Tag graben'. Es kam hinzu, daß wir damals in unserem Chambre garni und ich in der Abhängigkeit von dem stumpfen Brockhaus auch äußerlich im Hintertreffen waren, so daß ich seinem Snobismus auswich.—Noch einmal habe ich ihn in Settignano besucht und fand bei ihm die kl[eine] Photogr[aphie] der Giostra, die dann Felix vergrößern ließ. Ich hatte sie gestern parat (und nicht einmal daran gedacht, daß ich B[erenson] diese verdankte). Der Beginn des Besuchs brachte das übliche Scheingefecht: Berenson äußerte sich [im] Empfangszimmer sehr hart über Carlyle und Norton, was ich auffing und in aller Ruhe parierte und regulierte. Erzählte von m[einem] Besuch bei Norton. Daß sich alles in die Bahn eines fast enthusiastischen gegenseitigen Verstehens lenkte, war auch der gleichzeitigen Anwesenheit von Mr. und Mrs. Kingsley Porter (die er mitgebracht hatte) zu verdanken und der Anwesenheit seiner Bibliothekarin Miss Nicky Mariano, die nicht nur sehr sachverständig ist: sie scheint ein 'angelo custode' für den zarten Mann. Im großen Saal fiel ihm sofort die B[rie]fm[arken] Litt[eratur] auf: es schnürten sich ab: Barbados—Vergil—Neptun—Dürer, Pathosformel (wirkte überzeugend—bis Akropolis von Oraibi. (Offenb[a]r[un]g für Amerikaner) Am stärksten aber wirkte die große Photogr[aphie] des Cassone und die Möglichkeit d[er] Datier[un]g f[ür] d[ie] Pferdezügel—Guidagnolo—<u>das</u> erfreute ihn, denn er glaubt, daß d[er] Maler Domenico Veneziano sei und hatte nur auf das Datum gewartet. Ich sagte B[erenson] bei dieser Gelegenheit, daß ich den Cassone in Yale selbst zu interpretieren hoffe und auch nach Cleveland wolle, wegen des 'Corso del Palio' (NB. Mr. Williken, der Direktor des Mus[eums] ist Kingsley Porter sehr gut bekannt, wie denn die Idee, daß ich herüber kommen würde, später mit wirklich tiefem Verständnis aufgenommen wurde); ich erklärte z[um] Schluß, daß ich die Verbindungsbrücken zwischen deutschem und amerikanischem Studententum herstellen wolle; daß es keinen besseren Typus geben könne als z[um] B[eispiel] Mr. Kuhn. 'Unser Schüler, sagte Frau Kingsley Porter und wir zeigen Ihnen drüben noch bessere.' 'Na also'. Saxl hatte erfreulicher Weise Veranlassung, sich in die Corona einzufügen, weil ich das 'Paukblatt' haben wollte (NB wo ist die Photogr[aphie]? bei Bildern Festwesen?). Dadurch ergab sich eine wertvolle Zweistimmigkeit im Kampfe um Eisslers [*sic*] Charakter, den Berenson

Claudia Wedepohl

nicht recht einordnen konnte.—Fr[äu]l[ei]n Bing fehlte leider; ich hätte ihr nicht erlauben sollen, fernzubleiben. Beim Abschluß der Besichtigung wollte ich einen 'Abteiler' überreichen. Anstatt das [sic] Heydenreich, dem ich es sagte, sofort davonflog, wurde erst der Instanzenzug nach unten gewahrt: wenn ich—todmüde—4 ¼—7 ¼ in irgend etwas Unterstütz[un]g verlange, so ist Jeder (ich inklusiv) nichts als Atom in unserem Planetensystem. Nur keine narcissige Holzbockigkeit. Bin sonst mit dem Einwirken unser [sic] Bibliothek auf diesen Besuch herzlichst zufrieden

EIGHT

Bernard Berenson and Islamic Culture
"Thought and Temperament"

MARIO CASARI

Bernard Berenson's long and complex encounter with Islamic culture began in his student days, and from the earliest period at I Tatti until his death he actively acquired the major books on Islamic history and arts. In 1910, he bought the first Persian miniatures that would constitute the heart of his small collection of Islamic art. By 1913, the Islamic phase of his collecting was over, and thereafter it did not compete with the central fields of his connoisseurship and scholarship. Nevertheless, Berenson's engagement with the Islamic world constitutes a strand, sometimes thin and at other times robust, that entwines other interests throughout his long career.

This essay uses a broad definition of "Islamic culture" that includes the religious aspect implied by the adjective, but refers also to a system of civic life, a complex of sociocultural relations across a wide geographical area involving three continents and spanning fifteen centuries. Despite its extremely complex and diverse nature, Islam can be associated with certain cultural forms that have given rise to a flourishing of art, literature, philosophy, and science in numerous languages, styles, and techniques. The "Islamic world" should be understood as the web of societies in which Islam is recognized as socially dominant, but where non-Muslims have played an integral part, manifesting their own cultural, social, and political mores, though often expressed in the same languages and techniques as the dominant Muslim populations.[1] Berenson often viewed the Islamic world and its culture

I would like to thank the organizers of the conference "Berenson at Fifty" and, in particular, the former director and assistant director, respectively, of Villa I Tatti, Joseph Connors and Louis Waldman, for having invited me, while I was a fellow at the villa, to undertake the research

as intrinsically linked to the other cultures of Asia, especially the Indian subcontinent and China and Japan, under the all-embracing labels of "Orient" and "Oriental." Such terms will be maintained in this essay when they correspond to Berenson's view.

To trace Berenson's relationship with this broader concept of Islamic culture requires exploration across a wide range of sources, from his travel diaries and correspondence to his autobiographical works and his essays on aesthetics. The formation of his Islamic art collection and of his Oriental Library, today the Asian and Islamic Collection of the Biblioteca Berenson, are also included in this research, as is the accumulation of material relevant to Islamic art in the Biblioteca Berenson and Fototeca at I Tatti. I have attempted to compose a mosaic in which Berenson's curiosity and his passionate pursuit of objects play a role, but so do his eventual diffidence and aloofness toward this exotic world, which exerted a strong fascination but also evoked a deep-seated and reciprocal hostility with the West—a sentiment that was particularly clear in the colonial era of which Berenson was a part.

The thread that I will weave out of occasional material from this wide and heterogeneous range of sources may offer us insights not only into this sector of Berenson's activities, but also into his entire life's work. The phrase in my title, "thought and temperament," derives from a poem by the young Berenson. I have adopted it here to encapsulate the duality of his approach toward the world that is the object of this study, an approach constantly torn between reflection and impulse, curiosity and diffidence, fascination and repulsion. I have organized the material into three parts, which reflect chronology but also embody coherent themes that recur over his entire lifetime, ebbing and flowing as his attitudes toward Islamic culture developed.[2]

presented in this essay on this still quite little-explored subject concerning the figure of Bernard Berenson. There are many people whom I should like to thank for their generous help throughout this research, especially Michael Rocke, Giovanni Pagliarulo, and Ilaria Della Monica, responsible respectively for the Biblioteca, Fototeca, and Archivio Berenson, as well as the current assistant director Jonathan Nelson, for their constant assistance in the consultation and reproduction of the various materials presented here, and for the valuable suggestions and advice that they have offered me at various stages in my work.

1 Terminological issues are still strongly debated, and the reader should be aware of the intentionally broad sense given here to the adjective "Islamic." Additionally, in recent decades, some scholars have questioned the term "Islamic art." The term reflects a modern notion, developed by European and American art historians in the late nineteenth and early twentieth centuries, in order to schematize a still unfamiliar visual world, which seemed to contain common features from regions as diverse as Andalusia and Iran, and whose producers were Arabs as well as Persians, Turks, or others. But "Islamic art" remains widely used in scholarly and general texts, and the term will be used in this essay, in part because it accurately reflects how Berenson and his contemporaries looked at this broad area of human artistic production. On these issues, see Hodgson 1974, esp. 1:3–69; the two collective volumes Komaroff 2000 and Vernoit 2000; and Blair and Bloom 2003.

2 The fundamental tools that have provided the basis for this research include the two published inventories, *Bibliografia di Bernard Berenson* (Mostyn-Owen 1955) and *The Berenson Archive* (Mariano 1965), as well as the large electronic finding aid of the Biblioteca Berenson at Villa I Tatti. Central to the research, in addition, are Bernard Berenson's biographies: *Berenson* (Sprigge 1960), *Being Bernard Berenson* (Secrest 1979), *Bernard Berenson: The Making of a Connoisseur* (Samuels 1979), and *Bernard Berenson: The Making of a Legend* (Samuels 1987). The transcription of

Learning *Überhaupt*

In one of his most intimate writings, composed late in life, Berenson speaks of feeling at times like "a typical 'Talmud Jew.' 'Talmud' means 'learning' *überhaupt* and that has been my chief pursuit."[3] An encyclopedic curiosity similar to Talmudic learning was indeed the basis of Berenson's formation as a young Orientalist. After entering Harvard University in the autumn of 1884, Berenson dedicated particular care to the study of languages: Latin and Greek, but also Hebrew, a subject in which he excelled thanks to his childhood education and the tutelage of Professor David Gordon Lyon. He went on to study Sanskrit with Professor Charles Rockwell Lanman and Arabic with Professor Crawford Howell Toy.[4] It was Arabic that he preferred: "he felt that only Arabic was really profitable, because it led him into belles lettres and art, whereas Sanskrit and Hebrew were like 'biting on the trunks of trees' whose fruit he 'had already enjoyed.'"[5] The vast and variegated list of Berenson's youthful reading matter, recorded by Mary Berenson in a diary entry of 1890, includes the following: "Sacred Books of the East (some in the original), Arabian Nights (in the original, and Burton and Payne), Persian (followed orientalism and philosophy)," and shortly after, "craving for oriental languages, histories, literature, for philology as a method."[6] Much later, in his *Sketch for a Self-Portrait*, when he surveyed his own youthful trajectory, Berenson affirmed the value of acquiring a language in order to comprehend the thought categories of a people and to enjoy direct contact with its art and literature:

> The person of general culture has no idea how much he is misguided by fanatical propagandists and sheer fakers who claim or pretend to inform him about things of the Moslim or Hindu world. An acquaintance with the grammar of their languages opens an insight into their categories of thought, an even slight familiarity with their literatures in the originals, with their modes of feeling, and of course a direct contact with their arts, of the world as they desire it and want to see it."[7]

Berenson's linguistic education was never completed, however. In 1910, at the height of his interest in Oriental art, Berenson complained in a letter to Isabella Stewart Gardner that he could remember none of his Sanskrit and Arabic.[8]

Arabic and Persian terms and names is given in the most simplified and common way, except for book titles, which have been transcribed, for the sake of precision, according to the scholarly system.

3 Note dated 26 February 1953: see Berenson 1963b, 302.

4 Samuels 1979, 28–33.

5 Ibid., 31; Berenson's quotations are from his petition letter for the Parker Traveling Fellowship in 1887 (on which see below), reported in Sprigge 1960, 58–60 (quotations on 59).

6 Samuels 1979, 25. I could not find the original diary in the Biblioteca Berenson. Sacred Books of the East was a celebrated series of key religious texts edited by the linguist and scholar of comparative religion, Max Müller, and issued by Oxford University Press between 1879 and 1910.

7 Berenson 1949, 101–102.

8 "I am plunged deep in Egyptian and Babylonian history and art, and primitive, and Oriental things in general. I now wish I remembered my Sanscrit and Arabic": Berenson to Gardner, 17 April 1910; see Hadley 1987, 470. And again in Berenson 1949, 101: "I have forgotten the very alphabet of Sanskrit

In his student days, Berenson was first a collaborator and then editor in chief of the *Harvard Monthly*. He produced nineteen essays, reviews, poems, and short stories, including one piece on an Islamic subject.[9] Published in the spring of 1887, it bore the title, "Was Mohammed at all an Impostor?," which though it sounds provocative does not intend to be denigrating.[10] Rather, the piece is an attempt at a psychological interpretation of a figure from the distant past following the theories of William James, which Berenson would later apply, in quite different fashion, to his Italian painters.[11] His at times severe assessment of what he saw as the lustful and ecstatic personality of Mohammed derives from classic authors such as Edward Gibbon, Gustav Weil, Theodor Nöldeke, William Muir, and Aloys Sprenger,[12] interspersed with an initial meditation on some passages from the Koran, which he was reading in the original under the guidance of Professor Toy. His conclusion has both an emotional and an aesthetic component:

> We gain little by adjudging Mohammed this, or by adjudging him that. We gain a great deal, however, if through the study of Mohammed we come to the conviction, that he, in common with such men as Savonarola and Luther possesses a certain virtue, each of his own,—a virtue which we lack; which they can supply to us: a certain grandeur, a certain transcendency, a certain sincerity withal, that has a potent tonic effect upon us.[13]

Here we have an echo of Thomas Carlyle[14] and a fascination with romantic Orientalism more than the embryo of specialized research on Islam and the Arab world.

Indeed, Berenson's study of Arabic and Islamic culture grew fainter over time. Among his papers one finds a pair of short manuscript translations of two poems by Imru'l Qays and Labidh from the *Mu'allaqāt* (a collection of seven celebrated Arab poems from the pre-Islamic period), together with their respective commentaries.[15] These translations, which cite the original Arabic in good calligraphy, were done by John Orne Jr. in Cambridge in June 1885 and August 1886 (Fig. 1). Orne, who later became curator of

and it occurs to me to regret the youthful energies spent on trying to learn it as well as other marginal or exotic languages equally forgotten. They did discipline me, not only as an undergraduate but for years afterwards, rousing curiosities eager to be satisfied, curiosities which are not yet spent. But in the human lot there is no more gain without loss than loss without gain. What I have gained is not only the possibility of keeping up, to the extent of my leisure, with results of research in various fields; but immunization against humbug."

9 See Mostyn-Owen 1955, 33–35.

10 Berenson 1887b.

11 See Samuels 1979, 44–45; see also Rubin 2000a, esp. 207–209, and Alison Brown's contribution to this volume.

12 See Gibbon 1845, chap. L; Weil 1843; Nöldeke 1863; Muir 1858; and Sprenger 1861.

13 Berenson 1887b, 63.

14 See Carlyle 1866, 38–69 ("The Hero as Prophet"). Carlyle also appeared on the list of Berenson's important readings cited by Mary Berenson (see above), and in 1900 Berenson declared himself "Carlyle mad" (Berenson to Senda Abbott, 3 October 1900; see Samuels 1979, 345).

15 The translations are based on Arnold's edition (Arnold 1850), which is still in Berenson's book collection, while the two commentaries are by an unidentified writer and the celebrated al-Zawzani.

the Arabic manuscripts of the Harvard Semitic Museum (1899–1911), must have given them to Berenson as a personal gift in those years, although it has not been possible to discover how Berenson used them himself. Later notes refer to his reading of the *ghazals* (love poems) by the Persian poet Hafez, and to his amazement at the fact that they celebrate men.[16] He also used a disquisition on Arabic verse to beguile Vernon Lee during their first Florentine meeting when he was still young.[17] Together, these fading traces of engagement with the literatures of the Islamic world represent a small corpus of references that seem to be an extract of a book he appreciated, Johann Wolfgang von Goethe's *West-Östlicher Diwan*, rather than the product of independent reading.[18]

Berenson's education in Oriental studies would, therefore, remain a potential that was never realized. It is perhaps a sign of fate that his application for a traveling fellowship was rejected. On 30 March 1887, he applied for one of the four Parker Traveling Fellowships to study in Europe, including courses in Hebrew, Arabic, and Persian, buttressed by strong recommendations from his language professors. On the application, he wrote:

> The Arabic which I am reading with Prof. Toy is interesting me more, and more, and it is my intention to devote a good portion of my time in the future to the literary study of Arabic literature. I feel what few have realized: that Arabic literature has a tangibility, a virility, and a sanity of passion not only to inspire the student,

16 "When I was young, at Harvard—I must have been seventeen or eighteen—one day I sat down to read a quantity of Arab poetry by Hafiz, and with amazement saw that love was being addressed to boys. So I asked my professor what this meant, and he—and I don't believe he was being hypocritical—explained to me that in those times it was not permissible to dedicate verses of love to women, so the poets changed the names of their loved ones and pretended to have masculine lovers": 3 February 1931; see Morra 1965, 8. The gross mistake of Arabizing the famous Persian poet Hafez should be ascribed to Morra's mistranscription of the conversation rather than to Berenson's unlikely confusion.

17 "When I first knew her, she ascertains, I was only interested in Arabic poetry. Actually the story goes as follows: I was in Florence for the first time—very young (very handsome, according to her, and I am convinced; also very seductive, but this I have no way of knowing) and I had a letter for her which she told me to deliver at her house at about ten o'clock some evening when I had nothing else to do. I went one evening and found a flock of women around her (she was uglier than she is today) all striking more or less Botticellian poses, all breathing an aura of acute Renaissance. What was I going to do in the midst of them? I had to interest them and stupefy them with some thing which they would never have thought of. I knew a little bit about Arab poetry, and I spoke about Arab poetry, and I brought her a volume of translations which furthermore I didn't believe she would ever give back": 2 November 1931; see Morra 1965, 93.

18 Goethe was, of course, in Mary Berenson's list of 1890, mentioned above, but an explicit acknowledgment of his *West-Östlicher Diwan* is in a later diary in the Biblioteca Berenson (23 August 1946): "Greatly enjoying Goethe's appendix to his 'West-Östlicher Divan'. He never wrote better expository prose. Amazing how he assimilated and grasped the essence of the recently discovered Orient. He has a better sense of what it was in character and as achievement than is the case with most scholars and historical pundits of today. To think Goethe achieving this as an elderly man in the midst of so much else." (Compare also with Berenson 1959, 196–197, a slightly varied transcription of the observations contained in the original diary, 30 August 1946, Bernard and Mary Berenson Papers, Biblioteca Berenson, Villa I Tatti—The Harvard University Center for Italian Renaissance Studies [hereafter BMBP].)

A
Literal Translation
of
Amrolkais,
The 1ˢᵗ Poem of the
Moallakat.
Arnold's Edition.
1850.
By John Orne Jr.
Cambridge. Mass.
June, 1885.

1.

Stay, we-will-weep at remem-
brance of the-dear-one and-of-
the-station, by-the-edge of-the-
sand between Dachul and-
Haumel

1

English translation of
Imru'l-Qays' *mu'allaqa*,
by John Orne Jr.,
June 1885. Bernard and
Mary Berenson Papers,
Biblioteca Berenson,
Villa I Tatti—The
Harvard University
Center for Italian
Renaissance Studies.
It is one of the few
material traces of
Berenson's juvenile
engagement with
Arabic studies.

but also to be a revelation to the Occident, where Arabic literature has been very little appreciated.

It is not my intention, however, to hunt for new treasures, or to edit new editions. I mean to learn to appreciate the Arabic classics so well, that my appreciation may tempt others,—a temptation I hope to foster by my writings. All this, and much more I owe to Prof. C. H. Toy, who understands me, and to him I appeal.[19]

19 Berenson's plans were vast and ambitious: "From the middle of July to the opening of the university at Berlin I should make Paris my head-quarters ... The winter semester I should spend in the study of practical art problems, and of Arabic at Berlin. Then I should go [to] Italy where I should spend

The application was rejected, however, and it soon became clear that Berenson's destiny lay elsewhere. He still managed to depart for Europe, thanks to the support of admiring friends like Isabella Stewart Gardner, but his new directions did not include the study of Oriental languages.[20]

On another level, however, the legacy of those early studies was considerable, and not only because *One Thousand and One Nights* became one of his most beloved books, cited on numerous occasions in his memoirs and reflections. (He began reading the work in the original Arabic, then the English versions by Richard Francis Burton and John Payne, and especially the French translation by J. C. Mardrus.)[21] More importantly, the competence he acquired in the field helped him give shape to the Asian and Islamic section of his great library, which also covers India and the Far East. The Islamic section contains a more or less exhaustive collection of the principal publications up to his death, covering history, anthropology, philosophy, religion, literature, and art, as well as a number of geographical and ethnographical reportages and travel diaries. These cover a great variety of regions, from the west of North Africa to northern India and central Asia. Some texts of particular value were the fruit of suggestions and generous exchanges with experts in the field of Islamic art and archaeology whom Berenson met later, such as Friedrich Sarre, Rudolf Meyer-Riefstahl, Mehmet Aga-Oglu, and Archibald Creswell: these contacts were made through mutual friends, or by chance, or through specific interests. Some of the volumes acquired by Berenson during this period remain a unicum among Italian libraries.

There has been some growth in the Asian and Islamic Collection in the five decades since Berenson's death. It currently contains approximately 3,400 books; 1,000 periodical volumes, including 30 titles in complete runs and 19 currently received; and 1,000 auction catalogues of Islamic and Oriental art objects, miniatures, and carpets.[22] The material on

the rest of the year in the study of art, and Italian literature. Art prevails in this programme, because it is there where I feel myself weakest ... In a sojourn abroad of three years I should much extend my plans. I should devote a good part of the time to the study of the literature which had its origin in the places in which I happened to sojourn. I also should avail myself as much as possible of opportunities for literary study of Arabic, Hebrew, and Persian." Professor Toy expressed himself with particular enthusiasm: "His natural gifts and his attainments appear to me to be uncommonly excellent ... His reading is enormous without being superficial. He combines in a very unusual way acquaintance with Eastern and Western literatures." Perhaps the commission did not appreciate Berenson's strongly self-eulogistic tone. For the whole matter, see Samuels 1979, 49–51, with related references. The almost complete document is reported in Sprigge 1960, 58–60, in a slightly different form.

20 Anxious to depart, he left with a friend the task of receiving his diploma: honorable mention in Semitic languages and English composition. Then, "Education went on apace in Berlin. ... Professor Toy's influence had clearly waned, for one reads nothing further about Arabic studies": Samuels 1979, 73. Toy remained in contact with Berenson and they met again in Cambridge, Paris, and also Florence: ibid., 216.

21 Only the versions of Payne and Mardrus are now present in the Biblioteca Berenson. "She [Hortense Serristori] was in ecstasy yesterday hearing Nicky read the story of Sharkan and Abriza in Mardrus' version of the *Thousand and One Nights*. Then we recalled with what enjoyment we read these volumes as they kept appearing, one after the other, and how once she exclaimed, 'What shall we do without further volumes of Mardrus!'": 8 November 1957; see Berenson 1963b, 503. See also Berenson 1960a, 59; and Morra 1965, 13.

22 One can refer here to the Berenson Library website; see also Rocke 2001.

the Islamic world constitutes more than one-third of the total. In a more comprehensive overview, one would add the considerable number of books in the House section of the library that deal with North Africa and the Middle East, which reflect Berenson's dream of embracing all human endeavor in his mind. Berenson's personal vision of the Mediterranean world thus led the research center that followed in his wake to be the prototype of a universalist approach to the study of the Renaissance.[23]

Berenson's reading and his association with figures such as Sarre, Meyer-Riefstahl, Aga-Oglu, and Creswell stimulated his curiosity about Islamic architecture, which he discovered during his first visit to Egypt in 1921–22. It made a strong though not unalloyed impression: "Such a treat as Arab architecture," wrote Mary to her mother from Cairo, "for two hardened sight-seers was never invented, for not only is it as grand and beautiful & varied & important as our own Northern Gothic, but it is almost unknown!... Bernard says 'It has ruined me as a European,' but he is so intoxicated with it that he <u>doesn't care</u>."[24] The I Tatti Fototeca still holds a copy of Creswell's photographic archive that is almost the equivalent of the originals in the Ashmolean Museum.[25] In addition, Berenson and Nicky Mariano continued to add cuttings and leaflets on this subject from various sources over the years.[26] Some scholars continued to see Berenson as a reliable source of advice on aspects of Islamic decorative arts as reflected in European art, and on scholarly publications.[27] Berenson always responded with interest, providing moral support (such as for the appointment of Aga-Oglu as curator at the Detroit Institute of Arts)[28] but occasionally also material support, as in the case of Creswell, whom he met in Cairo in 1922[29] and whose photographic campaigns he partly financed.[30] Creswell reciprocated by sending Berenson all of his publications as they came out. More valuable still, in 1954, Berenson asked Creswell to send him a draft of Creswell's vast bibliography on Islamic art, published only in 1961,[31] a sign of Berenson's indefatigable efforts to establish a complete library, even in a collateral field.[32]

23 My thanks to Scott Palmer, responsible for the periodicals collection at Villa I Tatti, with whom I discussed various issues concerning the actual form of the Asian and Islamic Collection.

24 Mary Berenson to Judith Berenson, 17 December 1921, Houghton Library, Harvard. Thanks to Ilaria Della Monica for pointing out this passage and transcribing it for me.

25 They are grouped into thirteen different folders; thanks to Martina Rugiadi for her careful comparative work on this.

26 Five boxes in the Fototeca contain various materials on "Indian Islamic Miniatures," "Islamic Architecture and Sculpture," "Persian & Islamic Decorative Arts. Textiles, Pottery, Frescoes," "Persian Miniatures," and "Damascus."

27 For instance, see Berenson's correspondence (BMBP) with Ernst Kühnel, curator of the Islamic collections of the State Museum (Kaiser Friedrich) in Berlin; Louis Massignon, the French Catholic theologian and scholar of Islamic studies; Teodor Macridy Bey, vice director of the Ottoman Museum in Istanbul; and Leo Avy Mayer, from the Government Museum of Antiquities in Jerusalem.

28 See Berenson's correspondence with both Rudolf Meyer-Riefstahl and Mehmet Aga-Oglu, BMBP.

29 See Mariano 1966, 46.

30 See Berenson's rich correspondence with Creswell (BMBP), spread over a wide period of time (twenty-four letters, 1922–58).

31 Creswell 1961.

32 Toward the end of his life, it was indeed his universalistic library that Berenson considered to be his greatest legacy. "What treasures in every field of art. Scarcely anything missing that really counts,

Nonetheless, Berenson remained focused on the idea of the Mediterranean as the cradle of the great civilization of which he felt himself son and bard. He drove himself to explore the Greco-Roman Mediterranean with all of its neighboring and superimposed cultures, wherein he found material for his long-term project on the decline and recovery of the arts.[33] This Mediterranean was the object of many journeys in the 1920s and 1930s with Mary, or Nicky, or both, which included countries that we would consider part of the Islamic world but which were, for Berenson, witnesses especially to Greco-Roman and Byzantine culture.[34]

From Berenson's scattered annotations, from Nicky Mariano's descriptions (in *Forty Years with Berenson*), and above all from Mary's three accounts, cast in the style of the aristocratic travel diary in vogue at the time,[35] we can form an impression of these intense journeys. The terrain could be wild and inhospitable, but the exotic context—with its sketches of veils, turbans, caravansaries, bazaars, and evocative sounds, as in classic Orientalist literature—provided only the framework for Berenson's conception of the Mediterranean, which was centered elsewhere (see Figs. 2–7).[36] Although Arabic architecture had made a strong impression on Berenson during his visit of 1922, the Egypt of the pharaohs, with

from the whole earth, illustrated books from the most luxurious to the horrid Soviet publications on the prehistorical art of Siberia. Photos and magnificent reproductions of not only Italian or Greek and Roman art, but of every province of Antiquity, or Far-Eastern, or Indian, or pre-Columbian American. They give me the only real satisfaction that my so-long and so-varied past can still offer me": 10 November 1957; see Berenson 1963b, 503–504.

33 See, for instance, Berenson 1948, esp. 182–183; and for a detailed study, Capecchi 1998. See also Origo 1960.

34 The most important travels to note for the present study are: Egypt, 1921–22; Turkey (Constantinople and Anatolia), 1928; Palestine and Syria, 1929; Tunisia and Algeria, 1931; Libya (Tripolitania and Cyrenaica), April–May 1935; and Libya (Tripoli and Leptis Magna), May 1955. To this list the following should also be added as tangential to our discussion: travels in Greece in 1923, Spain in 1929, and Yugoslavia in 1936; to Cyprus, Rhodes, and Crete in 1937; again to Rhodes and Asia Minor in 1938; and to Sicily in May 1953. "Yours of the 3d finds me here, not in the desert, but in one of the spots where, on the contrary, one feels the presence of the Classical Antique almost as poignantly as in Athens itself, and far more than in Piedmontized, Fascistized Roma. It is for the traces of that world for which I always feel so homesick, that I am exploring the shores of the Mediterranean. And I must say that I have found in Tunisia and am finding now here in Algeria far more than I expected": Berenson to Louis Gillet, Timgad, Algeria, 7 April 1931, BMBP; see also Samuels 1987, 387. On Berenson's Byzantine interests, see also Bernabò 2003, esp. 118–124 and 130–138.

35 Mariano 1966; Mary Berenson 1933, 1935, and 1938.

36 "I wish I had the capacity to recreate the enchantment of those days beginning with the sound of the rhythmic songs of the sailors washing the decks and ending with the reflection of the glorious sunsets in the river and the procession along the banks of peasant families with their animals returning to their villages after a day's work in the fields. Sometimes a single woman would appear, wrapped in a blue cloak, her baby in her arms and her husband leading the donkey—a perfect flight into Egypt": Mariano 1966, 48. "Yes, though the Arabs have swept like a pest over the lands so gloriously developed and built on and civilized under the Roman sway, turning the proudest edifices into shapeless heaps of stone, cutting down the fruit trees and the olive orchards, letting the aqueducts fall into decay, extinguishing the lamps of art and learning, and blighting all intelligible civilized history for 1300 years, we could not hate them then, but only love the merry sounds that the air bore to our ears from the encampment, and open our hearts to the romance wrapt up in that other magic word 'Arab'": Mary Berenson 1935, 6.

2

Egypt, 1921–22. Bernard
and Mary Berenson
Papers, Biblioteca
Berenson, Villa I Tatti—
The Harvard University
Center for Italian
Renaissance Studies.

3

Camp in Anatolia, 1928. Bernard and Mary Berenson Papers, Biblioteca Berenson, Villa I Tatti—
The Harvard University Center for Italian Renaissance Studies.

4

The "Pilgrimage"
in Palestine and
Syria, May 1929.
Bernard and Mary
Berenson Papers,
Biblioteca Berenson,
Villa I Tatti—The
Harvard University
Center for Italian
Renaissance Studies.

5

Palmyra, Syria, 1929. Bernard and Mary Berenson Papers, Biblioteca Berenson, Villa I Tatti—
The Harvard University Center for Italian Renaissance Studies.

6

At the spring of
Jaddo, Libya, 1935.
Bernard and Mary
Berenson Papers,
Biblioteca Berenson,
Villa I Tatti—The
Harvard University
Center for Italian
Renaissance Studies.

7

Leptis Magna, Libya,
1955. Bernard and
Mary Berenson Papers,
Biblioteca Berenson,
Villa I Tatti—The
Harvard University
Center for Italian
Renaissance Studies.

its sequence of dynasties and styles, attracted his attention more.[37] At Constantinople (he preferred the older appellation to the "corrupt" form of Istanbul), he fell in love with Hagia Sophia, which he judged to be the model for the succession of Ottoman mosques.[38] The pilgrimage to the Holy Land offered him the opportunity to visit the holy places of Judaism and early Christianity, while in Syria he visited the majestic ruins of Palmyra.[39] In Tunisia and Algeria, accompanied by readings of Gustave Flaubert's *Salammbô*, he principally explored the classical world at the site of such places as Djemila, El Djem, Tozeur, and Sbeitla, although professing not to be indifferent to the untouched charm of the Holy Muslim City of Kairouan.[40] His two visits to Libya, spaced twenty years apart, centered on the archeological sites of Cyrene, Gadames, and Leptis Magna.[41] With the evaporation

37 "Norman de Garis Davies, the famous English archaeologist, went around with us more than once, and I remember his amazement over B.B.'s being fascinated by the freshness and intensity of colour on the hieroglyphs": Mariano 1966, 50. In Luxor, they associated with Lord Carnarvon and Howard Carter, who were to discover the Tutankhamun tomb a half a year later; ibid, 49–50.

38 "The year 1928 has become identified for me with the magic word 'Constantinople.' B.B. insisted on using the classical name and not the Turkish mispronunciation of the Greek *iz tin Polis*—to the town—whereby it became Istamboul": Mariano 1966, 200. "Yes, S. Sophia is all you say. It is perhaps the most sumptuous building interior I have ever seen. But as a space-effect several mosques of Sinan & his pupils here & in Adrianople seem far more successful achievements": Berenson to Charles Henry Coster, Istanbul, 3 October 1928; see Constable, Beatson, and Dainelli 1993, 9. "The Turkish mosques are the development and the fulfillment of Santa Sofia": 9 June 1932; see Morra 1965, 115.

39 "We leave in ten days for Syria & Palestine.... There is scarcely an area of that historical region which is not sacred to a humanist like myself": Berenson to Paul Sachs, 17 March 1929; see McComb 1964, 106. "Beautiful as are the Mount Carmel and the road from it to Jerusalem, steeped in historical and religious associations as is every parcel of the land, these are not the only things that impose themselves upon the traveller. Even those who set out to confine their attention to beauty and archaeology cannot but end by taking a fascinated interest in geology and geography, the basis and chief determining factor of all these"; "And have I really been in Palmyra? I ask myself, sitting comfortably surrounded by books, endeavouring to hold fast the memories of our wonderful journey. Was it really old me, with my rheumatism, my luxurious habits of comfort, my devotion to the day's ordered routine, who travelled across the Syrian desert in the blast of the sun, who lingered for days among the temples and colonnades, the fleshless ghosts of Zenobia's stately town; who saw the thousands of camels brought to water by their wild Bedouin herdsmen? I remember it all, so I suppose I must be the same person who had this great adventure, though everything around me, save this sheet of writing paper, and everything in me, save a vital spark of memory, contradicts it": see Mary Berenson 1933, 37 and 197. But the visit to the Muslim site of the Dome of the Rock left a deep impression on Mary: see ibid., 53–71.

40 "The landscape is lovelier, the hotels are better, the 'Roman' remains more interesting & more important, but most unexpected of all is the unspoiled Orientalism of a town like this where even in the European quarter there is scarcely a jarring note, & in the Arab town not the least touch that one would have different": Berenson to Coster, Kairouan, 3 April 1931; see Constable, Beatson, and Dainelli 1993, 33. "In the Turkish remains there was less that interested us—one can scarcely attend to a pipe when a great orchestra is filling one's ears"; "To the sacred city of Islam, one of the most glorious relics of the Roman rule in North Africa, the vast Coliseum, El Djem, was a great contrast. But travellers must be adaptable, and both exoticism and classicism blend harmoniously in memory, the impenetrable *otherness* of the Arab world; the nearness to ourselves of the Roman— but a nearness heightened by a grandeur we have lost": Mary Berenson 1935, 22 and 156.

41 "So I have been to Cyrene, *und das kann mir niemand wegnehmen*! I fear I shall never return, for there are so many other journeys I should like to take—Asia Minor, the Greek Islands, Morocco, Egypt again—only, if you get strong enough, I must bring you here, no matter what else I miss":

of his youthful linguistic interests and competence in the field, it might be thought that Berenson came to consider Islamic civilization as merely a folkloristic veneer on the ancient essence of Mediterranean culture. This would be an error, however. His encyclopedic curiosity flowered in a brief but intense season of love for Islamic art.

A Matter of Passion

After his youthful linguistic and literary studies and then his shift toward the fine arts, Berenson's passion for the art of Asia was sparked by a visit in 1894 to the collection of Chinese and Japanese painting at the Museum of Fine Arts in Boston.[42] Italian Renaissance art would soon become Berenson's central interest, but his horizons were opened by a visit to the great Islamic art exhibition in Munich in 1910, organized by Friedrich Sarre and Fredrik Robert Martin. This extravaganza aimed to replace the older ethnic and national categories of Arab, Persian, and Turkish art with a more comprehensive view grounded in the total region and culture (see Fig. 8).[43]

Berenson's interests were shifting at the time of the exhibition. He wrote to Edith Wharton: "the tide of my interests is flowing fast and strong to eastward. Strange what transmutations are taking place unbeknownst to oneself under one's jacket. Softly and silently it has happened, and I suddenly find that the Renaissance is no longer my north star."[44] The notes that he sent from Munich to Mary Berenson and Isabella Stewart Gardner reveal even greater enthusiasm than he had expected: "We spent the entire p.m. at the Muslim show, and thus far have seen only half of it. Overwhelming is the word. The quantity is immense, the quality very high or very interesting, and the arrangement a revelation of order, taste, and distinction";[45] and again: "I have been here some days studying

Bernard Berenson to Mary Berenson, 21 April 1935; see Mary Berenson 1938, 63. Mary could not join her husband and Nicky on this trip. Her travel diary is based mainly on the letters that she received from them and Coster all along the journey; see also Constable, Beatson, and Dainelli 1993, 62–79. "Leptis is, all considered, one of the most impressive fields of ruins on the shores of the Mediterranean and can stand the comparison even with Palmyra, the desert port, and with Baalbek": Bernard Berenson, Leptis Magna, 16 May 1955; see Berenson 1960b, 137—this passage is absent in the original diary and was probably added by Berenson for the publication of the volume. "Lovely drive to the Oasis of Tagiura with its grand, austerely simple mosque.... Often I have wondered how a Roman wore his toga. Here rich and poor wear it, be it dazzling white or dirty greyish, new or in rags, and stride along utterly unaware of how Antique they look to us": Bernard Berenson, Tripoli, 24 May 1955; see ibid., 137. Slightly different version in original diary, BMBP.

42 On this issue, see Roberts 1991, a catalog of the Far Eastern pieces in Berenson's collection; Rocke 2001; and Carl Brandon Strehlke's contribution in this volume.

43 There were 3,600 items on display in over 80 rooms. The Berenson Library contains a most precious commemorative work on this exhibition, published in the following years, 1911–12, immediately acquired by Berenson himself: four volumes in folio format, of which the fourth is considered to be particularly rare and precious (Sarre 1912).

44 Berenson to Wharton, 6 May 1910; see Rocke 2001, 375.

45 Bernard Berenson to Mary Berenson, 27 August 1910, BMBP.

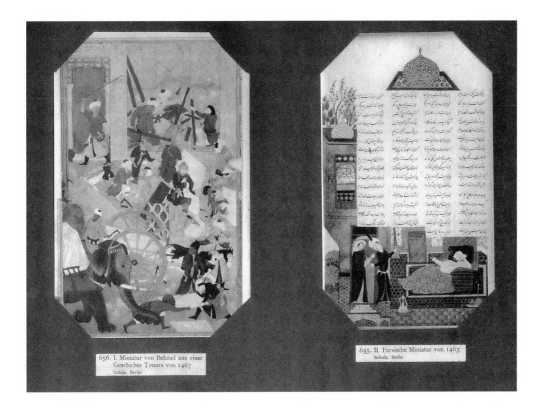

656. I. Miniatur von Behzad aus einer
Geschichte Timurs von 1467
Schulz, Berlin

655. II. Persische Miniatur von 1463
Schulz, Berlin

8

Page from Friedrich
Paul Theodor
Sarre, *Meisterwerke
muhammedanischer
Kunst auf der
Ausstellung München
1910* (Munich, 1912).
Biblioteca Berenson,
Villa I Tatti—The
Harvard University
Center for Italian
Renaissance Studies.

the marvellous Muslim, chiefly Persian things here. There never was such a thing, and there scarcely will be again in my lifetime."[46]

Berenson's new and seemingly spontaneous passion was, in fact, part of a wider vogue among intellectuals, collectors, and dealers. In the second half of the nineteenth century, the discipline of Islamic art history began to emerge from under the shadow of history in European academic circles. It was a concomitant development with colonial expansion and the consequent rise of travel by artists and scholars. The period witnessed the first specialist publications and journals as well as the first important collections of Islamic art in the West, initially of coins and manuscripts and later of artifacts like glass, pottery,

46 Berenson to Gardner, 29 August 1910; see Hadley 1987, 479—in this volume the transcription is "the marvellous Muslims, chiefly Persian things here," but I corrected it after consulting a copy of the original conserved in the BMBP. This enthusiasm was shared by Mary, who up until then had been extremely diffident. Arriving separately in Munich a week later, she wrote to Bernard the same night after her visit to the exhibition: "We spent all day at the Moslem Exhibition. It is a revelation. I have never seen anything to compare to some of these carpets and stuff! And then the bronzes, and the miniatures, and the objects—it is too marvellous! I wouldn't have missed it for anything. And I am particularly glad as it takes away the latent (very stupid) hostility I felt towards the Orient" (Mary Berenson to Bernard Berenson, 7 September 1910, BMBP; see Rocke 2001, 377). It is worth noting, however, that in her juvenile years at Harvard, before meeting Berenson, Mary had had a brief but intense love for the Persian poet Khayyam, whose quatrains she had learnt by heart; see Mary Berenson, "A Life of Bernard Berenson. Chapter 1," BMBP.

metalwork, woodwork, lacquer, textiles, and carpets. At the end of the nineteenth century, many collectors and curators traveled back and forth between the Middle East and North Africa, Egypt in particular, in search of acquisitions. The great exhibitions of Islamic art in Europe, of which the Munich exhibition was only one, represent the opening of the field to a larger public. The haphazard arrival in commercial galleries of dispersed materials, from fragments of monumental size to smaller ceramics, metalwork, miniatures, and carpets, was the final step in this rapid course.[47] One of the main consequences of this process was the widespread vandalism and dismembering of a rich cultural patrimony. When Berenson decided that Islamic pieces would have a place in his own collection, he, like his friend Isabella Stewart Gardner, knew a range of specialist dealers in Europe and America, such as Claude Anet, Georges Demotte, Charles Vignier, Léonce Alexandre Rosenberg, Meyer-Riefstahl himself, and Dikran Kelekian. All of them were responding to the fashion with varied offerings and steadily rising prices that were only capped at the outset of the First World War.[48]

These figures offered Berenson, perhaps at discounted prices, all the objects in his Islamic collection in the brief period between 1910 and 1913. After a considerable amount of reselling, which can be partly traced in the papers of the Biblioteca Berenson, the collection now consists of three Persian manuscripts, a fragmentary manuscript of the Koran in Arabic, two Arabic and four Persian detached miniatures, two Kashan ceramics, a Persian silver lobed cup, a Mamluk brass bowl, and a number of carpets.[49] The heart of the collection is certainly the manuscripts and miniatures. They center on the art of the book, sacred and secular, which Islamic civilization raised to the highest degree.[50] Despite its small scale, in Richard Ettinghausen's words, "the Berenson collection is of high quality and comprises examples of nearly all the schools known and available at that

47 On the whole question, still partially neglected by historians of Islamic art, see the excellent volume *Discovering Islamic Art*, in particular its editor's own contribution (Vernoit 2000), and the collective volume "Exhibiting the Middle East" (Komaroff 2000). On the role played in this period by a key figure like Friedrich Sarre in the field of Islamic art, see Kröger 2008. Sarre had a good relation with Berenson, testified by a few letters in the Berenson Archive. On meeting Sarre's daughter in 1955, Berenson recalled him with admiration, writing: "Her father virtually started rational collecting and study of Islamitic art, and made the collection of that art in Berlin" (30 October 1955; see Berenson 1963b, 405).

48 "I can see and buy here—from buying much I am prevented first by poverty, then by Mary's dislike for Oriental things, and finally by the fact that I have little room for it. But I am in contact with all the amateurs and dealers who go backward and forward. I can get the pick of their best, and at the lowest figures. Just now it is Persian miniatures one should go in for, because the market will soon be exhausted. The very finest are still to be had for say from two to five thousand francs apiece. In a year or two that will be impossible": Berenson to Gardner, Oxford, 12 August 1910; see Hadley 1987, 477.

49 The single pieces shall not be discussed here in detail; a catalog of the collection is in preparation under the auspices of Villa I Tatti. For the manuscripts and the miniatures, see below in this essay. The finest carpet of the collection, a Mamluk rug of the early sixteenth century, has been dealt with in Spallanzani 2007, 57, 68, 232; and Okumura 2007, 156–157 n. 35.

50 Interestingly enough, the commemorative volume of Munich's exhibition for the first time reverses the usual layout in cataloguing Islamic arts, and places the chapters on the arts of the book in first position, followed by the others on manufactures. See Vernoit 2000, 20.

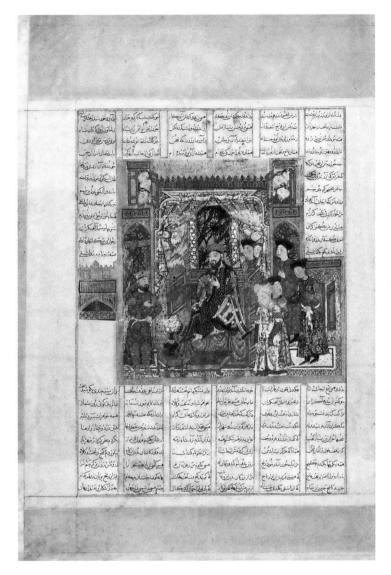

9

Esfandyar calls for Gushtasp's abdication, leaf from the Great Mongol *Šāhnāme (Book of the Kings),* by Ferdowsi (Ilkhanid period, ca. 1335, Tabriz, Iran). Berenson Collection, Villa I Tatti—The Harvard University Center for Italian Renaissance Studies.

time."[51] But the more interesting issue is the way in which an interpretive model then current among scholars and collectors guided the acquisition of these books, precariously imposing the value scale of Renaissance art on the Islamic world. There was a preference for works produced during the late fifteenth and early sixteenth centuries. The focus was on connoisseurship and the role of the individual artist was exalted, so that the few min-

51 See Ettinghausen 1961, 5. This thin volume, published in a limited number of copies by the Edizioni Beatrice D'Este (Officine Grafiche Ricordi), is a first attempt to present some of the miniatures belonging to the collection. Other partial descriptions are in Vertova 1969b, Piemontese 1984, Soucek 2001, and Bailey 2001 and 2002.

iature painters named in the documents were disproportionately celebrated—this was especially true of Behzad (died ca. 1535), the Timurid painter working at the court of Herat, to whom only a handful of paintings can be assigned with any certainty. Finally, noble families were glorified for their patronage and a recurrent parallel tended to equate the Timurid dynasty (1370–1507)—which governed eastern Iran for more than a century—with the Medici.[52]

Berenson's Islamic manuscript collection was shaped by this Renaissance-oriented approach. It includes, in chronological order: a problematic fragment of the Koran, apparently from the eleventh century; a folio from the Great Mongol *Šāhnāme* (*Book of the Kings*), the Persian epic by Ferdowsi (Ilkhanid period, ca. 1335, Tabriz, Iran), which Berenson bought from the Belgian dealer Georges Demotte, who was responsible for the destruction of the manuscript and the scattering of its beautiful miniatures (Fig. 9); and two Arabic miniatures from a manuscript of the Arabic treatise on engineering *Kitāb fī maʿrifat al ḥiyāl al-handasiyya* (*Book of Knowledge of Ingenious Mechanical Devices*) by al-Jazari (Bahri Mamluk period, 1354, Egypt), which now ornament the Berenson Reading Room at I Tatti (Fig. 10). The dealer who sold them to Berenson misrepresented them as works from the reign of Saladin, while they actually date to the later Mamluk period.[53] Continuing the list, we have the Persian *Al-Rasāʾil* ("Treatises," known as *Anthology*) of Prince Baysunghur (Timurid period, 1427, Herat, Afghanistan; Fig. 11); a folio from the Persian *Ẓafarnāme* (*Book of Victory*) by Sharaf al-din Yazdi (probably Timurid period, 1436, Shiraz, Iran); two Persian miniatures from uncertain books, attributable to the periods and areas of the Turkmen and the Uzbek dynasties respectively (end of the fifteenth and beginning of the sixteenth centuries; Fig. 12); a complete manuscript of Ferdowsi's *Šāhnāme* from the Safavid period, enriched by thirty-three fine miniatures (Safavid period, ca. 1524–76, Shiraz, Iran; Fig. 13); and finally, a Safavid manuscript of the Persian narrative poem *Farhād va Šīrīn* (*Farhad and Shirin*) by Mulla Vahshi (Safavid period, beginning of the seventeenth century, Isfahan, Iran).

Each of these pieces has its place in the history of the Islamic art of the book.[54] When acquiring them, Berenson furnished reproductions to interested people and institutions, often receiving equivalent material in exchange.[55] Thus, these works, partially buried in a

52 See the excellent essay by Soucek (2001). On the creation of the myth of Behzad, see Martin 1909 and the critical analysis in Roxburgh 2000. On the cultural role of the Timurid dynasty and of Prince Baysunghur, see Lentz and Lowry 1989.

53 See Berenson's correspondence with the dealer Léonce Alexandre Rosenberg. On the subject of these miniatures, Berenson also exchanged news and information with various scholars on account of their debated attribution; see, for instance, Berenson's correspondence with Edgar Blochet and Meyer-Riefstahl, BMBP.

54 Occasional or more substantial references to some of the pieces in Berenson's collection can be found in various scholarly works. Besides the essays mentioned above in note 51, see Gray 1961, 84–86; Robinson 1965, 132, tav. 12; Grube and Sims 1979, 156, 177–78, fig. 88; Grabar and Blair 1980, 90–91; Lentz 1985, catalog 16–23:328–341; Lentz and Lowry 1989, 122, 124, 368–369; Curatola 1993, 34, 364–367, 372–373; Hillenbrand 2004; and Uluç 2006, 142–149.

55 A strict spiritual and material exchange in this field was also kept with Isabella Stewart Gardner, whose small Islamic collection can be considered as an overseas equivalent to that of Villa I Tatti. See Horioka, Rhie, and Denny 1975, esp. 97–136.

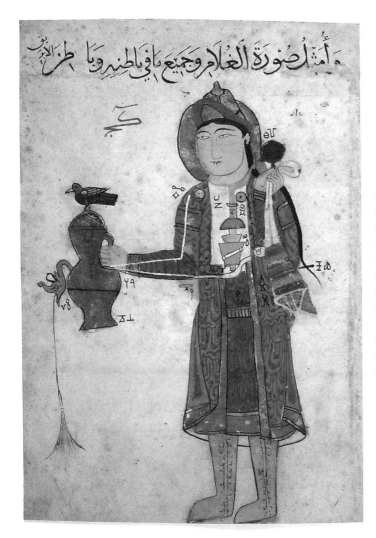

predominantly Renaissance collection, gradually attracted the attention of scholars, from Meyer-Riefstahl to Aga-Oglu, from Edgar Blochet to Ernst Kühnel, and finally Richard Ettinghausen, who contacted Berenson after he found reproductions of Berenson's miniatures at the Fogg Museum.[56] In Berenson's last years, Ettinghausen visited I Tatti to work on these pieces, although his selective survey of the Persian miniatures would not be published until 1961.[57] Ettinghausen realized that the miniatures which Berenson

56 Ettinghausen to Berenson, 10 January 1955, BMBP.

57 But Berenson must have been very proud to receive from Ettinghausen in 1957 this note accompanying an article of his: "It is a study of Persian miniatures which was mainly written in 'I Tatti' where I also did a good deal of the research for it. This may be the first time that this has happened in your library, and it should prove how good it is even in this more unusual field" (Ettinghausen to Berenson, 19 August 1957, BMBP). Ettinghausen's volume was warmly welcomed by Denys Sutton with an article in the *Financial Times*, entitled "Persian Enchantment" (26 August 1962), whose incipit was in open praise

11

The games of chess and backgammon, miniature from the manuscript of Prince Baysunghur, *Anthology* (Timurid period, 1427, Herat, Afghanistan). Berenson Collection, Villa I Tatti—The Harvard University Center for Italian Renaissance Studies.

acquired as being by Behzad were not, in fact, by the hand of that master, but had a value in their own right apart from the outdated attribution: they are the two Persian miniatures from uncertain books mentioned above. The reattributions show in some measure how the trade routes in Islamic art, along which Berenson moved in the early years of the twentieth century, were peopled with sirens and swindlers.

Berenson's masterstroke was one of his early acquisitions, Baysunghur's *Anthology*, purchased in October 1910 from the French dealer Claude Anet.[58] This is a group of seven

of Berenson's merits: "Anything which touches on the personality and career of Bernard Berenson is of perpetual fascination. . . . Not least owing to the fact that he viewed art in a broad manner; his curiosity was considerable and he was concerned with Far Eastern Art as well as with Western."

58 This acquisition is mentioned in a commercial note from Anet dated 18 October 1910, BMBP. Anet kept soliciting Berenson's interest toward the Islamic art objects, appeasing him with little gifts and even literary hooks. In a postcard from Tiflis, dated 12 September 1913, Anet offered him this poem

12

*Assembly of disciples and
sages around a master,*
leaf from an uncertain
book (Uzbek period,
ca. 1500–50, Bukhara,
Turkmenistan).
Berenson Collection,
Villa I Tatti—The
Harvard University
Center for Italian
Renaissance Studies.

Persian treatises on courtly themes by various authors, which include seven fine minia-
tures. It was commissioned by the Timurid Prince Baysunghur (d. 1433), one of the great-
est art patrons of the Islamic world. Sumptuously symbolizing Berenson's journey toward
Islamic art, the main figure in them may be an ideal representation of Prince Baysunghur
himself, the true hero of the manuscript, but also the incarnation of the Orientalist-
Renaissance ideal.

Despite Berenson's successful creation of this small but solid collection, the sudden,
intense passion that marked its beginning endured only briefly. Even before the outbreak
of the First World War, Berenson had already stopped acquiring. After 1917, he acquired

of the Persian Omar Khayyam: "O Khayyam, si tu peux t'enivrer de vin, sois content. / Si tu es assis
près d'un jeune visage, sois content. / Comme le compte de la vie se reduit à la fin énèant, / Suppose
que tu n'es plus; tu vis, donc sois content" (BMBP).

13

Bahram and Azada, miniature from the manuscript of Ferdowsi, *Šāhnāme*, (Safavid period, ca. 1524–76, Shiraz, Iran). Berenson Collection, Villa I Tatti—The Harvard University Center for Italian Renaissance Studies.

little or nothing in any field of art since his house was full and his resources strained. His enthusiasm for Islamic art was beginning to wane, and he increasingly distanced himself from it.[59] As we have seen, the Mediterranean trips that would mark Berenson's life and intellectual experience in the interwar period only served to increase that distance, apart from a feeble flame of appreciation for Islamic architecture that soon died out.

Yet, Berenson's penchant for the latest bibliography and the best photography led him to continue collecting cuttings pertaining to Islamic art and reproductions,

59 There are traces of an interest in Armenian miniatures around 1920, probably leading to the acquisition of the few Armenian miniatures now present in the collection. See Berenson's correspondence with Dikran Kelekian and Calouste Sarkis Goulbekian, BMBP.

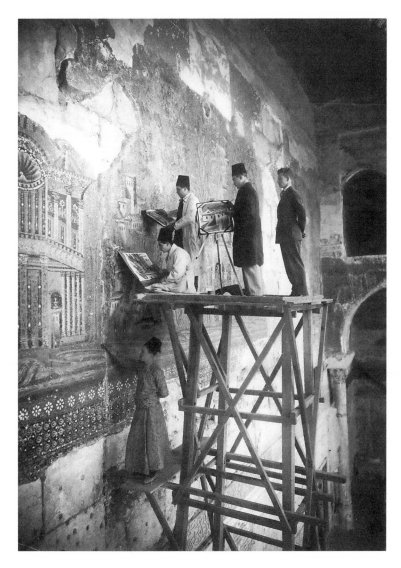

14

Restoration works in the Umayyad Mosque, Damascus, Syria, 1929. Bernard and Mary Berenson Papers, Biblioteca Berenson, Villa I Tatti—The Harvard University Center for Italian Renaissance Studies.

especially of monumental architecture and miniatures, though these were shifting to the margins of his interests.[60] The Fototeca Berenson at I Tatti holds a small but complete section devoted to the Umayyad Mosque of Damascus. The discovery of the glorious eighth-century mosaics within the mosque had profoundly touched the scientific community, and Berenson had the chance to admire them during his "pilgrimage" of 1929 (see Fig. 14).[61] His interest in this remarkable monument, however, stems from another

60 It is especially from this period on that many materials came to be collected, now filling the boxes of the Fototeca, mentioned above in note 26.

61 This is how Mary recalls that experience: "Our most overwhelming surprise was the eighth century mosaic decoration in the entrance to the Grand Mosque and along one side of its courtyard, for this,

source. In an exchange with Creswell in 1958, Berenson, by this time quite aged but still lucid and curious, wanted to know if it was true, as some scholars had maintained, that the Great Mosque of Damascus was in fact the reconsecrated former Christian basilica of St. John the Baptist. This view was upheld for some time, on the basis of the contradictory information provided by the sources, and of the mosque's unusual plan, similar to that of a basilica. From the tone of Creswell's response, we can understand that Berenson was disappointed. Creswell, along with other scholars, had determined that the Umayyad caliph al-Walid had torn down the earlier building in its entirety in order to construct a completely new edifice. In this view, the result, one of the most beautiful monuments of the Mediterranean, was therefore to be considered wholly Islamic.[62]

Sunset and Twilight

This minor exchange was in some ways representative of Berenson's guiding ideas about Mediterranean civilization and art. In correspondence and in personal reflection he often posed a crucial "what if" question—namely, what might have happened if the Hellenic culture and the Roman Empire had been able to consolidate their hold on the eastern Mediterranean and stopped the incursions of the "Mohammedan."[63] The question was based on an assumed superiority of the Greek legacy and its ramifications: "Hellenism is not a fixed state of things but a path, a way, a reaching out towards a humanity that is as remote from chaos as it can succeed in soaring above and beyond 'nature.'"[64] After

being still in the process of resurrection from its winding sheet of whitewash, had not yet become the common property of students. . . . All the mosaics exhibit an amazing delicacy of shading recalling the best frescoes at Pompeii, or even the matchless paintings of a garden in the Villa Livia at Rome. They carry on without a doubt the Hellenistic tradition of representation. Some of the finest trees, with their shadows in mauve and light pink, curiously anticipate, as do those at the Villa Livia at Rome, the paintings of Cézanne! . . . it must have been one of the most gorgeous sights on the face of the earth" (Mary Berenson 1933, 161–162).

62 See Berenson's correspondence with Creswell, particularly his letters of 1958, BMBP.

63 "One thing, in fact two things, were missing in the Roman Empire: the conquest of Germany and the conquest of Arabia. If the conquest, and thereby the permeation of Hellenism, had occurred in these regions too there would never have been either the barbarian invasions or the triumphs of the armies of Islam. The world of today would be the same as then, united under the standard of Rome": 1 June 1934; see Morra 1965, 188. See also ibid., 267. Such a historical preoccupation a posteriori endures up until the question of the Crusades: "I was reading recently how Andrea Dandolo turned the Fourth Crusade aside from its idealistic purpose of liberating the Holy Land from the Moslem yoke. Instead, he induced it to conquer, impoverish, and ruin the only Christian power that might act for Europe as a shield and buckler against the invading Turk, Seljuk, or Ottoman" (19 December 1943; see Berenson 1952b, 202).

64 Berenson 1948, 244. Also his interest in Islamic architecture, which had flourished during the period of his travels in Egypt, gradually became less pronounced. This is reflected in a note sent by Meyer-Riefstahl after Berenson's stay in Turkey in 1928: "Your visit here has certainly started something. . . . I begin to learn something; at the same time I proceed to some re-valuation of values which is not altogether in favor of the Turkish. I begin now to be able to see with the help of van Millingen the original status of a remodeled Byz. building, and I see how right you were emphasizing the almost perfect proportion that is in almost all of them. There is a wisdom of playing with harmonies of space which is rare in the Turkish monuments" (Meyer-Riefstahl to Berenson, 22 March 1929, BMBP).

having studied Islamic art as part of his reconstruction of the artistic journey of mankind, Berenson found himself perceiving the extraneousness of that tradition.

Berenson found a paradoxical comfort in correspondence with leading scholars concerned with the cultures of Islam, some of them resistant to the nascent discipline of aesthetics that appeared to them as already succumbing to conformity. Revealing in this sense is his correspondence with René Grousset and later Louis Massignon,[65] and above all with Edgar Blochet, a prolific scholar and curator of Arabic, Persian, and Turkish manuscripts at the Bibliothèque nationale de France, as well as author of many relevant publications in the field of Islamic painting. In a postcard of thanks for an article sent in 1931, Blochet complains to Berenson: "Le sujet que vous traitez a infiniment plus d'attrait pour moi que la peinture orientale; l'art orientale, dans tous les domaines, est une manifestation secondaire de l'ésprit humain, comme d'ailleurs les litteratures orientales, sauf la Bible, pour l'Asie Anterieure, qui est un livre unique, et quelques ouvrages chinois." Blochet reaffirmed these sentiments in a postcard of 1932: "Je vous remercie vivement de l'amabilité avec laquelle vous m'avez envoyé votre excellent article sur la peinture florentine; ces oeuvres sont toute autre chose que les enluminures des livres musulmans, persans et arabes, devant les quels des gens sans aucune culture artistique tombent en admiration pour snobisme."[66] Comforted by such authority when he undertook his general work on aesthetics, Berenson was to have no more doubts: "Little more can be said of Islamitic Persian and all 'Arab' arts, despite the exaggerated importance given recently to both. They must eventually find their place. But it will not be at the centre of the stage."[67]

65 See the attendant correspondence in the BMBP.

66 "The subject you are dealing with is much more attractive for me than Oriental painting; Oriental art, in every domain, is a secondary manifestation of the human spirit; and one may say the same of oriental literature, except the Bible in the Near East—which is a unique book—and a few Chinese works." Blochet to Berenson, postcard, 15 July 1931, BMBP. "Thank you very much for being so kind in sending me your excellent article on Florentine painting; these works are so different from the miniatures in Islamic books—Persian and Arabic—in front of which people without any artistic culture bow in admiration out of snobbery." Blochet to Berenson, postcard, 1 May 1932, BMBP.

67 This extract follows a more general consideration on what Berenson classified as the exotic arts: "The question of the exotic arts is more complicated. . . . Compared with our art of the last sixty centuries with its endless variety of subject matter, of material, of kind and quality, every other art, Chinese included, is limited. I had the good fortune to be one of the first to feel the beauty of the various exotic arts and to encourage collectors and dealers and amateurs to give them attention. . . . Even Chinese, by far the most valuable of all the arts from beyond our pale, can offer students of visual representation its landscape only, as an achievement that our painters have not equalled or surpassed. . . . The exotic arts soon weary" (Berenson 1948, 238–241). The question also slips from the level of the visual arts to literature, where Berenson begins to make a subtle distinction between Arabs and Persians that skims across even one of his most loved texts, *One Thousand and One Nights*: "The Arabs have no power of fantasy in their literature; the whole 'bewitched' part of *The Arabian Nights* is not indigenous but is of Persiano-Indian origin. They have qualities of descriptive realism and qualities of poetic transfiguration, the qualities which one finds in English literature and which are the true artistic qualities in the long run—one cannot be abstracted from the other; together they form the essence of any work of art. But in the Arab lyrics (and descriptions) as in every other exotic art—Chinese, for example—a restricted world is being dealt with—sounds from only a few strings—and compared to the field of English art they add up to a paltry, extremely limited manifestation" (11 August 1937; see Morra 1965, 243–244).

Behind this aesthetic disillusionment, Berenson was brooding over a vague but increasingly rigid conception of the "Orient." Even during the period of his infatuation, Berenson always perceived it as a unified culture, joining the Islamic world with India and the Far East. Berenson's reading of Ernest Renan and Arthur de Gobineau may have conveyed to him a specific current of European Orientalism, although their more or less open anti-Semitism could not but hurt his feelings—especially after the Second World War—as he remained tied to his Jewish roots, even if in a conflicted and contradictory way.[68] Berenson's notes on this theme were occasional and unstructured, though a clear guiding idea of Asia emerges as a mass civilization in contrast with the Europe of the individual: "When I say 'East' I have in mind civilizations where the horde, the tribe (as in Japan), the mass (as in China) prevails, and individuality exists only negatively, not positively; by what the single person fails to do, not by what he could do if he were encouraged."[69]

Theoretical elements in the history of civilization mixed in Berenson's mind with the accumulated experiences and impressions, some not edifying, of his Mediterranean explorations. Already evident in his travels in 1922, an increasingly tenacious diffidence emerges in which aesthetic reactions cross with cultural and social ones, reaching peaks of contempt for the feudal impression made on him by the *fellah* and the Egyptian bureaucrat.[70] In 1928, in the course of his preparations for his trip to Constantinople, the (missing)

68 Still, attending Renan's lectures was among Berenson's purposes in his application for the Parker Traveling Fellowship: "In Paris I would be listening to Renan and going to the theatre" (Sprigge 1960, 60). In Berenson's personal library (in the house section), we can find still today almost all of the principal works by Renan and de Gobineau. On Berenson's complex attitude toward his own Jewish identity, see Mariano 1966, 205, referring to the 1922 "Pilgrimage"—"B.B. was not a Zionist in those days. He had to go through the Hitler years before he could feel real sympathy with the heroic effort of the Israelite state builders. Only the danger of orthodox Jewry having the upper hand in Israel filled him with horror and became a sort of obsession with him during his last years"—but above all the "Epistle to the Americanized Hebrews," written by Berenson in 1944 and never published (preserved in various copies in BMBP). The latter is a document to which specific attention should be given, and which constitutes also, to some extent, an attempt to distinguish the identity of the diasporic and assimilated Jews from that of other Semitic peoples, like the Arabs.

69 Note is dated 3 February 1942; Berenson 1952b, 78.

70 Of the many passages that could be quoted: "B.B. also in the midst of his breakfast seemed very gloomy. 'Have you had a bad night?' 'Oh no, but it disgusts me to come across such carelessness.' And saying this he pointed to the milk jug. The handle was broken off" (Mariano 1966, 209; the episode took place in Sbeitla, Tunisia, 1931). "In Mecca there congregate every species, type, and color of human being. What unites and identifies them all as of the true faith is their genuflections, prostrations, and ejaculations—not words and prayers and sentences that can easily be learned, whereas the first are difficult to acquire after early and unconscious childhood": 17 December 1941; see Berenson 1952b, 47. "Eastern, and semi-Eastern, and Near Eastern people seem to find difficulties in distinguishing between a government that cares not how much harm it does to attain its ends, and one that tries to reduce to a minimum the odious but necessary evils that accompany politics and administration": 25 June 1942; see ibid., 98. "The same in Egypt. There the Turkish and Turkicized Arab landowners exploit the peasantry, treating them as no better than cattle. Their hygienic conditions were revolting. Their standard of life was scarcely neolithic. The English tried hard to improve their lot. In vain, and when Zagloulites in the course of their campaign against the English started markets outside the towns, the fellahin flocked to them": 28 March 1944, see ibid., 278. "The Vandal does not seem to have been a Vandal at all, but the Arab was one to the extent at least that he wrenched capitals & columns from their places & carted them hither by the many hundreds to construct this town & its great mosque. In that mosque there is not a capital that is not interesting,

15

Rudolf Meyer-Riefstahl's
ironic advice, on Berenson's
departure for Turkey on
28 August 1929: "For your
guidance: Don't expect
this:" (top); "But this:"
(bottom). Bernard and
Mary Berenson Papers,
Biblioteca Berenson, Villa
I Tatti — The Harvard
University Center for
Italian Renaissance Studies.

letters he wrote to Rudolf Meyer-Riefstahl, his principal contact there, must have shown serious concern, since his archaeologist friend responded warmly and ironically, but also quite severely: "Your otherwise pure mind must have been corrupted by some vile Greek or Armenian propaganda. What you describe may have happened in the blackest days of Hamidian ignorance and suspicion, but not in the modern and democratic republic of Turkey."[71] In another letter written shortly after, Meyer-Riefstahl permits himself once more to tease Berenson affectionately about his slightly archaic Orientalism, sending him a humorous vignette on what awaited him in Istanbul (Fig. 15).[72]

Yet in general, Berenson's political attitude was multifaceted and animated by a critical spirit. He condemned in no uncertain terms the Italian campaign in Libya,[73] even if he later partly changed his mind, offering a positive assessment of certain aspects of the occupation and maintaining cordial epistolary relations with the governor, Italo Balbo, whom he met in 1935.[74] He also welcomed Massignon's mournful defense of the Algerian revolt

& few are not late Antique": Berenson to Coster, Kairouan, 3 April 1931; see Constable, Beatson, and Dainelli 1993, 33–34. Even more caustic was Mary Berenson's aesthetic judgment of the Muslim faith from in front of the Dome of the Rock in Jerusalem: "As to the cult there practised, I could take it peacefully. The religion of Islam is not mine; I never come across anything but the picturesque side; no one that I know argues that the Mahometan Faith is the True Faith; the people I care about do not prostrate themselves in that absurd and revolting attitude with their foreheads on the floor and the less honoured part of their persons sticking up; I am not forced to concern myself about all that, and am far enough away to be calm about the Arab conquest and about the defects of the votaries of the Mahometan religion. So the vision of the Dome of the Rock was not alloyed with any sense of personal responsibility" (Mary Berenson 1933, 56). Her consideration of Kairouan's inhabitants in 1931 was not very different: "So long unchanged, the natives seem to wear their garments as animals wear their skin, or birds their feathers, and it suits them as it suits their brothers of the animal world, although their coverings are far less clean than the fur and feathers of beasts and birds. Their hooded and draped figures stream along, night and day, in tatters and rags, the wearers as unconscious of their picturesqueness as of their filthiness" (Mary Berenson 1935, 37).

71 Meyer-Riefstahl to Berenson, end of July 1928, BMBP.

72 Meyer-Riefstahl to Berenson, 28 August 1929, BMBP.

73 "We still are stewing here. Tripoli in return for the predatory behaviour of Italy is returning us a most fierce scirocco": Berenson to Henry Walters, 8 October 1911, BMBP. "There is nothing new. This unspeakable war in Tripoli is keeping our Italian acquaintances away from us. They are too well aware what they would think of any one else who committed murder & robbery in this fashion upon peaceable householders—I am not referring to the so-called massacre which I believe to be a foul calumny, but to the ethics of falling upon Tripoli as the Italians have done. The economic effect upon Italy will be disastrous but nothing comparable to the moral debasement. A people like the Italian which so recently became a nation not by its own strength but thro' the sympathy, pity & powerful aid of stronger nations, has no right to become the cowardly oppressor of weaker races": Berenson to Walters, 11 December 1911, BMBP. On the relationship between Berenson and Henry Walters, see Mazaroff 2010.

74 The first impact was quite folkloristic, as Mary Berenson recalls it in her vicarious memory: "Their dinner with Balbo confirmed their impression of him: exuberant, talkative, discursive, with endless pet theories of his own about history and art and politics—'a self-ejecting, self-diffusing, even self-universalizing entity'" (Mary Berenson 1938, 12). But see the correspondence with Balbo in BMBP, where the "Maresciallo dell'Aria" remembers Berenson's visit with sympathy and thanks him for his article on Libya in the "National Institute News Bulletin of New York" (Balbo to Berenson, 5 April 1936). Thanks to Ilaria Della Monica's careful investigation, it has been discovered that this was more precisely the National Institute of Arts and Letters, where the fellows used to publish a yearly note on their work and research. In the 1936 issue, Berenson wrote: "In the spring I spent two months

against the French.[75] In the 1940s and 1950s, he continued to interrogate his correspondent friends, such as Charles Henry Coster, Hugh Trevor-Roper, Stewart Perowne, and George Huntington.[76] His diaries show notes on the major political issues of North Africa and the Near and Middle East: the ascent of Gamal Abdel Nasser in Egypt and the Suez Crisis; the reforms in Morocco; the discussion on the role of Turkey during the Second World War; the fall of Mohammad Mosaddeq in Iran; and the Palestinian question and the birth of Israel. In these notes and in the responses from friends, we have the impression of a man with a profoundly skeptical perspective: Eurocentric, but also critical of the imperialistic attitudes of the English and French; afraid of communism, but uncertain about how to evaluate the growing power of America; sympathetic in the abstract for some nationalist causes, but doubtful about the capacity of formerly colonized peoples to make progress.[77]

The question of Israel is a theme around which Berenson's hardening anti-Arab sentiment developed. On the one hand, Berenson, the great opponent of theology, lamented the absurdity of the growing enmity between the two peoples: "No difference in blood, yet the bitterest of enemies—*frères ennemis*. What but material interests wrapped in dogma separates them?"[78] On the other hand, as a Jew, even if nominally converted to Christianity and previously unsympathetic to Zionism, Berenson had been sorely tried by fascism and the war and had begun to understand the reasons why Jewish men and women desperately sought a homeland in Palestine. He shared their hopes and appreciated their zeal.[79] The ordeal of Nazism was incommensurable, and to the blindness of that totalitarian project Berenson attached his view of mass societies. The Second World War appeared to him as the definitive failure of the German attempt, lasting a full seven centuries, to push the Greco-Roman-German civilization eastwards. "Nazism is an attempt on

in Tripolitania and Cirenaica. I strongly advise all to go there before it gets tourist ridden. Cyrene, Leptis and Ghadames should be visited by all who love Greece, Rome and the desert." In a letter to Mary of 1936, Balbo thanks her for sending him her volume *Across the Mediterranean*. In a later diary from Tripoli, Berenson expressed a clear appreciation of the Italian contribution to Libya's modernization: "How much human industry and perseverance and capital has been expended here during the Italian occupation. One cannot help wondering what will happen once the Allied control comes to an end. Will the Libyans want to carry on and preserve what may seem to them an intrusion from a hostile world?" (Tripoli, 11 May 1955; see Berenson 1960b, 134). In general, Berenson's diary notes from Tripoli in 1955 are full of considerations on the Italian legacy and the present English "indirect rule" (BMBP).

75 See Massignon to Berenson, 9 November 1956, BMBP. A long diary entry on 10 January 1956, translated into Italian, would become an article on the theme of colonization for the daily newspaper *Corriere della Sera* (Berenson 1956). It presents a diachronic perspective that reflects on the formation of colonies as a natural phenomenon and fruit of human history, yet destined to fail when implanted in terrains already ruled by organized civilizations.

76 See Berenson's correspondence with these individuals in the Berenson Archive. See also Constable, Beatson, and Dainelli 1993; and Davenport-Hines 2006; particularly remarkable are Trevor-Roper's reports on Iran in 1957. On the complex political views of Trevor-Roper, see Gaddo 2007.

77 An interesting integration of this picture can be found in the text "Cos'è e dov'è l'Europa," which Berenson prepared for publication, again in the *Corriere della Sera*, in 1955 (published 1 February); see also Berenson 1959, 231–239.

78 Bernard Berenson, diary, 10 April 1947, BMBP; see also Berenson 1963b, 12.

79 On Berenson's attitude toward Jewish identity, besides the works already mentioned in note 68, see Fixler 1963.

the part of Germany to Asiatize itself completely, destroying and eradicating everything in itself that spells Europe, which Europe is equivalent to Mediterranean. It began with the easiest to accomplish, the wholesale massacre of the Jews, always the spearhead of Mediterranean civilization."[80]

Perhaps the image of the Islamic world that Berenson formed during his travels as one of social backwardness,[81] deprived of any sense of individuality, was overlaid by a painful association with Nazism and with what he saw as Germany's Orientalization. The question of Israel, immediately following the Holocaust, then hardened some of his assertions:

> I question whether for the last thirty centuries any people have contributed more than the Jews. They have inspired and started the great religion of the White Race.... Compared with the Arab-speaking world, their output of work promoting civilization, culture, high living is overwhelming. In comparison, the Arab world has nothing for centuries, not since ibn-Khaldun has a Muslim written anything, or done anything else of a creative and constructive contribution to the City of Man.... In comparison with what Jews for three thousand years have contributed that is still operative, still fermenting, still creative, 'the Arab' is nowhere.[82]

In fact, in the annotations Berenson wrote on his readings throughout the year of 1942, in hiding during the war, we find a quite dry note: "Began also the *Nazi Koran* [italics in original], *Mein Kampf*, for Hitler, besides much else in common with Mohammed, has given his adherents *a book*."[83]

80 Note dated 3 February 1942; see Berenson 1952b, 78. See also Berenson 1963b, 125 (note from Bernard Berenson, diary, 12 April 1949).

81 See again the quotations in note 70. A late and skeptical observation of Ramadan and its consequences was offered during Berenson's travels in Tripoli in 1955: "Heard later that it had not been easy to secure porters because of Ramadan being in full progress, the great Muslim fast when no food or drink may be touched from sunrise to sunset. Who can blame the porters for shirking their work under such circumstances?" (Berenson 1960b, 130; see also ibid., 138). These quotations, however, seem to have been cut compared with the original diaries.

82 Bernard Berenson, diary, 1 July 1954; see Berenson 1963b, 351–352. He continues as follows: "As a townsman [the Arab] has scarcely put foot on the lowest rung of civilization. Yet such is still the force of anti-Jewishness, that the majority of the Christian world is outraged by the Jew who returns to the Land of Israel, where he regards the Arab as intruder and usurper, in which, the survivor of torture and massacre, he wants to ensure for himself a city of refuge. Cramped, confined, always on the *qui vive* against the Arab marauder supported by all the Oil Interests, yet the Israeli Jew not only makes the desert smile like the rose, but pursues every kind of intellectual work, including good history, on as high an average as is being written anywhere in the European world. But pious anti-Jew pity for the Arab will have none of this."

83 21 January 1942; see Berenson 1960a, 13. A few months later, Berenson received an unexpected but still warmly welcomed scholarly confirmation of his personal diffidence: "Wölfflin's three short essays on Jacob Burckhardt, interesting information and right in feeling. Burckhardt was one of the greatest humanists of all time and the last effective German one. Reading his 'Weltgeschichtliche Betrachtungen,' I was amazed in discovering how much he anticipated me in my conclusions regarding the past. How well informed he is and of what sound judgment. Everything he says about Islam, for instance, is masterly and should put to shame the admirers of its civilizations and culture and the believers in its equivalence or even superiority to ours" (4 July 1942; see ibid., 87–88).

It is very difficult to recognize here the young student from Harvard who ventured into reading the Koran in Arabic. Time had passed, however, and more things had taken place than simply the loss of an aesthetic passion. Berenson never ceased to be curious or to exult at the pearls he found in the darkness, and he savored subtlety to the end. It allowed him, after his harsh rejection of Islamic art, to draw nuanced distinctions between the roles of the Persians and Arabs,[84] and to declare an ardent love of Seljuk architecture as the offspring of the free nomadic culture of the Turk.[85] The same might be said for his positive evaluation of Mohammad as an eloquent and poetic communicator.[86] There remained for Berenson a nostalgic vein of Orientalist fascination with a world suffused with the images of *One Thousand and One Nights*, though overlaid with skepticism.[87] He was growing tired,[88] however, and in this fluctuating course backward and forward the framework of his thought had profoundly and definitively changed.

84 Bernard Berenson, diary, 15 December 1957, BMBP: "As a matter of fact, except for the alphabet, the Arabs gave nothing to Persia. Even Mohammedanism is a very different religion there from what it is in the Semitic world. Their verse owes nothing or mere expletives to the Arabs, and as for Persian art of any kind, it was absurd to speak of Arab influence, even if there were Arab art. Persian art owes a great deal to Central Asia, to the Turks, to reminiscences of Hellenistic achievement in the wide-flung Achemenide Empire. Of course I talk as one who has never been there, but I have seen endless reproductions, and ever so many original."

85 Bernard Berenson, diary, 6 May 1949, BMBP: "Ever since my youth my nomadic mind has been fascinated by the nomadic peoples of all times and places . . . most of all by the rush westwards of people, streaming, eddying, whirling westwards from the heart of Asia, pushing everything before them. Then the various Turkish infiltrations, invasions and conquests of Iran, of India, and for me above all of Asia Minor and the rest of Mediterranean Asia and Africa. The Seljuks fascinate me, not because I know or care for their military and political history, but that their art delights me. Its sources and even its executants may have been Persian, but they have a delicacy and refinement, color and pattern, that to my taste are beyond all other Islamic art"; see also Berenson 1962, 281. This love was reaffirmed in a nostalgic prefatory letter for the photographic book by his friend Derek Hill (Hill 1964): "What a miracle is this Seljuk architecture! It has an elegance, a distinction of design and a subtle delicacy of ornament surpassing any other known to me since French Gothic at its best." Berenson's letter is dated 1958; I thank Carl Brandon Strehlke for highlighting this text to me.

86 "Mohammad, if we may take what is supposed to be his table talk, the *Hadith*, to witness, must also have been a most stirringly eloquent talker, and what a poet he was we see in the finer suras of the *Koran*": Berenson 1949, 36. There were also moments when the influence of certain guests forced Berenson to distinguish the hard weight of current affairs from the light legacy of his early intellectual passions: "At Casa al Dono Addie Kahn, now seventy, challenged him with her frank sympathy for the Soviets and the Arabs, and the two old friends agreed to disagree . . . The much-traveled Arabist Freya Stark, who was now a twice-a-year habitué, put in an appearance, and with her Berenson shared his appreciation of older Arab culture" (Samuels 1987, 511; the episode refers to 1946).

87 "I feel about as lazy and slack as the observers of the Ramadan fast and not up to any exertion. Walking about in the garden, sitting by the pond with the water-lilies, reading or being read to, chatting, dreaming, watching the sunset from the roof terrace satisfies me completely . . . Non è questa la vita che la nostra immaginazione nutrita di racconti arabi e persiani attribuisce a un vecchio orientale? No; mi manca qualcosa: le vesti appropriate, l'esercizio di una particolare pazienza, certi gesti d'origine rituale, una vera e propria rinunzia a forme attive d'indagine e di studio": note dated 7 May 1955, from Tripoli; I composed it matching two correspondent passages in Berenson 1960b, 132, and 1959, 81 (Italian version by Arturo Loria). Strangely enough, the original diary in the Berenson Archive does not include this note, which must have been the fruit of various editings.

88 In Rome, after having seen the great exhibition on miniatures, which included pieces from Arabic manuscripts as well as Persian and Syriac, Berenson wrote disconsolately: "I have paid twenty visits to the illuminated manuscript exhibition at Palazzo Venezia and what have I carried away? Only a

"Thought and Temperament": A Provisory Conclusion

It is difficult to try to draw conclusions from the fragmentary and often random nature of the material cited in this essay, which is marginal compared with Berenson's primary field of study. There would be some value in integrating these reflections into a larger study of Berenson's complex political trajectory. Nevertheless, the thread I have followed here runs through the entire fabric of his life, and perhaps it is possible to highlight some points.

Berenson was a child of his time. He was an intellectual of Euro-American formation who viewed the Islamic cultural world through the lens of the developments taking place in Oriental studies during the late nineteenth and twentieth centuries.[89] He also witnessed the contradictory effects of European colonization, and, through the tragic experience of two world wars, he observed the beginning of decolonization and the geopolitical realignment of the Middle East brought about in part by the question of Palestine and the birth of Israel. Coming from the periphery of Europe and from a minority, which he never forgot, he nevertheless became an ardent advocate of the leading role played by Greco-Roman civilization, and subsequently Europe, in the human journey. As a secular intellectual, who had consistently distanced himself from his own faith tradition, he remained instinctively and profoundly diffident toward a civilization that appeared to him as predominantly imbued by religion and by faith.

At the same time, Berenson appears to us as an independent thinker, free from political and academic conformity, infinitely curious and decisively selective, who did not hesitate to give voice, in amiable conversation or in letter, to his most intimate thoughts and instincts. His reflections were subtle, but he also allowed himself to express quite openly feelings of profound attraction or crude repulsion.[90] He formed a section of Arabic and Islamic scholarship in his library almost at a specialist level, but then he denied that culture any recent contribution to civilization. During a few years of passionate collecting, he was capable of assembling a precious legacy of Islamic art, only to reject the essence of this art a few years later. The phrase "Thought and Temperament" seemed to me to encapsulate this process. It did not come to me by chance—rather, it is the title of a short poem that Berenson published as a student in the *Harvard Monthly*. The complete title is "*Ghazel*: Thought and Temperament." *Ghazel*, or better *ghazal*, is the name of a traditional Arabic and Persian poetic form, roughly equivalent to a love sonnet, which was practiced by the

vague feeling of how much there is to study. To master them artistically and philologically would take a lifetime" (30 November 1953; see Berenson 1960b, 34). For a complete list of the miniatures, see *Mostra storica nazionale della miniatura* (Florence, 1953).

89 The conditions for the emergence of "Orientalism" in the nineteenth century were outlined by Edward Said in his celebrated study (Said 1978), which is mainly devoted to the relationship between Europe and the Islamic world. Said's ideas about the role of Eurocentric prejudice in the formation of conceptions of the East set a fashion that still persists, although his main arguments have been intensely debated. See Tibawi 1979, Mahdi 1990, Irwin 2006, and Varisco 2008.

90 Among the various reviews that his *Sketch for a Self-Portrait* received in 1949, Samuels says that Berenson had a predilection for the quite pungent but all in all appreciating assessment written for the *New York Times* by Ferris Greenslet: "The 'homunculus' that emerges is a fascinating creature at once sensitive and shrewd, affectionate and cynical, a realist and a mystic" (Samuels 1987, 508).

celebrated Hafez, whom Berenson liked to mention in conversation. In light of the small number of Berenson's references to the themes related to our inquiry, I quote it here.[91]

"Ghazel: Thought and Temperament"

Ringing silence is hissing around me.
Numbing thought to the rock fast hath bound me
From which I gaze at a bare and bleak world.
Here, resistless, all sorrows have found me
From which I ever had made myself free.
Blank and bleak are the sights that surround me.
Chill and gray, overhead, are flat uncurled
Frozen mists from wan seas that had drowned me
With gloom, were my heart not blithe within me,
Glad to war with the griefs that would ground me
On slimy shallows of shoreless sorrow.
Living sunshine is teeming around me,
Madly carolling songs of mad gladness,
To the ripe wheat ears waving around me.

It is a mannered and gloomy poem, and it would not be appropriate to read his future thoughts in it. Yet, the intimate, almost solipsistic form of this reflection in verse seems analogous to the kind of material I have been dealing with in my research. Berenson loved travel, but from the small paradise of I Tatti he would also travel in the mind, and he was capable of both love and repulsion for objects that he knew only through his insatiable reading. I Tatti increasingly became a protected refuge from which to observe and assess the infinite contradictions of the outside world. In his ninetieth year, after a climb to the hilltop town of Settignano near I Tatti, he wrote: "What are the views from the heights above Damascus compared with those I was enjoying of Florence and its beyonds in every direction!"[92]

91 Berenson 1887a; this was the same issue in which Berenson published his article on Mohammed (see note 10).
92 Bernard Berenson, diary, 10 July 1954; see Berenson 1963b, 353.

NINE

Bernard Berenson and Asian Art

CARL BRANDON STREHLKE

O N 2 JANUARY 1907, at I Tatti, Mary Berenson wrote in her diary: "I walked up the hill & got some marvellous Japanese effects of mist & hills & trees."[1] Likewise in 1931, her husband Bernard said of the Settignano countryside: "With the snow high on the mountains all around and vapors of fog in the valleys going down to the Arno, this could be a Japanese landscape."[2] Neither had been to Japan, but Bernard had long trafficked in such analogies, publishing as early as March 1894 in *Venetian Painters of the Renaissance* that Carlo Crivelli's forms "have the strength of line and the metallic lustre of old Satsuma or lacquer" and "are no less tempting to touch."[3] This statement engendered a violent reaction from Charles Eliot Norton, Bernard's former professor at Harvard University, who, as Bernard later recalled, "protested vigorously against my venturing to give naturalization papers ... to Japanese art and ranking Carlo Crivelli for his essential qualities with their lacquers, rather than with European painting."[4] The puritanical Norton, who had

1 Unless otherwise stated, all letters and diaries are in the Bernard and Mary Berenson Papers, Biblioteca Berenson, Villa I Tatti—The Harvard University Center for Italian Renaissance Studies. Villa I Tatti holds photocopies of Mary Berenson's letters to her family, which are held by the Lilly Library at Indiana University, as well as photocopies and some originals of Bernard Berenson's letters to Yashiro Yukio, which come from Yashiro's family. Some of the material in this essay appears in my essay "Berenson, Sassetta, and Asian Art" (Strehlke 2009).

2 Quoted in Morra 1965, 2.

3 Berenson 1894, ix–x.

4 Berenson 1949, 45.

upbraided the undergraduate Berenson for reading Walter Pater, was not going to let the adult Berenson get away with slipping Satsuma ware into a text about a Renaissance master. He also may not have been happy that Crivelli, a painter much loved by his generation—close to that of Charles Eastlake, who in the 1850s and 1860s had bought significant works by the artist for the National Gallery in London—was only mentioned in the preface and not the text. So too Satsuma and lacquer spoke of clipper ships and overstuffed Victorian drawing rooms—Norton's Boston, not Berenson's new world, or at least the one that was soon to be, for as we shall see, in October of that year Berenson's view of Asian art changed radically.

Italian critics of the *Venetian Painters* took the opposite track of Norton.[5] For them the book was too scientific. Angelo Conti, the then recently appointed director of the Accademia in Venice, in his monograph on Giorgione published the same year, felt that the new criticism, such as represented by Berenson, was unable to "capture that element of poetry that makes up every artistic soul."[6] Conti later wrote in an article with the apt title of "La visione imminente" that to experience a Venetian master to full effect, one needed to imbibe the atmosphere of the Serenissima: "the stillness of the waters" and "the walls laden with color."[7] The publisher Putnam's cover design of the *Venetian Painters* with its gondola embossed in gold (Fig. 1), which had so disappointed Bernard as touristy,[8] would have suited Conti, who in a later direct attack on Berenson described the myriad impressions of a ride through the lagoon—significantly in the company of the Italian writer and aesthete Gabriele D'Annunzio—as a counter to the vacuity of the American's aesthetics.

A taste for the East also characterized turn-of-the-century Italian aestheticism, so much so that the *verista* literary critic Felice Cameroni had called Japan "that suburb of Europe."[9] Cameroni had superintended the production of Carlo Dossi's *Amori*, for which the author wanted a cover like a Japanese manga (Fig. 2) as the most fitting expression of the chaste childhood loves recounted therein. It was designed by Luigi Conconi, who was proud of what he termed the "giapponesismo" of his own work.[10] D'Annunzio was less delicate in his appropriation of the East. He had written an article about the 1884 arrival in Rome of the Japanese ambassador, Tanaka Fujimaro, a westernizing educational reformer who had been to Amherst College, but whom D'Annunzio turned into a mystery from the East in order to find an excuse for a languid description of the Roman boutique of Maria

5 On Berenson's Italian critics in the 1890s, see Cinelli 1986, 176–178; and Strehlke 2009, 42.

6 See Conti 1894, 10. Conti had previously been director of the Gabinetto Disegni e Stampe degli Uffizi, during which time he wrote the monograph, which was published by the Fratelli Alinari in Florence. He ended his career as director of Capodimonte in Naples. On Conti, see the introduction by Pietro Gibellini in *La beata riva: Trattato dell'oblio* (Conti 2000), and the introduction by Ricciarda Ricorda to the 2007 reprint of *Giorgione*.

7 Conti 1896, 1 (reprinted in Conti 2000, 148–149).

8 Samuels 1979, 182.

9 Quoted in Dossi 1977, 206. On Japonisme in Italian artists, see Troyer 1984; Becattini 2003b, 2004; and Farinella 2009.

10 Quoted in Dossi 1977, 178. The cover of this edition of *Amori* reproduces the original.

1

Cover of Bernard
Berenson, *Venetian
Painters of the Renaissance*
(New York and
London, 1894).

Beretta, who specialized in Japanese objects and aristocratic clients.[11] There was a similar
shop, the Atelier Janetti, in Piazza Antinori in Florence.[12] Japanese characters and things
also appear at key moments in D'Annunzio's 1890 novel *Il Piacere*, which brought the
aesthetic movement to full flower in Italy. The protagonist, Andrea Sperelli, claims that
Count Sukumi, part of his nation's delegation to Rome, who has a face like a Katsushika

11 Originally published in *La tribuna*, 1 December 1884. Reprinted in D'Annunzio 1996, 197–204; see
 also Federico Roncoroni's notes on pp. 1272–1273. On D'Annunzio's Japonisme, see Trompeo 1943;
 and Lamberti 1985.
12 Becattini 2003a.

Luigi Conconi,
cover of Carlo
Dossi, *Amori* (Rome,
1887). An example
of Italian fin-de-
siècle Japonisme.

Hokusai and who has fallen in love with Elena, Duchessa di Scerni, would commit ritual
suicide with a *wakizashi* that their hostess uses to cut the pages of a Western book, because
Sukumi espied the duchess touching it. As for his conational, the Princess Issé, she fails to
fit in because she looks so maladroit in her European dress. Sukumi had also appeared in
D'Annunzio's novella *Mandarina*, in which a Roman lady decides she wants a love affair
with a Japanese man but then recoils at actual physical contact.[13] Whereas D'Annunzio
used the foreigners to underscore the divide between the cultures and to heighten the
exotic sensuality of the narrative in *Il Piacere* by having the semiautobiographical Sperelli
and the Asian Sukumi pursue the same *nobildonna*, Berenson tried to reconcile East

13 In *Capitan Fracassa*, 22 June 1884; reprinted D'Annunzio 1992, 515–524.

Carl Brandon Strehlke

and West, most famously in his 1903 articles on Sassetta, which took full account of his discovery of Asian art that was specifically not Satsuma, lacquer, or the ukiyo-e print.[14]

If asked whether their statements on the Japanese effects of the I Tatti landscape with which I opened this essay brought to mind any particular artist, the Berensons, I believe, would have replied Andō Hiroshige, a woodblock artist known for his snow scenes, whom Bernard said in a letter to Mary of 1894 was better than James McNeill Whistler, the American painter most associated with Japonisme. (Whistler even ate with chopsticks and lined his Chelsea studio, nicknamed "Nagasaki," with Hiroshige prints, such as can be seen in his *Caprice in Purple and Gold: The Golden Screen* [Freer Gallery of Art, Washington], in which that artist's views of the *60-Odd Provinces* are spread before the kimono-clad sitter.) The occasion that led to Bernard's comment on Hiroshige and Whistler was a visit to Boston's Museum of Fine Arts, in which he spent an afternoon looking at Japanese prints until, as he wrote, "there was no more light in the sky," also reminding Mary of the print exhibition that they had attended in Paris in 1890. The latter event, I believe, was the first time either had taken a sustained look at any Asian art; certainly, it was the first time together. This was the exhibition that Mary Cassatt had brought Edgar Degas to see and that famously inspired her own set of ten drypoint and aquatint prints, exhibited in 1891 as an "Essai d'imitation de l'estampe japonaise." She had previously written enthusiastically to Berthe Morisot about going to the exhibition, where she had already bumped into Henri Fantin-Latour and James Tissot, saying that she now only dreamed of color on copper.[15] Berenson got enough out of his two forays into the ukiyo-e world to make some amusing analogies, but not much else. In the *North Italian Painters of the Renaissance*, he wrote: "Hokusai, in his extreme old age, used to sign himself 'The Man-mad-about-Drawing,' and with equal fitness, Tura, all his life, might have signed 'The Man-mad-about-Tactile-Values.'"[16] This was in 1907, by which time Berenson had begun collecting Asian art, but ostensibly not woodblock prints.

If four years earlier, in September 1903, a subscriber to *The Burlington Magazine for Connoisseurs* let that month's issue fall open by chance to an illustration of a Chinese painting (Fig. 3), she might have been surprised to see that it was in an article signed by Bernard Berenson that was about the Sienese artist Sassetta. In the Chinese painting, Berenson wrote, "we feel an ecstasy of devotion and vision, here we behold a transubstantiation of body into soul, whereof we rarely get as much as a vanishing glimpse in our own art."[17] Berenson asked why Christian art had never found a common manner for depicting its founder, and he went on to compare Buddhism with Franciscanism: "for what can be more like in spirit than certain phases of Buddhism and certain phases of Franciscanism?"

We can be forgiven, however, for suspecting some amount of playacting in this assessment, as is sometimes the case with Berenson. Indeed, he virtually admitted as much in an epilogue to a 1946 reprint of articles:

14 Berenson 1903a.
15 Cited in Matthews 1984, 214.
16 Berenson 1907, 58.
17 Berenson 1903a, 8.

3

Zhou Jichang, *Lohan Demonstrating the Power of the Buddhist Sutras to Daoists*, ca. 1178, as reproduced by Bernard Berenson with the caption "Chinese Painting of the Twelfth Century" in Bernard Berenson, "A Sienese Painter in the Franciscan Legend," *Burlington Magazine* 3 (1903). Denman Waldo Ross Collection, Museum of Fine Arts, Boston.

At the ... time pre-Ken-Lung, even pre-Ming Chinese art was revealed to us and what had hitherto been undreamt of, Tang, Sung and even Buddhist paintings. As early as the winter of '94–95 of the last century I had the good fortune to help unpack a shipload of Chinese pictures that Fenollosa had procured for Boston and in the following Spring I brought back the news to an incredulous Europe. I naturally tended to exaggerate its expressive qualities as opposed to those of our mediaeval artists.[18]

Regardless, in 1903 Berenson had inquired, "why is Christian art so unreligious, so unspiritual, as compared with the art of Buddhism?" The answer was that Western art had "a fatal tendency to become science" and "an inherent incapacity for spiritual expression." "Of European schools of design," Berenson wrote, "none comes so close to those of the far east as the school of Siena."[19]

Sassetta was his example, but Berenson actually missed the only element in that artist's oeuvre that can lay claim to Asian influence: the pastiglia in the frame of the San Sepolcro altarpiece, in which the pattern of intertwined morning glories with the buds and leaves seen from different points of view is Chinese in origin (Fig. 4). The pattern began as a naturalistic representation of the plant in the underglaze decoration of Yuan pottery, becoming more abstract as the design moved throughout Asia, as can be seen in derivations of the theme in Korean lacquerware. Its arrival in the West is due to Turkish derivations in tiles of Chinese ceramics dating from the late fourteenth and early fifteenth century.[20] Probably from some such source, or textiles, the design made its way to Siena, finding a natural home as a decorative subsidiary element of altarpieces, and not only Sassetta's.

In books about Far Eastern art from the early 1900s, it was not uncommon to assert specific influences, not just parallel developments, as Berenson had done. Ernest Francisco Fenollosa's *Epochs of Chinese and Japanese Art* of 1912 contains chapters with the now improbable titles of "Greco-Buddhist Art in China. Early Tang" and "Greco-Buddhist Art in Japan. Nara Period." The Hellenistic influence on Indian art—and consequently on that of East Asia—was a popular notion at the time, but it irritated Indian nationalists like the Irish-born Sister Nivedita and other Asian writers like Okakura Kakuzo,[21] the Japanese curator of Asian art at the Museum of Fine Arts in Boston, with whom Berenson was in touch via Isabella Stewart Gardner; in 1906, Berenson wrote her to ask Okakura what he thought of Lafcadio Hearn's *Japan: An Attempt at Interpretation*.[22] Okakura's and others' denials of any Greek influence in Asian art (Gandharan sculpture, however, being

18 Berenson 1946, 49–50. I quote from Berenson's 1945 English-language manuscript preserved in the Berenson Archive.
19 Berenson 1903a, 13.
20 On the tiles in the mosque of Sultan Murad II, or the Muradiye, in Edirne, which are the best surviving example of the transmission of Chinese motifs in ceramics to the West, see Carswell 1998, 18–24; and Degeorge and Porter 2001, 196.
21 On this subject, see Guha-Thakurta 1992, chap. 5; and Strehlke 2009, 49.
22 "I am reading it with great interest, but am eager to know what such an intellectual Jap as Okakura thinks of it": Berenson to Gardner, I Tatti, 11 January 1906; Hadley 1987, 373.

a

b

c

d

4a

Detail of a large serving dish, Chinese, Yuan dynasty (1279–1368), ca. 1330–38, Jingdezhen. British Museum, London, given by Robert G. Bruce (no. 1951,1012.1).

4b

Detail of a small box with decoration of peony scrolls, Korean, Joseon dynasty (1392–1910), fifteenth–sixteenth century. The Metropolitan Museum of Art, New York, lent by Florence and Herbert Irving (SL.8.2009.7.2).

4c

Tiles, Turkish, ca. 1435–36. Murad II Mosque, Edirne.

4d

Detail of the gilt pastiglia of Sassetta, *The Funeral of Saint Francis*, 1437–44. National Gallery, London (no. 4763).

a sticking point) later forced Fenollosa to reduce the question to a matter of dating. The controversy can also be found in other writings of the time and the influential 1908 book on the art of Sri Lanka by Ananda K. Coomaraswamy, lifelong curator of Indian art at the Boston Museum of Fine Arts from 1917. He and his then wife Ethel Partridge (later Mairet) used contemporary folk practices to illuminate medieval Sinhalese art.[23]

The practice of making broad cultural comparisons persisted to mid-century. In his 1955 Pelican volume on Japanese art, Robert Treat Paine, also a curator in Boston, whose very name encapsulates that old Boston of which the young (and even old) Berenson was always somewhat enthralled, asserted just as Berenson had in 1903 that "the Japanese feeling for art is summed up in the problem of decorative designing... If one thinks of European parallels, of illuminated manuscripts or of Sienese painting, the analogy is again between arts dependent on faith and feeling rather than on reason and science."[24]

The key moment in the formation of Berenson's taste for Asian art came during an October 1894 visit to the Boston Museum of Fine Arts with the Harvard fine arts professor Denman Ross, to meet Ernest Francisco Fenollosa. At the time, Fenollosa was organizing his huge collection of Japanese art, which eventually came to the institution, as well as a show of paintings from Daitokuji in Kyoto. From the Harvard class of 1874, Fenollosa had gone to Japan and become "native," entering the rarefied cult of Tendai Buddhism and officially cataloguing the country's national treasures for the Japanese government. He also brought texts of Japanese and Chinese poems to the West, including the *Tale of Genjii*, which (thanks in part to his literary executor Ezra Pound) was later translated by Arthur Waley, a keeper at the British Museum who was also a friend of the Berensons. The couple read the novel, but as indicated by Mary's penciled note in one of the tomes of the multivolume work, it was only at chapter five of the fifth volume that they began to think it was getting interesting. Nevertheless, Bernard was an avid reader of Asian literature; on 4 May 1914, Mary wrote to Bernard's mother Judith Mickleshanski: "My tray is carried into his room, where he lies reading Chinese poetry, listening to the wind in the trees."[25]

Fenollosa showed Berenson various things in Boston, including "a figure of a saint with all the literary qualities and much of the charm of Lorenzetti" and

> a series of Chinese paintings from the 12th century, which revealed a new world to me. To begin with they had composition of figures and groups as perfect and as simple as the best that we Europeans have ever done. Then they had, what we never dream of in oriental art, powerful characterization, now surpassing Dürer, and now Gentile Bellini... they are profoundly contrite, full of humility, love, humanity, of the quality of the tenderest passages in the Gospels, or in the story of St Francis... I was prostrate. Fenollosa shivered as he looked. I thought I should die, and even Denman Ross who looked dumpy Anglo-Saxon was jumping up and down. We had to poke and pinch each other's necks and wept... We ended

23 Coomaraswamy 1908.
24 Paine and Soper 1955, 3.
25 Berenson Family Papers, Houghton Library, Harvard College Library, Harvard University.

with seeing a large screen by Koreen [*sic*] [Fig. 5], a wild sea with green waves, toothed and fanged like terrible beasts gnawing rocks as strange as in Lorenzetti. Oh, the freedom, the wind, the sunshine, the salt smell, the coolness, and great spirit of nature that was in this![26]

What should we make of this sudden, overwhelming aesthetic experience? First of all, it was typical of the mid- to late nineteenth century,[27] and in the Anglo-Saxon world, Asian, not Western art, was often the stimulus. The American artist John La Farge had felt a similar ecstasy some decades before on stumbling across a Japanese print in a New York City junk shop, later writing that he could "well remember the various impressions and rapid conclusions of the moment."[28] Secondly, Berenson's session with Fenollosa opened up a whole new world of Asian art. From then on, Berenson became primarily interested in Chinese art, largely ranging from the Tang dynasty through to the Song. The series of Song paintings from Daitoku-ji—of which Ross purchased a group for Boston— were later the impetus for the comparison between Siena and the art of the East. For the Sassetta article, Berenson simply quoted directly from Fenollosa's catalog of the exhibition, which toured three East Coast cities in 1894–95. Until recently, the I Tatti copy was for the most part uncut, showing that Berenson's interest in obtaining actual information about the paintings dated only from when he had to put something about them in his Sassetta article. The aesthetic experience or memory of the pictures remained primary.

Over the next decade, Berenson became more serious about Asian art. When he first republished his article on Sassetta in 1909, he wrote that he had planned to add three other essays "elaborating what I had to say about the religious painting of Japan, about imaginative design, and above all about the claims of illustration as a separate art."[29] One reason why he may never have finished these essays is an awareness of a growing professionalism in the field. In 1904, Gardner wrote to the Berensons that "Okakura is busy at the Museum, cataloguing the Japanese things that have been huddled there since Fenollosa's time, and finds forgeries and forgeries!!! And has a great contempt for Fenollosa. *Sic transit.*"[30]

The attractions of Asian art continued to fascinate, however; after a 1914 visit to Charles Lang Freer's collection, then in Detroit, Berenson wrote to Gardner: "How I wish I were starting out in life! I should devote myself to China as I have to Italy."[31] And in

26 Berenson to Mary Smith Costelloe (later Berenson), Northampton MA, 26 October 1894.

27 This is what the art historian Kenneth Clark would describe as "pure aesthetic sensation." Such an experience had also formed part of Clark's artistic awakening. In his autobiography, he described seeing in 1965 some *Fusuma-e* screens in the Chishaku-in, a little-visited temple in Kyoto, which provoked the uncovering of a buried childhood memory of having viewed them at a London 1910 show of Japanese art, and the realization that this youthful experience with such a totally unfamiliar work of art had contributed to his beginnings as an aesthete. It was his Japanese friend Yashiro Yukio, who had been at I Tatti in the 1920s (see below), who told Clark that he was indeed right about the screens having been in London: see Clark 1974, 43–44.

28 La Farge 1903, 221; see also Strehlke 2009, 41.

29 Berenson 1909, vii.

30 Hadley 1987, 335.

31 Ibid., 531; see also Strehlke 2009, 46.

Detail of the waves "toothed and fanged like terrible beasts" of Ogata Kōrin, *Waves at Matsushima*, eighteenth century, six-panel folding screen. Museum of Fine Arts, Boston, Fenollosa-Weld Collection (no. 11.4584). Berenson saw it with Ernest Francisco Fenollosa, Denman Ross, and Mary McNeill Scott (Fenollosa's assistant) at the Museum of Fine Arts, Boston, on 25 October 1894.

1918, he published another book on Sienese art in which he again took himself to task for never completing his essay on "the relations between Sienese Art and the Arts of the Far East." He had, however, been collecting and reading about Asian art. During a 1909 visit to Boston, he even sat for the society photographer Sarah Choate Sears looking at a Tang equestrian figure of the type of which he later bought two.[32] The next year at the British Museum, he saw the Tang paintings that Aurel Stein had recently discovered in the caves of Dunhuang. This experience must have inspired Berenson's acquisition in 1914 of his most important painting, the *Dancing Girls of Kutcha*, then also thought to be original Tang. Stein and Laurence Binyon, the English poet and keeper of Oriental prints and drawings at the British Museum, later published Berenson's picture. Stein wrote his part of the article while on a mission in Kashmir with the aid of color photographs specially prepared at Berenson's request in Milan (Fig. 6) and sent to Stein from there.[33]

In an earlier 1912 letter to Gardner, Berenson said that "personally I only buy Chinese and Persian" but also admitted "Mary's dislike for Oriental things." Because of that aversion, her letters to her family in England are invaluable for gauging Berenson's thinking about Far Eastern art. In one from 31 October 1909, she wrote of how when her husband

32 Strehlke 2009, fig. 15.

33 Stein and Binyon 1928–29. On Berenson and Asian art at the British Museum, see Ying Ling Huang 2013, 466.

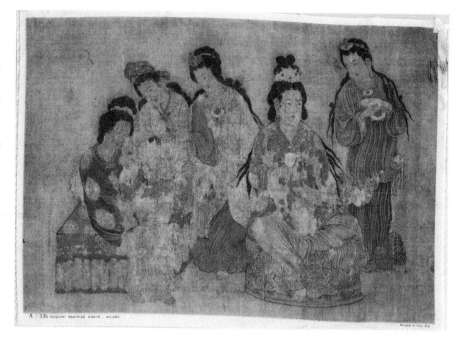

brought back from Paris an eighth-century Javanese tufa head of the Buddha (Fig. 7), he proclaimed it a tremendous example of "Tactile Values" and glorious as "pure art." "But," Mary went on,

> it is so idol-like, and so hideous as representation, that you are quite upset to have it in the room. I am afraid it is going to knock all our other things to pieces, artistically and spiritually, but yet it is awful and revolting, in a way. I must have a photograph of it taken for you to see what B.B. considers a real 'Masterpiece'."

On 5 December, as she later wrote to her mother, Mary was in for another shock:

> A case arrived, & I told [Roberto, the manservant] to open it & bring the contents up for me to see. This he did, & then he placed on my bed two Chinese works about 2000 years old, we both burst into irresistible roars of laughter. This is what they looked like. B.B. says that they are "of the very essence of art," but if so, they are so "essential" that they really look like nothing at all. We laughed & laughed. When I told B.B., he smiled a superior smile, in the consciousness of holding the doctrine (Fig. 8).

Two days later, Bernard's Matisse, now in Belgrade, arrived; this, as Mary said, "again caused Roberto and me to unite in a hearty laugh."[34]

34 Mary Berenson to her family in England, I Tatti, 7 December 1909.

7

Head of Ānada, Javanese, Sailendra dynasty (eighth–eleventh century), ca. 760–830, stone, probably from Candi Borobudur, Magelang, Java. (Photo: Gabinetto Fotografico, Polo Museale Fiorentino.) Photograph taken for the Berensons by Harry Burton, ca. 1910.

Mary's attitude began to change in 1910, following a visit to the great Munich exhibition of Muslim art—one of those shows, like the 1890 Paris exhibition of Japanese prints, that helped transform European taste. She wrote: "I have just got back from the exhibition, dead tired, but *so* interested and pleased that I really can't express half. <u>All</u> my sort of foolish prejudice against Oriental Art has gone—I begin to understand its fascination. I have no more 'grudges'."[35] And indeed she did not. Six years later, Mary wrote in her diary, "The new library looks splendid—the Buddha is very impressive seen at the end of my corridor (Fig. 9)."[36]

35 Mary Berenson to her family in England, Munich, 7 September 1910; see also Strachey and Samuels 1983, 161.

36 Mary Berenson, diary, 29 February 1916. The Buddha is actually of the Buddha's disciple Ānanda.

9a

View of the niche
in the New Library,
as installed in 1916
with the sculpture
of Ānanda, ca. 1960.

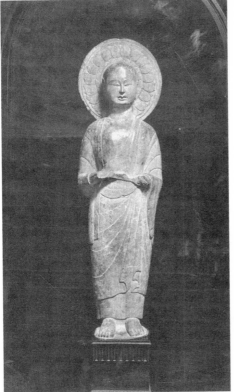

9b

Ānanda, Chinese, Northern
Qi dynasty (550–77), ca. 570.
(Photo: Gabinetto Fotografico,
Polo Museale Fiorentino.)
Photograph taken for the
Berensons by Vittorio Jacquier,
ca. 1911.

10

Interior view of
Villa I Tatti, with
a mix of Italian
paintings and
Asian objects,
mid-1960s. (Photo:
Luigi Artini.)

Whereas the landscaping of I Tatti is often cited for the way it influenced garden design in Tuscany and elsewhere,[37] the innovation of its interior decoration does not often get credit. Most of the design was set in the years before the First World War. (The Berensons rarely bought any Asian art after that date.) The combination of Italian gold-ground and other pictures with art from Asia that was largely pre-Song Chinese and for the most part figurative was absolutely new (Figs. 10 and 11). There is, for instance, hardly any porcelain, then part and parcel of most gatherings of Asian art. Furthermore, the installation is very clean, with no accumulation of knickknacks and the other para-phernalia typical of an early twentieth-century house, particularly in Umbertine Italy, but also America and England. The difference between I Tatti and other collections of Asian art, like the Isabella Stewart Gardner Museum, is striking.[38] Perhaps the best comparison would be with Frank Lloyd Wright's Taliesin, his Wisconsin studio that was begun in 1911 (though rebuilt twice), in which Asian art is cleanly arranged along the shelving (although high and unreachable). Unfortunately, it is not known if Wright

37 Fantoni, Flores, and Pfordresher 1996; and Liserre 2008.
38 See Chong 2009, 42–44, figs. 23, 41, 45–46, 48–51.

Carl Brandon Strehlke

11

Interior view
of Villa I Tatti,
showing Asian
sculptures before
Sassetta's Borgo
San Sepolcro
Altarpiece, ca. 1960.
(Photo: Luigi
Artini.)

visited I Tatti and saw its collections when he lived nearby in Fiesole for a few months
in 1910.[39]

Berenson did not become the scholar of Chinese art that he had hoped. It was his
Finnish colleague Osvald Sirén, professor at Stockholm University, who took up its study
after a career devoted to Florentine Trecento and Quattrocento painting from Giotto to
Buffalmacco to Lorenzo Monaco.[40] This included in 1916 a catalog of the Jarves collection
of early Italian painting at Yale University—a work that in 1927 the critic Richard Offner
systematically destroyed in a magisterial display of the new connoisseurship.[41] Speaking
of the troubled history of the collection's display and upkeep at the university, he wrote
that Sirén's catalog was "a final sop to its story."[42] If anyone, then, it was not Sirén but
Berenson who was Offner's principal interlocutor.[43] The poor reception that Sirén's attri-

39 Levine 1996, 67–71. A website by Gianpaolo Fici and Filippo Fici, Frank Lloyd Wright Fiesole 1910
 (architettura.supereva.com/wright/index.htm), also gathers information about Wright's stay and
 his design for a house and studio in Fiesole.

40 Vakkari 2002, 109–110.

41 In November 1908, Berenson told the Philadelphia collector John G. Johnson that he had once
 wanted to catalog the Jarves collection. See Strehlke 1989–90, 428.

42 Offner 1927, 1.

43 Offner enjoyed correcting Berenson's attributions. He did so concerning Berenson's 1913 catalog
 of the John G. Johnson Collection in a series of lectures held at Johnson's house in 1926–27. See
 Strehlke 2004, 12.

butions received in the small world of connoisseurs concerned with such things does not seem to have been the reason he turned to China,[44] which he first visited in 1918, because throughout his life he continued to write articles on Tuscan art—but by the 1920s, his publications on China began to overtake all other subjects. A talented photographer, Sirén illustrated many of them himself, and as John Harris has noted, they were often magnificent examples of printing.[45] Sirén's compilation of Chinese criticism (first published in 1936) is still consulted as a primary source, and his essays on Chinese gardens, including a study of eighteenth-century European chinoiserie gardens, were important early investigations on the subject.[46] Sirén's friendship with Berenson dates to 1902, and Berenson owned many of Sirén's publications on Chinese art, though late in life Berenson told his Japanese friend Yashiro Yukio that he was "deeply disappointed in Sirén's first volume on Chinese painting."[47]

Berenson and Yashiro had an acquaintance going back to the 1920s. It was revived after the war and engendered a regular correspondence between Settignano and Tokyo, with Berenson sometimes even asking Yashiro to welcome distinguished friends like the New York collectors Charles and Jayne Wrightsman[48] and the dancer Katherine Dunham to Japan, and sending him a book on contemporary Japan by Fosco Maraini for his opinion.[49] Maraini was an inveterate traveler in Asia who later became professor of Japanese at the Università di Firenze. In 1950, Berenson had written a short introduction to Maraini's first book, an account of Maraini's travels in Tibet.[50] In 1953, Maraini took a particularly engaging photograph of Berenson at the Villa Palagonia in Bagheria, Sicily, which he titled *Homo civilissimus*,[51] and he served as a guide to Berenson and Nicky Mariano throughout their stay in Sicily at that time (Fig. 12).

Berenson and Yashiro first met in 1921, after Laurence Binyon of the British Museum, who had been close to Fenollosa, wrote Berenson a letter of introduction to "a young Japanese friend of mine called Yashiro who has just lately gone to Florence . . . He is much more articulate than most Japanese & talks English quite well. He has come to Europe to study European art, but hasn't turned his back on his own. He cares about poetry, too, and

44 Theosophy, a religion that combined elements of Eastern mysticism and of which Sirén was a member, may have influenced Sirén's attraction to Chinese art, but unlike Berenson's commentary on Sassetta, Sirén's writings never sought to explain Chinese spirituality in art.

45 Harris 1991, 104.

46 Sirén 1936, 1949, and 1950. The latter was reprinted by the Dumbarton Oaks Research Library and Collection in 1990 with an introduction by Hugh Honour.

47 Berenson to Yashiro, I Tatti, 3 July 1957, concerning Osvald Sirén's *Chinese Painting: Leading Masters and Principles* (Sirén 1956–58).

48 "Show them all the best in Japan that they can see in a short time." Berenson to Yashiro, Casa al Dono, Vallombrosa, 5 September 1956.

49 Maraini 1958. Berenson's interest in East Asian art was known to a wide circle. The dedication on a catalog of the postwar traveling show of Japanese masterpieces (*Exhibition of Japanese Painting and Sculpture Sponsored by the Government of Japan*) reads, "To BB / With affectionate wishes / from Fern Shapley." As Berenson warmly acknowledged in the preface, Fern Shapley had seen the second edition of his *Drawings of the Florentine Painters* (1938, ix) through the press.

50 Maraini 1951, 5–6. The preface is dated I Tatti, 23 March 1950.

51 Maraini and Chiarelli 1999, 89.

12

Bernard Berenson
with Topazia Alliata
di Salaparuta,
her husband the
Orientalist Fosco
Maraini, and their
daughter Dacia
Maraini, Bagheria,
1953. Berenson
Collection, Villa
I Tatti—The
Harvard University
Center for Italian
Renaissance Studies.

in himself he seems to me really charming."[52] Yashiro worked in the I Tatti Library, seemingly having a pleasant effect on the household. After resettling in Tokyo as the director of the newly found Institute of Art Research in Ueno Park, he wrote to Berenson:

> It is a nice little building, and I am sure that both Mr. and Mrs. Berenson would smile, imagining that naughty boy Yuki installed in it as director! What I want really to show to you is the work itself, and it is one of my most cherished dreams to be told by Mr. Berenson that he did not educate Yuki uselessly, seeing that a new method of study in the field of Oriental art is actually being opened according to the idea of Mr. Berenson, transmitted to the Far East by Yuki!![53]

In an earlier letter to Mary, he claimed that his "special interest is in the comparative study of the Eastern and Western arts, and in Japan one gets absolutely no chance to study the western art in the original."[54] In Florence, he set out to remediate this with a study of Sandro Botticelli, as well as an acquisition of a Botticelli for Japan. In the latter he failed. About that, he wrote to Mary Berenson from London on 10 January 1924:

52 Binyon to Berenson, London, 21 October 1921. Also on Yashiro, see Takagishi 2007.
53 Yashiro to Berenson, Tokyo, 1 August 1928. The institute, bequeathed an endowment by Viscount Kuroda Seiki, a painter in the *yōga*, or Western style, officially opened in 1930. It is now the National Research Institute for Cultural Properties, which oversees research on Japan's artistic heritage. The original building, which still stands and is now a gallery, was designed in a Beaux Arts style by Okada Shinichirô.
54 Yashiro to Mary Berenson, Paris, 10 November 1923.

Perhaps you remember how I was enthusiastic when I told you that I saw a <u>real</u> Botticelli in the restorer's room in the Uffizi Gallery. I understood at that time that it belonged to Prof. Toesca.[55] At that time I was anxious to get it bought by a Japanese collector & I had a big hope in it when that damned earthquake[56] put an end to it.

He later also wrote to the Berensons about his find of Botticelli's *Trinity*, this time admitting that he had tried to buy it for himself.[57]

Yashiro's three-volume monograph on Botticelli, published in 1925, was distinguished for the quality of its illustrations (Fig. 13), and particularly the details, an innovation for the time.[58] Because of the expense of reproducing them, Yashiro had long despaired of finding a publisher, but Sirén and the British travel writer Edward Hutton finally found him one.[59] Yashiro occasionally enlisted the Berensons to help procure photographs from private collectors like Gardner, but otherwise Giorgio Laurati of the Brogi firm took the photographs.[60] In the acknowledgments, the author credited Laurence Binyon and Arthur Waley with first encouraging his "'Oriental' enthusiasm for Botticelli"; indeed, Yashiro persevered in finding Asian undercurrents in Botticelli. My favorites are in chapter five, in the book's second section dedicated to the "Sensuous Botticelli," in which he discusses the artist's flowers; the subtitles include "Flowers of the Japanese Painters: Korin and Old Tosa Schools," "Senuous Flowers," "Utamaro's Flowers," "Sensitive Flowers," "Flowers in Buddhistic Paintings," and "Oriental Influences in Flower Painting in Italy." Yashiro's acknowledgments are a veritable who's who of Italian art history at that time, and include a wide range of art historians and museum officials. Berenson may have been irritated by the equal acknowledgment to both him and Herbert Horne (1864–1916), whom Yashiro had never met but whose *Alessandro Filipepi, Commonly Called Sandro Botticelli* was an invaluable precedent.[61]

Tensions over other aspects of the book caused temporary fallings-out with the Berensons, and seemingly Yashiro's removal from significant research on the revised edition of Berenson's *Drawings of the Florentine Painters* (a position later filled by

55 Pietro Toesca, an influential art historian, created a distinguished collection of Italian paintings. This Botticelli was probably the *Annunciation* sold by Toesca to Louis F. Hyde (now at the Hyde Collection, Glens Falls, NY). It was published by Berenson in the June 1924 issue of *Art in America*. Lorizzo 2009, 113.

56 He is referring to the Great Kanto Earthquake of 1 September 1923, which devastated Tokyo, Yokohama, and surrounding areas.

57 Yashiro to Bernard and Mary Berenson, London, 5 November 1924. It is not clear if Yashiro was also the potential purchaser of the Toesca picture. The *Trinity* is in the Courtauld Institute, London.

58 Kenneth Clark acknowledged that this inspired him to do the same in his books of photographs of the National Gallery, *One Hundred Details from the National Gallery* (Clark 1938), and *More Details of Pictures from the National Gallery* (Clark 1941). See Clark 1974, 259.

59 *Sandro Botticelli* was published by the Medici Society in London and Boston in an edition of 630 copies (Yashiro 1925). A second, revised edition was issued in 1929.

60 On the firm, see Silvestri 1994.

61 Horne 1908. Berenson and Horne had had a falling-out over Botticelli attributions; see Strehlke 1989–90, 427–438.

Kenneth Clark).[62] In late 1923 and early 1924, Yashiro passed a lonely period in Paris and London worried about the Great Kanto Earthquake and the Botticelli volumes. Berenson introduced him to Salomon Reinach, whose *Apollo* was the first book on Western art that the Japanese scholar had read. Otherwise, Yashiro complained about depression, passing time in "stupid cinemas," his mother alone in Japan, and the absence of the *Jahrbuch der Preußischen Kunstsammlungen* in the Bibliothèque nationale.[63] In another letter, he wrote that he had "no friend in U.S.A., except perhaps Offner, but I don't know where he is, he never writes me."[64] In the preface to *Botticelli*, he would write that Offner "in our daily company in Italy gave me sound influence by his seriousness of study in Florentine masters."[65]

During his time in London, Yashiro laid plans for the new Tokyo art history institute, writing to Berenson that he had persuaded "the interested people in Japan to establish an institute where practically your method of study is to be pursued in the field of Oriental art. You may have heard of this 'Institute of Art Research' from Sir Robert Witt."[66]

A number of years later, Berenson wrote to Yashiro expressing how much he was looking forward to seeing something from Yashiro's hand:

But I am happy to learn that you have been applying our methods to the study of Chinese painting, & I beg of you as a personal favour to make haste & give me a specimen of your work. I am so bored with most everything, whether general or particular about Eastern art that it would give me joy to read something that was neither soap-bubbles nor microscopic pebbles.[67]

62 There was a misunderstanding over a request by Yashiro's publishers for the Berensons to provide letters of introduction for his first trip to the United States. A letter from Yashiro to Mary Berenson dated London, "late in the night" on 25 August 1924, indicates that their refusal distressed him. Mary later did write to Isabella Stewart Gardner for him; see Hadley 1987, 665–666. As can be deduced from a letter dated London, 4 November 1924, Bernard was annoyed with Yashiro's draft for a list of Botticelli's works, and even told Yashiro that he could only do photographic research on the revision of *Drawings of the Florentine Painters*. Though the preface of the Botticelli monograph suggests that Yashiro planned to return to Japan, he stayed in Europe for several more years, and his time at I Tatti overlapped with that of Clark. Yashiro tried to meet Clark in England in October 1925 (letter to the Berensons, dated 4 October: "I have heard that your book of Drawings is being prepared for a smaller edition & that an excellent young scholar from Oxford, whom I was about to meet & missed the chance, is helping you. I am very glad to hear that, as I am among the most ardent to see the book come out in a form within convenient reach of a student"). Yashiro and Clark became good friends, and Yashiro gave the Clarks' first baby, born at San Martino, a Mensola, a present of pink Japanese silk (Clark 1974, 168). Other misunderstandings with the Berensons may have followed, as a later, undated letter reveals that Yashiro was not visiting I Tatti, but nevertheless frequenting the Clarks' residence at San Martino.
63 Yashiro to Mary Berenson, Paris, 10 November 1923. The library still does not own a run of the periodical.
64 Yashiro to Mary Berenson, London, 10 January 1924.
65 Yashiro 1925, xii.
66 Yashiro to Bernard and Mary Berenson, 4 October [no year indicated].
67 Berenson to Yashiro, I Tatti, 31 January 1936.

13

Yashiro Yukio
examining an
illustration proof
of *Sandro Botticelli*
published by the
Medici Society of
London and Boston
in 1925, ca. 1925.
(Photo courtesy of
Tanaka Atsushi.)

The war years were difficult for Yashiro because, as he wrote in an undated letter (now
at I Tatti) to John Coolidge at the Fogg Museum, of "his international way of thinking."
Berenson had addressed a letter to Paul Sachs at the Fogg recommending that the uni-
versity take on the Japanese scholar: "Far Eastern studies are as all other art-historical
subjects being pursued in a way that makes me despair of the subject & wish often that the
teaching of art history should be altogether abandoned. Yashiro would be a corrective."[68]
The corrective was, of course, the Berensonian method; Yashiro also admitted this, say-
ing that the "history of Eastern Art, especially that of Eastern painting, is just like [the]
History of Italian painting, before it was reconstructed with a new scientific method by
Morelli and B.B."[69]

68 Berenson to Sachs, I Tatti, 5 February 1949. See McComb 1963, 259.
69 Yashiro to Coolidge, Oiso, Japan, 1949.

Yashiro did not get a position at Harvard[70] and remained in Japan, visiting both Europe and America occasionally.[71] Ill health delayed publication of his *2000 Years of Japanese Art*, which came out in 1958 with a dedication to Berenson, whom, he said, "illuminated and enriched my work in Eastern fields."[72] The then ninety-four-year-old Berenson was losing his energies, but Nicky Mariano wrote of how pleased he was by the book.[73]

For a long time, Yashiro had also been shepherding the publication of a Japanese translation of Berenson's *Italian Painters of the Renaissance*.[74] It was issued in 1961. However, in 1954, the same year as a Cecil Beaton photo of Berenson in front of his Sassetta and statues of the Buddha,[75] Berenson had already prepared a dedication of the translation to Yashiro in which he spoke of Botticelli's affinity with Japanese art with the same enthusiasm that he had of Sassetta's in 1903:

> Botticelli's swift flame-like yet modelling line is almost unique in European art but I have encountered it frequently in Japanese drawings. Indeed there is a great affinity between the draughtsmanship of Florentine and Japanese artists. Thanks to you, my dear Yashiro, we Europeans have come to have subtler and more penetrating appreciation of the achievement of your countrymen and they of ours.[76]

70 A position at Harvard had already been discussed in 1924. Mary Berenson mentioned in a letter to Isabella Stewart Gardner (I Tatti, 15 January 1924) that Edward Forbes, director of the Fogg Museum, had talked of bringing Yashiro to Harvard; see Hadley 1987, 665–666. Yashiro had given lectures at Harvard in 1933, and had also returned to Boston in 1936 on the occasion of an exhibition of Japanese art sent by the government to the Museum of Fine Arts to celebrate the tercentenary of Harvard University. At that time, he studied other works in the Boston museum. See Fontein 1992, 14.

71 In January 1952, Yashiro brought one of Berenson's most important Chinese paintings, *In the Palace, or Ladies of the Court (Kong-zhong tu)*, to Tokyo for restoration; see Roberts 1991, 27–31, cat. 2.

72 Yashiro 1958.

73 "Your book has been in the house already for over a week, but B.B. has taken a long time looking at it and now I can tell you how delighted he is with it and with the quality of the illustrations and deeply grateful for the dedication." Mariano to Yashiro Yukio, I Tatti, 4 March 1959.

74 In November 1956, the translator Yashiro Masui visited Berenson at I Tatti. In New York in April of the same year, Yashiro Yukio began negotiating with Phaidon Press about the translated version.

75 Strehlke 2009, fig. 16.

76 Berenson to Yashiro, 3 December 1954; see Yamada 1961.

TEN

Bernard Berenson and Kenneth Clark

A Personal View

WILLIAM MOSTYN-OWEN

WHAT I HAVE TO SAY is not strictly speaking art historical, but rather a backward glance at two great exponents of aestheticism and connoisseurship, Bernard Berenson and Kenneth Clark, to both of whom I owe a great debt, in order to show, in spite of popular rumor to the contrary and their own public reluctance to admit it, how remarkably close they were to each other. I shall not take the advice of the King of Hearts in *Alice's Adventures in Wonderland*[1] but will begin at the end, in the autumn of 1959, and go on to the beginning—in other words, to their first meeting in the autumn of 1925.

In 1959, John Russell, the editor of the arts pages of the London *Sunday Times*, commissioned a series of articles from Clark on individual great paintings of his choice. One of these, on Rogier van der Weyden's *Deposition* in the Museo Nacional del Prado, was due to go out on 11 October. Some time on 6 or 7 October, however, Clark learned of Berenson's death. He asked Russell to postpone the van der Weyden article and allow him the full page for an appreciation of Berenson. He is said to have stayed up all night, a bottle of whiskey beside him, to produce what must have been the longest obituary ever printed in the *Sunday Times*, excepting heads of state. It is also a remarkable document: a mixture of admiration, regret, nostalgia, criticism, and affection for a man who had, in a sense, become his spiritual father, though he never admitted it publicly. Some time early in the

1 Chapter 12: "'Begin at the beginning,' the King said gravely, 'and go on till you come to the end: then stop.'"

morning, and with the bottle of whiskey almost empty, he wrote a concluding paragraph which is one of the most intimately human expressions he ever put to paper:

> His fear of pedantry made him unwilling to give the generations of young men who frequented I Tatti any sort of formal instruction. But I think we may properly consider ourselves his pupils: for at almost every meal, and on those unforgettable walks, our eyes were opened and our minds were filled. At first we might resent the hard knocks administered to local gods. But as we came to realise that neither Oxford nor Bloomsbury nor Cambridge Mass. had established the ultimate boundaries of civilisation, we found ourselves entering a larger inheritance. We were educated, as few young men have been educated since the Renaissance, or perhaps I should say since the Reformation, for we learned to think of civilised life as catholic and apostolic. We learned, in Johnson's immortal phrase, to suspect "the cant of those who judge by principles rather than perception"; and we came to believe that the love of art is only a part of the love of life. I owe him more than I can say and probably much more than I know; and I can only try to repay this debt by holding onto the values which he maintained for so many years.[2]

And thus did the Deposition of Jesus Christ give way to the Apotheosis of Bernard Berenson.

Things were not always like that. At their first meeting in the autumn of 1925, the twenty-two-year-old Clark was alarmed by the household and not very taken with the sixty-year-old Berenson. Writing on 15 September, Mary Berenson confided in Nicky Mariano: "He is very rich. You are sure to like him and he is as keen as snuff on most of the things we care for."[3] On the other hand, Nicky herself had a very bad impression and found him "not too easy to talk to, rather standoffish and cutting in his remarks, also not free from conceit for one so young."[4] Mary's brother Logan, meanwhile, had fallen in love with him (the whole household for some reason had decided he was gay), and only Berenson was totally enthusiastic, but planning to have Clark as his assistant rather than his collaborator on the revision of his *Drawings of the Florentine Painters*—a crucial difference that would turn out to be disastrous.

In early 1926, Clark and Berenson worked together in the library and pored over photographs, and in the summer Clark went to work in the Dresden Print Room, returning in the early autumn. Mary wrote to her family on 10 November:

> It is quite moving to see how Kenneth admires BB. Nothing is lost on that boy; he is so marvellously cultivated that he can follow intelligently almost every intellectual path that BB opens. He says that he has never before been with a person who,

2 Clark 1959.
3 Mariano 1966, 132.
4 Ibid., 132–133.

in three weeks, never repeated himself or with any older man whose mind did not seem poured into moulds.[5]

At the end of the year, however, without any warning, he announced that he was about to get married and left at the beginning of January—unbelievably, only one day before his wedding. He then brought his wife back, without any honeymoon, to live at San Martino at the end of the month. Throughout 1927, Berenson and Clark continued to work together, and visited the British Museum, Windsor Castle, the Ashmolean Museum, and the Musée du Louvre.

In the New Year of 1928, Clark was back at San Martino with his wife Jane, but the two returned to England at the end of the year for the birth of their first child, Alan, and for the publication of *The Gothic Revival*. Among the acknowledgments of this work, Clark wrote gnomically, "Although I have never heard Mr. Bernard Berenson mention the Gothic Revival, I owe him a debt, difficult to describe and impossible to repay, which most of those who have heard him talk will understand."[6] In 1929, he returned to San Martino to work in the Uffizi Print Room on further revisions of the *Drawings of the Florentine Painters*.

Before his return to San Martino, however, Clark heard a lecture by Aby Warburg in Rome and was so impressed by Warburg's doctrine of symbols that "my interest in connoisseurship became no more than a kind of habit, and my mind was occupied in trying to

5 Strachey and Samuels 1983, 262.
6 Clark 1928, vi.

answer the kind of questions that had occupied Warburg"; puzzlingly, he claimed that the chapter in *The Nude* entitled "Pathos" was entirely Warburgian.[7] Mary Berenson reported to her sister Alys Russell that Clark was keen to concentrate on Leonardo da Vinci and that he loathed "the petty-fogging business of correcting notes and numbers and there will be a lot of that to do if he means to help BB." She commented, "he has an ungenerous self-centred nature and BB needs devotion."[8] By now, Clark could hardly wait to leave, and, considering the circumstances, Berenson seems to have been remarkably generous; writing from Baalbek in May 1931, he tells Clark to devote his "gifts for scholarship and words to a task which will prove one of those contributions to the history of ideas and taste which by their existence advance culture."[9] This was the end of their collaboration, and Clark immediately moved into organizing the great Italian Art Exhibition in London in 1930—Berenson disapproved of this event, regarding it, rightly, as a propaganda stunt by Benito Mussolini.

In 1931, Clark was appointed keeper of Western art at the Ashmolean. Writing in June, Berenson had begged him not to accept, describing the Ashmolean as "a toyshop for grownups" and adding: "the post will fix you down in the world of collectors, curators, dons. You will, altho' remaining a plum yourself, [be] more and more embogged in a pudding."[10]

On New Year's Day 1934, at the age of thirty-one, Clark became director of the National Gallery in London. Berenson wrote mischievously to Jane Clark on 16 January: "I wonder how Kenneth is inserting himself into his new charge, how he is filling it with his own personality & whether it is still softly & cosily upholstered, or whether already showing the points of the Nuremburg Virgin. Not that, I hope, altho' one can scarcely expect roses, roses all the way & never a stab at all."[11] In early February, Clark replied hubristically: "I am enjoying myself immensely here. The spikes which you so rightly anticipate are hardly perceptible as yet.... As far as I can see, I am extremely lucky in my Staff, who have shown great generosity in not resenting my intrusion. At present there is lots to do which we can all agree on and I believe that this state of affairs will last for a few years."[12] The Berensons lunched with the Clarks in London in June 1934, after which Mary commented, "he is a queer mixture of arrogance and sensitive humility"[13]—and it was this arrogance, coupled with surprising insensitivity, that was to lead to disastrous relations between Clark and his curatorial staff.

Meryle Secrest, chosen by Clark to be not only Berenson's biographer but also his own, tries to make out that a great rift between the two was created the following October, when Clark asked Berenson to write an article for *The Burlington Magazine* on the Sassetta

7 Clark 1974, 108.
8 Strachey and Samuels 1983, 275.
9 Berenson to Clark, May 1931, Bernard and Mary Berenson Papers, Biblioteca Berenson, Villa I Tatti—The Harvard University Center for Italian Renaissance Studies (hereafter BMBP).
10 Berenson to Clark, 10 June 1931, BMBP.
11 Berenson to Jane Clark, 16 January 1934, BMBP.
12 Clark to Berenson, 5 February 1934, BMBP.
13 Mary Berenson, diary, 22 June 1934; see Strachey and Samuels 1983, 294.

panels which the National Gallery intended to buy.[14] Berenson wisely refused: he could foresee the embarrassing situation for Clark once the public realized that Duveen's expert was praising paintings to be acquired from Duveen by the National Gallery, of which Duveen himself was a highly questionable trustee. Clark seemed naively unaware of the danger to his own position, or perhaps just too arrogant to care. Unwisely, Clark sent Berenson photographs of the four little pastoral scenes with the *Story of Damon* that he had insisted on buying for the gallery in 1937, on the grounds that they were by Giorgione (they are now generally accepted as the work of Andrea Previtali). In the accompanying letter, he wrote revealingly:

> At last I am able to send you photographs of our small Venetian pictures. For some reason they defy the camera, & you cannot judge the beauty of the pictures until you see the original. I am sure you will like them: they are full of poetry. However I do not expect you to think or say that they are by Giorgione. When my Trustees bought them, I told them that they must do so purely because of their

14 Secrest 1984, 97–98.

beauty & that there would never be agreement or certainty into their authorship. They accepted this very well, but rather unfortunately have insisted in the pictures being published as Giorgione. It does not greatly matter as they certainly are all that the ordinary educated man means by that name, & further one can hardly go.[15]

Berenson replied diplomatically:

I thank you for the photos of the four little idylls you have recently purchased for the NG. I am ready to believe that the photos give an incomplete idea of their attractiveness. I fear I see nothing in them that is more than Giorgionesque, nothing in the drawing & everything else that a photo renders, which comes into my definitely circumscribed concept of Giorgione himself.[16]

15 Clark to Berenson, undated (autumn 1937), BMBP.
16 Berenson to Clark, 21 October 1937, BMBP.

Secrest goes on to imply that Clark never again consulted Berenson, but the only appropriate occasion on which the latter's encouragement might have been welcomed would have been over the purchase of the four exquisite panels by Giovanni di Paolo from the J. P. Morgan sale in London early in 1944, when there would have been no way for Clark to communicate with Berenson in Italy—and indeed, Berenson wrote to congratulate Clark on their acquisition on 21 March 1945.[17] In fact, apart from the war years, the two wrote four or five letters to each other every year.

In 1938, the Chicago second edition of Berenson's *Drawings of the Florentine Painters* was published; a copy was dispatched to Clark, who wrote appreciatively:

> It is with a real pang of emotion that I have unpacked and opened the volumes of the "Florentine Drawings". They are intimately connected with the whole of my life, with my early ambition and my first apprenticeship, and also with a good many regrets at the later course of my career. For all these reasons I needn't tell you how touched I am by your reference to me in the introduction; and I am almost equally delighted by what you say about my Windsor Catalogue in your second volume. The work I did on the Leonardo was a direct fulfilment of my apprentice work for you and so is my best contribution to your great work.[18]

Berenson replied: "I am touched, as I seldom have been, by your words about the book on which we were to have worked together. Dear Kenneth, I shall never cease regretting what might have been and I can assure you the regret is of the most affectionate and nostalgic kind."[19]

After a visit to I Tatti the same month, Clark wrote saying how much he had enjoyed "a period of tranquility and rational discourse. Much as I enjoyed the landscape and the library, it was your company, dear BB, which was the real joy of our visit. There was a flow of reason and learning combined with a genial warmth which made me feel I was living in a golden age of culture, a sunset of culture no doubt, but nonetheless beautiful for that."[20] In the summer of 1939, Clark sent Berenson his *Leonardo da Vinci*. Berenson replied:

> I have this moment finished yr. Leonardo & I take real pleasure in telling you how much it has impressed, stirred and delighted me. It is informative, illuminating and beautifully written. Not overwritten, no purple patches, but where the subject demanded, imposed it. The book as the biography of an artist is at once the plainest task & the most radiant yet sensitive appreciation of a great genius that I have come across in a very long time.[21]

17 Clark Papers, Tate Gallery Archive, London (hereafter CP).
18 Clark to Berenson, 1938, BMBP.
19 Berenson to Clark, 6 December 1938, BMBP.
20 Clark to Berenson, 1938, BMBP.
21 Berenson to Clark, 12 August 1939, BMBP.

In 1946, after the war, the Clarks returned to I Tatti, where they found that "if the building had not changed, and the servants had not changed, the atmosphere had. Vituperation had become very rare, explosions practically unknown."[22] This was due to the smooth running of I Tatti by Nicky Mariano following the death of Mary Berenson in 1945. At the same time, Clark resumed sending Berenson all his publications. In November 1949, Berenson wrote: "Your 'Landscape into Art' is a delight. I have read every word with zestful interest, & it has given me a delicious feeling of repletion."[23]

From the summer of 1950, Clark was loaned the Villino Corbignano three times and the Villa I Tatti twice; Berenson invited Clark to work in his study, where Clark wrote much of his *Piero della Francesca* and *The Nude*. When Clark's *Piero* was published in 1951, Berenson was bewildered to find that it was dedicated to Henry Moore, the admiration for whose work, particularly on the part of Clark, astonished him (although he found Moore "one of the most appreciative persons I ever took through the house").[24] In writing to thank him, Berenson, tongue in cheek, told Clark that Rembrandt was the only artist he really understood, but added graciously, "Piero becomes intelligible under your gaze, and alive as well."[25] In November 1956, Clark wrote: "Before I see you again you will have received a copy of my book on the Nude which you kindly allowed me to dedicate to you. You will see how much of it is due to you on every page. It was conceived on walks on the hills behind the Tatti during one of those blissful periods when you let me stay there."[26] Berenson replied:

> Let me congratulate you on surpassing even yourself in "The Nude." Much as I always have expected from you the achievement goes beyond expectation. You unfurl the subject to its widest horizons, & fill it with details so perfectly communicated, such precious epithets, such illuminating, evocative phrases, such rhythms sometimes that it is a delight to read and read and read. I admire your scholarship and the way you have assimilated it. Wonderful your analysis of the Apollonian nudes. You end by constructing a scheme of common characteristics regarding the figure. No province or representation that you fail to illuminate.[27]

Having summarized the chronology of their relationship, it is time to turn to those predecessors whose writings they both acknowledged. In *Aesthetics and History*, Berenson praised the following: John Ruskin, Walter Pater, Jacob Burckhardt, Heinrich Wölfflin, Wilhelm von Bode, Eugène Fromentin, Charles Baudelaire, Émile Mâle, Alois Riegl, and Michael Rostovtzeff. Clark would have agreed with this list, save for Rostovtzeff, for he was never much concerned with central Asia, but he would certainly have added Roger

22 Kenneth Clark in Mariano 1966, xiv.
23 Berenson to Clark, 9 November 1949, CP.
24 Bernard Berenson, diary, 28 May 1948; see Berenson 1963c.
25 Berenson to Clark, 21 April 1951, CP.
26 Clark to Berenson, 2 November 1956, BMBP.
27 Berenson to Clark, 9 December 1956, BMBP.

Fry and Ernst Gombrich (whose *Art and Illusion* was published one year after Berenson's death, and which Clark regarded as one of the greatest contributions to twentieth-century art studies). Clark had read Riegl in German with great difficulty at Oxford and "dreamed of a great book which would be the successor to Riegl's *spätrömische Kunst-Industrie* and would interpret in human terms the slow, heavy, curve of Egyptian art or the restless, inward-decorations on a Chinese bronze. It has haunted me ever since and, although I have not written my 'great book', I know what kind of book it ought to have been."[28] Meanwhile, Berenson was haunted by the fact that he never wrote his "great book" on "Decline and Recovery in the Figure Arts." Both of them felt they had allowed themselves to be led astray from what they should have done: Berenson by his Florentine drawings and time-consuming lists, and Clark by his museum directorships and public persona, his infatuation with lecturing both on and off television, and his acceptance of the first chairmanship of the Independent Television Authority (he wrote to Berenson in September 1955 that the opening ceremony gave him the feeling that he "had constructed a handsome building which was inhabited by barbarians").[29] In September 1957, Clark wrote, "My television years are over. I was a great success and was beloved by all!"[30] Berenson said to the present writer prophetically that Clark would not be able to resist the wish to become "un grand vulgarisateur"; ten years later, Clark was preparing *Civilisation*.

28 Clark 1974, 108.
29 Clark to Berenson, 23 September 1955, BMBP.
30 Clark to Berenson, 7 September 1957, BMBP.

They both admired Ruskin. Berenson wrote in *One Year's Reading for Fun* (1942): "Ruskin's *Queen of the Air*, eloquent, magniloquent, unctuous, mad, absurd, penetrating, visionary, fantastic, all in one. What a curious mytho-poet was Ruskin. How conveniently he handles the Greek deities with the freedom of old friends whose secret histories he alone knows. Yet what sublime impudence on the part of Ruskin."[31] In his diary on 18 June 1948, he wrote, "Rereading selections from Ruskin about Venetian things. Ruskin's prose is not, good as it is, good enough to be independent of it contents. And yet Ruskin remains the greatest writer on art up to date."[32] For his part, Clark wrote, revealingly, in his introduction to the 1949 edition of Ruskin's *Praeterita*, "When, after one of his lectures, a member of the audience tried to tell him how much he had enjoyed his works, Ruskin replied, 'I don't care whether you enjoyed them, did they do you any good?'"[33] And here is another Clark quote: "It is no accident that the three or four Englishmen whose appreciation of art has been strong enough to penetrate the normal callosity of their countrymen—Hazlitt, Ruskin, Roger Fry—have all come from philistine, puritanical homes. Was the 'fourth Englishman' a conscious or sub-conscious reference to himself?"[34] And again: "Ruskin never doubted he was one of the elect.... Perhaps this messianic confidence is contrary both to reason and to good manners. The civilised man of taste may claim that his prefer-

31 Berenson 1960a, 86–87.
32 Berenson 1963c, 86.
33 Clark 1949a, vii.
34 Ibid., xxi.

6

Bernard Berenson
at Poggio allo
Spino, 1931.
(Photo: Guglielmo
degli Alberti.)

ences are entirely personal, and that he has neither the right nor the desire to force them on others. But no windows are opened, no horizons enlarged, no spirit set free by this wise indifference."[35] Messianic indeed!

Both also admired Walter Pater, but while Berenson's descriptions of art and nature are closer to Pater in style, Clark looks more toward Ruskin for his descriptive prose. Let us compare, for example, their comments on Giovanni Bellini's *St. Francis in the Desert* in the Frick Collection. First, Berenson: "Here there is no passive ecstasy and no horrid wilderness, but a free man communing with his ideal and in surroundings completely humanised. The saint need not retire to the wilderness to find his God. He can find him close to the haunts of men."[36] And Clark: "Here, at last, is a true illustration of

35 Ibid., xxii.
36 Berenson 1916, 98.

St. Francis's hymn to the sun. No other great painting, perhaps, contains such a quantity of natural details, observed and rendered with incredible patience: for no other painter has been able to give to such an accumulation the unity which is only achieved by love."[37]

Again, both of them believed in moments of heightened perception—these were what Clark called "Moments of Vision," the title he gave to a 1954 lecture citing many examples both from painting and from literature; while Berenson famously recalled such a moment for him in the Boston museum in 1894, which is described in Carl Brandon Strehlke's contribution to the present volume.

There is one particular mystery which is likely to remain unsolved. In 1950, Clark was elected president of the Associated Societies of the University of Edinburgh, and his opening address, entitled "Apologia of an Art Historian," was published in the *University of Edinburgh Journal* the following summer, but never republished in his two rather disappointing volumes of collected pieces. I offer a few quotes which may have echoes elsewhere:

> We must believe that the frieze of the Parthenon, the West portal of Chartres and the ceiling of the Sistine are great works of art long before we have any idea how great they are: in fact we never shall know how great they are, but only that each time we see them we come a little closer to understanding.... Last year as I left the church of San Francesco in Arezzo, my first thought was that I had never seen them before [the frescoes of Piero della Francesca]. I kept on repeating to myself "How can I have been so blind?" Well, that has been, and is increasingly my experience before all great works of art, and I suppose it is the same with everyone who responds to them.... I believe in a central tradition of art beginning, as Herodotus said, in Egypt [he is referring presumably to Saqqâra], reaching its perfection in Greece, dividing, like the Empire, into East and West, passing imperceptibly into Byzantine and Medieval, reaching its second perfection in France in the twelfth and thirteenth centuries, and so forth, down to our own times.... I recognise that this belief in one catholic and apostolic art may seem to you narrow, and even bigoted. Twenty years ago it would have seemed so to me, and I still derive pleasure and stimulus from the works of the Periphery, fish caught in that stream of ocean which surrounds the known world. The so-called folk-wandering style of the Dark Ages—the style of animal ornament—achieved a decorative vitality which has never been surpassed.... I believe that art is concerned with life, and that the emotions aroused by a work of art are those which we experience in life, clarified and concentrated so that we may apprehend them in a flash.... The only reliable documents are the works of art themselves. Their interpretation is far more disputable and subjective than that of a manorial record. Moreover, their aesthetic value is essential, not only the ultimate purpose of our study, but a great part of the evidence. It is true that we sometimes study worthless artifacts in order to provide a background to the history of taste; but even then we must discriminate between changes of taste, which are due to fresh artistic invention, and those due

37 Clark 1949b, 24–25.

7

Kenneth Clark
delivering his
encomium on Bernard
Berenson, Palazzo
Vecchio, Florence,
May 1960. (Photo:
© Banca Dati dell'
Archivio Foto Locchi
Firenze.)

to the deformation of laziness or to what Mr. Berenson has called the originality of incompetence.... The history of art is inseparable from a sense of critical values.[38]

Now, Berenson could justly lay claim to all these pronouncements or variations thereon. Was it the case that Clark was consciously aware of this and decided not to republish the piece in order to distance himself from Berenson?

What was their true relationship? The question is difficult to answer. I have stated at the beginning of this essay that Clark regarded Berenson as his spiritual father, and

38 Clark 1951.

I suppose Berenson regarded Clark as a gifted but wayward son. There was a nervous tension between them, however, and Clark always seemed ill at ease at I Tatti. Berenson felt this, and wrote a despairing letter in October 1937:

> If there is anything that I now crave for it is for your affection. You may say I have it, and far would it be for me to doubt it. I want affection with perfect confidence, perfect ease, without timidity or holding back of any sort. What I crave is a brotherly comradeship. It is to be had, and others younger, one younger even than yourself, give it to me. What comes in between you and me? It can't be wives, for all the others I have referred to are married. I wonder sometimes whether there is something of schoolmasterly suspicion, or even criticism, in my attitude. You have, it is true, not taken the path I expected you to take, but I have long ago concluded that on that score you were right. I felt all the same that you did not trust me with much feelings towards you and found a certain tone of superiority, and perhaps some aggressive superiority, on my part. Only last autumn, did the ice really seem to melt, and thaw. I want you, dear Kenneth, to read what I have just written for what it is intended—a cry for the good will, and cordial confidence that I miss to a degree that amounts at times to real unhappiness. From your side, and to you, it may seem irrational. Remember however that affection belongs to the realm of the irrational and that the Christian religion itself is perhaps founded on and certainly permeates with one idea of Grace, that is to say irrational craving for love.[39]

Clark replied:

> Your last letter has been much in my mind. It touched me deeply, but I find it very hard to answer. I come of an undemonstrative family & my feelings are as stiff as an unused limb. You must never doubt that my admiration for you is combined with great affection—more than my way of writing will allow me to show. But to me our relations must always be those of master & pupil. It is true that in the field of administration I have arrived at an independent position, but on things of the mind & particularly in the history of art, I have advanced very little in the last years, & in those subjects which I love to discuss with you it would be foolish for me to pretend to talk as an equal.[40]

All the same, Clark adopted many traits from Berenson, as I was able to witness. For example, the interior of Saltwood Castle and, in particular, Clark's study was characterized by a mixture of paintings, sculpture, Eastern objects, and textiles, all of which were such a familiar and delightful feature of I Tatti; and when I showed Berenson's study to Clark's son Alan, he exclaimed, "Now at last I understand Papa." Walking with Clark on Romney Marsh was not as invigorating as walking on the Florentine hills with Berenson,

39 Berenson to Clark, 21 October 1937, BMBP.
40 Clark to Berenson, 1 January 1938, BMBP.

but, like Berenson, Clark would stop and, pointing at some willow stump, say, "Look at that tree—pure Rembrandt." On the other hand, when I was once on a walk with Berenson, he turned to me and said regretfully, "I love K, but, you know, I'm not sure I like him."

Both men were preoccupied by money, but for very different reasons. For Berenson, it was because funds were running low, and the I Tatti ship was only kept afloat by Wildenstein's annual retainer. Having despaired at the failure of Oxford University Press to sell more than a few hundred copies of his *Italian Painters of the Renaissance* since 1932, it was touching to see his excitement when the royalties started to roll in for the first print of sixty thousand copies of the illustrated edition produced by Phaidon Press under the brilliant guidance of its founder Bela Horowitz (whom Berenson described as "that distilled quintessence of Zentral Europa"),[41] and more was to follow from numerous foreign translations. A constant gripe of Berenson's was the fact that Clark was born rich and that his numerous dealings were never questioned—he was clearly unaware of the feelings of the National Gallery staff—whereas Berenson himself had to earn his living, and his every move was regarded with suspicion. As for Clark, one would have thought money problems were far from his mind, but he eventually started to sell his paintings, beginning with Pierre Auguste Renoir's *Baigneuse Blonde*, and worried over his family investments, about which, much to my surprise, he asked my opinion. Berenson was determined that, if at all possible, every painting should remain at I Tatti; Cecil Beaton chose to portray him leaning, almost lounging, against the credenza beneath the merciful gaze of Sassetta's *St. Francis*. Clark's beloved remaining treasure, by Joseph Mallord William Turner, was sold by his heirs for £7 million.

I think it is fair to say that Berenson, in the years I knew him, never sought public adulation and detested any invasion of his privacy, even after his postwar "rediscovery" and the success of his autobiographies and diaries, though matters were clearly very different in the 1920s and 1930s. It was sometimes hard to keep persistent admirers at bay, and much of the responsibility fell on the shoulders of the luckless Nicky Mariano. What he really enjoyed was the company of a small group of close friends who would aid and abet him in carrying on a sort of improvised near-monologue. Clark wrote to me in the spring of 1955, worried that nothing was being done to celebrate Berenson's ninetieth birthday in the summer. He could hardly believe my answer: Berenson wanted no celebration and no Festschrift, but I added that I was preparing in secret a bibliography of all his writings on behalf of his publishers, which Nicky thought would give him more pleasure than anything else. But then Clark would constantly express amazement that Berenson had never given a lecture or made a speech—not even a speech of thanks. Clark liked sometimes to be totally alone or, more often, in the company of a beautiful and intelligent woman; otherwise, he craved adulation from an audience, initially at lectures, where he would not allow questions, and later on television, culminating in the *Civilisation* series, which, he wrote, "was in the nature of a performance." But his movements were jerky and nervous, and he had an irritating habit of running his tongue over his teeth, usually in close-up;

41 Berenson to Clark, 1 September 1951, CP.

8

Bernard Berenson
and William Mostyn-
Owen in the garden
at I Tatti, 1954.
(Photo: Du, Zurich.)

a *Sunday Times* profile commented that his programs "were, as yet, somewhat uneasy per-
formances in which the great elucidator woos his great audience with the head move-
ments of a super-sapient tortoise and many an artful lapse into demotic speech."[42] The
tortoise analogy is accurate; Clark's withdrawal into his shell made it clear that there was
no room for discussion.

So, what is Clark remembered for today? The problem lies in sifting through the diver-
sity of activities which occupied his time—leading one weekly to describe him as "six men
in search of a character"—and attempting to decide which of them could be said to have
retained some value. In his eleven years as director of the National Gallery, he succeeded
in buying a few outstanding paintings, but he also made some injudicious purchases; at

42 "Gallery Profile," *Sunday Times*, 27 September 1959.

the same time, he continued to buy nineteenth-century masterpieces by Renoir, Paul Cézanne, and Georges Seurat for himself; and he hobnobbed too much with his trustees, to the great detriment of his relations with his curatorial staff, some of whom he treated with arrogant contempt. His effort at the wartime Ministry of Information was, in his own words, "short and unsuccessful."[43] He joined far too many committees and councils. But his promotion of a new generation of war artists and, in particular, John Piper, Moore, and Graham Vivian Sutherland—to succeed Paul Nash and Stanley Spencer—was a stroke of brilliance. This leaves his writings and lectures. His only book conceived as a book was the first monograph in English on Piero della Francesca, still immensely readable and with some marvelous descriptive and analytical passages, but research in the last fifty years has rendered it rather out of date. His other books started out as lectures, which is inevitably restrictive. The most successful are his *Leonardo da Vinci* and *The Nude*—in both cases, he had time to revise and vary the chapter lengths—and *Rembrandt and the Italian Renaissance*, which took an entirely original approach.

Berenson's most visible legacy is the Villa I Tatti, its contents, its library, and its photographs, which he bequeathed as a center of Renaissance studies. For a personal summing-up, let us turn to Clark, who in May 1980 gave a talk to the I Tatti fellows in which he said:

> The passages in Berenson's work which are likely to retain their value are few and short. But the pages of Pater's "Criticism" that we care to reread are not numerous, and with a scholar such as Warburg, the actual writings are almost unreadable. The history and criticism of art is a literary form in which quantity and quality are seldom united. What we value in a critic is a general attitude of mind revealed, it may be, in isolated judgments, which nonetheless imply a new direction of thought, fresh historical intuitions and insights that enlarge our own range of understanding. All these we find in the works of Berenson, explicit in the prefaces, implicit in the lists, half-buried in the historical reflections. We may not agree with them, any more than we agree with Ruskin, but they spring from qualities that are seldom found in combination—learning, intelligence, sensibility and faith in man—and I think with posterity we will value them, even though they often seem to us to be imperfectly expressed.[44]

43 Clark 1977, 42.
44 Clark 1981, 129.

ELEVEN

Bernard Berenson and Arthur Kingsley Porter

Pilgrimage Roads to I Tatti

KATHRYN BRUSH

T HIS ESSAY EXPLORES A NOVEL TOPIC: Bernard Berenson's multifaceted relationship with the pioneering American medievalist Arthur Kingsley Porter (1883–
1933) (Fig. 1). Porter, who was appointed research professor in the department of fine arts
at Harvard University in 1920, is best known today for his book *Romanesque Sculpture of
the Pilgrimage Roads*, which appeared in 1923.[1] In that monumental study, consisting of one
volume of text and nine volumes of photographs, the New World scholar boldly inverted
the Christopher Columbus paradigm by crossing the Atlantic to redraw Europe's artistic
and cultural map. Porter rejected the nationalist interpretations of medieval culture propounded by his European counterparts, most notably the French, proposing instead that
the pilgrimage roads to Santiago de Compostela (and elsewhere) had been channels of
communication that united all of medieval Europe. His vision of a simultaneous and bor-

⚭ I am very grateful to Joseph Connors and Louis A. Waldman for encouraging my research by inviting
me to participate in the "Bernard Berenson at Fifty" conference at Villa I Tatti in October 2009. I
also wish to acknowledge the generous assistance of Ilaria Della Monica and Giovanni Pagliarulo
(Villa I Tatti); Kyle DeCicco-Carey, Timothy Driscoll, Michelle Gachette, Robin McElheny, and
Barbara Meloni (Harvard University Archives); Jane Callahan, Thomas Lentz, Laura Morris, and
(†) Susan von Salis (Harvard Art Museums); Joanne Bloom (Special Collections, Fine Arts Library,
Harvard University); Robert G. La France (University of Illinois at Urbana-Champaign); Pamela
M. Jones (University of Massachusetts, Boston); and the Social Sciences and Humanities Research
Council of Canada. The ideas introduced in this essay will be developed and contextualized more
fully in a book which I am preparing on the life and scholarship of Arthur Kingsley Porter.
1 Porter 1923.

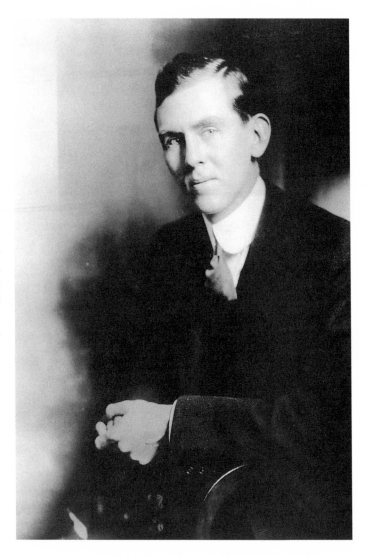

derless transmission of artistic ideas suddenly made modern, nationalist-driven concepts of cultural priority appear irrelevant. Porter's text was controversial. His photographic corpus catapulted Romanesque sculpture into mainstream discourse and provided endless provocation for later scholars. His imaging of eleventh- and twelfth-century sites from the Mediterranean to the Baltic was unparalleled until the advent of the Internet.

Porter's role in the international development of art scholarship is universally recognized, and the top research prize of the College Art Association—the Arthur Kingsley Porter Prize—bears his name. But it is not widely known that the celebrated scholar of the Romanesque pilgrimage roads penned a considerable amount of his groundbreaking treatise at Villa I Tatti—indeed, while sitting at Berenson's own writing table (Fig. 2). Close study of Porter's unpublished papers reveals that the medievalist was a confirmed I Tatti-ophile, and that he made many pilgrimages there after he met Berenson in 1919.

The two men had begun to correspond two years earlier, in 1917, by which time Porter was already a seasoned scholar. Berenson initiated the epistolary exchange with his younger American compatriot.[2] In his first response to Berenson, Porter wrote: "I have read and re-read and admired your works so intensely, that an autograph from you carries with it the romance of a relic."[3] In the same letter, he confessed to Berenson that "your scholarship has been my inspiration" and that during Florentine sojourns he had "looked longingly towards Settignano."[4] Porter's intellectual and spiritual journey to I Tatti had thus begun much earlier than his first visit.

Remarkably, however, the personal and professional bonds that linked Berenson and Porter—the two giants of American art scholarship in the early twentieth century—have remained unexplored until now. Instead, the two men have traditionally received separate analysis because they have been seen as representing distinct subfields of art history: Renaissance and medieval art (Figs. 3 and 4). Yet in 1917, when the two scholars first forged ties, such specialist categories were not so firmly demarcated. Moreover, Berenson's many biographers have paid scant attention to the scholar of the pilgrimage roads, usually mentioning Porter only as Berenson's traveling companion to Greece in 1923, and to Germany a few years later, where the two men paid a joint visit to Aby Warburg.[5] Ernest Samuels, Berenson's primary biographer, probed the furthest, suggesting in 1987 that Berenson's relationship with Porter had been "one of the most intellectually rewarding friendships of Berenson's life."[6] But Samuels did not elaborate on this provocative statement, preferring instead to focus on other academic and literary stars in Berenson's galaxy.

Perhaps the greatest stumbling block to understanding the relationship of Porter and Berenson is that no critical analysis has yet been conducted into Porter's intellectual biography and the genesis of his investigative approaches. The many scholars who have been

2 Berenson to Porter, undated letter, Harvard University Archives, Arthur Kingsley Porter Papers, correspondence with Bernard Berenson 1916–56, HUG 1706.185 (hereafter HUA, AKPP, BB) The first sheet of Berenson's letter, equivalent to two pages, is missing. To judge from the context, Berenson's letter was likely written in July or early August 1917. Porter had sent Berenson a copy of his *Lombard Architecture* (discussed below), and in this initial letter, Berenson commented on that publication. He also pointed out that they had a mutual friend, the New Jersey collector Dan Fellows Platt, and that Platt had mentioned Porter "tantalizingly" to him.

3 Porter to Berenson, 27 August 1917, Bernard and Mary Berenson Papers, Biblioteca Berenson, Villa I Tatti—The Harvard University Center for Italian Renaissance Studies (hereafter BMBP). Porter wrote: "Your letter gave me more delight than anything which has happened to me in a long while. I have read and re-read and admired your works so intensely, that an autograph from you carries with it the romance of a relic."

4 Ibid.

5 It is typical of the neglect of Porter that Meryle Secrest devoted only a few paragraphs of her 398-page narrative to Berenson's friendship with the medievalist (Secrest 1980, e.g. 327–329, 359). For Porter's travels with Berenson, see Mariano 1966, 77–82 (Greece), 164–166 (Germany) (Nicky Mariano also accompanied Berenson on these trips); and Samuels 1987, 307, 311–313 (Greece), 356 (Germany). The visit of the two American scholars to Aby Warburg in August 1927 is well documented; for a discussion of these sources and the larger contexts behind them (Warburg was planning to extend his intellectual project to the United States at the time), see Brush 2003, 187–191.

6 Samuels 1987, 224. Samuels provided a partial account of Berenson's dealings with Porter; ibid., 223–224, 262, 265, 279, 290, and 406.

2

Bernard Berenson at
his writing table at
Villa I Tatti, 1948,
photograph by
Barsotti. Bernard and
Mary Berenson Papers,
Biblioteca Berenson,
Villa I Tatti—The
Harvard University
Center for Italian
Renaissance Studies.

inspired by Porter's publications have focused narrowly on revising details of his argu-
ments (e.g., chronologies and attributions at individual medieval sites) rather than on
considering how and why he arrived at his novel theories. The few biographical accounts
that do exist derive from a single source: a sensationalistic five-page memoir published by
Porter's widow Lucy shortly after his premature death in 1933.[7] Mrs. Porter provided no
clues about her husband's relationship with Berenson. Instead, she wrote a fairy-tale-like
account that cast her partner in the role of a romantic hero—and, in fact, he had bought a
castle in Ireland in 1929 and drowned there a few years later. Not surprisingly, later schol-

7 See Lucy Kingsley Porter, "A. Kingsley Porter," in Koehler 1939, xi–xv (Lucy Kingsley Porter
 incorporated "Kingsley" into her name shortly after her husband's death on 8 July 1933).

Kathryn Brush

3

Bernard Berenson
at Villa I Tatti, 1903.
Bernard and Mary
Berenson Papers,
Biblioteca Berenson,
Villa I Tatti—The
Harvard University
Center for Italian
Renaissance Studies.

ars have followed in her tracks, dwelling on Porter's wealth, the glamour of his inveter-
ate travels, and the mystery of his tragic death, instead of investigating the specific early
twentieth-century contexts in which he formulated his ideas.[8]

I am currently preparing a book on Porter that draws on his unpublished papers and
voluminous correspondence to map his scholarly imagination. My archival work is yield-
ing a different picture of Porter that will necessitate major adjustments to our legendary
view of his life and scholarship. One of my most important discoveries is that Berenson
was the primary mentor and confidant of Porter until the latter's death in 1933. This find has
enormous implications for our understanding not merely of Porter, but also of Berenson.
The present essay takes the first small step toward opening up this rich, revisionist topic

8　Many of the writers of these narratives were Porter's own students and/or graduates of Harvard,
where the mythologizing of Porter was centered for most of the twentieth century. Examples
include Whitehill 1933, Conant 1934, and Seidel 1993. Seidel relied heavily on Lucy Porter's narrative,
but she also operated at some distance from the events, making her various accounts of Porter the
most analytical of those of the Harvard-trained scholars.

4

Arthur Kingsley
Porter at Carracedo,
Léon, ca. 1920,
photograph by
Lucy Wallace
Porter. Harvard
University Archives,
Cambridge.

by focusing on the years between 1917 and 1921, when Berenson and Porter's friendship took root and began to flourish. The goal is twofold: to sketch how and why these two prime movers of American art scholarship came to engage with each other, and in doing so, to illuminate a previously unknown chapter in the history of I Tatti.

In hindsight, it seems inevitable that the two New Englanders would have been drawn to each other. Berenson graduated from Harvard in 1887, while Porter, who was eighteen years younger and from Stamford, Connecticut, studied at Yale University from 1900 to 1904. Both were grounded intellectually in the literary and artistic culture that spawned the Anglo-American cult of the Middle Ages and Renaissance in the late nineteenth century: the writings of John Ruskin, Walter Pater, John Addington Symonds, Charles Eliot Norton, and others. Porter's correspondence shows that already during his

undergraduate years he despised the "respectable mediocrity" of American academic culture.[9] Like Berenson, the high-minded young Porter embarked on a mission to elevate standards for American art scholarship, recognizing that this project would be difficult and polemical. There were also parallels between Berenson's and Porter's approaches. Both men shared the conviction that firsthand study of artworks was imperative; hence, they explored not only Europe's highways, but also its byways, charting virgin terrain en route. Their voyages to the past were supported by modern technologies: the automobile and the camera (Figs. 5 and 6). Much of their scholarship was based on Germanic-derived methods of connoisseurship, and both believed in the "scientific" value of photography. In both cases, too, the impact of their work extended from the academic arena to the public domain, influencing collecting and the formation of taste in Europe and America.

⁓

There were also differences. Berenson's work was primarily concerned with painting, while Porter focused on the plastic arts of architecture and sculpture. In contrast to Berenson's longevity as a cultural prophet, Porter's scholarly activity was confined to just over two decades. Yet in that short time the medievalist published some twenty volumes, an accomplishment that was due to his focus, his disciplined work ethic, and the ease with which he could generate prose, even while on the move.[10] Their backgrounds also diverged because Porter was born into the moneyed class, making it unnecessary for him to commercialize his knowledge in the manner of Berenson. Porter's disinterested pursuit of culture represented the ideal to which Berenson aspired.

Although Porter is most readily identified by today's scholars with the medieval pilgrimage roads in France and Spain, most of his publications prior to 1919 examined Italian topics. Like other educated Americans at the turn of the century, this Connecticut Yankee was swept up in that era's Dante-mania and obsession with the lure of Italy. During his undergraduate years at Yale, he enrolled in a course at the Yale Art School and decided that his future lay in the study of culture. Porter's studies at Yale more or less coincided with the publication and dissemination of Berenson's "Four Gospels," which rapidly became the textbooks for a nascent American art history curriculum.[11] They had special significance at Yale, because that institution possessed the Jarves collection, the largest assemblage of Duecento and Trecento painting then on display in America. To make a long story short, my research suggests that the medievalist Porter cut his academic teeth on Florentine and Sienese painting. Only a month after his Yale graduation, he made his

9 The specifics of Porter's family background, intellectual formation, and early travels will be discussed in my book.
10 See "Bibliography of the Writings of A. Kingsley Porter," in Koehler 1939, xvii–xxiv. Berenson acknowledged in his *Sketch for a Self-Portrait* (Berenson 1949, 32) that he "was born for conversation and not for writing books." Indeed, the socialite Berenson characterized himself as a "lazy" writer (ibid., 31). Porter, a quieter and more retiring personality, had a definite literary bent, and easily produced his scholarship in hotel rooms, trains, and the like.
11 Berenson's celebrated books on Venetian, Florentine, and central and northern Italian painters of the Renaissance, published between 1894 and 1907, earned him international recognition.

5

Mary and Bernard
Berenson in
a chauffeured
automobile, Italy,
ca. 1910. Bernard
and Mary Berenson
Papers, Biblioteca
Berenson, Villa
I Tatti—The
Harvard University
Center for Italian
Renaissance
Studies.

6

Lucy and Arthur
Kingsley Porter in
their chauffeured
automobile, Lenno,
Lake Como,
ca. 1912–13. Harvard
University Archives,
Cambridge.

Kathryn Brush

first trip to Florence.[12] I propose that Porter's early exposure to originals—both at Yale and in Europe—helped condition his taste for so-called "primitive" art.

Porter went on to study for two years at the Columbia School of Architecture, where he sharpened his technical and observational skills. Extended periods of firsthand study in Europe resulted in his first book, a massive 981-page study, *Medieval Architecture*, that appeared in 1909, when he was just twenty-six years old.[13] But Porter soon refocused on Italy, and in 1911 he published a book on *The Construction of Lombard and Gothic Vaults*.[14] Following his marriage in 1912, he and his wife spent a year and a half in Italy, conducting research for a four-volume book, *Lombard Architecture*, that appeared between 1915 and 1917.[15] While he was engaged in the study of Lombard architecture, Porter also began to assemble a collection of Italian painting. He began by fine-tuning his skills in connoisseurship, inspecting major European collections, and confirming or modifying Berenson's attributions. While in Florence in 1913, Porter purchased his first painting, a *Madonna and Child* by Niccolò di Pietro Gerini (Fig. 7). He continued to build his collection, now at Harvard's Fogg Museum, after his return to New York.[16] In 1915, he was appointed assistant professor at his alma mater, Yale. Porter's engagement with the Jarves collection intensified, and his papers show that he befriended Osvald Sirén, who was then cataloguing it.[17] Sirén advised Porter on several acquisitions he made from New York dealers—and, in fact, many of the works Porter purchased were by the Florentine and Sienese masters represented at Yale, such as Bernardo Daddi and Sano di Pietro.[18]

The publication of Porter's *Lombard Architecture* marked the beginning of direct contact between the medievalist and Berenson. In 1917, when all four volumes had appeared, Porter arranged for a copy to be sent to Berenson. The Renaissance scholar was overwhelmed. In his thank-you letter he proclaimed that the publication was "beyond... praise," proposing that at the war's end he and Porter should "explore some Lombardic sights together."[19] Berenson also underscored his pride in Porter "as a fellow

12 Porter's correspondence with his friends and family shows that he graduated from Yale in late June 1904, and left immediately for Europe. He spent most of August 1904 in Florence and its region.

13 Porter 1909.

14 Porter 1911.

15 Porter 1915–17.

16 Porter bequeathed his art collection to Harvard, and following the death of his wife Lucy in 1962, the collection entered the Fogg Museum. The full spectrum of Porter's collecting activities will be analyzed in my book.

17 Sirén 1916.

18 Some of these attributions have been changed or refined in the interim; for example, a large triptych showing the *Crucifixion with Saints* (Fogg Museum, Harvard Art Museums, 1962.292) that Porter believed to be by the hand or school of Bernardo Daddi is now assigned to Puccio di Simone (left and center panels) and the Master of Barberino (right panel). Correspondence between Porter and Sirén, who was involved in the New York art trade, shows that the latter sometimes advised Porter on his acquisitions; for example, on 1 November 1917, Sirén attributed a painting of the *Virgin and Child with Saints Jerome and Bernardino* to Sano di Pietro, and Porter immediately purchased it from the F. Kleinberger Galleries (now Fogg Museum, Harvard Art Museums, 1962.284). See the object file in the Harvard Art Museums and HUA, AKPP, Correspondence: Folders Not Included in Main File, HUG 1706.105, Box 1.

19 Berenson to Porter, undated letter, HUA, AKPP, BB (as in note 2).

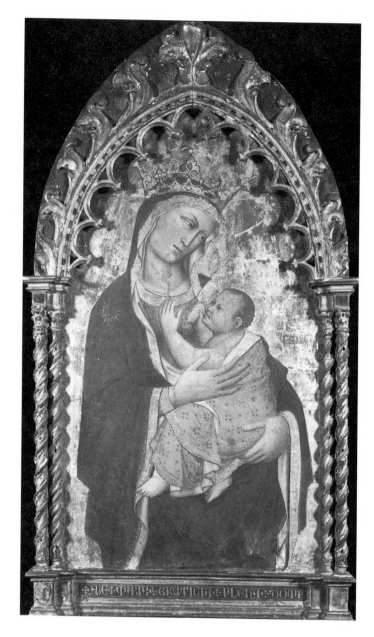

7

Niccolò di Pietro Gerini, *Madonna and Child*, fourteenth–fifteenth century, tempera transferred from panel to canvas, Harvard Art Museums / Fogg Museum, bequest of Lucy Wallace Porter, 1962.285.

countryman."[20] It seems likely that Porter sought Berenson's approbation because his corpus of Lombard churches was modeled not only on Germanic precedents, but also on the first important American exemplar of this genre: Berenson's own weighty two-volume corpus of Florentine drawings published in 1903.[21] Indeed, the physical and intellectual scale of *Lombard Architecture*, with its exhaustive lists of monuments and synthesis of

20 Ibid.
21 Berenson 1903b.

minute detail and broad visions, announced to the academic community at large and to Berenson in particular that a second major American art scholar—one whose work could match, challenge, or even surpass Berenson's achievement—had emerged. Half of Porter's book was devoted to the so-called accessory arts, and methodologically he began to graft approaches employed for the study of Italian painting—for example, connoisseurship, with its identification of individual artistic personalities—onto the study of medieval sculpture and painting.

Berenson must have been even more gratified the following year when Porter sent him a volume of essays, *Beyond Architecture,* in which Porter discussed the work of Giotto and other early Tuscan painters, engaging critically with many of Berenson's trademark principles, including "tactile values," "decoration," and "illustration."[22] In his first letter to Porter, Berenson had noted a "kinship" between their methods;[23] in his book of 1918, Porter made his Berensonian source of inspiration abundantly clear. Indeed, he seems to have conceived of "Mr. Berenson," cited repeatedly in his text, as his imaginary interlocutor. This dialectical relationship operated on the visual level as well, with Porter self-consciously illustrating works discussed by the senior scholar.[24] Porter attempted, too, to move beyond his predecessor, extending such Berensonian concepts as "space composition" to works of other media and cultures, notably medieval architecture and sculpture.

Now to the big question: How did Berenson respond to Porter's challenge?

The two men first encountered each other in person in Paris in early 1919. Porter was in the French capital because he was surveying damaged medieval monuments in the devastated regions for the Commission des Monuments Historiques. He was accompanied by his wife Lucy, a gifted photographer who enabled her husband's work (Fig. 8).[25] Berenson and the Porters quickly became friends. The Porters were not impressed by the glitter

22 Porter 1918. The series of essays had its genesis in Porter's lectures at Yale (according to Porter's prescript: ibid., ix–xi); most were revised versions of articles which Porter had published elsewhere. They ranged in topic from Roman architecture to medieval and Renaissance architecture, sculpture, and painting, and also engaged with contemporary (that is, early twentieth-century) art and architectural practices.

23 The first sheet (two pages) of Berenson's first letter to Porter in 1917 (as in note 2) is missing, but it is clear that Berenson had pointed to "kinship" between his work and that of the younger scholar, because in his reply to Berenson (Porter to Berenson, 27 August 1917, BMBP), Porter wrote: "I wish I dared believe you when you say that there is kinship between my method and yours. I think it may be so in the sense that your scholarship has been my inspiration. You have proved to me two very important facts—first that an American could be thorough, and secondly that at least one man has been at the same time brilliant and sound. And I have consciously tried to carry over something of your way of grasping the essential among the endless possibilities which make art so bewildering—and fatiguing!"

24 Porter's essays reveal that his study of Berenson's writings provided a major point of departure for his own thought. He directly referred to "Mr. Berenson" (Porter 1918, 51–54 and 82, for example), and on the page facing the title page of his essay on "The Gothic Way" (ibid., 66–100), he illustrated Sassetta's *Mystic Marriage of St. Francis* (Musée Condé, Chantilly). Berenson had employed this image earlier for the title page of his groundbreaking book on Sassetta (Berenson 1909). Porter owned a copy of this book printed in 1910 (his personal copy is now in the Fine Arts Library, Harvard University, FA3098.7.4.6).

25 I am preparing a separate study of Lucy Porter's biography and her photography.

8

of Berenson's exhaustive socializing, but they were irresistibly drawn to his brilliance and charm, and they tolerated "befrizzled" countesses over rich meals in order to savor Berenson's "suggestive ideas" and the imaginative workings of his mind.[26] For Porter, firsthand interaction with this sage, whom he regarded as having "the greatest mind I have ever come in contact with," was life-changing and life-enhancing.[27] Until this point,

26 Lucy Porter's diaries (HUA, AKPP, Diaries and Appointment Books of Lucy W. Porter [hereafter DALWP], HUG 1706.127) provide vivid glimpses into the circumstances in which the Porters met Berenson in Paris in early 1919. She described a "befrizzled" countess in her diary entry of 1 February 1919, when she and Porter were among the guests lunching with Berenson at Laurent's: "Luncheon was in a private room. The curator of South Kensington, the yellow-haired baroness and a much befrizzled dark countess (very young) ate the rich food with us. The conversation was brilliant and the view of the naked branches of the Champs Elysées Japanesy." Lucy's diary indicates that she and her husband had met Berenson for the first time a week earlier; the curator of the South Kensington Museum was Eric Maclagan, who was among the many members of the international art world in postwar Paris.

27 Porter to Joanna Krom, 24 August 1919, HUA, AKPP, family correspondence, correspondence of A. K. Porter and Lucy W. Porter with Joanna ("Aunty") Krom (hereafter HUA, AKPP, FC), HUG 1706.113. In his letters to his aunt of earlier that year, Porter repeatedly described Berenson in admiring terms (for example, as "the greatest of American scholars": 24 July 1919, HUA, AKPP, FC). He also portrayed the older man's many idiosyncrasies, noting in his letter of 24 July: "He is a curious little man—a brilliant conversationalist, very spicey and quite malicious. I fancy he is very fond of titled society—he seems to know many princes and notables and enjoys talking about them." In a letter of the next day to his aunt (25 July 1919, HUA, AKPP, FC), Porter described

Porter had worked as a "lone lance," making the counsel of this long-admired father figure all the more welcome.

The intellectual provocation flowed in both directions. Berenson was electrified by Porter's keen mind and industry, and he eagerly immersed himself in the medievalist's work. Berenson's diaries show that during a three-month trip to Spain from May to July 1919, he not only advised on the rehanging of the Museo Nacional del Prado, but also journeyed along the medieval pilgrimage roads to Santiago.[28] Berenson's pilgrimage had been largely inspired by lively exchanges about Spanish architecture with Porter in Paris. My work shows that at that time the medievalist knew Spain only through books, and that he was somewhat irked that Berenson had capitalized on his suggestions and was a step ahead.[29] Berenson, however, had greatly valued Porter's stimulus, and only a few days after his return to Paris he rushed to Senlis, where the Porters were stationed (Fig. 9). Even his dear friend Edith Wharton was put on hold.

Berenson sandwiched his visit to Wharton between two trips with the Porters: a three-day tour of the war zone, where the lover of beauty waxed eloquently on the grandeur of the ruined cathedrals; and a ten-day trip to visit Romanesque churches in Burgundy, among them Cluny, Vézelay, and Autun.[30] Porter had already begun to work out a radically new chronology for these churches, located along the medieval pilgrimage roads, because he recognized that the carved capitals from the ambulatory of the ruined abbey church of Cluny, the motherhouse of the Cluniac order, traditionally dated by French scholars to the mid-twelfth century, had likely been executed much earlier in the 1090s.[31] If this were so, the Île-de-France-centric dating of Romanesque monuments used by the French was faulty. With Berenson at his side (Fig. 10), Porter excitedly formulated his "Burgundian Heresy," enlisting connoisseurship and iconographic and technical evidence to help him envision the itineraries and chronologies of individual medieval masters responsible for

Berenson as "intensely stimulating, but also intensely exhausting," emphasizing his "extraordinary fund of energy" and his "stream of conversation with which it was difficult to keep pace."

28 Berenson's diary of 1919 (BMBP) shows that he left Paris for Spain on 2 May. After dealing with obligations in Madrid and elsewhere, he traveled along the medieval pilgrimage roads from 27 June to 12 July; he spent 30 June and 1 July in Santiago de Compostela.

29 See Porter to Krom, 25 July 1919, HUA, AKPP, FC, in which Porter reported that "he [Berenson] is going to Provins to visit some churches I told him about before I can get there myself, and he has already done the same thing with Spain."

30 Berenson's diary of 1919 (BMBP), Lucy Porter's diaries (HUA, AKPP, DALWP), and Porter's correspondence with his family (HUA, AKPP, FC) show that Berenson spent 22–25 July with the Porters in the devastated regions (Berenson's diary indicates that he had arrived back in Paris from his lengthy Spanish trip on 17 July). He traveled with them to Burgundy from 14 to 24 August. In her diary entry of 23 July, Lucy Porter emphasized that she and her husband found Berenson exhausting, but that they were equally captivated by the older man's "eagle-like vision of beauty" which "brushes aside the less good so that he dwells upon the highest." At Angicourt (Oise) that same day, Berenson "responded at once in eloquence to the pure Gothic of the ruined church."

31 Porter recognized that the capitals had likely been carved shortly after 1088, when construction had begun on the choir of the third church at Cluny (the high altar was consecrated in 1095). Porter outlined his position, which countered the "logic" of entrenched French architectural theory, in Porter 1923, 1:77–101; see ibid., 3–17, for "The Chronological Problem" that in his view affected the dating of Romanesque sites all over Europe.

9

creating the region's early sculpture.[32] Lucy Porter's diary not only records the growing closeness between the two men, but also provides picturesque portrayals of Berenson's pronouncements on life and art, his tireless hunt for "repainted Giorgiones" in the medieval churches, and his delight in drinking tea in unusual locations, such as the nave at Vézelay and the narthex of the church of St. Philibert in Tournus.[33]

I have found that until this point, Porter had intended to write a book on churches of the *régions dévastées*. But Berenson's account of "undiscovered" Romanesque sites that he had seen in Spain, together with his provocative mentorship on site at Romanesque churches in Burgundy, made a huge impression on the medievalist. Berenson urged Porter to journey to Spain, emphasizing that firsthand knowledge of the Iberian Peninsula was essential for the study of French medieval art. The die had been cast. Porter abandoned his project on the dead and mutilated churches of northern France, turning instead to the "forcefully living" art of the pilgrimage to Santiago.[34] Later on, Porter was to assign Burgundy and Spain generative roles in the development of Romanesque sculpture.

32 Porter's "Burgundian Heresy" is referred to several times in his correspondence with both Berensons during 1920 and 1921. I provide a detailed analysis of the contexts in which Porter formulated his theories about Burgundy and Cluny in "Arthur Kingsley Porter et la genèse de sa vision de Cluny" (Brush 2012).

33 Lucy Porter's diary (HUA, AKPP, DALWP) records that on 23 August 1919 she drank tea with Berenson "in the back of church [Vézelay]"; already on 19 August she had made tea and "we [Lucy and Berenson] drank it in the narthex of [the] church [St. Philibert, Tournus]." Later correspondence indicates that a priest at Tournus had been irritated by this activity.

34 Porter employed this description in *Romanesque Sculpture of the Pilgrimage Roads* (Porter 1923, 1:72), where he evoked "an inner vitality. . . . still forcefully living at Santiago."

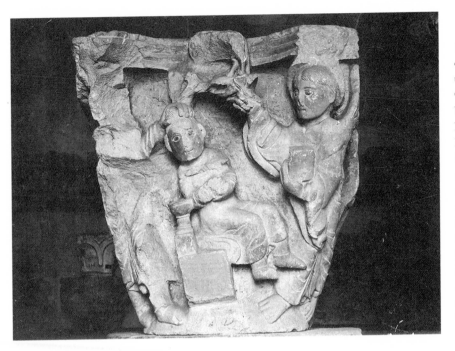

The Sacrifice of Abraham, carved capital from the abbey church at Cluny, photographed by Arthur Kingsley Porter in the Musée Ochier, Cluny, August 1919, during his trip with Berenson. Arthur Kingsley Porter Photograph Collection, Courtesy of Special Collections, Fine Arts Library, Harvard College Library, Cambridge.

Might Berenson have had ulterior motives in encouraging Porter to study Romanesque sculpture and in steering him toward Spain? Did he view the younger man, who deftly produced scholarship on both medieval art and Italian painting, as a potential rival on his turf? While these questions merit further consideration, my work so far suggests that Berenson's investment in Porter was almost entirely for intellectual benefit and friendship. A few days after his return from Burgundy, Berenson wrote ecstatically to Isabella Stewart Gardner, to Paul Sachs of Harvard's Fogg Museum, and to Porter himself that he reveled in the art of the twelfth century, and indeed this subject became his "dominating passion" for the next three years, precisely when Porter was preparing his book.[35] Berenson viewed Porter as an intellectual equal who could also furnish stimulus for his long-term project exploring the death and resurrection of form, and many years later he dedicated the book that resulted from these meditations to Porter.[36]

35 Berenson described "French early medieval sculpture" as "a dominating passion taking the first place in my day's work" in a letter of 9 December 1919 to Isabella Stewart Gardner (Hadley 1987, 614); his correspondence with Gardner continued in this vein. Immediately after the Burgundian trip, he wrote a letter of 26 August 1919 to Paul Sachs, in which he proclaimed that: "I am getting almost as familiar with it [the twelfth century] as I am with later phases of art and revel in it. In Spain that century too was my chief delight" (McComb 1964, 86–87). In a letter of 5 September 1919 to Porter (HUA, AKPP, BB), Berenson wrote: "How I wish that I were back with you in the 12th century—the only climate where I feel happy at the present moment."

36 Berenson 1948. Berenson wrote: "To Denman Ross and Kingsley Porter *in Elysium.* May we meet there and quarrel as merrily as we have here on earth." The Boston collector, painter, and scholar-theorist Denman Ross taught at Harvard's Architecture School and fine arts department from 1899 until his death in 1935; Porter became Ross's colleague when he was appointed to Harvard

There was, however, another key reason for the closeness of the two men's relationship: their aesthetic universes were closely aligned. This topic merits a separate study, but for the purposes of the present essay, it is important to note that Porter had a deep artistic sensibility. In addition to his scholarly works, he wrote poems and plays, and he was sensitive to the aesthetic pleasure to be derived from contemplating a cultural object, whether a Renaissance altarpiece, a building, a Japanese screen, or the carved voussoir of a church along the pilgrimage roads. In brief, like Berenson and many other thinkers of their generation, Porter was not merely concerned with studying the intrinsic qualities of an art object from the past—its material, technique, iconography, and so on. His primary goal was to penetrate beyond the surface of the work in order to understand and reexperience the creative act in all of its variability.[37] Yet, from the 1920s onward, the exclusive reception of Porter's writings as "scholarly science" has denied the presence of this vital emotive and empathic dimension in his work. My research suggests that it was precisely this dynamic tension in both Berenson and Porter's thought—that is, their engagement with scientific method, on the one hand, and with the psychology of forms, on the other—that helped to bond these two pioneering American art scholars.

There is much more to the story. By the summer of 1919—shortly after they met Berenson—the nomadic Porters began to contemplate the possibility of settling in Florence, at Berenson's suggestion. In September, a month after the trip to Burgundy, they made their first pilgrimage to I Tatti, where they were welcomed by Mary Berenson and Nicky Mariano. Mary and Nicky were setting up the household after the war, and Berenson's art collection had just been reinstalled. Porter, who had made countless mental pilgrimages to the mythical I Tatti, was mesmerized by his firsthand experience of the sacred shrine, describing to Berenson his "shivers" of aesthetic delight when he was ushered into the sanctum sanctorum, the *salone* with Sassetta's *Saint Francis in Glory*.[38]

Mary Berenson was enlisted to help the Porters locate a suitable villa in Florence. They fell in love with Villa Gamberaia in Settignano, though it proved unobtainable.[39]

in 1920. Berenson's interest in Asian art had been awakened in October 1894, when he and Ross visited Boston's Museum of Fine Arts in the company of the charismatic scholar-curator Ernest Francisco Fenollosa, who was preparing an exhibition of Chinese painting. For the significance of this encounter, see most recently Strehlke 2009.

37 For a preliminary discussion of Porter's concern with the psychology of medieval art production, particularly vis-à-vis German-language scholarship of the early twentieth century, see Brush 2007, esp. 135–136.

38 Porter to Berenson, 2 October 1919, BMBP. Porter wrote: "Among the moments of pure joy in Florence were those at 'I Tatti.' It was a strange sensation to arrive for dinner and be ushered into the room with the St. Francis. I wondered how many of the shivers were my own direct reaction and how many the mesmerism of your description." Porter also recorded his responses to Berenson's other "delights," asserting that "one always ends by going back to the Sassetta." For a highly evocative photograph of 1954 showing Berenson in front of his Sassetta paintings, see Strehlke 2009, 48, fig. 16.

39 For example, in his letter of 2 October 1919 to Berenson (BMBP), Porter described Villa Gamberaia as "a dream." It is clear from this letter, and Porter's earlier correspondence with Berenson, that Mary Berenson had already planted the seed of this idea several months earlier. The New York collector Carl Hamilton was also in Florence in the fall of 1919, and the same letter of 2 October 1919 shows that Mary had proposed the villa to him as well; Porter admitted that he could not rival Hamilton.

The matter soon had to be put on hold because the Porters were recalled to New York. Berenson arrived back at I Tatti on 9 October 1919, shortly after the Porters' departure. Only a week later, he penned an extraordinary letter to the younger scholar. This letter adds an important new chapter to our understanding of the genesis of Berenson's conception of I Tatti as a center for scholarly research. Berenson wrote to Porter:

> you offer such chances of cooperation that I am determined to do all I can to realize them. And oh the pity of it that you had to go back this winter! How profitable mentally it would have been & morally as well could you [have] been wintering here. Perhaps a kind Providence may yet make it possible. Do come back directly [if] you can.
>
> The Gamberaia will I fear be too expensive.... But it occurs to me that the biggish ramshackle place that belongs to me which forms [a] block with the church of S. Martino might suit you as a site. I would sell it or let it to you on a life-long lease—the latter better—which would be so inexpensive that you could afford to reconstruct it to your needs. Meanwhile you could live in our villino.
>
> The only drawback I can see is that the too close vicinity of the church bell might get on your nerves. In other respects it is pleasant. There is [a] quite big enough garden, fine views, & all that....
>
> The blessedness of such a scheme would be that we should be so near that we practically could count on each other's libraries as one & see each other every day.[40]

Berenson went on to say that this "heavenly" scheme would enrich the thought of both scholars, and that "Moreover, it might work in with a scheme for the disposal of our property when Mary & I are no more."[41] Berenson had begun to contemplate the future of his villa with its library and art collection before the First World War, but the onset of the conflict had prevented him from making concrete plans. His encounters with Porter in post-war Paris, and his growing affection for the younger scholar, evidently encouraged him to think that Porter would make the ideal "collaborator" who might participate in and also carry on his intellectual project.[42] Thus, it was the medievalist Porter, and not the usual suspects, among them Richard Offner, Kenneth Clark, and John Walker, whom Berenson initially conceived of as the ur-I Tatti fellow.[43] And, in fact, Berenson never gave

In the end, neither man was able to acquire it. For evocations of the villa's ambience in the early twentieth century, see Osmond 2004.

40 Berenson to Porter, 16 October 1919, HUA, AKPP, BB.

41 Ibid.

42 In a letter of 24 December 1919 to Porter (HUA, AKPP, BB), Berenson employed the term "collaboration" to describe his desired intellectual partnership with Porter.

43 In short, the medievalist Porter must be accorded a "starring role"—that is, the lead role—in the formulation of Berenson's conception of I Tatti as a center for humanistic research, a topic that I will continue to explore in my research. Moreover, Porter must now be inserted at the beginning of the narrative about Berenson's prominent male protégé-disciples—a narrative that has traditionally been restricted to scholars of Renaissance art and culture, among them Richard Offner, Kenneth Clark, John Walker, Sir John Pope-Hennessy, and William Mostyn-Owen. The

up hope of establishing an intellectual partnership with Porter in Settignano, as the later correspondence shows.[44]

Although Porter found Berenson's proposal extremely tempting, during his New York sojourn in December 1919 he was recruited by Paul Sachs for a research professorship in Harvard's department of fine arts.[45] Berenson's letters to Porter express his personal regret that Porter accepted the post, but also his delight that Porter would introduce "scholarship" to his beloved Harvard.[46] Their ongoing correspondence reveals that Porter planned to live in Cambridge during the academic year, but still intended to use Florence as his research base.[47] Indeed, Porter delayed his Harvard appointment until the autumn of 1921, arguing that he needed to conduct additional research in Europe.

papers delivered at the conference at Villa I Tatti in October 2009, many of which overlapped, pointed to a "different," more positive side of Berenson that helps to counterbalance the widespread view of him as a demanding, self-absorbed, and wily art dealer who profited from others to further his commercial interests. Berenson's generosity to Porter and to other younger scholars demonstrated his humanity, and his genuine longing for love, friendship, and moral support. A second fascinating observation emerged from the discussion at the October 2009 conference: the male scholar-disciples favored by Berenson from the mid-1920s onward shared Porter's attributes—that is, most were tall, good-looking, intelligent men of wealth and social position who had the means to "live out" Berenson's dream of the disinterested pursuit of culture. By contrast, Berenson, who was tiny in stature, had grown up in humble circumstances, and was forced to make a living through the art trade.

44 For example, in a letter of 18 October 1931 from Berenson to Porter (HUA, AKPP, BB) which begins "My dear Kingsley," Berenson writes: "I wish ... you had settled down here [in 1929, Porter had bought a castle in Ireland for summer use]. For one thing, we should have greatly profited from each other's stories, & by each other's attainments and temperaments. Then it would have been a great resource for me, now particularly that I am getting on, & society has totally deserted me, & 'fellow'-students don't come near me. Finally, you'd be living in a country wh. remains at the very centre of our art history. . . . Is it too late? You still could have Villa S. Martino = our house by the church, & the full run of the Tatti library." Berenson's attachment to Porter is also indicated by a report that he "wept" profusely when he received a cable from Lucy Porter on 13 July 1933 (BMBP), in which she informed him about her husband's death on the island of Inishbofin, Ireland, a few days earlier (8 July 1933); see Samuels 1987, 406. Lucy later sent two photographs of her husband to the Berensons (both now in BMBP); one of the photographs, labeled in Berenson's hand ("Arthur Kingsley Porter sent by his wife Lucy, Sept. 1933") is faded, suggesting that Berenson displayed it on or near his desk, as he did in the case of other "followers" (see Fig. 2).

45 For the contexts of Porter's appointment to Harvard, see Brush 2003, 35–37, 54–58.

46 In a letter of 24 December 1919 to Porter (HUA, AKPP, BB), Berenson stated that he would "rejoice" if Porter decided to join him at I Tatti, but that Harvard "would be worth while" and that "If you want to put a little scholarship into them [the Harvard students], you would be performing a humane & Christian act. It would almost console me for being deprived of your collaboration out here."

47 Already in his letter of 24 December 1919 to Porter (HUA, AKPP, BB), Berenson proposed that Porter should restrict his teaching at Harvard to six months per year. This arrangement would allow him to "instal [sic] your central studio here, doing your research & creative work here & giving it out over there. That would give us months together." The ensuing correspondence shows that the Porters, who traveled around Europe for the next two years conducting research for *Romanesque Sculpture of the Pilgrimage Roads*, were still undecided about employing Cambridge as their primary base of operations.

11

Villa I Tatti, three
photographs by Lucy
Wallace Porter, 1920–
21, later mounted
on cardboard.
Arthur Kingsley
Porter Photograph
Collection,
Courtesy of Special
Collections, Fine
Arts Library, Harvard
College Library,
Cambridge.

To give the Porters more time to consider their Florentine plans, Berenson loaned them I Tatti during his trip to America in the winter of 1920–21 (Fig. 11).[48] By that point, the Porters had traveled through Spain in the company of the same chauffeur used by Berenson, and Porter had also exchanged ideas and photographs for his book on Romanesque sculpture with his trusted adviser. Like later I Tatti fellows, Porter was intoxicated by his experience of the "paradise" of Berenson's villa, with its library, art and photograph collections, gardens, cypress allée, and olive groves. Indeed, he wrote part of the manuscript for *Romanesque Sculpture of the Pilgrimage Roads* at Berenson's writing table, where Berenson had left an inspirational note saying that he would have "much pleasure" thinking of Porter working there.[49]

If we can now recognize that Berenson was the *provocateur* for one of the most influential books on medieval art ever produced, we must also identify I Tatti as the material and spiritual backdrop against which Porter staged his imaginings about Romanesque sculpture. The important issue of context has never before been factored into the consideration of Porter's opus. Yet, as I page through *Romanesque Sculpture of the Pilgrimage Roads*,

48 The Porters moved into I Tatti on 13 November 1920 and left on 1 April 1921, as Lucy Porter's diaries (HUA, AKPP, DALWP) demonstrate.
49 Undated note on I Tatti stationery, labeled "Thursday" (HUA, AKPP, BB); this was 11 November 1920, the day when Berenson departed for America. Berenson wrote: "Dear Kingsley. Before turning this writing table over to you, I want to tell you how much pleasure I shall have thinking of you here. I wish you zest for your work, I wish you a sense of leisure, & I wish you enjoyment of the moments as they pass. With love to you both, B.B."

knowing that much of the text was generated in an environment created by Berenson, it is clear to me not only that Porter's approach to medieval artistry was conditioned by his study and appreciation of early Renaissance painting, but also that many of the medievalist's ideas were actively inflected by his intellectual and sensory experience of Berenson's art collection that enveloped him as he wrote.[50] In other words, Porter's celebrated narrative about eleventh- and twelfth-century sculpture can also be read as a vital record of Porter's multidimensional responses to Berenson and his Villa I Tatti. In short, we need to broaden our traditional conception of I Tatti as a site constructed to stimulate the visualization of the Italian Renaissance, for Berenson's I Tatti also served as a powerful stimulus for the visualization of the Middle Ages.

50 This topic will receive special attention in my ongoing exploration of Porter and his scholarship.

TWELVE

Bernard Berenson and Paul Sachs

Teaching Connoisseurship

DAVID ALAN BROWN

WHEN, AS A HARVARD UNDERGRADUATE visiting Florence, I got to peek into the villa that Bernard Berenson had bequeathed to his alma mater, I never imagined that, a short six years later, I would be ensconced there as a fellow. That experience led me to curate the exhibition *Berenson and the Connoisseurship of Italian Painting*, held at the National Gallery of Art in Washington in 1979. Coming twenty years after his death, the exhibition (Fig. 1) focused on Berenson's role in bringing Italian paintings to America. It included books, photographs, letters, even a telegram and a newspaper clipping, as well as masterpieces by Sandro Botticelli and Raphael. After the exhibition was over, I took up other matters, returning to Berenson only occasionally in later years. [1]

My interest in Paul Sachs is more recent. If Berenson's pursuit of connoisseurship began, as he claimed, at a café in Bergamo, this paper got its start in a Roman trattoria, where an American couple asked me to join them for dinner. She turned out to be the granddaughter of Paul Sachs, whom we discussed over saltimbocca. After returning to Washington, I discovered that the National Gallery's librarian, Neal Turtell, had acquired an extensive series of notes from the famous Museum Course that Sachs taught at Harvard University. These notes, preserved at the National Gallery and elsewhere in the form of neatly typed transcripts, formed the basis for a 2001 PhD dissertation on the course by another granddaughter, Sally Anne Duncan, now unfortunately deceased. [2]

1 Brown 1993 and 1996.
2 Duncan 2001 and 2002. The principal holdings of the Museum Course transcripts are preserved in three locations. Those in the Harvard Art Museum Archive cover 1923 to 1925, September to May

1

Entrance to *Berenson
and the Connoisseurship
of Italian Painting*, 1979.
National Gallery of
Art, Washington, D.C.

Duncan's dissertation offers an exemplary treatment of its subject, but does not exhaust the potential for further research.

Sachs's course, entitled "Museum Work and Museum Problems," provided a comprehensive introduction to all aspects of museum organization and management. Held over a period of nearly three decades from 1921 to 1948, it played a vital role in what Duncan called the "institutionalization" of American museums. The transcripts also provide a

1931, and December 1939 to March 1941, and were obtained from different sources. The National Gallery of Art Library owns a complete set for the years from 1931 to 1939. The recording secretary during this period was Mary Wadsworth, who corresponded with Sachs while he was abroad. The Getty Research Institute has a complete run of the transcripts from 1926/27 to 1946/47, in twenty-one volumes with more than four thousand pages of text. This set was the one bound for Sachs, who made numerous annotations throughout. Unfortunately, none of the transcripts have a finding aid or even a contents list, and none are available online. References in this essay are to the copies at the National Gallery of Art.

David Alan Brown

remarkable glimpse into the upper echelons of the art world. More or less evenly divided between men and women, many of the Museum Course graduates—including such luminaries as Alfred H. Barr Jr., James Rorimer, John Walker, Henry Russell Hitchcock, Lincoln Kirstein, Beaumont Newhall, and H. W. Janson, to name but a few—went on to distinguished careers. The course was organized as a graduate seminar in which the members, who the syllabus explained would be treated as "colleagues," made presentations, like Miss Smart on the Sodoma tondo, or took part in debates, a favorite topic being whether general museums should collect modern or contemporary art. Distinguished visitors also spoke to the class, such as Hans Tietze on forgeries or John Nicholas Brown on Paul Cézanne. Sometimes a former classmate returned to share his experiences, as when Francis Henry Taylor advised the students that the "public is not as dumb as we think they are." All this and more was recorded, typed, paginated, indexed, mimeographed, and distributed.

Sachs based the Museum Course on his experience at Harvard University's Fogg Museum in Cambridge, Massachusetts. Thirteen years Berenson's junior, Sachs (Fig. 2) was born in New York in 1878. Upon graduating from Harvard in 1900, he joined the family investment firm, all too famous today as Goldman Sachs, only to leave at an early age to join the museum profession. Sachs's passion for art and art collecting was such that in 1915, Edward Forbes appointed him assistant director and then associate director of the Fogg, where Sachs remained until his retirement in 1948. Though lacking an advanced degree, Sachs also taught art history at Harvard as a full professor after 1927. In teaching the Museum Course, he combined the roles of academic and museum administrator. Around the time that Sachs took up museum work, he and Berenson formed the enduring friendship that is reflected in the many letters they exchanged. Their correspondence, preserved at I Tatti and the Harvard Art Museum Archive, began, appropriately, with an Italian painting, Masolino's *Annunciation* (Fig. 3), now in the National Gallery of Art, which Sachs's uncle Henry Goldman acquired from the collection of the Earl of Wemyss in 1916. Informing Berenson about the acquisition in a letter of 27 March 1916, Sachs failed to disclose that the picture had been offered first to the Fogg and then to Goldman by Berenson's rival, R. Langton Douglas. Congratulating Sachs, Berenson reminded his friend that he had discovered the painting and offered to publish it in an article which duly appeared in *Art in America* that same year.[3]

Apart from a few awkward moments, as when Sachs declined to purchase a drawing that Berenson had endorsed as a Michelangelo and when Berenson reattributed to Lorenzo Lotto a portrait that Sachs's brother had acquired as a Titian, the tone of the correspondence is invariably cordial. And over the years, as Berenson became "BB" and Sachs became "Paul," it grew more personal, with each man freely divulging to the other his cherished goals. Sachs confided to Berenson on 5 February 1927: "your attitude at Settignano when we last met was, I felt, so sympathetic and so understanding, that I have dared ever since to suggest ... many of the things that are near and dear to my heart in

3 About the painting, see Miklós Boskovits in Boskovits and Brown 2003, 466–471.

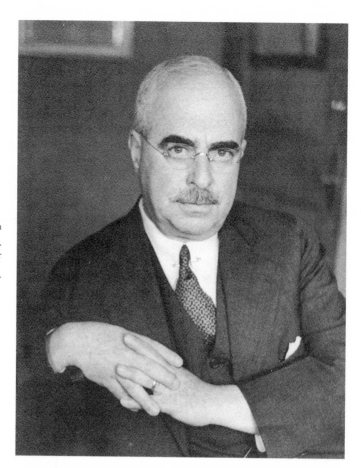

2

Paul Sachs, photograph
by Richard Tucker.
National Gallery of
Art, Washington, D.C.

connection with the work to which I am passionately devoted."[4] A couple of years later, on 23 April 1929, Sachs added that he was "sharing confidential experiences with [Berenson] just as if [they] were sitting in front of the fire at Shady Hill or at Settignano."[5] As early as 1926, Berenson had revealed to Sachs that he planned to bequeath I Tatti to Harvard. It is, in fact, the fate of Berenson's legacy, and not his incessant requests for photographs, that is the central concern of the letters.

The two friends shared many of the same traits and values. Both were short, dapper, and cosmopolitan in outlook. Both were Harvard graduates, and both created or fostered institutions to benefit their alma mater. Both were Jews whose exceptional abilities won them high positions in the art world and in society. Though both taught art history, neither had studied it. Both inspired fierce loyalty among their pupils and assistants. Even the settings in which they worked were not that different. Sachs held the Museum Course

4 Sachs's letters to Berenson, preserved in the Bernard and Mary Berenson Papers, Biblioteca Berenson, Villa I Tatti—The Harvard University Center for Italian Renaissance Studies (hereafter BMBP), were kindly copied and made available to me by Ilaria Della Monica, and my research on the topic was also greatly facilitated by Louis Waldman.
5 Sachs to Berenson, 23 April 1929, BMBP.

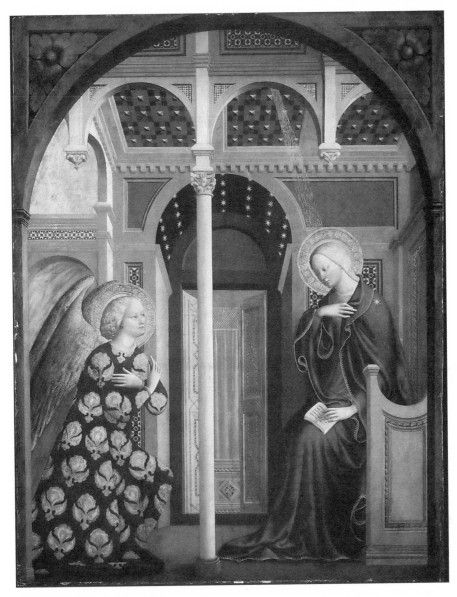

at Shady Hill, the stately home that belonged to Berenson's old teacher Charles Eliot
Norton, and in the Naumburg Room (Fig. 4) at the Fogg—settings not unlike the beauti-
ful book-lined interiors at I Tatti.

In other respects, however, the two were quite unlike each other. Sachs was born to
wealth, while Berenson, through his involvement with the art market, became wealthy.
Sachs was an avid collector of prints and drawings, while Berenson helped others form
collections. As a writer, Sachs was essentially a popularizer: aside from a catalog of draw-
ings at the Fogg, which he coauthored with a former student, he wrote only two books,
on the subject of collecting prints and drawings. As Sally Anne Duncan put it, Sachs saw

4

Paul Sachs teaching
the Museum
Course in the
Naumburg Room,
Fogg Museum,
1943–44. National
Gallery of Art,
Washington, D.C.

his concepts and principles "actualized" in his students, who joined the front ranks of the museum profession. Berenson, on the other hand, was prolific, writing numerous catalogues and scholarly articles as well as essays and personal reminiscences. His bibliography lists more than thirty books and hundreds of other publications, nearly all centering on Italian art. Sachs's taste was more catholic; in particular, he admired modern art, which Berenson generally deplored.

The question implied by the title of my talk on Berenson and Sachs might seem to be answered by the success of their efforts. The aim of this paper, however, is not to judge from results, nor to ask whether connoisseurship can or should be taught; rather, it is to compare and contrast how the two men imparted the discipline and to ask what their methods tell us about their personalities and goals. Of course, Berenson and Sachs agreed on the nature of connoisseurship and its importance for the history of art; indeed, they tended to equate the two. The centrality of the object and the necessity of close visual analysis and recall were fundamental to the exercise of connoisseurship in any field. Berenson and Sachs were both self-taught as connoisseurs, and that may explain why they paid so little attention to the history of their métier. Connoisseurship in the sense of visual discrimination applied to art is older than the history of art, but there weren't always connoisseurs. Artists were thought to be the best judges of art until, in the eighteenth century, the practice spread to amateurs, who were obliged to explain themselves. Matters of concern to Berenson and Sachs, like the subjective nature of connoisseurship and its potential for error, had already vexed Jonathan Richardson and Pierre-Jean Mariette. Berenson

and Sachs adopted a pragmatic approach—buttressed by theory in Berenson's case—in which they performed as connoisseurs themselves and transferred their knowledge and skills to others. For this, a sterile classroom was not the proper training ground. Berenson often took a pupil along on his visits to churches or museums, while Sachs organized field trips (Fig. 5) during winter and spring breaks to study public and private collections in New York, Philadelphia, Baltimore, and Washington. After examining the Widener Collection displayed in a palatial setting at Lynnewood Hall outside Philadelphia, Sachs's students were invited to stay for lunch. Berenson advised the Wideners and catalogued their Italian holdings, and for both him and Sachs, it is to fair to say, connoisseurship had a practical outcome in collecting.

In the Museum Course, connoisseurship was part of a larger introduction to museum work in which the students mastered principles that they could later put into practice. These prospective curators and directors might have lacked Berenson's gifts and experience, but they still had to exercise connoisseurship on behalf of their institutions, often outside their specialty. Above all, they needed guidelines for making acquisitions. With that in mind, Sachs frequently assigned an actual object for study, a pioneering use of original works of art for teaching purposes that is still with us today. Much time was also spent on visual exercises that Berenson would probably have considered puerile: "Look at the object, let it speak to you. Does it arrest your attention? Do you approach it with enthusiasm? If not, is it because it does not lie in your field of interest?" Sachs said that a graduate of his course should be able to determine the period of an object and whether or not it is authentic, and should then, perhaps, show it to an expert—Berenson is named—for further advice. Artists' techniques were also important: Alan Burroughs spoke regularly on the use of x-radiographs in making attributions, a practice Berenson disliked, while Sachs's colleague Edward Forbes offered a separate course on artists' methods and materials.

Museum ethics were not ignored. Berenson once again comes up, this time as a bad example—at a meeting on 18 December 1935, the students learned that "Mr. Berenson, not connected with any museum, but a distinguished scholar and writer, has been Duveen's expert for a number of years. Those who are jealous say that he does it to get money." As a former banker, Sachs maintained friendly relations with dealers, whom he regarded as useful allies. Berenson's art dealings were a source of embarrassment, however, and there is no mention of the topic in the correspondence between the two. Not so in the Museum Course, the students of which were sworn to secrecy—among the disarmingly candid comments found in the transcripts, one made at a meeting on 6 April 1936 concerns Berenson, cited by Sachs as a great scholar who had come to regret his involvement in the trade. But Berenson was at least independent, unlike certain museum officials, such as Wilhelm von Bode in Berlin, who profited from the attributions they made.

While on a trip to America with his wife Mary, Berenson actually spoke to the Museum Course students on 14 March 1921. Unfortunately, there is no record of what he said, as the course transcripts begin three years later, but we can safely assume it was on some aspect of Italian art. Berenson dreaded public speaking and could not be persuaded to open his talk to the public, so it fell to Mary to address a wider audience the

5

Paul Sachs and
Museum Course
students, en route to
the Widener Collection,
Philadelphia. National
Gallery of Art,
Washington, D.C.

next day. Berenson's appearance must have been a success, in any case, since in a letter of 24 October 1927, Sachs invited him to return as a visiting professor, wisely proposing a weekly seminar on any subject. In his reply three months later (24 January 1928), Berenson confessed that, though deeply touched by the offer, he was too busy preparing new editions of his books to accept it. In fact, once Berenson had decided to give I Tatti to Harvard, he began to take a keen interest in the fine arts curriculum at the Fogg and was irked to discover that Erwin Panofsky had addressed the group on iconography in February 1937. The truth was that Berenson had little use for classroom instruction. As a Harvard undergraduate himself, he had been unimpressed by Charles Eliot Norton's

lectures and resented that his teacher did not show him sympathy. And in the case of his two idols, Berenson failed to gain entrance to Walter Pater's class at Oxford in 1888, and he barely even met Giovanni Morelli before the latter's death in 1891. It was their books that made a profound impression on him.

Berenson might not have personally instructed the students, but he could, following the example of his mentors, reach them through his publications. In an important letter to Sachs of 8 April 1927, Berenson offered to do just that. Alerting Sachs to the recent publication of his *Three Essays in Method*, he explained the philosophy that lay behind it:

> Connoisseurship, i.e. the question of attribution and authenticity is like a boulder barring the road to further study and understanding of art. I mean art in a wide humanistic sense... which requires for its comprehension a substructure of very precise and accurate chronological joining which connoisseurship alone provides. What connoisseurship is and how it is pursued I attempted to state in the abstract some 35 years ago and the essay was reprinted in one of my volumes of Study and Criticism.... This time I have taken laboratory experiments— as it were—and described them as well as I could without abusing the reader's patience. As I re-read these essays the other day I felt that a seminar course in connoisseurship could not at present find a better textbook than this new book of mine. I do not flatter myself that my attributions are final, but I dare hope that, at worst, they are on the way to truth and not to error.[6]

The first work to which Berenson refers is his first major essay, begun about 1894 and published in 1902 as "Rudiments of Connoisseurship," in which he sought to offer a logic for the Morellian method of morphological comparisons. The latter series of articles, collected as *Three Essays in Method*, purports to show his working procedure but reads more like a lengthy re-examination of results reached by what must have been a more intuitive process. The concept of attribution as provisional, which Berenson advances in the letter, no doubt interested Sachs, but the virtuoso display of the connoisseur's powers seen in the book could never be replicated by a student. In his reply of 12 May 1927, therefore, Sachs merely thanked Berenson for the book, which he "looked forward to reading with close attention." The Berenson volume that Sachs assigned as reading in the Museum Course was not the tortuous *Essays in Method* but the famous lists of Italian pictures that Berenson accepted as authentic, combined in a handy pocket-sized edition of 1932.[7] Many

6 Access to the Sachs Papers at the Harvard Art Museum Archive was kindly granted by Susan J. von Salis, associate curator of archives, whose colleague Jane A. Callahan, archivist and records manager, provided every assistance and made working there a pleasure. The source for quotations from Berenson's letters to Sachs, preserved in the archive, is given here as HAMA. In a letter to Berenson of 17 January 1955, Sachs asked his permission to quote from the 1927 letter with its "valuable words about connoisseurship."

7 Berenson's four early volumes on the Italian painters of the Renaissance were complemented, in each case, by lists of works he accepted, and these lists were constantly under revision at I Tatti as he changed his mind about their authorship or as new works came to light. The major effort in revision came in the years leading up to 1932, when the essays on the Italian painters and the lists of their

of the artists included do not have oeuvre catalogues even today, so the book continues to be useful. The scholarly publication by Berenson that Sachs most admired, however, was the monumental *Drawings of the Florentine Painters*, which Sachs described as a "classic, the best book on drawings ever written."[8]

If in the Museum Course, Sachs and his students acted as a group with multiple voices and perspectives, Berenson opted for a different mode of instruction, akin to a tutorial. He never formed a circle, preferring to deal individually with his disciples. Here, it is useful to distinguish between the live-and-work protégés, two of whom we will consider in greater detail, and the legions of devoted assistants, most of whom were female. The duty of the latter was to help with the revision of Berenson's publications, chiefly the lists and *Drawings of the Florentine Painters*. For this task, Berenson explained that little was needed beyond patience and attentiveness—this was connoisseurship at the level of attribution and classification, and the material of study usually consisted of photographic reproductions, not original works of art. The team of research assistants aided Berenson rather like an artist's pupils, whose goal was to collaborate with the master in productions that went out under his name. But connoisseurship also meant the perception of quality, and for this the pupil had also to be gifted with the right endowment or temperament. In these few privileged individuals, Berenson sought to cultivate the aesthetic sensibility needed for more advanced study of art, a process in which he himself would serve as an example. The problem was that even a gifted proto-connoisseur needed basic training.

Berenson's union with Mary was childless, but—preoccupied as he was with his legacy—what he really wanted was a successor, not a son. Kenneth Clark was the first in a series of "golden boy" protégés and potential heirs—smart, handsome, patrician—who came to I Tatti to study with the master for extended periods. At their very first meeting, Berenson, entranced by Clark, offered to take him on, and Clark, after much hand-wringing, accepted. The apprenticeship began well enough in the spring of 1926, with Clark accompanying his mentor on long trips to northern Italy and later to Paris; Berenson was at his best during these excursions, responding to works of art like the famous *Concert Champêtre* in the Musée du Louvre, which was unframed for his perusal. Though Berenson and Clark greatly enjoyed and profited from looking at art together, back at I Tatti the aspiring young acolyte was properly put to work. Under Mary's guidance, Clark prepared material for the revision of the lists and *Drawings of the Florentine Painters*, but such tedious, self-effacing labor did not sit well with Clark, who had ambitions and plans of his own. Berenson felt "betrayed," Mary said, when Clark married in 1927. Worse still, the young man had secretly been working on the manuscript for a book that would appear in print as *The Gothic Revival*. Also acting on his own initiative, he had begun a special study of Leonardo that would eventually lead to his pioneering catalog of the artist's drawings at Windsor Castle, published in 1935, three years before the revised *Drawings of the*

pictures parted company, resulting in the collected lists, arranged in alphabetical order by artist and published in Oxford in 1932. Ongoing research eventually led to a renewed splitting-up of the lists into schools in the definitive, illustrated editions that appeared between 1957 and 1961.

8 For a recent evaluation of Berenson's monumental survey, see Bambach 2009.

Florentine Painters. To Mary, Clark confided that he "loathed the . . . business of correcting notes and numbers."[9] Berenson had no choice but to dismiss Clark, which he did in 1929. Clark's brilliance was undeniable, but Berenson had clearly come to view him as a potential rival, one more example of the intellectual competitiveness that marred BB's relations with Roger Fry and others. Berenson's ambivalence contrasts with the welcome Clark received when he spoke to the Museum Course about Leonardo's drawings on 29 October 1936. Sachs praised Clark in a letter to Berenson: "May I congratulate you on such a disciple," he wrote on the last day of the year, "and on such a devoted friend."[10]

Clark and the promising young men who followed him seem to have represented an ideal type to which Berenson aspired.[11] Sachs, who would provide the next candidate, defined the type in his unpublished memoir entitled "Tales of an Epoch": such an individual should be "sensitive and receptive, alert and responsive, well-read and stimulating, attractive and free from inhibitions, and, withal, a good listener." Sachs reminded Berenson of the time when, sitting in the *limonaia* at I Tatti, the latter had "painted a vivid picture of the day when students would be at home in his library." Berenson had urged Sachs to send him "promising young art historians, one at a time. He wanted each one in turn to live at I Tatti and be his companion, his disciple for several years."[12] Sachs wrote to Berenson on 7 May 1930 that he had found "just the right boy . . . a really gifted lad . . . John Walker the 3rd." More important than his academic record, Walker's "attitude toward life, his cultivation, his innate dignity, his cheerfulness, and the fact that he is a true gentleman" recommended him—"He is, in short, exactly the type of man that I have long wished to send you."[13] Not surprisingly, Berenson concurred, only suggesting that the young man "learn Greek, and if possible, Arabic, Hebrew, and Russian."[14]

Walker, who would live and work with Berenson for three years from 1930 to 1933, made up for Clark's deficiencies as a devoted apprentice. A photograph shows him towering over his master, rather than sitting at his feet as a pupil might have been expected to do (Fig. 6). All the parties were delighted. Walker wrote to his former teacher on 8 November 1930 that he would: "never be able to thank you enough for giving me the opportunity of studying under Mr. Berenson . . . I am completely captivated by his charm [and] may be of some help to him . . . I have great respect and awe for his mental ability and am a little

9 Quoted in Samuels 1987, 363. Clark returned to Berenson often in his writings, including his autobiography *Another Part of the Wood* (Clark 1974, 133–165), and he made a documentary film about his mentor in 1970.

10 Sachs to Berenson, 31 December 1936, BMBP. Knowledgeable about all aspects of museum administration, Sachs reported to the course members that Clark had sought advice about air conditioning. On another occasion, 20 February 1939, Sachs recalled how Clark had experienced a museum director's worst nightmare: the acquisition of a misattributed work, in his case four little panels by Andrea Previtali that the London National Gallery director had wrongly taken to be Giorgione's.

11 In his "A Personal Reminiscence," J. Carter Brown described his own experience at I Tatti, aptly referring to himself and his predecessors as "student admirers" (Kiel 1974, 20).

12 HAMA. This and the previous quote are from chap. 13, pp. 274–287, of Sachs's unpublished "Tales of an Epoch."

13 Sachs to Berenson, 7 May 1930, BMBP.

14 Berenson to Sachs, 29 July 1930, HAMA.

6

Bernard Berenson
and John Walker on
the garden terrace
at Villa I Tatti, 1939.
Bernard and Mary
Berenson Papers,
Biblioteca Berenson,
Villa I Tatti—The
Harvard University
Center for Italian
Renaissance
Studies.

uneasy as to whether I can keep up with him . . . I hope to acquire some Italian. The other languages that Berenson considers useful, Hebrew, Russian, and Arabic, will have to wait."[15] Berenson informed Sachs on 7 December that he had "never met with such a stimulating and satisfactory audience."[16] Sachs promised, after Walker left, to find another disciple, whom Berenson hoped might one day step into his place.

Like Clark, Johnnie, as Berenson called him, accompanied the master on his travels—and, also like Clark, was set to work updating BB's publications. Taking up where Clark left off, Walker quickly grew disenchanted with the drudgery of research, just as Clark had.

15 Walker to Sachs, 8 November 1930, HAMA.
16 Berenson to Sachs, 7 December 1930, HAMA.

David Alan Brown

Instead of leaving, however, he found a more congenial task. With Berenson's encouragement, Walker had managed to do a bit of his own work on Antonio Pollaiuolo's engravings and on Edgar Degas's copies of the Old Masters, but his attention now focused mainly on Mary Berenson's project for an anthology to be called "Beautiful Italian Paintings" or "The Paintings of Humanism." Walker kept Sachs informed about the project, which, in effect, excerpted the masterpieces from Berenson's all-inclusive lists. At first Mary made the selection, only occasionally taking Walker's opinion into consideration. Soon enough, however, Johnnie and Mary were collaborating on the choice of works, which they divided into two categories: the great and the merely good. The division tested Walker's skills as a connoisseur: "I know of no way in which connoisseurship could be better taught," he wrote in another letter to Sachs, "and I feel that I have gained a great deal in taste, as well as in knowledge of the whole field."[17] In a preface by Walker and a lengthy introduction by Mary, the coauthors sought to justify the project, which sadly never came to fruition.

Sensitive, receptive, and stimulating, the two "gilded youths"—Berenson's own term—both went on to distinguished careers as heads of two of the world's preeminent art museums. Clark for a time led the National Gallery in London; a better writer than Berenson, he authored many well-received books, the last of which is titled *Moments of Vision*. For his part, Walker went on to become the first chief curator and then director of the newly opened National Gallery of Art in Washington, where he often solicited Berenson's advice on acquisitions. With Walker at the helm for thirty years, the National Gallery, like many other institutions across the United States, incorporated Sachs's vision of the ideal museum. As for teaching and learning connoisseurship, Sachs's instruction in general principles only went so far, as he admitted. Museum officials still had to seek the advice of experts or, in cases like those of Clark and Walker, go to study with them. The "advanced placement" model worked well when it came to evaluating or appreciating art, but Berenson's disciples quickly tired of the tedious labor that he himself lamented had taken him away from his true calling. It was not a question of temperament, since the restive Clark and the docile Walker both balked at a program that offered little scope to develop their own ideas. That said, Berenson left an indelible stamp on both men. Clark planned to write a life of his mentor, in which the biographer would presumably play a major role; and the thriving research institute that is now part of Harvard is in some sense a tribute to Walker, who, with Berenson's other supporters, helped to ensure that BB's dream for I Tatti became a reality.

17 Walker to Sachs, 17 December 1930, HAMA.

THIRTEEN

"The Cookery of Art"

Bernard Berenson and Daniel Varney Thompson Jr.

THEA BURNS

In his celebration of the memory of Bernard Berenson, published in 1960, Kenneth Clark recalled the great connoisseur's lack of interest in the physical aspects of pictures. "If there was one thing that bored the young Berenson more than documents it was technique, and though he learnt to be much more careful in these matters, to the end of his days he never had quite enough respect for the skill of restorers."[1] On being asked by Berenson to confirm whether certain pictures were painted in oil or tempera, the Sienese painter and restorer Icilio Federico Joni (1866–1946) commented: "While in his writings he made a great display of technical terms, when faced with a practical case he

∞ I wish to acknowledge the following individuals and institutions: at Villa I Tatti—Harvard University Center for Italian Renaissance Studies: Joseph Connors, Louis Waldman, Michael Rocke, Ilaria della Monica, and Jonathan Nelson; at the Archives of American Art, Smithsonian Institution: Wendy Hurblock Baker, Marisa Bourgoin, and staff; at Harvard Art Museums Archives: Susan von Salis and Jane Callahan; at the Straus Center for Conservation: Penley Knipe; and at the Courtauld Institute of Art Archives, University of London: Ruth Fremdo; Nancy Bell, The National Archives, Kew; Kathryn Brush, University of Western Ontario; Stephanie Cassidy, Art Students League, New York; Andrew Jirat-Wasiutynski, London; Joe Soave, London; Karen Parsons, The Loomis Chaffee School; Pamela Spitzmueller, Weissman Preservation Center, Harvard University; Mark Clarke, Antwerp; Bibliothèque Nationale, Paris; National Art Library, London; Stauffer Library, Queen's University, Kingston; and Widener Library, Harvard University.
1 Clark 1960, 382.

1
Daniel Varney
Thompson Jr., August
1923. Daniel Varney
Thompson Papers,
1848–1979, Photographs
1902–1972, Archives
of American Art,
Smithsonian Institution,
Washington, D.C.

really knew nothing about it at all."[2] As we shall see, Berenson admitted as much himself. How is it possible, then, that an affectionate, decades-long friendship and an extensive wide-ranging correspondence, attested to by the abundance of letters surviving at Villa I Tatti, the Harvard Art Museums, the Smithsonian Institution, and elsewhere, took root and flourished between Berenson and Daniel Varney Thompson Jr. (1902–1980), a passionate student of historical artists' treatises who possessed a deep curiosity about and knowledge of the materials and techniques of medieval painting (Fig. 1)?

2 Joni 2004, 328–329. I have chosen to use the earlier designation "restorer," used by Thompson and Berenson, in this paper. Today, the professional whose primary occupation is the practice of conserving cultural property for the future is known as a "conservator."

As a teenager, Thompson was introduced to Cennino Cennini's late fourteenth-century treatise, *Il libro dell'arte*, by his friend and teacher, the artist, social activist, and ardent Zionist Louise Waterman Wise, a longtime student at the Art Students League in New York City.[3] In old age, he recalled poring over copies of Mary Philadelphia Merrifield's *Original Treatises on the Arts of Painting* (London, 1849) and Robert Hendrie's English translation of one manuscript of Theophilus's *Schedula: An Essay upon Various Arts* (London, 1847) in the library at the Loomis Institute in Windsor, Connecticut. When Thompson applied for admission to Harvard College in 1918, as he later recalled: "I wrote to my future professor of analytical chemistry to ask whether I might be given as unknowns such substances as I might encounter in the study of medieval paintings."[4] At Harvard, he studied physics, chemistry, mathematics, and fine arts, completing four years' study in three and graduating cum laude in 1922 with a degree in general studies.

While an undergraduate, Thompson enrolled in Edward Forbes's Egg and Plaster course. This course had begun as a hands-on component of Forbes's course on Florentine painting in 1909–10. By 1915, however, the primary focus had shifted to reflect Forbes's fascination with the materials and techniques of artists and his concern with the care of works of art.[5] Forbes recruited students, assistants, artists, and other museum and faculty members to lecture and help with the demonstrations.[6] Alfred H. Barr Jr. described Forbes's course, formally titled Methods and Processes of Italian Painting, in a 1924 letter to his parents: "The last is genuinely an overall course: plaster in your hair and paint in your eyes. We fresco walls, prepare gesso panels, grind colours, analyse fakes, read [Cennino Cennini] and have a glorious time of it."[7] In addition to fresco, students experimented with tempera and encaustic painting, graphic art techniques, manuscript illumination, and making mosaics. They examined works of art and practiced diagnosing the works' condition so that they could communicate effectively with restorers.[8] Forbes believed that collections of artists' old recipes and alchemical secrets would repay study and, alongside experimentation with the materials used by painters, would clear up disputed points and ensure better care of old pictures and more durable execution of new ones.[9]

Late in life, in an oral history interview conducted for the Archives of American Art, Thompson credited Forbes with kindling his interest in the history of the technology of art.[10] Thompson was Forbes's teaching assistant for several years in the early

3 Thompson 1962, v. Written communication, Stephanie Cassidy, Art Students League, 3 March 2010; Wise registered for courses at the Art Students League intermittently between 1910 and 1941 and studied with, among others, Robert Henri (from 1915–17).

4 Thompson 1969, 11.

5 Forbes 1920. The technical aspects of art, endorsed by John Ruskin, had long formed part of the fine art curriculum at Harvard: see Kantor 1993, 164–165.

6 Bewer 2001, 15. Bewer's book *A Laboratory for Art* (New Haven, 2010) was not published in time to be consulted for this article.

7 Kantor 2002, 50–51.

8 Bewer 2001.

9 Forbes 1920, 162–163.

10 Archives of American Art, Smithsonian Institution, "Oral History Interview with Daniel Varney Thompson, 1974 Sept. 25–1976 Nov. 2" (hereafter AAAO), tape 4, side 1.

1920s and also undertook research at the Fogg Museum on the chemistry of paints and Old Master paintings.[11] Granted a Sheldon Fellowship by Harvard, Thompson sailed for Europe in June 1922 and spent the next year studying and traveling there. He passed the early summer in northern France and England, and in August 1922 met Forbes and family in Liverpool. He accompanied Forbes to Edinburgh, where they introduced themselves to Professor Arthur Pillans Laurie of Heriot-Watt College; Laurie was a pioneer in the application of science to understanding the physical condition of works of art, particularly the use of microscale techniques for identifying pigments and media (well before these became orthodox procedures).[12] Forbes, Laurie, and Thompson discussed the possibility of Thompson doing future work with Laurie.[13] In October, Thompson left the Forbes family in Paris to study painting materials, techniques, and analysis in Munich with Professor Max Dörner at the Akademie der bildenden Künste (Academy of Fine Arts) and with the organic chemist Dr. Alexander Eibner at the Versuchsanstalt für Maltechnik, Königliches Technisches Hochschule, where Eibner was director; Thompson hoped to audit the latter's course on oils, varnishes, waxes, and balsams.[14] Thompson's letters home to Boston from Munich do not describe his actual course of studies in any detail; he did, however, assure his parents that the time spent there was profitable: "Dörner lecture this morning—interesting as usual."[15] He left Munich earlier than planned, in February 1923, because, as he wrote to his mother Grace Thompson, after the Franco-Belgian occupation of the Ruhr in January 1923, "food and coal are already becoming scarce and 'they say' that foreigners won't be welcome to share very much longer. Also in case of the state of war, I'm not sure that I'd care to stay here."[16] In late January 1923, he wrote to his father, "I don't know whether Hintl, or whatever his name is, did manage to pull off his Coup d'État today; there's no outward sign of it, at least. I took Miss Bowen to lunch."[17] Much later Thompson recalled, "They were terrible terrible times [in Munich] . . . I was getting very run down and the doctor said I had better go somewhere where the food was better and the weather was warmer, so I made my way down to Italy."[18] Forbes had invited Thompson to stay with him and his family at the Villa Curonia in Florence, which he had rented for the spring. While there and "through the liberality of Mr Forbes," Thompson, sometimes accompanied by Forbes, studied painting practice with the Russian-born fresco painter Nicholas Lochoff, "the peerless copyist of early Italian painting," in Florence, and with Icilio Federico Joni, "master of historical styles and methods."[19] Lochoff and Joni's high-quality, systematic,

11 Bewer 2001.

12 See Ritchie 1949, 988; and Forbes 1949–50.

13 Forbes 1949–50, 206.

14 Daniel Varney Thompson Jr. to Grace Thompson, 12 January 1923, Daniel Varney Thompson Papers, 1848–1979, Archives of American Art, Smithsonian Institution (hereafter DVTP).

15 Daniel Varney Thompson Jr. to Grace Thompson, 7 November 1922, DVTP.

16 Daniel Varney Thompson Jr. to Grace Thompson, 20 January 1923, DVTP.

17 Daniel Varney Thompson Jr. to Daniel Varney Thompson Sr., 30 January 1923, DVTP.

18 AAAO, tape 1, side 1. Unfortunately, chronologically earlier material in this interview apparently could not be transcribed.

19 Cennini 1933, xiii. Olivetti and Mazzoni 1988 describes two Quattrocento painting restorations done in the 1920s by Joni in Siena, one possibly dating to 1922–23. In his autobiography, Joni recorded

2

Daniel Varney
Thompson Jr., Edith
Simonds, and Isabel
Hopkinson Halsted
assisting Edward
Forbes painting the
fresco *St. Francis and the
Wolf of Gubbio* at Villa
Curonia, Arcetri,
Florence, 1923. Daniel
Varney Thompson
Papers, 1848–1979,
Photographs
1902–1972, Archives
of American
Art, Smithsonian
Institution,
Washington, D.C.

and historically based work must have fascinated Thompson (Fig. 2), and he continued to study tempera painting intermittently with Joni through the autumn of 1924 (Fig. 3).

Thompson, in his seventies, recalled meeting Bernard Berenson at I Tatti for the first time at lunch on 17 March 1923.[20] As he described the meeting:

> [Berenson] was charming, wonderful . . . After tea, he took me walking in the garden. He asked me what I was doing. I told him, and he said, "Well that's just [cookery]." I said, "Well . . . it may just be [cookery, but] it's not the boundary of my interest. I'm very much concerned by the efforts of some people to teach art appreciation . . . personal preferences and taste . . . I'm very tired of hearing people tell how works of art affect them personally." Berenson replied, "I'll tell you exactly how I feel about it. I may have spent last night in the arms of the most beautiful woman in France, but for me to describe my sensations to you would be boastful, fanciful [vulgarity]."[21]

The villa and its contents were, Thompson recalled later, "a glimpse into an unsuspected world of beauties moulded to personalities."[22] At the time, Thompson had written

that Forbes regularly sent American students to Florence to study tempera painting: see Joni 2004, 328. See also Daniel Varney Thompson Jr. to Grace and Daniel Varney Thompson Sr., 7 March 1923, 12 March 1923, and 24 March 1923, DVTP.

20 AAAO, tape 1, side 1; and tape 4, side 1. Daniel Varney Thompson Jr. to Grace and Daniel Varney Thompson Sr., 17 March 1923, DVTP.

21 AAAO, tape 1, side 2.

22 Thompson to Mary Berenson, 29 April 1935, Bernard and Mary Berenson Papers, Biblioteca Berenson, Villa I Tatti—The Harvard University Center for Italian Renaissance Studies (hereafter BMBP).

3
Daniel Varney
Thompson Jr.,
St. Mark, 1923,
tempera on panel,
inscribed verso:
"Siena July 1923/
Painted under
the supervision/
of Federigo
Ioni." Photo:
Katya Kallsen
© President
and Fellows of
Harvard College.

4

Snapshot, inscribed verso: "Dan examining Triumph of Death, Campo Santo, Pisa, June 1923." Daniel Varney Thompson Papers, 1848–1979, Photographs 1902–1972, Archives of American Art, Smithsonian Institution, Washington, D.C.

to his parents: "This noon we lunched with Berenson and his wife in their Villa—an Eden of a place. There were many guests, but B.B. forsook them all, & walked with me in the garden. He advises me to return to Cambridge next year. He invited me to spend a fort-night with them in June, and I've accepted." Thompson added, with a note of caution: "Relations with him are excessively delicate and even dangerous so please say nothing of this."[23] On that trip to Italy, he visited Berenson several times thereafter but does not appear to have taken up the invitation to stay (Fig. 4).[24]

In the late summer of 1923, Thompson settled for a time in Edinburgh to work with Laurie; in mid-September 1923, he accompanied Laurie, Joseph Duveen's chief technical

23 Daniel Varney Thompson Jr. to Grace and Daniel Varney Thompson Sr., 17 March 1923, DVTP.
24 Daniel Varney Thompson Jr. to Grace and Daniel Varney Thompson Sr., 18 June 1923, DVTP.

adviser, and the group of art experts assembled in Paris to compare the Musée du Louvre's *Belle Ferronière* with the Hahn version of Leonardo's painting, which had been sent for the occasion from Kansas City.[25] Duveen had been charged with slander of title by Hahn because of his offhand dismissal of the authenticity of the painting. Although Berenson was also involved as an expert witness in this lawsuit, he gave his evidence earlier in the month, and he and Thompson did not meet at this time.[26]

While they were still in Europe, Forbes asked Thompson to advise the art historian Langdon Warner (1881–1955) prior to the Fogg Museum's First China Expedition in 1923–24, which took Warner to the isolated site of the Caves of the Thousand Buddhas at Dunhuang, Western China.[27] There, in a series of chapels cut into a long, low cliff of limestone conglomerate, Warner intended to identify, excavate, and collect unique artifacts, particularly wall paintings, to safeguard them and to enhance teaching programs at the Fogg.[28] At the time, wall paintings were often detached by sawing out and cutting off sections of painted surface and underlying wall; this operation, known by the Italian name of *stacco*, damaged the walls and resulted in heavy, jigsaw-like pieces and wax- and glue-darkened paint layers which required extensive cleaning and reassembly.[29] Because Warner did not wish to have the objects he collected restored, he wrote to Forbes to ask how best to transfer Italian frescoes.[30] Thompson, who had trained briefly in Italy on the appropriate application of the *strappo* technique for stripping away the surface of a painting in true fresco (*buon fresco*) from a wall, was asked to advise Warner. In the *strappo* procedure, the painted surface was coated with a layer of dilute glue to stabilize it; next, a thicker adhesive—for example, animal glue—was applied hot to pieces of cloth which were firmly pasted onto the painting in overlapping layers; the glue was then allowed to dry thoroughly, and finally the cloth strip was peeled away from the wall, carrying the painted surface with it (Fig. 5).[31] Theoretically, the technique of *strappo* left both the wall and the paint layer structurally intact, minimized scarring of the wall, and facilitated transportation of the artifacts. Thompson cautioned Warner, however, that the technique's efficacy was unknown on Asian wall paintings, which were not true frescoes.[32]

Thompson remained in Europe through the fall of 1923, returning to Harvard for the winter semester of 1924. There, he began working toward a master's degree in fine arts (completed in 1926), assisted Forbes with the lab component of his class, and undertook restoration projects on a contract basis.[33] "About that time, I began to feel the need of more documentary evidence, and I wasn't particularly satisfied by the state of the text of

25 Secrest 2004, 234; Gimpel 1992, 241; and Daniel Varney Thompson Jr. to Grace and Daniel Varney Thompson Sr., 11 November 1923, DVTP.

26 Samuels 1987, 314–318; and AAAO, tape 1, side 2.

27 AAAO, tape 2, side 1.

28 Balachandran 2007, 5, 7, and 13.

29 Ibid., 13, 27, n. 76; and Thompson to Warner, 2 November 1924, DVTP.

30 AAAO, tape 2, side 1.

31 Balachandran 2007, 13.

32 Ibid.

33 Daniel Varney Thompson Jr. to Grace and Daniel Varney Thompson Sr., 6 June 1926, DVTP.

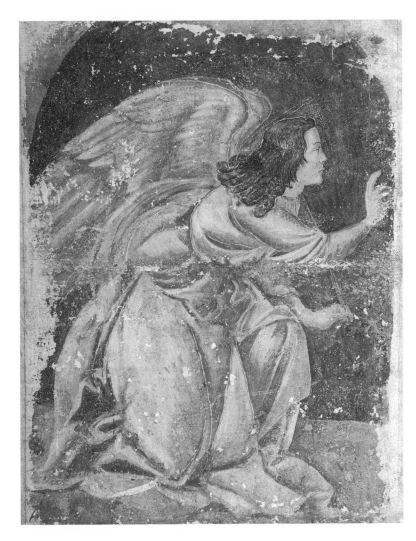

5

Henry Scott after
Sandro Botticelli,
*The Archangel
Gabriel*, 1923,
fresco painted
at the Villa
Curonia, Florence,
April 1923, then
transferred
to canvas by
Daniel Varney
Thompson Jr. in
May 1923. Photo:
© President
and Fellows of
Harvard College.
The fresco was
folded into his
suitcase and taken
to Cambridge,
Massachusetts,
to show Langdon
Warner the results
of *strappo*.

[Cennino Cennini], so I embarked on a [new edition] and then went on to look for new materials."[34] He proposed to Forbes that he study and attempt to prepare "obscure" pigments on the basis of "old receipts" (Fig. 6).[35]

Warner returned from China to Cambridge in June 1924 with twelve wall paintings, damaged because, in midwinter, he had not been able to follow Thompson's directions exactly:[36] "The milk fixative froze at once and could not penetrate even when put on hot, and by the time the glued cloths had been handed up my ladder and straightened out, they were not hot enough."[37] At the Fogg, Thompson was charged with handling problems

34 AAAO, tape 1, side 1.
35 Thompson to Forbes, 28 July 1923, Harvard Art Museums Archives (hereafter HAMA).
36 Balachandran 2007, 14, 28, n. 78.
37 Bowie 1966, 117.

6
Boston newspaper
illustration,
16 April 1924,
"DVT Jr, assistant
to Director Forbes
of the Fogg
Art Museum at
Harvard, making
an exact copy of a
rare and valuable
Italian painting."
Daniel Varney
Thompson Papers,
1848–1979, Printed
Material, Archives
of American
Art, Smithsonian
Institution,
Washington, D.C.

caused by Warner's inexperience.[38] For the year 1924–25, Thompson received a second Sheldon Fellowship from Harvard "to enable me to prepare in Europe for the Second Fogg Expedition to China."[39] He did independent research there, "on the trigger," ready at a moment's notice to sail for the Orient.[40] At twenty-two, Thompson accompanied the six other members of the Fogg's Second China Expedition (1924–25) as the technical adviser and wall painting specialist. Ostensibly this expedition sought to establish relationships

38 Balachandran 2007, 15–17.
39 AAAO, tape 2, side 1.
40 Thompson to Forbes, 12 October 1924, DVTP.

with Chinese universities in the hope of creating a Peking-based institute for the study of Chinese culture.[41] An important focus, however, was on returning to Dunhuang to study, photograph, and remove wall paintings. The group arrived in Peking in January 1925.[42] The aims of this expedition were blocked because of China's developing awareness of its cultural heritage, and no significant objects were obtained for the Fogg's collections.[43] Instead of the projected stay of eighteen months, Thompson and his colleagues were forced to leave Dunhuang after only three days at the site.

Thompson returned via Russia to Harvard in the autumn of 1925, intending to qualify as a PhD candidate under Forbes's supervision. "I should suggest that the subject of my thesis might excellently contribute toward ... your technical-catalogue material. I should be interested ... to make the thesis a commentary on Cennino, with special reference to the paintings in the Fogg Museum."[44] Since he was never paid for his participation on the China expedition, he had to take a poorly paid position as a tutor at Harvard, concurrently with his studies, for the 1925–26 academic year.[45] He took his comprehensive oral exam in May 1926, but failed to pass.[46]

Thompson accepted a teaching post at Yale University in May 1926; he was hired as an instructor by the dean of the School of Fine Arts, Everett Meeks, to teach the history of art, at that time appended to the studio curriculum.[47] Thompson continued to have a low opinion of what he called "art appreciation":

> Art appreciation ... doesn't seem to me a subject for direct teaching ... [Under certain Yale instructors, students] learned to write [essays], gave the approved reaction, gave the approved comments, feeding back what they'd been told ... My feeling is that anything which causes the student to be ... exposed to the operation of the work itself ... may produce a reaction of love and admiration, maybe of strong distaste. I don't care what it is, as long as it's a genuine reaction.[48]

Thompson also taught tempera painting to Yale undergraduates, "not as an [Antiquarian] thing but as a working method."[49] He was increasingly interested in documents about medieval painting techniques, and was given a Sterling Fellowship to take half a year off. In fact, he recalled that Meeks ordered him to "'Go off and get your books out of your system and then come back and do some more teaching.' ... I spent the summer and autumn of 1931 having a quick turn round in libraries to see how much unedited

41 Balachandran 2007, 18.
42 Bowie 1966, 123.
43 Balachandran 2007, 20.
44 Thompson to Forbes, 13 September 1925, DVTP.
45 AAAO, tape 2, side 2.
46 Daniel Varney Thompson Jr. to Everett Meeks, 12 May 1926, DVTP.
47 Meeks to Thompson, 12 May 1926, DVTP; and Kantor 1993, 164.
48 AAAO, tape 3, side 1. See also Hills 1995, 138; the term "art appreciation" suggests the extent to which art history was seen not as a rigorous academic subject but as a "congenial study."
49 AAAO, tape 2, side 2.

material might be there and found a good deal of it."[50] Back at Yale, Thompson offered a course in documents of the history of the technology of art. With his lone student, the future art historian George Heard Hamilton, he translated into English and edited the so-called *Naples Manuscript* (Naples, Biblioteca Nazionale, MS XIIE.27), a fourteenth-century Latin text, which Yale University Press published in 1934 as *De arte illuminandi*. As an extension of the translation proper, Thompson and Hamilton's very full notes identified and defined the materials and operations described in the text; their hope was that the publication would be useful in the interpretation of less systematic texts.[51] This goal typified that of the other articles which Thompson published at the time.

"The end came at Yale in '32" with structural changes in fine arts teaching of which Thompson did not approve, although he did not resign his teaching post there until 1933.[52] He then took up an eight-month-long fellowship from the American Council of Learned Societies "to make a fairly systematic survey of some of the main European libraries for works on the history of technology of the arts . . . In the course of the next year, 1933–1934, I handled . . . perhaps 10,000 manuscripts and found at least a couple of hundred new additions [to the literature] of the [technology of] the arts, some of which I've since published."[53] This research resulted in the bulk of his publications on medieval technical manuscripts (see Appendix).

Thompson recalled that he did not get close to Berenson until 1930 or 1931. Then "Belle Green [*sic*] . . . said to me one day I was a perfect fool not to pursue my acquaintance with BB."[54] She "filled me [with] the conviction [that Berenson] was the great figure in art . . . I started writing to him. Every time I wrote to him I got a letter back. And sometimes I would get a letter [from] him that wasn't [an] answer. And the letters were absolutely delightful. For the next 30 years, we kept up a pretty lively correspondence."[55] The earliest letter from Thompson to Berenson preserved among the Berenson Papers at I Tatti is dated 12 February 1930; in a postscript, Thompson noted, "in spite of your counsels I still esteem the 'Cookery of Art' and am bringing out the text of Cennini this year, in a critical edition!"[56] This is followed by a break in the preserved correspondence until early 1933, when Berenson wrote to thank Thompson for sending him a copy of Thompson's recently published English translation of Cennino Cennini's *Il libro dell'arte*: "I cannot sit down in cold blood to read it from cover to cover. But I have glanced at it here and there and everywhere and it seems satisfactory, interpretive and helpful. In the course of years I hope to use it frequently."[57] Their correspondence continued regularly until the end of Berenson's life, except for a break during the Second World War. Thompson later recalled:

50 AAAO, tape 3, side 1.
51 Thompson and Hamilton 1933, x–xi, xiii.
52 AAAO, tape 3, side 1.
53 AAAO, tape 3, side 1.
54 AAAO, tape 4, side 1.
55 AAAO, tape 1, side 2.
56 Thompson to Berenson, 12 February 1930, BMBP.
57 Berenson to Thompson, 19 July 1933, BMBP.

[In 1931] Yale gave me a half year off and a Sterling Scholarship . . . and I went to Rome to do some work at the Vatican and the [Biblioteca Magliabechiana at the Biblioteca Nazionale Centrale in Florence] . . . I was trying to distribute papers in as many different [kinds of] journals as possible and this went to the journal of the *Sonderdruck aus Mitteilungen zur Geschicte der Medizin der Naturwissenschaften und der Technik* . . . They wanted the article in German . . . I wrote it in German and said, "This is a good chance to . . . brush up acquaintance with BB." So I sent it to him and said, ". . . I should be much obliged if you'd give this a coup de grace." And he wrote back and said, "You do write shockingly good German . . . My German is so colored by hatred that I can't touch it. But Nicky, whose mother's perfect in German and who's good in German herself, has made a few changes."[58]

In the spring of 1934, while on his fellowship, Thompson was invited to lecture at the Courtauld Institute of Art at the University of London; he referred to the text of his presentation as his "apologia" to Berenson.[59] In it, he argued that the "function of technique has not been clearly assessed by writers on art . . . yet art cannot exist without craftsmanship. . . . In the creation of the work of art spirit and matter are inextricably mixed; the existence of a relationship between them must be recognized." He listed various approaches for gathering material and technical information about early paintings. Thompson subsequently accepted a post, offered by the University of London, as research and technical adviser to the Department and Laboratory for Scientific Research which opened in early 1935 at the bottom of the garden of the Courtauld Institute in Portman Square:[60]

The position that they [made] for me was very generous, I had a free hand and for a very short time I had a few students . . . I was expected to pass on the condition of things . . . and advise on restoration . . . we didn't do any restoration . . . I wanted to make studies in the materials and techniques of works of art . . . I carried out some quite basic scientific studies . . . did some X-ray [diffraction] work.[61]

In 1937, Thompson was made professor at London University and head of his department; its name was changed to the department of the history of the technology of art. Research there concentrated on the study of manuscripts and medieval painting materials: "Experimental work was done on the absorption spectra of dyestuffs produced from natural products mentioned in medieval recipes."[62] Thompson recalled, "I was never able to assemble very much of a school because the war came along so very soon after. . . . I

58 AAAO, tape 4, side 1. Here, Thompson misremembered the chronology. This incident is referred to in a later letter: Thompson to Berenson, 28 February 1934, BMBP.
59 Thompson to Berenson, 12 May 1934, BMBP. See Thompson 1934 for the full text of this lecture.
60 AAAO, tape 3, side 1; and Thompson 2007, 7.
61 AAAO, tape 3, side 1.
62 Thompson 2007, 7.

turned [the laboratory and machine shop facilities] over to the war effort and turned [them] into a[n] instrument and gauge making outfit."[63]

Thompson is probably best known today as the translator and editor of an English-language version of Cennini's late fourteenth-century treatise, *Il libro dell'arte*.[64] Convinced that he could improve upon Lady Christiana Herringham's then-standard 1899 English translation of the 1859 Milanesi Italian edition of the *Libro*, he approached this task in the belief that the "real business of translation is a 'laboratory' matter, involving a knowledge of each rule in practice."[65] He told Forbes that he had followed Cennini's instructions literally, all the way through the treatise.[66] Thompson intended his edition of the treatise, published by Yale University Press in Italian in 1932 and in English the following year as *The Craftsman's Handbook*, for "the convenience of the practising student and painter," noting that Cennini himself had insisted that the *Libro dell'arte* was "made and composed for the use and good and profit of anyone who wants to enter the profession...Every effort has been made...to translate [Cennini's materials and methods] into the resources of modern commerce and the idiom of modern craftsmen."[67]

Thompson described his approach to the history of art techniques as objective and experimental. Because he had confidence in the scientific objectivity and integrity of the original underlying texts of later copies of medieval artists' treatises and recipe books, he believed that an old text in its surviving rough, perhaps corrupted, form meant what it said, and required understanding, not correction, in order to yield up all its potential content to the student of medieval art.[68] He undertook the accurate transcription of medieval technical documentation and the establishment of transmission mechanisms and manuscript recensions. In his articles, written in the 1930s, documenting medieval technical information, Thompson transcribed the contents of manuscripts (sometimes in the original Latin or German, at other times accompanied by an English translation), compared his transcriptions with those of other contemporary scholars, and sought to elucidate the texts and establish their positions in particular recensions by carefully comparing words, the contexts of words and phrases, variants, alterations of word order and syntax, etc., with other manuscript versions. This scholarship was an astonishing task to undertake and requires a specialized interest to engage with today. Thompson continued to campaign for the value of what Berenson dismissed as "the Cookery of Art": "Documents which describe the materials and methods used by the old masters suggest lines of investigation to the analyst and the synthetist...What the analyst finds out about materials and what the trained hand and eye discover about method make it possible to interpret the contents of these documents."[69]

After a visit to I Tatti at the beginning of 1934, Thompson reported to Forbes:

63 AAAO, tape 3, side 1.
64 Cennini 1933.
65 Herringham 1899; and Cennini 1933, x–xiii.
66 Thompson to Forbes, 11 February 1935, HAMA.
67 Thompson to Berenson, 12 February 1932, BMBP; Cennini 1933, xiii, 1, 2.
68 Thompson 1935, 440, and 1932, 203.
69 Thompson 1934, 7.

BB was very contemptuous of my "cook-books," as always, but I took a very firm line with him and came away with the feeling that he was more than half testing me out when he knocked my job . . . He said today, "But what can it all lead to?" I replied that I believe it would lead to an understanding of one more facet of the medieval mind, one more aspect of the painter's task, one more chapter of the history of science, that it would provide more data for weighing the relations of style and techniques—"Yes," he said, "But what will it lead to for <u>you</u>?? . . . I wanted you to do something of <u>human</u> interest, something with some warmth and passion in it."[70]

Berenson continued to be concerned about whether Thompson made full and appropriate use of his considerable abilities and lobbied for many years, without success, to help him find professional employment in the fine arts in the United States. Much later, in 1951, when Thompson had moved on to earn a living as a consulting engineer, Berenson wrote, "There is so much of high value and purpose in you dear Dan . . . Have you published nothing—you who have so much to say on so many subjects—+ write so well?"[71]

During their decades-long friendship, Berenson never acknowledged the value of Thompson's approach in his letters. In May 1934, he wrote:

My contention is that the work of art is first and last an aesthetic phenomenon, + as such its appeal is the central fact + not the question of how it got to be. That question seems to belong to the pre-natal history of the work of art. Pre-natal states are . . . scarcely the most interesting part of a person's biography. In short, I regard all questions of technique as ancillary to the aesthetic experience, + you seem to make it in fact if not in theory, its own end.[72]

Berenson went on to qualify these remarks:

Human energy is limited, or at least mine is. If I had greatly more there is nothing about all the "ancillary" aids to the understanding of a work of art that I should not try to master . . . I am only too happy that there should be those who do . . . My quarrel with you is first that you seem to me to expect too much from contemporary "documents" + in the second place that you seem to me to be made for—now curse me—for better I mean bigger things . . . [73]

With Berenson, Thompson came to realize that he was "cultivating fruits of research which you scorn to anticipate . . . You say of my hobby that you will 'leave it to Meder.'"[74] Yet, he insisted:

70 Thompson to Forbes, 6 January 1934, HAMA.
71 Berenson to Thompson, 11 February 1951, DVTP.
72 Berenson to Thompson, 16 May 1934, BMBP.
73 Ibid.
74 Thompson to Berenson, 28 February 1934, BMBP. The reference is to Joseph Meder, author of an important book on the materials and techniques of drawing, *Die Handzeichnung* (Vienna, 1919).

Surely nothing is less foreign to a work of art than the materials and methods that give it form ... You have taught me not to ask for objective history of art, and I have learned that lesson. I still cling to the belief that the road to Parnassus is paved with solid knowledge: that the winds of understanding at the summit blow ONLY for those who, like yourself, have made the factual ascent. I still believe that there is road mending for those to do who will never see the 360 [degree] horizon from the top and that my own labor in getting a solid stepping stone here & there in a small quagmire on the way will erase the traffic, if it does not improve the view![75]

In the spring of 1934, Berenson wrote to Thompson, reassuring Thompson that he loved his attitude; it was Thompson's specific interests which seemed to Berenson accidental and not essential. "The attitude is everything ... You seem to me to be one destined to do the work of a grown-up."[76]

The pair's agreement to disagree is one key to their long friendship. Berenson saw them at bottom as soul mates—humanists: "I have a faint hope that a time may come, when if I Tatti carries over, it may offer shelter to spirits like our own + aid + abet their activities."[77] As a friend, Berenson tolerated Thompson's endeavors with a sense of humor. "He'd tease me about it, he'd say, [cookery, cookery, cookery]. I prefer the dining room, you prefer the kitchen, well alright then, you can't have one without the other."[78] After the war, when Thompson had left the fine arts field, Berenson conceded, "My dear Dan it is not the subject of one's studies or occupations that count, but the approach. Yours is an artist's whatever you do, + engineering of the kind you describe, allows scope enough for aesthetic delight in the doing. You need never fear my disapproving, except as it is a matter of proportions, anything you try."[79] He later added, "Few lives lived in my time are as worthwhile as yours, who never flinched from being at all costs your own true self."[80]

Berenson wrote a foreword to Thompson's *The Materials and Techniques of Medieval Paintings*, published in 1936—or rather, Berenson refused to write it but encouraged Thompson and his publisher to craft a preface out of material they found in his letters to Thompson (Fig. 7).[81] The contents of the preface, which is readily available in libraries, were considerably toned down and reorganized from those expressed in a letter of January 1935 sent from Berenson to Thompson which, in part, is quoted here:

The history of the visual arts is in the same plight as the histories of all the other arts, including literature + music. Taken together their history should be the

75 Thompson to Berenson, 28 February 1934, BMBP. Meder also referred to his own attempts to schematize the technical aspects of drawing as "road-mending": Meder 1978, 23.

76 Berenson to Thompson, 29 April 1934, DVTP.

77 Berenson to Thompson, 22 May 1935, DVTP.

78 AAAO, tape 4, side 1.

79 Berenson to Thompson, 10 July 1945, DVTP.

80 Berenson to Thompson, 14 January 1935, DVTP.

81 Thompson to Berenson, 5 January 1936, DVTP.

7

Cover of Daniel
Varney Thompson Jr.,
*The Materials and
Techniques of Medieval
Painting* (Dover, 1960).

history of the humanization of the completely bipedized anthropoid...their business is to make of him the civilized being we hope he may some far distant day become...also what kind of a world he should live in. In so far as representation grosso modo achieves these ends it is ART. Short of that it may still be handicraft, ornament, tayloring [*sic*], hairdressing [,] shodding, gloving, etc. Still lower down it becomes mere artifact...Prehistorians, + students of the basest difformities [*sic*] of the 11th, 12th, 10th and 14th century medieval illumination + panel painting, + "sculpture" may...pursue their petty tasks without any intrusively fecundating considerations as beauty or quality. However when you come to the art of civilized historical ages, leaving out beauty and quality is equivalent to leaving

man out of the animal kingdom or leaving Greece out from human history. To my ideal history of art all sorts of savants would bring tribute, all sorts of workmen would be summoned to help. The delver in archives would surely be among them. So would the student of the materials, the chemistry + the technique, etc. etc. etc. But neither singly nor collectively do they constitute a history of art. So talk to me not of an objective history of art ... And never mistake the history of techniques, or the history of artists with the history of art. I dream of one in which the names of an artist would never be mentioned ...[82]

Despite the vehemence of Berenson's views, Thompson welcomed them and did not take offence.[83]

Particularly during the 1930s, Berenson and Thompson discussed the purpose of art study in their letters. In 1934, Berenson wrote:

I fear I believe less than ever in "institutionalizing" the cult of art ... And in universities it almost always ends in anecdote-pedling [sic], messing with paints or metaphysico-sociologico-theologico humbug. The result at best is a troop of obsequious salesmen with a sly resentment at times against the goods they are made to sell ... Art is a mystical experience, + institutions are by their nature bound to oppose every kind + quality of mysticism.[84]

In 1935, he stated:

I do so little feel in sympathy with what art teaching there is at present at Harvard. From my point of view it gives far too much attention to "technique" on the one hand, and to mere historicity on the other. Even that historicity is more and more devoted to the Middle Ages ... It is philology and not art study. Of the study of form there is scarcely a trace at present.[85]

During the 1930s, Berenson and Thompson met annually, if not more often. After the outbreak of war, Berenson and Thompson never met again. "Noncommittal" messages from some correspondents, but not Thompson, were passed to Berenson by an intermediary and with difficulty during the war. Immediately afterward, the two resumed their correspondence, and it continued to the end of Berenson's life. Thompson returned to the United States in 1947 and settled in eastern Massachusetts, where he found employment as a consulting engineer. He worked in this field in various capacities including, from 1956 to 1967, for the missile systems division of AVCO Corporation in Wilmington, Massachusetts, until his compulsory retirement in 1967 (Fig. 8). In the fine arts field, he worked on and off

82 Berenson to Thompson, 14 January 1935, DVTP.
83 Thompson to Berenson, 11 July 1936, BMBP.
84 Berenson to Thompson, 17 September 1934, DVTP.
85 Berenson to Thompson, 10 October 1935, BMBP.

Snapshot, inscribed
verso: "DVT reflected
in one of the parabolic
mirrors he designed for
a Schlieren system at the
Ryerson Labs of Pratt
and Whitney (about
1955?)." Daniel Varney
Thompson Papers,
1848–1979, Photographs
1902–1972, Archives
of American Art,
Smithsonian Institution,
Washington, D.C.

on translations of Theophilus's *Schedula* text and the *Secretum Philosophorum*, which he
never completed, and produced occasional scholarly book reviews. A record of his inten-
tion, unrealized, to produce a paper for a Festschrift for Belle da Costa Greene, published
in 1954, is preserved in an inscription on the verso of a photo-reproduction at the Archives
of American Art (Fig. 9). A paper on this topic was later published by the art historian
Robert Calkins.[86] In his retirement, Thompson went on to yet another productive career
as a writer of food and garden columns and essays for *Gourmet*, *Horticulture*, and *Yankee*
magazines, among others.[87] He died in a car accident in Madrid in 1980.[88]

Berenson devoted his life to the connoisseurship of Italian Renaissance paintings;
he studied the finished work of art directly, visually, and judged its merits and decided

86 Miner 1954; and Calkins 1978.
87 Thompson 1969, 13. Thompson's extensive files on these topics are preserved in the Daniel Varney
 Thompson Papers at the Archives of American Art, Smithsonian Institution.
88 Samuels 1987, 421.

its probable period and source by that means. Thompson, who never ceased to be fascinated by the materials and techniques of medieval manuscript illumination, combined an admiration for the aesthetics of the finished product with a scientist's desire to know the details of its materials and production. Both men sought in their own ways to bring order and system to their respective areas of the discipline. Much has been written about Berenson's approach, but Thompson's scholarship has yet to be evaluated critically. Thompson distinguished between two categories of medieval technological records— those made up out of selections from traditional sources and those, "much rarer," written firsthand by artists out of their own experience: "it is the latter class which enable us to distinguish among the corpus of traditional recipes . . . those which were retained in active use by practising workmen."[89] This latter class interested him, particularly the materials described and their manipulation according to each recipe. In actual fact, the demarcation between the two classes of records is not at all clear, since they have been shown to hark back to a greater or lesser extent to traditional sources.[90] Thompson sought to clarify the contents of individual recipes through the microanalytical investigation of objects of known date and provenance, the reproduction of recipes in the laboratory, and the microlevel codification of written traditions of medieval technology. He worked according to the principles of "scientific" editing by classifying manuscripts into a "genealogical tree" that would permit the editor to discover the manuscript(s) closest to the lost original.[91] He sought a fixed text that was as transparent as possible. This approach may explain Thompson's lack of concern for the material artifacts of medieval technical literature, for the physical nature of the manuscripts themselves, and for manuscript culture.[92]

In his published writings and correspondence, Thompson never placed his beloved medieval artists' treatises and recipe books into a broader context. Indeed, he wrote, rather astonishingly,

> Benevolent Providence, which . . . placed in human viscera a particular disposition in favour of writing cook-books . . . saw fit, for reasons which I cannot question, to deny these authors the humble literary virtue of clarity . . . [in their] collections of recipes and "secrets" and accounts of technical procedures which are to a high degree un-understandable to anyone who does not understand them.[93]

Thompson's task in his research and publication was to discover what the individual recipes were about: "They generally prove to have been quite clear all the time, but it requires science and experience to read them with intelligence."[94] With hindsight and

89 Thompson 1933, 339–340.
90 Tosatti 2007.
91 Nichols 1990, 5.
92 Ibid., 3, 7.
93 Thompson 1934, 7.
94 Ibid. See also Thompson 1967, 331–332, 339.

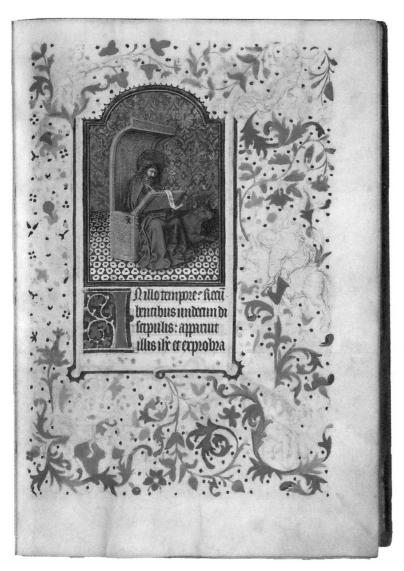

9

St. Luke, 1440s. Pierpont
Morgan Library, New
York, MS M.358, fol. 19r.
(Photo: Graham Haber,
2010.) The miniature is
complete; the initial, text
frame, and border are
partly executed while the
marginal figures remain as
metalpoint underdrawing.
A photograph of this
manuscript page in
the AAAP is inscribed
verso, "Unfinished.
Best example known to
DVT, Jr., to show steps
in medieval illumination
process . . . DVT JT hadn't
time to do [article] for
Festschrift to Belle
da Costa Greene."

changes in scholarly fashions, it is difficult to understand why Thompson was not more
curious about the original function of medieval technical compilations—why they were
composed, why they were preserved, and how, when so much material was omitted from
the text or lost in the course of its descent into the surviving manuscript, the latter could
have served craftspeople.[95]

Although the texts studied by Thompson look like practical workshop handbooks
superficially, they were, as more recent scholarship has shown, distorted echoes of an ear-
lier period of technology.[96] An unbroken tradition of manuscripts describing the chem-

95 Thompson and Hamilton 1933, 30, n. 56.
96 Eamon 1994, 33.

istry of the arts extends from late antiquity through the late Middle Ages. It is unlikely that these texts were composed by or for practicing artisans; they are very often written in Latin, "a fairly certain sign of the presence nearby of a text," in the scriptorium of the monastery, not in the busy workshop of the practicing craftsman, and they show no signs of frequent or workshop use, which suggests that they were probably kept in a library. William Eamon has clearly demonstrated that such texts are literary creations within a complex literary tradition.[97] Thus, medieval writing concerned with practical activities is reflective and aphoristic, not directly descriptive and operational.[98] Its authors' purposes were not those of the age of mechanical or digital reproduction. Eamon wrote: "Medieval writing does not produce variants; it is variance."[99] Mechanical arts were practiced by manual workers; medieval scholars had little direct interest in craft techniques but did have reasons to refer to them allusively.[100] Technical information, transmitted to generations of craftsmen primarily through oral traditions, came to be preserved in secret within a guild context. With the spread of literacy in the later Middle Ages, technical procedures began to be recorded more openly for reasons which we can better appreciate— to communicate important technical information, to train apprentices, to stake claims to specific inventions, and to define particular activities.[101] This was a gradual process, and today it appears that medieval technical manuscripts may be mined as reliably "objective" (Thompson's word) historical sources only if each section of every text is carefully and thoroughly reviewed and embedded in the historical milieu of its conception.

In a letter to Berenson written in 1933, Thompson had expressed his hope that, by benefiting from the great connoisseur's "sympathetic interest (and) ... breadth of understanding," he would increase the usefulness to the broader art field of his researches in technology.[102] It is apparent from the content of their correspondence that Berenson sensed and was impatient with the narrowness of Thompson's approach, hence his diffidence, but he never articulated the reasons for his hesitation with sufficient force or clarity to move Thompson beyond the "scientific" philological methodology of his investigation of medieval manuscripts on "the Cookery of Art."

97 Ibid., 30–37, 87.
98 Ong 2005, 43, 234.
99 Eamon 1994, 82.
100 Ibid., 83–89.
101 Baroni 1998.
102 Thompson to Berenson, 14 August 1933, BMBP.

~~~~~

# Appendix

Publications by Daniel Varney Thompson Jr. on European medieval technical manuscripts on the arts.

### 1926

"'Liber de Coloribus Illuminatorum Siue Pictorum' from Sloane Ms. No. 1754," *Speculum* 1:280–307. Thompson set out to publish this manuscript for the first time "in extenso" and in both the original Latin and English translation.

"'Liber de Coloribus': Addenda and Corrigenda," *Speculum* 1:448–450.

### 1932

"The 'Schedula' of Theophilus Presbyter," *Speculum* 7:199–220. Describes the copies, excerpts, commentaries, and editions that link Theophilus's text with the present day (199).

"The *De clarea* of the So-Called 'Anonymous Bernensis'", *Technical Studies* 1:8–19, 69–81. This is a new study of the Latin manuscript MS Berne A.91.17 accompanied by an English translation. It is preserved in fragmentary condition and may be an extract from a lost work of the later eleventh century; it meticulously describes details of the illuminator's practice.

### 1933

"'Ricepte d'affare piu colori' of Ambrogio di Ser Pietro da Siena," *Archeion* 15:339–347. "This is the only treatise so far brought to light which deals with the technique of painting or illuminating by . . . a medieval Sienese" (339). His article aims only to make available the Italian text of this short treatise (342).

*The Craftsman's Handbook: "Il libro dell'arte,"* New Haven.

*An Anonymous Fourteenth-Century Treatise, De arte illuminandi: The Technique of Manuscript Illumination*, with George Heard Hamilton, New Haven.

Review of *The Art of Limning* (Ann Arbor, 1932), *Technical Studies* 2:35–37.

"Artificial Vermillion in the Middle Ages," *Technical Studies* 2:62–70.

"The Study of Medieval Craftsmanship," *Bulletin of the Fogg Art Museum* 3:3–8.

"Traktätchen, wie man Tinte und andere Farben bereiten soll, aus MS. Vat. lat.598 (saec. XIII)," *Sonderdruck aus Mitteilungen zur Geschichte der Medezin du Naturwissenschaften und Technik* 3:193–195.

Review of Hilaire Hiler, *Notes on the Technique of Painting* (London, 1934), *Technical Studies* 3:237–243. "An attractive but unreliable book" (238).

"'Tractatus qualiter quilibet artificialis color fieri possit' from Paris, B.N., MS. Latin 6749^b," *Isis* 12:456–468.

"Trial Index to Some Unpublished Sources for the History of Medieval Craftsmanship," *Speculum* 10:410–431. Here, Thompson "undertakes to extend acquaintance with the literature of art-technology up to 1500 by a summary analysis of a number of unpublished texts" (410).

Review of Wilhelm Theobald, *Technik des Kunsthandwerks im zehnten Jahrhundert* (Berlin, 1933), *Speculum* 10:437–440. Publication of second and third books of Theophilus's *Schedula*.

"'De coloribus, naturalia exscripta et collecta' from Erfurt, Stadtbücherei, Ms. Amplonius quarto 189," *Technical Studies* 3:133–145. This short text on colors of the late thirteenth or early fourteenth century "requires no special comment to explain the twenty short chapters of which it is composed" (133).

"Medieval Parchment-Making," *The Library* 16:113–117. Excerpts a "circumstantial account of the process of making parchment" from a thirteenth-century German manuscript, British Museum, MS. Harley 3915, fol. 148r, and compares this with modern parchment-making techniques and with information in other medieval texts (114).

"The *Liber Magistri Petri de Sancto Audemaro de coloribus faciendis*," *Technical Studies* 4:28–33. Thompson corrects errors in Merrifield's English translation (1849) of this Latin text.

"Medieval Color-Making: *Tractatus qualiter quilibet artificialis color fieri possit* from Paris, B. N., MS. Lat 6749^b," *Isis* 22:456–468. The Latin text of this manuscript is printed for the first time. Thompson examines the problematical relationships among various manuscripts in which the recipes appear.

## 1936

"More Medieval Color-Making: *Tractatus de coloribus* from Munich, Staatsbibliothek, MS, Latin 444," *Isis* 24:382–396. Thompson publishes a fuller version of the Paris, B.N. Lat 6749[b] text and places it in the relevant *stemma*.

*Materials and Techniques of Medieval Painting*, with a foreword by Bernard Berenson, New Haven.

*The Practice of Tempera Painting*, with Louis E. York, New York. "This book is intended for painters, modern painters, preferably very modern painters. I shall be glad if it is acceptable to the historian as an exposition of Trecento Italian techniques, but that is not its purpose" (vi).

## 1963

Review of E. Ploss, *Ein Buch von Alten Farben: Technologie der Textilfarben im Mittelalter mit einem Ausblick auf die festen Farben* (Heidelberg, 1962), *Speculum* 38:491–493.

## 1966

Review of Viola and Rosamund Borradaile, *The Strasburg Manuscript: A Medieval Painter's Handbook Translated from the Old German* (London, 1966), *Speculum* 43:125–128. "The Misses Borradaile have adopted a free and charming mode in translation which is highly appropriate and effective" (128).

## 1967

"Theophilus Presbyter: Words and Meaning in Technical Translation," *Speculum* 42:313–339. A lengthy review of the English-language translations of Presbyter's *De diversis artibus: The Various Arts* by C. R. Dodwell (London, 1961) and *On Divers Arts: The Treatise of Theophilus* by John G. Hawthorne and Cyril C. Smith (Chicago, 1967).

## 1971

"Letter from America," *Tempera* (Society of Painters in Tempera), April, pp. 7–8.

## 1972

Review of H. Roosen-Runge, "Farbegung und technik fruehmittelalterliche Buchmalerei; Studien zu den Traktäten 'Mappae Clavicula' und 'Heraclius,'" *Art Bulletin* 54(4):539–40.

FOURTEEN

# The Antiquarian Carlo Alberto Foresti of Carpi, a Correspondent of Bernard Berenson

*Unknown Documents for the History of a Dispersed Collection*

ELISABETTA LANDI

*In memory of my grandfather, Carlo Alberto Foresti.*

"WHAT DO WE KNOW ABOUT great antiquarians like Count Carlo Foresti of Carpi, when even about someone like Contini we know next to nothing?" With these words, written in the *Giornale dell'arte* in 1986, Federico Zeri voiced his regret for the loss of the documents—not to mention the protagonists—of the "intense and profitable period of collecting" during the first decades of the twentieth century.[1] A trace of that "miraculous draught of fishes"[2] in the ocean of private collections can be found in the documentary material preserved in various archives and photo libraries. In fact, the Villa I Tatti possesses letters from Carlo Alberto Foresti (Carpi, 1878–1944), an antiquarian and collector in touch with the most important scholars of the time and also actively involved with the art market.[3] The correspondence in the family archive[4] attests to his relations with Bernard Berenson, Roberto Longhi, Adolfo and Lionello Venturi, Suida, Leo Planiscig,

   I wish to thank Villa I Tatti for granting me the permission to consult the letters of Carlo Alberto Foresti, and Louis Waldman for having encouraged my work. My gratitude also goes to Luigi Foresti for help with research in the family archive and to Giovanni Pagliarulo and Anchise Tempestini for their valuable collaboration.

1   Zeri 1986, 16.
2   Ibid.
3   "Foresti, Carlo," 1926–35 (5 letters), 1927–29 (3 letters), Bernard and Mary Berenson Papers, Biblioteca Berenson, Villa I Tatti—The Harvard University Center for Italian Renaissance Studies (hereafter BMBP).
4   Private archive of Luigi Foresti, Carpi.

Van Marle, Heimann, Gronau, Toesca, Fiocco, Morassi, Mayer, and especially Contini Bonacossi, Frederick Mason Perkins, and Robert Langton Douglas, whom he first met in Venice in 1922 (Fig. 1). Foresti had a long-standing association with Mason Perkins, who is portrayed together with Berenson in the photo accompanying Zeri's interview. There were several encounters: at Santa Margherita Ligure together with Langton Douglas (1926); at Assisi, Sassoforte, and Lastra a Signa.[5]

"We had been friends for many years, but before I got to know him I had already met his father ... therefore I can boast that I was practically a friend of the family," wrote Mason Perkins on 25 January 1946 in expressing his condolences upon hearing the news of the "atrocious tragedy ... from Sig. Jenny."[6] Carlo Alberto Foresti had died on 30 September 1944 during a robbery, and this led to the dispersal of some of his documents and works of art.

The events of the Second World War brought about a change of scene and pushed the era of collecting toward a turning point. No one was spared by the war. Mason Perkins wrote:

> Thank God we are doing fairly well as far as our physical health is concerned, but I am sorry that I can't say the same for our moral and spiritual condition ... it was truly a miracle that the allies found us alive when they entered Umbria. I still feel the effect of that long period of tension, and I am not yet able to study and work normally.[7]

The loss of such crucial evidence as letters, archival papers, and notes, as well as the dispersal of many of the masterpieces, makes it difficult to investigate the patrimony of Carlo Alberto's collection, especially in connection with the market. Carlo Alberto was an antiquarian with international links. His father Pietro (Carpi, 1854–1926), by contrast, is best remembered for his artistic taste and substantial donation (1914) that was instrumental in the creation of the Museo Civico of Carpi.[8] Overlooked for years, the Foresti collections are now the center of attention, and the names of Carlo and Pietro have begun to appear in specialized studies and exhibition catalogs. Pietro's significant role in the cultural life of Carpi was the subject of research published in 1991 and an essay published in 2004.[9] Carlo's activity, intertwined with the art market, is more problematic to reconstruct.

This is not the occasion to pursue fully such a complex and detailed issue, however. Instead, we intend to limit ourselves to sketching an outline of the figure of Carlo Alberto Foresti in order to explain his formation and the network of his relationships, with the purpose of drafting a "map"—also bibliographical—for the study of his collection.

Some information about the historical background will be helpful here. As mentioned, Carlo Alberto grew up in the cultured atmosphere of Palazzo Foresti (Fig. 2), a

5   Colli and Foresti 1999, 71–72.
6   Frederick Mason Perkins, autograph letter, Assisi, 25 January 1946, original document in author's possession.
7   Frederick Mason Perkins, author's personal collection.
8   Rossi and Previdi 2004.
9   See Garuti 1991a, 47–59; Colli and Foresti 1999; Martinelli Braglia 2004; and Rossi 2010, passim.

*1*

Carlo Alberto Foresti with his wife Erminia, Frederick Mason Perkins, and Irene Vavasour Elder in Santa Margherita Ligure, 1926. Archivio Luigi Foresti, Carpi.

neo-Renaissance building (1892) designed for his father by Achille Sammarini (1827–1899), an important figure in the Commissione di Storia Patria e Belle Arti. This latter institution was, to a certain extent, a guiding spirit in Pietro Foresti's culture, which was based on the "evergetic model" described by Krzysztof Pomian in "Collezionisti, amatori e curiosi."[10] His projects and aesthetic taste were inspired by fin de siècle collecting at the time of an emerging national conscience, which also influenced the education of his son Carlo. Pietro's love for art was inextricably linked to a culture that was "close to the experiences of the Anglo-Saxon aesthetic of John Ruskin, championed in Italy and the *pianura padana* . . . by Camillo Boito and Alfonso Rubbiani." The family palace was a fine expression of this culture, the "place of an imagined, rediscovered renaissance," where "in the construction and decoration . . . the multiple aspects of pragmatic knowledge [converged] on these walls to celebrate a great creative return."[11] Pietro embellished the architecture of his "home museum" with objects found on the market, together with reusable elements such as the brick mullioned window from a demolished house, the tondo of a *Madonna and Child* salvaged in Bologna in 1913 from a ruined building, and the slab with an escutcheon: "almost a little Lapidary."[12] Those were the years of historicism: in 1882, Hans Semper published *Carpi, ein Fürstensitz der Renaissance*, and Pietro became enthralled with the patronage of the prince.[13] The descendent of an ancient family of Carpi that had ventured

10   Pomian 1987, cited in Albano Biondi 1991, 15–31.
11   Emiliani 1991.
12   For the window and the "Stone Madonna," see Ravenna, Biblioteca Classense, Sezione Fondi Antichi, 70, Carteggio Ricci, no. 13495, 18 October 1910, and no. 13517, 13 April 1913; see also Martinelli Braglia 2004, 12.
13   See Rossi 2001 and 2004a.

into business in the nineteenth century, Pietro revived their traditional love for art.[14] In 1634, an ancestor, Luigi Foresti, had commissioned Matteo Loves to paint the altarpiece of *Sts. Filippo Neri and Joseph*[15] for the family chapel in the duomo. In 1680, another Luigi, an archdeacon, ordered the Carrarese sculptor Tommaso Lazzoni to carve statues of *St. Peter* and *St. Paul* (1680) for the duomo facade.[16]

The collections of Palazzo Foresti, "well known to amateurs," were open to scholars and "lovers of the fine arts, if . . . presented by friends and acquaintances."[17] They attracted intellectuals and connoisseurs, who met in the rooms decorated by Carlo Grossi, Lelio Rossi, and Fermo Forti (Fig. 3).[18] In the visitors' book of the Raccolte artistiche Foresti,[19] we find the signatures of such notable men as Adolfo Venturi (1902), Matteo Campori (1903), Gustavo Frizzoni (1904), Tito Azzolini (1906), and Corrado Ricci (1910). Among the names of visitors mentioned in Alessandro Giuseppe Spinelli's 1902 guide are those of Hans Semper, professor of art "in Inspruch [Innsbruck]"; Julius Lessing, "Director of the *Kaiserliche Kunstsammlungen* in Berlin"; "F. Hark"; and "Prof. Chr. Tsountas, director of the Archeological Museum at Athens."[20] All these contacts were fundamental to Carlo's formation.

14  Archivio Guaitoli, Museo Civico, Carpi, "Foresti", 93, fasc. 4; Carpi, Biblioteca Comunale, *Genealogia della famiglia Foresti di Carpi compilata sopra autorevoli documenti da Paolo Guaitoli l'anno 1857*. See also Grazia Biondi 1991. The family, originally from Bergamo, boasted historians and scholars. Jacobus Philuppus Foresti Bergomensis published a *Supplementum Cronicarum* in Venice in 1503; see Agosti 2005, 96–97 n. 36.

15  Garuti 2010, 122 n. 21.

16  Martinelli Braglia 2004, 7.

17  Spinelli 1902, 18 n. 1.

18  See "Carlo Grossi" in Landi 1989. See also Rivi 1991, 68–71; and Martinelli Braglia and Borsari 2002.

19  Private archive of Luigi Foresti, Carpi.

20  Spinelli 1902, 19.

*Elisabetta Landi*

3

Palazzo Foresti,
Carpi, La Galleria.
Archivio Luigi
Foresti, Carpi.
(Photo: Pietro
Foresti.)

Another interesting aspect of the collection is the way in which it functioned as a synthesis of the local art patrimony. Besides paintings there were sculptures, drawings, woodcuts, engravings, bronzes (porcelain and faience arms acquired en bloc from the Ferazzini collection of Carpi), scagliola, fans, and an extraordinary cache of medals—as many as 250 gold coins and over 2,000 silver coins. The collection even included objects from the Risorgimento, such as the model of Trubetzkoy's *Monument to General Manfredo Fanti*, which had historic as well as artistic significance.[21]

In 1897, Cavalier Foresti wrote to his friend and consultant Corrado Ricci: "It gives me great pleasure to announce that I have already acquired Franciosi's entire picture gallery and brought it home"; and further, "I take it upon myself to inform you that Franciosi's paintings are now in order and all that remains to be done is choose the best works to hang in the salon." Over ninety letters were exchanged by Pietro Foresti and Ricci—director of the Regia Galleria of Modena, superintendent of the Gallerie Fiorentine, and from 1906 director general of antiquities and fine art—letters in which Pietro asked for advice and information about acquisitions as well as for help with the conservation of Carpi's monuments.[22] Since 1894, numerous works of art had arrived at the palace in via San Francesco: from the collections of the Franciosi in Carpi; from the Diena, Campori,

21 See ibid., 18–26; Martinelli Braglia 2004, 13; and *Catalogue de la Galerie et du Musée appartenents à M.r le Chev: Pietro Foresti de Carpi*, Milan, 1913 (hereafter *Catalogue*).
22 See Bosi Maramotti 1991, 34; and Martinelli Braglia 2004, 7.

*The Antiquarian Carlo Alberto Foresti of Carpi, a Correspondent of Bernard Berenson*     313

Molza, Malmusi, Abbati Marescotti, and the Palazzo Ducale in Modena; and from Cavriani in Mantua, Coccapani Imperiali in Genoa, the von Klement gallery in Prague, and the Galleria Patrizi in Rome. Relations with Florence were intense. There were many purchases from the Galleria Panciatichi and—we wish to emphasize—from the collection of Stefano Bardini. Pietro, who had "visited [Bardini's gallery] on numerous occasions," acquired several works that are recorded in a document I found in the archive of the Museo Bardini.[23] Was it Bardini, "one of the greatest geniuses behind the art market,"[24] who reinforced the historic model guiding the Foresti collections? We are convinced that it was, and it gives us pleasure to note that the Carpi museum also had Tuscan roots, a subject awaiting further research.

Striving to transcend the local dimension, Pietro aspired to international taste.[25] His ambition is apparent in the enfilade of salons in Palazzo Foresti, which were inspired by the house museums of the time—Bardini, Poldi Pezzoli, Bagatti Valsecchi, Sacrati Strozzi. Pietro, a highly skilled "dilettante," captured them in photographs, and in his awareness of the usefulness of a photographic record he was well ahead of his time.[26] The display in the palace gallery provides an extraordinary document of the collection: Foresti's photographs show Denys Calvaert's *Baptism of Christ*, the *Portrait of Almerico d'Este*, and the one attributed to Moroni; in the background, we can make out the cabinets that had once belonged to the princes of Correggio.

Pietro participated in auctions (a letter to Corrado Ricci reveals that he was in contact with Duveen),[27] frequented the art market, visited the Universal Expositions, got to know the artistic patrimony of the nobility, acquired and catalogued reproductions, and consulted with experts, preferably Corrado Ricci and Adolfo Venturi. As a collector, he preferred Trecento painting, Flemish art, portraits—particularly of the Este—and battle and genre scenes, but above all he favored classical works, the pride of every collector: his treasures included the *Madonna of the Pinks*, formerly attributed to Raphael[28] but in fact a copy of the painting in the London National Gallery, and the *Madonna and Child with the Infant St. John the Baptist*, attributed to Sassoferrato, a version of the painting in the London National Gallery, recently exhibited at the Davis Museum at Wellesley College in Massachusetts.[29] He also appreciated nineteenth-century painting, owning as many as twenty pictures by Giovanni Muzzioli, the "Italian Alma-Tadema." Pietro admired Muzzioli for his international character and the associations with the Parisian Salon. He

23  Archivio Bardini, Museo Bardini, Florence, *Carteggio*, 22 January 1907–5 February 1907, no. 22, progr. 2. See Landi 2004, 83.

24  Ferrazza 1985, 433.

25  Pietro Foresti's extra-provincial calling, misunderstood by Bosi Maramotti, is correctly perceived by Martinelli Braglia (2004, 13).

26  See Nora 2004, 41–46; and Martinelli Braglia 2004, 13. For the project of a photographic census proposed by Pietro Foresti to Corrado Ricci, see Carteggio Ricci, no. 13501, 8 February 1911.

27  Carteggio Ricci, no. 13523, 26 March 1920.

28  *Catalogue*, V, no. 68.

29  *Catalogue*, IX bis, no. 40 bis; and Martinelli Braglia 2004, 21.

photographed Muzzioli's Florentine studio along the Lungo il Mugnone and reserved a room in his palace for the display of Muzzioli's paintings.[30]

The Foresti palace buzzed with the opinions of experts: "Prof. Bode wrote me that [the painting] is worthy of being hung in one of the foremost galleries ... Prof. Venturi was enthusiastic about it," Pietro related to Corrado Ricci regarding a *Holy Family* formerly attributed to Maineri, cited in the correspondence with Ricci.[31] The Carteggio Ricci in the Biblioteca Classense of Ravenna is an essential source for reconstructing the "first" Foresti collection, which was highly important for Carlo's aesthetic development. Further helpful information is found in the essays by Bosi Maramotti on Pietro's relationships with Ricci and by Martinelli Braglia on the formation of the collection.[32] The correspondence tells us about the collections Pietro visited: the Legnani in Bologna, the Crespi in Milan, the Franchi in Rome. In the letters, we read about his judgments on works of art—once in disagreement with Frizzoni[33]—and find mention of objects he had come across or donated—for example, the terracotta "of Antonio Begarelli representing St. John, a Michelangelesque nude," presented to the Galleria Estense of Modena, where it is still conserved.[34] But above all, the letters reveal the movements of the works listed in the sales catalog of 1913, the year in which the collection was broken up and consigned to the Milanese auction house Lino Pesaro.[35] Nonetheless, disagreements with the auctioneer led Pietro to withdraw a part of the collection. Prior to the sale, paintings of local interest and objects grouped philologically had been selected for transfer to the Carpi museum, which was inaugurated on 7 June 1914 under the direction of Pietro Foresti, *ispettore* (supervisor) since 1904.[36] His friend Corrado Ricci, director general of antiquities and fine art, attended the event, which was described as a "magnificent art feast."[37]

The 1913 catalog is the fundamental research tool for investigating the Foresti collection. It has allowed Martinelli Braglia to trace the provenance and movements of many of the paintings.[38] To mention just a few: the *Portrait of Laura Dianti*, based on Titian's portrait in the Kisters collection, Kreuzlingen, attributed to Sebastiano del Piombo and close to a version in the Geri collection;[39] the two views by Antonio Jolli (*Burning of Troy*, *Samson Destroying the Temple*, formerly in the Diena collection) in the Museo Civico of

30  See Landi 1991 and 1994; and Martinelli Braglia, Nicholls, and Rivi 2009.

31  Carteggio Ricci, no. 13444, 22 October 1899. Published in Malaguzzi Valeri 1903, 146, the Foresti altarpiece, which was sold to A. J. Sulley in London, was attributed to Lazzaro Grimaldi because of its affinity to the Kaufmann panel, in Zamboni 1975, 63; see also Bosi Maramotti 1991, 63; and Martinelli Braglia 2004, 17.

32  See Bosi Maramotti 1991, 34–35; and Martinelli Braglia 2004, 17.

33  Carteggio Ricci, no. 13454, n.d.

34  Carteggio Ricci, no. 13451, 11 September 1901, and no. 13491, 1 July 1910; and Righi Guerzoni 1996, no. 22.

35  Carteggio Ricci, no. 13515, 10 November 1912.

36  Carteggio Ricci, no. 13478, 21 January 1907.

37  "Il Museo Civico di Carpi inaugurato con un discorso di G.Piva," *Il Sordo*, 8 June 1914; see Rossi 2004b, 39.

38  Martinelli Braglia 2004.

39  *Catalogue*, XIX, 133. See Stefania Mason in Bentini 1998, 150–151 n. 3.

Modena;[40] the *Portrait of the Family of Adeodato Malatesta*, a charming conversation piece acquired directly from the heirs of the artist (1896);[41] and finally the paintings hanging in the Muzzioli room in the Palazzo Foresti.[42] Many prestigious names appear in the catalog—Bruegel, Clouet, Van Dyck, Van Honthorst, Magnasco—although all the old attributions need to be reviewed.

We have some more facts to add to Martinelli Braglia's essay: our research has shown that Giovan Battista Moroni's *Portrait of a Gentleman*, "a fine museum work,"[43] went to the Achilito Chiesa collection in Milan, and from there to the Agosti and Mendoza collections, as did the two *capricci* by Francesco Guardi (formerly in the Manfroni collection), which Fiocco had mentioned in the Foresti collection.[44] The Panciatichi *St. Sebastian*, which Berenson attributed to Luca Signorelli in 1913, has also been linked to Girolamo Genga,[45] while the *Innocence*, listed in the catalog as by Marcantonio Franceschini, became "School of Guido Reni" when it entered the collection at Castello Chigi di Castelfusano.[46]

But what we want to draw attention to here is the Foresti panel with *Sts. John the Baptist and John the Evangelist* (Fig. 4), attributed in 1913 to Spinello Aretino,[47] which can be identified with the panel attributed to Bicci di Lorenzo by Robert Lehman, who refers to its Foresti provenance (1928).[48] When it was in the Lehman collection (New York), Zeri recognized it as the right wing of the *Triptych of St. Nicholas in Cafaggio* (1433).[49] He compared it to *Sts. Nicholas and Benedict* in the museum of Grottaferrata, which Mario Salmi had attributed to Bicci (1913),[50] and to the *Madonna and Child with Angels* in the Galleria Nazionale of Parma.[51] The dismembered polyptych—mentioned in Berenson's 1963 *Florentine School*[52]—was thus reassembled and the figure of St. John the Evangelist (in the ex-Foresti panel) correctly identified as St. Matthew.[53] In his article, Zeri noted the provenance of the painting from the Coccapani collection of Modena. On the basis of what appeared in the 1913 sales catalog we can add to the provenance the collection of the Marchese Menafoglio, from whom Pietro had purchased the painting a few years before.

---

40  See *Catalogue*, XV, no. 216; Manzelli 1999, 127, 7–8; and Martinelli Braglia 2004, 16.

41  See *Catalogue*, no. 110; Poppi 1998, 122–124; and Martinelli Braglia 2004, 16–17.

42  See *Catalogue*, 31–36; and Martinelli Braglia 2004, 21.

43  See *Catalogue*, XXII, no. 168; and Botta 1936, XLVIII, cat. 313.

44  *Catalogue*, IV, no. 142. See Fiocco 1923, 46: "Possiamo datare come del 1752 i due capricci Manfroni, poi Foresti e oggi Chiesa . . ."

45  *Catalogue*, IX, fig. 100. There is a photograph of the painting in the Fototeca Berenson, catalogued under the homeless works "with Signorelli." On the back, the note "Foto Reali" attests to the painting's passage to the Albrighi collection in Florence (C 78.3). In the Fototeca of the Kunsthistorisches Institut in Florence, the painting is catalogued under Gerolamo Genga (*Ausland*, no. 156276, neg. 22547).

46  *Catalogue*, XV, no. 202. Fototeca Biblioteca Hertziana, Rome, neg. 171952 (Hutzel 1970).

47  *Catalogue*, III, no. 176: "Spinello dit l'Aretin/Saint Jean Baptiste et saint Jean l'Evangeliste."

48  Lehman 1928.

49  Zeri 1958, 69, fig. 44.

50  Salmi 1913, 208–227.

51  Zeri 1958, 69.

52  Berenson 1963b, 30, fig. 506.

53  See Zeri 1958, 69; and Richa 1758, 35.

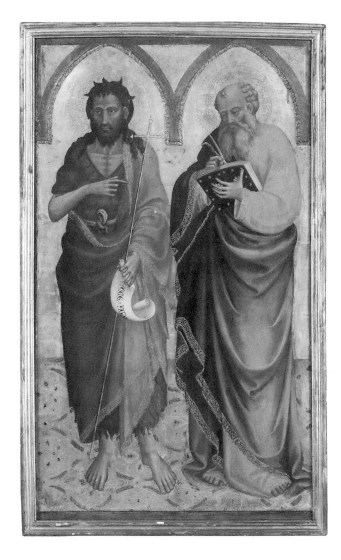

*4*
Bicci di Lorenzo,
*Saints John the Baptist and*
*Matthew*, possibly 1433,
tempera on wood, gold
ground. Metropolitan
Museum of Art, New
York. (Photo: © The
Metropolitan Museum
of Art / Art Resource,
New York.)

According to the catalog,[54] the panel was among the "most famous" works listed by the Ministero della Pubblica Istruzione, as Pietro communicated to his friend and consultant Corrado Ricci in 1908.[55]

The correspondence with Ricci contains further references to paintings illustrated in the catalog, which, like the others, have had various attributions over time. The panels of *Tobias and the Archangel Raphael* and *St. Jerome* are a case in point. Pietro bought them from the Marchese Panciatichi in Florence in 1902 with an attribution to Andrea del Castagno and immediately wrote to Ricci about his purchase.[56] Today, the paintings are

54 *Catalogue*, 27, no. 176.
55 Carteggio Ricci, no. 13482, 1 April 1908.
56 Carteggio Ricci, no. 13457, 26 May 1902.

respectively in the Museo de Arte de Ponce in Puerto Rico and in the Bowdoin College Museum of Art in Brunswick, Maine, with an attribution to Biagio d'Antonio. Sold at auction in 1913,[57] they were in Paris with Georges Demotte in 1920 and then went by way of Contini Bonacossi to the Kress collection in 1939 with the same attribution,[58] which Bernard Berenson changed to Giovan Battista Utili.[59]

To return to Carpi: the paintings reserved for the Museo Civico were intended to glorify the history of the territory, thereby reflecting Carlo's perception of the museographic ideal of the post-unification period. The same motive was behind the conservation of the Castello Pio, an economic as well as cultural commitment on the part of both Pietro and his son, who financed major restoration campaigns.[60] An overview of the local artistic patrimony can be found in the museum catalog and in various studies.[61] From among the masterpieces donated in 1914, we would like to single out three panels by Bernardino Loschi that are expressions of the artistic culture that flourished at the time of Alberto III: two of the *Nativity* and a *Madonna and Child and St. Nicholas of Tolentino*.[62] For Pietro, the Renaissance suggested an ideal continuity, which he pursued in his collecting. It also inspired his studies, resulting in an essay on the chapel of the Pio court.[63] The patronage of the princes constituted a driving force for the donation—from the paintings of Loschi to medals, the woodcuts of Ugo da Carpi, incised slipware, scagliola, documents, and photographic plates—and a premise for the reconstruction of the historic face of Carpi. An outstanding part of the collection at the Castello is the Emilian art of the sixteenth and seventeenth centuries: the *Annunciation* of Ippolito Scarsella, known as Scarsellino, which had come from Santa Chiara,[64] and the *Baptism of Christ* by Denys Calvaert, from San Giovanni Battista, both formerly in the Franciosi collection (1897);[65] and *Jacob Blessing the Sons of Joseph* (before 1646), a copy of Guercino's painting donated by Carlo (1922).[66]

Following the example of his father, Carlo added to the civic collections. His concern for the local public patrimony reveals one aspect of his formation, but whereas Pietro was mainly interested in Emilian culture, Carlo looked further abroad. As director of the museum, he donated paintings that were significant for the region, such as the copy after Guercino and the *Portrait of Ciro Menotti*, an early work by Adeodato Malatesta, though

57 *Catalogue*, XVIII, no. 108.

58 *St. Jerome*: Bowdoin College Museum of Art, Brunswick; *Tobias and the Archangel Raphael*: Museo de Arte de Ponce, Puerto Rico. See Shapley 1966, 132–133, figs. 358–359.

59 Berenson 1963b, 211 (as "Utili"). In the Fototeca Berenson, the two panels are reproduced in photographs F261 and F261.6. A note on the back, in pencil, reads "Utili da Faenza."

60 See Bentini 1991, passim; and Rossi and Previdi 2004, passim. For the restorations financed by Carlo Alberto, see below.

61 Garuti 1990 and 1991b, 50–53.

62 Manuela Rossi in Rossi and Previdi 2004, 50–51 n. 2; see also Rossi 2004a.

63 Foresti 1912.

64 See Garuti 1990, 43; Manuela Rossi in Rossi and Previdi 2004, 56–57 n. 6; and Tania Previdi in Rossi 2010, 80–81 n. 1.

65 See Garuti 1990, 42–43; Manuela Rossi in Rossi and Previdi 2004, 56–57 n. 6; and Tania Previdi in Rossi 2010, 92–93 n. 7.

66 See Garuti 1990, 48–49; Manuela Rossi in Rossi and Previdi 2004, 56–57 n. 6; and Cristina Dieghi in Rossi 2010, 120–121 n. 20.

he was inclined to select his donations from the broader artistic culture available on the antiquarian market. In 1928, when living in Milan, Carlo wrote a letter to the mayor of Carpi that he was sending a signed work by Jacopo Palma il Giovane, representing the *Victory of Pleasure over Virtue*.[67] Three years later, he donated *The Philosopher*, which had once belonged to Marchese Onofrio Campori and subsequently went to Barone Michele Lazzaroni, from whom Foresti bought it for 70,000 lire. After the painting was compared to the series of philosophers and especially the *Prophet* in Catania, the old attribution to Murillo was changed to Circle of Ribera.[68] And finally, in 1939, Carlo presented the museum with a painting by Mattia Preti: "I took it, advised by both Professor Roberto Longhi and Senator Professor Adolfo Venturi, who would willingly illustrate it … I hope you will like it, and I am pleased to secure it for the Museum, since the painter is so unusual and interesting."[69] With these words, Carlo, then director of the museum, told Ricci about the acquisition of the work, an "opulent display in the manner of Veronese,"[70] in which the dramatic Caravaggesque light dissolves into iridescent colors. The painting was thought to represent the *Banquet of Solomon and the Queen of Sheba* until a restoration undertaken in 1998 revealed the subject to be the *Revenge of Procne*, showing the moment when Procne's husband Tereus is offered the head of their son Itys. On Foresti's request, a restorer had disguised the bloodcurdling image in order to ease the macabre tension of the subject.[71]

In addition to building up Carpi's civic collections, Carlo, like his father, showed great concern for the artistic patrimony, assuming the cost of conserving the Castello Pio. One of the most important projects there was Achille Casanova's restoration of Bernardino Loschi's frescoes in the Sala del Principe[72] (the room described by Hans Semper), which was begun in 1923. The completion of work three years later was celebrated with a memorable feast.[73] In 1937, the altarpiece of the *Annunciation* in the Pio chapel underwent restoration. Formerly attributed to Marco Palmezzano, it was published as a work of Catena by Bernard Berenson in 1905, after he had seen it in the Castello.[74]

Berenson's presence in Carpi at that time is significant, and we propose that it marked the beginning of his relationship with Carlo. Berenson may already have known Pietro, who ensured that the connoisseurs he frequented also played a role in his son's education. Carlo was conditioned by the philology and expertise of Berenson and Adolfo and Lionello Venturi, and by exchanges with Roberto Longhi, Toesca, Contini, and Mason Perkins. One could say, in short, that he was influenced by the Gotha of art history.

67  Archivio Storico Comunale, Carpi, Carteggio, autumn 1928; see Garuti 1990, 45; Martinelli Braglia 2004, 18; and Rossi 2010, 88–89 n. 5.

68  Archivio Storico Comunale, Carpi, AN, A10, 1, 1931, c. 100. See Garuti 1982, 16–17, and 1990, 45; see also Spinosa 2003, 229; Martinelli Braglia 2004, 17; and Tania Previdi in Rossi 2010, 174–175 n. 51.

69  Carteggio Ricci, n. 155, 8 December 1909, in Rossi and Previdi 2004, 77.

70  Spike 1999, 122.

71  Information kindly provided by Luigi Foresti. See Garuti 1990, 45; Angelo Mazza in Preti 1999, 98; Manuela Rossi in Rossi and Previdi 2004, 58–59 n. 7; and Rossi 2010, 172–173 n. 50.

72  See Colli and Foresti 1999, 80; and Rossi and Svalduz 2008, 184, 201 n. 110.

73  Grappini 1934, 257.

74  See Garnier 1901 (as Palmezzano); Berenson 1905 and 1936, 119; and Ferriani 2004.

The chapters in the volume dedicated to Carlo by his son Luigi shed more light on this argument.[75] There is no doubt that Carlo felt the effect of the legacy of Giovanni Battista Cavalcaselle, which lived on in British historiography, mediated by R. Langton Douglas, custodian of the memory of the historian from Legnago.[76] Inspired by an interest in research conducted on location and by the model of Giovanni Morelli, young Carlo went exploring in Tuscany. "This is the panel painting on the only altar at the back of the church, which is all frescoed and covered with pictures, discovered in part by me," he wrote in the margin of his copy of *La Montagna Maremmana*, published in 1911. The printed guide, which he either found in his father's library or purchased at that time, spurred him to make the journey, and he immediately left for Magliano to admire Neroccio di Bartolommeo de' Landi's *Madonna del Latte* of 1495 in the church of the Annunziata.[77] His sensitivity for the artistic patrimony and interest in connoisseurship were determining factors, but Carlo, unlike his father, had a European vision. It is important to remember that he went to school in Switzerland, attending the Institut Schmidt (now Institut auf dem Rosenberg) in St. Gall, where he was exposed to the Anglo-Saxon culture that proved useful in making international contacts.

Carlo's debut, as it were, took place in 1914 when, nearly forty years old, he began to emulate his father, although acting autonomously. His first donation, the *Portrait of Ciro Menotti*, dates from that time, as does his acquisition of the important Mantegna *Christ*, now at the Museo Civico of Correggio.[78] Formerly in the collection of Prince Giovanni Siro, the *Christ* was sold to the Congregazione di Carità, who in turn sold it to two secondhand dealers. Foresti bought it from them for 10 lire and offered it for 250 lire to Marchese Matteo Campori,[79] who sent it to Milan to be restored by Moroni. Frizzoni, seeing the painting in Milan, identified the artist as Mantegna and published it in 1916 in *L'arte*.[80]

Those years mark the beginning of Carlo's activity as an antiquarian and connoisseur. His move to Milan in the 1920s signaled his liberation from his father. Intellectuals gathered in the "Studio" in Palazzo Borromeo in via Manzoni, where they exchanged opinions and read the testimonies of experts in rooms stuffed with paintings and sculptures. Before long, Carlo became a central figure in the antiquarian realm of Renaissance and baroque art, but not only there—occasionally, he was also able to contribute to the success of contemporary artists. Gregorio Sciltian, in describing his solo show at the Galleria Skopinic of Milan, provides an account of the authoritativeness of Carlo, whose unexpected purchase changed the fate of the sale and sealed the fortune of the artist:

75  Foresti, "La cultura e il mondo di Carlo Foresti," in Colli and Foresti 1999, 71–80.
76  Agosti 1992, 25.
77  Foresti, "Nel mondo dell'arte," in Colli and Foresti 1999, 62–64.
78  See Lusetti, Pratissoli, and Riccomini 1995, 65; Lucco 2006, 84–85 n. 9; and Giovanni Agosti in Agosti and Thiébaud 2008, 306–308 n. 123. The attribution to Mantegna, rejected by Berenson, was included in the posthumous lists: see Berenson 1968, 1:239.
79  Benati, Pagella, and Peruzzi 1996, 23–24.
80  Frizzoni 1916.

I came on closing day with anguish in my heart. In the afternoon however ... I saw Longhi arrive with his wife Anna Banti.... They were passing through Milan and had come to see my show with an imposing gentleman who introduced himself as the antiquarian Foresti. All three were complimentary about my paintings, and when Longhi whispered something in the antiquarian's ear, Foresti pointed to the three still lifes and said to me, "I'll take these, come to my office in via Manzoni 44 [43] tomorrow." All of a sudden my situation had taken a volte-face because the next day Foresti gave me five thousand lire for my three pictures, which was a real fortune.... I felt instinctively ... from the enthusiasm with which Foresti had bought my paintings ... that it was going to be easier to find people who loved my art in Milan.[81]

The above excerpt documents the influence of Carlo Foresti's taste on the art market during those years. It also helps us understand his relationship with the era's collectors. The men with whom Foresti dealt were Prince Trivulzio, the banker Rasini, the industrialist Bonomi, Senator Prampolini, and the attorney Rimini. Many of the acquisitions were mediated by Jacob Heimann, who had been presented to Foresti by Mason Perkins in 1935.[82] Their encounters were frequent, first in Milan and then in New York. Heimann secured, among other works, the *Portrait of Alfonso d'Este*, which Carlo had shown at the exhibition of Ferrarese Renaissance painting. Nino Barbantini, who saw it there in 1933, commented: "In the opinion of Adolfo Venturi and others, the third portrait of Alfonso I, which hangs in this exhibition and belongs to Commendator Foresti of Milan, is the original by Titian." It was included by Lionello Venturi in his *Pitture italiane in America*.[83]

Foresti also had dealings with Samuel H. Kress, which were mediated by Contini. Many paintings from the Foresti collection arrived in America, and as often as not they were famous ones. The panels of *St. Peter Martyr*, *St. Augustine* (?), *St. John the Baptist*, and *St. Stephen* from the polyptych painted by Vittore Carpaccio around 1514 went to Tulsa; acquired by Kress in 1934, the panels were published by Bernard Berenson and documented in his photo archive.[84] Kress also acquired—again through Contini—the Franciscan scenes of Alessandro Magnasco (*The Consecration* and *The Burial of a Franciscan Friar*),[85] hanging in the El Paso Museum of Art, and Giuseppe Maria Crespi's *Visitation*, displayed at the University of Arizona Museum of Art. Crespi's painting was

81   Sciltian 1963, 406–407. I am grateful to Giacomo Agosti for the reference.
82   In the private archive of Luigi Foresti is a letter to Carlo Alberto Foresti from Frederick Mason Perkins, dated 1935, in which Mason Perkins recommends Jacob Heimann, who "has pictures of quite a high quality, extremely interesting." Thanks to Luigi Foresti for the reference.
83   See Venturi 1931, 390; Barbantini 1933, 165 n. 202; and Wethey 1971, 197, L10 (under "Lost Works"), Foresti collection.
84   See Berenson 1957, 1:58; and Shapley 1966, 53–54, figs. 122–125. Fototeca Berenson, V 54.6, V 54.11; see Humfrey 1991, 121–123 n. 35 (nos. 3352, 3353, 3355, 3356, Philbrook Art Center).
85   Shapley 1973, 110–111, figs. 215–216.

exhibited by Carlo Foresti in the 1935 *Mostra del Settecento Bolognese*[86] together with the *Self-Portrait in His Studio*, which ended up at the Wadsworth Atheneum through Arnold Seligmann.[87] Further paintings from Foresti are at the San Diego Museum of Art. They were published by Julia Gethman Andrews in 1947 with attributions that are by now out of date: two panels ascribed to Domenico Ghirlandaio,[88] a *Road to Calvary* attributed with reservations to Ercole de' Roberti,[89] a panel by Jacopo Bellini missing from Berenson's lists, a *Madonna and Child with the Young St. John the Baptist* given to Titian,[90] and a *Figure in Landscape*, attributed to Lorenzo Lotto but dismissed by Lotto scholars.[91]

The Art Institute of Chicago received the *Madonna with the Standing Child*, one of the paintings from the circle of Bellini that transited between Milan and Carpi. A variation of Giovanni Bellini's *Willys Madonna* was attributed to Rocco Marconi by Fritz Heinemann; the work was listed by Berenson in his *Venetian School*.[92]

Numerous paintings, many of them masterpieces, passed through Foresti's hands. As indicated earlier, this is not the occasion to reconstruct the "second" Foresti collection; nonetheless, we would like to mention a few useful resources consulted in the course of our ongoing research. The catalog of the Severi collection, published in 1991, illustrates the paintings that entered the collection, hanging in the palace that once belonged to Pietro: there are works by Zaganelli, Bagnacavallo, Girolamo da Carpi, Giovanni Larciani (the Master of the Kress Landscapes), Benedetto Diana, Lelio Orsi, Romanino, Guercino, Marcantonio Bassetti, Francesco Guardi, and Carlo Maratti.[93] The Bombelli photo archive, also published in 1991,[94] is an invaluable source for the "homeless" paintings that passed through the Foresti collection in Carpi and Milan. Among these we would like to mention a panel by Ottaviano Nelli (*Madonna and Child with Sts. John the Baptist and Jerome and Donors*), the history of which we tracked in the Fototeca Berenson;[95]

---

86  See *Mostra del Settecento Bolognese*, Bologna, 1935, 20 n. 16. See also Shapley 1973, 103–104, fig. 191; and Merriman 1980, 253 (in the text, Merriman confuses Carlo Foresti with the "well-to-do Signor Foresti of Bologna," a patron of Crespi).

87  See *Mostra del Settecento Bolognese*, Bologna, 1935, 10 n. 20; and "Hartford: Two Masterpieces of the Settecento," *Art News* 35, 2 (1937): 8, 20. See also Merriman 1980, 299 n. 222; Spike 1986, 168–169 n. 29; and Cadogan and Mahoney 1991, 126–127.

88  Andrews 1947, 22. See also *The Fine Arts Gallery of San Diego Catalogue: A Selective Listing of all the Collections of the Fine Arts Society* (hereafter *San Diego Catalogue*), San Diego, 1960, 63.

89  Andrews 1947, 39–40.

90  Ibid., 45–47 (photograph in the private archive of Luigi Foresti) and 54, respectively.

91  Ibid., 57–58; see also *San Diego Catalogue*, 65, 68.

92  Heinemann 1959, 1:16 n. 50 (the original, the *Willys Madonna*, today at the Museum of San Paolo), and 2:fig. 217; Berenson 1957, 1:36 (Art Institute of Chicago, no. 1933-550). Fototeca Berenson, V 28.6c. See also Fototeca, Kunsthistorisches Institut, Florence, no. 425569.

93  Bentini 1991. The authors who wrote these entires determined the authorship on the basis of attribution alone. Subsequent research in the Foresti Archive, however, resulted in the discovery of important documents that shed different light on the history and authorship of some of the paintings. See ibid., 138, no. 30 (provenance: Mantua, Palazzo d'Arco), no. 73 (attributed to P. Batoni), and n. 70 (attributed to Bazzani, but with some documents indicating authorship by Pier Francesco Guala).

94  Angelelli and De Marchi 1991.

95  Ibid., 226 n. 459. Fototeca Berenson, C 20.7; see Berenson 1968, 1:291 and 2:291, fig. 511. See also Todini 1989, 1:235 and 2:288, fig. 640. Photographs of the painting are found in the Fototeca Foresti.

the drawing by Amico Aspertini representing *The Funeral of Patroclus*, shown in the exhibition on Aspertini;[96] panels by Zaganelli (*Mystic Marriage of St. Catherine*) and Bagnacavallo (*Madonna with Child and the Young St. John the Baptist*), which are in the Severi collection;[97] a *Madonna and Child* by Giovanni Bellini, spotted by Angelelli and De Marchi in Heinemann's monograph;[98] and finally Bicci di Lorenzo's *Mystic Marriage of St. Catherine*, documented with photographs not only in the Bombelli archive but also in the Jacquier collection and the Fototeca Berenson.[99] A point of departure for the census of the Foresti paintings is the catalog of homeless paintings at I Tatti. The numerous reproductions of paintings from the hands of Jacopo di Cione, Niccolò di Pietro Gerini, Lorenzo Veneziano, Jacobello del Fiore, Antonio Vivarini, Giovanni Bellini, and Domenico Tintoretto testify to the fluctuating size of the collection and the ongoing contact between the antiquarian and Berenson.[100]

The inventory, even though it is still a work in progress, has already helped to shed light on the collection, putting it into a context of events. For instance, information inscribed on the back of one of the photographs reveals that Jacobello del Fiore's *Crucifixion* transited through the Foresti collection;[101] this is an extremely important clue which is confirmed by the reproduction of the painting in the family photo archive. Thanks to this find we can reconstruct a previously unknown intermediate phase of the route traveled by the work. Published by Carlo Volpe and Federico Zeri,[102] Jacobello's *Crucifixion* (now De Zoti collection, Brescia) was one of a series of thirteen panels formerly in the Bishop's Palace in Fermo. By 1920, the panels were in Milan, where Foresti probably purchased them; from there, they passed to Achillito Chiesa, one of Foresti's clients. When the Chiesa collection was dispersed, they were exported to New York and ended up in Denver, except for the *Crucifixion* panel, which reappeared in Milan.

A search among the homeless paintings listed at the Biblioteca Berenson furthermore made it possible to establish that Antonio Vivarini's *St. Catherine of Alexandria*, published by Berenson, was in Foresti's collection in 1930.[103] We also made two "Bellinian"

---

96  See Angelelli and De Marchi 1991, 79 n. 136; and Faietti and Scaglietti Kelescian 1995, 250–251 n. 35.

97  Angelelli and De Marchi 1991, 80 n. 138 and 271 n. 579. See also Emilio Negro in Bentini 1991, 106–107 n. 15 and 108–109 n. 16.

98  See Angelelli and De Marchi 1991, 90 n. 156; and Heinemann 1959, 1:9, no. 36L.

99  See Angelelli and De Marchi 1991, 104 n. 182; and Tamassia 1995, 89 n. 50162. In the brief entry on the Foresti collection, only Pietro Foresti and the 1913 catalog are mentioned. Berenson 1963b, pl. 500; Fototeca Berenson, no. 100859 (no mention is made of Foresti).

100  Fototeca Berenson, Jacopo di Cione, *Madonna del Latte* (no. 105255, Foresti 1930) (photograph also in the private archive of Luigi Foresti); Antonio Vivarini, *St. Catherine of Alexandria* (no. 105555, Foresti 1930); Agnolo Gaddi, *Madonna and Child* (no. 101912, Foresti 1931); Niccolò di Pietro Gerini, *Martyrdom of St. Agatha* (no. 101984, Foresti "July 1932"); Lorenzo Veneziano, *Four Saints* (nos. 102663 and 102677, Foresti 1932); Jacobello del Fiore, *Crucifixion* (nos. 111505–111506, 105471, Foresti); Giovanni Bellini, *Madonna and Child* (no. 106028) (for the paintings in the circle of Giovanni Bellini, see below); Domenico Tintoretto, *Admiral Sansovino* (no. 111003, Foresti, Milan) and *Portrait of a Man* (no. 110999, Foresti, November 1940).

101  Fototeca Berenson, Jacobello del Fiore, *Crucifixion*, no. 111505.

102  See Volpe 1962, 438; and Zeri 1983, 38–41, figs. 34–35.

103  Fototeca Berenson, no. 105555 (Foresti 1930); and Berenson 1957, 1:200, fig. 87 (homeless).

---

finds: the version of the *Burrel Madonna* of Giovanni Bellini, attributed to Rocco Marconi and mentioned by Heinemann in the collection, is reproduced in photo no. 105959, on the back of which is written "Foresti/Jan 1935."[104] Secondly, among the homeless paintings, the "gracious and sweet" *Madonna with Child* (which later resided in the collection of Contini Bonacossi), a version of the *Maniago Madonna* close to Rondinelli, was "hosted" in "March 1932" in the studio in via Manzoni, the "private collection" to which Heinemann's volume refers.[105]

Besides the photographs inventoried in the Fototeca Berenson, the archive has other helpful resources. This brings us to the objective of our paper: the letters sent to I Tatti by Carlo Foresti between 1926 and 1935. Foresti directed eight letters to I Tatti, five to Bernard Berenson and three to Nicky Mariano. There is also the related correspondence still preserved in the family archive, which consists of a series of letters sent from Mariano to Foresti between 1932 and 1942, some sent to Milan, others to Carpi. The relationship between Berenson and Foresti was clearly one of mutual esteem; Foresti's respect for and devotion to "Professor and Maestro" Berenson[106] were reciprocated with respect and consideration, the occasional confirmation of an opinion,[107] and an agreeable, shared understanding. Typical too is this letter from Nicky Mariano to Foresti: "Dear Commendatore, I don't want another day to go by without letting you know that we received the beautiful photographs and that Mr. Berenson is most grateful to you for remembering his 'greediness' when it comes to photographs. He has taken them into his study and is examining them."[108]

It is not always possible to know precisely which works the letters refer to, but every so often, reading between the lines, we can detect hidden clues. In some cases, a letter can be connected to one of the photographs from the collection at I Tatti, of which there are copies preserved in the Foresti archive. On 14 February 1928, Foresti wrote:

> Dear Mr. Berenson, I have discovered a marvelous Jacopo Bellini on panel, about one meter high. Madonna and Child with a gold background, a little worse for wear but marvelously majestic, with its frame (one corner missing). The painting is unpublished, unknown, never seen or photographed ... the owner wants to sell it, but by a strange coincidence while the owner was here in my studio ... in walked Mr. Perkins ... who became very excited, declaring [that] it was the most beautiful Jacopo Bellini in existence ...

---

104 Heinemann 1959, 1:9 n. 36 (original, Glasgow, coll. Burrel) and n. 36(1) (Foresti 1934); Fototeca Berenson, no. 105959.

105 Fototeca Berenson, no. 105783 (Foresti/March 1932). The passage to Contini Bonacossi is noted on the back of the photo; Heinemann 1959, 1:5 n. 22 (the "missing original") and n. 22a (as "Milan, private collection) and 2:222, fig. 194.

106 Foresti to Berenson, 16 October 1935, BMBP.

107 "What attribution would you give to the portrait of a lady?": Mariano to Foresti, 30 July 1942, private archive of Luigi Foresti, Carpi.

108 Mariano to Foresti, 29 July 1942, private archive of Luigi Foresti, Carpi.

The painting described in the letter—in which Foresti reveals an uncommon flair for combining meetings and nonchalantly bringing about situations favorable for business—can be linked to a photograph of the *Straus Madonna* in the Fototeca Berenson. Kept in the Jacopo Bellini folder, it in fact shows that a corner of the frame is missing. The note on the back reads "Foresti 1928," an important clue revealing that this panel, which Berenson listed at the Fine Arts Gallery of San Diego, had passed through the studio in via Manzoni.[109]

To continue on the theme of Bellini: the letter sent to Nicky Mariano on 19 May 1929 contains evidence that the Stroganoff panel with a *Pagan Sacrifice*, now in Berea College, Kentucky, had transited through the Foresti collection. A photograph of the painting in the Fototeca Berenson has a note on the back with the name "Carlo Foresti" and the date of the letter.[110] Paul Kristeller, who had seen the work together with its pendant in the Kaiserliche Galerie of Vienna, changed the attribution from Ercole de' Roberti to School of Mantegna (1911).[111] Years later, Longhi saw the painting in a "Milanese collection"[112] and, with a detailed description, attributed it to Giovanni Bellini. The "Milanese collection" was, of course, Foresti's studio in via Manzoni, as both the photograph at I Tatti and Foresti's letter prove. When Foresti received the panel "in exchange from Trivulzio" in 1927,[113] he quickly informed Longhi, asking for his expert opinion. "Dear Signorina," Foresti wrote to Mariano, "allow me to send you a copy of the letter that I have from Roberto Longhi."[114] The letter was about the Trivulzio grisaille, "a work close to Giovanni Bellini, even if not . . . entirely his. . . . I would be very pleased to illustrate it in my Review."[115] Longhi, true to his word, published it in *Vita artistica* in 1927, the same year Foresti acquired the panel.

In his essay on the painting, Longhi wrote:

> The chiaroscuro that I recently discovered in a Milanese collection . . . is painted in gradations of sepia with highlights of white lead, and this quasi monochromatic treatment, in addition to the remarkable thickness of the panel . . . leads me to think that what we have here is a fragment of the old decoration of a "cassone" or a "*restello*." To the sides of an altar, or rather of the stepped pedestal of a flaming tripod, are four figures arranged in couples; to the left a warrior armed with a spear and shield, next to him a very ungainly old man (*pappo*) . . . at right two fauns or sylvans . . . while a fifth figure, a rustic type . . . sits behind the tripod with his back turned to it, on the lowest step of the marble pedestal. The scene is set against a brown background, as though feigned *marmo mischio*.

109  Foresti to Berenson, Milan, 14 February 1928, BMBP. Fototeca Berenson, V 10, NT; Berenson 1957, 1:38, fig. 65: "Strauss Madonna," Fine Arts Gallery, San Diego.
110  Foresti to Mariano, Milan, 29 May 1929, BMBP.
111  Kristeller 1911.
112  Longhi 1927.
113  Foresti to Mariano, Milan, 2 June 1927, BMBP.
114  Foresti to Mariano, Milan, 29 May 1929, BMBP.
115  The text of Longhi's letter transcribed in Foresti's letter from Milan, 29 May 1929.

There is no doubt that the artist of this painting defers, at least iconographically, to Mantegna: the illusionistic reliefs in the architecture of the Eremitani are the precedents.... But in making the comparison with Mantegna one cannot go beyond this generic observation.... Look at the delicate reliefs, treated almost as if they were monochrome paintings, in the parapet of the scene of *The Blood of the Redeemer* in London. And now look at the panel, likewise of an obscure antique subject, which was formerly in the Stroganoff collection under the name of the Ferrarese de Roberti.... And then we have ... from around 1475, those combatants, on foot and on horseback ... in the relief decorating the upper part of the throne in the Pesaro altarpiece. The figures on the right already appear substantial enough to presage the manner of the San Giobbe altarpiece; in particular, the faun in profile on the right already alludes to the form of St. Sebastian in the Uffizi *Allegory*; at the same time the draperies of the sylvan on the left ... are handled in a way that recalls the Madonna of Bergamo (Lochis), and his hair, like that of the warrior, with curls that almost appear drawn with the sculptor's tool rather than that of a painter, is the same as the hair of the putti in the *Madonna dell'Orto*, or in the similar work in Berlin. And wholly in the spirit of the young Giovanni, son and assistant of Jacopo, is the figure of the warrior, so slender and angular ... as not to displease Dürer ... [and] which could be inscribed, roughly, in a starfish, like those gothic men of Villard de Honnecourt. All this leads us to conclude, therefore ... that this work was painted by Bellini shortly after the Pesaro altarpiece ... the five-year period 1475–1480 seems to us to offer a general time frame for the probable date of this Milanese chiaroscuro.[116]

Mason Perkins agreed with the attribution to Bellini, but Berenson was of a different opinion, classifying as a "study" both the monochrome formerly belonging to Foresti and the pendant representing a *Pagan Sacrifice*, with a pleasant green ground, conserved at Saltwood Castle. Reproductions of both works survive in the Fototeca Berenson.[117]

Heinemann agreed as well, although he preferred to ascribe the "chiaroscuro" to an "Anonymous Painter" who worked in the style of Bellini.[118] He based his judgment about the authorship on the "handling of the background" and a similarity to "the analogous subject by Girolamo Mocetto in the collection of Sir Kenneth Clark," a "Mantegnesque" work "with the adoption of Bellinesque types." Fern Rusk Shapley sided with the Bellini expert and defined the painting at Berea as "Venetian School," underlining the affinity with the *all'antica* iconography of *The Blood of the Redeemer*, which had already been

116  Longhi 1927, 134ff.

117  Berenson 1957, 1:32 (New York) and 1:34 (Saltwood Castle). For the Trivulzio grisaille, see Fototeca Berenson, V 28.2; for the panel in the Clark collection, see Fototeca Berenson, V 37.1, n. 111530.

118  See Heinemann 1959, 1:284, V. 451, formerly in the collection of Prince Trivulzio, Milan, and the Samuel H. Kress Foundation, New York; and 2:758, fig. 872, with "Anonymous Painter." For the *Pagan Sacrifice* in the Clark collection, see ibid., 1:258, V. 271.

recognized by Roberto Longhi.[119] The *Pagan Sacrifice* entered the Kress collection in 1941, coming, as Shapley inform us, "from a private collection in Milan (c. 1927)," which we can now identify as the Foresti collection.[120] As a matter of fact, Foresti had considered selling the grisaille to Duveen; we do not know if there were intermediate passages, but it is probable that the painting went directly from Foresti to Contini, and from there, as we saw, to Samuel Kress.

But let us continue reading the correspondence:

> Dear Cavaliere Foresti … [the] decorative Mantegnesque panel … seems very charming [to Professor Berenson]. … He would like to know if it is painted on canvas or panel and if by chance you know where it comes from? He thinks he saw it already many years ago, but he does not remember where or if he saw the original or perhaps a reproduction. It is monochrome, isn't it? Possibly with some highlighting in gold?[121]

The work in question, which Mariano had discussed with Berenson,[122] is probably the decorative panel attributed to the Circle of Andrea Mantegna (*Satyrs and Marine Deities with Musical Instruments*). It was in the studio of via Manzoni until the 1940s and may have come from the Loeser collection, as suggested by the following letter, written the following week: "Dear Commendatore … forgive me for the delay in answering you and thanking you for the information you supplied about the little panel that came from the Loeser collection. That explains why it looked so familiar to Mr. Berenson!"[123]

Known to Toesca,[124] the painting was ascribed to the artist's workshop in Berenson's *Italian Pictures of the Renaissance*,[125] where he gave its location (and that of the pendant) as the Foresti collection. Berenson received a photograph of the pendant two years later. "In the meantime we received the most charming Mantegnesque panel, companion … of the one that you sent us circa two years ago," Mariano wrote to Foresti in July 1942.[126] A third panel, with the *Triumph of Neptune*, completed the series. It may have been intended for a keyboard instrument. It was recognized, like the other two panels, in the Bombelli photograph collection by Angelelli and De Marchi.[127] Inspired by the *Codex Escurialensis* (fol. 5v), the Foresti panels are decorated *all'antica*, with brushstrokes of gilt on the grisaille to evoke the gleam of bronze. They can be related to the *Battle of the Sea*

119  Shapley 1968, 47, K. 594, fig. 93. For the painting by Giovanni Bellini, see Heinemann 1959, 1:56–57 n. 191 and 2:32, fig. 28; and Tempestini 2008, 55 n. 7, nos. 152–155.

120  Shapley 1968, 47.

121  Mariano to Foresti, 4 December 1940, private archive of Luigi Foresti, Carpi.

122  Ibid.

123  Mariano to Foresti, 13 December 1940, private archive of Luigi Foresti, Carpi.

124  "This is a classic vision of Andrea Mantegna …" Letter of 30 July 1942 from the Lido of Venice, in Negro 2009, 169–170. See also Negro and Roio 2010.

125  Berenson 1968, 1:239 and 2:fig. 711.

126  Mariano to Foresti, 15 July 1942, private archive of Luigi Foresti, Carpi.

127  Angelelli and De Marchi 1991, 218 n. 434.

*Gods* by Mantegna,[128] whose monogram, discovered on the third panel during a recent restoration, confirms the high quality of the work. Federico Zeri dated it to Mantegna's mature period.[129]

"If you happen to have a photograph of the Veronese portrait to send to Mr. Berenson he would be very pleased," Mariano wrote to Foresti on 19 March 1932.[130] The request was satisfied: lying in the Paolo Veronese folder in the Fototeca Berenson is the image of a seductive young woman, inscribed on the back "Foresti March 1932."[131] Together with a second photograph in the Foresti archive (Fig. 5), it identifies the painting referred to in the letter as the *Portrait of a Lady*, which had been attributed to Veronese in 1931.[132] According to Giuseppe Fiocco, in 1934 the portrait was in the collection of the industrialist Bonomi, mentioned above as one of Carlo's clients, and therefore it must have been acquired or sold by Foresti around that time.[133]

An exquisite and highly polished work, it held the place of honor in the via Manzoni studio in 1932. We like to think that it was there that Irene Vavasour Elder, art historian and wife of Mason Perkins, saw the painting when she came to visit with her husband. She was a fashionable lady who would have understood the elegance of the portrait. It is easy to imagine her together with her friend Erminia, Foresti's graceful consort, admiring the details of the costume ("Richly dressed in the gorgeous costume of her time"). The painting so impressed her that she decided to publish it, and thus it was—appropriately— a lady who initiated the critical fortune of that sumptuous female portrait.[134] Vavasour Elder's note in *Apollo* was followed the same year by the comment of Adolfo Venturi:

> This picture by Paolo Veronese is among the greatest and most important of the master, contemporaneous with the works he painted for the noble Cuccina family, which are now in Dresden. In Paolo's hands even the portrait becomes a work of decoration.... He exalts the beauty of the young lady with ... lace and velvet, with his frothy whites and deep greens. All for sweet youth: a pearly collar with borders and drops of gold, veils that take the warmth of pink on the neckline with stripes dotted with gold; cloth with a snow-white flowered pattern.... For the lady, flower of courtesy, a golden chain with links shaped like musical instruments, the gold turning green on that superb dress.... It is a feast of colors for the young blond lady, with her white skin suffused with pink. She is dressed for a

128 Andrea Mantegna, *Battle of the Sea Gods*, engraving, Duke of Devonshire, Chatsworth: see Andrea Canova in Agosti and Thiébaud 2008, 279–281 n. 108; and Blumenröder 2008, 175–176, "Kunstliteratur und Kunsttheorie: 1 Begriffe für Grisaille."

129 Federico Zeri, letter, 10 December 1997, in Negro 2009, 170.

130 Mariano to Foresti, 19 March 1932, private archive of Luigi Foresti, Carpi.

131 Fototeca Berenson, 151.4, nos. 109619 and 109620.

132 The first attribution made in 1931 was based on the written opinion of Amadore Porcella; see Garton 2008, 231, fig. 69 (as "Circle of Paris Bordone").

133 Fiocco 1934, 44, pl. LVIII; *Portrait of a Lady*, Bonomi collection, Milan.

134 Elder 1932, 268 ("The picture [with Paolo Caliari] is in a private collection").

5

Paolo Veronese, attr. (school of Paris Bordone), *Portrait of Dama*, previously in the Foresti Collection, now in a private collection in Genoa. Archivio Luigi Foresti, Carpi.

wedding, and looks at the world with her blue eyes.... Thus Paolo Veronese created a magnificent work that is both painting and poetry.[135]

The painting was soon included among Veronese's portrait masterpieces. Fiocco, comparing it to the Musée du Louvre's *Bella Nani*, perceived the "Brescian touch and the Correggio-like qualities of Paolo's painting, achieved with transparent veils."[136] Nonetheless, critics eventually began to question Veronese's authorship, and in 1968 Remigio Marini ranked the portrait among the attributed works. He was followed by Terisio Pignatti in 1978,[137] and most recently by John Garton, who in his survey of

135  Venturi 1932, 404–405.
136  Fiocco 1934, 44.
137  See Marini 1968, 134 n. 359; and Pignatti 1978, 1:194, A. 191 and 2:fig. 885.

Veronese's portraits classified the painting—by now in a private Genoese collection—as "Circle of Paris Bordone."[138]

We still do not know where the portrait went immediately after Foresti–Bonomi's (or Bonomi–Foresti's) ownership. In 1940, it left Europe for New York, where it was sold to the Acquavella Gallery. Three years later, it turned up in Washington in a private collection. It was back in New York in 1986, sold at auction at Christie's and then returned to Italy.

And that is what we have gleaned to date from the correspondence regarding the most important works. We also found a few minor clues about paintings that are now difficult to identify, which we include below for the sake of documentation.

"Dear Commendatore, many thanks for the photographs you recently sent of the Venus with all those magnificent details, the female portrait, the St. Sebastian, and the portrait of a friar. Mr. Berenson finds this last one ... very close to Caroto.... To whom would you attribute the portrait of a Lady? ... I find it ... almost Caravaggesque."[139] The letter that Nicky Mariano sent to the Palazzo Foresti in Carpi on 15 July 1942 lists several works, but we have been able to identify only two: the *Portrait of a Friar*, the quality of which needs to be verified, found in the Caroto folder,[140] and the *Portrait of a Lady*,[141] referring to an original in the Foresti collection.

> Most Illustrious Professor and Maestro, I have a very rare, important little painting to show you, a profile portrait of a beautiful young woman, with a landscape background, in good condition, attributed to Pier della Francesca, and absolutely guaranteed to be authentic from that period. The noble family to whom it belongs needs to sell it and is asking 35,000 pounds sterling. It is a rare and beautiful piece, never before seen by anyone and uncatalogued ... deposited in a bank in Switzerland ...[142]

We know even less about the fate of this second female portrait, which passed through the studio in via Manzoni in 1925 with an attribution to Piero della Francesca, probably long out of date. We have no idea what Berenson thought of it. There is no trace of the panel, not even, it seems, in the folders of the Biblioteca Berenson. All the same, we would like to end our paper with a photograph from the Foresti archive, proposing to link it to this letter as a note to the correspondence, a minute piece of what is a very large puzzle.

138 Garton 2008, 231.
139 Mariano to Foresti, 30 July 1942, private archive of Luigi Foresti, Carpi.
140 Fototeca Berenson, N 91.10.
141 Fototeca Berenson, B 158.6.
142 Foresti to Berenson, Milan, 16 October 1925, BMBP.

FIFTEEN

# Bernard Berenson and Archer Huntington

ISABELLE HYMAN

I<small>T WAS BY CHANCE THAT</small> I discovered the connection between Archer Huntington (1870–1955) and Bernard and Mary Berenson. As an architectural historian working at that moment away from a Renaissance subject, I was carrying out research for an article about the design and construction of the Collis P. Huntington mansion (now demolished) in New York City, built in 1890 by George B. Post, one of the premier architects of America's Gilded Age.[1]

An extensive archive of Huntington family and business papers, including documents about the building of that grand house and about its furnishings and decoration, is kept in the Special Collections Research Center of Syracuse University Library in Syracuse, New York.[2] It took me by surprise to find among those papers a folder of Berenson–Huntington correspondence. Since at one point Berenson wrote to Archer Huntington, "I keep no copies of letters [I write],"[3] it appeared that these were little known, if known at all. The

∞ I wish to express my gratitude for my fellowship year at I Tatti. It allowed me to develop and to refine practices of archival research so that even these many years later, among the primary source materials in the Syracuse University Library, I could still find my way back to Florence, and to Berenson.

1 Hyman 1990.
2 Anna Hyatt Huntington Papers (hereafter, AHH Papers), Special Collections Research Center (SCRC), Syracuse University Library, 1887–1973. For bringing the Huntington materials to my attention, I am indebted to Kathleen Manwaring, former supervisor, SCRC, Syracuse University Library. Also at the SCRC, I am grateful to Nicolette A. Dobrowolski, head of public services and reference and access services librarian, and to the staff.
3 Berenson to Huntington, 6 February 1940, AHH Papers, Correspondence.

letters preserved in Syracuse from Archer Huntington to the Berensons are carbon copies. Some but not all of the originals, which were dictated to a secretary or typewritten by Huntington himself, are in the Berenson Archive at Villa I Tatti. The letters to Archer Huntington from Bernard and Mary Berenson were written by hand. Even though Archer had given Mary a typewriter as a gift, she did not consider it polite to use it for personal correspondence.[4]

The friendship between the Berensons and Archer Milton Huntington (Fig. 1) and his family began at a dinner party in New York City in January 1909. Mary Berenson reported on the evening in a letter to her mother: "No lady except myself had on a dress that cost less than £75," she wrote, and "there were about two million worth of diamonds."[5] Mary did not identify the hosts, but she did say that the guests feasted on the conceit of a "red" dinner, for which all the "favours and ornaments, and candles and cakes and fruits and ice-creams were red."[6]

The Berensons were on a visit to the United States in the autumn and winter of 1908–9 (two years after acquiring I Tatti), in part so that Berenson, now advising Joseph Duveen,[7] could assess paintings in the notable collections of American millionaires. Finance (including paying off the debt on I Tatti) was, therefore, a subject very much on their minds.[8] "My hostess said I was to have a Mr Archer Huntington on my other side (her husband being on my left)," Mary continued,

> and she hoped it would be all right . . . he almost never went out except to their house but was a very interesting man etc. So a huge man in an especially large chair provided for him took his seat—we passed the time of day. Suddenly he asked "Who is your favorite poet?" "Milton, I think," I replied. "Good God! Do you mean it? . . . Is it possible you are fond of reading?" "I am," I said. "Well," he said, "you are the first woman I ever met who is. You're sure you aren't a fraud?" "About that, no."[9]

"After this opening we got into a great talk," Mary wrote, concluding:

> This monstrous (but very jolly) creature spluttering and gasping at almost everything I said. . . . After dinner he rushed up to our hostess and said "I have never met such a wonderful woman! I can't believe it! It is like discovering Niagara!" We were hardly to be separated for the rest of the evening, and the very next day came invitations from his wife to dine, etc, etc. Well, who was he? He was the *one man in America* we most wanted to meet for every reason. And we had almost given up hope, for

4    "But for politeness I would have written this note on the adorable typewriter you gave me, which I use all the time!" Mary Berenson to Huntington, 15 December 1922, AHH Papers, Correspondence.
5    Mary Berenson to Whitall Smith, 15 January 1909, in Strachey and Samuels 1983, 148–149.
6    Strachey and Samuels 1983, 148.
7    Secrest 1979, 231.
8    Strachey and Samuels 1983.
9    Ibid., 149.

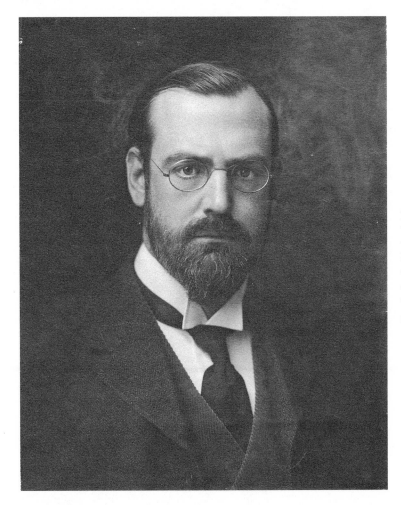

*1*

Archer Milton
Huntington, ca. 1905.
Anna Hyatt Huntington
Papers, Special
Collections Research
Center, Syracuse
University Library,
Syracuse.

he is rather inaccessible. He already has about a hundred million dollars and will inherit 80 million more, to mention the grossest fact first . . . and but for "Society" we should probably never have met him! So thee must admit, even thee, Grandma, that for our circumstances, fashionable dinners and so on are most useful.[10]

Useful indeed was that "grossest fact" of Archer Huntington's fortune, as at this time the Berensons' circumstances, as Mary referred to them, were largely dependent on the business of art, for which Berenson was discreetly seeking a larger circle of clients. Their current circumstances also involved expenditures for "furnishing, decorating, embellishing, renovating, and building an addition to" I Tatti, as the project has been described by Berenson's biographer Meryle Secrest.[11] Even negotiations pertaining to the basic pur-

10   Ibid.
11   Secrest 1979, 235.

2

Arabella Huntington.
(Photo: Mariners'
Museum, Newport
News.)

chase of I Tatti had not yet been concluded. Within a few days of their first meeting, the Berensons and Archer Huntington took up with each other, and Mary reported in a letter to Isabella Stewart Gardner that "B.B. is slowly rising from his canvas-backed bed to go to see Mr. Huntington's Spanish Museum this morning. Mr. Huntington and I fell in love with each other two nights ago, over a topic rather ethereal for two such bulky persons— the poetry of Milton!"[12] A few weeks later, Archer Huntington and the Berensons, still in New York, continued to enjoy each other's company. On 7 February 1909, Mary wrote to Isabella Stewart Gardner that "Nothing very interesting has happened to us since you were here, except seeing the huge Ex[hibition] of Sorella's paintings which Mr. Archer Huntington has imported."[13]

12    Mary Berenson to Gardner, undated (probably ca. 15 January 1909), in Hadley 1987, 432.
13    Hadley 1987, 435.

The source of Huntington's wealth, so impressive to the Berensons, had been the marriage in 1884, when Archer was fourteen, of his widowed mother, Arabella Duval Yarrington Worsham (Fig. 2),[14] to Collis P. Huntington (Fig. 3). The ceremony was performed in New York City by the charismatic preacher Henry Ward Beecher, celebrated for his eloquence and regarded by many at the time as "the most famous man in America."[15] Arabella Huntington was a remarkable woman of high ambitions and ambiguous background.[16] Collis P. Huntington, one of the most successful of America's legendary nineteenth-century transcontinental railroad and shipyard tycoons, had built

14   Whether Arabella Yarrington had, in fact, been married to John Archer Worsham is not known. On this question, see Mitchell and Goodrich 2004, 27.

15   Applegate 2006.

16   See note 14.

out of nothing a gigantic financial empire. Identified officially as Archer Huntington's stepfather, Collis was beyond doubt his biological father and was understood to be so by Archer himself.[17] While the matter of Archer Huntington's lineage belongs to an intriguing family history that is not relevant here, what is relevant is Meryle Secrest's observation that when Collis P. Huntington died in 1900, he left Arabella Huntington one of the wealthiest women in the world.[18] Arabella's greatest treasure was her only child, Archer, and it was to his interests above all else in her life that she was zealously devoted. She encouraged his intellectual pursuits and his travels to Spain; she oversaw his education, mostly by private tutors; and she and Collis had astutely trained him in business and finance. Arabella enlisted Archer's aid in her correspondence, and he also served as something of a secretary in the family's business. Both museum lovers, mother and son traveled the world together to look at art. For a time, she shared her great house with him and his first wife.[19] As a result, he learned at first hand, and effectively, how to manage the complexities, responsibilities, and privileges of a huge fortune.[20]

Not unexpectedly, considering their status and their requirements, Collis and Arabella Huntington had been clients of the Duveen Brothers since at least 1892. At that time, Duveen Brothers was primarily a decorative arts firm, the premier art and antiques dealer for wealthy patrons but not yet a dealer in Old Master paintings.[21] The Huntingtons made vast purchases from the firm as they furnished and decorated their opulent new Fifth Avenue mansion.[22] By 1907, however, Joseph Duveen himself was advising the widowed Arabella Huntington on collecting art.[23] Well before this, she had acquired the urbanity and savoir faire that were essential to becoming a force in New York society and the larger world, and these qualities would distinguish her for the rest of her life. She had become one of Joseph Duveen's most important clients for European paintings by 1907, holding her own as a sophisticated collector in the competitive company of Henry Clay Frick, Robert Altman, J. P. Morgan, and the Wideners. Bernard Berenson's advantageous partnership arrangement with Duveen since 1906 is well known.[24] Berenson may have disdained it, but it lasted until 1938. Just as Berenson had his Isabella Stewart Gardner, Duveen had his Arabella Huntington.

17  He spoke of it to A. Hyatt Mayor, his nephew by marriage, and Mayor knew the history of the Huntington family. See Mayor 1969, 46; and Mitchell and Goodrich 2004.

18  Secrest 2004, 120. Arabella Huntington continued to pursue a full and vibrant life after the death of Collis. She became an important collector of art, and in 1913 she married Collis's nephew and trusted business associate, Henry E. Huntington, who was also her coheir to Collis's enormous estate (and who built the Huntington Library and Art Gallery in San Marino, California).

19  Proske 1963, 4.

20  No definitive biography of Archer or Arabella Huntington has yet been published. A short narrative of Archer's professional life by Proske was published in 1963 by the Hispanic Society of America (Proske 1963). In 2004, Mitchell and Goodrich released their account of the marriage and philanthropies of Archer Huntington and his second wife, sculptor Anna Vaughan Hyatt Huntington (Mitchell and Goodrich 2004).

21  Secrest 2004, 43–46.

22  Hyman 1990, 10–22.

23  Secrest 2004, 120–123.

24  Ibid., 88–90.

In the summer of 1907, the year before the Berensons' visit to the United States, Joseph Duveen purchased, and was famously disposing of, the estate in Paris of the great German collector Rodolphe Kann following Kann's death.[25] From that estate, he sold to Arabella Huntington a prodigious quantity of goods. The bill of sale, dated 4 February 1908 and listing all her purchases, survives in her papers at Syracuse.[26] Among the many objects from the Kann collection that Duveen sold to Arabella were a Rogier van der Weyden, two portraits by Frans Hals, Rembrandt's *Portrait of Hendrickje Stoffels*, and one of the most famous and magnificent Old Master paintings in the world, *Aristotle with a Bust of Homer*, dated and signed by Rembrandt. According to Cynthia Saltzman, who has studied this art market and its buyers, Rembrandt was a favorite painter of most of the American millionaire collectors in that booming period of the economy.[27] The price paid to Duveen by Arabella Huntington made the *Aristotle* the second most expensive painting on record for that time. (The first was Raphael's *Colonna Madonna*, which was purchased in 1901 by J. P. Morgan, even though it left Berenson unimpressed to the point that he recommended against its purchase when it had been offered first to Isabella Stewart Gardner.)[28]

Given that stimulating history, it was not surprising that Archer Huntington, the only son of one of the most important of Duveen's clients, was for the Berensons in 1909 "the *one man in America* we most wanted to meet for every reason." It is subtly indicative of the nature of the Berenson–Duveen partnership, and perhaps of an ambiguous opinion of Duveen held by Archer Huntington, that from New York in 1908–9, the Berensons could remark that Archer was "inaccessible" and that they had "almost given up hope" of meeting him.[29] It suggests that Archer Huntington kept himself at a distance from Duveen and the art trade, at least distant enough that despite their efforts he had allowed the Berensons no access until chance brought them together at a dinner party.

From their unexpected and convivial first encounter, a friendship between the Berensons and Archer Huntington, largely epistolary, began. It lasted for almost a half century until Archer died in 1955, four years before Bernard Berenson. The friendship enlarges and enriches the already remarkable chronicle of Berenson's life and thought, though with a few minor exceptions it never concerned specific works of art or the world of art at all.

A serious and important scholar of Spanish culture, history, and literature, Archer Huntington—thirty-nine years old when he and the Berensons met—was a brilliant and self-motivated autodidact.[30] Educated by private tutors, he did not attend university but ultimately received honorary degrees from Yale University (master of arts, 1897), Harvard University (master of arts, 1904), and Columbia University (doctor of letters, 1907; doctor of humane letters, 1908). The Berensons admired and respected him for his erudition and

25  Ibid., 71–74.
26  Bill of sale, 4 February 1908, Arabella Huntington Papers, Inventories–Paintings, SCRC, 1888–1925.
27  Saltzman 2008, 76.
28  Ibid., 97.
29  Strachey and Samuels 1983, 149.
30  See note 20.

his intellectual accomplishments. A distinguished Hispanist, he composed and published poetry and essays in Spanish. He also knew Arabic. He was a highly esteemed translator of Spanish texts into English (his translation of *El Cid* was for many years the classic one). He edited books about Spanish medieval manuscripts in the British Museum, he was a serious collector of rare books and coins, and he lived the life of the mind. "You are to send us anything you publish," Mary commanded him in a letter of 15 December 1922.[31] Some years later, doing exactly that, Archer received a response from Bernard to a book of Archer's poetry: "I have received and enjoyed, and lilted, and lolled and rolled about with your verses; and I have thoughts within thoughts, good thoughts, deep thoughts, while reading and singing and murmuring them. With what ease you make music, what a bard lives in you. Bravo, bravissimo, again and again."[32]

In 1904, five years before first meeting the Berensons, Archer founded the Hispanic Society of America. He built a huge and grandly classical building in New York to house it, and installed in it a stunning collection of objects, manuscripts, printed books, prints, and paintings that he had acquired expressly for that purpose. To bring the Berensons' early interest in Archer into focus, it should be pointed out that in August 1909, seven months after the "red" dinner party, Arabella Huntington purchased from Joseph Duveen—for a considerable price and "expressly to please her son"—a forceful full-length Diego Velázquez portrait, the *Count-Duke of Olivares*, which she then gave to the Hispanic Society in Archer's name.[33] When offering the painting to Arabella in a letter from London in July 1909, Duveen described it as "one of the most celebrated pictures in the world and the only authenticated full-length Velazquez outside the Museums; no collector in the world owns a full-length authenticated work by that artist."[34]

Neither Arabella Huntington nor her son had, generally speaking, an overriding preference for Italian painting of the Renaissance, the center of Berenson's world. They equally appreciated the great Spanish and Dutch masters, reflecting the historical connections between those regions as well as Archer's profound commitment to Hispanic culture. Gently berating Archer for not traveling often enough to Europe, Mary at one time asked, "Do you never come across the Atlantic, never visit *your* Spain and *our* Italy?"[35] Such impartiality may have even warded off some potential rivalries between Isabella and Arabella—two of America's most affluent and acquisitive art-collecting women, who were born only a decade apart and who were to die in the same year—even though such rivalries, imagined or otherwise, were often fomented by Duveen. For example, in a letter written on 27 July 1916, urging Arabella to buy a Titian that had come on the market, Duveen told her, "Its acquisition would considerably enhance the importance of your collection of Italian pictures. Indeed, after Mrs. Gardner's it would be the first in the country."[36]

31 Mary Berenson to Huntington, 15 December 1922, AHH Papers, Correspondence.
32 Berenson to Huntington, 28 February 1937, AHH Papers, Correspondence.
33 Secrest 2004, 106.
34 Duveen to Arabella Huntington, 17 July 1909, Arabella Huntington Papers, Correspondence.
35 Mary Berenson to Huntington, 30 June 1935, AHH Papers, Correspondence.
36 Duveen to Arabella Huntington, 27 July 1916, AHH Papers, Correspondence.

The correspondence between the Berensons and Archer Huntington focused on matters other than connoisseurship and art history. Their letters engendered mutual respect and a "cherished friendship" that lasted nearly five decades.[37] At one point in their long years of correspondence, Archer referred to the Berensons as "two persons adapted to the perfect life."[38] Archer, like his father, was of statuesque height (about six feet, five inches), weighed more than 250 pounds, and was impressively handsome.[39] His range of talents was imposing, as was his mind. John K. Wright, director of the American Geographical Society, of which Archer had been a fellow since 1893 and eventually became president, wrote, "There is something in Mr. Huntington that suggests a humanist prince of the Renaissance."[40] That aspect of the man had resonance for the Berensons, who perceived his princely status in a particularly Florentine way.

At the time the Berensons met Archer, he was married to the English writer Helen Manchester Gates.[41] They divorced in 1918, and five years later Archer remarried. His new wife—forty-seven and never married up to that point—was the notable American sculptor Anna Vaughan Hyatt (Fig. 4). She was widely admired for her large-scale academic equestrian statues, classical figures, and realistic representations of animals in bronze. Responding to the news of Archer and Anna's marriage in 1923, Bernard and Mary wrote, "we shall always have ready for both of you an apartment at I Tatti."[42] Explaining a lengthy silence in a letter to Mary of 3 December 1923, Archer wrote, "You must have thought of me strangely that I did not write, but I can only plead that marriage is a confusing and disturbing influence and that I have been ill—and that I have been swamped readjusting things."[43] Whatever that might have meant, the Huntingtons settled into a long and harmonious relationship.[44] Some years later, Bernard Berenson wrote to Archer: "A great favour. I want good up-to-date photos of yourself and of your wife. I long to know how you look now, and how she looks whom you look at all the time."[45] It was through the eventual bequest of Anna Hyatt Huntington, who died in 1973 at the age of ninety-seven, that the papers of the Huntingtons and of her distinguished family, the Hyatts and the Mayors, were deposited in the archives of Syracuse University Library.[46]

37   Huntington to Berenson, 14 July 1936, AHH Papers, Correspondence.
38   Huntington to Mary Berenson, 31 July 1936, AHH Papers, Correspondence.
39   A physical description of Archer Huntington is given in Mayor 1969.
40   Quoted in Mitchell and Goodrich 2004, 107. Archer Huntington served as president of the American Geographical Society from 1907 to 1911, and as honorary president from 1911 to 1916.
41   Helen Manchester Gates Huntington was Archer's cousin. Her mother, Ellen Maria Huntington, was Collis P. Huntington's youngest sister. Her father was Collis's private secretary as well as his brother-in-law. Archer was Helen's second husband (she had been married to a Mr. Criss). She and Archer were married in 1895 in London; they were divorced in 1918 after she fell in love with—and later married—British actor-producer Harley Granville-Barker.
42   Bernard and Mary Berenson to Archer and Anna Huntington, 20 December 1923, AHH Papers, Correspondence.
43   Huntington to Mary Berenson, 3 December 1923, AHH Papers, Correspondence.
44   Mitchell and Goodrich 2004.
45   Berenson to Huntington, 1 January 1937, AHH Papers, Correspondence.
46   Syracuse University bestowed an honorary degree (doctor of fine arts) on Anna Hyatt Huntington in 1932, initiating both her and Archer's warm feelings toward the university, which resulted in

4

Marion Boyd Allen,
*Portrait of Anna Vaughan
Hyatt* (Mrs. Archer
Huntington), 1915,
Maier Museum of Art,
Randolph College,
Lynchburg.

Along with the Huntington–Berenson correspondence in Syracuse, of particular interest for Berenson and for the intellectual life of I Tatti is a handwritten travel journal from 1925–26 labeled "I Tatti Provence Burgundy" (Fig. 5). The author was Archer's nephew by marriage, the art historian A. Hyatt Mayor, son of Anna Hyatt Huntington's sister. His journal would be later published posthumously.[47] Mayor greatly admired his new uncle, whom he recalled in an interview conducted by Paul Cummings in 1969:

> I was very, very fond of him. He was an extraordinary man. He came of that generation which could dine out if they talked well; and he talked divinely. I have never heard anybody with that instant lapidary wit. He was at ease in any language, French, Spanish (the only non-Spaniard I've ever met who spoke Spanish eloquently—not only correctly—but eloquently). He could recite scraps of the Koran in Arabic. He was an astonishing man.[48]

Highly intelligent and well educated, Mayor graduated from Princeton University in 1922, taught art history for a year at Vassar College, was a Rhodes scholar at Oxford University (1925–26), and studied at the American School of Classical Studies in Athens. He joined New York's Metropolitan Museum of Art in 1932 and, from 1946 to 1966, was its distinguished curator of prints, succeeding his mentor, a curator of global fame and the first to occupy the position at the Metropolitan, William M. Ivins Jr. After Archer's death in 1955, Mayor succeeded his uncle as president of the Hispanic Society of America. Archer recognized Mayor's intellectual gifts and potential, and gave Mayor his support. He commended Mayor to Berenson and smoothed Mayor's path to I Tatti, where, in 1924, Mayor became one of the scholar-apprentices who for a time sat at Berenson's feet. In later years, Mayor sustained an independent friendship with Bernard and Mary, and some of his letters to them survive in the Berenson Archive at Villa I Tatti.

Mayor kept his journal during his visit to Florence, on a break from Oxford in the winter of 1925–26. He was twenty-two years old, and it had been his habit since childhood to write frequently and eloquently to family and friends, a practice he continued during his years of study and travel. Mayor was eager to record not only the activities and personal interactions of the "salon culture" around Berenson but also the substance of the conversations that were at the heart of social and intellectual life at the villa.

One day in December 1925, when "everybody" (meaning all the secretaries and Nicky Mariano) was in the big library, sitting on the floor and sorting photos, Mayor recorded

---

bequests of land to Syracuse University by Archer (Mitchell and Goodrich 2004, 57) and eventually (beginning in the 1960s) in the donation of the papers of Anna Hyatt Huntington and of her family to Syracuse University Library.

47  Mayor wrote steadily in his journals. He died in 1980. In 1992, letters to his family and extracts from his journals (which he sent to his family) were published in "A. Hyatt Mayor Abroad," *Archives of American Art Journal* 32 (1992): 2–18. Quotations from his journal in this paper are taken from the unpaginated autograph manuscript now in Syracuse University Library; to a great extent, they duplicate the material published in 1992.

48  Mayor 1969, 46.

5
A. Hyatt Mayor
Travel Diary, 1925–26.
A. Hyatt Mayor
Papers, Special
Collections Research
Center, Syracuse
University Library,
Syracuse.

his impressions. Although it had been a year since his first visit, he wrote that "all the old things struck me as fresh and new: BB's pallor, the heaviness of his head for such a delicate little body, the feline calculations of his movements as though each were an ambush, softly set."[49] Berenson was at this time sixty years old and had known Archer for almost two decades. In her memoir, published in 1966, Mariano remembered some of the young art historians who came to I Tatti:

> One of these was a young American recommended by old friends of BB's and Mary; he turned up after our return from Rome and came to work in the library

49 A. Hyatt Mayor's journal.

and to join us for meals or for drives and walks. His name was Hyatt Mayor and I remember him as particularly responsive and sensitive, and both Mary and BB became very fond of him. There was even some talk of his becoming attached more permanently to I Tatti but other things intervened.[50]

The account appears in Mariano's book as a footnote—she may or may not have known much about Mayor's distinguished career at the Metropolitan Museum of Art, as she went on to write: "Probably he found a job that attracted him more."[51]

It is apparent from the earliest journal entries that Mayor was awed and intimidated by Bernard Berenson but critical of him at the same time. He observed on one occasion that Berenson was "holding a monologue against a poor American student here, and butchered him with each gently enunciated damnation." Mayor was partial to Mary, with whom he felt himself to be in a greater comfort zone: "Mrs. B. is really one of the kindest women ever," he wrote. "[Berenson] ought really to be more grateful." A few days later, having overcome his initial feelings of uncertainty and fright in the presence of Berenson, Mayor wrote that "BB really talked this evening. I have been waiting for it all along." It was after dinner in the big library with only the Berensons and Mariano present when Mary asked Mayor in what direction his interests were starting to narrow. When he answered "probably sculpture," Berenson, in a mellow and expansive mood, urgently advised him to learn Greek and to spend the next winter in Athens (which he did), and then to look at Egypt, Java, and China. "Suddenly," wrote Mayor, "in the quiet BB began talking, really giving his opinions about the origins of art . . . I cannot remember all, and it was most suggestive." Berenson cited Alois Riegl's theory of the derivation of all form from the tendril and the lotus, and claimed he believed that ideas of art had originally sprung up in only very few places, but that because those ideas were slowly blown about, it seemed instead as if there had been many origins instead of few. For example, Buddhist art, at least in its early phase, bore the same relation to Greek art as to early Christian. In Berenson's view, according to Mayor, there had been two great starting points for art. One was the prehistoric unformulated art of movement, as found in cave drawings in Altamira in northern Spain and elsewhere. Among the last and most beautiful expressions of this was Minoan art, with its images of the tendril and the octopus. Minos alone would not have produced Greece, however—there had to have been another starting point, and it was what Berenson considered the great, unrecognized contribution of Egypt, which, circa 5000 BC, brought a discipline, a proportion, a weight, and a stability that intersected with the art of movement. Egyptian art then made Greek art what it was: the lotus, the column, the proportion of the body.

Berenson held Egyptian art in high esteem. He and Mary had made a trip to Egypt a few winters earlier in 1921; in a letter to Archer, Mary called it "the most glorious experience we ever had in our lives. There one ceases to care for anything but looking and

---

50  Mariano 1966, 142.
51  Ibid., 142 n. 3.

wandering."[52] Bernard Berenson's vigorous interests outside the geographical and historical mainstream of art and art history, and his will and energy to pursue them, were astonishing. In 1936, for example, he wrote to Archer: "I have been exploring old Serbia to see which light its architecture and painting throw on the history of art, and I want to return next spring to complete my survey."[53]

Berenson was famously born to talk, and Mayor, like so many others, longed to hear him. Iris Origo has described the substance of Berensonian talk as "adventures of the mind."[54] At I Tatti during the week after Christmas 1925, Mayor encountered Vernon Lee (Violet Paget) at lunch. She seemed to be breaking the ice after a rupture with Berenson that had lasted two decades. She told Berenson she wanted to talk about Marcel Proust, "and talk on Proust she did," Mayor wrote. "She left BB worn out as she pumped him like a reporter, forcing him to compose an essay on Proust with no diversions. But I never heard him talk better as she made him really put his mind to it." A portion of Mayor's journal is devoted to Berenson's recollections of Proust and the flamboyant Count Robert de Montesquieu, whom Berenson knew well. Mayor also wrote of Berenson's relationship to the "monde" in Paris, a world that included not only Proust but also André Gide, Henri Bergson, and Henri Matisse, with whom Berenson had a brief acquaintance. Lee asked Berenson if Proust's aesthetic as well as the moral and the sentimental essays were de Montesquieu's. "BB said no, that their thought was Proust's tho their expression was de M's."

When Lee left after lunch, Berenson "collapsed into his chair almost fainting." Nevertheless, he then joined everyone else present for a walk; they first motored to Fiesole, then strolled to a rocky prominence with cypresses. There, Berenson spoke of the Italian landscape as "so much more beautiful than anything created in it" and said that the "miracle of life was that we could feel such beauty when it had nothing to do with our comfort or means of existence." Lee had tired him, but she had left his mind working, Mayor observed.

Another visitor, on 21 December, was "an interesting man who came out to I Tatti to consult BB about recruiting scholars to write on art for a huge all-Italian encyclopedia he was organizing." After discussing possibilities, the visitor asked Berenson what he currently was doing. Berenson replied that he was tired of activity, that what he wanted now was to instruct himself, and that he wished he had fifty more years of life (he was to have thirty-five) because, if he did, he would write an all-inclusive history of art from Constantine to Giotto. He envisioned that particular historical stretch as "the great mummy of Byzantium lasting, and then gradually being left behind, with the 10th Century as the turning point," and he would present all of it simply and concretely. This was an impossible ambition because of the insufficient time remaining to him, however. Instead, he said, he would like to work on a more limited subject: an inquiry into the life and work of Domenico Veneziano, which would bear on the most critical and intellectually challenging aspect of Quattrocento art history.

52   Mary Berenson to Huntington, 15 December 1922, AHH Papers, Correspondence.
53   Berenson to Huntington, 6 August 1936, AHH Papers, Correspondence.
54   Moorehead 2002, 138.

Soon after Christmas, Kenneth Clark arrived from Oxford to spend a few weeks at I Tatti. It is poignant to read in the journal of the hostility and negativity that Clark's visit engendered in Mayor, who knew him from Oxford and described him unkindly and inaccurately as a "second-hand intelligence": "He strikes me as suspicious and malignant. However, the BBs like him so I say nothing though my impressions are oddly confirmed by Niccy Mariano's being precisely the same." To his credit, Mayor soon got hold of himself—in a calmer frame of mind, he wrote:

> In discussing Clark with Niccy I said I did not want her to think I disliked him because I was jealous. And then I wondered if I were in fact jealous and I burned with vicious *schadenfreude* desires and agonized at the anticipation of his ruining me with BB. But then, at the end of a day and a night, it all stopped—almost as suddenly as it had come.

From Mary Berenson's diary entry of 2 January 1926, however, one learns that as much as Mayor disliked Clark, Clark disliked Mayor, referring with disdain to Mayor's "Americanisms" and his "nuisance manners," among other reproofs.[55]

That experience of what John Pope-Hennessy has referred to as "the competitive atmosphere at I Tatti"[56] gave young Mayor new insight and maturity. He wrote:

> I am more and more glad I have come to BB and I Tatti as a part-time disciple only. What I get most from him is listening to him talk to his contemporaries, or the rare moments when he talks to me because I am the only one to listen to what is on his chest. But then he remembers the difference of age, and it is all over. I believe it is a great mistake to stay all the time in this house. It is too tight a mold for any strong and independent development.

The Berensons, however, were well disposed toward Mayor, writing during his stay at I Tatti to Archer that "your wife's nephew, Mayor, is really splendid. He has just found us some books we have long been seeking . . . and he is tackling Greek for he wants to spend next winter, on our advice, at the American School in Athens."[57] By 1932, Mayor had launched his own successful career.

During the 1930s, American politics and culture became subjects in the Berenson–Huntington letters for the first time. Huntington had become increasingly significant to Berenson as one of his desirable and continuing *American* connections. Other friends in this category were the great judge Learned Hand, who was very helpful to Berenson regarding the latter's status as an American residing abroad, and the prominent political columnist Walter Lippmann. These alliances allowed Berenson to identify himself

---

55  Mary Berenson, diary, 2 January 1926, Bernard and Mary Berenson Papers, Biblioteca Berenson, Villa I Tatti—The Harvard University Center for Italian Renaissance Studies.

56  Pope-Hennessy 1991, 59.

57  Mary Berenson to Huntington, 25 February 1926, AHH Papers, Correspondence.

as an American, albeit as a self-described "expat." In a letter of 14 July 1936, Huntington reported that "America is in a curious state—one of those periodic convulsions through which it has so often passed—but this is rather the worst of the lot."[58] He was referring to the Roosevelt era and the New Deal, to which both he and Berenson were, predictably, opposed. In 1937, Huntington wrote to Berenson lamenting that "there are no more living Americans. All, or nearly all I ever knew, have moved heaven or hellward out of the dust raised by our Government."[59] "We have been having a rather hard time in this country," Huntington wrote in April 1938, "and things are not in line with the mental attitude of the past generation, to which I belong."[60] In fact, Huntington and Berenson belonged to the same generation—they were only five years apart in age—and in a jesting response to Huntington's criticism of his increasingly illegible handwriting, Berenson wrote, "things I have never taken to are: the telephone, the radio, jazz, cocktails—and typewriters."[61] Huntington unreservedly abhorred modernist art and, anticipating a visit to the United States by Berenson in 1936, he wrote: "Do bring Mary with you . . . she need not fear the bother that usually attended your visits here because things have so changed in this country. The interest in art has become the interest of the uneducated, and it becomes more hopeless every day."[62] By 1940, increasingly appalled by what he called the "tailspin" into which art had fallen, Huntington wrote to Berenson that "art in America has gone up a tree and starts gibbering in the branches. I keep well away from it, fearing it may hurl coconuts!"[63]

Decades earlier, in 1919, Huntington had been elected to the prestigious American Academy of Arts and Letters for his notable achievements in literature, and in 1922 he was elected its director. The academy, a highly distinguished honorary society of America's most notable artists, writers, and composers, was founded in 1904. Its home in New York was built on land close to the Hispanic Society of America that was donated by Huntington. Berenson intensely wished to be elected to membership, and although Huntington apparently proposed him, he was not at first accepted, though eventually he was elected. Berenson wrote to Huntington on 10 November 1937: "I hear I have been elected member of the Academy of Arts and Letters. I'm sure I owe it largely to you."[64] The two continued to address this subject through the autumn of 1938. "It is the one and only honor I have cared to receive," Berenson wrote, "the one public recognition I craved for. Without your efforts I never should have got in, seeing that I am an expatriate and personally almost unknown. But just because I am an expatriate I want my Americanism recognized. I am certain I owe most of it to you."[65] To Berenson's gratitude, Huntington responded gallantly: "I am delighted you were pleased with the election . . . we could not

58  Huntington to Berenson, 14 July 1936, AHH Papers, Correspondence.
59  Huntington to Berenson, 4 August 1937, AHH Papers, Correspondence.
60  Huntington to Berenson, 12 April 1938, AHH Papers, Correspondence.
61  Berenson to Huntington, 6 February 1940, AHH Papers, Correspondence.
62  Huntington to Berenson, 8 September 1936, AHH Papers, Correspondence.
63  Huntington to Berenson, 26 February 1940, AHH Papers, Correspondence.
64  Berenson to Huntington, 10 November 1937, AHH Papers, Correspondence.
65  Berenson to Huntington, 3 December 1937, AHH Papers, Correspondence.

get by the fact that we had not elected yet the most distinguished art critic in the world."[66] "By the way," wrote Berenson, "I am proud of the [Academy] badge and I wish we also had something to wear in one's button hole, not a ribbon but a very small enameled badge like the one worn by the Italian Academicians."[67] When the desired buttonhole emblem reached him four months later, Berenson wrote to Huntington (although it is a little hard to judge the sincerity of the thought): "it is now on my writing table to remind me that I have achieved the one honor I have ever cared for—namely: to be remembered with my peers in my own country. I am associate or foreign member of other academies. I even have orders and decorations I could not refuse. They mean nothing to me."[68]

During the last years of their correspondence, Berenson and Huntington wrote to each other about their legacies. As early as 1938, Huntington lamented that "there never was a time perhaps in the history of our country when it was so difficult to reach a decision as to which is the appropriate institution for the management of a property after one's death."[69] Almost a decade later, in 1947, Berenson wrote:

> I am not good for much creative work any more but I can still try to complete my library in such a way that those who follow me will follow me spiritually as well, reading—or at least being aware—of the kind of world created in these 40,000 volumes that have been so carefully selected. This library, by the way, will form with the rest of my estate a Harvard Institute in Florence for the study of Mediterranean art.[70]

Yet in 1938, still heady with the pleasure of his election to the academy, Berenson had told Huntington: "at times I wonder whether Harvard is the best institution to which to leave [this library], and I have toyed with the question of whether the American Academy might be a more enterprising and faithful trustee."[71] Despite these probably artificial and passing sentiments, one senses that Berenson never seriously considered not leaving I Tatti to Harvard, to which he had committed it as early as the 1920s. For that decision, all those assembled must be thankful.

66  Huntington to Berenson, 22 November 1937, AHH Papers, Correspondence.
67  Berenson to Huntington, 24 March 1938, AHH Papers, Correspondence.
68  Berenson to Huntington, 18 July 1938, AHH Papers, Correspondence.
69  Huntington to Berenson, 13 September 1938, AHH Papers, Correspondence.
70  Berenson to Huntington, 7 June 1947, AHH Papers, Correspondence.
71  Berenson to Huntington, 21 September 1938, AHH Papers, Correspondence.

# Bernard Berenson and Count Umberto Morra

## *"Do Not Forget Me"*

ROBERT AND CAROLYN CUMMING

I N NOVEMBER 1925, Bernard Berenson, having just turned sixty years old, wrote to the forty-three-year-old William M. (Billie) Ivins:

> I wish I could see you very often. How sad that the handful of people who really life enhance are apt to be centrifugally located or disposed. Edith Wharton is at Hyeres. I have a few playfellows in Paris, as many in London, as many again in New York. Here none, alas! Except such as are brought like Elijah's food by the ravens.[1]

Ivins had first met Berenson in 1924 and had visited I Tatti earlier in 1925, but he resided in New York, where he was curator of the print department of the Metropolitan Museum of Art. What Berenson did not realize, or failed to report, is that the ravens had already brought food that would provide continuous lifelong and life-enhancing nourishment in the shape of two unexpected young visitors—Umberto Morra, whose first meeting with Berenson was in June 1925, and Kenneth Clark, who first set foot in I Tatti in September 1925.

---

1   Samuels 1987, 331. William M. Ivins (1881–1961) was the curator of prints at the Metropolitan Museum of Art in New York. A Harvard graduate, he had studied for a year in Munich and then took a law degree at Columbia University. In 1916, he founded the print department at the Met. Berenson found in him a kindred spirit to whom he wrote hundreds of gossipy and intimate letters (there are 364 letters from Ivins to Berenson at I Tatti).

The reason for Morra's visit was unusual and his immediate mission was unsuccessful, yet he was invited to stay for supper and accepted into the whole Berenson family circle with a rapidity and intimacy which was possibly unique.[2] On the face of it, it was an unlikely friendship, but it continued from that moment until Berenson's death in 1959. Apart from the resident members of the household, Morra spent more time with Berenson at I Tatti and on travels with him than anyone else. Paradoxically, however, he remains the most unrecognized and unknown of all Berenson's most important friends, acquaintances, and correspondents.[3] The purpose of this short paper, therefore, is to sketch a brief portrait of Morra and, in particular, to explore what it was that drew the two men together and the bonds that evidently tied them so closely to one another.

## The First Meeting

When Berenson and Morra met in 1925, Berenson was in his early sixties and Morra in his late twenties. For reasons we shall discover, it was between that first meeting and the outbreak of war in 1939 that each was most influential, the one with the other; and in spite of the age difference, it was mutual. The significance of the friendship is recorded by that keen observer of human character, Nicky Mariano, in her memoir *Forty Years with Berenson*. Mariano (born in 1885) was twelve years older than Morra, but they formed a close and affectionate bond, as that of older sister and younger brother:[4]

> From the first moment there was such a feeling of warmth, of mutual understanding between this young man and the three of us that he stayed on to supper that same day and from then on became a constant visitor. His name was Count Umberto Morra di Lavriano, the descendant of an old Piedmontese family of military traditions and no doubt he too would have been brought up for service in the army had he not been struck by coxitis as a small boy. Tall and slender he would have been well made but for the lameness that this illness had left him with. His

2   Kenneth Clark, although initially welcomed with enthusiasm, soon came under suspicion following his engagement to Jane Martin. Morra himself told us that the Berensons considered Clark to have stolen her from another—she broke off a previous engagement to Janet Ross's nephew to marry Clark—and this they deemed unacceptable. Mary, who had strong likes and dislikes, and having been enthusiastic about Clark, took against him in particular, and her letters to Berenson contain increasingly disparaging remarks about Clark. For example, having lunched with the Clarks in London in 1934 when he was director of the National Gallery, she wrote to Berenson that she found him "a queer mixture of arrogance and sensitive humility": Samuels 1987, 414.

3   For example, there are only fourteen references to him in Samuels 1987, mostly recording simply his presence on a particular occasion.

4   Bernard and Mary Berenson Papers, Biblioteca Berenson, Villa I Tatti—The Harvard University Center for Italian Renaissance Studies. There are several dozen letters from Morra to Nicky in the I Tatti Archive, none of any great consequence but full of the day-to-day requests, news, and trivia that characterize typical family correspondence; he also used "Nicchi" as an intermediary when he wanted to request something from Berenson. Morra wrote to Mariano in Italian, whereas he wrote to Berenson in English.

*1*

Elena Carandini,
Umberto Morra,
and Bernard
Berenson at Torre
in Pietra, June 1932.
Bernard and Mary
Berenson Papers,
Biblioteca Berenson,
Villa I Tatti—The
Harvard University
Center for Italian
Renaissance
Studies.

subtle intelligence combined with great sensitivity showed in his features and in his expression. A great help in his becoming almost a member of the family was his familiarity with the English language, literature and history. For Mary at any rate it was essential. She never felt really at home in another language and probably was never able to think in it.[5]

Later, when mentioning many of the young people that Berenson took under his wing, Mariano wrote: "perhaps of all these men the one BB talked to most during his frequent visits to I Tatti and to Poggio allo Spino was Umberto Morra. He had a special gift of drawing out BB."[6] These sentiments were echoed by Berenson himself—in 1935, he wrote to Mariano: "you ask about Morra. He is simply perfect and I feel not a thin sheet of paper between us. He takes almost as much interest as your darling self in all that pertains to me."[7]

What brought the two together initially, and what held them together particularly in those prewar years, was a passionate and indignant hatred of fascism.[8] Morra had become

5   Mariano 1966, 124. There are more references to Morra in the book than to anyone else outside the immediate Berenson ménage.

6   Ibid., 147.

7   Ibid., 219.

8   Morra 1965, 37. The word "indignant" is chosen with care. In 1929, Berenson wrote of Alberto Moravia, whom Morra had just introduced: "he lacks a sense of humour but instead possesses in the highest degree a sense of the absurdity of things and this may make him laugh, but more often it leads him to a sense of the tragic. He perceives reality clearly, and more than anyone else is capable of indignation: moral indignation and political indignation like a Hebrew prophet—a rare thing in Italy."

an intimate member of a circle of young writers and intellectuals who were opposed to Benito Mussolini, especially centered around the charismatic young radical campaigning journalist Piero Gobetti.[9] From time to time, these men were actively harried, persecuted, imprisoned, and even killed by the fascists. Gobetti, for example, was beaten up by fascist thugs in 1925 and died shortly afterward in Paris from his injuries. They were also close to the eminent socialist writer Gaetano Salvemini, who, although a generation their senior, shared the same ideals and objectives. Salvemini was an old friend of the Berensons, having first met them in June 1908, and he became a regular visitor to I Tatti and Vallombrosa.[10]

On 2 June 1925, Salvemini was arrested in Rome and imprisoned in Florence.[11] Following the arrest, Morra was asked either by Carlo Placci or Salvemini's wife Fernande (or possibly both) to visit Berenson with two requests: to put aside any notices of the incident appearing in the foreign press, and to ask if Salvemini might borrow Berenson's passport in order to effect an escape to Switzerland. Both men looked remarkably similar and it was an ingenious suggestion, but it did not meet with favor.[12]

It was in that fateful year of 1925 that Mussolini assumed dictatorial powers and began to construct a police state. All of this was watched by Berenson with interest and anxiety.

Morra did not bring to I Tatti any particular interest or expertise in art or the art world. What he did bring was his network of young antifascist contacts, and over the next few years many of them became visitors to I Tatti. Through Morra, Berenson met the Bracci family in Rome;[13] the Ruffinos at la Rufola near Naples, with whom Salvemini took refuge after his release; Alberto Moravia;[14] Pietro Pancrazi; and many more. Guglielmo degli Alberti, Alessandro Passerin d'Entrèves, and Morra were an especially close trio of antifascists connected with Berenson.[15] Alberti, a descendant of Leon Battista Alberti,

9   Gobetti believed that liberal ideals could only be achieved through struggle and conflict (whereas fascism sought to absorb its political opponents). He also thought that the Italian people could learn to reject totalitarianism by means of an education in European culture. This latter view had a deep influence on Morra's thought and actions, especially after the end of the Second World War.

10  The intermediary who effected the introduction appears to have been Carlo Placci, who was coincidentally also a friend of Morra's parents and who had met Morra as a boy at about the same time, 1908.

11  Salvemini was a professor of history at the University of Florence and was especially hated by the fascists for having opposed Italian ambitions in the Adriatic. Berenson warned him of the dangers of speaking out against the fascists, but Salvemini was hopeful that their opposition might still bear fruit. He wrote articles for the underground newspaper *Non Mollare*, but a typesetter there denounced him to the authorities.

12  Bellando 1990, 97; Mariano 1966, 123; Morra 1965, vii; and Samuels 1987, 334–335.

13  See Bellando 1990, 49, for an explanation of the connection between the Papafava and Bracci families and Morra's links with and indebtedness to them. Francesco Papafava, whose family from Montepulciano were close friends with Morra and shared his political sympathies, kindly gave the authors a copy of his article "Un amico di famiglia ricorda Umberto Morra di Lavriano," published in *Nuova Antologia* in April/June 2002.

14  Mariano 1966, 234.

15  They all knew they had no chance of toppling the fascist regime or even of holding the tide, but they were determined in their own words "to keep the flame of liberty alight" against the day when the fascists would be defeated and free speech and constitutional liberty restored to Italy. Morra, Alberti, and d'Entrèves were affectionately known as *I tre Conti*.

translated *Rumour and Reflection* into Italian for publication in 1950.[16] Thus, in Mariano's words, "B.B. ended by belonging to a network of anti-Fascist intelligentsia and wherever he went could be sure of meeting kindred spirits."[17] What Berenson and the I Tatti household gave Morra was an intimacy and a type of friendship which he clearly craved.

## Umberto Morra

Morra was born on 13 May 1897 in Florence, a healthy, lively, well-formed son, the first and only child of elderly parents. His father, then aged sixty-seven, was Count Roberto Morra di Lavriano, who had established a highly successful career in the military, politics, and diplomacy. Close to the royal family, Roberto Morra had participated in the independence movement of 1848, fought against the Austrians in 1849, and fought in the 1866 war which recovered the Veneto for Italy. A deputy and senator between 1874 and 1890, he was sent by Umberto I in 1884 to Sicily, where he was responsible for a bloody suppression of a peasant uprising. From 1897 to 1904, he was the Italian ambassador in St. Petersburg, organizing the state visit to Russia of Umberto I.[18] In 1895, at the age of sixty-five, he married for the first time; his bride was Maria Teresa Bettini (always called Lucia), the widow of the noble Cortonese Pirro Laparelli di Lapo, whom she had married at the age of seventeen.[19] General Morra and Colonel Laparelli were close friends in the army, and when the colonel died of an incurable illness in 1893, the general wooed his beautiful and wealthy widow, then aged forty.[20] Within two years of the marriage, Umberto Morra was born in the headquarters of the Eighth Army Brigade in Florence (which General Morra then commanded), and was christened in the Royal Chapel at Monza. King Umberto and Queen Margherita were his godparents.[21]

From his father, Morra inherited a certain Piedmontese dryness and severity of character as well as a love of history, politics, diplomacy, and foreign travel.[22] It is sometimes speculated that the massacre in Sicily turned the son against the father and caused Morra to pursue left-wing ideals. There is perhaps some truth to this, though on balance it is unlikely to have been a major cause, as Morra was devoted to his parents; they were a close-knit family, and he later preserved his parents' house as a shrine to them and his godparents.[23]

---

16  Berenson 1952b; see also Berenson 1950b.

17  Mariano 1966, 127, 236.

18  Vidal-Nacquet and Siliotti 1997, 56.

19  The Laparellis were one of the oldest and most distinguished families in Cortona, tracing their ancestry directly back into the fifteenth century. The celebrated architect Francesco Laparelli was born in 1521. See Bellando 1990, 36.

20  Morra's mother was born in 1855.

21  Bellando 1990, 33.

22  This latter trait was exemplified by Roberto Morra's journey to Egypt in 1869 for the opening of the Suez Canal, during which he kept a detailed journal: see Vidal-Nacquet and Siliotti 1997.

23  Morra's favorite preprandial drink was a bitter-tasting vermouth called Punt e Mes, manufactured in Turin by G. B. Carpano. Morra always referred to it as "Carpano." His father had been born in 1830 in the Torinese Palazzo Asinari di San Marzano, which became the headquarters of the drinks company and was renamed Palazzo Carpano: the new name is inscribed on every bottle of the

Rather, we would suggest that Morra inherited from his father an intense patriotism and love of country. In his father's case, following the Risorgimento, this manifested itself in a deep loyalty to the monarchy; whereas in Morra, it manifested itself, following the turmoil of the First World War and the rise of fascism, in an equally deep loyalty to constitutional democracy and modern liberty. From his mother, Morra inherited his much-loved country house outside Cortona at Metelliano, an abiding attachment to the landscape of the province of Arezzo, an unpredictable sense of humor, a Tuscan passion for debate and independent thought, and a curiosity about the unknown.

In spite of the advantages bestowed on Morra at birth, the years before he met Berenson were not without their difficulties. He was struck down with tuberculosis at the

---

drink. It would be typical of Morra to have chosen this drink for no other reason than as a memorial to his father.

age of five, and this left him permanently crippled.[24] His mother died when he was twelve, and his father when he was twenty. His early education was interrupted by his illness and the search for cures.[25] His ambitions to study law at university were frustrated by the First World War, and he abandoned them without taking a degree in 1919. His desire to establish himself as a political writer and to be part of the shaping of a new liberal framework for a modern Italian state was crushed by the rise of fascism.[26]

The formal facts about Morra's life are well documented and accurately set out in the celebratory volume of Morra's life and writings that was published in 1967, when the citizens of Cortona honored him with the title of *Castellano*, in succession to the painter Gino Severini.[27] Yet in all that has been documented of Morra's life, and of what has been written about him, the least explored aspect is that of his relationship with Berenson and the circle of I Tatti.

## Umberto Morra at I Tatti

After the death of Gobetti in February 1926, Morra went underground (like many antifascist intellectuals) and based himself principally in his villa at Cortona. It became a place of refuge for antifascist thinkers and writers, a sort of sanctuary. A near neighbor was the fellow journalist and sympathizer Pietro Pancrazi, so Morra's retreat was not isolated. Although handsome and spacious, the villa was tucked away unobtrusively in the hamlet of Metelliano, behind high walls, and invisible from the road—yet it was easily accessible by rail, being on the main line from Florence to Rome, and also not too far distant from I Tatti. Morra's political views and friendships were known to the authorities, and although watched by them, he was left undisturbed. There is speculation that his royal connections gave him some protection, and perhaps this is true. Also, he did not promote protest and agitation, realizing their futility at the time. His aim was simply "to keep the flame of liberty alight" in readiness for the time when its illumination would be able to shine again.

Away from Metelliano, Morra spent time in Rome, where the Bracci family allowed him use of a room in their property on via 10 Novembre, and of course at I Tatti and La Consuma. He regularly stayed at both of the latter two places—four, five, or six times a year—and could be in residence for a total of two to four months per year, or even more.[28] In 1937, for example, he seems to have been with the Berenson entourage for most of January, the first half of April, for two weeks in mid-June, in early July, for two to

---

24  He was taken from hospital to hospital in search of a cure, and to Lourdes in the hope of a miracle. See Bellando 1990, 39.

25  After his mother died, Morra lived in Rome and went to the Liceo Classico Torquato Tasso, where he was taught art history by Roberto Longhi. Longhi was reputed later to be Berenson's "arch adversary," but the reputation may owe more to rumor than to substance; Berenson considered Longhi "the most gifted among Italian art historians and critics" (Samuels 1987, 567).

26  Bellano 1990, "Con Piero Gobetti nella bufera," chap. 3, 57–74.

27  Fresucci and Morra 1967, 45–137.

28  There is, of course, no specific record, but one can work out the overall pattern via the entries in Morra's own book *Colloqui con Berenson* (Morra 1965). Between 1931 and 1939, Morra kept a summary of Berenson's conversations on occasions at which he was present, including dates.

three weeks in August, and for three weeks in December. In addition, there were the times when he accompanied Berenson on his travels: for example, he traveled with Bernard, Mary, and Nicky Mariano to Spain in the early autumn of 1929 on a long expedition which lasted until early December.[29]

—

We hope we have sketched enough detail, and with sufficient evidence, to give the outlines of Morra's formative and interwar years, and of how he became part of the life of the Berenson circle. After the Second World War, Morra had a busy life of his own, but even so the connections with the Berenson circle remained strong and important.

But what of the subtle tones and shades that lend substance and interest to the outline? Our own memories of Umberto Morra in the early 1970s are of a tall, gaunt, elderly, angular figure, at first sight potentially intimidating, but softened by a welcoming smile which signaled approval. Not everyone was approved, and those who came under his wing were treated with respect in the local community. He was energetic, kindly, humorous, gentle, gregarious, and sometimes endearingly childlike in what amused him; yet at the same time he could be acerbic, melancholic, and aloof. He admitted to an ingrained pessimism.[30] He never married[31] but he had a very wide circle of friends, was respected by men and women of all classes and backgrounds, and was much loved.[32] He set very high standards for himself, and expected them in others. He was uncomplaining, completely without vanity and social snobbery, though he would not tolerate fools. He was frugal and indifferent to material comfort, personal adornment,[33] and material possessions.[34] Above all, he was unswervingly loyal to the people and causes that mattered to him. In pursuing our recent researches we have found no cause to change one syllable of this personal view, and we have been delighted to find it so often reciprocated in the mouths of others.

Yet it also emerges that many of his fellow Italians found him baffling and enigmatic,[35] whereas his Anglo-Saxon friends seem to have found in him a kindred spirit which

29  Mariano 1966, 207: "Morra accompanied us on most of the trip, sometimes driving with us, sometimes going by train to places not included in our programme. A delightful companion and a helpful one through his firm knowledge of the language."

30  Umberto Morra, diary, 31 January 1955: see Bellando 1990, 28.

31  See ibid., 103, for an account of Morra's relationship with *la contessa* Giuliana Benzoni.

32  One of Morra's closest friends in Cortona was Count Lorenzo Passerini, who shared his social and political views. The local community, which was noted for its vigorous independence and left-wing political sentiments, was thrilled to have in its midst not just one "Conte Rosso" but two. See ibid., 11–32, in which Bellando makes especial reference to Morra's gift for friendship and interest in the young.

33  See ibid., 19, quoting an unnamed source to say that Morra's inelegance of dress was legendary, but unforgettable.

34  Alain Vidal-Nacquet told the authors that in Rome, when it was cold, Morra, in order to read his newspapers and keep warm, would sit in bed wearing gloves. When Vidal-Nacquet suggested he acquire an electric fire, Morra replied that it would be an unnecessary luxury. Vidal-Nacquet bought him an electric fire as a present.

35  Ibid., 16–23. Perhaps this was one of the reasons why he was never appointed to higher political office after the Second World War; equally, however, Morra would not make the compromises of principle which were expected in the rapidly shifting patterns and loyalties of postwar Italian

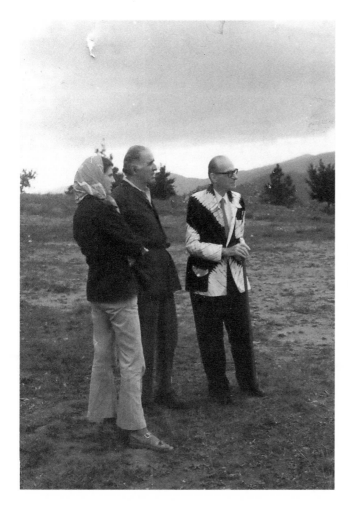

*3*
Umberto Morra with
Lyndall and Renzo
Passerini, Cortona, 1973.
(Photo: Robert and
Carolyn Cumming.)

required no explanation or unraveling.[36] Indeed, several commentators have noted the Anglo-Saxon character in Morra, and with Berenson's own self-confessed admiration for Anglo-Saxon culture and people this must have been one of the things that drew them and kept them together. Not everyone was allowed, in Berenson's own words, to become *unsereiner*—one of us—and Morra was certainly well aware of the rareness of that blessing. It was an acknowledgment that enabled him to become part of something, an intimate entrée into an intellectual and familial group which arrived fortuitously, just at the

---

politics, or become a fully committed member of any political party. To have done so might have demonstrated a truly Italian character, but such a thing would have been simply outside his nature.

36  Clark, an exemplar of Anglo-Saxon civilization, wrote of his first visit to I Tatti: "I did however make one friend whose sweet character, intelligence and absolute sincerity have been a joy to me ever since, Umberto Morra. . . . The thought of meeting Umberto again was one of the factors which made me look forward to returning to the world of i [*sic*] Tatti in the following autumn" (Clark 1974, 157). It also seems that one of the happiest periods of Morra's life was during his time in London as director of the Italian Cultural Institute (July 1955 to January 1959).

moment—after the death of Gobetti—when he most needed it; and we think it also filled a void that his own early life had left in him. Capable of affection and warmth himself, he also needed to receive it in return.

As we explored further Morra's own character and that of Berenson, we started to keep a checklist of those aspects of character that they shared in common, and those that they did not share. There was, of course, a difference in age of over three decades, but Berenson and Morra came together just at that mutual moment, which occurs not infrequently in men's lives, when there is a desire to find and develop a paternal rather than fraternal relationship.[37]

What were the differences? Morra was a perfectionist, capable of strict self-denial, and committed to an ideal of public service, and we are not convinced that these were qualities that were natural to Berenson. Although not devoid of aesthetic sensibility, Morra lacked confidence when it came to the visual arts. His first love was literature—he was well-read and learned, and a significant part of his day was set aside for reading literature and newspapers. He also enjoyed reading aloud, giving particular pleasure to his audiences at Cortona and I Tatti.[38]

The resonances between Berenson and Morra were deep and strong. Both had obstacles to overcome in finding and establishing themselves in early life; both had an insatiable curiosity; both were indefatigable sightseers;[39] both enjoyed walking in the countryside and had a deep love of Italian landscape.[40] Above all, both of them enjoyed conversation and clearly indulged in it together to the full. Each was given to self-analysis and introspection;[41] each could be, and at times clearly wished to be, aloof. In spite of this, it seems that each had a great fear of loneliness,[42] although each addressed it in a different way. Berenson hid from his demon by surrounding himself with distractions and acquaintances;[43] Morra faced his demon alone in the dark hours of the night, determined to outstare it and conquer it unaided. Each found writing necessary but difficult, and each failed to bring much-hoped-for writing projects to completion.[44] And, of course, each was

---

37  Morra quotes Berenson as saying, "One should prepare oneself with young friends for one's old age, and transfer the enjoyment of life from oneself to them": Morra 1965, 4.

38  Samuels 1987, 350: "They often read aloud of an evening and were especially charmed by Morra's beautiful rendering of Italian texts."

39  See Bellando 1990, 21, one of the many accounts which recalls that, in spite of their individual physical limitations, Berenson and Morra would bound about like mountain goats, exhausting their more robust companions.

40  See Morra 1959. We are grateful to William Mostyn-Owen for drawing our attention to this article.

41  Bellando 1990, appendix, "Il diario di Umberto Morra," 283–291. This characteristic also emerges clearly from Berenson's own diaries.

42  See Samuels 1987, 536, referring to Mally Dienemann's visit to I Tatti in 1951: "Observing [Berenson's] life at I Tatti she came to feel he could not bear to be alone."

43  See Samuels 1987, 536, quoting the American writer Elizabeth Hardwick, also a visitor to I Tatti in 1951: "Berenson's nature destined him to be an inn-keeper ... his absorbing inclination was the simple fear of missing someone ... almost as if these countless visitors and travelers had a secret the exile pitifully wished to discover."

44  Kenneth Clark Papers, Tate Gallery Archive, 8812/1/3/213-292. Berenson's later correspondence with Clark, for example, is full of regrets about books he would have liked to have written but

fascinated by politics and contemporary events, and both were united in their absolute determination to oppose all forms of totalitarianism in whatever guise it chose to raise its ugly head.[45]

Morra also gave Berenson what he craved for and most needed: an active and engaged listener. An ability to listen was perhaps one of Morra's most valuable and typically selfless qualities, and one that he shared with many. Many also were those who acknowledged the value of it, but perhaps nobody summed it up so well as Alessandro Passerin d'Entrèves:

> I think it was in Morra exactly that singular gift of sympathy, that interest, that inexhaustible curiosity about things and for people that captured the affection and the estimation of the old sage of Settignano, [who was] sometimes stern and sometimes even merciless in his judgement of the young. A good judge of Italy and the Italians, I think that Berenson might have seen and cherished in Umberto that quality which has become so rare in our compatriots of today: an acuteness of judgement, an absence of servility, with a mistrust of rhetoric and above all (and this was a quality which Morra possessed in the highest degree) the art of listening . . .[46]

### "Do not forget me"

Several subtitles suggested themselves to us for this essay. One was "Morra is here," a phrase frequently to be found in Berenson's letters and diary. Another was "Constans et Fidelis," Morra's own personal motto, which was printed on his writing paper.

We got to know Morra during three summers between 1972 and 1975, and we subsequently corresponded with him. In one of Morra's last letters, he wrote "do not forget me," and that phrase became the spur to our researches which commenced in earnest in 2008. It was like a tap on the shoulder for us both, spurring us on to visit I Tatti and research the archives. For that reason, we chose it as the subtitle.

We are also grateful to Joe Connors and Louis Waldman and the organizers of this conference for giving us the opportunity to participate, and thereby to repay in part the continuing debt that we owe to Morra for enhancing our own lives and for connecting us to the I Tatti community in the widest sense—thereby ensuring, we hope, that we do not, indeed, forget him.

### *Postscript*

As a consequence of the conference at I Tatti, two interesting publications, previously unknown to the authors, were brought to their attention.

---

knew he never would; and, of course, his own autobiography never got beyond a *Sketch for a Self-Portrait*. Morra started a biography of Gobetti but never completed it, even though he had been commissioned by a publisher and had agreed to undertake the task.

45  William Mostyn-Owen commented to the authors that Morra was one of the few Italians that Berenson could totally trust during the fascist years.

46  Morra 1984.

*4*

Morra's study
at the Villa
Morra, Cortona,
October 2009.
(Photo: Robert
and Carolyn
Cumming.)

Charlotte Cabot Brown gave the authors an article by Morra, "Ricordi su Berenson," which appeared in *Scuola e Cultura nel Mondo*, no. 34 (published in the 1960s), and in which Morra talks about life at I Tatti and the writing of his book *Conversations with Berenson*. The article also includes a recollection by Morra of Roberto Longhi, who taught art history at the *liceo* in Rome that Morra attended as a teenager. Longhi introduced his pupils to Berenson's "tactile values." He also recalls how Carlo Placci tried to introduce him to Berenson sometime before 1925, and took him to I Tatti: Berenson was absent in the United States, and the proposed encounter never occurred. Francesco Papafava kindly gave to the authors a copy of his article "Un amico di famiglia ricorda Umberto Morra di Lavriano," published in *Nuova Antologia* in April/June 2002. Price Zimmermann has alerted the authors to three publications with reminiscences of Morra: James Merrill's autobiography, *A Different Person* (New York, 1993); Richard Demby's novel, *The Catacombs* (New York, 1965); and extracts from the diary of Benedetto Croce, *Croce, the King and the Allies, July 1943–June 1944* (translated by Sylvia Sprigge, London, 1950). In the week prior to the conference at I Tatti, the authors visited Cortona and were kindly allowed access to Villa Morra by the current owner Ivo Vincioni, who also permitted them to examine a substantial number of uncataloged papers and photographs that they had not previously seen; these concerned Umberto Morra's parents and early family life, his relationships with the circle of I Tatti and Giuliana Benzoni, and his political and diplomatic activities after the Second World War.

The authors are very grateful to all of the above for adding substantially to their knowledge and understanding of Umberto Morra.

~~~~~~

Appendix

Alberto Moravia on Umberto Morra

The following is Robert Cumming's translation of an interview with Moravia, recorded in Alfonso Bellando's biography of Morra (Bellando 1990, 88).

Morra and I met in 1926. I was then living at Perugia and I remember that there were at Assisi some celebrations for the seven hundredth anniversary of the death of St. Francis, with the participation of Cardinal Merry del Val, who passed with much solemnity among the crowd.

Morra, who had received a letter about me from somebody or other in the region, came to Assisi and it was there that we met. He was with me, at once, very kind and he invited me to seek him out. That was the beginning of a friendship which was to last until his death. Then, in 1926 I was writing *Gli indifferenti*, which I had begun when I was not yet seventeen years old. Part of the book I wrote at Morra's, but not all of it. In fact, I think there is in the villa still a photograph in which you see me in bed, my chest naked, while I am writing. Because that was how I wrote in bed, in the mornings.

The years of the greatest frequentation, the years when we most often visited, were from 1926 to 1940. At that time, I was also at his house for one or two months. Morra was not rich but he was very generous. There is an episode which I recorded. At a certain moment I was about to get married; the marriage would have been a mistake and fortunately it did not happen. I was short of money and Morra bailed me out, with complete spontaneity, his financial contribution enabling me to satisfy a loan which otherwise I would have had to reimburse prematurely.

Morra was a worthy man, but extremely self-contained; his only luxury was to buy books and to have guests, normally never more than one or two, to keep him company. I remember the presence of Alberti Lamarmora, Passerin d'Entrèves, and, among the foreigners, Berenson and Kenneth Clark. I would like to say that during those days I led a very peaceful life. We worked in the morning; when the newspapers arrived, Morra stood in front of the window and began to read aloud; the articles which interested him were marked with crosses in red or blue pencil. Tonino then took them and cut them out and pasted them, but always under [Morra's] control. After lunch, at about four o'clock, [Morra] went for a walk, and in the evening stayed at home. Morra loved to read aloud. He read, and commented, and I stayed to listen. Someone had given him all the works of Saint-Simon. I think there are twenty-three volumes, and we read the best part of them. In cold weather he occupied the first floor because there was a stove there; the villa was very cold; in the morning my bedroom was an icebox. The bed was heated with something called a "priest," containing a warmer filled with hot embers.

In 1941 I married and my marriage took me a long way from Metelliano. We went for preference to Capri; thus I became a bit detached, but not in the sense of friendship: we remained the best of friends, but when one is married that sort of bachelor life doesn't work any longer. Elsa, nonetheless, had a great rapport with Umberto.

It is not easy to give a judgment about Morra. He was one of those people that it is difficult to find in Italy, people with strong cultural interest who live well and are distanced from the uproar of the city. In England and in France I believe such people are quite frequent, but not in Italy. I do not think he had ambitions for a diplomatic career. I can say that he was, in fact, a true diplomat, also a bit old-fashioned. He knew how to receive, an ability very important for a diplomat, he knew how to make conversation, he was cultured; nevertheless it was not a pedantic culture, not a university one, it was the culture of a man of the world; he knew languages, something which he desired more of . . .

Was he happy? Difficult to say. Besides being ironic and distant he was certainly very serene, but a little old, and I have to say that he always had the attitude of an old man. From the beginning. He did not have that fierceness, which springs from the moods that are typical of the young. At twenty-nine years old, when I knew him he was characterized already by those behaviors of an old man. And he was already somehow physically old.

I can point out another of his characteristics: he was very inflexible, he had at heart a toughness probably attributable to the fact that he was from Piedmont. Because he could also be tough in other ways, for example, in a Tuscan manner. A toughness "typically Piedmontese," coming from the military surroundings of his ancestors, from his father the General. He wasn't very indulgent, Morra. I would say that his apparent benevolence came from an effort, from a violence which he had to make to his true character, naturally inclined toward severity and rigor, toward himself, and toward others.

He was well placed in the Piedmontese liberal tradition: I am not sure if he would have voted for the Socialists, since his inclination carried him toward the Liberals and the Republicans. And it is certain that the vote that he made was for the person more than the party, since he was much persuaded to appreciate individuals, if they were worth it. We never talked about ideas, about principles. Our conversations were essentially about literature; literature was a true passion for him. I can say that he was a very important person in my life.

Bernard Berenson and Katherine Dunham

Black American Dance

JOSEPH CONNORS

O N 23 MAY 2006, an obituary appeared in the *New York Times* for Katherine Dunham, who had died at the age of 96. It had high praise for her achievement in the world of dance: "By creating popular and glamorous revues based on African and Caribbean folklore, Miss Dunham acquainted audiences, both on Broadway and around the world, with the historical roots of black dance."[1] The article went on to speak of her achievement in founding, in the 1930s, America's first self-supporting black modern-dance troupe,

∽ At the Morris Library Special Collections, I offer sincere thanks to Pam Hackbart-Dean, Lea (Broaddus) Agne, and Aaron Lisec, as well as to I Tatti Fellow Holly Hurlburt, for facilitating my long-distance research in every way. At the Biblioteca Berenson, where seventy-three of Katherine Dunham's letters are deposited, I offer my warm thanks to Giovanni Pagliarulo, Sanne Wellen, and Ilaria Della Monica.

For the outline of Dunham's life and career, I am indebted to the fine biography by Joyce Aschenbrenner, *Katherine Dunham: Dancing a Life* (2002), and the comprehensive collection of materials in Vèvè A. Clark and Sara E. Johnson's *Kaiso! Writings by and about Katherine Dunham* (2005), which is a much-enlarged second edition of *Kaiso! Katherine Dunham: An Anthology of Writings* (Clark and Wilkerson 1978). The web page "Selections from the Katherine Dunham Collection at the Library of Congress" (http://lcweb2.loc.gov/diglib/ihas/html/dunham/dunham -home.html) contains photographs and a selection of videos of Haitian dance filmed by her as well as her own performances. The timeline on the site does not always agree with Aschenbrenner's authoritative biography. Like all contributors to this book, I am greatly indebted to Ernest Samuels's *Bernard Berenson: The Making of a Connoisseur* (1979) and *Bernard Berenson: The Making of a Legend* (1987).

1 See Anderson 2006 and Dunning 2006; for another obituary, see Sommer 2006.

which had visited more than fifty countries on six continents. The author dwelled on Dunham's affection for Haiti and mentioned that she eventually became a priestess of the *vodun* religion. It cited her choreography for *Aïda* at the Metropolitan Opera, her work with Georges Balanchine in 1940, her influence on Alvin Ailey, and her career in film in the early 1940s. It quoted Dunham on the diversity of response that her work inspired: "Judging from reactions the dancing of my group is called anthropology in New Haven, sex in Boston, and in Rome—art!" Her many accolades culminated in an honorary doctorate from Harvard University in 2002, which she received along with eleven other distinguished personalities of the worlds of science, economics, humanities, and politics.[2] She counted two black presidents among her friends: Dumarsais Estimé of Haiti, who made her a Chevalier of the Légion d'Honneur et Mérite of that country in 1949, and Léopold Senghor of Senegal, who invited her as an unofficial American ambassador to the Festival of Black Arts in Dakar, Senegal, in 1966.[3] She is reported as saying that the three great influences on her life were Robert Maynard Hutchins, the president of the University of Chicago at the time of her study there; Erich Fromm, the psychologist and social theorist; and Bernard Berenson.[4]

The first two made sense, but the relationship with Berenson seemed out of character. He was forty-four years older than Dunham, and they lived continents apart. Race was still a barrier in polite European society, and it was hard to imagine common interests. Indeed, in the extensive literature on Berenson there is little mention of Katherine Dunham. For details of his private life, one usually turns to Nicky Mariano's intimate biography.[5] Mariano was curious about the loves of Berenson's early life and got to know some of them: Gladys Deacon, Lady Sassoon, Belle da Costa Greene, Gabrielle Lacase, Natalie Barney, Countess Hortense Serristori. When new stars rose in the sky she could be consumed with jealousy, but eventually she became comfortable with them and ended up by enjoying his new half-amorous friendships "as a mother enjoys a new toy for her baby." Nicky compared them to the instruments in an orchestra, though some, she said, were comparable to solo performers: Pellegrina Del Turco, who was shot by the Germans near the end of the Second World War; Clotilde Marghieri, "*la Ninfa del Vesuvio*," with whom Berenson corresponded for decades; Addie (Mrs. Otto H.) Kahn; Katie Lewis; Paola Drigo of Venice; Frances Francis, wife of Henry Francis of the Cleveland Museum of Art; Freya Stark, the travel writer; Rosamond Lehmann, the novelist; Katherine Biddle, the poet. Yet Mariano remained silent on Katherine Dunham. Even the scrupulous and highly detailed biography by Ernest Samuels only accords brief mentions of Dunham's visit to I Tatti in the "social season" of 1948 and Berenson's visit to a performance of her dances in Rome.[6]

2 *Harvard Magazine*, July–August 2002. Other honorands included economist Albert Hirschman, Senator Daniel Moynihan, philosopher Bernard Williams, historian Peter Brown, and former Harvard president Neil Rudenstine.

3 Clark and Johnson 2005, 412–417.

4 For example, in Hagan 1955.

5 Mariano 1966.

6 Samuels 1987, 517, 519, 536.

The published literature thus did not help to dispel the mystery enveloping Dunham's claim that Berenson was a major influence in her life. In the cloudy sky of my research, however, a rainbow finally appeared, one end resting in Florence, where Dunham's letters are kept in the Biblioteca Berenson at Villa I Tatti, and the other in Carbondale, Illinois, where Berenson's letters are kept amid the material Dunham donated to Southern Illinois University. I have been able to read about 130 letters written in the decade between 1949 and 1959. They shed light on an epistolary friendship which, in spite of a near rupture at a crucial point, was deeply meaningful to both and continued until the end of Berenson's life.

Katherine Dunham was born in Chicago in 1909 to a black father, Albert Dunham, and a mother of white French-Canadian ancestry, Fanny June Dunham. She was raised in the Chicago suburb of Glen Ellyn and, after dance lessons at school, began to study ballet seriously in 1928. In 1929, she entered the University of Chicago, where her older brother, Albert, was studying philosophy. Chicago was the right university for a young woman with a vibrant personality and interests equally scholarly and artistic. Founded in 1891 as a coeducational institution, there was no more open and liberal university in America. Both brother and sister lived in Bronzeville, the black theater and jazz district of Chicago. It was Albert who encouraged Katherine's ambition to be in the theater. The poet and dancer Mark Turbyfill sensed her talent in dance and wanted Dunham to become the first black American ballerina. Although the dance establishment did not believe that classical ballet was appropriate to the physique and temperament of black dancers, Dunham attended performances by Isadora Duncan and the Ballets Russes, and was taught dance by Ludmilla Speranzeva. She created the short-lived Ballet Nègre in 1930, one of the first black ballet companies in America, which performed in the Beaux Arts Ball in Chicago, but then was disbanded in 1931.

Dunham was highly intelligent and responded well to academic stimulus. The University of Chicago exuded intellectual energy—Robert Maynard Hutchins, the iconoclastic young president from 1929 to 1950, saw the mission of the university as the breaking down of barriers between academic disciplines. He started the department of anthropology in 1929 and attracted to it brilliant, idiosyncratic scholars from Europe and America. The anthropology teachers and visiting lecturers of those years make an impressive list; with characteristic humor, Dunham sketches their traits:

> the personal appeal and dry wit of Robert Redfield, the crashing daring of a man like Robert Warner, dapper far-travelled Fay-Cooper Cole, Margaret Mead, who exposed sexual habits in the Pacific, Malinowski, who exposed sex habits wherever he happened to be stationed, Radcliffe-Brown . . . a gaunt old yellow-toothed lion given to floating around the lecture hall dropping verbal bombs on tender blossoms—I being one of them—then retreating and grinning at the wreckage.[7]

7 Aschenbrenner 2002, 37.

It was Robert Redfield who realized that Dunham's disparate inclinations, to dance and to anthropology, were not incompatible. With his support, she won a grant from the Julius Rosenwald Fund to study Caribbean dance in 1934. It was at a Rosenwald reception that she first met Erich Fromm, who was long to remain a friend and mentor. At Columbia University, Franz Boas encouraged her, saying that she might be able to discover knowledge that was inaccessible to nondancers.[8] In 1935, to prepare for her trip, she began to study with the anthropologist Melville Herskovits of Northwestern University. Herskovits had worked in the Caribbean, and he encouraged Dunham to visit Jamaica and to study the dances of the remaining Maroon communities, the descendants of escaped slaves who had fought (and eventually made peace with) the British colonial government but who remained highly secretive. After a stop in Haiti, Dunham arrived in Jamaica in July 1935 with a recommendation from Herskovits to a colonel in the Maroon village of Accompong. She published a literary version of her field notes in 1946 (entitled *Journey to Accompong*), which still makes for vivid reading.[9]

The journey of this twenty-six-year-old student to the interior of the island was not easy. No outsider had ever stayed with the Maroons more than one night; even Herskovits had only visited them for a day. Dunham made her way to their village and stayed for a month. To add to the difficulties of living and eating, she found the dialect almost unintelligible and felt quite alone. She knew the fighting history of these resilient people, fierce and distrustful of outsiders. Herskovits supposed that among them one might find many vestiges of their West African past, such as respect for the world of spirits, polygyny, and a collectivist spirit. Dunham also hoped to see the Karomantee war dance, which was banned by the British authorities and kept highly secret, if it still existed at all.[10] As the month wore on, however, Dunham grew more frustrated. The only dance she saw was a Maroon version of the quadrille. Then, on the eve of her departure, when the colonel of the village who disapproved of the old customs was away, almost as a going-away present, she finally saw, and filmed, the Karomantee war dance. Later, when she visited the Caribbean island of Martinique, she recorded another martial dance, the *l'ag'ya*: "From Martinique came the ball L'agya with its Creole gaiety, its vivid festival scene, of the Mazurka, the beguine, and majumba, its zombie Forest, its superstition and its tragic ending."[11] Dunham participated in the dance herself. The field anthropologist had become an insider.

Haiti came to be the center of Dunham's anthropology and life. Herskovits did extensive fieldwork in a village called Mirebalais in 1934, and Dunham followed in his footsteps

8 Ibid., 50; Dunham's relationship with Fromm, which entered a romantic phase between 1938 and 1940, is discussed in Friedman 2013, 82, 92–96.

9 Reviewed by Zora Neal Hurston in "Thirty Days among Maroons" (1947), in Clark and Johnson 2005, 272–273. The books by Katherine Dunham in the Biblioteca Berenson are: *Journey to Accompong* (Dunham 1946), *Las danzas de Haití* (Dunham 1947), and *A Touch of Innocence* (Dunham 1959). These arrived during Berenson's lifetime, while *Island Possessed* (Dunham 1969) was sent a decade after his death.

10 Aschenbrenner 2002, 62–63.

11 Ibid., 64.

with a research trip in 1935. She was a less orthodox anthropologist than her mentor, however. She formed a friendship, perhaps an intimate one, with the progressive politician Dumarsais Estimé (1900–1953), who was later elected to the presidency of Haiti and held the office from 1946 to 1950, when he was toppled by a coup and exiled to Paris. Estimé, Dunham tells us, would show her the exceptional courtesy of taking off his holster as they lay on the bed to talk. One evening, Dunham borrowed Estimé's car under false pretenses and had his terrified chauffeur drive her at night to a village deep in the interior. She had heard that an old *bocor* (witch doctor) had died there three days before, but had still to pass on his knowledge to his apprentices, called *counci*. Terrified of the still-living dead, the driver fled as soon as he could, leaving Dunham behind. She passed the nights sleeping on the floor of a village house, below the pet python of her host family. Even though she was an intrepid woman, and later in life reached a sort of communion with the snake god Damballa, she nevertheless found the experience unnerving. However, she had no fear of human violence throughout the days and nights in which knowledge was transmitted from the dead to the living.

In 1938, Katherine submitted her thesis for a master's degree at the University of Chicago, entitled "A Comparative Analysis of the Dances of Haiti: Their Form, Function, Social Organization, and the Interpretation of Form and Function."[12] It was published in Spanish and English in Mexico in 1947, followed by a French translation in 1950. In the preface to that edition, Claude Lévi-Strauss makes an interesting observation about Katherine's rapport with her subjects:

> To the *dignitaires* of the Vodun who were to become her informants, she was both a colleague, capable of comprehending and assimilating the subtleties of a complex ritual, and a stray soul who had to be brought back into the fold of the traditional cult; for the flocks of slaves lost on the large continent to the north had forgotten how to practice and had lost the spiritual benefits. These two reasons placed the researcher in a favored position.[13]

Like Herskovits, Dunham saw the dances of the entire Caribbean region, as far as New Orleans and other black communities of North America, as survivals of West African rituals, kept alive throughout the trauma of slavery.[14] It would have been difficult for Dunham to go further with doctoral work in this direction, however, as Herskovits published his own magisterial book on Haiti in 1937. He includes dance in a much larger panorama of social structure, property, wealth, marriage, *vodun*, and ritual, and his work is informed by a profound knowledge of both Haitian history and the anthropology of the region of Africa from which large numbers of Haitian slaves were taken, the Kingdom of Dahomey. He was very much the professional anthropologist, who observed many cases

12 Clark and Johnson 2005, xviii, 215.
13 Ibid., 383.
14 See Herskovits 1941 for the classic statement of this position, and its reflection in Katherine Dunham, "The Negro Dance" (1941), in Clark and Johnson 2005, 217–226.

of spirit possession during dance and spoke with many informants over a long residence in his village. His contribution was to de-sensationalize *vodun* ritual and see it as part of the relived African ancestry of the participants.[15]

By way of contrast, Dunham is more intuitive and spontaneous in her fieldwork, and less systematic in her analysis of the total culture. Long before Clifford Geertz, she understood the power of empathy in fieldwork and saw the dramatic character of the events she was studying.[16] Her anthropologist's mind absorbed field data while her dancer's eye feasted on the theatrical element in the culture. She crossed boundaries that were not often crossed. She spent time in a Port-au-Prince bordello watching the dances of the Dominican women who worked there. She entered *vodun* ritual to the point of trying to be possessed, to promise the *loa* (spirits) that some day she would consummate the *kanzo* (ceremony). Another appreciative French anthropologist, Alfred Métraux, saw her participation in the rites as the secret of her success as a field anthropologist. In 1962, he wrote:

> her talents took her all the way to the top of the Vodun hierarchy. In any case, it is from her experience as an ethnographer, acquired right on the spot, that Katherine Dunham borrowed the most beautiful themes for her dances. She has tried to release in a nutshell the moments in which the rituals reach their highest point. Rhythms of drums, songs and dances, bring us an echo of the ceremonies that, from Cuba to the Amazon, convene the African gods on American soil.[17]

With the encouragement of Robert Redfield, Dunham's path would take her not into academic anthropology but into dance, turning her thesis into Broadway, as she put it in an essay of 1941.[18] The transfer of dance in primitive societies to the American stage was possible because the primitive dances were themselves choreographed, after a fashion. Her task was to rechoreograph the dances and make them into high art. In 1938, in the Federal Theatre in Chicago, Dunham staged the *l'ag'ya* of Martinique, which culminates in a warrior dance. She wrote about it the following year in *Esquire*:

> It is the player of the *pit bois*, or little wooden sticks, who sets the basic rhythm, the drummer, who indicates the movements of the dance, the advance and the retreat, the feints, the sudden whirls and lightning like leaps in the air to sharp drops flat on the ground. He indicates the marking time as the two opponents eye each other, each anticipating every gesture on the part of the other. He keeps them there, hypnotized marionettes on a string. Then he hurls them into an embrace and as suddenly tears them apart. He draws them to a crisis as their excitement and that of the crowd mounts, and again to a finale as they become exhausted. With the true finesse of a stage manager he arranges and re-arranges them to the best advantage.

15 See Herskovits 1937, esp. 177–198, "Vodun Worship: The Dance."
16 See especially Aschenbrenner 2002, chap. 5, "Anthropology and Dance."
17 Clark and Johnson 2005, 386.
18 "Thesis Turned Broadway" (1941), in Clark and Johnson 2005, 214–216.

With the quick perception of a director he senses the reactions of the audience. As the hidden prompter in the little box beneath the footlights carries each breath of the opera singer, so he lives the performance with the two contestants. A real *l'ag'ya* is a pantomime cockfight. But I have seen the dance of the cockfight in the cockpits of Jamaica; the cockfight itself in Haiti, and I find no parallel between the droll, staccato strutting, mincing movements of this mimicry and the deep roll of the *l'ag'ya.*[19]

Dunham's dance career began in Chicago in 1938 and soon included seasons on the New York stage in 1939–40. Her first appearance in film dates to 1939, while her second, in *Stormy Weather*, released in 1943, included her entire troupe. In 1948, she went on her first European tour, including a run at the Prince of Wales Theatre in London, performing to admiring reviews and the occasional presence of royalty. She remarked that Europe saved her company, and the next years would include frequent returns to the countries she liked most, France and Italy—and those she liked least, Sweden, Switzerland, and Austria.

Katherine Dunham and Bernard Berenson met during her European tour of 1948–49.[20] She had read about Berenson in *Life* magazine, and was brought to lunch at I Tatti by Serge Tolstoy, the son of the novelist. She began the correspondence after this meeting: "Dear B.B. (Life says that's what friends call you . . .)." She continued it with a letter from Stockholm a fortnight later:

> Dearest B.B. . . . Let me just say that I have now joined your long list of admirers. Unfortunately I am not adept enough in the field of painting to do little more about it than be thrilled by it on occasion; I do however trust myself always in personal judgements and for me my pleasure in knowing you lay in your vitality, charm and wisdom that are found only in truly great people. All of this is reflected in everything around you. Well enough of compliments . . .[21]

The language of her letters quickly moves from friendship and admiration to love of some sort, as far as this was possible between a married forty-year-old woman and the

19 Katherine Dunham (writing as Kaye Dunn), "L'ag'ya of Martinique," in Clark and Johnson 2005, 201–207, esp. 202–203.

20 There is conflicting evidence for the date of their first meeting, which took place either in 1948 or 1949. In an interview in the *San Francisco Chronicle* (Hagan 1955), Dunham says she was brought to lunch at I Tatti by Serge Tolstoy in 1948, and Samuels places her visit in that year as well (Samuels 1987, 517). Her first letter to Berenson, written from Antwerp, seems at first sight to be dated 9 May 1945. The final digit is hard to read, however, and the year 1945 is impossible (though it is used for the date parameters in *Bernard Berenson: An Inventory of Correspondence* [Berenson 1965, 29]). It could also be read as 1948, though in the letter, Katherine refers to the 1949 article "Life Calls on Bernard Berenson" (*Life*, 11 April 1949, 158–164, available online through Google Books, searching "Berenson Life 1949"; my thanks to Jennifer Snodgrass for bringing this internet link to my attention). The article includes the phrase "Bernard Berenson, who is known as 'B.B.' to his friends" (159). The letters that immediately follow in the correspondence are clearly dated May 1949. I tend to think 1949 is the correct date for their first meeting.

21 Dunham to Berenson, 20 May 1949, Bernard and Mary Berenson Papers, Biblioteca Berenson, Villa I Tatti—The Harvard University Center for Italian Renaissance Studies (hereafter BMBP).

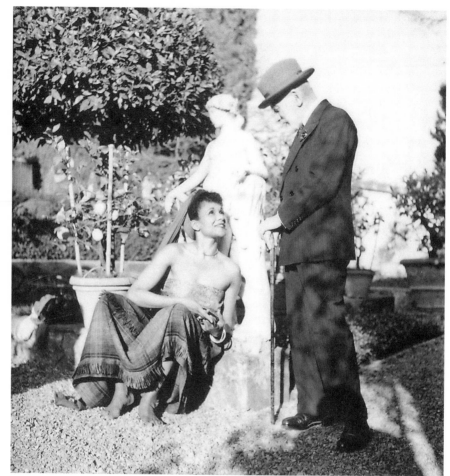

1

Bernard Berenson
and Katherine
Dunham in the
garden at I Tatti,
ca. 1950. Bernard
and Mary Berenson
Papers, Biblioteca
Berenson, Villa
I Tatti—The
Harvard University
Center for Italian
Renaissance Studies.

eighty-five-year-old Sage of Settignano. The initiative seems to have come from Katherine. Nicky Mariano astutely observed this general pattern: "Perhaps in his relations to women, whether serious or superficial, he always preferred to let them take the first step. Like the guests of *Schlaraffenland* he liked to have the roast pigeons fly into his mouth."[22]

The affection and admiration of this dynamic black intellectual and artist took Bernard somewhat by surprise, but he felt the magnetism. Photographs taken in the I Tatti garden of Katherine dressed in an exotic Orientalizing costume may date to this occasion (Figs. 1 and 2).[23] A passage in Bernard's diary shows what he was thinking on this visit:

> Katherine Dunham, looking like an Egyptian queen, like Queen Ti, dressed in stuff that clings to her, although of a quite current cut, particoloured green checkered with red, draping rather more than clothing her. Whence this sureness of

22 Mariano 1966, 39.
23 One of the photographs is reproduced in Samuels 1987, 490–491, fig. 35.

Joseph Connors

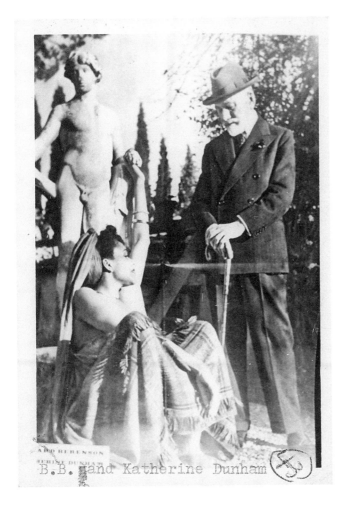

2

Bernard Berenson and
Katherine Dunham in
the garden at I Tatti,
ca. 1950. Bernard and
Mary Berenson Papers,
Biblioteca Berenson,
Villa I Tatti—The
Harvard University
Center for Italian
Renaissance Studies.

colour and its creative use, positive, bold, and not negative as in most of us, that
seems a birthright of the Blacks? Or is it that dark chocolate or dark bronze is a
background on which all colours look well, and so encourages the inventive and
courageous use of them? Be that as it may, Katherine Dunham is herself a work of
art, a fanciful arabesque in all her movements and a joy to the eye in colour. I won-
der whether her performance will enhance these qualities for me.[24]

He explained his feelings in a letter the next day to his long-lasting confidant in
Naples, Clotilde Marghieri:

Yesterday we all went to see Katherine Dunham and I was completely hypnotized
by the tam-tam effect of it all, its appeal to what in one is almost pre-human. There
lurks in me a stern Puritan whom all this alarms; yet I could not help enjoying it,

24 Bernard Berenson, diary, 26 February 1950, in Berenson 1963c, 162.

like Saint Augustine's penitents who confessed they could not help enjoying it when raped by the Vandals.[25]

Clothilde knew Bernard well enough to see that he was falling in love a little, once more, and she wrote him back:

> I just heard from Derek [Hill] that Katherine Dunham is coming back from Paris to say farewell before she leaves. Instead of feeling jealous I felt admiration for her . . . and envy. Yes, a sort of envy not of her affection for you, not of yours for her. But of her youth, beauty, energy, health and spirit of enterprise, *vitality* in a word, which in her must be developed to the fullest, and in me is declining. And now I understand your admiration for her, and her nostalgia for the world you represent. How I should have liked to meet her and see the two of you together![26]

Bernard wrote back, downplaying Katherine's charm to assuage Clotilde's jealousy:

> I fear I must disenchant you about Katherine Dunham. . . . I doubt whether she has any feeling for me of a "sentimental" nature. She may feel a bit better for being treated as an equal by a countryman of a country where blacks are not received in private. It may be a feather in her cap to be known as frequenting I Tatti.
>
> On my part, I admire her as an artist just as you would, and with a little sex feeling. She has, as you say, great vitality and elegance and creative taste. I was entranced by her performance and it still haunts me. Last time I saw her, two days ago, her husband, a white Canadian who does the costumes and scenery of her performances, was talking to Salvemini and Raymond Mortimer. She sat apart with me and began to tell me how she feels with her personality absorbed completely by the institution she has herself created. And the tears flowed as we talked.
>
> There it is, my dearest of Darlings. Perhaps my "success" with women now is so great because something in me leads them to reveal themselves to themselves. I long to see you and to embrace you. B.B.[27]

Yet Katherine remained on his mind, and he found her rare visits fascinating:

> Katherine Dunham talked with no Negroid lisp or richness of voice, on the contrary with a cultivated accent and vocabulary, and revealed an unusually subtle but rational personality, completely free of mannerisms of any kind. She complained of many things, but most of all that New York was ruining her art (and all the arts) by insisting on mere newness. To produce it creators of a ballet had to

25 Berenson to Marghieri, 27 February 1950, in Biocca 1989, 253.
26 Marghieri to Berenson, 28 March 1950, in Biocca 1989, 253.
27 Berenson to Marghieri, 31 March 1950, in Biocca 1989, 254–255.

hurry and fuss, and do anything sensational, being given no time to meditate and mature. She thought the best ideas come while daydreaming, ruminating, and not when searching as for a bull's-eye in the dark.[28]

So we have Bernard's side of the conversation. What was Katherine thinking? At the time of their first encounters in 1949 and 1950, she badly needed a guiding star. Her cherished older brother Albert, who had watched over her through university and introduced her to theater and dance, died in 1949 after years of hospitalization for depression. He had made a brilliant start as a philosopher at Chicago, but then, when he tried to assume an academic career, he hit the color ceiling, went into a tailspin, and withdrew into himself. His death affected Katherine enormously, and she returned to seek help from her former lover, the psychologist Erich Fromm. Berenson was a symbol of impeccable high culture to many, Katherine included, but for her he also assumed another dimension. She projected emotions onto him as one might onto one's analyst. From Paris, she would later write of her feelings of loss as she could not be near Bernard and his great store of knowledge and wisdom and perception: "I need a master badly at this moment and unless I am blind there are practically none left in the world."[29] She hoped that Berenson, with his vast erudition, might help her find a fitting subject for a play or movie that she would produce with her troupe.[30] In 1952, she wrote to him of her thrill on becoming pregnant, and the supportive reaction of her husband John, even though he knew that the child could not be his, and when she lost the pregnancy, she described her dejection to Bernard.[31] Strangely, Katherine never mentioned the daughter that she and John Pratt adopted in Paris at the age of four in 1951, Marie-Christine Dunham Pratt.[32]

The beautiful surroundings of I Tatti meant something to her as well. In 1949, she had acquired an estate in Haiti, Habitation Leclerc, which had been built by General Charles Victor Emmanuel Leclerc, husband of Napoleon's sister Paulina Bonaparte. Gruesome memories of the torture of slaves during the campaign to subdue the black insurrection on the island were attached to the property; these ghosts had to be exorcized and the grounds put into order. In I Tatti, she could see an example of a landscape made fruitful and beautiful, an ideal toward which Habitation Leclerc could aspire some day. From Buenos Aires, she wrote to tell Bernard of the many times that she had seen in her mind's eye the quiet avenues of I Tatti, and heard the buzzing of the bees, as on the first day they sat in the empty greenhouse:

> You have no idea the number of times that I see in my mind's eye those quiet avenues of "I Tatti" and even hear the buzzing of the bees or flies or whatever they were that first day as we sat in the sunlight in the middle section of the empty

28 Bernard Berenson, diary, 2 April 1950, in Berenson 1963c, 166.
29 Dunham to Berenson, Paris, 14 December 1951, BMBP.
30 Dunham to Berenson, Stockholm, 17 June 1949, BMBP.
31 Dunham to Berenson, London, 24 January 1952, BMBP; Dunham to Berenson, London, 7 February 1952, BMBP; and Dunham to Dr. Sacha Nacht, London, 10 February 1952, BMBP.
32 Clark and Johnson 2005, xviii.

greenhouse. It was a distinct childhood sound and made me feel like being somewhere again that was warm, sunny and protected. I am sure that over the course of these two thousand years and more I have seen things and places as beautiful as your habitation, but they evidently have escaped me or at least are not a part of the level on which I now live and dream. It is interesting to note as I write this and unfold these thoughts to you that one of my many recurring dreams for a number of years has been a dilapidation and decay and material deprivation which was some part of the material surroundings of some part of my childhood and I work in these dreams for years and years to clean, paint, scrub, disinfect, de-mouse, de-rat and make habitable and charming this dilapidated building. Undoubtedly there is a great sharpening of impressions and it can't have been as bad as all that, besides it is more a symbol than anything else. I think I have then hit upon our "anima" correspondence and all of these things which surround you as a waking counter-balance.[33]

We have already seen Bernard's reaction to her performance in Florence in 1950. He saw her again in Rome in 1952, and recorded his impressions in detail:

Performance of Katherine Dunham. All based on Negro beliefs, rites, and holiday extravagances. From our point of view, it is a call of the wild, and a very successful one. It wakes up and brings to life in one even like myself the sleeping dogs of almost prehuman dreads, aversions, aberrations, appeals. The shrieks so staccato, the metal of the instruments, the dry crack of castanets, the shimmy-shakes, the stampeding, all go to one's marrow. How all this would have horrified most of us fifty years ago. Should have found it squalid, vulgar, shaking [shocking?], and now babes and sucklings come with their parents to see and hear and be entranced, hypnotized, overwhelmed. We feel at last free to return to the primitive, the infantile, the barbarous, the savage in us, even the way Greeks of the best period did to Bacchic rites, so wild, so cruel, so filthy![34]

However brief their meetings were, an attachment came to be formed between this unlikely pair. Katherine was the one who initiated it and nourished it with frequent letters written during her far-flung travels with her troupe. From Zurich, she reminded Bernard of the pleasure of receiving letters, the familiar handwriting that testifies that one is thought of, that one counts: "When I read 'Dearest Katherine' or 'my darling' I feel

33 Dunham to Berenson, Buenos Aires, 14 November 1950, BMBP.

34 Bernard Berenson, diary, 20 October 1952, in Berenson 1963c, 279, with photograph of Katherine Dunham between 470 and 471. Mariano transcribed but omitted the following passage from the publication of Berenson's diary: "Dec. 6, 1952. Non-Europeans still fill me with instinctive distaste that I have to fight against and the American West African I encounter with a repulsion I find it hard to get over, even in the case of a woman so remarkably intelligent intellectual and truly humanized as Katherine Dunham" (courtesy of Sanne Wellen).

such pleasure and comfort," she confided.[35] From Lima, she wrote that she composed letters in bed, in her dressing room, in the bathtub, but that this was dangerous because they seemed to be getting done but weren't.[36] From Port-au-Prince, she wrote that "For nights on end I lie in bed and write to you on the fabric of my mind and imagination."[37] From Paris, she wrote that almost every day she composed a letter or at least a note: "They are not on paper, but I will have to count on you to feel this communication."[38]

When Bernard was at the height of his powers as a connoisseur he used to keep a fake Renaissance painting on his desk to invite the admiration of the unwary. Now he used Katherine as a touchstone in judging authenticity in people. If they approved of her, they might be all right:

> Lady Mallet hitherto treated me as if I were a bad smell, and I felt toward her somewhat as I did toward Edith Wharton between our two first meetings. Yesterday she spoke of Katherine Dunham with such penetrating, such subtle, and such delicately human admiration, that I there and then concluded that if chance favoured, she and I could be intimate friends. Even if for some interested reason she revealed what was in her, and not of any interest in me, the revelation was unmistakable, and changed my pattern of her.[39]

Southland

For a brief moment at the beginning of 1953, this new friendship was sorely tested. Katherine engaged in the most daring project of her career, and Bernard advised against it. Their love was put on ice, briefly, only to return more ardently and with deeper understanding than before. The problems arose over Bernard's attitude to *Southland*, a ballet Katherine performed about a lynching in the American South.[40]

As early as 1937, Katherine had introduced the theme into the ballet *Tropic Death*, performed at the Young Men's Hebrew Association in New York. In it, her teacher, Talley Beatty, was cast as a fugitive from a lynch mob. The subject was highly topical in these years. Between 1936 and 1946, forty-three lynchings of mostly southern blacks were reported, as well as hundreds of close escapes. There were no prosecutions. The National Association for the Advancement of Colored People had fought for a federal antilynching bill for thirty years, but it was killed in the US Congress in 1950. Protest came in poetry, music, and dance, especially in *Strange Fruit*, the song of 1930 that was popularized by

35 Dunham to Berenson, 17 August 1950, BMBP.
36 Dunham to Berenson, Lima, 24 January 1951, BMBP.
37 Dunham to Berenson, Port-au-Prince, 13 June 1951, BMBP.
38 Dunham to Berenson, Paris, 29 October 1951, BMBP.
39 Bernard Berenson, diary, 22 November 1952, BMBP, but not included in Berenson 1963c (courtesy of Sanne Wellen).
40 An in-depth study can be found in Hill 1994, reprinted without photographs in Clark and Johnson 2005, 345–363.

Billie Holiday and interpreted in dance by Pearl Primus, as well as in Talley Beatty's dance of 1947 on the theme of Reconstruction in the Old South, *Southern Landscape*.

Katherine created *Southland* while on tour in South America in 1950–51. In the preface to the French version, she says:

> Though I have not smelled the smell of burning flesh, and have never seen a black body swaying from a southern tree, I have felt these things in spirit... Through the creative artist comes the need to show this thing to the world, hoping that by exposing the ill, the conscience of the many will protest.[41]

Southland was presented in Santiago, Chile, in January 1951, with music incorporating blues and spirituals by the Jesuit composer Dino Di Stefano. At center stage was a magnolia tree and a southern mansion. Black lovers, Lucy and Richard, embrace under the tree until the drunken, quarrelsome white lovers, Julie and Lenwood, enter. Lenwood beats Julie and leaves the scene, but when she awakes and sees Richard, she accuses him of rape and advocates his lynching. The crime is soon carried out by the crowd. Lucy has left the scene, and when she returns, she finds Richard's body. There follows the song *Strange Fruit*, and then the funeral procession, moving among singers and gamblers in a smoky cabaret, where a black man, in a symbol of vengeance, plunges a knife into the floor.

A communist journalist in Chile told Katherine that there would be no reviews of *Southland* other than his own, since the United States would cut off newsprint to any paper that dared publish one. The American ambassador in Santiago, Claude G. Bowers, had written a book in 1929 criticizing Republican policy during Reconstruction and justifying the rise of the Ku Klux Klan. *Southland* was not performed again during the company's South American tours of 1951 and 1952, but during its next European tour, Katherine rehearsed the ballet in Genoa and presented it in Paris in January 1953. She tried to see the American ambassador beforehand, but was told he was out. The American cultural attaché who received her at the embassy simply said: "We trust you and your personal good taste and we know that you wouldn't do anything to upset the American position in the rest of the world."[42] Katherine later said: "He wouldn't go any farther. So I did it." But she paid a price.

Reviews were mixed, with predictably opposite reactions from the conservative and left-leaning press. *Le Monde* summed up the puzzlement of some critics by asking, "What has happened to the anthropologist we once admired?" Katherine was glad, at least, that the communist newspapers had not used the ballet for anti-American sentiment, and she felt that by showing that freedom of speech still remained a basic principle of American democracy, the performance had done more good for the American government than it realized. Her strong feelings were not widely shared, however. Her own company had not wanted to perform the ballet—they wanted to shed feelings of racial difference, which

41 Program of *Southland*, Paris, Palais de Chaillot, January 1953, BMBP.
42 Dunham to Berenson, Paris, 1 February 1953, BMBP.

they felt they had succeeded in doing on tours outside of America. Paris had accepted them, and they did not want to change the world, yet the dance made them more conscious of color than they wanted to be.

Southland was not maintained in the company's repertoire after its performance in Paris. The dance historian Constance Valis Hill sees a kind of quiet censorship at work on the part of the US State Department. In spite of its policy of supporting American music and art abroad, the American government never subsidized Katherine's troupe, and it refused permission for her to accept an invitation from China in 1956. Hill sees the lack of governmental support as the reason for the eventual dissolution of the company. The dance was last performed in the Apollo Theater in Harlem in 1965. It inspired other protest dances: Talley Beatty's *Road of the Phoebe Snow*, Donald McKayle's *Rainbow 'Round My Shoulder*, Eleo Pomare's *Blues for the Jungle*, and Alvin Ailey's *Masekela Language*. Hill concludes: "Although *Southland* instigated the dissolution of Dunham's company, it laid the moral groundwork for subsequent expressions of affirmation and dissent and may forever embolden all those who dare to protest in the face of repression."[43]

Berenson has entered the Dunham literature as the disapproving critic of Katherine's brave protest. Indeed, he did advise her not to perform the piece in Europe. However, their letters tell a nuanced story in which a close friendship is tried but survives and grows deeper than before. Let us allow the protagonists to speak for themselves.

Katherine did not at first tell Bernard about the performance of *Southland* in Santiago in 1951, but on 1 November 1952 she wrote to him saying that she was going to perform *Southland* in Paris. She visited I Tatti around Christmas 1952 and left in some distress, which she recounted in a letter written a year later: "Just a year ago Thursday we were together and I left your house in such despair, but since in essence we were both right there is nothing lost but rather much gained."[44] Early in the new year of 1953, still in Genoa, she wrote again about the lynching ballet that she was about to perform. This last letter is missing, but we have Bernard's reply, written on 6 January 1953. He assumed that the ballet was still in the planning stage and advised her against it. Using an unfortunate metaphor, he said that if it was too late for a miscarriage or abortion, she should have it born in America. If it were produced in Europe, he felt it would fuel anti-American propaganda and damage her career.

By the time Katherine received Bernard's advice, however, *Southland* had already opened at the Palais de Chaillot on 9 January 1953. Courageous but vulnerable, Katherine was hurt by his discouragement. It seemed that a precious friendship had been severed by him, unfairly, because she had been faithful to her innermost feelings. A month later, she wrote a long letter to Bernard from Paris about the distress she felt over his advice. She acknowledged his feelings toward the State Department and its power to hurt her career, but she dwelled on the importance of integrity. She was upset that such a deep affection as that which had existed between them could be abruptly terminated by an act that had grown out of integrity. She stressed her innocence in performing *Southland*, "a thing to

43 Hill 1994, 7–8.
44 Dunham to Berenson, Rome, 22 December 1953, BMBP.

me of great beauty and of a newness in the theater, and an expression of some of the passion which is in me just as much as those things that you have seen and admired." She went on to mention the paradoxical reactions in the French press, with praise coming from both the Gaullist right and the communist left. Most of all, she was hurt by "this irrevocable rejection," which threw a dark cloak around her whole being for the weeks she was in Paris.

Bernard was not in Paris at the time of the single performance and never saw the ballet. Once he received a copy of the Paris program, he realized that it had already been performed, and that Katherine was terribly hurt by his letter. He immediately tried to control the damage and repair the friendship. He wrote on 7 February 1953 to tell her that he would not have counseled stopping the ballet had he known that it was already in production. He told her that the synopsis was fascinating and that he wished he could see the ballet staged. A month later, he wrote again to reassure her of his love and to complain about the distressing reviews he had read in the Parisian press about her performance. By the summer of 1953, the friendship had been repaired, and the electricity flowed even more deeply than before. From Reno, Nevada, she wrote him a four-page typed letter covering subjects ranging from the segregation and squalid living conditions of blacks to the recently detonated atomic bomb. She returned to *Southland*:

> But believe me, B-B-, I do not speak with bitterness or resentment or any of the things that you seemed to feel that I was trying to express or satisfy in myself in *Southland*. I do feel and have always felt as as [sic] sort of objective observer in this thing. My own life had been so different that I see this as one of the vast problems of the entire human race.... I had to do Southland, and I believe that many an American, even in the diplomatic service, admired the amount of strength, not courage, that it took to do it, *not* for propaganda or negation of one's national heritage.[45]

The correspondence of these two unlikely friends continued with its old intensity and intimacy in the six years between *Southland* and Bernard's death in October 1959. Once again, Bernard assumed the role of analyst, while Katherine combined the roles of descriptive anthropologist and self-aware analysand. She even sent him a carbon copy of the nine-page letter that she wrote to her husband, John Pratt, in 1957, detailing all that was wrong with their marriage, which seemed on the brink of dissolution. In that letter she told John that "BB's constant, constant letters just about saved my life on one or two occasions."[46]

Bernard told Clotilde Marghieri in 1950 that he admired Katherine "with a little sex feeling." It might have been a lot more had he been younger and had they had more time alone together. Their few meetings, however, were at I Tatti, where Nicky Mariano was on hand to welcome and to watch. In any case, Bernard spelled out his attitude to sublimated

45 Dunham to Berenson, Reno, Nebraska [*sic* for Nevada], 17 June 1953, BMBP.
46 Dunham to Berenson, 13 November 1957, BMBP.

sex in a passage in his diary, written ostensibly about Hortense Serristori, but applicable also to Katherine:

> Friendships with women are never sex-free, but sublimated into an atmosphere of delicate, subtle tenderness. It is an exquisite relation, and perhaps the inspiration of much of the very noblest painting, music, and above all of poetry. It has played a great part in my own life, ever so much more than mere animal sexuality.... Sublimated sex can last a lifetime. It certainly has in mine.[47]

Katherine felt free to write about sex to Bernard in the way that one might speak of it to an analyst. She confided to him that she was afraid of actual contacts, even when they seemed successful, and that this was what was wrong with her sexual life. From Zurich, she wrote to him about the easy sexual encounters of her dancers, which contrasted with her own loneliness:

> But the amazement to me is the chance meeting in a bar, the greeting at a street corner, the signing of an autograph at the stage door that results for these extroverted young animals in a night, or maybe just moments of completely abandoned pleasure. Our backgrounds are reasonably the same, so I can no longer lay my "inadequacy of the moment" at the doorstep of Puritanism. It must be the result of a gradual, continual system of either insurance against harm or refinement of taste over the years. And we can be so trapped by our refinements. So that while they burst with the curiosity of what each day may bring to them as an individual, while they compare teeth marks and other "épreuves" of passion, I read and think and work and wonder if my life would seem any more livable were my day revolving around a certainty of anonymous passions at night.[48]

It was not sex that Katherine wanted from grandfatherly Bernard, but understanding bathed in love. A few hours after leaving I Tatti, she wrote a love letter from the Hotel Baglioni in Florence:

> I have just left you and am so used to arriving at the rail crossing (that seems to be a landmark) sad and alone. This time I suddenly melted into floods of tears. I know that when we were alone for those few moments something wonderful happened—that I experienced a true love and meaning of love that was too big for this mortal self. And I have left with you something that perhaps you gave me a thousand years ago—a part of myself that is deep and inner and that I am scarcely aware of, only through feeling.
>
> I sat in your beloved presence a different self... [You] made me feel fuller and calmer and more sure of the great plan of life and its inevitable circular

47 Bernard Berenson, diary, 8 June 1957, in Berenson 1963c, 485.
48 Dunham to Berenson, Zurich, 19 November 1952, BMBP.

motion.... You must feel me breathe into you my love, my warmth, and the saving grace of this dark blood.... Stay with me, dearest B.B. and stay with all of us who love you as I do. [49]

In her letters, Katherine offered Bernard her anthropologist's eye, letting him see places he would never visit and hear of societies he would never know in person. In 1950, she wrote to him from São Paulo, Brazil, about witnessing sacrifices of goats, sheep, and chickens at ceremonies called *macumbas*, where the officiating priest became possessed of a warrior god and started eating raw livers. [50] She added that it affected the troupe's appetite for many days. In the long letter from Reno ("the last frontier in America") of 1953 that is quoted above, Katherine asked Bernard:

Can you imagine what it must be like to work for a full hour before, or rather surrounded by, within touching distance, the faces and bodies of thugs and gamblers and hustlers and prostitutes and exploiters and touts and all of the ones that are the only ones who can afford these places, and while one works with perspiration dripping over ones false eyelashes and knee with a floating cartilage threatening betrayal at any minute and muscle and joint and heart weariness struggling to take control, this great sodden beast eats steaks, drips spaghetti, guzzles bourbon, talks, laughs, and once in a while gets up to go to the water closet . . . [51]

She then touched on the theme of sex and the erotic element in her art:

The success we have at these places is very strange. It seems to be chiefly on an erotic basis as that is the most direct way to reach them. This type of person comes to a place like that to see Negroes only as a burlesque character, or to have their sluggish currents pepped up by a jazz beat, by the out-do all that the human body seems capable of doing that has meant the success of the Negro tap dancer . . . always something ingratiating, physical agility. Or the Negro singer that transports them in abandon. The foreign element that we bring puts them ill at ease at first . . . then the drums reach something, though they don't know just what. My form of sex is more refined than they are used to, but sets them to thinking that they might be missing something. Above all, I believe that they are impressed by a certain intellect that they can't define, and a certain untouchability that makes them wish that they had it themselves. [52]

49 Dunham to Berenson, Florence, 11 March 1954, BMBP.
50 Dunham to Berenson, São Paulo, 14 July 1950, BMBP.
51 Dunham to Berenson, Reno, Nebraska [*sic* for Nevada], 17 June 53, BMBP.
52 Ibid.

In October 1954, Katherine wrote from Buenos Aires about conditions under the Peronist regime after the passing of Evita Peron.[53] She gave a masterly summing-up of her visit to Mexico,[54] and Bernard thanked her, recalling his own early interest in pre-Columbian art:

> Pity that I have not been able to get there, altho' my interest in its art goes back to my college days. Then I discovered at Harvard a show full of Aztec and Mayan sculpture, and was deeply impressed. I have since then tried to see all that could be seen out of Mexico itself, and I have most of the illustrated publications in the library of I Tatti.[55]

From Las Vegas, Katherine sent him some samples of her "prose-poetry."[56] From Melbourne, she wrote in 1956 about giving a speech for an Aboriginal girls' hostel. From New Zealand, she wrote about attending a gathering of three thousand Maori from several tribes to bid farewell to a Maori girl leaving for England to play in a tennis tournament: "The songs and dances in native costume were so full of affection and spiritual care for the girl—they were so proud, and so integrated that I looked on with a certain envy, I must admit. Surely there are not many such people in the world. Handsome and open and undestroyed by white colonization."[57] From Kuala Lumpur, she wrote in 1957 about the excitement in the air as freedom was about to be granted from the British colonial occupation, but also of the fears inspired by the communist bands sweeping in from the jungles to the north and infecting Singapore with strikes and riots.[58]

In 1957, Katherine disbanded her company. Financial travails were part of the cause, but she was also growing tired of the tensions within. She wanted to find a new career. In 1949 and 1950, in Paris and Buenos Aires, she had tried painting. Seriously misjudging his aesthetic preferences, she sent photos of her canvases to Bernard, with a disclaimer: "They are not really paintings at all but expressions of a search of other selves which in me seem to be multiple."[59] What did Bernard think of her paintings? A Florentine newspaper clipping shows Katherine and her dancers in the Boboli Gardens in 1950 (Fig. 3), and puts into a headline his improbable advice: *"Keep on painting,* says Berenson to Dunham."[60] But it is difficult to imagine that Berenson, who had shed his early admiration for Henri Matisse and Paul Cézanne and who was at that time engaged in a study of the decline

53 Dunham to Berenson, Buenos Aires, 17 October 1954, BMBP.

54 Dunham to Berenson, San Ángel, Mexico, 5 June 1955, BMBP.

55 Berenson to Dunham, Naples, 15 June 1955, Katherine Dunham Papers, Special Collections Research Center, Morris Library, Southern Illinois University, Carbondale (hereafter KDP).

56 Dunham to Berenson, Las Vegas, 11 March 1955, BMBP.

57 Dunham to Berenson, New Zealand, 23 March 1957, BMBP.

58 Dunham to Berenson, Kuala Lumpur, 20 July 1957, BMBP.

59 Dunham to Berenson, Buenos Aires, 14 November 1950, BMBP.

60 Camille Cederna, "Continui a dipingere disse Berenson alla Dunham," undated newspaper clipping, ca. 1950, with a photograph of Katherine Dunham with her dancers in the Boboli Garden, and a photograph of one of her paintings, BMBP.

of form in Western art, really approved. More honest was his encouragement for her to turn to writing: "I am sure there is a real woman of letters tucked away in you," he wrote in 1955. A month later, he continued: "Your bitter-sweet verses delight me. They are so charming, and yet so deep-sounding, light, almost gay, but with a distant rumbling of a tragic sea . . . [To get them published] TRY younger people if there be any you suspect of aesthetic heart and mind." [61]

After the return of her dancers to America from their last Asian tour, Katherine stayed in Japan in 1957 and 1958 to write her autobiography. She sent a draft to Bernard in February 1958, but he seems to have found it obscure and in need of correcting. [62] Indeed, although not a short book, it covers only her childhood and adolescence, not the formative years at the University of Chicago or the foundation of American black dance. Strong emotions welled up and kept her writing slowly: "It is so painful. I weep over many pages, but after five times, it will be writing, not emotion, I hope." When *A Touch of Innocence* came out in 1959, she dedicated it to Bernard.

The admiring affection between Bernard and Katherine echoes, in a more platonic vein, Bernard's ardent affair with Belle da Costa Greene (1883–1950) a generation earlier. [63] Born Marion Greener, Belle was the daughter of Richard Greener, the grandson of a Virginia slave and the first black person to graduate from Harvard College. His career, at least in its early stages, was spent in campaigning for the right of suffrage and for public education for blacks in the post–Civil War era. Greener openly identified with his black ancestry and was an active advocate of racial equality, but he also claimed the right to live in white society, as befitting a cultured and educated member of the middle class. His wife and family, however, all light-skinned, disassociated themselves from their father's identification with blacks. Belle, in particular, broke with three generations of black activism to live as a white person. She adopted a Portuguese name, da Costa, to explain her Mediterranean complexion to the many people who noticed her exotic looks. It was a strategy adopted gradually between 1894 and 1900, and it served her well in the spectacular career she developed under the patronage of J. Pierpont Morgan and his family. The severe and unpleasant Isabella Stewart Gardner, stung by Belle's criticisms of her collection, thought of her as a "half-breed." [64] But Belle never thought of herself as black, and admitted only veiled and humorous allusions to her dark complexion. Most of her acquaintances and romantic attachments in New York society accepted her fiction of a southern Mediterranean ancestry, and admired her beauty, vivacity, exotic looks, and growing knowledge of rare books and manuscripts. Bernard never alludes to questions of race, although Mary and Nicky sensed there was something exotic about this "most wild and woolly and EXTRAORDINARY young person" [65] who swept Bernard off his feet.

61 Berenson to Dunham, Settignano, 29 March 1955, KDP.

62 Dunham to Berenson, Tokyo, 10 February 1958, BMBP.

63 There is a brief but fascinating chapter in Strouse 1999, 509–520, but the definitive study, with probing thoughts on larger questions of race in the period, is Heidi Ardizzone's *An Illuminated Life* (2007).

64 Hadley 1987, 463.

65 Ardizzone 2007, 123.

3

Katherine Dunham
and her troupe
in the Boboli
Gardens, ca. 1950.
Bernard and Mary
Berenson Papers,
Biblioteca Berenson,
Villa I Tatti—The
Harvard University
Center for Italian
Renaissance Studies.

Katherine Dunham represents a diametrically opposite stance on race. Also a light-skinned African American, she actively identified with the American Negro. This was a conscious choice. Race was not a barrier for her at the University of Chicago the way it would have been at most elite universities. In her fieldwork in Jamaica and Haiti, her color was a distinct advantage in achieving empathy with the communities she studied. Katherine fought discrimination all her life, protesting in hotels and theaters where her troupe was not treated equally.[66] Any attempt at "passing" or living as white was simply out of the question for this strong personality.

Bernard and Katherine each overlooked barriers that are usually effective in keeping elective affinities from becoming passionate. For Bernard, it was the barrier of race, which he lowered to accept Katherine's offer of "the saving grace of this dark blood." The barrier

66 Dunham mentioned hotels that refused persons of color in São Paulo (Dunham to Berenson, 14 July 1950, BMBP); Reno, Nevada (Dunham to Berenson, 17 June 1953, BMBP); Las Vegas (Dunham to Berenson, 24 January 1955, BMBP); and San Francisco (Dunham to Berenson, 12 October 1955, BMBP).

Katherine overlooked was that of age. Forty-four years would in most cases constitute a firebreak that ardor could not overleap, but Katherine was completely nonchalant about the issue. Early in their relationship, when she was preparing for a visit to Venice, she offered to fly to see Bernard:

> Then on one of these inbetween days I will make it a point to take advantage of this technological age and fly to whatever point you may be stationed. Then we can talk about material for a play, the glories of the Renaissance, your beloved Italy, my beloved Haiti, bronze statuary, and those utterly unfounded notions of yours about time and age, as I am sure that you realise that extending backward and forward there is no such thing as a conclusion of anything, even the human mechanism at 84, so I count on you for that eternal youth which I enjoy myself, because at 38 I feel neither young or old, but just as timeless as I am sure you feel at 84, and as I am sure I will feel at 187.[67]

The meaninglessness of age in relationships is a theme that returned often in Katherine's letters. She reassured Bernard that it was the inner man she loved, notwithstanding the waiflike weakness of his octogenarian and then nonagenarian body. On his side, Bernard was always conscious of this barrier, and he was all the more grateful to Katherine for ignoring it. Living to his age was an adventure he did not recommend to anyone. In 1955, he wrote to her:

> I have weathered the cape of 90. I have avoided ceremonials by refusing to go to Oxford to receive an honorary degree, and by keeping away from Rome and Florence.... There have been "gratifying" words about me in many American, English, Italian, even French and German papers. They don't mean much to me and do not reconcile me to myself—a self toward which my esteem is uncertain and my affection dubious. I cling to you and to the few who really love me. You ask me why[.] I cannot tell.[68]

And Katherine, on her part, assured him, when he was ninety-one, that she kept a picture of him above her mirror: "I am so happy that it is never too late to love."[69] In 1957, when he was ninety-two, she replied to his laments: "Don't worry about your looks. You are there inside the same dear and alert self as always—I can tell from your letters. Do you still wear the shoes that I admire so much?"[70]

After Bernard's death in 1959, Katherine did not become a writer or a painter, but rather a teacher and a social activist. Her last Broadway performance was in 1962, but she choreographed *Aïda* for the Metropolitan Opera in 1963. She founded the Performing

67 Dunham to Berenson, Amsterdam, 15 July 1949, BMBP.
68 Berenson to Dunham, 23 July 1955, KDP.
69 Dunham to Berenson, 31 December 1956, BMBP.
70 Dunham to Berenson, 22 November 1957, BMBP.

Arts Training Center in East Saint Louis, Missouri, in 1967, and the Katherine Dunham Museum and Children's Workshop in the same difficult, ghettoized city in 1979. It was here that she initiated a fast to call attention to the plight of Haitian refugees turned away from the United States in 1992.

Bernard Berenson thought of Katherine Dunham as a living work of art, beautiful like a bronze statue, and animated by a deep inner vitality. She appreciated and in fact needed this response from the ultimate aesthete, and reciprocated with a love that survived his critique of *Southland*. Her letters lit up his final decade, and his offered her an anchor in times of emotional upheaval and constant global travel. Fresh and not at all cloying, they still make wonderful reading.

~~~~~~

# Appendix

*Correspondence of Katherine Dunham and Bernard Berenson*
*Regarding the Performance of the Ballet* Southland *in Paris in January 1953*

**Doc. 1.** Dunham to Berenson, Santa Margherita Ligure (Genoa), 1 November 1952. (Bernard and Mary Berenson Papers, Biblioteca Berenson, Villa I Tatti—The Harvard University Center for Italian Renaissance Studies [hereafter BMBP].)

In Paris in January I plan to do our ballet *Southland* which we did only once in Santiago, Chile. Part of my feeling of incapacity and creative immobility comes from not saying what I want to say—that is, having more to say than the medium which I have chosen permits.

**Doc. 2.** Berenson to Dunham, Settignano, 6 January 1952 [*sic* for 1953]. (Katherine Dunham Papers, Special Collections Research Center, Morris Library, Southern Illinois University Carbondale [hereafter KDP].) Berenson misdates the letter, forgetfully carrying over the old year 1952, although he wrote the letter in 1953.

Beloved Katherine,
Thanks for a dear word from Paris.
If you feel too far gone in pregnancy to expect a miscarriage or to have resource to an abortion you, an American of such destination must have it born in America. The child I have in mind, as of course you know, is the idea of turning a lynching into a ballet,—"suffering into song". If you produce such a ballet in the States, and it takes on there, you could bring it over to Europe. If you produce it here, it will serve only to give fuel to the fire of anti-American propaganda. All the communists in Western Europe will take it up, and the Soviets and their satellites from the Elbe to the Yangtse, will feast on it and more. A mad resentment will be roused against you in the United States. It may end by driving you to seek refuge in Russia.
Can you face such a possible result?
Therefore:—Either give up the idea, or carry it out and produce it in America.
Your loving friend
B.B.
P.S. Happily Nicky's health is improving.

**Doc. 3.** Dunham to Berenson, Paris, 1 February 1953. (BMBP.) Paragraph six is quoted in Hill 1994, 6, republished in Clark and Johnson 2005, 354.

Dearest B.B.,

I have put off writing to you for some time hoping that the distress which I felt leaving I Tatti that rainy night and have felt ever since would diminish. I know and respect all of your feelings towards State, many of which I have, but I know also that in your wisdom you must feel and know the importance of integrity to oneself and one's creative drive. And while I might have expected to have been abjured by you, I did not expect that a deep affection, to say nothing of the love that one individual can have for another—such as I thought we had—could be so rudely destroyed because of an action obviously growing out of a fundamental integrity.

I have turned every possible searchlight and inner eye on my feeling towards performing *Southland* at this time, and I must say that I feel absolutely innocent. It was a thing to me of great beauty and of a newness in the theater, and an expression of some of the passion which is in me just as much as those things that you have seen and admired. Amusingly enough it has been severely attacked not only by "right" press, but by even such a communist press as *Le Combat* from a theater point of view. It has been equally praised by the communist *Humanite*, by the extreme rightist Gaullist *Ce matin—Le Pays*, and in between has reached a storm of enraged criticism as well as personal attack not only on *Southland* but on me in general, because I have betrayed the French and not continued to give them the opiate which they first received in 1948. There have been as many exceedingly laudatory criticisms and a number of congratulations on my efforts to break away from the limiting category in which I had been placed against my will by the French. I have not, however, been approached by either communists or the communist press who I believe, since after all they are often very perceptive people, do not see anything either in the ballet or in the material for anti-American usage.

On one side I see repeated with the rhythm of an out of gear piece of machinery "music hall", "betraying of racial origins in emphasising orchestra instead of tam-tam", "cerebralism", "Sorbonnism", "intellectualism". On the other side I find words such as "beauty", "unforgettable theater", "courage," "improvement of production and technique", "charm, wit and fortitude."

Naturally I admit that I have been deeply grieved by some of the unkind remarks, but I would have been more deeply grieved had I betrayed myself. The next grief to this comes in the loss of your understanding and friendship, and in this I feel helpless because somewhere in me are roots stronger than I am, based probably more on intuition than reason, which seem to walk hand in hand with my own will and judgement so that I seldom falter in an act, and if I do I am almost always regretting and ashamed.

As to the repercussions of this ballet, its symbolism is far over the heads of most of the French and it is treated on the stage in a combination of symbolism and realism which they do not understand at all. Many Americans have seen it. Some do not like it a bit and others (not by any possible means or stretch of the imagination communist) have come backstage to thank me for making them think. A number of people, some of them southern, have met the company in various bars and told them how much they admired the ballet and the manner in which that particular subject was presented. I go out very little myself and therefore have small opportunity to meet this sort of person.

A few days before the opening in my distress I asked to see the Ambassador whom I know to ask his opinion. He was not in town but the Cultural Attaché very warmly recommended that I have no reserves in relationship to what the American Government might think and agreed with me that to stop the presentation when it is known that this work is repertoire would have a far more serious repercussion on the American Government than its presentation ever could. In my heart of hearts and with my own primitive animal intuition, I know also that this has done more good for the American Government than perhaps even they know, although I feel sincerely that some of them do. It has proven to the world that the thing of which they are being accused every day due to the acts of such people as Senator Macarthy and so forth, has not yet become a fact, and that freedom of speech still remains one of our basic principles.

In my opinion, since I know the truth with which the ballet is presented and its lack of propagandistic structure, I feel that the American Government has moved a step ahead in the eyes of European Government in not interfering and in calmly taking for granted this thing as they do articles in the various foreign editions of their publications on such subjects.

Literally it is documentary, and since I allowed the year 1952 to pass without performing it and there we[re] no lynchings in that year it is away ahead historically. Dramatically it is a high point in my own efforts at welding mime and motion. Choreographically it is extremely simple but with high moments of gymnastic beauty and plastic flow. Auditorally there is some beautiful singing in it and I myself like the orchestra arrangement. From a production point of view I feel that it is a real achievement in lighting and staging, especially with our own slender means. But I would not apologise for this even on Broadway.

So my dearly beloved friend during these years of our close association I have always turned to you with eagerness for those words of wisdom which you know so well how to mete out. I have felt that the only way which I could repay you would be to try and reach somehow your level of thinking, which is hard for me in reality because I live in this continuous removed intuitive, even I suppose semi-mystic state. I have felt unworthy of you and unworthy of knowing you and I would willingly have withdrawn from knowing you would it in any way be profitable to yourself or even comfortable to you. But I have not expected from the

greatness which you have always meant to me the irrevocable rejection which was the result of my own poor efforts to try and clarify and to strive and help.

This feeling threw a very dark cloak around my whole being for the first two weeks that we were in Paris so that much of it seems dream-like. Then I felt exceedingly sensitive to the mass illness that is going on here in France and to the trials at Oradour and to the way of the world in general to the point where a few days ago in a false movement I knocked two vertebrae out of place. Since I can never afford to be bed-ridden for more than twelve hours at a time, with the aid of instruments and drugs there I was again doing the show without interruption and now again one day has begun to follow the other much as before.

You have no idea how important it is for me to get this letter written to you as it has been on my mind every day and I have picked up a pen and put it down and wandered past a typewriter on so many occasions knowing that once it was written at least it would be something definite. Now I must ask you to try and think of the better things that you knew about me.

My warmest love to Nicky and my continued love to you no matter what you might choose to do, because I know that whatever it would be it could only be worthy because it would come from you.

<div align="right">Katherine</div>

**Doc. 4.** Berenson to Dunham, Settignano, 7 February 1953. (KDP.)

Darling, Dearest Catherine:

I am deeply moved that you should have thought me worthy of the marvellous letter you wrote Febr. 1st. So extraordinary that you should place such value on what I think of you and my attitude toward you. I am awed and want to shout <u>Domini non sum dignus</u>. Almost I could welcome the <u>misunderstanding</u> which brought out such an appeal.

Yes, a misunderstanding due in part to you and in great part to my obtuseness. If you received the answer I addressed to you to Hotel Lotti to the note I had from you written there, you would have realized that I assumed the ballet centering around a lynching was something you were going to compose and orchestrate—NOT, as now turns out, one you already had arranged to perform immediately. Had I known that you were going to Paris to produce it, I should have spoken and written differently. So long as there was a possibility of putting you off from what seemed to me a hazardous offering I felt I must do all I could to persuade you to drop it. Had I known that it was ready to be performed immediately and in Paris, I either would have said nothing or tried to cheer and comfort you.

I never meant to stop loving you, for I could not if I tried. Yet, if the U.S.A. took the performance as offensive and harmful and frequenting you had been scowled at, I am not in a position to defend you or even to go on seeing you. For

I myself am only an alien-born American, an absentee, who has not been back in 30 years, and therefore am offensive to the mind of the State Department bureaucracy. Happily the U.S.A. Cultural Attaché, with all the authority and power of his office, has not disapproved, and I certainly have no reason (as the French say) to be "more Catholic than the Pope", in my case to be more patriotic than our Cultural <u>Attaché</u>. And it comforts me to learn from you that the communist press thus far has made no capital out of yr. ballet.

So let me hope that it will be in every way satisfactory, both culturally and financially.

Let me not forget that yr. synopsis is altogether fascinating and makes me wish I could see the whole staged.

Are you no longer at the Lotti? I like to be able to place you. "c/o" is so vague.

Trust me to be ever and always
> Your loving friend,
> B.B.

**Doc. 5.** Berenson to Dunham, Settignano, 19 March 1953. (KDP.)

Dearest Katherine,

So glad to hear from you after a too long silence, and I love this last photo of yourself, and portrait of the woman Katherine whom I love so much. I do not want to guess, so try to tell me what precisely are the changes 6 wks. have brought about. The photo does not look as if they were for the worse—I was distressed as well as shocked by some of the comments about yr. performance that I read in Paris dailies and weeklies. There is no place on earth where cliques enjoy greater power, and influence opinion more effectively. You seem to have got in the way of the Spanish solo dancing interest, which now hypnotizes the Parisian public.

I am glad you liked Nina de Cencis. She is a dear child despite her 70 years more or less. Another woman who is eager to know you is Lady Mallet in Rome, the wife of the Brit. Ambassador there.

I wish you were here in this golden weather, and before we get overwhelmed by the season's visitors.

Ever so much love
> B.B.

**Doc. 6.** Dunham to Berenson, Florence, 11 March 1954. (BMBP.)

March 11, 1954
Grand Hotel Baglioni Palace, Florence, Italy

Dearest B.B.

I have just left you and am so used to arriving at the rail crossing (that seems to be a landmark) sad and alone. This time I suddenly melted into floods of tears. I know that when we were alone for those few moments something wonderful happened—that I experienced a true love and meaning of love that was too big for this mortal self. And I have left with you something that perhaps you gave me a thousand years ago—a part of myself that is deep and inner and that I am scarcely aware of, only through feeling.

I sat in your beloved presence a different self knowing you somewhere else, and it was future because Niki's sister was Niki for me until Niki came in, and I vaguely remembered wondering if she had been ill or was it many years from now. There didn't seem to be time, only a fusion of something from me to you (you have always been the one to give) that made me feel fuller and calmer and more sure of the great plan of life and its inevitable circular motion. That feeling (knowledge) will always be with me and that part of me will always be with you wherever and whenever.

Everything deeper than I am tells me this and the tears that burned out of me were the tears of a final knowledge and the realization of an arrested moment in time. You must feel me breathe into you my love, my warmth, and the saving grace of this dark blood.—What else do I have? Stay with me, dearest B.B. and stay with all of us who love you as I do.—Katherine

# Bibliography

AGOSTI, GIACOMO, ed. *Archivio Adolfo Venturi: Introduzione al carteggio*. Pisa, 1992.

AGOSTI, GIACOMO, et al., eds. *Giovanni Morelli e la cultura dei conoscitori: Atti del Convengo Internazionale Bergamo, 4–7 giugno 1987*. 3 vols. Bergamo, 1993.

AGOSTI, GIOVANNI. *Su Mantegna*. Vol. 1, *La storia dell'arte libera la testa*. Bologna, 2005.

AGOSTI, GIOVANNI, and DOMINIQUE THIÉBAUD, eds. *Mantegna 1431–1506*. Exhibition catalog, Paris, Musée du Louvre. Milan, 2008.

ANDERSON, JACK. "Katherine Dunham, Dance Icon, Dies at 96." *New York Times*, 23 May 2006.

ANDERSON, JAYNIE, ed. *Collecting, Connoisseurship, and the Art Market in Risorgimento Italy: Giovanni Morelli's Letters to Giovanni Melli and Pietro Zavaritt (1866–1872)*. Venice, 1999.

———. *I Taccuini manoscritti di Giovanni Morelli*. With scientific coordination by MARINA MASSA. Milan, 2000.

ANDREWS, JULIA GETHMAN, ed. *A Catalogue of European Paintings, 1300–1870*. San Diego, 1947.

ANGELELLI, WALTHER, and ANDREA G. DE MARCHI. *Pittura dal duecento al primo cinquecento nelle fotografie di Girolamo Bombelli*. Vol. 1. Milan, 1991.

APPLEGATE, DEBBY. *The Most Famous Man in America: The Biography of Henry Ward Beecher*. New York, 2006.

ARDIZZONE, HEIDI. *An Illuminated Life: Belle da Costa Greene's Journey from Prejudice to Privilege*. New York and London, 2007.

ARNOLD, FRANZ AUGUST, ed. *Septem Mo'allakât, carmina antiquissima Arabum*. Leipzig, 1850.

ASCHENBRENNER, JOYCE. *Katherine Dunham: Dancing a Life*. Urbana, 2002.

BAILEY, GAUVIN A. "The Bernard Berenson Collection of Islamic Painting at Villa I Tatti: Mamluk, Ilkhanid, and Early Timurid Miniatures. Part I." *Oriental Art* 47, no. 4 (2001): 53–62.

———. "The Bernard Berenson Collection of Islamic Painting at Villa I Tatti: Turkman, Uzbek, and Safavid Miniatures. Part II." *Oriental Art* 48, no. 1 (2002): 2–16.

BALACHANDRAN, SANCHITA. "Object Lessons: The Politics of Preservation and Museum Building in Western China in the Early Twentieth Century." *International Journal of Cultural Property* 14 (2007): 1–32.

BAMBACH, CARMEN C. "Bernard Berenson's 'The Drawings of the Florentine Painters Classified, Criticized, and Studied as Documents in the History and Appreciation of Tuscan Art with a Copious Catalogue Raisonné,' 1903." *Burlington Magazine* 151 (2009): 692–693.

BARBANTINI, NINO. *Catalogo della esposizione della pittura ferrarese del rinascimento*. Ferrara, 1933.

BARBERINI, GIULIA. "'È nota a tutti la rovina economica che ha colpito il Principe...' 1887–1902: Il passaggio allo Stato della Galleria Borghese." *Ricerche di storia dell'arte* 23 (1984): 33–44.

BARDAZZI, FRANCESCA, ed. *Cézanne a Firenze. Due collezionisti e la mostra dell'Impressionismo del 1910*. Exhibition catalog, Florence, Palazzo Strozzi. Milan, 2007.

BARDAZZI, FRANCESCA, and CARLO SISI, eds. *Americans in Florence: Sargent and the American Impressionists*. Venice, 2012.

BARON, HANS. *The Crisis of the Early Renaissance: Civic Humanism and Republican Liberty in the Age of Classicism and Tyranny*. 2 vols. Princeton, 1955.

BARONI, SANDRO. *"Riducendoli al triare de' colori*: Precepts on Colors in the *Libro dell' arte* of Cennino Cennini." *Annali della Facoltà di Lettere e Filosofia dell' Università degli Studi di Milano* 51 (1998): 53–64.

BECATTINI, MARTINA. "I negozi di giapponeserie." *Art e dossier* 194 (2003a): 31.

———. "Sapore d'oriente, studi e riscoperte: Il japonsime di Primoli e D'Annunzio." *Art e dossier* 194 (2003b): 26–31.

———. "Come il Giappone arrivò in Italia: Vittorio Pica e il Japonismo." *Art e dossier* 200 (2004): 32–36.

BEHRMAN, SAMUEL N. *Duveen.* New York, 1958.

BELLANDO, ALFONSO. *Umberto Morra di Lavriano.* Florence, 1990.

BELTING, HANS. "Vasari und die Folgen: Die Geschichte der Kunst als Prozess?" In *Theorie der Geschichte.* Vol. 2, *Historische Prozesse,* edited by KARL-GEORG FABER and CHRISTIAN MEIER, 98–126. Munich, 1978.

BENATI, DANIELE, ENRICA PAGELLA, and LUCIA PERUZZI. *Collezionisti si nasce: La Galleria di Matteo Campori a Modena.* Exhibition catalog. Modena, 1996.

BENTINI, JADRANKA, ed. *Fondazione Umberto Severi.* Vol. 1, *Arte antica.* Modena, 1991.

———. *Sovrane passioni: Le raccolte d'arte della Ducale Galleria Estense.* Exhibition catalog. Milan, 1998.

BERENSON, BERNARD. *"Ghazel*: Thought and Temperament." *Harvard Monthly* 4 (March–July 1887a): 33.

———. "Was Mohammed at All an Impostor?" *Harvard Monthly* 4 (March–July 1887b): 48–63.

———. *Venetian Painters of the Renaissance.* New York and London, 1894.

———. *Venetian Painting, Chiefly before Titian.* London, 1895.

———. *The Florentine Painters of the Renaissance.* New York and London, 1896. Reprinted in *The Italian Painters of the Renaissance.* London, 1952a.

———. *The Central Italian Painters of the Renaissance,* New York, 1897.

———. *The Study and Criticism of Italian Art.* Vol. 1. London, 1901.

———. "Rudiments of Connoisseurship." In *The Study and Criticism of Italian Art,* by BERNARD BERENSON, 2:111–148. London, 1902.

———. "A Sienese Painter of the Franciscan Legend." *Burlington Magazine* 3 (1903a): 3–35, 171–184. Reprinted in *A Sienese Painter of the Franciscan Legend.* London, 1909.

———. *The Drawings of the Florentine Painters: Classified, Criticised, and Studied as Documents in the History and Appreciation of Tuscan Art, With a Copious Catalogue Raisonné.* 2 vols. London and New York, 1903b. Reprinted Chicago, 1938.

———. "Carpi: Un dipinto del Catena." *Rassegna d'Arte* 5, no. 10 (1905): 158.

———. *North Italian Painters of the Renaissance.* New York and London, 1907.

———. *A Sienese Painter of the Franciscan Legend.* London, 1909.

———. *Venetian Painting in America.* New York, 1916.

———. *Essays in the Study of Sienese Painting.* New York, 1918.

———. *Italian Pictures of the Renaissance: A List of the Principal Artists and Their Works, with an Index of Places.* Oxford, 1932.

———. *Pitture italiane del Rinascimento: Catalogo dei principali artisti e delle loro opere con un indice dei luoghi.* Milan, 1936.

———. *Sassetta: Un pittore senese della leggenda francescana.* Translated by ACHILLE MALAVASI. Florence, 1946.

———. *Sketch for a Self-Portrait.* London, 1949.

———. *Aesthetics and History in the Visual Arts.* New York, 1948. Reprinted as *Aesthetics and History,* London, 1950a.

———. *Echie Riflessioni: Diario 1941–1944; Bernard Berenson.* Translated by GUGLIELMO DEGLI ALBERTI. Milan, 1950b.

———. *Piero della Francesca o dell'arte non eloquente*. Florence, 1950c.

———. *Rumour and Reflection, 1941–1944*. London 1952b.

———. "Cos'è e dov'è l'Europa." *Corriere della Sera*, 1 February 1955.

———. "Colonizzazione." *Corriere della Sera*, 26 January 1956.

———. *Italian Pictures of the Renaissance: Venetian School*. 2 vols. London, 1957.

———. *Pagine di Diario: Letteratura, Storia, Politica, 1942–1956*. Milan, 1959.

———. *One Year's Reading for Fun (1942)*. London, 1960a.

———. *The Passionate Sightseer*. London, 1960b.

———. *The Bernard Berenson Treasury*. Edited by HANNA KIEL. New York, 1962.

———. *Italian Pictures of the Renaissance*. Revised edition. Vol. 1. Oxford 1963a.

———. *Italian Pictures of the Renaissance: Florentine School*. Vol. 1. London, 1963b.

———. *Sunset and Twilight: From the Diaries of 1947–1958*. Edited by NICKY MARIANO. London, 1963c. Reprinted New York, 1964.

———. *Bernard Berenson: An Inventory of Correspondence*. Edited by NICKY MARIANO. Florence, 1965.

———. *Italian Pictures of the Renaissance: Central Italian and North Italian Schools*. 3 vols. London, 1968.

———. "Isochromatic Photography and Venetian Pictures." In *Art History through the Camera's Lens*, edited by HELENE E. ROBERTS, 127–131. Langhorne, 1995.

———. *Amico di Sandro/Bernard Berenson*. With an essay by PATRIZIA ZAMBRANO. Milan, 2006.

BERENSON, MARY. *A Modern Pilgrimage*. New York and London, 1933.

———. *Across the Mediterranean*. Prato, 1935.

———. *A Vicarious Trip to the Barbary Coast*. London, 1938.

BERNABÒ, MASSIMO. *Ossessioni bizantine e cultura artistica in Italia: Tra D'Annunzio, fascismo e dopoguerra*. Naples, 2003.

BEWER, FRANCESCA. "Technical Research and the Care of Works of Art at the Fogg Art Museum (1900–1950)." In *Past Practice—Future Prospects*, British Museum Occasional Paper 145, edited by ANDREW ODDY and SANDRA SMITH, 13–18. London, 2001.

BIOCCA, DARIO, ed. *A Matter of Passion: Letters of Bernard Berenson and Clotilde Marghieri*. Berkeley and Oxford, 1989.

BIONDI, ALBANO. "Pietro Foresti, tra erudizione e collezionismo nella Carpi di fine Ottocento." In *Fondazione Umberto Severi*. Vol. 1, *Arte Antica*, edited by JADRANKA BENTINI, 15–31. Modena, 1991.

BIONDI, GRAZIA. "Biografia della famiglia Foresti." In *Fondazione Umberto Severi*. Vol. 1, *Arte Antica*, edited by JADRANKA BENTINI, 55–59. Modena, 1991.

BLAIR, SHEILA S., and JONATHAN M. BLOOM. "The Mirage of Islamic Art: Reflections on the Study of an Unwieldy Field." *Art Bulletin* 85, no. 1 (2003): 152–184.

BLUMENRÖDER, SABINE. *Andrea Mantegna die Grisaillen: Malerei, Geschichte und antike Kunst im Paragone des Quattrocento*. Berlin, 2008.

BODE, WILHELM VON. *Mein Leben*. Edited by THOMAS W. GAETGENS. Berlin, 1997. First published 1930.

BOEHM, GOTTFRIED. "Hildebrand und Fiedler im Florentiner Kontext." In *Storia dell'arte e politica culturale intorno al 1900: La fondazione dell'Istituto germanico di storia dell'arte di Firenze*, edited by MAX SEIDEL, 131–141. Venice, 1999.

BORDOGNA, FRANCESCA. *William James at the Boundaries: Philosophy, Science, and the Geography of Knowledge*. Chicago, 2008.

BOSI MARAMOTTI, GIOVANNA. "Il collezionista e lo storico dell'arte. Pietro Foresti e Corrado Ricci." In *Fondazione Umberto Severi*. Vol. 1, *Arte Antica*, edited by JADRANKA BENTINI, 33–45. Modena, 1991.

BOSKOVITS, MIKLÓS, and DAVID ALAN BROWN. *Italian Paintings of the Fifteenth Century*. Washington, 2003.

BOTTA, GUSTAVO. *Le collezioni Agosti e Mendoza*. Milan, 1936.

BOWIE, THEODORE ROBERT. *Langdon Warner through His Letters*. Bloomington, 1966.

BRASSAÏ. *Conversations avec Picasso*. Paris, 1964.

BREWSTER, HARRY. "Fourteen Letters." *Bottegne oscure* 19 (1957): 182–195.

——. *The Cosmopolites: A Nineteenth-Century Drama*. Wilby, 1994.

BREWSTER, HENRY B. *The Theories of Anarchy and of Law: A Midnight Debate*. London, 1887.

——. *The Statuette and the Background*. London, 1896.

BREWSTER HILDEBRAND, ELIZABETH. *Natura e bellezza: Elisabeth Brewster Hildebrand*. Edited by SUSANNA RAGIONIERI and FRANCESCA CENTURIONE SCOTTO BOSCHIERI. Lucca, 2007.

BROWN, ALISON. "Vernon Lee and the Renaissance: From Burckhardt to Berenson." In *Victorian and Edwardian Responses to the Italian Renaissance*, edited by JOHN LAW and LENE ØSTERMARK-JOHANSEN, 185–211. Aldershot, 2005.

——. "Vernon Lee, Brewster, and the Berensons in the 1890s." In *Vernon Lee e Firenze settant'anni dopo*, edited by SERENA CENNI and ELISA BIZZOTTO, 125–141. Florence, 2006.

BROWN, DAVID ALAN. *Berenson and the Connoisseurship of Italian Painting: A Handbook of the Exhibition*. Exhibition catalog, National Gallery of Art. Washington, 1979.

——. "Giovanni Morelli and Bernard Berenson." In *Giovanni Morelli e la cultura dei conoscitori*, edited by GIACOMO AGOSTI, MARIA ELISABETTA MANCA, and MATTEO PANZERI, 2:387–397. Bergamo, 1993.

——. "Bode and Berenson: Berlin and Boston." In *Jahrbuch der Berliner Museen*. Vol. 38. Beiheft, 1996.

BROWN, J. CARTER. "A Personal Reminiscence." In *Looking at Pictures with Bernard Berenson*, edited by HANNA KIEL, 15–20. New York, 1974.

BRUSH, KATHRYN. *Vastly More than Brick and Mortar: Reinventing the Fogg Art Museum in the 1920s*. Cambridge MA, 2003.

——. "Arthur Kingsley Porter and the Transatlantic Shaping of Art History, ca. 1910–1930." In *The Shaping of Art History in Finland*, edited by RENJA SUOMINEN KOKKONEN, 129–142. Helsinki, 2007.

——. "Arthur Kingsley Porter et la genèse de sa vision de Cluny." In *Constructions, reconstructions, et commémorations clunisiennes, 1790–2010*, edited by DIDIER MÉHU. Rennes, 2012.

BUCK, AUGUST. "Burckhardt und die italienische Renaissance." In *Renaissance und Renaissancismus von Jacob Burckhardt bis Thomas Mann*, by AUGUST BUCK, 5–12. Tübingen, 1990.

BURCKHARDT, JACOB. *Die Cultur der Renaissance in Italien: Ein Versuch*. Edited by WERNER KAEGI. Basel, 1930.

——. *Force and Freedom: Reflections on History*. New York, 1943.

——. *Briefe*. Edited by MAX BURCKHARDT. Vol. 4. Basel, 1961.

——. *Der Cicerone: Eine Anleitung zum Genuss der Kunstwerke Italiens*. Stuttgart, 1978.

——. "Weltgeschichtliche Betrachtungen (Über das Studium der Geschichte)." In *Jacob Burckhardt's Werke, Kritische Gesamtausgabe*, edited by JAKOB OERI, 10:349–665. Munich and Basel, 2000.

CADOGAN, JEAN K., and MICHAEL R. T. MAHONEY. *Wadsworth Atheneum Paintings*. Vol. 2, *Italy and Spain: Fourteenth through Nineteenth Centuries*. Hartford, 1991.

CALKINS, ROBERT. "Stages of Execution: Procedures of Illumination in an Unfinished Book of Hours." *Gesta* 17 (1978): 61–70.

CALLMANN, ELLEN. *Apollonio di Giovanni*. Oxford, 1974.

——. "Apollonio di Giovanni." In *The Dictionary of Art*, edited by JANE TURNER, 2:228–229. Basingstoke, 1996.

CALO, MARY ANN. *Bernard Berenson and the Twentieth Century*. Philadelphia, 1994.

CAMBIERI TOSI, MARIE-JOSÉ. *Carlo Placci: Maestro di cosmopoli nella Firenze fra Otto e Novecento.* Florence, 1984.

CAMPBELL, MARGARET. *Dolmetsch: The Man and His Work.* London, 1975.

CANNADINE, DAVID. *The Decline and Fall of the Aristocracy.* New Haven and London, 1990.

CAPECCHI, GABRIELLA. "In margine alle *collezioni fiorentine*: Bernard Berenson e le suggestioni dell'antico." In *In memoria di Enrico Paribeni*, edited by GABRIELLA CAPECCHI, 107–125. Rome, 1998.

CARLYLE, THOMAS. *On Heroes, Hero-Worship, and the Heroic in History.* New York, 1866.

CARSWELL, JOHN. *Iznik Pottery.* London, 1998.

CARTER, MORRIS. *Isabella Stewart Gardner and Fenway Court.* Boston, 1925.

CARUS, TITUS LUCRETIUS. *On the Nature of Things.* Translated by HUGH MUNRO. London, 1908.

CENNINI, CENNINO. *The Craftsman's Handbook: "Il libro dell'arte."* Translated by DANIEL VARNEY THOMPSON JR. New Haven, 1933.

CHERNOW, RON. *The Warburgs: A Family Saga.* London, 1993.

CHONG, ALAN, ed. *Eye of the Beholder: Masterpieces from the Isabella Stewart Gardner Museum.* Boston, 2003.

———, ed. *Gondola Days: Isabella Stewart Gardner and the Palazzo Barbaro Circle.* Boston, 2004.

———. "Introduction: Journeys East." In *Journeys East: Isabella Stewart Gardner and Asia*, by ALAN CHONG and MURAI NORIKO, 14–51. Exhibition catalog, Boston, Isabella Stewart Gardner Museum. Boston, 2009.

———. "Isabella Stewart Gardner, Bernard Berenson, and Otto Gutekunst." In *Colnaghi: The History*, edited by JEREMY HOWARD, 26–31. London, 2010.

CHONG, ALAN, and MURAI NORIKO. *Journeys East: Isabella Stewart Gardner and Asia.* Exhibition catalog, Boston, Isabella Stewart Gardner Museum. Boston, 2009.

CINELLI, BARBARA. "Arte e letteratura: Fra Bernard Berenson e Gabriele D'Annunzio (1896–1901)." In *Il Marzocco: Carteggi e cronache fra ottocento e avanguardie (1887–1913)*, edited by CATERINA DEL VIVO, 169–191. Florence, 1986.

CLARK, KENNETH. *The Gothic Revival.* London, 1928.

———. *One Hundred Details from the National Gallery.* London, 1938.

———. *More Details of Pictures from the National Gallery.* London, 1941.

———. Introduction to *Praeterita*, by JOHN RUSKIN, vii–xxii. London, 1949a.

———. *Landscape into Art.* London, 1949b.

———. "Apologia of an Art Historian." *University of Edinburgh Journal* 15, no. 4 (1951): 232–239.

———. "The Sage of Art." *Sunday Times*, magazine section, 11 October 1959, 15.

———. "Bernard Berenson." *Burlington Magazine* 102, no. 690 (1960): 381–386.

———. *Another Part of the Wood: A Self-Portrait.* London, 1974.

———. *The Other Half: A Self-Portrait.* London, 1977.

———. "The Works of Bernard Berenson." Reprinted in *Moments of Vision*, by KENNETH CLARK, 108–129. London, 1981.

CLARK, VÈVÈ A., and MARGARET B. WILKERSON, eds. *Kaiso! Katherine Dunham: An Anthology of Writings.* Berkeley, 1978.

CLARK, VÈVÈ A., and SARA E. JOHNSON, eds. *Kaiso! Writings by and about Katherine Dunham.* Madison, 2005.

COLAJANNI, NAPOLEONE. *L'Italia del 1898: Tumulti e reazione.* Milan, 1898. Reprinted 1953.

COLAPIETRA, RAFFAELE. *Il novantotto: La crisi di fine secolo (1896–1900).* Milan, 1959.

COLLI, DANTE, and LUIGI FORESTI. *Casa Foresti: Storia, vicende e avventure artistiche.* Carpi, 1999.

COLLINGWOOD, R. G. *The Principles of Art.* Oxford, 1938.

CONANT, KENNETH. "Arthur Kingsley Porter." *Speculum* 9 (1934): 94–96.

CONSTABLE, GILES, ed., in collaboration with ELIZABETH H. BEATSON and LUCA DAINELLI. *The Letters between Bernard Berenson and Charles Henry Coster.* Florence, 1993.

CONTARINI, SILVIA, and MAURIZIO GHELARDI. "'Die verkörperte Bewegung': La ninfa." In *Aby Warburg: La dialettica dell'immagine*, edited by DAVIDE STIMILLI, 121/122:32–45. Milan, 2004.

CONTI, ANGELO. *Giorgione*. Florence, 1894. Reprinted Novi Ligure, 2007.

———. "La visione imminente." *Il Marzocco*, 19 April 1896.

———. *La beata riva: Trattato dell'oblio*. Edited by PIETRO GIBELLINI. Venice, 2000.

COOMARASWAMY, ANANDA K. *Mediaeval Sinhalese Art*. Broad Campden, 1908.

COON, DEBORAH. "'One Moment in the World's Salvation': Anarchism and the Radicalization of William James." *Journal of American History* 83 (1996): 70–99.

COPPEL, STEPHEN. "George Salting (1820–1909)." In *Landmarks in Print Collecting: Connoisseurs and Donors to the British Museum since 1753*, exhibition catalog, British Museum, edited by ANTHONY GRIFFITHS, 189–210. London, 1996.

CRESWELL, ARCHIBALD C. *A Bibliography of the Architecture, Arts, and Crafts of Islam to 1st Jan. 1960*. Cairo, 1961.

CURATOLA, GIOVANNI, ed. *Eredità dell'Islam, arte islamica in Italia*. Exhibition catalog, Venice, Palazzo Ducale. Milan, 1993.

CVJETĆANIN, TATJANA, ed. *The Prince Paul Museum*. Belgrade, 2011. Serbian edition, 2009.

DAMISCH, HUBERT. "These Are All about Me." In *Meyer Schapiro Abroad: Letters to Lillian and Travel Notebooks*, edited by DANIEL ESTERMAN, 6–16. Los Angeles, 2007.

D'ANNUNZIO, GABRIELE. *Tutte le novelle*. Edited by ANNAMARIA ANDREOLI and MARINA DE MARCO. Milan, 1992.

———. *Scritti giornalistici*. Edited by Federico Roncoroni. Milan, 1996.

DAVENPORT-HINES, RICHARD, ed. *Letters from Oxford: Hugh Trevor-Roper to Bernard Berenson*. London, 2006.

DEGEORGE, GÉRARD, and YVES PORTER. *The Art of the Islamic Tile*. Translated by DAVID RADZINOWICZ. Paris, 2001.

DE MARCHI, ANDREA G. "Falsi Primitivi: Negli studi, nel gusto; E alcuni esempi." PhD diss., University of Lausanne, 2001.

DERRIDA, JACQUES. *La verité en peinture*. Translated by GEOFF BENNINGTON and IAN MCLEOD. Chicago, 1987. First published Paris, 1978.

DIECKVOSS, STEPHANIE. "Wilhelm von Bode and the English Art World." MA thesis., Courtauld Institute of Art, 1995.

DOCHERTY, LINDA. "Religion and/as Art: Isabella Stewart Gardner's Palace Chapels." College Art Association meeting lecture. New York, 23–26 February 2000.

———. "Creative Connection: James McNeill Whistler and Isabella Stewart Gardner." In *James MacNeill Whistler in Context: Essays for the Whistler Centenary Symposium, University of Glasgow, 2003*, Freer Gallery of Art Occasional Papers, edited by LEE GLAZER, MARGARET F. MCDONALD, LINDA MERRILL, and NIGEL THORP, n.s., 2:183–203. Washington, 2008.

DOSSI, CARLO. *Amori*. Edited by DANTE ISELLA. Milan, 1977. First published Rome, 1887.

DOWLING, LINDA. *Charles Eliot Norton: The Art of Reform in Nineteenth-Century America*. Lebanon NH, 2007.

DUNCAN, SALLY ANNE. "Paul Sachs and the Institutionalization of Museum Culture between the Wars." PhD diss., Tufts University, 2001.

———. "Harvard's 'Museum Course' and the Making of America's Museum Profession." *Archives of American Art Journal* 42, no. 1/2 (2002): 2–16.

DUNHAM, KATHERINE. *Journey to Accompong*. Introduction by RALPH LINTON, drawings by TED COOK. New York, 1946.

———. *Las danzas de Haití*. Edited by JAVIER ROMERO. Mexico City, 1947.

———. *A Touch of Innocence*. London, 1959.

———. *Island Possessed*. Garden City, 1969.

DUNNING, JENNIFER. "How Katherine Dunham Revealed Black Dance to the World." *New York Times*, 23 May 2006.

EAMON, WILLIAM. *Science and the Secrets of Nature: Books of Secrets in Medieval and Early Modern Culture*. Princeton, 1994.

EKSERDJIAN, DAVID. "Colnaghi and the Hermitage Deal." In *Colnaghi: The History*, edited by JEREMY HOWARD, 37–41. London, 2000.

ELDER, IRENE VAVASOUR. "An Unknown Portrait by Paolo Veronese." *Apollo* 15, no. 90 (1932): 268.

ELKINS, JAMES, and DAVID MORGAN, eds. *Re-Enchantment*. New York and Abingdon, 2009.

EMILIANI, ANDREA. "Per un modello di collezionismo civico." In *Fondazione Umberto Severi*. Vol. 1, *Arte antica*, edited by JADRANKA BENTINI, 10–14. Modena, 1991.

ETTINGHAUSEN, RICHARD. *Persian Miniatures in the Bernard Berenson Collection*. Milan, 1961.

FAIETTI, MARZIA, and DANIELA SCAGLIETTI KELESCIAN. *Amico Aspertini*. Exhibition catalog. Modena, 1995.

FANTONI, MARCELLO, HEIDI FLORES, and JOHN PFORDRESHER, eds. *Cecil Pinsent and His Gardens in Tuscany: Papers from the Symposium, Georgetown University, Villa Le Balze, Fiesole, 22 June 1995*. Florence, 1996.

FARINELLA, VICENZO. "Signorini e Hiroshige: Un'ipostesi sulle fonti visive dell'*Alzaia* (e un'apertura sul giapponismo dei macchiaioli)." In *Telemaco Signorini e la pittura in Europa*, exhibition catalog, Padua, Palazzo Zabarella, edited by GIULIANO MATTEUCCI, 44–57. Venice, 2009.

FEI, SILVANO. *Firenze 1881–1898: La grande operazione urbanistica*. Rome, 1977.

FERGUSON, WALLACE K. *The Renaissance in Historical Thought: Five Centuries of Interpretation*. Cambridge MA, 1948.

———. "The Reinterpretation of the Renaissance: Suggestions for a Synthesis." In *Facets of the Renaissance*, edited by WILLIAM H. WERKMEISTER, 1–18. New York, 1963.

FERRAZZA, ROBERTA. "Elia Volpi e il commercio dell'arte nel primo trentennio del novecento." In *Studi e ricerche di collezionismo e museografia Firenze 1820–1920*, Quaderni del seminario di storia della critica d'arte, 391–450. Pisa, 1985.

FERRIANI, DANIELA. "L'Annunciazione di Vincenzo Catena: L'opera, la tecnica e la vicenda conservativa." In *Alberto III e Rodolfo Pio da Carpi collezionisti e mecenati*, edited by MANUELA ROSSI, 268–272. Tavagnacco, 2004.

FIOCCO, GIUSEPPE. *Francesco Guardi*. Florence, 1923.

———. *Paolo Veronese*. Rome, 1934.

FITZGERALD, MICHAEL. *Making Modernism: Picasso and the Creation of the Market for Twentieth-Century Art*. Berkeley, 1995.

FIXLER, MICHAEL. "Bernard Berenson of Butremanz." *Commentary*, August 1963, 135–143.

FLAUBERT, GUSTAVE. *Correspondance, tome 3 Janvier 1859–Décembre 1868*. Paris, 1991.

FLETCHER, IAN. *Rediscovering Herbert Horne: Poet, Architect, Typographer, Art Historian*. Greensboro, 1990.

FONTEIN, JAN. *Selected Masterpieces of Asian Art, Museum of Fine Arts, Boston*. Boston and Tokyo, 1992.

FORBES, EDWARD WALDO. "The Technical Study and Physical Care of Paintings." *Art Bulletin* 2 (1920): 160–170.

———. "Arthur Pillans Laurie." *College Art Journal* 9 (1949–50): 206–207.

FORESTI, PIETRO. "La cappella Pio nel castello comunale di Carpi." *Bollettino d'arte* 6, no. 8 (1912): 303–322.

FORSTER, E. M. *A Room with a View*. Edited by OLIVER STALLYBRASS. London, 1978. First published 1908.

FRASER, HILARY. *Beauty and Belief: Aesthetics and Religion in Victorian Literature*. Cambridge, 1986.

FREEDMAN, JONATHAN. "An Aestheticism of Our Own: American Writers and the Aesthetic Movement." In *In Pursuit of Beauty: Americans and the Aesthetic Movement*, edited by DOREEN BOLGER BURKE, 384–407. New York, 1986.

FRESUCCI, BRUNO, and UMBERTO MORRA. *Brani Cortonesi di Umberto Morra*. Arezzo, 1967.

FRIEDLÄNDER, MAX J. *Reminiscences and Reflections*. Edited by RUDOLF HEILBRUNN, translated by RUTH MAGURN. New York, 1969.

FRIEDMAN, LAWRENCE J., with ANKE M. SCHREIBER. *The Lives of Erich Fromm Love's Prophet*. New York, 2013.

FRIZZONI, GUSTAVO. "Un dipinto inedito di Andrea Mantegna nella Galleria Campori di Modena." *L'arte* 19 (1916): 65–69.

GADDO, IRENE. *Il piacere della controversia: Hugh R. Trevor-Roper storico e uomo politico*. Naples, 2007.

GAMBA, CARLO. "Necrologio" (for Enrico Costa). *Rassegna d'arte* 12 (1912): iv–v.

GARDNER, ISABELLA STEWART. *A Choice of Books from the Library of Isabella Stewart Gardner, Fenway Court*. Boston, 1906.

GARNIER, GEORGES. "Tre dipinti del Palmezzano inediti." *Rassegna d'arte* (July 1901): 104–105.

GARSTANG, DONALD. *Art, Commerce, and Scholarship: A Window on the Art World 1760–1984*. London, 1984.

GARTON, JOHN. *Grace and Grandeur: The Portraiture of Paolo Veronese*. Turnhout, 2008.

GARUTI, ALFONSO. *Restauri al patrimonio artistico comunale*. Carpi, 1982.

———. *Carpi, Museo Civico "Giulio Ferrari": I dipinti*. Bologna, 1990.

———. "La donazione Foresti al Museo Civico di Carpi." In *Fondazione Umberto Severi*. Vol. 1, *Arte antica*, edited by JADRANKA BENTINI, 47–53. Modena, 1991a.

———. "La qualità delle opere." In *Fondazione Umberto Severi*. Vol. 1, *Arte antica*, edited by JADRANKA BENTINI, 50–53. Modena, 1991b.

———. "Matteo Loves." In *Rare pitture: Ludovico Carracci, Guercino e l'arte nel seicento a Carpi*, exhibition catalog, edited by MANUELA ROSSI, 122–123. Carpi, 2010.

GAUTHERIE-KAMPKA, ANNETTE. *Les allemands du dôme: La colonie allemande de Montparnasse dans les années 1903–1914*. Berne, 1995.

GEE, MALCOLM. *Dealers, Critics, and Collectors of Modern Painting: Aspects of the Parisian Art Market between 1910 and 1930*. New York and London, 1981.

GELHAAR, CHRISTIAN. *Picasso: Wegbereiter und Förderer seines Aufstiegs 1899–1939*. Zurich, 1993.

GIBBON, EDWARD. *The History of the Decline and Fall of the Roman Empire*. Vol. 5. Philadelphia, 1845.

GILMORE, MYRON. "Villa I Tatti, The Harvard University Center for Italian Renaissance Studies: The First Ten Years." *Harvard Library Bulletin* 19, no. 1 (1971): 99–109. Published in Italian as "I Tatti a dieci anni dalla morte di Bernard Berenson," *Antichità viva: Rassegna d'arte* 8, no. 6 (1969): 48–52.

GIMPEL, RENÉ. *Diary of an Art Dealer*. London, 1992.

GOETHE, JOHANN WOLFGANG VON. *Italian Journey (1786–1788)*. Translated by W. H. AUDEN and ELIZABETH MAYER. London, 1970.

GOMBRICH, ERNST H. "Apollonio di Giovanni: A Florentine Cassone Workshop Seen through the Eyes of a Humanist Poet." *Journal of the Warburg and Courtauld Institutes* 18 (1955): 16–34.

———. *Art and Illusion: A Study in the Psychology of Pictorial Perception*. London, 1960. Reprinted London, 1968.

———. *Aby Warburg: An Intellectual Biography*. Leiden, 1970. Reprinted Oxford, 1986.

GRABAR, OLEG, and SHEILA BLAIR. *Epic Images and Contemporary History: The Illustrations of the Great Mongol Shahnama*. Chicago and London, 1980.

GRAÑA, CÉSAR. *Bohemian versus Bourgeois: French Society and the French Man of Letters in the Nineteenth Century*. New York, 1964.

GRAPPINI, FRANCO. *Gente di nostra stirpe*. Vol. 3. Turin, 1934.

GRAY, BASIL. *Persian Painting*. Geneva, 1961.

GREGOROVIUS, FERDINAND. *Römische Tagebücher, 1852–1889*. Edited by HANNO-WALTER KRUFT and MARKUS VÖLKEL. Munich, 1991.

GRUBE, ERNST J., and ELEANOR SIMS. "The School of Herat from 1400 to 1450." In *The Arts of the Book in Central Asia*, edited by BASIL GRAY. Paris and London, 1979.

GUHA-THAKURTA, TAPATI. *The Making of Indian Art*. Cambridge, 1992.

GUNN, PETER. *Vernon Lee: Violet Paget, 1856–1935*. London, 1964.

HADLEY, ROLLIN VAN N. "Altamura: The Enigma." *Fenway Court* (1978): 31–34.

———, ed. *The Letters of Bernard Berenson and Isabella Stewart Gardner, 1887–1924, with Correspondence by Mary Berenson*. Boston, 1987.

HAGAN, R. H. "Katherine Dunham Tells of Debt to Berenson." *San Francisco Chronicle*, 30 September 1955.

HALL, NICHOLAS. *Colnaghi in America*. New York, 1992.

HALPERN, MARTIN. "The Life and Writings of Henry B. Brewster." PhD diss., Harvard University, 1959.

———. "Henry B. Brewster (1850–1908): An Introduction." *American Quarterly* 14 (1964): 464–482.

HARE, AUGUSTUS. *Walks in Rome*. Vol. 1. London, 1903.

HARRIS, JOHN. "In Honour of Osvald Sirén—and Recollections." *Apollo* 134, no. 354 (1991): 104–107.

HASKELL, FRANCIS. *History and Its Images: Art and the Interpretation of the Past*. New Haven, 1993.

HEGEL, GEORG WILHELM FRIEDRICH. *The Philosophy of History*, New York, 2007. First published 1899.

HEINEMANN, FRITZ. *Giovanni Bellini e i Belliniani*. 3 vols. Venice, 1959.

HERDING, KLAUS. *Freuds Leonardo: Eine Auseinandersetzung mit psychoanalytischen Theorien der Gegenwart*. Munich, 1998.

HERRINGHAM, CHRISTIANA JANE. *The Book of the Art of Cennino Cennini*. London, 1899.

HERSKOVITS, MELVILLE J. *Life in a Haitian Valley*. Introduction by EDWARD BRATHWAITE. New York, 1937. Reprinted New York, 1964.

———. *The Myth of the Negro Past*. New York and London, 1941.

HILDEBRAND, ADOLF VON. *Das problem der Form in der Bildenden Kunst*. Translated by MAX MEYER and ROBERT MORRIS OGDEN. New York, 1907. First published Strasbourg, 1893; reprinted Kessinger, 2009.

HILL, CONSTANCE VALIS. "Katherine Dunham's *Southland*: Protest in the Face of Repression." *Dance Research Journal* 26, no. 2 (1994): 1–10.

HILL, DEREK. *Islamic Architecture and Its Decorations: AD 800–1500*. London, 1964.

HILLENBRAND, ROBERT, ed. *Shahnama: The Visual Language of the Persian Book of the Kings*. Aldershot, 2004.

HILLS, HELEN. "The Making of an Art-Historical Super-Power?" Review of *The Early Years of Art History in the United States*, edited by CRAIG HUGH SMYTH and PETER M. LUKEHART. *Oxford Art Journal* 18, no. 1 (1995): 137–140.

HINKS, ROGER. *The Gymnasium of the Mind: The Journals of Roger Hinks, 1933–1963*. Edited by JOHN GOLDSMITH. Wilton, 1984.

HINKS, ROGER, and NAOMI ROYDE-SMITH. *Pictures and People: A Transatlantic Criss-Cross*. London, 1930.

HODGSON, MARSHALL G. S. *The Venture of Islam: Conscience and History in a World Civilization*. 3 vols. Chicago and London, 1974.

HOLMES, CHARLES JOHN. *Pictures and Picture Collecting*. London, 1903.

HOLROYD, CHARLES. "Unanswered Questions about the Norfolk Holbein." *Burlington Magazine* 15, no. 75 (1909): 135–137.

HORNE, HERBERT. *Alessandro Filipepi, Commonly Called Sandro Botticelli*. London, 1908.

HOWARD, JEREMY. "Titian's *Rape of Europa*: Its Reception in Britain and Sale to America." In *The Reception of Titian in Britain from Reynolds to Ruskin*, edited by PETER HUMFREY, 189–199. Turnhout, 2013.

———. "A Masterly Old Master Dealer of the Gilded Age: Otto Gutekunst and Colnaghi." In *Colnaghi: The History*, edited by JEREMY HOWARD, 12–19. London, 2010.

HUBERT, HANS W. *Das Kunsthistorische Institut in Florenz: Von seiner Gründung bis zum hundertjährigen Jubiläum (1897–1997)*. Florence, 1997.

———. "August Schmarsow, Hermann Grimm und die Gründung des Kunsthistorischen Instituts in Florenz." In *Storia dell'arte e politica culturale intorno al 1900: La fondazione dell'Istituto Germanico di Storia dell'Arte di Firenze*, edited by MAX SEIDEL, 339–358. Venice, 1999.

HUGHES, DANIEL. "'Marius' and the Diaphane." *Novel: A Forum on Fiction* 9 (1975): 55–65.

HUIZINGA, JOHAN. "Das Problem der Renaissance." In *Wege der Kulturgeschichte: Studien*, 89–139. Leipzig, 1930.

HUMFREY, PETER. *Carpaccio: Catalogo completo dei dipinti*. Florence, 1991.

HYMAN, ISABELLE. "The Huntington Mansion in New York: Economics of Architecture and Decoration in the 1890s." *Syracuse University Library Associates Courier* 25 (1990): 3–29.

IAMURRI, LAURA. "Berenson, la pittura moderna e la nuova critica italiana." *Prospettiva* 87–88 (1997): 69–90.

———. "Adolfo Venturi e Bernard Berenson." In *Adolfo Venturi e la storia dell'arte oggi*, edited by MARIO D'ONOFRIO, 187–192. Modena, 2008.

IRWIN, ROBERT. *For Lust of Knowing: The Orientalists and Their Enemies*. London, 2006.

JAMES, HENRY. *The American Scene*. New York and London, 1907.

———. *Italian Hours*. New York, 1987.

———. "The Madonna of the Future." In *Henry James: Complete Stories*. Vol. 1, *1864–1874*, 730–766. New York, 1999.

JAMES, WILLIAM. *The Principles of Psychology*. 2 vols. Cambridge MA, 1890. Reprinted 1893; London, 1907; and in paperback, New York, 1950.

———. *Talks to Teachers on Psychology*. New York, 1901. Reprinted Cambridge MA, 1983.

———. *A Pluralistic Universe*. London, 1909. Reprinted in WILLIAM JAMES, *Works*. Cambridge MA, 1977.

———. "The Energies of Men." In *Memories and Studies*, 227–264. London, 1911 (I Tatti copy). Reprinted in WILLIAM JAMES, *Essays in Religion and Morality*, 129–146. Cambridge MA, 1982.

———. *The Will to Believe and Other Essays in Popular Philosophy*. Reprinted in WILLIAM JAMES, *Works*. Cambridge MA, 1979. First published 1896.

———. *The Correspondence of William James*. Edited by IGNAS SKRUPSKELIS and ELIZABETH BERKELEY. 12 vols. Charlottesville, 1992–2004.

JONI, ICILIO FEDERICO. *Affairs of a Painter*. Edited by GIANNI MAZZONI. Siena, 2004.

KANNES, G. "Gustavo Frizzoni." In *Dizionario biografico degli Italiani*. Vol. 50. Rome, 1998.

KANTOR, SYBIL G. "The Beginnings of Art History at Harvard and the 'Fogg Method.'" In *The Early Years of Art History in the United States*, edited by CRAIG HUGH SMYTH and PETER M. LUKEHART, 161–174. Princeton, 1993.

———. *Alfred H. Barr, Jr., and the Intellectual Origins of the Museum of Modern Art*. Cambridge, 2002.

KELLER, ULRICH. "Picture Atlases from Winckelmann to Warburg and the Rise of Art History." *Visual Resources* 17 (2001): 179–199.

KIEL, HANNA, ed. *Looking at Pictures with Bernard Berenson*. With a personal reminiscence by J. CARTER BROWN. New York, 1974.

KILMURRAY, ELAINE, and RICHARD ORMOND, eds. *John Singer Sargent*. London, 1998.

KING, DAVID JAMES. *Artistic Houses: Being a Series of Interior Views of a Number of the Most Beautiful and Celebrated Homes in the United States*. Vol. 1. New York, 1883–84.

KLEE, PAUL. *The Diaries of Paul Klee: 1898–1918*. Edited by FELIX KLEE. Berkeley, 1968.

KOEHLER, WILHELM R. W. *Medieval Studies in Memory of A. Kingsley Porter*. Vol. 1. Cambridge MA, 1939.

KOMAROFF, LINDA, ed. "Exhibiting the Middle East: Collections and Perceptions of Islamic Art." *Ars Orientalis* 30 (2000), special issue.

KRAUTHEIMER, RICHARD, et al. *Corpus Basilicarum Christianarum Romae*. 5 vols. Vatican City, 1937–77.

KRISTELLER, PAUL. "Zwei decorative Gemälde Mantegnas in der Wiener kaiserlichen Galerie." *Jahrbuch der Kunsthistorischen Sammlung in Wien* 30 (1911): 29–48.

KRÖGER, JENS. "Friedrich Sarre und die islamische Archäologie." In *Das Grosse Spiel: Archäologie und Politik (1860–1940)*, edited by CHARLOTTE TRÜMPLER, 274–285. Essen and Cologne, 2008.

KULTERMANN, UDO. *Geschichte der Kunstgeschichte: Der Weg einer Wissenschaft*. Frankfurt, 1981.

LA FARGE, JOHN. *Great Masters*. New York, 1903.

LAMBERTI, MIMITA. "Giapponeserie dannunziane." In *La conoscenza dell'Asia e dell'Africa in Italia nei secoli XVIII e XIX*, edited by ALDO GALLOTTA and UGO MARAZZI, 2:295–318. Naples, 1985.

LANDI, ELISABETTA. *Liberty in Emilia*. Modena, 1989.

———. "Giovanni Muzzioli e Pietro Foresti: La fortuna di un artista nel collezionismo privato di fine Ottocento." In *Giovanni Muzzioli*, exhibition catalog, edited by ENRICA PAGELLA and LUCIANO RIVI, 31–34. Modena, 1991.

———. "La fortuna postuma di un artista modenese: Giovanni Muzzioli e Pietro Foresti." In *Gli anni modenesi di Adolfo Venturi*, edited by PAOLA BAROCCHI, 93–97. Modena, 1994.

———. "Le conseguenze di un amore." *IBC: Informazioni commenti inchieste sui beni culturali* 12, no. 4 (2004): 83–84.

LEE, VERNON. "A Review of *Florentine Painters of the Renaissance* by Bernard Berenson." *Mind* 5, no. 18 (1896): 270–272.

———. "Nietzsche and the 'Will to Power.'" *North American Review* 179 (1904): 842–859.

———. *The Gospels of Anarchy and Other Contemporary Studies*. London, 1908.

LEE, VERNON, and C. ANSTRUTHER-THOMSON. "Beauty and Ugliness." *Contemporary Review* 72 (October–November 1897): 544–588.

———. *Beauty & Ugliness and Other Studies in Psychological Aesthetics*. London, 1912.

LEHMAN, ROBERT. *The Philip Lehman Collection*. Vol. 8. Paris, 1928.

LENTZ, THOMAS W. "Painting at Herat under Baysunghur ibn Shahrukh." PhD diss., Harvard University, 1985.

LENTZ, THOMAS W., and GLENN D. LOWRY, eds. *Timur and the Princely Vision: Persian Art and Culture in the Fifteenth Century*. Exhibition catalog, Los Angeles, Los Angeles County Museum of Art. Washington, 1989.

LEVINE, NEIL. *The Architecture of Frank Lloyd Wright*. Princeton, 1996.

LIMOUZE, DOROTHY. "The History of the Warburg Gift." In *The Felix M. Warburg Print Collection: A Legacy of Discernment*, exhibition catalog, Frances Lehman Loeb Art Center, edited by Vassar College, 9–22. Poughkeepsie, 1995.

LINGNER, RICHARD. "Isabella Stewart Gardner's Spiritual Life." In *The Art of the Cross: Medieval and Renaissance Piety in the Isabella Stewart Gardner Museum*, edited by ALAN CHONG, 29–39. Boston, 2001.

LISERRE, FRANCESCA ROMANA. *Giardini anglo-fiorentini: Il rinascimento all'inglese di Cecil Pinsent*. Florence, 2008.

LODOVICI, SERGIO SAMEK. "Introduction to Adolf von Hildebrand." In *Il problema della forma*, 3–32. Messina, 1949.

LOGAN, MARY. "Compagno di Pesellino et quelques peintures de l'école." *Gazette des Beaux-Arts* 3 (1901): 333–343.

LONGHI, ROBERTO. "Un chiaroscuro e un disegno di Giovanni Bellini." *Vita Artistica: Studi di storia dell'arte diretti da Roberto Longhi ed Emilio Cecchi* 2, no. 1 (1927): 133–138.

LORIZZO, LOREDAN. "Pietro Toesca all'Università di Roma e il sodalizio con Bernard Berenson." In *Pietro Toesca e la fotografica: Sapere Vedere*, edited by PAOLA CALLEGARI and EDITH GABRIELLI, 103–125. Milan, 2009.

LÖWY, MICHAEL, and ROBERT SAYRE. *Romanticism Against the Tide of Modernity*. Durham, 2001.

LUCCO, MAURO, ed. *Andrea Mantegna 1460–1506*. Exhibition catalog. Milan, 2006.

LUSETTI, GIAN PAOLO, VALTER PRATISSOLI, and EUGENIO RICCOMINI. "Le opere esposte." In *Il Museo Civico di Correggio*. Milan, 1995.

MACLEOD, DIANNE SACHKO. *Enchanted Lives, Enchanted Objects: American Women Collectors and the Making of Culture, 1800–1940*. Berkeley, 2008.

MAHDI, MUHSIN. "Orientalism and the Study of Islamic Philosophy." *Journal of Islamic Studies* 1 (1990): 73–98.

MALAGUZZI VALERI, FRANCESCO. "La pittura reggiana nel Quattrocento." *Rassegna d'arte* 3 (October 1903): 146.

MANZELLI, MARIO. *Antonio Jolli: Opera pittorica*. Venice, 1999.

MARAINI, FOSCO. *Segreto Tibet*. Bari, 1951.

———. *Ore giapponesi*. Bari, 1958.

MARAINI, FOSCO, and COSIMO CHIARELLI, eds. *Il miramondo: 60 anni di fotografia*. Exhibition catalog, Florence, Museo Marini. Florence, 1999.

MARIANO, NICKY, ed. *The Berenson Archive: An Inventory of Correspondence Compiled by Nicky Mariano on the Centenary of the Birth of Bernard Berenson 1865–1959*. Florence, 1965.

———, with an introduction by KENNETH CLARK. *Forty Years with Berenson*. New York, 1966.

MARINI, REMIGIO. *L'opera completa del Veronese*. Milan, 1968.

MARTIN, FREDRIK ROBERT. "Two Portraits by Behzad, the Greatest Painter of Persia." *Burlington Magazine* 15, no. 73 (April 1909): 4–8.

MARTINELLI BRAGLIA, GRAZIELLA. "'Divine stanze': La Galleria Foresti e la tradizione del collezionismo carpigiano." In *Alle origini del museo 1914–2004: La donazione Foresti nelle collezioni di Carpi*, edited by MANUELA ROSSI and TANIA PREVIDI, 7–26. Carpi, 2004.

MARTINELLI BRAGLIA, GRAZIELLA, and PAOLA BORSARI, eds. *Carlo Grossi: Pittore liberty tra Emilia e Lombardia (1857–1931)*. Exhibition catalog. n.p., 2002.

MARTINELLI BRAGLIA, GRAZIELLA, PAUL NICHOLLS, and LUCIANO RIVI. *Muzzioli. Il vero, la storia, la finzione*. Exhibition catalog. Turin, 2009.

MARWILL, JONATHAN. *Frederic Manning: An Unfinished Life*. North Ryde, 1988.

MASON, ALEXA, ed. *Villa I Tatti, The Harvard University Center for Italian Renaissance Studies: Forty Years, 1961/62–2001/02*. Florence, 2002.

MATTHEWS, NANCY MOWLL, ed. *Cassatt and Her Circle: Selected Letters*. New York, 1984.

MAYOR, A. HYATT. Oral history interview. Archives of American Art, Smithsonian Institution, 21 March–5 May 1969.

MAZAROFF, STANLEY. *Henry Walters and Bernard Berenson: Collector and Connoisseur*. Baltimore, 2010.

MCCAULEY, ANNE. "Henri Matisse." In *Eye of the Beholder: Masterpieces from the Isabella Stewart Gardner Museum*, edited by ALAN CHONG, 218–221. Boston, 2003.

MCCOLL, DUGALL S. *Confessions of a Keeper and Other Papers*. London, 1931.

MCCOMB, ARTHUR KILGORE, ed. *The Selected Letters of Bernard Berenson*. London, 1963. Reprinted Boston, 1964.

MEDER, JOSEPH. *The Mastery of Drawing*. Translated and revised by WINSLOW AMES. Vol. 1. New York, 1978.

MELIUS, JEREMY. "Connoisseurship, Painting, and Personhood." *Art History* 34, no. 2 (2011): 288–309.

MERRIMAN, MIRA PAJES. *Giuseppe Maria Crespi.* Milan, 1980.

MINER, DOROTHY E. *Studies in Art and Literature for Belle da Costa Greene.* Princeton, 1954.

MITCHELL, MARY, and ALBERT GOODRICH. *The Remarkable Huntingtons: Chronicle of a Marriage.* Newtown, 2004.

MOOREHEAD, CAROLINE. *Iris Origo: Marchesa of Val d'Orcia.* Boston, 2002.

MORELLI, GIOVANNI. *Della pittura italiana studii storico-critici: Le Gallerie Borghese e Doria-Pamphili in Roma.* Edited by JAYNIE ANDERSON. Milan, 1991.

MORRA, UMBERTO. "Le Passegiate di Berenson." *La Nazione,* 7 October 1959.

———. *Conversations with Berenson.* Translated by Florence Hammond. Boston, 1965. First published 1963.

———. *Vita di Piero Gobetti: Con una testimonianza di Allesandro Passerin d'Entreves.* Turin, 1984.

MOSTYN-OWEN, WILLIAM, ed. *Bibliografia di Bernard Berenson.* Milan, 1955.

———. Review of *The Bernard Berenson Treasury,* by HANNA KIEL; *Colloqui con Berenson,* by UMBERTO MORRA; and *Sunset and Twilight: From the Diaries of 1947–1958,* by BERNARD BERENSON. *Burlington Magazine* 107 (1965): 328–329.

———. Review of *Bernard Berenson: The Making of a Connoisseur,* by ERNEST SAMUELS; and *Being Bernard Berenson,* by MERYLE SECREST. *Burlington Magazine* 123 (1981): 317–318.

MUIR, WILLIAM. *The Life of Mahomet.* 5 vols. London, 1858.

NEGRO, EMILIO. "Un'importante precisazione per le tre Tavole Foresti." In *Andrea Mantegna e la creazione iconografica,* edited by SIRA WALDNER, 167–171. Ascona, 2009.

NEGRO, EMILIO, and NICOSETTA ROIO, eds. *Andrea Mantegna: Le tre tavole della collezione Foresti.* Modena, 2010.

NICHOLS, STEPHEN G. "Introduction: Philology in a Manuscript Culture." *Speculum* 65 (1990): 1–10.

NÖLDEKE, THEODOR. *Das Leben Mohammeds.* Hannover, 1863.

NORA, LUCIANA. "Pietro Foresti e la fotografia." In *Alle origini del museo 1914–2004: La donazione Foresti nelle collezioni di Carpi,* edited by MANUELA ROSSI and TANIA PREVIDI, 41–46. Carpi, 2004.

OFFNER, RICHARD. *Italian Primitives at Yale University: Comments and Revisions.* New Haven, 1927.

OKUMURA SUMIYO. *The Influence of Turkic Culture on Mamluk Carpets.* Istanbul, 2007.

OLIVETTI, ALBERTO, and GIANNI MAZZONI. "Entre restauration et vente: La peinture médiévale au début du XX$^e$ siècle." *Médiévales* 14 (1988): 73–90.

ONG, WALTER J. *Orality and Literacy: The Technologizing of the Word.* London, 2005. First published 1982.

ORIGO, IRIS. "The Long Pilgrimage: One Aspect of Bernard Berenson." *Cornhill Magazine* 1023 (Spring 1960): 139–155.

OSMOND, PATRICIA J., ed. *Revisiting the Gamberaia: An Anthology of Essays.* Florence, 2004.

PAINE, ROBERT TREAT, and ALEXANDER SOPER. *The Art and Architecture of Japan.* Baltimore and Harmondsworth, 1955.

PANOFSKY, ERWIN. "Three Decades of Art History in the United States: Impressions of a Transplanted European." In *Meaning in the Visual Arts: Papers in and on Art History in the United States,* 321–346. Garden City, 1955.

———. *Korrespondenz 1910–1968: Eine kommentierte Auswahl in fünf Bänden.* Edited by DIETER WUTTKE. Vol. 1. Wiesbaden, 2001.

PANTAZZI, SYBILLE. "The Donna Laura Minghetti Leonardo. An International Mystification." *English Miscellany* 16 (1965): 321–348.

PANZERI, MATTEO, and GIULIO ORAZIO BRAVI. *La figura e l'opera di Giovanni Morelli: Materiali di ricerca.* Bergano, 1987.

PARKER, ROBERT ALLERTON. *A Family of Friends: The Story of the Transatlantic Smiths.* New York, 1959.

PATER, WALTER. *Appreciations: With an Essay on Style.* London, 1889.

———. *The Renaissance: Studies in Art and Poetry*. London, 1893.

———. *The Renaissance: Studies in Art and Poetry*. Edited by D. L. HILL. Berkeley, 1980.

———. *Marius the Epicurean: His Sensations and Ideas*. Kansas City, 2008.

PERRY, RALPH. *Present Philosophical Tendencies*. London, 1912.

PIEMONTESE, ANGELO MICHELE. "I manoscritti persiani della collezione Berenson." In *Studi in onore di Francesco Gabrieli nel suo ottantesimo compleanno*, edited by RENATO TRAINI, 631–639. Rome, 1984.

PIGNATTI, TERISIO. *Veronese L'opera completa*. 2 vols. Venice, 1978.

POMIAN, KRZYSZTOF. "Collezionisti, amatori e curiosi, Parigi-Venezia XVI–XVIII secolo." Milan, 1987.

POPE-HENNESSY, JOHN. *Learning to Look*. New York, 1991.

POPPI, CLAUDIO. *Modelli d'arte e di devozione: Adeodato Malatesta 1806–1891*. Exhibition catalog. Milan, 1998.

PORTER, ARTHUR KINGSLEY. *Medieval Architecture: Its Origins and Development*. 2 vols. London and New York, 1909.

———. *The Construction of Lombard and Gothic Vaults*. New Haven, 1911.

———. *Lombard Architecture*. 4 vols. New Haven, 1915–17.

———. *Beyond Architecture*. Boston, 1918.

———. *Romanesque Sculpture of the Pilgrimage Roads*. 10 vols. Boston, 1923.

PRETI, MATTIA. *Mattia Preti tra Roma, Napoli e Malta*. Exhibition catalog. Naples, 1999.

PREYER, BRENDA. "Renaissance 'Art and Life' in the Scholarship and Palace of Herbert P. Horne." In *Gli anglo-americani a Firenze: Idea e costruzione del Rinascimento*, edited by MARCELLO FANTONI, 235–248. Rome, 2000.

PROSKE, BEATRICE GILMAN. *Archer Milton Huntington*. New York, 1963.

RADKAU, JOACHIM. *Das Zeitalter der Nervosität: Deutschland zwischen Bismarck und Hitler*. Munich and Vienna, 1998.

REHM, WALTHER. "Der Renaissancekult um 1900 und seine Überwindug." *Zeitschrift für deutsche Philologie* 54 (1929): 296–328.

REHM, WALTHER, and REINHARDT HABEL. *Der Dichter und die neue Einsamkeit: Aufsätze zur Literatur um 1900*. Göttingen, 1969.

RICHA, GIUSEPPE. *Notizie Istoriche delle chiese Fiorentine*. Vol. 7. Florence, 1758.

RICHTER, IRMA, and GISELA RICHTER, eds. *Italienische Malerei der Renaissance im Briefwechsel von Giovanni Morelli und Jean Paul Richter 1876–1891*. Baden-Baden, 1960.

RICHTER, JEAN PAUL. *Leonardo da Vinci*. London, 1880.

———. "Die dresdener Gemäldegalerie und die moderne Kunstwissenschaft." *Unsere Zeit: Deutsche Revue der Gegenwart (Neue Folge)* 24 (1888): 345–360.

———. *The Mond Collection: An Appreciation*. Vol. 1. London, 1910.

———. *Altichiero: Sagen, Tradition und Geschichte; Originaltext und Übersetzung einer Veroneser Handschrift mit Kommentar*. Leipzig, 1935.

———, ed. *The Literary Works of Leonardo da Vinci*. 2 vols. New York, 1970.

RIGHI GUERZONI, LIDIA. "Antonio Begarelli (Modena 1499–1565)." In *Sculture a corte: Terrecotte, marmi, gessi della Galleria Estense dal XVI al XIX secolo*, edited by JADRANKA BENTINI, 44–45. Modena, 1996.

RILKE, RAINER MARIA. *Das Florenzer Tagebuch*. Edited by RUTH SIEBER-RILKE and CARL SIEBER. Frankfurt and Leipzig, 1994.

RINEHART, MICHAEL. "Bernard Berenson." In *The Early Years of Art History in the United States*, edited by CRAIG HUGH SMYTH and PETER M. LUKEHART, 89–96. Princeton, 1993.

RISCHBIETER, JULIA LAURA. *Henriette Hertz: Mäzenin und Gründerin der Bibliotheca Hertziana in Rom*. Wiesbaden, 2004.

RITCHIE, PATRICK DUNBAR. "Obituaries: Dr. A. P. Laurie." *Nature* 164 (1949): 987–988.

RIVI, LUCIANO. "Decorazione d'interni a Palazzo Foresti." In *Fondazione Umberto Severi*. Vol. 1, *Arte antica*, edited by JADRANKA BENTINI, 68–71. Modena, 1991.

ROBERTS, LAURENCE. *The Bernard Berenson Collection of Oriental Art at Villa I Tatti*. New York, 1991.

ROBERTSON, GILES. *Vincenzo Catena*. Edinburgh, 1954.

ROBINSON, BASIL W. *Persian Drawings (Drawings of the Masters)*. New York, 1965.

ROBINSON, DAVID M., ed. "Necrology." *American Journal of Archaeology* 41, no. 4 (1937): 607–608.

ROCKE, MICHAEL. "'Una sorta di sogno d'estasi': Bernard Berenson, l'Oriente e il patrimonio orientale di Villa I Tatti." In *Firenze, il Giappone e l'Asia Orientale*, edited by ADRIANA BOSCARO and MAURIZIO BOSSI, 367–384. Florence, 2001.

ROECK, BERND. "Una città all'alba dei tempi moderni: Aby Warburg a Firenze." In *Storia dell'arte e politica culturale intorno al 1900: La fondazione dell'Istituto Germanico di Storia dell'Arte di Firenze*, edited by MAX SEIDEL, 271–279. Venice, 1999.

———. "Wahrmund, ein kleiner Gelehrter: Der Kulturhistoriker Aby Warburg wird in einem Renaissancedrama von Wilhelm Uhde lächerlich gemacht." *Frankfurter Allgemeine Zeitung*, 12 September 2001, "Geisteswissenschaften" section.

———. "Von Bismarck bis Picasso: Wilhelm Uhde und die Geburt der Avantgarde." In *Ordnungen in der Krise: Zur politischen Kulturgeschichte Deutschlands 1900–1933*, edited by WOLFGANG HARDTWIG, 481–497. Munich, 2007.

———. *Florence 1900: The Quest for Arcadia*. Translated by STEWART SPENCER. New Haven and London, 2009.

ROMANO, JOSEPH. "Connoisseurship and Photography: The Methodology of Mojmir Frinta." In *Art History through the Camera's Lens*, edited by HELENE E. ROBERTS, 153–177. Langhorne, 1995.

ROSSI, MANUELA, ed. *La città del principe. Semper e Carpi: Attualità e continuità della ricerca*. Pisa, 2001.

———, ed. *Alberto III e Rodolfo Pio da Carpi collezionisti e mecenati*. Tavagnacco, 2004a.

———. "Un pubblico enorme assisteva alla magnifica festa d'arte." In *Alle origini del museo 1914–2004: La donazione Foresti nelle collezioni di Carpi*, edited by MANUELA ROSSI and TANIA PREVIDI, 37–39. Carpi, 2004b.

———, ed. *Rare pitture: Ludovico Carracci, Guercino e l'arte nel seicento a Carpi*. Exhibition catalog. Carpi, 2010.

ROSSI, MANUELA, and ELENA SVALDUZ. *Il palazzo dei Pio a Carpi: Sette secoli di architettura e arte*. Venice, 2008.

ROSSI, MANUELA, and TANIA PREVIDI, eds. *Alle origini del museo 1914–2004: La donazione Foresti nelle collezioni di Carpi*. Carpi, 2004.

ROXBURGH, DAVID J. "Kamal al-Din Bihzad and Authorship in Persianate Painting." *Muqarnas* 17 (2000): 119–146.

RUBIN, PATRICIA. "Bernard Berenson, Villa I Tatti, and the Visualization of the Italian Renaissance." In *Gli Anglo-Americani a Firenze: Idee e costruzione del Rinascimento*, edited by MARCELLO FANTONI, 207–221. Rome, 2000a.

———. "Portrait of a Lady: Isabella Stewart Gardner, Bernard Berenson, and the Market for Renaissance Art in America." *Apollo* 152 (September 2000b): 37–44.

RUBIN, WILLIAM STANLEY. *Picasso and Braque: Pioneering Cubism*. Boston, 1989.

RUSSOLI, FRANCO. *La raccolta Berenson*. Milan, 1962. Published in English as *The Berenson Collection*, Milan, 1964.

SAID, EDWARD. *Orientalism*. New York, 1978.

SALMI, MARIO. "Spigolature d'arte toscana." *L'arte* 16 (1913): 208–227.

SALTZMAN, CYNTHIA. *Old Masters, New World: America's Raid on Europe's Great Pictures, 1880–World War I*. New York, 2008.

———. "'The Finest Things': Colnaghi, Knoedler, and Henry Clay Frick." In *Colnaghi: The History*, edited by JEREMY HOWARD, 32–36. London, 2010.

SAMUELS, ERNEST. *Bernard Berenson: The Making of a Connoisseur.* Cambridge MA, 1979.

⸺. *Bernard Berenson: The Making of a Legend.* Cambridge MA and London, 1987.

SARRE, FRIEDRICH PAUL THEODOR. *Meisterwerke muhammedanischer Kunst auf der Ausstellung München 1910.... Photographische original-aufnahmen ... die in dem grossen Ausstellungswerk von Sarre-Martin nicht veröffentlicht sind.* Munich, 1912.

SATTLER, BERNHARD. *Adolf von Hildebrand und seine Welt: Briefe und Erinnerungen.* Munich, 1962.

SAUMAREZ SMITH, CHARLES, with contributions from GIORGIA MANCINI. *Ludwig Mond's Bequest: A Gift to the Nation.* London, 2006.

SCHÄFER, HANS-MICHAEL. *Die Kulturwissenschaftliche Bibliothek Warburg: Geschichte und Persönlichkeiten der Bibliothek Warburg mit Berücksichtigung der Bibliothekslandschaft und der Stadtsituation der Freien und Hansestadt Hamburg zu Beginn des 20. Jahrhunderts.* Berlin, 2003.

SCHAPIRO, LILLIAN MILGRAM, and DANIEL ESTERMAN, eds. *Meyer Schapiro: His Painting, Drawing, and Sculpture.* New York, 2000.

SCHAPIRO, MEYER. "Mr. Berenson's Values." *Encounter* (January 1961): 57–64.

SCHINDLER, THOMAS. *Zwischen Empfinden und Denken: Aspekte zur Kunstpsychologie von Aby Warburg.* Münster, 2000.

SCHLESIER, RENATE. "Ungestraft unter Palmen: Freud in Italien." In *Vorträge aus dem Warburg-Haus,* by UWE FLECKNER et al., 8:167–198. Berlin, 2004.

SCHMIDT, PETER, and DIETER WUTTKE. *Aby M. Warburg und die Ikonologie.* Wiesbaden, 1993.

SCHNEIDER, MARK. *Culture and Enchantment.* Chicago, 1993.

SCHOPENHAUER, ARTHUR. *The World as Will and Representation.* Translated by E. F. J. PAYNE. Vol. 1. New York, 1969.

SCHUBRING, PAUL. *Cassoni: Truhen und Truhenbilder in der Italienischen Frührenaissance; Ein Beitrag zur Profanmalerei im Quattrocento.* Leipzig, 1915.

SCILTIAN, GREGORIO. *Mia avventura.* Milan, 1963.

SECREST, MERYLE. *Being Bernard Berenson: A Biography.* New York, 1979. Reprinted London, 1980.

⸺. *Kenneth Clark: A Biography.* London, 1984.

⸺. *Duveen: A Life in Art.* New York, 2004.

SEIDEL, LINDA. "Arthur Kingsley Porter: Life, Legend, and Legacy." In *The Early Years of Art History in the United States,* edited by CRAIG HUGH SMYTH and PETER M. LUKEHART, 97–110. Princeton, 1993.

SHAND-TUCCI, DOUGLASS. *The Art of Scandal: The Life and Times of Isabella Stewart Gardner.* New York, 1997.

SHAPLEY, FERN RUSK. *Paintings from the Samuel H. Kress Collection: Italian Schools, XIII–XV Century.* London, 1966.

⸺. *Paintings from the Samuel H. Kress Collection: Italian Schools, XV–XVI Century.* London, 1968.

⸺. *Paintings from the Samuel H. Kress Collection: Italian Schools, XVI–XVIII Century.* London, 1973.

SHAW, JAMES BYAM. *J. B. S. Selected Writings.* London, 1968.

SILVESTRI, SILVIA. "Lo studio Brogi a Firenze: Da Giacomo Brogi a Giorgio Laurati." *ATF: Semestrale dell'Archivio Fotografico Toscano; Rivista di storia e fotografia* 10, no. 20 (December 1994): 9–32.

SIMPSON, COLIN. *Artful Partners: Bernard Berenson and Joseph Duveen.* New York, 1986.

⸺. *The Partnership: The Secret Association of Bernard Berenson and Joseph Duveen.* London, 1987.

SIMPSON, MARIANNA SHREVE. *The Illustration of an Epic: The Earliest Shahnama Manuscripts.* New York, 1979.

SIRÉN, OSVALD. *A Descriptive Catalogue of the Pictures in the Jarves Collection Belonging to Yale University.* New Haven, 1916.

⸺. *The Chinese on the Art of Painting.* Beijing, 1936.

———. *Gardens of China*. New York, 1949.

———. *China and Gardens of Europe of the Eighteenth Century*. New York, 1950.

———. *Chinese Painting: Leading Masters and Principles*. 7 vols. London and New York, 1956–58.

SMITH, LOGAN PEARSALL. *Reperusals and Re-Collections*. New York, 1936.

———. *Unforgotten Years*. Boston, 1938.

SMITH, LOGAN PEARSALL, with BERNARD BERENSON and MARY SMITH COSTELLOE (BEREN-SON). "Altamura." *The Golden Urn* 3 (1898): 99–107.

SOMMER, SALLY. "Katherine Dunham: African-American Dancer, Choreographer, Anthropologist, Activist, and Vodoo Priestess." *Guardian*, 23 May 2006.

SONTAG, SUSAN. *Against Interpretation*. London, 1994.

SOUCEK, PRISCILLA. "Walter Pater, Bernard Berenson, and the Reception of Persian Manuscript Illustration." *Res: Anthropology and Aesthetics* 40 (autumn 2001): 113–128.

SPALLANZANI, MARCO. *Oriental Rugs in Renaissance Florence*. Florence, 2007.

SPIKE, JOHN T. *Giuseppe Maria Crespi and the Emergence of Genre Painting in Italy*. Florence, 1986.

———. *Mattia Preti: Catalogo ragionato dei dipinti*. Florence, 1999.

SPINELLI, ALESSANDRO GIUSEPPE. *Sosta a Carpi*. Modena, 1902.

SPINOSA, NICOLA. *Ribera: L'opera completa*. Naples, 2003.

SPRANG, FELIX. "Carlyle and Warburg: The Dynamics of Culture as a 'Process of Devastation and Waste.'" In *Cultures in Process: Encounter and Experience*, edited by RALF SCHNEIDER and STEPHEN GRAMLEY, 161–169. Bielefeld, 2009.

SPRENGER, ALOYS. *Das Leben und die Lehre des Moḥammad*. 3 vols. Berlin, 1861.

SPRIGGE, SYLVIA. *Berenson: A Biography*. London, 1960.

STECHOW, WOLFGANG. "Marco del Buono and Apollonio di Giovanni: Cassone Painters." *Bulletin of the Allen Memorial Art Museum, Oberlin College* 1 (1944): 5–21.

STEIN, AUREL, and LAURENCE BINYON. "Un dipinto cinese." *Dedalo* 2, anno 9 (1928–29): 261–282.

STEIN, ROGER. "Artifact as Ideology: The Aesthetic Movement in Its American Cultural Context." In *In Pursuit of Beauty: Americans and the Aesthetic Movement*, edited by DOREEN BOLGER BURKE, 22–51. New York, 1986.

STIMILLI, DAVIDE. "L'impresa di Warburg." In *Aby Warburg: La dialettica dell'immagine*, edited by DAVIDE STIMILLI, 121/122:97–116. Milan, 2004.

———. "Aby Warburg in America Again, with an Edition of His Unpublished Correspondence with Edwin R. Seligman (1927–1928)." *Res: Anthropology and Aesthetics* 48 (2005): 193–206.

———. "Aby Warburg's *Pentimento*." *Yearbook of Comparative Literature* 56, no. 1 (2010): 140–175.

STRACHEY, BARBARA, and JAYNE SAMUELS, eds. *Mary Berenson: A Self-Portrait from Her Letters and Diaries*. London, 1983.

STREHLKE, CARL BRANDON. "Bernhard and Mary Berenson, Herbert P. Horne, and John G. Johnson." *Prospettiva* 57–60 (April 1989–October 1990): 427–438.

———. *Italian Paintings 1250–1450 in the John G. Johnson Collection and the Philadelphia Museum of Art*. Philadelphia, 2004.

———. "Berenson, Sassetta, and Asian Art." In *Sassetta: The Borgo San Sepolcro Altarpiece*, edited by MACHTELT ISRAËLS, 1:37–49. Florence and Leiden, 2009.

STROUSE, JEAN. *Morgan: American Financier*. New York, 1999.

SUTTON, DENYS. "Persian Enchantment." *Financial Times*, 26 August 1962.

TAINE, HIPPOLYTE. *Voyage en Italie: Florence et Venise*. Paris, 1990.

TAKAGISHI, AKIRA. "A Twentieth-Century Dream with a Twenty-First-Century Outlook: Yashiro Yukio, a Japanese Historian of Western Art, and His Conception of Institutions for the Study of East Asian Art." In *Asian Art in the Twenty-First Century*, edited by VISHAKHA N. DESAI, 138–48. Williamstown, 2007.

TAMASSIA, MARILENA. *Collezioni d'arte tra ottocento e novecento: Jacquier fotografi a Firenze, 1870–1935*. Naples, 1995.

TEMPESTINI, ANCHISE. "Temi profani e pittura narrativa in Giovanni Bellini." In *Giovanni Bellini*, exhibition catalog, edited by MAURO LUCCO and GIOVANNI CARLO FEDERICO VILLA, 53–65. Milan, 2008.

THOMPSON, BARBARA. "The Courtauld Institute of Art 1932–1945." *Courtauld Institute of Art News* 22 (2007): 5–9.

THOMPSON, DANIEL VARNEY, JR. "The 'Schedula' of Theophilus Presbyter." *Speculum* 7 (1932): 199–220.

———. "'Ricepte d'affare piu colori' of Ambrogio di Ser Pietro da Siena." *Archeion* 15 (1933): 339–347.

———. "The Study of Medieval Craftsmanship." *Bulletin of the Fogg Art Museum* 3 (1934): 3–8.

———. Review of *Technik des Kunsthandwerks im zehnten Jahrhundert*, by Wilhelm Theobald. *Speculum* 10 (1935): 437–440.

———. *The Practice of Tempera Painting*. New York, 1962. First published 1936.

———. "Theophilus Presbyter: Words and Meaning in Technical Translation." *Speculum* 42 (1967): 313–339.

———. "Story of a Drop-Out." *Lawrentian (The Lawrenceville Alumni Bulletin)* 34 (1969): 11–13.

THOMPSON, DANIEL VARNEY, JR., and GEORGE HEARD HAMILTON. *An Anonymous Fourteenth-Century Treatise, De arte illuminandi: The Technique of Manuscript Illumination*. New Haven, 1933.

TIBAWI, ABDUL LATIF. "A Second Critique of English-Speaking Orientalists and Their Approach to Islam and the Arabs." *Islamic Quarterly* 23 (1979): 3–43.

TIRYAKIAN, EDWARD. "Dialectics of Modernity: Reenchantment and Dedifferentiation as Counterprocesses." In *Social Change and Modernity*, edited by HANS HAFERKAMP and NEIL SMELSER, 78–94. Berkeley, 1992.

TODINI, FILIPPO. *La pittura umbra dal duecento al primo cinquecento*. 2 vols. Milan, 1989.

TOSATTI, SILVIA BIANCA. *Trattati medievali di tecniche artistiche*. Milan, 2007.

TROMPEO, PIETRO PAOLO. "Vetrine giapponesi." In *Carducci e D'Annunzio: Saggi e postille*, 173–189. Rome, 1943.

TROTTA, ANTONELLA. *Rinascimento Americano: Bernard Berenson e la collezione Gardner 1894–1924*. Naples, 2003.

———. *Berenson e Lotto: Problemi di metodo e di storia dell'arte*. Naples, 2006.

TROYER, NANCY GRAY. "Telemaco Signorini and Macchiaioli Giapponismo: A Report of Research in Progress." *Art Bulletin* 66 (1984): 136–145.

UHDE, WILHELM. *Am Grabe der Mediceer: Florentiner Briefe über deutsche Kultur*. Dresden, 1899.

———. *Paris: Eine Impression*, Berlin, 1904.

———. *Picasso et la tradition française*. Paris, 1926.

———. *Von Bismarck bis Picasso*. Zurich, 1938. New edition 2010.

ULUÇ, LALE. *Turkman Governors, Shiraz Artisans, and Ottoman Collectors: Sixteenth Century Shiraz Manuscripts*. Istanbul, 2006.

USENER, HERMANN. *Philologie und Geschichtswissenschaft*. Bonn, 1882.

VAKKARI, JOHANNA. "Alcuni contemporanei finlandesi di Lionello Venturi: Osvald Sirén, Tancred Borenius, Onni Okkonen." *Storia dell'arte* 101 (2002): 108–117.

VARISCO, DANIEL MARTIN. *Reading Orientalism: Said and the Unsaid*. Seattle, 2008.

VENTURI, ADOLFO. "Ritratto di dama di Paolo Veronese." *L'arte* 35 (July 1932): f. IV, vol. III, n.s., 404–405.

VENTURI, LIONELLO. *Pitture italiane in America, illustrate da Lionello Venturi*. Milan, 1931. English edition New York, 1933.

———. *Storia della critica d'arte*. Florence, 1948.

VERNOIT, STEPHEN. "Islamic Art and Architecture: An Overview of Scholarship and Collecting, c. 1850–c. 1950." In *Discovering Islamic Art: Scholars, Collectors, and Collections, 1850–1950*, edited by STEPHEN VERNOIT, 1–61. London and New York, 2000.

VERTOVA, LUISA. "Bernard Berenson: Early Italian and Oriental Art." In *Great Private Collections*, edited by DOUGLAS COOPER, 60–73. London, 1963.

———. "I Tatti." *Antichità viva: Rassegna d'arte* 8, no. 6 (1969a): 53–78.

———. "La raccolta Berenson di pagine e codici miniati." *Antichità viva: Rassegna d'arte* 8, no. 6 (1969b): 37–44.

VIDAL-NACQUET, ALAIN, and ALBERTO SILIOTTI. *Journal de voyage en Egypte: Roberto Morra di Lavriano et son journal de voyage*. Paris, 1997.

VILLHAUER, BERND. *Aby Warburgs Theorie der Kultur: Detail und Sinnhorizont*. Berlin, 2002.

VISCHER, ROBERT. *Über das optische Formgefühl: Ein Beitrag zur Aesthetik*. Leipzig, 1873.

VOGELER, MARTHA SALMON. "The Religious Meaning of Marius the Epicurean." *Nineteenth Century Fiction* 19 (1964): 287–299.

VOLPE, CARLO. "Una 'Crocifissione' di Jacobello del Fiore." *Arte antica e moderna* 20 (1962): 438.

VON MOOS, STANISLAUS. *Le Corbusier: Elements of a Synthesis*. Revised and expanded version. Rotterdam, 2009.

WALKER, JOHN. *Self-Portrait with Donors: Confessions of an Art Collector*. Boston and Toronto, 1969.

WARBURG, ABY. "Botticellis 'Geburt der Venus' und 'Frühling.'" PhD diss., Hamburg and Leipzig, 1893.

———. *Ausgewählte Schriften und Würdigungen*. Edited by DIETER WUTTKE. Baden-Baden, 1992.

———. *The Renewal of Pagan Antiquity: Contributions to the Cultural History of the European Renaissance*. Los Angeles, 1999.

———. *Der Bilderatlas Mnemosyne*, edited by MARTIN WARNKE in collaboration with CLAUDIA BRINK. Reprinted in *Gesammelte Schriften: Studienausgabe*. Vol. 2, no. 1. Berlin, 2000.

———. *Tagebuch der Kulturwissenschaftlichen Bibliothek Warburg mit Einträgen von Gertrud Bing und Fritz Saxl*, edited by KAREN MICHELS and CHARLOTTE SCHOELL-GLASS. Reprinted in *Gesammelte Schriften: Studienausgabe*. Vol. 7. Berlin, 2001.

WARREN, JEREMY. "Bode and the British." In *Jahrbuch der Berliner Museen*. Vol. 38. Beiheft, 1996.

WEAVER, WILLIAM. *A Legacy of Excellence: The Story of Villa I Tatti*. With photographs by DAVID FINN and DAVID MOROWITZ. New York, 1997.

WEDEPOHL, CLAUDIA. "'Wort und Bild': Aby Warburg als Sprachbildner." In *Ekstatische Kunst— Besonnenes Wort: Aby Warburg und die Denkräume der Ekphrasis*, edited by PETER KOFLER, 23–46. Bozen, 2009.

WEIL, GUSTAV. *Muhammad der Prophet, sein Leben und seine Lehre*. Stuttgart, 1843.

WELLEK, RENÉ. "Vernon Lee, Bernard Berenson, and Aesthetics." In *Friendship's Garland: Essays Presented to Mario Praz on His Seventieth Birthday*, edited by VITTORIO GABRIELI, 2:233–251. Rome, 1966.

WETHEY, HAROLD E. *The Paintings of Titian*. Vol. 2, *The Portraits*. London, 1971.

WHARTON, EDITH. *A Backward Glance*. New York, 1934.

WHITE, HAYDEN. *Metahistory: The Historical Imagination in Nineteenth-Century Europe*. Baltimore and London, 1973.

WHITEHILL, WALTER MUIR. "Arthur Kingsley Porter (1883–1933)." *Harvard Alumni Bulletin* 36 (17 November 1933): 221–222.

WINDHOLZ, ANGELA, ed. *Mir tanzt Florenz auch im Kopfe rum: Die Villa Romana in den Briefen von Max Klinger an den Verleger Georg Hirzel*. Berlin and Munich, 2005.

WUTTKE, DIETER. *Aby M. Warburgs Methode als Anregung und Aufgabe*. Göttingen, 1978.

YAMADA, CHISABURŌ. ルネッサンスのイタリア画家. Tokyo, 1961.

YASHIRO YUKIO. *Sandro Botticelli*. London and Boston, 1925.

———. *2000 Years of Japanese Art*, edited by PETER C. SWAN. New York, 1958.

YASUKO HORIOKA, MARYLIN RHIE, and WALTER B. DENNY. *Oriental and Islamic Art in the Isabella Stewart Gardner Museum*. Boston, 1975.

YING LING HUANG, MICHELLE. "The Acquisition of the Wegener Collection of Chinese Paintings by the British Museum." *The Burlington Magazine* CLV, no. 1324 (2013): 463–470.

ZAITZEVSKY, CYNTHIA. *Frederick Law Olmsted and the Boston Park System.* Cambridge MA, 1982.

ZAMBONI, SILLA. *I pittori di Ercole I° d'Este: Giovan Francesco Maineri, Lazzaro Grimaldi, Domenico Panetti, Michele Coltellini.* Milan, 1975.

ZAMBRANO, PATRIZIA, and JONATHAN KATZ NELSON. *Filippino Lippi.* Milan, 2004.

ZERI, FEDERICO. "Una precisazione su Bicci di Lorenzo." *Paragone* 9, no. 105 (1958): 67–71.

———. *Diari di lavoro 1.* Turin, 1983.

———. "Una sala Alitalia ad Assisi nel sacro Convento: Le 57 opere più belle della collezione Mason Perkins." *Giornale dell'arte* 37 (1986): 16.

ZORZI, ROSELLA. "'Figures Reflected in the Clear Lagoon': Henry James, Daniel and Ariana Curtis, and Isabella Stewart Gardner." In *Gondola Days: Isabella Stewart Gardner and the Palazzo Barbaro Circle,* edited by ALAN CHONG, 129–154. Boston, 2004.

# Contributors

ALISON BROWN

Brown is emerita professor of Italian Renaissance history at Royal Holloway, University of London. Her recent books include *The Return of Lucretius to Renaissance Florence* (2010) and *Medicean and Savonarolan Florence* (2011), with forthcoming essays on "Piero de' Medici in Power," "Defining the Place of Academies in Florentine Politics and Culture," "Lucretian Naturalism and the Evolution of Machiavelli's Ethics," and "Leonardo, Lucretius, and Their Views of Nature."

DAVID ALAN BROWN

Brown is curator of Italian paintings at the National Gallery of Art in Washington, where he has organized many international loan exhibitions, including *Bellini, Giorgione, Titian, and the Renaissance of Venetian Painting* (2006). Brown's monograph on Andrea Solario earned him the Salimbeni Prize, Italy's most distinguished award for art books, in 1987. His study *Leonardo da Vinci: Origins of a Genius* (1998) won the Sir Bannister Fletcher Award in 2000 for the most deserving book on art or architecture. In recognition of his achievement in furthering the appreciation of Italian culture, Brown was awarded the Order of Merit of the Republic of Italy in 2003.

KATHRYN BRUSH

Brush earned her PhD at Brown University; she is professor of art history in the department of visual arts at the University of Western Ontario, Canada. Her research focuses on Romanesque and Gothic art, medieval sculpture, the historiography of cultural-historical thought, and histories of museums, archives, and art collecting. Her books include *The Shaping of Art History: Wilhelm Vöge, Adolph Goldschmidt, and the Study of Medieval Art* (1996) and *Vastly More than Brick and Mortar: Reinventing the Fogg Art Museum in the 1920s* (2003). She recently organized an exhibition, with accompanying book, on *Mapping Medievalism at the Canadian Frontier* (2010). Currently, she is preparing a book that explores the scholarly imagination of the pioneering American medievalist Arthur Kingsley Porter.

## THEA BURNS

Burns received her PhD from the Courtauld Institute of Art, University of London; her MAC from the art conservation program, Queen's University, Kingston, Ontario; and her BA (honors, first class) from McGill University, Montreal. She received a certificate in paper conservation from the Center for Conservation and Technical Studies, now Straus Center, Harvard University Art Museums. She served as Helen H. Glaser Senior Paper Conservator for Special Collections in the Weissman Preservation Center, Harvard College Library, as associate professor in the art conservation program, Queen's University, and as a conservator in private practice. She has published in numerous professional journals and conference postprints. She is the author of *The Invention of Pastel Painting* (2007) and *The Luminous Trace: Drawing and Writing in Metalpoint* (2012); she is currently an independent scholar.

## MARIO CASARI

Casari studied Persian and Arabic languages in Italy and the Middle East, and obtained his PhD in Iranian studies at the Istituto Universitario Orientale, Naples. He is lecturer in Arabic language and literature at the Italian Institute of Oriental Studies, University of Rome "La Sapienza." His research deals with cultural relations between Europe and the Islamic world from late antiquity to the modern age. He has published a number of studies concerning the transmission of narrative works in the Arabic and Persian traditions—in particular the *Alexander Romance*—and on the circulation of literary, iconographic, and scientific themes between East and West. In 2011, he was awarded the Al-Farabi-UNESCO prize for his book *Alessandro e Utopia nei romanzi persiani medievali* (1999). For his research on Oriental studies in Renaissance Italy, he was made Andrew W. Mellon Fellow at I Tatti in 2008–9, where he became acquainted with the Berenson Archive.

## ROBERT COLBY

Colby holds a PhD in art history from the Courtauld Institute of Art. He is currently working on a book about Bernard Berenson's aesthetic utopia, Altamura. In 2012, he held a Craig Hugh Smyth Visiting Fellowship at Villa I Tatti. In 2013, he received a Franklin Research Grant from the American Philosophical Society. He is currently a fellow at the Institute for the Arts and Humanities at the University of North Carolina at Chapel Hill.

## JOSEPH CONNORS

Connors, a New Yorker by birth and formation, earned his doctorate in 1978 at Harvard University and has taught Renaissance and baroque art at the University of Chicago, Columbia University, and Harvard University. He was director of the American Academy in Rome from 1988 to 1992 and of Villa I Tatti from 2002 to 2010. He has held fellowships from the Guggenheim Foundation, the National Endowment for the Humanities, and the American Council of Learned Societies; he has published books on Francesco Borromini, Roman urban history, and Giovanni Battista Piranesi.

ROBERT AND CAROLYN CUMMING

Robert Cumming is an adjunct professor of the history of art at Boston University. Educated at the University of Cambridge, he worked for the Tate Gallery and was then responsible for founding and running Christie's Education. In 2005, he joined Boston University to lead its London campus. He and his wife Carolyn, who is an independent scholar and garden designer, have devoted many years to the study of connoisseurship and the Berenson circle. Carolyn Cumming, who is high sheriff of Buckinghamshire and fellow of the Royal Society of Arts, has supported the Buckinghamshire and Milton Keynes Community Foundations by horse riding from the north to south of the county to raise funds for charities that support families and children.

JEREMY HOWARD

Howard is head of research at Colnaghi and senior lecturer in the history of art at the University of Buckingham, where he heads the department of art history and heritage studies. He studied English at Oriel College, Oxford, and Italian Renaissance art at the Courtauld Institute of Art. After working for thirteen years in the London art market, he taught history of art for ten years at the University of Buckingham and for three years at Birkbeck, University of London, before rejoining Colnaghi as head of research in 2006. He also runs an MA program in eighteenth-century interiors and decorative arts in collaboration with the Wallace Collection. His research interests lie mainly in the field of British eighteenth-, nineteenth-, and early twentieth-century collecting and the development of the London art market. Recent publications include *Frans Hals's St. Mark: A Lost Masterpiece Rediscovered* (2007), *Cranach* (2008), *Colnaghi: The History* (2010), and "Titian's *Rape of Europa*: Its Reception in Britain and Sale to America" (2013).

ISABELLE HYMAN

Hyman is professor emerita in the department of art history at New York University, where she taught for forty years. She received her BA from Vassar College, her MA from Columbia University, and her MA and PhD in art history from New York University's Institute of Fine Arts. Her fields of specialization are the history of architecture, Italian Renaissance art and architecture, and the architecture of Marcel Breuer. She has been the recipient of a Guggenheim Fellowship and a grant from the Graham Foundation for Advanced Studies in the Fine Arts; she was Kress Fellow at Villa I Tatti in 1972–73. She was Robert Sterling Clark Visiting Professor at Williams College, and for several terms served as editor and coeditor of the College Art Association's scholarly monograph series. In addition to articles and reviews, she is the author of *Brunelleschi in Perspective* (1974), *Fifteenth-Century Florentine Studies: Palazzo Medici and a Ledger for the Church of San Lorenzo* (1977), and *Marcel Breuer, Architect: The Career and the Buildings* (2001)— the latter was one of two winners in 2002 of the Alice Davis Hitchcock Book Award given annually by the Society of Architectural Historians for "the most distinguished work of scholarship in the history of architecture." She is also coauthor with Marvin Trachtenberg of *Architecture: From Prehistory to Postmodernity* (2002). She has served

on the boards of the College Art Association, the Society of Architectural Historians, the Friends of the Vassar Art Gallery, and the Muscarelle Museum at the College of William and Mary.

ELISABETTA LANDI

Landi, an official in the national heritage administration, is the granddaughter of the collector Carlo Alberto Foresti; she studied medieval and modern art at the University of Bologna. She focuses on the history of collecting, especially that of Carlo Alberto and Pietro Foresti, as well as the latter's connection with Adolfo Venturi, and the patronage of the artist Giovanni Muzzioli. She has published numerous articles on the baroque and neoclassical decorations of Emilia-Romagna, specifically on Stefano Orlandi, including his entry in the *Dizionario Biografico degli Italiani*. She has also studied the iconography and iconology of Pomona, Venus, and Heliades, and emblematic literature. Her current research is on mystical and ascetic women. She also contributes to several scholarly journals and organizes conferences.

WILLIAM MOSTYN-OWEN

Mostyn-Owen, who died on 2 May 2011, was introduced to Bernard Berenson and I Tatti by Rosamond Lehmann in the autumn of 1952 and acted as Berenson's assistant until the connoisseur's death in 1959, working on the revision of *Lorenzo Lotto* and, with Luisa Vertova, on the Venetian and Florentine Lists. He compiled the *Bibliografia di Bernard Berenson* (1955) and was instrumental in obtaining Harvard University's acceptance of the villa. He joined the Old Master department of Christie's, London, in 1965, was appointed a director at Christie's in 1968, and was made chairman of Christie's Education in 1977. He retired in 1987.

BERND ROECK

Roeck studied history and political science at the University of Munich, where he earned his PhD in 1979. Thereafter, he was a fellow of the Leibniz Institute of European History (Mainz) as well as scientific assistant at the University of Munich. In 1987, he obtained his habilitation with a study on the city of Augsburg during the Thirty Years' War. From 1986 to 1990, he was director of the Centro Tedesco di Studi Veneziani in Venice. From 1991 to 1999, he held the chair of medieval and modern history at the University of Bonn; from 1997 to 1999, he was on leave and filled the position of secretary general of the Villa Vigoni Association in Loveno di Menaggio, Italy. Since 1999, he has held the chair of modern history at the University of Zurich, Switzerland. His work covers the artistic, cultural, and social history of the Thirty Years' War and the European Renaissance.

DIETRICH SEYBOLD

Seybold, independent scholar at Basel, has, after completing his PhD at the University of Basel (2004), carried out research in the areas of history and art history. His book on Leonardo da Vinci and the Oriental world (2011) has reexamined the myth of Leonardo

traveling to the East and provided the first overview on all Oriental references in Leonardo's life, notes, and oeuvre. His main area of research is now the history of connoisseurship, with a forthcoming biography of the Leonardo scholar and pupil of Giovanni Morelli, Jean Paul Richter (1847–1937), as well as a brief history of the painting collection of Henriette Hertz, commissioned by the Bibliotheca Hertziana (2013, in Italian).

### CARL BRANDON STREHLKE

Strehlke, adjunct curator of the John G. Johnson Collection at the Philadelphia Museum of Art, is the author of the 2004 catalog of that collection's early Italian paintings. He has been involved in exhibitions on Sienese Renaissance art, Fra Angelico, Pontormo, and Bronzino at both the Philadelphia Museum of Art and the Metropolitan Museum of Art. He is chief editor of the forthcoming catalog of paintings in the Bernard and Mary Berenson Collection at Villa I Tatti.

### CLAUDIA WEDEPOHL

Wedepohl (PhD, University of Hamburg) is an art historian who joined the staff of the Warburg Institute in 2000. Since 2006, she has been the institute's archivist. Her research focuses on two fields: the reception of late antique models in fifteenth-century Italian art and architecture, and the genesis of Aby Warburg's cultural theoretical notions. She is the author of *In den glänzenden Reichen des ewigen Himmels: Cappella del Perdono und Tempietto delle Muse im Herzogpalast von Urbino* (2009), coeditor of Aby M. Warburg's *Per Monstra ad Sphaeram: Sternglaube und Bilddeutung* (2008; Italian edition, 2009), and coeditor of the multivolume edition of Aby Warburg's collected writings, *Gesammelte Schriften, Studienausgabe* (1998–).

# Index

Page numbers in *italics* indicate illustrations.

scandal, 52–53; Sargent portrait, 43; Stuart dynasty and, 51, 79; Villa I Tatti, visit to, 96; Yashiro Yukio and, 226, 227n62, 229n71. *See also* Altamura Garden Pavilion, Fenway Court; Isabella Stewart Gardner Museum/Fenway Court

Gardner, John Lowell ("Jack"; husband), 51n54, 52, 78, 84, 85

Gardner Museum. *See Isabella Stewart Gardner Museum*

Garstang, Donald, 34

Garton, John, 329–330

Gates, Helen Manchester, 339

Gauguin, Paul, 139

Geertz, Clifford, 368

Geffcken, Johannes, 159n80

Gellhorn, Martha, 18

Gemäldegalerie, Berlin, 27nn41–42, 34, 39, 40, 45–46

*Gems of the Manchester Art Treasures Exhibition* (Colnaghi and Agnew's, 1858), 37

Genettes, Madame Roger des, 90–91

Genga, Girolamo, 316

Gerini, Niccolò di Pietro, 15, 257, 258, 323

Germany, Bernard Berenson on "Orientalization" of, 202

*"Ghazel: Thought and Temperament"* (poem; Berenson), 174, 204–205

Ghirlandaio, Domenico, 159, 160, 161, 322

Giambono, Michele, *St. Michael Archangel Enthroned* (1440–45), 8, 19, 20, 27–30

Gibbon, Edward, 176

Gide, André, 344

Ginori, Richard, 131

Giorgetti, Alceste, 151

Giorgione, Giorgio Barabelli da Castelfranco, 5, 8, 27, 235–236, 262, 279n12

Giotto di Bondone, 15, 101, 120, 139, 140, 223, 259, 344

Giovanni di Paolo, 237

Glaenzer, Eugene, 55

*Gli Anglo-Americani a Firenze* (Fantoni, 2000), 6

*Gli indifferenti* (Moravia), 361

Glucksmann, Carl, 153

Gobetti, Piero, 10, 352, 355, 358, 359n44

Gobineau, Arthur de, 198

Goethe, Johann Wolfgang von, 3, 7, 123–124, 177

*The Golden Urn* (periodical), "Altamura," and Dionites, 9–10, 69–70, 71–72, 84, 85–86, 87, 88–96, 97, 98–99, 100. *See also* Altamura Garden Pavilion, Fenway Court

Goldman, Henry, 271

Goldman Sachs, 271

Goldschmidt, Adolph, 154

Gombrich, Ernst, 10, 103n5, 107, 108, 149n30, 152, 157, 159n83, 239

*Gondola Days* (exhibition, Isabella Stewart Gardner Museum, 2004), 8

*The Gospel of Freedom* (Herrick, 1898), 93

*Gospels of Anarchy* (Lee, 1908), 118

Gothic Revival, 78, 79, 84, 134, 233

*The Gothic Revival* (Clark, 1928), 233, 278

Goupil et Cie, 35–36

Grabar, Oleg, 13

Granville-Barker, Harley, 339n41

Gray, Simon, 5

Great Kanto Earthquake (1923), 226, 227

Great Mongol *Shahnama* (Ferdowsi): ca. 1335 manuscript of, 12, 189, 190; ca. 1524–76 manuscript of, 190, 194

Greene, Belle da Costa, 4, 5, 18, 294, 301, 303, 364, 382

Greener, Richard Theodore, 382

Greenslet, Ferris, 204n90

Gregorovius, Ferdinand, 124

Grimaldi, Lazzaro, 315n31

Gronau, Georg, 52, 154n54, 310

Grossi, Carlo, 312

Grousset, René, 197

Guardi, Francesco, 63, 316, 322

Guéraut, Robert, 36n10

Guercino, Giovanni Francesco Barbieri, 318, 322

*Guernica* (Picasso), 141

Guicciardini, Francesco, 131

Gulbenkian, Calouste, 63

Gurney, Edmund, 103, 113

Gutekunst, Heinrich G. (father), 35–36

Gutekunst, Lena Obach (wife), 36, 62, 64, 65, 66, 68

Gutekunst, Otto, and Colnaghi Gallery, London, 9, 33–68; American market and, 40, 42, 56–57, 63–64; background and early career, 35–36; Bernard Berenson as agent for, 5, 44, 55; Berenson, Mary, and, 52–55; British aristocracy, purchases of paintings from, 36–37, 38–40; Carstairs and, 38n21, 56, 59; death of Gutekunst, 66; Duveen and, 9, 34, 40, 57–59, 60, 63–64; first meeting with Bernard Berenson, 37n16, 42; Gardner/Bernard Berenson/Gutekunst, triangular relationship between, 9, 34, 38, 39, 40, 42–47, 49–55; Great Depression, retirement of

Gutekunst and World War II, 64, 66–67; Gritti portrait, contention with Bernard Berenson over attribution of, 65–66, 67, 67–68; Holbein affair, 57–60, 58, 60, 61; Old Bond Street offices, 66; as Old Master dealer, 36–42; Pall Mall East offices, 36, 38n19, 61n89, 64; Partridge Building offices, 61–62, 62, 66; photograph of, 35; relationship between Bernard Berenson and Gutekunst, 53–55, 64–68; before and during World War I, 60–63
Gutekunst, Richard (brother), 36

Hadley, Rollin Van N., 8, 70
Hafez, 177, 205
Hahn lawsuit, 290
Hall, Nicholas, 34
Hals, Franz, 337
Halsted, Isabel Hopkinson, 287
Hamilton, Carl, 264n39
Hamilton, George Heard, 294
Hand, Learned, 345
"Hans Across the Sea" (Punch cartoon, 1909), 59, 60
Hardwick, Elizabeth, 358n43
Hare, Augustus, 37n15
Harris, John, 224
Harvard Monthly, 176, 204
Harvard University: Bernard Berenson's education at, 6, 113, 175–177, 179; China Expeditions, 290–293; "Egg and Plaster" course of Edward Forbes, 285; Museum Course, Fogg Museum, 16, 17, 269–271, 272–273, 274, 275–278, 276, 279; Parker Traveling Fellowship, rejection of Bernard Berenson's application for (1887), 13, 84, 175n5, 177–179, 198n68; Porter appointed to research professorship at, 266; Porter's art collection at Fogg Museum, 257; Thompson at, 285–286; Villa I Tatti bequeathed to, 10, 16, 272, 276, 281, 347; Warburg's interest in connection with, 163, 166–168; Yashiro Yukio and, 228–229
Haskell, Francis, 126
Hazlitt, William, 34, 240
Head of Ānada (Javanese, eighth–eleventh century), 14, 218, 219
Hegel, Georg Wilhelm Friedrich, 103, 109, 120, 125–126
Heimann, Jacob, 310, 321
Heinemann, Fritz, 322, 323, 324, 326
Hemingway, Ernest, 18
Hemingway, Mary, 18

Hendrie, Robert, 285
Hendy, Sir Philip, 68
Hercules Strangling Antaeus (Pollaiuolo), 11, 116
Herskovits, Melville, 366, 367–368
Herodotus, 242
Herrick, Robert, 88, 93
Herringham, Lady Christiana, 296
Hesse, Hermann, 122, 128
Heydenreich, Ludwig Heinrich, 147
Hildebrand, Adolf von: Clark on, 3; in Florence, 129, 135, 141; forms, theory of, 11, 12, 104, 105–108, 129, 157; Lisl von Herzogenberg Playing the Organ (plaster cast relief; 1893), 106, 107; photograph of, 105; Das Problem der Form in der bildenden Kunst (1893), 11, 105–107, 108, 129, 157; on tactile values, 11, 104–109, 105, 106, 111, 117, 119, 157; Warburg and, 12, 104, 129
Hildebrand, Lisl (later Brewster; daughter), 106, 107, 117, 118, 119
Hill, Constance Valis, 377
Hill, Derek, 372
Hillenbrand, Robert, 13
Hinks, Roger, 116, 120
Hiroshige, Andō, 211
Hispanic Society of America and Archer Huntington, 17, 338, 341, 346
Histoire de France (Michelet, 1855), 126
History of Aesthetic (Bosanquet), 116n56
History of Greek Culture (Burckhardt), 136
The History of Philosophy (Hegel), 125
Hitchcock, Henry Russell, 271
Hokusai, Katsushika, 135, 209–210, 211
Holbein, Hans, 42, 51, 52, 53, 57–60, 58, 63
Holiday, Billie, 376
Holmes, Charles, 38
Holroyd, Charles, 60
Holy Family (formerly attrib. Maineri), 314
Holy Family with Saint John (Mantegna), 27
Holy Land (Palestine and Syria), Bernard Berenson's "pilgrimage" to, 183, 185, 195, 198n68
homosexuality: Clark believed by Bernard Berenson household to be gay, 232; Hafez love poems, Bernard Berenson's amazement of celebration of men in, 177; of Uhde, 137
Hope Collection, 40
Horne, Herbert, 7, 37, 52, 129, 130, 134, 226
Horowitz, Vela, 245
"house of life," 114, 115
Howard, Jeremy, 9, 33, 415
Huizinga, Johan, 123

Huntington, Anna Vaughan Hyatt (second wife), 336n20, 339, *340*, 341

Huntington, Arabella (mother), *334*, 335–337

Huntington, Archer, 17, 331–347; art collections of parents of, 336–337; Bernard Berenson's membership in American Academy of Arts and Letters and, 17, 346–347; *El Cid* translation of, 17, 338; correspondence with Berensons, 331–332, 337, 338, 339, 345–347; death of (1955), 337, 341; education and intellectual accomplishments, 336, 337–339, 341, 346; first meeting between Berensons and, 332–334, 337; Hispanic Society of America and, 17, 338, 341, 346; marriages of, 339; Mayor diary and, 16, *336n17*, 341–345, *342*; photograph of, *333*; typewriter given to Mary Berenson by, 332; wealth of, 332–336

Huntington, Collis P. (biological father/stepfather), *335*, 335–336, 339n41

Huntington, Ellen Maria (aunt), 339n41

Huntington, George, 201

Huntington, Helen Manchester Gates (first wife/cousin), 339

Huntington, Henry E. (cousin/stepfather), 336n18

Hutchins, Robert Maynard, 364, 365

Hutton, Edward, 226

Hyde, Louis F., 226n55

Hyman, Isabelle, 17, 331, 415

I Tatti. *See* Villa I Tatti

ibn-Khaldun, 202

*Ikonologie*, Warburg's concept of, 144, 155n57

*An Illuminated Life* (Ardizzone, 2007), 5

impressionism, 103–105, 120, 139. *See also specific artists*

Imru'l Qays, 176, *178*

*In the Palace, or Ladies of the Court (Kongzhong tu)*, 229n72

*Innocence* (formerly attrib. Franceschini, now School of Guido Reni), 316

International Conference of 1911, Florence, 11

Isabella Stewart Gardner Museum/Fenway Court: aerial photograph (1925), 77, *79*; Asian art collection compared to Villa I Tatti, 222; commemorative elements of, 98; "cultural re-enchantment," total design of Fenway Court as expression of, 77–86, *79*, *81*; design and construction of, 85–86, 98; Dionites, "Altamura," and *The Golden Urn* as inspiration for, 100; *Eye of the Beholder* (exhibition, 2003), 6, 8; *Gondola*

*Days* (exhibition, 2004), 8; *Journeys East: Isabella Stewart Gardner and Asia* (exhibition, 2009), 8; Old Masters paintings at, 9, 51; Palazzo Barbaro, Venice, and, 80, 98–99; photographs of, *79*, *81*; public mandate of, 80. *See also* Altamura Garden Pavilion, Fenway Court

Islamic art and culture, 12–13, 173–205; aestheticism and, 197–198, 203; architecture, Islamic, Bernard Berenson's interest in, 180, 181–185, 194, 203; Armenian miniatures, Bernard Berenson's brief interest in (ca. 1920), 194n59; collected by Bernard Berenson (1910–13), 173, 188–194, *189*, *191–194*, 204; Damascus, Great Mosque of, *195*, 195–196; defined, 173–174; education of Bernard Berenson in Oriental studies and, 175–177, 179; Greco-Roman and Byzantine culture, viewed as witness to, 81, 196–197, 204; library at I Tatti, Asian and Islamic collection of, 179–180, *189*, 190–194, *191–194*, 204; Munich exhibition of Islamic art (1910), 13, 14, 186–188, *187*; Orientalism and, 12–13, 176, 198–200, 203, 204n89; Orne translations of Arab poems, 176–177, *178*; political views of Bernard Berenson on, 198n68, 200–202; popularity at turn of the century, 187–188; "thought and temperament" reflecting duality of Bernard Berenson's approach to, 174, 204–205; travels of Bernard Berenson in Islamic world, 180–186, *182–184*, 194, 195, 198–200, *199*; views of Bernard Berenson in later years, 193–206

Israel, Bernard Berenson's views on, 198n68, 201–202

Israëls, Machtelt, 6, 13

Italian Art Exhibition, London (1930), 234

*Italian Journey* (Goethe, 1816–17), 123–124

*Italian Painters of the Renaissance* (Berenson, 1930), 14, 101, 102, 104, 116, 119, 120, 156, 229, 245

*Italian Pictures of the Renaissance* (Berenson), 14, 101, 102, 327

Italy, art export laws in, 37

Ivins, William M., Jr. ("Billie"), 341, 349

*Jacob Blessing the Sons of Joseph* (copy of Guercino, before 1646), 318

James, Henry, 80, 87, 111, 117, 128, 133–134

James, William, 7, 11, 103, 104, 109, 111–116, *112*, 117–120, 157, 176

James, William, Jr., 119

354, 357; relationship with Berensons, 350–353, 358–359; tactile values and, 360; at Villa I Tatti, 355–356; Villa Morra, Metelliano, Cortona, 354, 355, 360, 361

Mortimer, Raymond, 372

Mosaddeq, Mohammad, 201

Mostyn-Owen, William, 14–15, 231, 244–245, 246, 265n43, 359n45, 416

Mu'allaqāt, 176, 178

Muir, William, 176

Munich exhibition of Islamic art (1910), 13, 14, 186–188, 187, 219

Müntz, Eugène, 161

Museum Course, Fogg Museum, Harvard, 16, 17, 269–271, 272–273, 274, 275–278, 276, 279

museum ethics, 275

Museum of Fine Arts, Boston, 14

Mussolini, Benito, 352

Muther, Richard, 137

Muzzioli, Giovanni, 314–315, 316

Mystic Marriage of St. Catherine (Zaganelli), 323

Mystic Marriage of St. Francis (Sassetta), 259n24

NAACP (National Association for the Advancement of Colored People), 375

NACF (National Art Collections Fund), 59

Naples Manuscript, published as De arte illuminandi (Naples, Biblioteca Nazionale), 294

Nash, Paul, 247

Nasser, Gamal Abdel, 201

National Art Collections Fund (NACF), 59

National Association for the Advancement of Colored People (NAACP), 375

Nativity (Loschi), 318

Nazism, Bernard Berenson on, 201–202

Nelli, Ottaviano, 322

Nelson, Jonathan K., 6, 7

"The New Art Criticism," 113

New Deal, 346

New Theory of Vision (Berkeley, 1709), 103n5

Newhall, Beaumont, 271

Nietzsche, Friedrich Wilhelm, 103, 104, 109–110, 111, 114, 115, 117, 161

Nivedita, Sister, Margaret Elizabeth Noble, 213

Nöldeke, Theodor, 176

Norfolk, Duke of, 57, 59

North Italian Painters (Berenson, 1907), 24n23, 104n6, 155n11, 211

Norton, Charles Eliot, 44, 79, 80, 84, 146, 147–148, 207–208, 254, 273, 276–277

The Nude (Clark, 1956), 234, 238, 247

Obach family, 36, 62, 64

Oberlin cassone (Apollonio di Giovanni), 152

Obrist, Hermann, 130, 135, 139

Offner, Richard, 156, 223, 227, 265

Okakura Kakuzo, 82, 98, 213, 216

The Old Man and the Sea (Hemingway, 1952), 18

The Old Masters (play; Gray), 5

Olmsted, Frederick Law, 73–74, 74

Olympia (Manet), 137, 140

One Thousand and One Nights, Bernard Berenson's fondness for, 179, 197n67, 203

One Year's Reading for Fun (Berenson, 1942), 240

Order of the White Rose, 79

Orientalism, 12–13, 176, 198–200, 203, 204n89

Original Treatises on the Arts of Painting (Merrifield, 1849), 285

Origo, Iris, 1–2, 344

Orleans Collection, 49

Orne, John, Jr., 176–177, 178

Orsi, Lelio, 322

Orsini, Prince, 131

otium, 89

Oxford Movement, 78

Oxford University, 5, 7, 93, 232, 277, 384

Pagan Sacrifice (panel, attrib. Roberti/School of Mantegna/Bellini), 325–327

Pagan Sacrifice (pendant at Saltwood Castle), 326

Paget, Violet. See Lee, Vernon

Paine, Robert Treat, 215

Palazzo Barbaro, Venice, 80, 98–99

Palestine and Syria, Bernard Berenson's "pilgrimage" to, 183, 185, 195, 198n68

Palladio, 124

Pallas and the Centaur (Botticelli), 123

Palma il Giovane, Jacopo, 319

Palmezzano, Marco, 319

Pancrazi, Pietro, 352, 355

Panofsky, Erwin, 168, 276

Panciatichi, Marchese, 317

Papafava, Francesco, and Papafava family, 352n13, 360

Parker Traveling Fellowship application, rejection of (1887), 13, 84, 175n5, 177–179, 198n68

Partridge, Ethel (later Mairet), 215

passatism, 139

Passerin d'Entrèves, Alessandro, 352, 359, 361

Passerini, Count Lorenzo ("Renzo"), 356n32, 357